Al-Andalus

THE ART OF ISLAMIC SPAIN

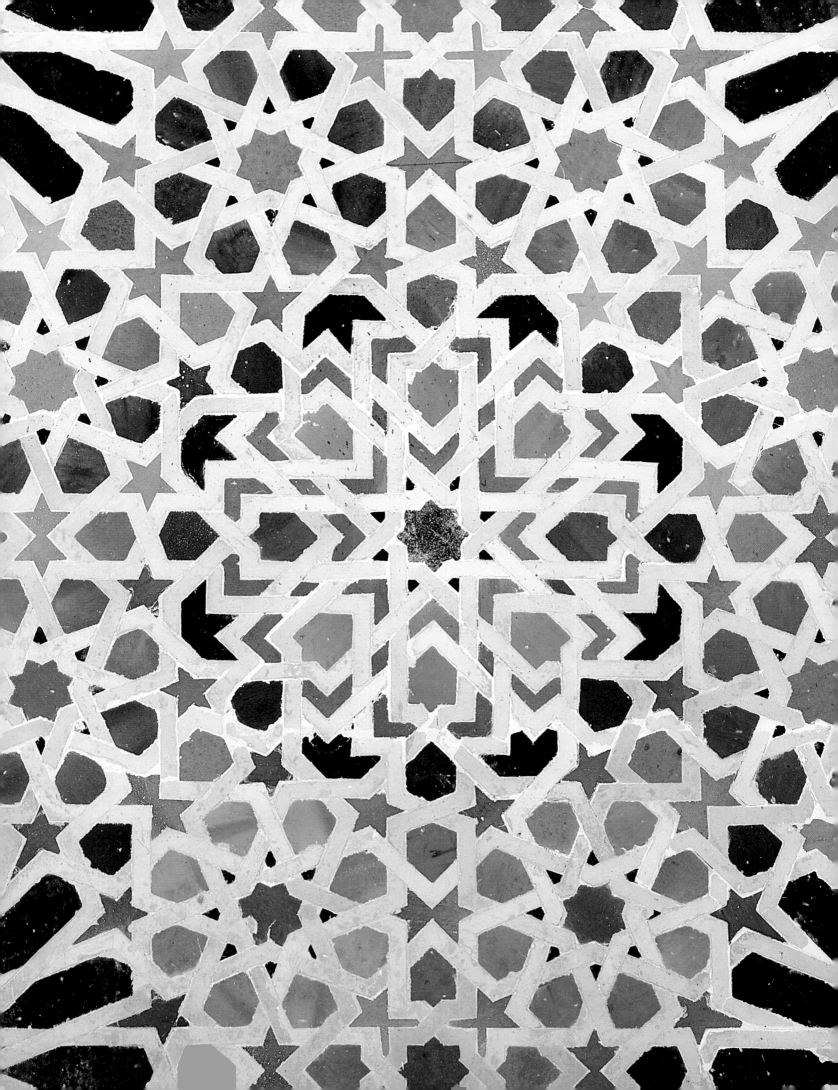

Al-Andalus

THE ART OF ISLAMIC SPAIN

EDITED BY JERRILYNN D. DODDS

THE METROPOLITAN MUSEUM OF ART, NEW YORK

DISTRIBUTED BY HARRY N. ABRAMS, INC., NEW YORK

This publication is issued in conjunction with the exhibition *Al-Andalus: The Art of Islamic Spain*, held at the Alhambra, Granada (March 18–June 7, 1992), and The Metropolitan Museum of Art, New York (July 1–September 27, 1992).

The exhibition was organized by The Metropolitan Museum of Art, New York, and the Patronato de la Alhambra y Generalife, under the joint patronage of the Junta de Andalucía, the Ministerio de Cultura, and the Ayuntamiento de Granada; it was sponsored by Banco Bilbao Vizcaya.

Transportation assistance has been provided by Iberia Airlines of Spain.

Additional support for the exhibition in New York has been provided by the National Endowment for the Humanities, a federal agency, and by an indemnity from the Federal Council on the Arts and the Humanities.

Published by The Metropolitan Museum of Art, New York

John P. O'Neill, *Editor in Chief*
Carol Fuerstein, *Editor*, assisted by Rachel Moskowitz Ruben, Joanne Greenspun, Barbara Cavaliere, Tayeb El-Hibri, Cynthia Clark, Ann M. Lucke, Kathleen Howard, Joan Holt, and Emily Walter
Bruce Campbell, *Designer*
Gwen Roginsky, *Production Manager*, assisted by Susan Chun

Many photographs taken in Spain and Morocco for this volume were commissioned by The Metropolitan Museum of Art: Site photography by Raghubir Singh, London, and Archivo Fotográfico Oronoz, Madrid; object photography by Bruce White, The Photograph Studio, The Metropolitan Museum of Art; Sheldan Collins, New York; and Archivo Fotográfico Oronoz, Madrid. For a complete listing of photograph credits, see p. 432.

Set in Aldus and Medici Script by U.S. Lithograph, typographers, New York
Separations by Professional Graphics, Rockford, Illinois
Printed by Julio Soto Impresor, S.A., Madrid
Bound by Encuadernación Ramos, S.A., Madrid

Translations from the Spanish by Margaret Sayers Peden except Juan Zozaya essay and entries 17–19, 50, 51, 53, 70–73 by Edith Grossman; Guillermo Rosselló Bordoy essay and entries by John Upton; Christian Ewert essay from the German by K. Watson, London; entries by Abdellatif El-Hajjami and Lhaj Moussa Aouni from the French by Ernst van Haagen

Maps by Wilhelmina Reyinga-Amrhein, plans by Irmgard Lochner except those on pp. 86, 88, 90–92, 94 by Christian Ewert and p. 171 by Francisco Prieto-Moreno

Jacket / Cover Illustrations
Front: Patio de los Leones, the Alhambra
Back: No. 3, *Pyxis of al-Mughīra*

Frontispiece
Detail, No. 119, *Panel from the Mexuar, the Alhambra*

LIBRARY OF CONGRESS CATALOGING-IN-PUBLICATION DATA

Al Andalus: the art of Islamic Spain / edited by Jerrilynn D. Dodds.
 p. cm.
 Exhibition catalog.
 Includes bibliographical references and index.
 ISBN 0-87099-636-3. — ISBN 0-87099-637-1 (pbk.). —ISBN 0-8109-6413-9 (Abrams)
 D.L. M-5599-1992
 1. Art, Islamic—Spain—Exhibitions. 2. Art, Medieval— Spain—Exhibitions.
3. Art—Spain—Exhibitions. I. Dodds,
Jerrilynn Denise.
N7103.A4 1992
709'.46'80747471—dc20
 91-41335
 CIP

Contents

Director's Foreword

Al-Andalus: The Art of Islamic Spain bears witness to the brilliant Islamic culture that was a preeminent force on the Iberian Peninsula from the year 711 until 1492. The exhibition, for the first time in a retrospective of such proportions, focuses on the profound cultural imprint left by Islam on the multifaceted mirror of the peninsula, an imprint whose subtle influence was felt as far away as northern Europe and the New World, when, in the sixteenth and seventeenth centuries, Spain's mighty Christian empire embarked on its mission of conquest. The only part of Europe with a heritage based in both Christianity and Islam, Spain, during its "golden age," occupied a position of absolute supremacy in a program of vast cultural expansion.

The magnificent legacy of Spanish Islam has yet to be fully explored and appreciated. Many of those elements of Islam that were absorbed over the centuries were carried imperceptibly forward in the great age of Spanish influence. Others traveled to North Africa, to Turkey and the eastern Mediterranean, and to France and Italy with refugee communities of Jewish and Muslim artisans, whose expulsion from Spain began in 1492 and continued into the following century. Today, echoes of Islamic culture are still discernible in the life of Spain—in the language, in place names, culinary habits, music and dance, and in many trades and crafts. Yet hand in hand with this great cultural diffusion came the fragmentation of a unique artistic culture, and so it has remained, dispersed, for half a millennium.

Now, with the unique collaboration of the Government of Spain and the Patronato de la Alhambra y Generalife, The Metropolitan Museum of Art has brought together more than one hundred objects from collections in the United States, Europe, North Africa, and the Middle East. Many are drawn from Spain's own museums, libraries, monasteries, and cathedral treasuries. These are seen first in the extraordinary setting of the Alhambra, the crowning Islamic architectural achievement in Spain, providing an opportunity for many treasures to return to their place of origin for the first time in five hundred years. The exhibition then travels to The Metropolitan Museum of Art in New York, where it will re-create for the American public a richly complex and relatively unknown civilization.

Al-Andalus: The Art of Islamic Spain has been five years in the making. In 1987 the Ministerio de Cultura of Spain approached the Museum with a proposal to mount an exhibition of Islamic art in Madrid in 1992. The Metropolitan was already collaborating with Spain, in particular with the Prado, on a number of exhibitions: *Zurbarán* had just opened; *Goya and the Age of Enlightenment* was under way; and *Velázquez* was in its earliest stages of discussion. The Islamic holdings of the Metropolitan Museum rank among the finest in the world, and the idea of sharing them with Spain on the occasion of the quincentennial seemed part of a natural progression. Negotiations were entrusted to Dr. Mahrukh Tarapor, then Special Assistant to the Director for Exhibitions. It was her idea to focus the exhibition on Spain's Islamic heritage and to mount it at the Alhambra; over the next two years this creative initiative was enthusiastically supported and advanced by the Government of Spain. The Junta de Andalucía, in an act of remarkable generosity, sanctioned the participation of the Alhambra in the project, and in October 1990 a Protocol Agreement was signed in Granada confirming that the Alhambra itself would house an exhibition of masterpieces created in Spain during the period of Islamic presence. The signatories were the Junta de Andalucía, the Ministerio de Cultura, the Ayuntamiento de Granada, the Banco Bilbao Vizcaya, and The Metropolitan Museum of Art.

We wish to extend singular thanks and profound appreciation to the following individuals: in the Junta de Andalucía, Manuel Chaves González, Presidente; Juan Manuel Suárez Japón, Consejero de Cultura y Medio Ambiente; and José Guirao Cabrera, Director General de Bienes Culturales; in the Ministerio de Cultura, Jordi Solé Tura, Ministro de Cultura de España; and José María Luzón Nogué, Director General de Bellas Artes y Archivos. We also wish to acknowledge the early encouragement and support of former ministers Javier Solana Madariaga, and Jorge Semprún Maura, as

well as former Subsecretario Miguel Satrústegui Gil-Delgado.

We are grateful as well to the Ayuntamiento de Granada, and in particular to the Patronato de la Alhambra y Generalife, through whose Comisión Técnica the project moved efficiently forward.

An exhibition is, ultimately, only as good as the generosity of its lenders, and here we are indebted to almost seventy institutions, whose names we list, with gratitude, on pages XVI–XVII. To colleagues outside Spain we would like to add a special word of thanks for their enthusiastic and ready collaboration in this unusual endeavor. In particular we wish to acknowledge the Kingdom of Morocco, which has sent many of its finest treasures to the exhibition. The Metropolitan Museum is mindful of this privilege and extends special thanks to Driss Basri, Ministre de l'Intérieur, and Mohamed Benaissa, Ministre de la Culture, for their ready endorsement of this venture.

An exhibition of such magnitude would not have been possible without the financial support of Banco Bilbao Vizcaya, whose generous assistance has further ensured that the exhibition be seen in both Spain and the United States. We would like to acknowledge, specifically, its President and Chairman of the Board, Emilio Ybarra y Churruca. We would also like to thank Iberia Airlines of Spain, in particular Miguel Aguiló, President and Chairman of the Board, for providing transportation assistance for the exhibition. Additional support for the exhibition in New York has been provided by the National Endowment for the Humanities, a federal agency, and by an indemnity from the Federal Council on the Arts and the Humanities.

To Plácido Arango, I want to extend my appreciation for his help on many levels, with this venture as with our many other projects in Spain. Indeed, this institution is greatly in his debt and is most proud to have his services as a trustee.

I salute and thank my colleague and fellow director Mateo Revilla Uceda for his unwavering commitment to a difficult and complicated project; for sharing with us that most precious loan of all, the Alhambra, to the direction of which he brings such energy and vision; for his gracious hospitality, over a period of nearly three years, to various members of the Metropolitan's exhibition team; and, above all, for the generosity and determination that have made this collaboration possible.

Finally, I would like to conclude with an envoi in profound gratitude and in praise of Mahrukh Tarapor, Assistant Director, the architect of this project, for which she has been virtually the mind and the heart. This is a characterization she will no doubt protest. But so long as those whose invaluable roles acknowledged above do not begrudge her this honor—as I feel sure they will not—I would like it to stand. This is because mind and heart best describe, on the one hand, the seriousness and scholarship, and, on the other, the inspiration and encouragement with which she has infused this immensely complex transatlantic, even global, project.

PHILIPPE DE MONTEBELLO
Director
The Metropolitan Museum of Art

Acknowledgments

In the five years since this exhibition was first conceived, a vast network of collaborative effort has slowly established itself on both sides of the Atlantic, expanding inevitably into a network of mutual indebtedness. My own foremost debt is to Philippe de Montebello and Mateo Revilla Uceda, without whose vision and courage this landmark exhibition could not have taken place. To each I can offer only the most inadequate expression of thanks, but surely it is rare indeed to have the opportunity to work so closely and with so much pleasure with two equally remarkable and dedicated directors. In what must have sometimes seemed an act of blind faith, one director committed the abundant resources of his institution to the fulfillment of an idea, while the other pledged the monument itself. As a result, three extraordinary objectives have been achieved: The Metropolitan Museum of Art, for the very first time, has initiated and organized an international loan exhibition in another country; the Alhambra, for the first time in five centuries, has gathered within its great halls masterworks from the rich artistic period of which this monument itself is the last poignant testimony; and the relatively undocumented art traditions of Islamic Spain have been examined in the first major exhibition devoted to the subject.

Al-Andalus: The Art of Islamic Spain is the largest and most comprehensive exhibition ever held of Spanish Islamic art during its period of highest accomplishment, the eighth through the fifteenth century. Nearly seventy institutions from fifteen countries agreed to participate in this venture by graciously lending works in their collections. Two deserve mention for their special generosity: the Museo Arqueológico Nacional, Madrid, and the Museo Arqueológico Provincial de Córdoba. Countless scholars, museum authorities, government officials, collectors, churchmen, translators, and friends have lent their time, support, and professional skills to the implementation of this project and to the creation of its ambitious catalogue. Some were especially instrumental in searching out elusive loans, and others, in particular Juan Zozaya Stabel-Hansen, Subdirector, Museo Arqueológico Nacional, Madrid,

offered constant and generous guidance. In Paris, Ute Collinet, Secrétaire Général, Réunion des musées nationaux, and Jean-Claude Meyer provided valuable assistance at critical moments, and in Berlin, Prof. Dr. Michael Meinecke, Director, Museum für Islamische Kunst, was a most helpful colleague. We are particularly indebted as well to Lord Palumbo, Chairman, Arts Council of Great Britain, José Angel Sánchez Asiaín, Presidente, Real Patronato del Museo del Prado, Madrid; and Jacques Soulillou, Director of Visual Arts, French Embassy, New York; and to Adi B.K. Dubash and Mrs. Kulsum Dubash, Honorary Consul, Consulate of Spain, Bombay. We also wish to thank Jonathan M. Bloom, Manuel Casamar Pérez, James Dickie, Christian Ewert, Thomas F. Glick, Francisco Godoy Delgado, Oleg Grabar, Purificación Marinetto Sanchez, Cristina Partearroyo Lacaba, Albert Rivera, Guillermo Rosselló Bordoy, D. Fairchild Ruggles, and Antonio Vallejo Triano. Both the exhibition and the catalogue have benefited immensely from their learned and scholarly contributions. Others to whom we extend our thanks are Charles Gifford, Julián Hernandez Miranda, Nina von Krogh, Margarita Mejía, and Marilyn Orozco.

The collaboration of more than twenty scholars both from within and outside Spain has been spearheaded by Dr. Jerrilynn D. Dodds, Associate Professor of Art and Architecture, City College, City University of New York, and Special Consultant for this project, whose guiding intelligence has shaped and molded the exhibition into a coherent whole. Working closely with Daniel Walker, Curator in Charge, Department of Islamic Art, Dr. Dodds selected the objects for the exhibition in consultation with her Spanish colleagues and edited the catalogue with the same intellectual rigor and generosity of spirit that have characterized every aspect of her involvement with this enterprise. We single her out, gratefully, for special thanks.

Converting, even for the brief period of the exhibition, the halls of the open and windswept Alhambra into a museum was in many ways the most critical and daunting aspect of the entire undertaking. It was recognized from the outset that the Alhambra's extraordinary

beauty, depending as it does for its effect on sinuous interweavings of light and shade, on subtle balances of interior and exterior space, on the playful and reposeful uses of water, and on a brilliantly kaleidoscopic decorative scheme, could not be compromised in any way. Nor could any original surface of the monument be touched or interfered with for purposes of installation. The technical teams of the Metropolitan Museum and the Alhambra, in consultation with the Comisión Técnica del Patronato de la Alhambra, were therefore called upon to exercise every possible ingenuity in the solution of such routine museum concerns as conservation and climate control, lighting design, and security. I would like to record my personal thanks to those listed below for their cooperative effort and for the patience, persistence, and good humor with which they cleared a seemingly endless path of obstacles, allowing the exhibition to progress steadily to its final grand design. They are: from The Metropolitan Museum of Art, Linda M. Sylling, Assistant Manager, Operations; Franz J. Schmidt, Manager, Buildings; Jack Soultanian, Jr., Conservator, Objects Conservation; David Harvey, Senior Exhibition Designer; Zack Zanolli, Lighting Designer; and John Barelli, Security Manager; from the Alhambra, Luciano Rodrigo Marhuenda, Jefe del Servicio de Conservación; Carmen Navarrete Aguilera, Jefe del Departamento de Restauración; Jésus Bermúdez López, Jefe del Departamento de Investigación y Difusión Cultural; Jorge Calancha de Passos, Jefe del Departamento de Obras; Julián Casares Garrido, Secretario General; Rocio Liñan Corrochano, Jefe del Negociado de Visitas; Genoveva Fernández Sánchez, Secretaria de Dirección; and Antonio Fernández Ortega, Jefe del Departemento Didáctico.

Til Hahn, of Glasbau Hahn, Frankfurt, shared his expertise in the first exploratory stages of the exhibition and patiently worked with us to design and create display cases that served the Alhambra's particular environmental needs.

Other Metropolitan Museum colleagues have made valuable contributions: William D. Wixom, Chairman, Department of Medieval Art and The Cloisters; Stuart W. Pyhrr, Curator, Department of Arms and Armor; William S. Lieberman, Jacques and Natasha Gelman Chairman, Department of Twentieth Century Art; Emily Kernan Rafferty, Vice President, Development and Membership; Daniel Berger, Manager, Mezzanine Gallery and Corporate Sales; Sharon H. Cott, Assistant Secretary and Associate Counsel; Kathrin Colburn, Assistant Conservator, Textile Conservation, The Clois-

ters; Herbert M. Moskowitz, Registrar; and Barbara Weiss, Graphic Designer. Richard R. Morsches, Vice President, Operations; Jeffrey L. Daly, Chief Designer; Nobuko Kajitani, Conservator, Textile Conservation; and James H. Frantz, Conservator in Charge, Objects Conservation, have endured, with abundant good will, frequently inconvenient absences of the staffs of their departments. We are grateful also to Laurence B. Kanter, Curator, Robert Lehman Collection, and to the Robert Lehman Foundation for making the Robert Lehman Wing galleries available for the exhibition in New York. Above all, I am indebted to Martha Deese, Senior Assistant for Exhibitions, who devoted her formidable organizational talents to handling all correspondence with lenders and to coordinating a wide variety of curatorial, administrative, and editorial responsibilities. It is not too much to say that her high degree of professionalism and unfailing good cheer have ensured the smooth and efficient advance of the exhibition from beginning to end.

Like the exhibition, the catalogue too is an international endeavor. It is our hope that it will be not only a record of the exhibition but also serve as a pioneering reference for the future study of the art of Islamic Spain. Its overall supervision and the shaping of its concept and design were the responsibility of John P. O'Neill, Editor in Chief and General Manager of Publications. The catalogue was edited by Carol Fuerstein, Senior Editor, whose skill and devotion were essential to its integrity and to its timely completion. Gwen Roginsky, Production Manager, corrected the color proofs and coordinated all phases of production. Bruce Campbell contributed the elegant and functional design. Susan Chun, Production Associate, and Rachel Moskowitz Ruben, Research Assistant, aided the project in their separate capacities.

Ediciones El Viso, Madrid, prepared the Spanish-language edition of the catalogue under the direction of its publisher, Santiago Saavedra, whose close collaboration on both the conception and development of the catalogue proved immensely valuable at every stage. His critical assistance has also extended to the exhibition, and I would like to thank him for being always the best of colleagues, as well as, to all of us who worked with him, a special friend. In his office, Lola Gómez de Aranda handled all details pertaining to the catalogue with skilled professionalism and inexhaustible energy.

We also wish to acknowledge the outstanding object photography of Bruce M. White of the Metropolitan Museum, Sheldan Collins of New York, and Javier

Oronoz of Madrid. Architectural and site photography in Spain was executed by the renowned photographer Raghubir Singh.

Among the most significant economic and cultural connections of al-Andalus were its ties with Morocco, its southern neighbor. For the Metropolitan Museum, one of the most gratifying experiences associated with the exhibition has been the discovery and exploration of Morocco's art treasures. We have been the recipients, in Rabat, Fez, and Marrakesh, of the richest traditions of Islamic hospitality, for which we offer our heartfelt thanks to officials of the Kingdom of Morocco: in Rabat, Driss Toulali, Directeur Général des Collectivités Locales, Ministère de l'Intérieur; Mohammed Melehi, Directeur des Arts, Ministère de la Culture; Abdelaziz Touri, Directeur du Patrimoine, Ministère de la Culture; and Mohamed Larbi El Khattabi, Conservateur, Bibliothèque Royale; in Fez, Mhamed Dryef, Wali de la Province de Fès; Abdellatif El-Hajjami, Directeur Général, Agence pour la Dédensification et la Réhabilitation de la Médina de Fès, Ministère de l'Intérieur; Hnia Chikhaoui, Chargé de la Conservation, Musée du Batha; and Lhaj Moussa Aouni, Archéologue et Collaborateur de l'Ader Fès; in Marrakesh, Ahmed Ben Yamani, Inspecteur des Monuments Historiques, Ministère de la Culture; Hassan Belarabi, Conservateur, Musée Dar Si Said; Hassan Sabah, Conservateur, Bibliothèque Ben Youssouf; and Zaki Boudelfa, Caid du Cabinet, Wali de Marrakech.

Our most profound thanks we have reserved for those government officials and museum colleagues in Spain without whom this exhibition could not have been realized. More than fifty percent of the exhibited works have been drawn from museums, private institutions, libraries, and ecclesiastical collections across the length and breadth of Spain. Officials in the Ministerio de Cultura, Spain, and the Junta de Andalucía, particularly, José María Luzón Nogué, Director General de Bellas Artes y Archivos, Ministerio de Cultura, and José Guirao Cabrera, Director General de Bienes Culturales, Junta de Andalucía, have provided invaluable advice and ready assistance at all stages, and to Philippe de Montebello's thanks I would like here to add my own appreciation of their many efforts on our behalf. Our communications with Spanish lenders have been facilitated at every level by the efficient intervention of Javier Aiguabella of the Centro Nacional de Exposiciones, Ministerio de Cultura, which is headed by Rosa Garcia Brage. The conservation of certain Spanish loans by the Instituto de Conservación y Restauración de Bienes Culturales (I.C.R.B.C.) has also been coordinated by Mr. Aiguabella. At I.C.R.B.C. we wish to thank Maria Paz Bolaños, Maria Isabel Herraiz, Maria Carmen Saldaña y Paz Navarro (Materiales), and Socorro Mantilla de los Ríos, Pilar Borrego y Camino Represa (Tejidos), as well as Dionisio Hernandez Gil, Director, and José Maria Losada, Subdirector de Bienes Muebles, for their expert assistance. We have valued especially the lively and informed interest that both Antonio Lopez Fernández and Carlos Paramés Montenegro of Banco Bilbao Vizcaya have extended to this project. Emilio Cassinello Aubán, Comisario, EXPO '92, Seville, has also been an intellectually stimulating and generous colleague.

Production of the video documentary that accompanies the exhibition has involved close collaboration with our colleagues in Madrid at Sogetel, and we acknowledge especially the efforts of Miguel Satrustegui Gil-Delgado, Project Manager; Miguel Salvat, Executive Producer; and Pablo Romero, Script Cowriter and Coordinator.

In conclusion, I would like to express my profound appreciation to four special friends whose encouragement and guidance contributed in no small measure to the success of *Al-Andalus*. Simeon Saxe-Coburg has enriched the exhibition by providing indispensable assistance in securing several important loans. Leopoldo Rodés has offered, unstintingly, both hospitality and efficient help. The exhibition has benefited enormously from the continued enthusiasm of Juan Cruz, and through him I have learned many valuable lessons about Spain's multifaceted culture. Above all, Plácido Arango has offered unwavering support and good counsel. For his friendship, and for his tireless efforts on behalf of the exhibition, I shall be lastingly grateful.

MAHRUKH TARAPOR
Assistant Director
The Metropolitan Museum of Art

Sponsor's Statement

In Washington Irving's sketches in *The Alhambra*, written in 1829, we read: "To the traveller imbued with a sense of the historical and poetical, so inseparably intertwined in the annals of romantic Spain, the Alhambra is as much an object of devotion as is the Caaba to all true Moslems." Many years earlier, in 1431, King John II of Castile, too, was fascinated by the beauty of the site, as is recounted, somewhere between history and legend, in *El Romance de Abenámar*:

"What castles are those shining there?
How tall they are upon the hill!"
"Alhambra, they call one, my lord,
the other is the Muslim temple."

This tall and shining palace is a unique setting for an exceptional selection of objects that represent almost eight centuries of Spanish history, a show that undoubtedly will be one of the major events of the 1992 quincentennial celebrations and one that for many reasons is symbolic for all Spaniards.

The Banco Bilbao Vizcaya takes very special satisfaction in participating in this project in conjunction with The Metropolitan Museum of Art in New York and various government and civic bodies in Spain: the Ministerio de Cultura, the Junta de Andalucía, the Ayuntamiento de Granada, and the Patronato de la Alhambra y Generalife. This exhibition is palpable proof of the efficacy of cooperation among the public sector, not-for-profit organizations, and private enterprise, all at the service of the noble cause of culture.

EMILIO YBARRA Y CHURRUCA
Presidente
Consejo de Administración, Banco Bilbao Vizcaya

Official Statements

The end of the last Islamic reign on the Iberian Peninsula and the discovery of America, both of which occurred in 1492, are historical landmarks that to a large degree imprint and distinguish the modern age in Spain and in Europe in general. Now, on the occasion of the quincentenary, we should recall that Andalusia was the setting for both events.

Today a meticulously selected exhibition of Islamic art evokes in Granada and in New York nearly eight centuries of Hispano-Islamic civilization and its rich contributions to the Spanish cultural heritage. Certainly this multiple legacy is evidenced in our language, customs, and habits, and helped to shape the structure of our territory. However, this legacy reached one of its most elevated peaks in artistic expression, in the numerous objects and decorative details that filled the halls and embellished the galleries of the handsome Naṣrid palaces.

These same riches serve now, five centuries later, to commemorate the creativity of the consummate artisans who produced them. Once again reunited in their original surroundings, they suddenly seem to revitalize the spell and fascination of the Alhambra.

The organization of a cultural event of the proportions of this exhibition demands the combined efforts and will of many institutions and individuals. The successful realization of this project has been made possible by the impetus provided by the Junta de Andalucía, the Ministerio de Cultura, and the Ayuntamiento de Granada, the invaluable participation of New York's renowned Metropolitan Museum of Art, the beneficent support of Banco Bilbao Vizcaya and Iberia Airlines of Spain, and the generosity of the many institutions that lent extremely valuable pieces.

MANUEL CHAVES GONZÁLEZ
Presidente
Junta de Andalucía y del Patronato de la Alhambra y Generalife

The arts of al-Andalus represent one of the most brilliant chapters in the history of centuries of superimposed cultures on the Iberian Peninsula. Hispano-Islamic master builders, craftsmen, and artists of every kind created works and styles we still see reflected in many areas of traditional Spanish popular art. Islamic medieval arts are even today among the most significant components of Spanish culture. The current exhibition at the Alhambra and at The Metropolitan Museum of Art is, therefore, intimately tied to one of the quintessential facets of Andalusian identity.

The pieces displayed at the Alhambra form a unity with the edifice in which they are housed, a unity impossible to realize in traditional exhibitions. Architecture embraces an assiduously selected group of pieces to form a harmonious and unique whole. Certain objects that were removed some five hundred years ago have been returned to the Alhambra; the beauty and uniqueness of others have been enhanced by the splendid setting.

The labor demanded by this undertaking has been exhaustive and difficult; thanks to the substantial efforts of a large group of specialists and the generous collaboration of the numerous museums involved in marking the historic date this exhibition celebrates, we have the good fortune to view the artistic grandeur of al-Andalus in the Alhambra of Granada, as well as at The Metropolitan Museum in New York. To all those concerned we offer our congratulations and our gratitude.

JORDI SOLÉ TURA
Ministro de Cultura de España

Coordination and dialogue between public institutions and private enterprise generates meaningful projects from which the public benefits. We now find ourselves on the threshold of just such an undertaking, the exhibition *Al-Andalus: The Art of Islamic Spain*, organized by The Metropolitan Museum of Art in New York with the collaboration of the Patronato de la Alhambra y Generalife under the joint patronage of the Junta de Andalucía, the Ministerio de Cultura, and the Ayuntamiento de Granada, with the additional sponsorship of the Banco Bilbao Vizcaya. The exhibition, housed in the Naṣrid palaces of the Alhambra before it travels to the Metropolitan Museum, brings together an array of objects of inestimable value—value that is even more emotional than material. In recent times these objects have been scattered about the globe, but now they will be on view for nearly three months in a space with universal meaning.

The symbiosis of the Alhambra and the city will be reinforced this year by the display of more than one hundred objects from the Hispano-Islamic epoch, the legacy of a civilization that cultivated, in addition to knowledge, arts that are firmly entrenched in Granada even now, as we approach the dawn of the twenty-first century: agriculture, the industrial arts, and commerce. The city responds to the wisdom of the selection of the Alhambra to house the exhibition and recognizes that this is the greatest possible homage to our ancestors, whose sensibilities, revealed in the beauty of their Naṣrid palaces, we appreciate and admire.

Visitors in general and we citizens of Granada in particular have the opportunity to relive a period of history in its most natural ambience. A walk through the Alhambra during the course of this exhibition offers us a direct bridge to a past that anticipated the future: Granada as a city open to all cultures. With the presentation of *Al-Andalus: The Art of Islamic Spain*, the sense of the principal role Granada plays in our culture will be reevaluated; I trust, therefore, that the relationship among the institutions involved in this event and others taking place in the city will establish the foundation for future collaborations.

I take this opportunity to express my hope—and that of all the citizens of Granada—that *Al-Andalus: The Art of Islamic Spain* will be a major event; indeed the Ayuntamiento and the city of Granada have labored for it with high expectations of success.

JESÚS QUERO MOLINA
Alcalde
Granada

Al-Andalus: The Art of Islamic Spain, which marks the quincentenary of the taking of Granada by the forces of Ferdinand and Isabella, captures our attention for two primary reasons. First, the exhibition's more than one hundred pieces from many different institutions offer a comprehensive image of Spanish-Islamic art through its several periods; second, because the objects displayed represent most of the typical techniques and materials of the art of al-Andalus (stone, ivory, ceramic, wood, metal, textiles) and a great diversity of function (ornamental, ritual, military), they demonstrate the wide range of creativity of Spanish-Islamic culture. A further attraction of the exhibition is the first setting in which it is presented, the Naṣrid palaces of the Alhambra.

Care has been taken to establish a dialogue between objects and architectural space at the Alhambra, thereby enriching our appreciation of both. The works of art assume a special quality in relation to the surroundings of the palaces; the architecture, in turn, is enhanced by the presence of the works of art. Architecture and objects originated from shared aesthetic presumptions and shared formal and technical principles: technical knowledge and manual skill, mastery of the medium and perfection of detail, decorative richness and a particular codification of imagination, and the unfailing presence of the arabesque and of script as distinctive and specific elements of the Muslim artistic sense, a presence that lends unity to all its plastic manifestations.

Temporarily ''rescued'' from the museums in which they are located today, these works glow with a different light within the walls of the Alhambra. Similarly, we perceive the palaces, with arabesques, inscriptions, and remains of polychromy displayed on their walls, as objects as precious as those housed for a time within them. Our eye rests on an object and then on a fragment of architecture, and in the two we appreciate that formal unity to which we have already alluded. Thus, not only the intrinsic interest of the pieces displayed but also their setting contribute to our fascination with this exhibition conceived to commemorate the enriching role Islamic culture played five centuries ago in Spain.

It is not difficult to imagine the technical and practical difficulties inherent in organizing an event of this nature in the Alhambra. Those difficulties were overcome thanks to four years of constant communication and interchange of ideas with the Assistant Director of The Metropolitan Museum of Art, Dr. Mahrukh Tarapor, the enthusiastic participation of the staff of the Metropolitan and the Conjunto Monumental of Granada, and the support of its Comisión Técnica. We want to express our appreciation for the bold vision of the Patronato de la Alhambra y Generalife and most especially to the members of its Comisión Permanente, His Excellency the Consejero de Cultura y Medio Ambiente, Juan Manuel Suárez Japón, our esteemed Alcalde of Granada, Jesús Quero Molina, the distinguished Director General de Bellas Artes, José María Luzón Nogué, and the distinguished Director General de Bienes Culturales of the Junta de Andalucía, José Guirao Cabrera; because of their valuable services we are able to offer this extraordinary exhibition.

MATEO REVILLA UCEDA
Director
Patronato de la Alhambra y Generalife

Lenders to the Exhibition

FOREIGN (excluding Spain)

Badiʾ Palace, Marrakesh

Basilique Saint-Sernin, Toulouse

Bayerische Staatsbibliothek, Munich

Biblioteca Apostolica Vaticana, Rome

Bibliothèque Ben Youssouf, Marrakesh

Bibliothèque Nationale, Paris

Bibliothèque Royale, Rabat

Braga Cathedral Treasury, Portugal

The British Museum, London

The David Collection, Copenhagen

Galleria Regionale della Sicilia, Palermo

General Egyptian Book Organization, Cairo

Germanisches Nationalmuseum, Nuremberg

Istanbul University Library

Kunsthistorisches Museum, Vienna

Madrasa Ben Youssouf, Marrakesh

Musée du Batha, Fez

Musée du Louvre, Paris

Museo Nazionale di San Matteo, Pisa

Museo dell'Opera del Duomo, Pisa

Museum für Islamische Kunst, Staatliche Museen
zu Berlin, Preussischer Kulturbesitz

Museum of Turkish and Islamic Art, Istanbul

Qarawiyyīn Mosque, Fez

Staatliche Kunstsammlungen, Kassel

State Hermitage Museum, St. Petersburg

Topkapi Saray Museum Library, Istanbul

Uppsala Universitetsbibliotek

Victoria and Albert Museum, London

SPAIN

Archivo Municipal de Tudela (Navarra), Spain

Ayuntamiento de Murcia, Centro de Estudios Arabes y
Arqueológicos "Ibn Arabi"

Ayuntamiento de Valencia

Cabildo Metropolitano de Zaragoza

Instituto de Valencia de Don Juan, Madrid

Monasterio de Santa María, Santa María la Real de
Huerta, Soria

Monasterio de Yuso, PP Agustinos Recoletos, Logroño,
Spain

Museo del Almudín, Játiva

Museo Arqueológico de Granada

Museo Arqueológico Nacional, Madrid

Museo Arqueológico Provincial de Córdoba

Museo Arqueológico de Sevilla

Museo de Burgos

Museo Diocesano-Catedralicio, Burgos

Museo del Ejército, Madrid

Museo Episcopal y Capitular de Arqueología Sagrada,
Huesca

Museo de Mallorca, Palma de Mallorca

Museo Nacional de Arte Hispanomusulmán, Granada

Museo Nacional de Cerámica "Gonzáles Martí,"
Valencia

Museo de Navarra, Comunidad Foral de Navarra,
Pamplona

Museo Provincial de Jaén

Museo de Santa Cruz, Toledo

Museo Taller del Moro, Toledo

Patrimonio Nacional, Museo de Telas Medievales,
Monasterio de Santa María la Real de Huelgas, Burgos

Museo de Teruel

Museo de Zaragoza

Museu Arqueològic de la Ciutat de Denia

Museu Tèxtil i d'Indumentària, Barcelona

Real Academia de la Historia, Madrid

Real Armería, Palacio Real de Madrid, Patrimonio
 Nacional

Tesoro de la Catedral de Gerona

Tesoro de la Catedral de Tortosa

UNITED STATES

The American Numismatic Society, New York

The Cleveland Museum of Art

Cooper-Hewitt Museum, The Smithsonian Institution's
 National Museum of Design, New York

Linton Collection, Point Lookout, New York

The Metropolitan Museum of Art, New York

The Textile Museum, Washington, D.C.

The Walters Art Gallery, Baltimore

Contributors to the Catalogue

LMA — Lhaj Moussa Aouni, *Archéologue et Collaborateur de l'Ader Fès*

RAR — Rafael Azuar Ruiz, *Conservador, Museo Arqueológico Provincial de Alicante*

MLB — Michael L. Bates, *Curator of Islamic Coins, The American Numismatic Society, New York*

JMB — Jonathan M. Bloom, *Richmond, New Hampshire*

Jesús Bermúdez López, *Jefe, Departamento de Investigación y Promoción Cultural del Patronato de la Alhambra*

Darío Cabanelas Rodríguez, o.f.m., *Profesor Emérito, Universidad de Granada*

MCP — Manuel Casamar Pérez, *Miembro, Junta de Adquisición de Obras de Arte, Ministerio de Cultura, Madrid*

James Dickie (Yaqub Zaki), *Advisor, The Muslim Institute for Research and Planning, London*

JDD — Jerrilynn D. Dodds, *Associate Professor of Art and Architecture, City College, City University of New York, and Special Consultant to The Metropolitan Museum of Art, New York*

AE-H — Abdellatif El-Hajjami, *Directeur Général, Agence pour la Dédensification et la Réhabilitation de la Médina de Fès*

Christian Ewert, *Director, Deutsches Archäologisches Institut, Madrid*

JAG — Josep A. Gisbert, *Director Técnico, Museu Arqueologic de la Ciutat de Denia*

Oleg Grabar, *Professor, School of Historical Studies, Institute for Advanced Study, Princeton*

CHC — Concha Herrero Carretero, *Conservadora de Tapices, Patrimonio Nacional, Madrid*

RH — Renata Holod, *Associate Professor and Chair, Department of History of Art, University of Pennsylvania, Philadelphia*

SK — Sabiha Khemir, *London*

DAK — David A. King, *Professor of History of Science, Johann Wolfgang Goethe-Universität, Institut für Geschichte der Naturwissenschaften, Frankfurt-am-Main*

PMS — Purificación Marinetto Sanchez, *Directora, Museo Nacional de Arte Hispanomusulmán, Granada*

RMMR — Rosa M. Martín i Ros, *Directora, Museu Tèxtil i d'Indumentària, Barcelona*

F-A DE M — François-Auguste de Montêquin, *Professor, Virginia Commonwealth University, Richmond*

JNP — Julio Navarro Palazón, *Director, Centro de Estudios Arabes y Arqueológicos "Ibn Arabi," Murcia*

CP — Cristina Partearroyo, *Colaboradora, Instituto de Valencia de Don Juan, Madrid*

CR — Cynthia Robinson, *Madrid, New York*

GRB — Guillermo Rosselló Bordoy, *Director, Museo de Mallorca, Palma de Mallorca*

DFR — D. Fairchild Ruggles, *Assistant Professor, Ithaca College, New York*

AS — Alvaro Soler, *Conservador, Real Armería, Madrid*

MPSF — María Paz Soler Ferrer, *Directora, Museo Nacional de Cerámica "Gonzales Martí," Valencia*

Antonio Vallejo Triano, *Director del Conjunto Arqueológico, Madīnat al-Zahrāʾ*

Juan Vernet, *Profesor Emérito, Universidad de Barcelona; Real Academia de la Historia, Barcelona*

DW — Daniel Walker, *Curator in Charge, Department of Islamic Art, The Metropolitan Museum of Art, New York*

JZ — Juan Zozaya, *Subdirector, Museo Arqueológico Nacional, Madrid*

Introduction

JERRILYNN D. DODDS AND DANIEL WALKER

Al-Andalus was, for over seven centuries, the occidental frontier of Islam. Floating on the western edge of the Mediterranean like an island welded to Europe only by a jagged chain of peaks, it was geographically isolated from both Europe and North Africa, from the pathways to Christian as well as to Islamic lands. Physical remoteness gave al-Andalus a privileged place in the histories and myths of Islam and medieval Christendom but also secluded it, separated it from either community. Thus, when the last Muslims were cast from the peninsula—when al-Andalus ceased to exist—it became a stepchild of history, receiving unsteady attention from both the Islamic world and the European land it had once inhabited. The arts of al-Andalus were viewed as the brilliant and exotic vestiges of a moment severed and exorcized from the history of Europe and lost to the world of Islam. And though a small and valiant group of scholars maintained the serious study of those arts through this century, the Islamic artistic heritage has not received a fraction of the attention it merits, as if we still believed, with Washington Irving, that "the Moslem empire in Spain was but a brilliant exotic that took no permanent root in the soil it embellished."[1]

The goal of this volume is to make a new place for the study of the art of Islamic Spain, to celebrate its value as part of an autonomous culture and also as a potent presence that had deep importance for Europe and the Muslim world. Toward this goal a group of international scholars has contributed a wide-ranging series of studies embracing the art, architecture, and cultural climate of al-Andalus, subjects approached in terms of a broad variety of methods. What we hope to offer here is a state of the question concerning the major achievements of art and architecture of al-Andalus, a volume that can serve both as an introduction to the visual world of a nearly vanished culture and as a point of departure for future scholarly study.

The arts of al-Andalus include the material culture of over seven hundred years of history, works that issue from diverse rules and traditions. The courtly arts are best known and preserved: They are the primary means by which the story of al-Andalus is told in this catalogue. The various palatine cultures and their arts are potent reminders of the extended and changing character of Islamic hegemony in Spain; they divert us from Irving's mythic view of the "Moor"—the monolithic other in brief intense polarity with the Christian west. Indeed, the way these arts were viewed and the way they functioned in each of the rules that produced them bear witness to the cultural and ideological divergences of those rules, to the complexity of a multifaceted and protean Islamic period on the Iberian Peninsula. The Spanish Umayyad period produced brilliant courts that carefully established an image of al-Andalus as an elegant capital for both the east and the west. The *Taifa* monarchs, whose kingdoms were small and politically impotent, nevertheless perpetuated the most refined elements in the Umayyad princely image. The invasions of the two conservative Berber sects, the Almoravids, then the Almohads, brought renewed force and a conscious sense of conservatism and constraint to the courts of al-Andalus. And, finally, the Nasrids created an opulent court that, from its very birth, looked nostalgically at the glories of an Islamic rule that had already slipped from their hands.

Since the overwhelming majority of surviving objects from al-Andalus were made for courtly settings, this exhibition necessarily presents a picture that relates primarily to the aristocratic, exclusive sectors of the Islamic society of the peninsula. It is our belief that these objects can provide a passage not only to visual and tactile experiences of beauty and power but also to an understanding of how the Muslims of al-Andalus saw themselves; they allow us to understand the meaning of courtly patronage and display for the Islamic princes of the Iberian Peninsula and to see the search for identity hidden within the folds of each work of art. For these were more than opulent adornments intended to impress—though on one level they were

certainly that; they were also the means by which the Muslim rulers of al-Andalus created a visual setting for themselves on the western frontier of Islam.

This was true in particular of the Umayyads, whose arts mark the first great passage of the culture of al-Andalus. Under the Umayyad emirate and the caliphate that followed, a series of artistic relationships was established that would be mined and renewed during nearly the entire history of al-Andalus. The new Muslim rulers of the peninsula accepted the pre-existing vocabulary of Hispano-Roman and Visigothic architecture: Columns and Corinthian capitals, even horseshoe arches, were used as long as they could be transformed through plan, elevation, and decoration into a product that bore the recognizable stamp of their Islamic hegemony. To this vocabulary were added evocations of Umayyad Syria when Damascus was the center of the caliphate, the capital of all Islam: details of plan, mosaics by artisans imported from the east, and imitations of fine marble revetment. And, finally, more recent developments from the eastern reaches of the Islamic world were reflected in the sudden spread to Spain from Iraq and Iran of fine stucco carving—translated into an original and local idiom. In religious building and decoration, each of these visual sources contributed to the development of ingenious and complex aniconic ornament that engaged the viewer in a contemplative rather than an empathetic relationship, which distinguishes Islamic religious arts from those of Christians.

In secular courtly arts, decorative inscriptions, which are often stylized and may constitute the primary ornamentation of a work, took on a significant role as a link between patronage and power. We see this in caliphal ceramics in which the phrase *al-mulk*, meaning the power or the dominion, is repeated and in the use—forbidden to all but the ruler—of strips with the caliph's name on *ṭiraz*, luxury textiles from royal workshops. Umayyad patrons did not demur from the representation of the figure, although its use was restricted. The figure is often integrated into an overall surface decoration of interlace and foliage so that it is poised ambiguously between formal device and bearer of meaning, much as the stylized inscriptions are stretched taut between ornament and writing. Ivory carving was developed to an extent unknown in most other parts of the Islamic world, and objects made of ivory bear scrutiny for their lively figural imagery. In examples such as the pyxis of al-Mughīra and the Pamplona casket, figures are clear carriers of an iconography of authority and power.

These ivories reveal that such figural expression may perhaps have been part of the privilege of princes—an idea that links the Umayyads of Spain to the Roman and Sasanian rulers of Syria and Iran, reminding us that Spanish caliphal art was profoundly affected by a memory of, and also a yearning for, a place at the heart of Islamic lands.

The *Taifa* kingdoms were financially and militarily restricted in comparison with the Umayyads they succeeded, but that did not prohibit them from enjoying both international contacts and a highly evolved local artistic production. Crafts that once centered almost uniquely around Córdoba now emerged in regional centers. Ivory carving and work in silver niello developed in Cuenca and Toledo, and widely dispersed courts produced architecture that with great wit and sophistication embroidered on the tradition of interlacing arches introduced by the Cordobán caliphate, as the Aljafería in Saragossa demonstrates. These regional courts—where the making of culture was one of the few unrestrained activities—nurtured the idea of ruler as patron and continued to employ the iconography of authority created by the Umayyads. In such urbane courts poetry and science flourished in visual settings that were original and impertinent interpretations of the powerful memory of the elegant caliphate.

The Almoravid invasions were a reaction to both the impotence and the indulgence of the *Taifa* kingdoms, and they thus brought about profound changes in the courtly arts of al-Andalus. Art and architecture were now drawn across the Strait of Gibraltar, as artisans from the peninsula worked in Marrakesh and Fez. Architecture took on a new conservatism in plan and a decorative austerity conveyed by stuccoed brick piers with cool, keel-arched arcades. When Cordobán wood-workers created the minbar for the Kutubiyya mosque in Marrakesh, they used decorative themes of geometric complexity that would become a hallmark of the arts of al-Andalus over the next four hundred years. Figural decoration, on the other hand, appeared somewhat less frequently and became rather more emblematic in this period, except in ceramics—in which it was firmly entrenched in ongoing traditions that were independent of the court—and in luxury textiles. The textiles are especially significant, in particular the rich silks created in Almería that were covered with bold representations of heraldic animals—our first indication of the seduction of the ascetic Almoravids by the most opulent crafts of al-Andalus. For though they had vanquished the *Taifa* rulers under a banner of austerity, the Almoravids at

some level had absorbed the idea that the patronage of costly arts was one of the signs of kingship.

The Almohads attacked the issue of fundamentalism and the arts with new rigor: They whitewashed or destroyed Almoravid mosques and built their own with a new degree of decorative restraint. The wild meandering arches of the caliphal and *Taifa* periods are now reduced to a bit of schematized lacework enclosed in a rectangle in La Giralda of Seville: a swatch of pattern that distills the sensuous mannerism of the caliphal and *Taifa* periods to a controlled planar texture in the Almohad minaret. In their rejection of opulence and excess, the Almohads began by outlawing the textile factories of Almería that had flourished in Almoravid times. Ultimately, however, they created a textile tradition of their own that in some cases continues Almoravid traditions and in others features inscriptions and abstract geometric designs—as epitomized in the banner of Las Navas de Tolosa—that take the place of Almoravid figural motifs. It is fitting that there should survive from the Almohad period both an extraordinary battle banner and certain bell lamps from the Qarawiyyīn mosque in Fez, for all reflect the military character of the Almohad hegemony. As Christian bells captured in battle and converted into mosque lamps, the bell lamps were victory symbols for the faith of Islam. Both the lamps and the banner underline the extent to which the Almohads created an image for themselves in purposeful opposition to the Christian kingdoms of the north—as distinct from the rulers of the caliphate and *Taifa* kingdoms whose identity was rooted simultaneously in the peninsula and in Umayyad Syria.

The Almoravid reaction against the indulgence of the *Taifa* courts manifested itself in a new emphasis on the art of the book in Islamic Spain, particularly with regard to the production of Qur'ans. The conservatism of the Almoravids, and of the Almohads as well, is reflected more in the emphasis on Qur'an production than in any visual austerity in the manuscripts themselves, for the latter frequently bear elaborate and sumptuous illumination. Not all examples were religious in nature, but there remains today only one illustrated literary manuscript, the *Ḥadīth Bayāḍ wa Riyāḍ*, the sole survivor of what must have been a rich pictorial tradition.

The tiny Naṣrid kingdom of Granada, the last Islamic state on the Iberian Peninsula, knew little political and military power but, thanks to its long survival and active patrons, produced a remarkable number of extremely influential objects of the highest quality. The palaces of the Alhambra contain an encyclopedia of Islamic ornament, from stucco carving to tile inlay to wooden ceilings, which together create an environment saturated with abstract decoration. The Naṣrids' arts elaborated upon the traditions of the Almohads and Almoravids but were unrestrained by the conservative attitudes of the latter dynasties. This opened the way for incredibly opulent courtly arts of every kind, including textiles, luxury arms, and the monumental Alhambra vases. Indeed, the creation of arts for the Naṣrids became part of the fashioning of a public image: defiant statements of artistic grandeur in a land nearly lost to Islam. It is as if the Naṣrids felt they could defy a rapidly encroaching Christian rule through the power of an old and potent visual culture.

The essays and entries joined here synthesize traditional wisdom concerning the courtly arts of al-Andalus with recent technical and formal studies, some of which are undertaken in the light of new methods, allowing us to consider these objects and monuments in a broader and richer cultural and historical context. The concentration in this volume of diverse scholarly approaches has been particularly fruitful for the study of specific sites, such as the great caliphal palace city Madīnat al-Zahrāʾ, near Córdoba. Madīnat al-Zahrāʾ emerges as a rich and multifaceted site because of meticulous archaeological and art historical analysis, by virtue of the socioeconomic and political meaning of its garden forms, and through an understanding of the way taste and the arts formed part of the courtly life created there. We can begin to see the palace as a worldly and elegant setting in which the Umayyads used patronage to play out their rivalry with the ʿAbbāsid caliphate in Baghdad, while creating their own visual identity on a western frontier, in a predominantly Christian land.

The new breadth of studies and diversity of methods further serve to free a monument such as the Alhambra from the romance of Orientalist interpretations, which have clung to it since the time of Washington Irving. A clear understanding of the Alhambra's history, the function of its rooms, the heritage of its complex planning, and the multivalent meanings of its gardens, the association of extraordinary textiles, ceramics, and metals with its elaborate interiors, and a vision of the lively urban fabric that flourished around the palaces tend to set loose the legendary monument from its mythical attributes of decadence and prurience. Together with a recent study of the political meaning of the Naṣrid fortress,[2] the synthesis of such essays removes the

Alhambra from the romantic gaze of the west and gives it a place in the lost, living culture of al-Andalus.

These texts reveal, however, not only the persuasive, influential character of powerful royal patrons but also the strength and continuity of regional traditions that survived the vicissitudes of political change. We can now begin to see the arts of the *Taifa* kingdoms less as simply the slavish imitations of Umayyad patronage and more as original products of nascent regional centers enriched by emerging local traditions and by independent links with both Christian kingdoms on the peninsula and Islamic states in the Mediterranean. These decentralizing developments cut across the entire history and geography of al-Andalus. It is the particular contribution of the archaeological studies conducted by scholars of the past two decades to reveal strong local developments in the ceramics of Valencia, Murcia, and the Balearic Islands. In the *cuerda seca* and sgraffito traditions of Valencia and Murcia, we have a hint of regional courtly style and also of the more widespread manifestations in popular arts that correspond to local domestic architecture.

These last developments are central for our understanding of the heritage of al-Andalus, for the parts of the Spanish Islamic tradition that continue to live on the Iberian Peninsula. For it is these elements of the tradition that were integrated into the fabric of Spanish life and were gradually perceived as belonging to a peninsular expressive vocabulary rather than to a particular religion or rule. This is the case with arts that are called Mudejar. Mudejar arts are traditional Islamic arts that continued to flourish in lands conquered by Christians, primarily because of the continuity of crafts and their adoption by Christian and Jewish patrons. A number of the artistic traditions loosely grouped under the rubric Mudejar endured not only as the result of the survival of Islamic workshops under Christian hegemony but also because many of the arts of al-Andalus were rooted in a local culture and economy rather than in a court or hegemony. Carpet manufacture, lusterware ceramic traditions, regional textile production, and the lively development of wooden ceilings were all introduced to Spain as part of Islamic culture; however, by the sixteenth century they were perceived as belonging both to Islamic tradition and to diverse groups of users and makers, as part of the shared culture of Christians, Jews, and Muslims.

The impact of the courtly arts on peninsular tradition was also significant. The arts of the Islamic courts were, of course, more charged with meaning and carried deeper associations with their original Muslim patrons than those shared by a broader society. Nevertheless, many of the luxury arts were subsequently adopted by Spanish Christians after the fall of al-Andalus. Arms like ivory handled ear daggers, gold jewelry, and luxury ceramics were highly regarded by Christians, and the manufacture of such products continued without pause. The image that Islamic monarchs of al-Andalus sought to create through patronage was powerful and transferred easily across the barrier of divergent politics and religion. Indeed, the Christian monarch Peter the Cruel appropriated the very architecture of the Alhambra for his palace within the Alcazar of Seville, and his vizier Samuel ben Meir ha-Levi Abulafia employed the same decorative styles and techniques in his synagogue in Toledo. Rich textiles with Arabic inscriptions were such a commonly held sign of luxury and power that Christians lined their coffins and reliquaries with them. Clearly their meaning of preciousness and importance—shared by Christians and Muslims alike—was more potent than any encumbering political or religious association.

As Islamic science and learning—as manifested in astrolabes, astronomical tables, translations of Aristotle, mathematics, and technology for the manufacture of paper—passed through Spain to France, northern lands were slowly beginning to feel the impact of the visual presence of al-Andalus on European soil. At Durham a ribbed vaulted Romanesque cathedral inexplicably sprouts dadoes with interlacing arches that create abstract patterns that are carried throughout the church— patterns that recall those of the Great Mosque of Córdoba and its progeny. From the moment the Almoravids invaded the Iberian Peninsula, the tiled mosques and palaces of Morocco began to reflect the influence of the greatest artistic achievements of al-Andalus. The mosque of Ibn Tūlūn in Cairo bears additions that show the impact of Córdoba, and there is evidence of communication between the Naṣrid and Ottoman artistic traditions during the last days of al-Andalus. But the most robust bequest of al-Andalus to both Europe and the Islamic world is the legend generated by this brilliant capital on Islam's western frontier. Al-Andalus was to many outsiders an exotic, elegant outpost, a place where the unexpected could happen, a world of splendid wonders. We need to look beyond such myths, of course, but must understand their sources as well. Though these images grow in large

part from the imagination of chroniclers, they are the result of the visual world created by audacious and creative patrons.

The Islamic arts created for these patrons are diverse; no single style characterizes the more than seven centuries of Islamic rule on the Iberian Peninsula. They are, rather, united by the very intensity that the insularity of the peninsula seemed to confer upon any enterprise undertaken in al-Andalus: Isolation and, at the same time, the proximity of other cultures deepened the need to use art to enforce a sense of place and identity. Many of the forms and meanings of the Islamic contribution acquired such force that they survived the demise of Islamic hegemony on the peninsula not only to feed legends but also to transform profoundly the nature of Spanish art and culture.

1. Irving 1991, p. 777.
2. Grabar 1978.

Note to the Reader

Transliterations from Arabic script follow the system most widely used in English-language periodicals such as the *International Journal of Middle East Studies.* Terms and place names that have entered the English language are cited as they appear in *Webster's Third New International Dictionary,* 1986, and *Webster's New Geographical Dictionary,* 1984. Some widely used Spanish versions of Arabic words are maintained.

Hijra dates are listed in the texts in parentheses after the common era date in the following manner: 711 (A.H. 92). A *hijra* date is not given if the year has no relationship to the Islamic presence in al-Andalus.

Dates cited are approximate when they refer to periods rather than to specific events. Differences in scholarly opinion account for variations in dates given in individual texts.

The Arthur J. Arberry translation is used for quotations from the Qur'an, except in the coin entries, where the translations are by Michael L. Bates.

Abbreviated references are used in the notes and literature citations. For full listings, see the Bibliography, pp. 395–412.

Entries are signed with authors' initials. For full names, see Contributors to the Catalogue, p. XVIII.

Measurements cited represent the maximum extension of the object's height (H.), width (W.), depth (D.), or diameter (Diam). Height precedes width, width precedes depth.

† indicates not in exhibition.

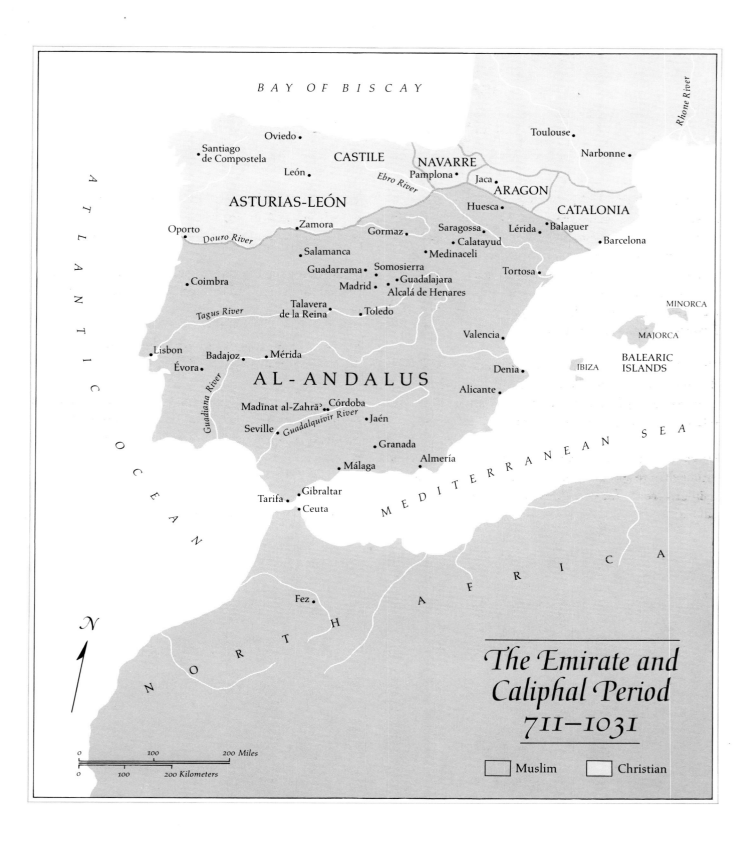

BAY OF BISCAY

Rhone River

ATLANTIC OCEAN

Oviedo

Santiago de Compostela

CASTILE

NAVARRE

Toulouse

Narbonne

León

Pamplona

Jaca

ARAGON

ASTURIAS-LEÓN

Ebro River

Huesca

CATALONIA

Oporto

Zamora

Douro River

Gormaz

Saragossa

Lérida

Balaguer

Calatayud

Barcelona

Salamanca

Medinaceli

Guadarrama

Somosierra

Tortosa

Coimbra

Madrid

Guadalajara

Alcalá de Henares

MINORCA

Talavera de la Reina

Toledo

Tagus River

Valencia

MAJORCA

Lisbon

Badajoz

Mérida

BALEARIC ISLANDS

Évora

Denia

IBIZA

AL-ANDALUS

Alicante

Guadiana River

Madīnat al-Zahrā

Córdoba

MEDITERRANEAN SEA

Seville

Jaén

Guadalquivir River

Granada

Almería

Málaga

Tarifa

Gibraltar

Ceuta

NORTH AFRICA

Fez

N

0 100 200 Miles
0 100 200 Kilometers

The Emirate and Caliphal Period
711–1031

Muslim Christian

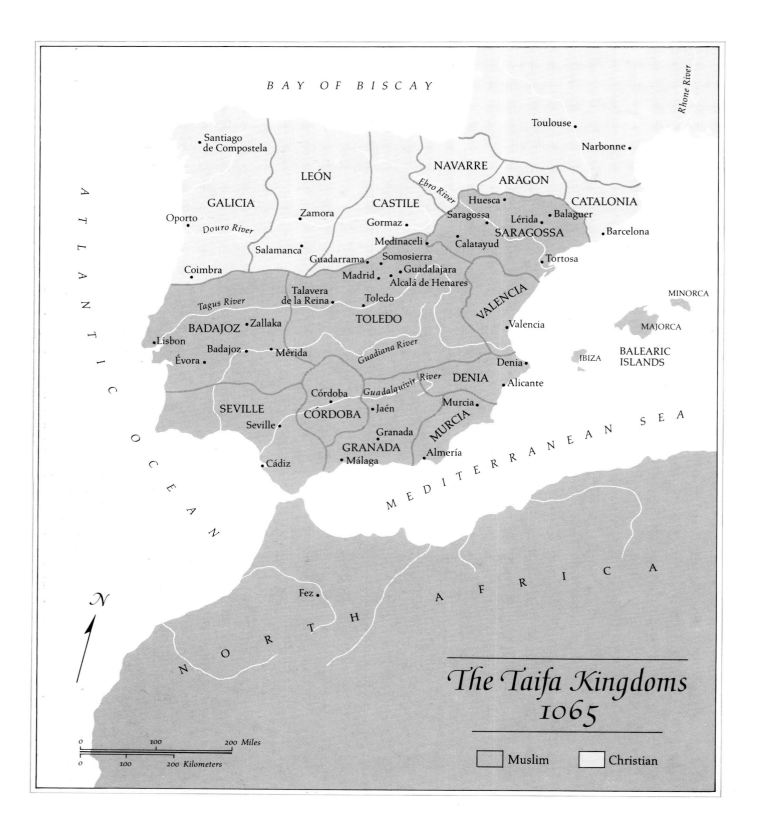

BAY OF BISCAY

Rhone River

Santiago
de Compostela

Toulouse

Narbonne

NAVARRE

LEÓN

ARAGON

GALICIA

CASTILE

CATALONIA

Huesca

Oporto

Douro River

Zamora

Gormaz

Saragossa

Lérida

Balaguer

SARAGOSSA

Salamanca

Medinaceli

Calatayud

Barcelona

Coimbra

Guadarrama

Somosierra

Tortosa

Madrid

Guadalajara

Talavera
de la Reina

Alcalá de Henares

VALENCIA

Tagus River

Toledo

MINORCA

BADAJOZ

Zallaka

TOLEDO

Valencia

MAJORCA

Lisbon

Badajoz

Mérida

Guadiana River

IBIZA

BALEARIC
ISLANDS

Évora

Denia

Córdoba

Guadalquivir River

DENIA

SEVILLE

CÓRDOBA

Jaén

Alicante

Murcia

Seville

Granada

MURCIA

GRANADA

Almería

MEDITERRANEAN SEA

Cádiz

Málaga

ATLANTIC OCEAN

NORTH AFRICA

Fez

N

*The Taifa Kingdoms
1065*

0 100 200 Miles

0 100 200 Kilometers

Muslim Christian

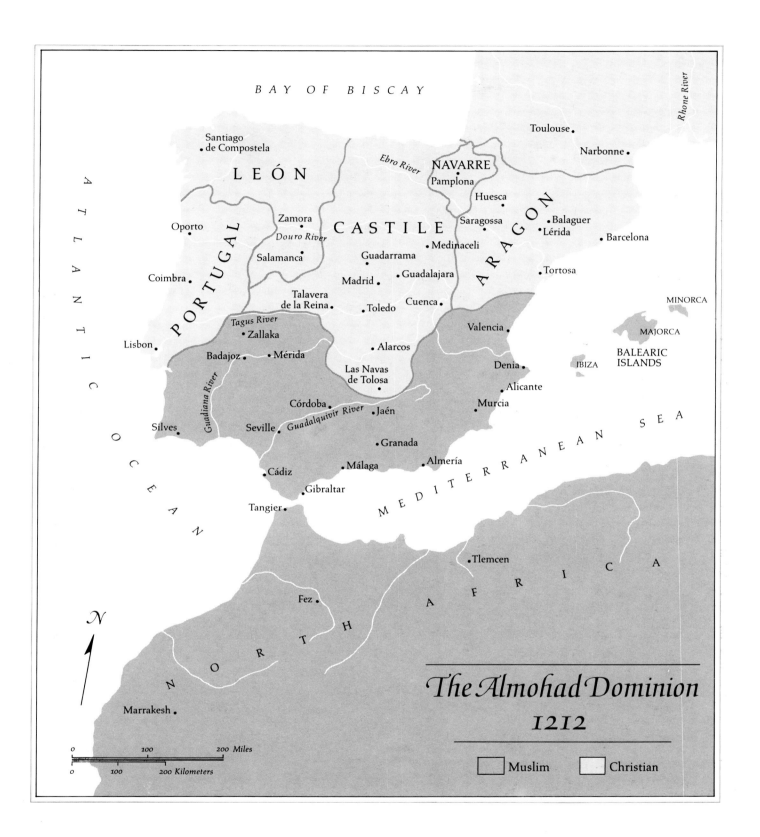

BAY OF BISCAY

Rhone River

Santiago
de Compostela

LEÓN

NAVARRE

Ebro River

Pamplona

Huesca

Toulouse

Narbonne

Oporto

Zamora

CASTILE

Saragossa

ARAGON

Balaguer
Lérida

Douro River

Medinaceli

Barcelona

Salamanca

Guadarrama

Coimbra

PORTUGAL

Madrid

Guadalajara

Tortosa

Talavera
de la Reina

Cuenca

Toledo

Tagus River

Zallaka

Lisbon

Alarcos

Valencia

MINORCA

Badajoz

Mérida

Las Navas
de Tolosa

Denia

MAJORCA

BALEARIC
ISLANDS

Alicante

IBIZA

Silves

Córdoba

Guadalquivir River

Jaén

Murcia

Guadiana River

Seville

Granada

MEDITERRANEAN SEA

Cádiz

Málaga

Almería

Gibraltar

Tangier

Tlemcen

NORTH AFRICA

Fez

ATLANTIC OCEAN

N

Marrakesh

The Almohad Dominion
1212

0 100 200 Miles
0 100 200 Kilometers

Muslim Christian

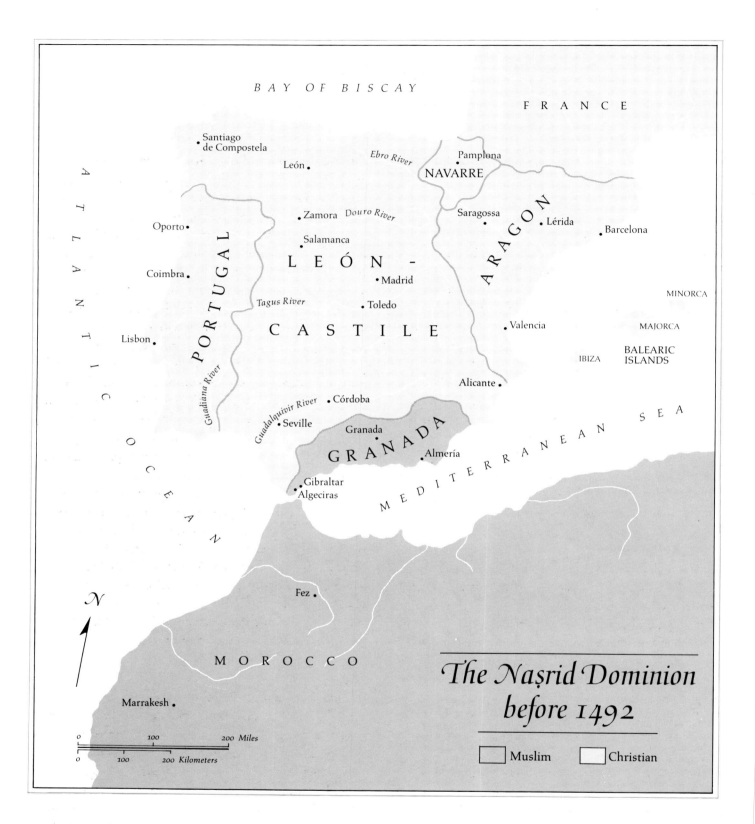

BAY OF BISCAY

FRANCE

Santiago
de Compostela

León

Ebro River

Pamplona

NAVARRE

Zamora *Douro River*

Saragossa

Lérida

Barcelona

Oporto

Salamanca

LEÓN -

A R A G O N

Coimbra

Madrid

MINORCA

Tagus River

Toledo

C A S T I L E

Valencia

MAJORCA

Lisbon

P O R T U G A L

BALEARIC
ISLANDS

IBIZA

Alicante

Guadiana River

Guadalquivir River

Córdoba

M E D I T E R R A N E A N S E A

Seville

Granada

A T L A N T I C O C E A N

G R A N A D A

Almería

Gibraltar
Algeciras

N

Fez

M O R O C C O

*The Nasrid Dominion
before 1492*

Marrakesh

| 0 | 100 | 200 Miles |
| 0 | 100 | 200 Kilometers |

☐ Muslim ☐ Christian

Chronology

Dates are approximate when they refer to periods rather than to specific events.

711–756 (A.H. 92–139)
Period of the Umayyad Governors

On July 19, 711 (A.H. 92), an army of Arabs and Berbers unified under the aegis of the Islamic caliphate landed on the Iberian Peninsula. Through diplomacy and warfare, they brought the entire peninsula except for Galicia and Asturias in the far north under Islamic control in seven years; however, frontiers with the Christian north were constantly in flux. The Muslims called the new Islamic land al-Andalus, a term that appeared on coins as the translation of Spania, the Latin name for Spain. Their territories were administered by a provincial government established in the name of the Umayyad caliphate in Damascus and centered in Córdoba. Of works of art and other material culture only coins and scant ceramic fragments remain from this early period.

756–929 (A.H. 139–316)
The Umayyad Emirate

When the Umayyad caliphate of Damascus was overthrown by the ʿAbbāsids in 750 (A.H. 133), the last surviving member of the dynasty fled to Spain and established himself as Emir ʿAbd al-Raḥmān I. ʿAbd al-Raḥmān I made Córdoba his capital and unified al-Andalus under his rule with a firm hand, while establishing diplomatic ties with the northern Christian kingdoms, North Africa, and the Byzantine Empire and maintaining cultural contact with the ʿAbbāsids in Baghdad. The initial construction of the Great Mosque of Córdoba under his patronage was the crowning achievement of this formative period of Hispano-Islamic art and architecture.

929–1031 (A.H. 316–423)
The Umayyad Caliphate

ʿAbd al-Raḥmān III reclaimed the Umayyads' right to the caliphate, declaring himself caliph in 929 (A.H. 316). Hispano-Umayyad art reached its apogee during the lengthy reigns of ʿAbd al-Raḥmān III and his son al-Ḥakam II and the regency of the powerful ʿAmirids, particularly al-Manṣūr, chamberlain to the nominal ruler, the child-prince Hishām II. Despite their open rejection of ʿAbbāsid political authority, the Umayyads of Córdoba emulated the opulent palatial arts of the centers of ʿAbbāsid power, Baghdad and Samarra. There was also influence from the Fāṭimid rulers, who had established an independent Shiʿite caliphate in Tunisia in 910 (A.H. 298) and occupied Egypt in 969 (A.H. 359). Perhaps in response to these eastern Mediterranean cultural impulses, which coexisted with a strong indigenous artistic component, there began to appear in Córdoba a nostalgia for the time when the Umayyads ruled the Islamic world from Damascus. Art patronage as a sign of kingship and authority is a theme that emerged from these creative appropriations from abroad and the past. Luxurious objects such as boxes of carved ivory and gilt silver, bronze animal statuary, and richly figured silks were commissioned for palaces decorated with ornate marble capitals, stucco wall panels, and marble fountains. ʿAbd al-Raḥmān III's palace city at Madīnat al-Zahrāʾ set the standard for artistic taste in the caliphate, and al-Ḥakam II's addition to the Great Mosque of Córdoba marked the imposition of a palatial level of luxury and hierarchy on this religious monument.

1031–1086 (A.H. 423–479)
Mulūk al-Ṭawāʾif or the Taifa Kingdoms

The Umayyad caliphate collapsed during the *fitna*, or civil war, of 1010 to 1013 (A.H. 401–4). In various provinces of al-Andalus local governors or chiefs designated themselves as autonomous *Taifa* rulers (*mulūk al-Ṭawāʾif*)—also known as party kings—establishing courts that attempted to equal the splendors of Córdoba in every possible way. These leaders lacked significant power because of internecine feuding; the strongest among them were Seville's ʿAbbādid rulers, whose outstanding king was al-Muʿtamid, Toledo's Dhūʾl-Nūn family, Saragossa's Banū Hūd rulers, and Granada's Zīrids. The *Taifa* kings continued the practice

of princely patronage and building monumental palaces, so that the number of centers of literature, music, and the opulent arts increased and important workshops appeared in diverse areas of the peninsula. Many *Taifa* art forms follow Cordobán trends but at times display a particular taste for the most complex and mannered models.

1088–1232 (A.H. 481–630)
The Almoravid and Almohad Rules

Led by Yūsuf ibn Tāshufīn, the Almoravids, a newly emerged Islamic power in North Africa, ethnically more Berber than Arab, entered al-Andalus after the fall of Toledo in 1085 (A.H. 478) in response to the *Taifa* leaders' pleas for help in repelling the Christian armies of northern Spain. The Almoravids assumed control of al-Andalus in 1090 (A.H. 483), while maintaining their primary seat of government in Marrakesh. Repudiating the lack of piety and what they considered to be the decadence of the *Taifa* kings, they disdained as well the opulent arts of the Spanish Muslims. Although they began by sponsoring austere programs of architectural decoration, their later monuments and textile manufactory in Almería indicate that the Almoravids eventually succumbed to the luxury culture of al-Andalus.

In the early twelfth century the Almoravids were supplanted by the Almohads, a new Berber dynasty from the southern Maghrib. By midcentury the Almohads had taken Seville, Córdoba, Badajoz, and Almería. The Almohads made Seville their capital in al-Andalus, while retaining Marrakesh as their center of power in North Africa. After the Almohads were defeated by the combined armies of Aragon and Castile at the Battle of Las Navas de Tolosa in 1212 (A.H. 609), a turning point in the peninsula's history, al-Andalus once again fractured into tribute-paying principalities, vulnerable to the depredations of Christian kingdoms. These principalities, except for Nasrid-ruled Granada, soon lost their sovereignty. The Almohads condemned the arts of the Almoravids; their own, especially architecture, were often but not always more austere. Their rigorous style saw the increasing schematization of ornament and the continued use of geometric designs. The Great Mosque and the minaret called La Giralda, which they built in Seville, are paradigms of Almohad style.

1238–1492 (A.H. 636–898)
The Naṣrid Kingdom

Founded by Muḥammad I of Arjona, the Naṣrid dynasty ruled Granada and neighboring Jaén, Almería, and Málaga in southern Spain. The early period of Naṣrid rule was characterized by insistent pressure from Christian armies of the north, which successively conquered Valencia, Játiva, and Jaén and made the Naṣrids tribute-paying vassals in 1243 (A.H. 641). From their palace city of the Alhambra, high on a hill above Granada, the Naṣrids formed tentative alliances with the Marīnids of the Maghrib and kept uneasy peace with their Christian overlords. Naṣrid arts grew from Almohad traditions but displayed far more variety and richness than their precursors. The finest military arts that survive from al-Andalus are from this period; the Naṣrid's luxury arms, which were probably never used in battle, offer examples of rich craft used to support a public image. During the fourteenth century the Naṣrid sultans dedicated themselves to the decoration of their splendid palaces. The Alhambra, the last major Islamic monument of Spain, was their greatest work. The creation of a succession of Naṣrid rulers, in particular Ismāʿīl I, Yūsuf I, and Muḥammad V, the Alhambra was conceived as a powerful image for a waning monarchy, a vast stage set for the diminishing power of the last Muslim rule on the peninsula. Severe political crises in the Maghrib in the fifteenth century, combined with the union of the Christian kingdoms of Castile and Aragon through the marriage in 1469 (A.H. 874) of Ferdinand and Isabella, whose avowed mission was the expulsion of the Muslims from the Iberian Peninsula, proved to be the downfall of the Naṣrids. The last Naṣrid ruler, Muḥammad XII (called Boabdil by Spanish historians), was exiled to the Maghrib on January 2, 1492 (A.H. 898).

Al-Andalus

THE ART OF ISLAMIC SPAIN

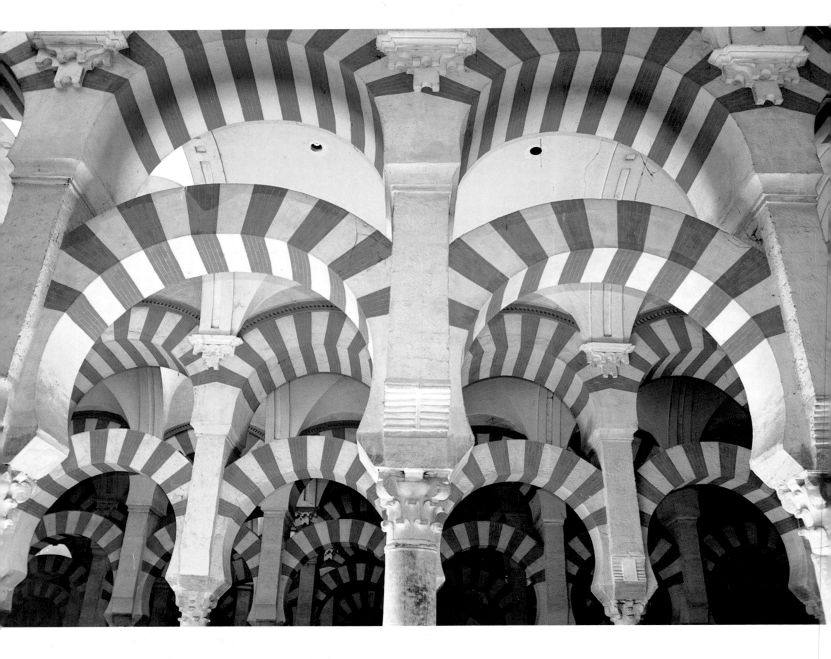

Islamic Spain, The First Four Centuries An Introduction

OLEG GRABAR

In 711 (A.H. 92) Arab and Berber forces crossed the Strait of Gibraltar and fairly rapidly established a measure of Muslim control over much of the Iberian Peninsula.[1] Almost four centuries later, in 1085 (A.H. 478), Toledo, the ancient seat of Christian power and culture and the more recent center of scientific and philosophical learning in the Arabic language, fell into the hands of the Christian princes from the north. Several centuries would elapse before Islam and the Arabs disappeared entirely from Spain, centuries that would be dominated by the struggle between Muslims and Christians. However, this struggle did not mark the period between 711 and 1084 (A.H. 477), when Islamic Spain became an area unique in all of Europe and the Mediterranean world. Al-Andalus, or the lands controlled by Islam on the Iberian Peninsula, was unique not only in terms of its tangible accomplishments but also for the ways in which it was perceived when it was a power and later, when it was remembered.

The first four centuries of Muslim presence and rule in Spain belong to a peculiar moment in the history of Europe, North Africa, and western Asia. This was a moment in which Roman and, to an only slightly lesser degree, Iranian imperial culture and political power no longer predominated as they had in the ancient world, and yet the presence of the Roman and Iranian pasts continued to be felt clearly. At another level, these centuries were not times of great clashes between competing and opposing cultures, as would be the case in later years, and yet there was

constant confrontation, peaceful or otherwise, between Christians and Muslims. These were not times of fabulous human, economic, and cultural expansion as would occur in the later Middle Ages of western Christendom and the era of the militant empires of Turco-Mongol Islam; and yet it was a period that radically altered the character of the Iberian Peninsula.

The purpose of this introductory essay is to explain these early centuries, to identify the threads within their fabric that make their art understandable, and also to set this art within the contemporary medieval culture of both the east and the west.

I have divided my remarks into three parts: *events* that set a few chronological guidelines and put what happened on a map; *society and culture*, with an attempt to point out some of the features of the society that was created in al-Andalus—its behavior and the way of life it engendered, as well as the culture that developed; *myth*, centered on examples of imaginary tales associated with early medieval Islamic Spain.

Events

Many stories have been spun around the decision by the Arab commander Mūsā ibn Nuṣayr to move a small army of horsemen—Arabs from the east and Berbers from neighboring Morocco, across The Straits into the Iberian Peninsula. All of these tales belong to the mythology of the Arab presence in Spain, and I shall return to one aspect of them in the third part of this essay. It is most likely that, during the heady decades of the late seventh and early eighth centuries,

Great Mosque of Córdoba, prayer hall of al-Manṣūr

highly energized Muslim Arab generals moved into any areas that were experiencing vacuums of centralized power or irreducible internal conflicts. Like North Africa, the bruised and battered Spain of Visigothic kings and of an until recently divided Christianity was such a place. Its political leadership was weak, its population scattered over a huge territory and torn by competing concerns, both ethnic and spiritual, that were at large in a vast land.

A few months after landing in 711, the Muslim armies were in Toledo, in the center of the peninsula. In 714 (A.H. 95) they were in Saragossa to the northeast, and raiding parties had reached almost every center of life in the entire territory of Spain. Other raids moved into southern France—Toulouse, for instance, was attacked in 719 (A.H. 101). The most celebrated of these expeditions led the Arabs all the way into central France, where they were turned back in 732 (A.H. 114) at a battle variously associated with Tours or Poitiers. Little noticed in the Muslim world itself, the battle assumed monumental proportions in Christian European, especially French, history. It was seen as the heroic brake applied to the expansion of an alien world by the west, as a minor skirmish by Arabs. From the very beginning there is thus established a difference in the perception and appreciation of the same events by Muslim and Christian sources. Whether this difference operated in respect to the perception of visual forms at the time they were created and used or, later, when they were studied, is one of the main issues that faces the historian of medieval art in Spain.

It is unclear what happened between 715 and 756 (A.H. 96–139). A rapid succession of governors in al-Andalus (during this period of forty-one years there were twenty-two of them, one of whom was at his post for five years) represented the central government of the Umayyad dynasty in Syria and the authority of the caliphs, successors to the Prophet Muḥammad as leader of all Muslims. The early governors' main duties were the collection of taxes and especially the channeling of booty toward the treasuries of the Umayyads in Syria. It is probable that they kept percentages for themselves and for their clients, and for this reason few were maintained for any length of time.

What that booty may have been is partly the subject of myth, which contributed to the perceived image of the peninsula in later times. However, several exports are known to have come from Spain or to have been acquired through Spain. Among them were rarities like amber, which came from northern Europe, and in particular both male and female slaves, whose beauty and strength are often mentioned in sources.

It is more difficult to know how the land itself and the population were transformed. There probably were not many immigrants, and these consisted of at least as many Berbers as Arabs. In all likelihood the immigrants married indigenous women, since there are almost no records of Arab or Berber women who came to the peninsula. Thus from the very beginning there was created a mixed culture, the nature of which probably contributed much to the unique character of the Arab Muslim civilization that developed in al-Andalus. It is known that the initial influx was primarily made up of soldiers and immigrants directed toward cities, but it is not clear whether the countryside was settled by Muslim Arabs or Berbers as early as the first half of the eighth century. Christians for the most part remained where they had always been and did not at first convert very rapidly to the new faith. Jewish communities in the cities assumed great importance. Persecuted and ill-treated by the Christians, Jews eventually found within Islam a legal system that left them relatively free to profit from the new world order created by the Muslims and to maintain their practices and beliefs. Specifically, they acquired easy access to the great centers of early medieval Judaism located near Baghdad.

Within a generation or two there seems to have been established a loosely organized frontier culture primarily dedicated to supplying the remote centers of the empire with natural resources. This was a culture that adapted itself to local conditions and opportunities. Indeed, the genius of the Arab governors sent from Syria to Spain or, for that matter, to the frontiers of China lay in their ability to foster an equilibrium wherever there were local ethnic, social, religious, or cultural tensions and a Muslim presence that was slowly formulating its own agenda for rule, for collective behavior, and for morality. I shall return in the second section of this essay to some of the features of this equilibrium.

It was in many ways an accident of history that took place far away from Spain that transformed a remote frontier province into a major political and cultural force. In 750 (A.H. 133), after several years

of civil war in Syria and Iraq, the Umayyad dynasty, which had established a vast Muslim empire from the Atlantic to India, was overthrown by religious, political, and social groups that came together to oppose its easygoing but self-serving rule. The caliphate was appropriated by the new dynasty of the ʿAbbāsids, and, more important for Spain, the focus of power shifted from Syria and the great Arabian tribes to Iraq, the center of urban Muslim populations, to a bureaucratic complex of administrators who often felt affinities with the culture of the Iranian world, and to a new army that was increasingly Turkic in constitution. The symbol of this change was the founding in 762 (A.H. 145) of the imperial capital Baghdad, officially called Madīnat al-Salām, the City of Peace, and meant to stand for Muslim rule everywhere. But the reality was even more important than the symbol, as Baghdad and other urban centers in Iraq such as Kufa, Basra, and Samarra developed into enormous and vital cities that for nearly three centuries were the major loci of intellectual, literary, and artistic activity for the Eurasian world.

The first ʿAbbāsids did their best to kill all the important members of the Umayyad dynasty. However, one of the Umayyads, ʿAbd al-Raḥmān ibn Muʿāwiya (eventually called al-Dākhil, the Incomer), escaped ʿAbbāsid assassins and in 755 (A.H. 138) reached al-Andalus, where he immediately found support among the Arab or arabicized immigrants, many of whom had come from Syria. In spite of this support, it took him some years to establish himself fully as the emir, or commander of all the local Muslim chieftains. He and his successors in both the emirate and caliphate ruled from their capital, Córdoba, until about 1030 (A.H. 421).

Each of these Umayyad rulers played an important and unique part in forging the new entity of al-Andalus. Hishām I (r. 788–96 [A.H. 172–80]) was an emir who introduced the legal system based on Muslim precedent that would subsequently be used throughout the western Islamic world. ʿAbd al-Raḥmān II (r. 822–52 [A.H. 207–38]) was a warrior who dealt with the emerging Christian kingdom in the north, with internal revolts, and even with Viking raiders who penetrated almost as far as Seville. His son and grandsons, who reigned from 852 to 912 (A.H. 238–300), continued to consolidate and hold together the large territory under Muslim control.

The Umayyad dynasty reached the acme of its power in the tenth century under ʿAbd al-Raḥmān III (r. 912–61 [A.H. 300–350]). He adopted the title of caliph, which signified that he was the successor to the rule of the Prophet Muḥammad, and thus challenged the pretenses of both Baghdad and the new heterodox Fāṭimid rulers of Tunisia, who would establish themselves in Egypt and found the city of Cairo in 969 (A.H. 359). After the reign of ʿAbd al-Raḥmān's son al-Ḥakam II (961–76 [A.H. 350–66]), al-Manṣūr, the main administrator of the court, wielded the royal power until 1002 (A.H. 393), when the regime began to disintegrate.

The two hundred years of Umayyad rule in al-Andalus transformed the southern part of Spain into an actor with a major role in the international relations of the time. There was a war with Charlemagne but also, according to some accounts, an attempt at a matrimonial agreement with the great ruler of the north. Byzantium probably saw in Córdoba a potential ally against the ʿAbbāsids in Baghdad and exchanged several embassies with the Umayyads, sending them a stream of gifts and perhaps artists who helped decorate the mihrab of the Great Mosque of Córdoba. Political connections with Iraq and Egypt may have been strained, but cultural and commercial relations were constant. Thanks to the development of revolutionary agricultural techniques and probably to the cultivation of silkworms and new products like rice and vegetables, hitherto unknown in the Mediterranean, al-Andalus became a rich producer of consumer goods that were transported as far as India by merchants of many faiths. Among the records of such merchants, those of the Jews have been preserved best and have provided a picture of wealth and of consumption almost unknown in the Christian north. It was in large measure because ʿAbd al-Raḥmān III was aware that the wealth of his lands allowed him to play a major role in the world that he saw fit to assume the title of caliph, which elevated him to the status of the rulers of Constantinople and Baghdad.

The centralized system of government developed by the Umayyad princes did not last. In a sense, the Muslims had been too successful—the lands they had conquered were too vast and rugged to control and govern. In all likelihood there were not enough Muslim soldiers and settlers to hold and populate such large territories. Furthermore, the Arabs had no

long-standing tradition of efficient dynastic or bureaucratic rule. And finally, Christian leaders were reasserting their power at this time.

By the end of the tenth century, local governors took advantage of the weakness in Córdoba and declared their independence in at least fourteen different districts. This was the period, which lasted from about 1031 to 1086 (A.H. 423–79), of the *mulūk al-Ṭawāʾif*, or *Taifa* kingdoms, the so-called party kings who transformed their cities into small capitals, fought with one another as much as with the resurgent Christian kings, and often made alliances with Christian rulers against their enemies, whether Christian or Muslim. Because such clashes often resulted in the ruin of local economies and the loss of land to the Christians, these petty rulers generally have been judged rather harshly by historians. Yet they made a contribution that bore considerable fruit over the following centuries. Under their rule a series of hitherto minor provincial areas like Málaga, Granada, Badajoz, Valencia, Almería, and Saragossa, as well as the old city of Toledo, which had lost some of its luster, acquired identities of their own. They became centers of literature and of culture, and their rulers, ministries, or rich inhabitants sponsored major works of art. Thus, when the Berber dynasties emerged at the end of the eleventh century to clash with the crusading princes of Castile or Aragon and to bring a rigid form of Islam to the warring states, they found an al-Andalus of many cities of distinct character and tradition.

Society and Culture
It is nearly impossible to reconstruct the life and the culture of the Arab Muslim world of al-Andalus in these early medieval centuries and to understand the nature of the people who prayed in the Great Mosque of Córdoba and used the extraordinary carved ivories produced in the workshops of Spain. I will merely attempt to suggest something of what that life and culture must have been by concentrating on two themes: the variety of people and goods that were found in al-Andalus, and the quality as well as originality of its literature, of its ways of life, and of its thought.

Ibn Ḥawqāl, a tenth-century geographer from Baghdad, visited Spain, in particular Córdoba, during the first half of the tenth century. He was a bit of a snob in his judgments of places far away from the capital of the Muslim world—he was, for example, very critical of the horsemanship practiced on the peninsula; but he took appreciative notice of the availability of mercury, iron, and lead, and especially of the manufacture of many different kinds of textiles, dyed wools, silks, felts, and linens. These were exported all over the Muslim world, as were slaves from Scandinavia and Slavic areas who had been bought in northern Christian markets, and ivory tusks acquired on the edges of the Sahara desert and crafted in the royal cities of al-Andalus. Before Cairo was founded, only Constantinople and Baghdad challenged Spanish cities in terms of the variety of exotic products and slaves available in their markets.

Muslim geographers usually discuss only Muslim populations. From them we have learned that most of the Muslim inhabitants of the cities and of the countryside in Spain were Arabs from the east and Berbers from North Africa, the majority of whom were totally arabicized. These Muslims, particularly if they could claim descent from immigrants from the east, considered themselves a social elite. Many, in fact, were landowners whose property, which was cultivated by others, had made them wealthy. A large number of Spanish Muslims, however, were *muwalladūn*, Christian natives of Spain whose ancestors had converted to Islam out of religious conviction or to gain higher social status or economic advantages.

Side by side with the Muslims lived large communities of Christians called Mozarabs because they had acquired an Arab culture although they remained strongly attached to their traditions. These attachments sometimes caused conflict—for example, in the middle of the ninth century, a group of Christians in Córdoba sought martyrdom by insulting the faith of the Muslims and provoking cruel retribution. But such cases were relatively rare, and, as has been noted, the Umayyads and their successors maintained a workable equilibrium between Christian and Muslim communities. Another significant group among the mixed population was made up of Jews, who played a particularly important role in the life of al-Andalus because they were among the richest and most successful merchants from Spain.

These disparate groups, no matter what had brought them to al-Andalus, shared a characteristic that is curious and most interesting in terms of its

psychological effect: They had an allegiance to centers or to issues outside of Spain. Christians technically were subject to the Roman hierarchy, which, during this period, admittedly was remote and inaccessible and often at odds with local theological, liturgical, and social aspirations. However, the bishops in the unconquered north of Spain gradually became more powerful and by the latter part of the eleventh century consolidated their control and encouraged the slow growth of the influential sanctuary of Saint James in Compostela. The Jews of Spain consulted the rabbis and learned men of Iraq in matters of faith. Moreover, they were connected through marriage with their coreligionists in North Africa, Sicily, Egypt, and even India. The northern or African slaves who worked on the peninsula or passed through it for lands even more remote from their birthplaces also brought with them traditions and memories of their native cultures, although they left no record of them.

It is fascinating that during the period of Islamic domination of Spain, even the Muslims expressed an affection for a place and time outside of their extraordinarily powerful rule—articulating a nostalgia for a past long gone and for lands and ways of life far away. The early Muslim settlers developed a kind of cult around memories of the Umayyad dynasty in Syria; they compared existence in Spain to a fantasy of what life had been in Syria, and they gave Syrian names to their creations in Spain. Thus al-Ruṣāfa, the name of the Umayyad capital in Syria, became the name of a palace in a suburb of Córdoba, and Arabic poetry in al-Andalus often sang of the beauties of Syrian landscape. This was a curious nostalgia that voiced no expectation of return, fostered perhaps because these memories helped sustain the struggles of the Spanish Umayyads against the ʿAbbāsids of Baghdad.

In the ninth century a second wave of influences from the east engulfed the Muslim elites of Spain. This wave is epitomized by the Iraqi singer Abū 'l-Ḥasan ibn Nāfiʿ, known as Ziryāb. It is difficult to identify his contributions precisely, as he is credited not only with the introduction of new and more sophisticated ways of singing poetry but also of refinements in the realm of everyday life and behavior: new techniques for cooking and for makeup, polite manners for dining with silken tablecloths, new fashions in hair and clothes. This revolution in manners was accompanied by an influx, starting in the ninth century,

of luxurious consumer goods from the East, such as the celebrated necklace known as al-thuʿbān (the snake), which had belonged to the wife of Hārūn al-Rashīd. Whether or not these accounts of elegant life and rich goods were true is not as important as the fact that they were believed. By the tenth century, the most brilliant and creative century of the early period of Islamic rule, the Umayyads thought themselves to be in the cultural succession of the great Baghdad of the eighth and ninth centuries. Nostalgia for a lost cultural past was replaced by a feeling of superiority: The Umayyads considered themselves to be more than the equals of the ʿAbbāsids, having forged a unique Andalusian Arab culture. It should be noted here that Spanish Christians, who held diverse religious views and had mixed feelings about their past as well as about the contemporary scene, created an extremely original culture, which was different from that of the Roman church of the north and often very close to the Arab culture of Muslims or to the Muslim culture of Arabs.

In at least two respects the culture of Cordobán Umayyad Spain reached a pinnacle, elaborating on traditions appropriated from ʿAbbāsid Iraq. First, Arabic poetic forms were cultivated, as witnessed in the love poetry of Ibn Ḥazm, which is suffused with a genuine lyricism that confers upon the verses a combination of amorous concreteness and esoteric imagination. There was also a new emphasis on learning, marked by a fascination with science, with the Arabic language, and with the philosophical discourse on reason and faith that had been a focus of the intellectual life of Iraq in the ninth century. Moreover, during the eleventh century these great accomplishments were transmitted from Córdoba to dozens of smaller centers in al-Andalus.

The world created by the Umayyads in Spain was one of striking wealth of many kinds. There was commercial wealth based on goods and slaves from the north and south that passed through al-Andalus. There was wealth in terms of consumption, as the caliph's court, first in Córdoba and then in the new capital city of Madīnat al-Zahrāʾ, commissioned and used thousands of objects in gold and ivory, masses of textiles of many different sorts, and whatever else made a life of high luxury. There was a wealth of productivity and of exchange, as artisans learned to make items such as silks and boxes for the pleasure of the rich everywhere,

and as goods changed hands in markets carefully supervised by well-trained officials. There was also a wealth of information, thanks to the libraries of Córdoba, which became celebrated all over the world, far outshining those of the Christian west. There was a wealth of thinking about the meaning of life, about God, and about material things. And there were poets to sing of all the ways of wealth.

Myth

Islamic Spain was present within the mythical memory of the entire Muslim community and most particularly within its Arabic-speaking areas, which had been fed on stories of the conquest. I will relate only four of these myths, as they suffice to provide a sense of the meaning of Umayyad Spain to Muslim culture as a whole.

The first story concerns the conquest itself. According to later historians, the daughter of a Christian governor was kidnapped by the last Visigothic king, Roderic. The governor called on the Arabs installed across the Mediterranean to help him avenge the dishonor done to his family, and they obliged by conquering Spain. Thus, the invasion of Spain was represented as a moral venture pursued to rectify a crime. It is difficult to determine why this rather unusual type of conquest story developed, but a likely guess is that it originally was spun by or for Christians seeking to explain to themselves the appearance of Arab Muslims in their midst as a consequence of their sins.

The other myths come from a rather extraordinary book compiled by al-Zubayr in the latter part of the eleventh century. One describes all sorts of gifts given or received by Muslim rulers. Among these was an exceptional object alleged to have been discovered in an old church of Saragossa by a treasure hunter (today he would be called an antique dealer). This was a cylindrical bronze pyxis that contained a glass pyxis; inside the glass pyxis was a black ring stone with an image of a sexually aroused monkey. It was said that a man who held the ring stone in his hand or mouth would have an erection; when the object was set aside, the erection subsided. The Arab grandee from Sicily who obtained the pyxis gave it to one of his eunuchs as a meanspirited joke. The eunuch broke the ring stone, and it became ineffective. In this tale an object from Spain brings eroticism and magic to another

Muslim land. The character of al-Andalus as a rich and remote frontier where license, wealth, and a strong, strange Christian culture mingled made it a mythic place for those who lived in other corners of the Islamic world. Significantly, works of art, as signs of wealth and cultivation, were at the center of the creation of such stories.

That these legends were conceived as a means to understand the identity of this remote and exotic appendage of the Islamic world is clear in two other stories, in which the mythical imagery is more political in nature. The first concerns a table of gold and silver with inlays of precious stones. Once the property of Solomon, the son of David, it had been carried from Jerusalem to Spain by a mythical king. According to legend, it was found during the Muslim conquest of a fortress near Toledo, and it eventually was brought to the Umayyad caliph in Syria. In the other story Ṭāriq ibn Ziyād, the conqueror of Spain, found a house with twenty-four locks. He was told that every king of Spain had put a lock on this house, but none save Roderic, the last Spanish king, dared enter because they did not wish to see what was inside. Within, Roderic saw pictures of armed and turbaned Arab horsemen and the inscription *If this house is entered, these people will enter this country.*

Stories such as these, which provide associations with Solomon or David or imply that the rule of the Iberian Peninsula was an Arab Muslim destiny, are not unique. They typify the kinds of myths that any culture uses to establish its links with the past of a land and thus its legitimate right to rule. These particular myths testify to the depth of the Arab Muslim involvement with al-Andalus and add an imaginative dimension to the reality of the complicated political, economic, and cultural history of the first four centuries of the brilliant Arab Islamic presence in Spain.

The Muslim Spain of the eighth to the eleventh century was unique within pre-Romanesque Europe and the newly created Islamic world culture. From the point of view of the rough and cold Christian north, it was a haven of warmth, sophistication, and refinement in every aspect of life—from the clothes that were worn to the buildings that were built to the ideas that were created and the knowledge that was pursued. From the point of view of the Iraqi centers of Islamic culture, it was an upstart province that had succeeded

in creating a literature and systems of thought that competed with the finest Arabic poetry and philosophical discourse of the past or present. From the point of view of the Byzantine Empire, it was a strange province that remained useful as a pawn in the struggle for control of the Mediterranean, even though it had been lost to heretics. For Africa or the northern Vikings, it was a place to sell one's wealth of raw materials. For the Iberian Peninsula itself, it was an astounding achievement: a land in which a totally new language and religion first overwhelmed and then interacted with a native tradition to produce a complex and original mixed culture that was to enrich the nature of Spanish civilization throughout its subsequent history.

1. By far the best introduction to the first centuries of Muslim rule in Spain is Lévi-Provençal 1950. Many wonderful insights are also found in Lévi-Provençal 1951 and in Torres Balbás [1971]. Important more recent histories are Wasserstein 1985 and Glick 1979. For the Jewish experience in all of its Muslim contexts, see Goitein 1967, 1971, 1978, 1983, 1988. The source for the stories in this essay's section on myth is Ibn al-Zubayr 1958 (see translation with commentary by Qaddumi [1990]).

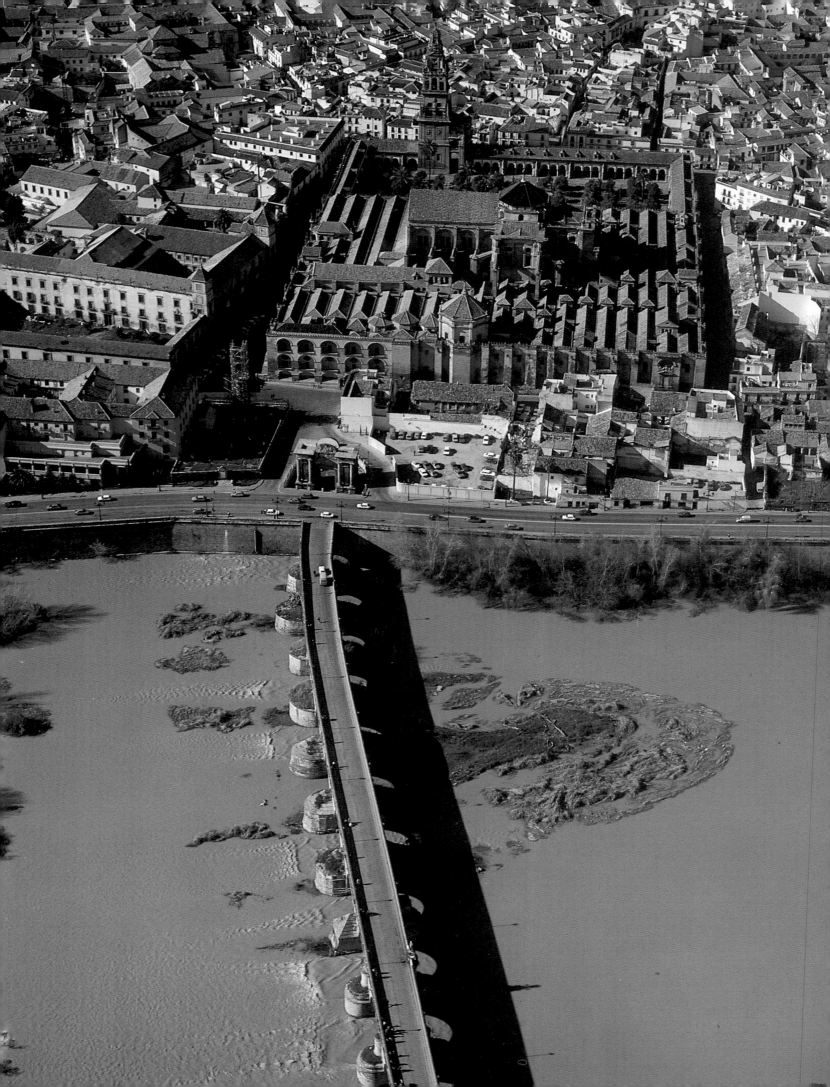

The Great Mosque of Córdoba

JERRILYNN D. DODDS

The Great Mosque of Córdoba, like a massive anchor, draws the city to the banks of the Guadalquivir River. Except for its minaret, the mosque cannot be seen over the lowest and most ancient rooftops, and yet its presence is felt everywhere in the old city: austere walls that hug the ground and yet also seem to give form to the urban fabric.

Córdoba's main congregational mosque was one of the first monumental expressions of Muslim rule in Spain. It was not only a powerful presence in Córdoba but also arguably the building that most fully embodied an image of the Muslim hegemony in al-Andalus during the caliphal period. What is extraordinary is that the mosque became such an image for both the Christians and the Muslims of western Europe—as if its singular forms could be understood as the natural outgrowth of the Islamic culture of al-Andalus and also as abstract symbols of the Muslim presence on the Iberian Peninsula. So the history of the mosque simultaneously chronicles the development of a Muslim language of forms on the western frontier of Islam and the creation of a series of potent visual symbols of what that Muslim culture meant to those within and without it.

The Early Mosque and the Emirate

The earliest accounts of the Great Mosque of Córdoba are shrouded in myth, which suggests that this particular monument began very early to embody important meanings in the Islamic world. A tradition transmitted by al-Rāzī tells us that at the time of the conquest of Córdoba, the Muslims "agreed with the barbarians of Córdoba to take half of their largest church which was situated within the city; in this half they constructed the mosque, while leaving the other half to the Christians, but destroying the other churches."[1] While this account is probably apocryphal and is bound up with preoccupations of later times to which I shall return, it recalls for us later Islamic historians' fascination with the necessary intimacy between an indigenous Christian population and the Muslim rulers. There were other newly conquered cities in the early Islamic world—Damascus and Jerusalem in particular—where unconverted Christians were a force to be reckoned with; yet Córdoba came over time to represent in the minds of Muslim historians the locus of encounter with the other, the idea that Spain was the edge of the Muslim world, Islam's frontier with a remote Christian north.

These were, however, not the primary concerns of the man who built the earliest parts of the monument that stands today, for the young emir ʿAbd al-Raḥmān I brought a different drama with him on his historic journey to al-Andalus. In an act that would shape the character of Islamic rule in Spain for centuries, this grandson of the Umayyad caliph Hishām escaped the ʿAbbāsid forces that sought his life, along with the destruction of the entire Umayyad royal family. He was forced to leave his home in Syria, the site of the caliphate, which had for close to a century been governed by his line, and to flee across the face of North Africa with ʿAbbāsid troops hard on his heels. He found allies with his mother's people in Morocco and, by the age of twenty-six, unified al-Andalus under his own rule.

Tradition has it that ʿAbd al-Raḥmān I began considering the construction of the mosque nearly thirty years after establishing himself in Córdoba.[2] The same historians who suggest that the Christian

Great Mosque of Córdoba with Catedral de Santa María, aerial view

and Muslim populations of Córdoba had been sharing the church of San Vicente on the site of the present mosque contend that he purchased from the Christians the half of the church they still shared with the Muslims, giving them permission to build additional churches outside the city walls. Ibn ʿIdhārī tells us that "Abd al-Rahman began the demolition of the church in 169H (785/6), and finished the new mosque in 170H (786/7)."[3]

ʿAbd al-Raḥmān I's original building (Fig. 1) survives in the southwestern portion of the prayer hall of the mosque in its final form (Fig. 2). A walled courtyard opened onto a wide hypostyle hall—together courtyard and hall originally measured about seventy-four meters square. The prayer hall roof is supported by columns sustaining ten arcades of twelve bays each, including a central aisle that is very slightly wider than the others and is also distinguished by red column shafts. Thus constructed, the building fits neatly into an established tradition of mosques with wide, dispersed spaces that depend on the repetition of a single support to create a hall for community prayer. The grouping of supports to the south drew the worshiper in what was thought to be the direction of Mecca, but little else in the building design points to the notion of a hierarchy involved in the act of worship. The hypostyle plan as it appears in the first campaign of the Great Mosque of Córdoba reflects the codification of an early Islamic space for prayer: It responds to the need for a communal gathering in which each individual prays without the intervention of clergy or liturgy and in which the mosque's users are comparatively unaffected by the kind of stridently hierarchical architectural forms that such intermediaries inevitably excite.[4]

This rather abstract account suggests a clarity in the mosque's typology that completely fails to convey the startling originality of its interior space (Fig. 3). For the columns that support the hypostyle hall explode into a labyrinthine elevation of superimposed horseshoe-shaped arches composed of voussoirs in which deep red brick and white stone alternate. This carnivalesque solution converts a basic building type that is repetitious and by nature somewhat monotonous into a

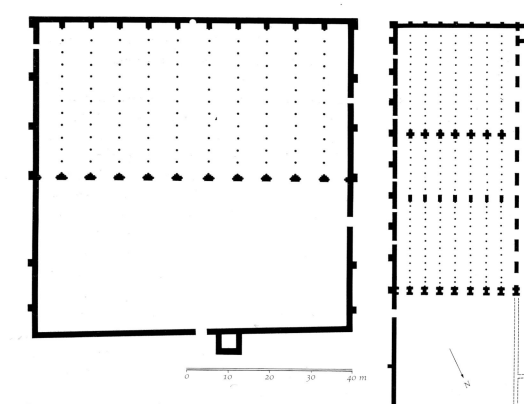

Fig. 1 Great Mosque of Córdoba, mosque of ʿAbd al-Raḥmān I, plan

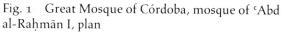

Fig. 2 Great Mosque of Córdoba as it appeared in 987 (A.H. 377), plan

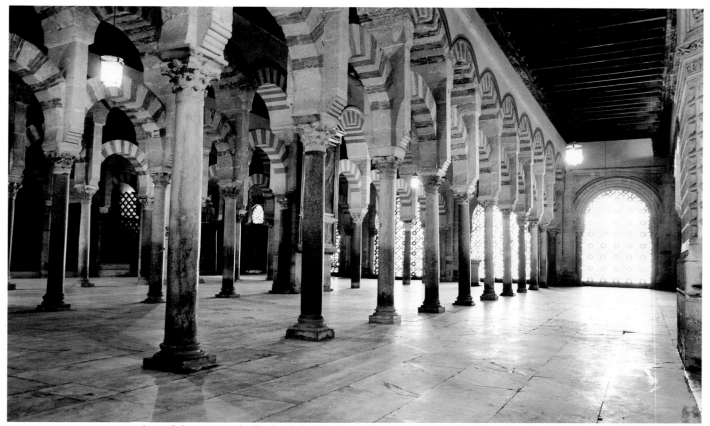

Fig. 3 Great Mosque of Córdoba, prayer hall of ʿAbd al-Raḥmān I

wild three-dimensional maze, a hall of mirrors in which the constant echo of arches and the unruly staccato of colors confuse the viewer, presenting a challenge to unravel the complexities these refinements impose upon the mosque's space. Interest in the mosque's interior is created, then, not by the application of a skin of decoration to a separately conceived building but by the transformation of the morphemes of the architecture itself: the arches and voussoirs. Because we share the belief that architectural components must by definition behave logically, their conversion into agents of chaos fuels a basic subversion of our expectations concerning the nature of architecture. The tensions that grow from these subverted expectations create an intellectual dialogue between building and viewer that will characterize the evolving design of the Great Mosque of Córdoba for over two hundred years.

The complex dialogue excited by this system of decoration can be seen as part of a subconscious collective experience common to many early Islamic societies: a struggle to create a language of architectural forms for the mosque within an aniconic culture—a way of identifying a place of worship with Islam and of engaging an audience without resorting to storytelling. But there are also conscious meanings encased in the specific forms chosen, meanings that relate to the particular experience of ʿAbd al-Raḥmān I and his earliest Muslim successors who ruled al-Andalus.

While the appearance and effect of the superposed horseshoe arches in the Great Mosque of Córdoba are startling, the practice of doubling arches in elevation had precedents, though in more prosaic contexts and in visually divergent forms. In Mérida, for example, a Roman aqueduct combines piggyback arches with alternating brick and stone masonry, calling to mind the alternating voussoirs of the mosque (Fig. 4).[5] Moreover, the Great Mosque of Córdoba consistently employed the horseshoe arch, an element of the indigenous church-building tradition of both pre-Muslim and Muslim dominated Spain.[6] And in proportion and construction, the arches of ʿAbd al-Raḥmān I's prayer hall are comparable to those of the church of San Juan de Baños, built in the seventh century by the Visigothic king Recceswinth (Fig. 5). For a number of reasons, it should not be surprising to find that these

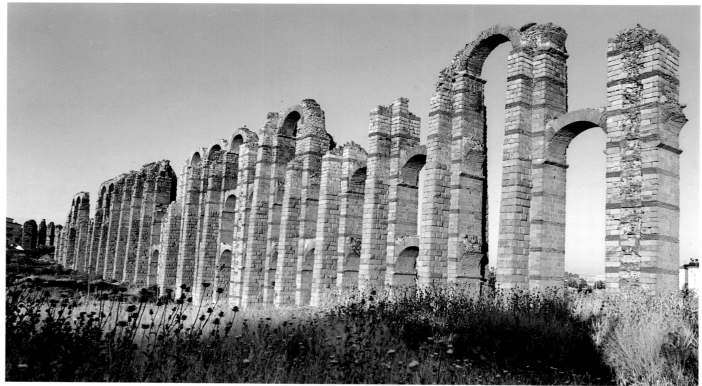

Fig. 4 Roman aqueduct, Mérida

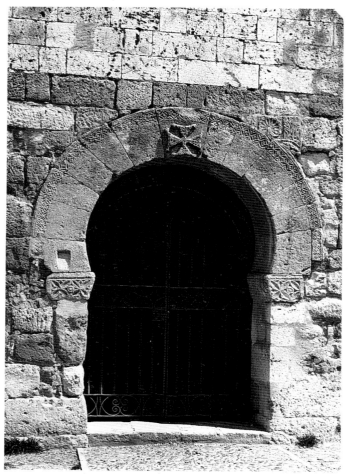

Fig. 5 San Juan de Baños, portal

features at Córdoba were taken over from earlier structures. All of the capitals in the initial campaign of the Great Mosque were *spolia*, and we know that no particular meaning that might inhibit their use in a Muslim context was attached to the appropriation of individual parts of ruined churches and Roman civic buildings. Indeed, early mosque architecture is part of the late antique building tradition in the Mediterranean. Thus, it would not be unexpected to see the appropriation of solutions such as those suggested by an aqueduct, for instance, which would help Cordobán architects heighten the ceiling of the Great Mosque, while employing reused columns of varying heights.

This said, however, we perhaps want to question whether the wild disposition of the mosque's elevation can be interpreted merely as a response to the practical need to elevate its roof or the passive adoption of an indigenous formal solution. I believe, rather, that the aqueduct of Mérida offered ʿAbd al-Raḥmān I a way to link his formidable act of patronage with his heritage and his aspirations. For it presented him with local techniques and materials that could evoke the important monuments built by his forbears, the Umayyad caliphs of Syria. The Great Mosque of Damascus tops its colossal arcade of reused

columns with a second, diminutive series of arches, almost an interior clerestory, that raises the height of the roof and punctures the upper wall.[7] An effect even closer to that achieved at the Great Mosque of Córdoba can be found in the Umayyad city of ʿAnjar, where a double arcade of slender semicircular arches cuts a dizzying and monumental profile through the center of the urban fabric. Further, Córdoba's alternating voussoirs of brick and stone surely must be an interpretation, in an accessible and less expensive medium, of the opus sectile colored voussoirs typical of late antique revetment. Recently scholars have begun to question whether the original marble revetment of the Dome of the Rock in Jerusalem or the Great Mosque of Damascus might not have included voussoirs of alternating colors.[8] When we remember that the aisles of the Great Mosque of Córdoba run perpendicular to the qibla in the manner of the mosque of al-Walīd I in Jerusalem,[9] the Spanish mosque emerges as a web of associations that link it with three of the most transcendent acts of patronage of the Umayyad caliphate in the Fertile Crescent. It is these fragments of architectural allusion that bring us to the heart of ʿAbd al-Rahmān I's personal concerns as a patron.

As the last surviving Umayyad ruler of a Muslim land, ʿAbd al-Rahmān I was deeply concerned with the authority provided him by virtue of his lineage. He had never forgotten the fate of his family or his own persecution by the ʿAbbāsids, and he effected as complete a political separation from ʿAbbāsid authority in Baghdad as was possible without claiming the caliphate for himself. We know, however, that he felt enormous nostalgia for the homeland he had been forced to flee: He named at least one palace outside Córdoba for an Umayyad country estate in Syria and wrote the following extraordinary poem to a single palm tree encountered on the Andalusian plain:

> In the midst of Ruṣāfa has appeared to us
> a palm-tree in a Western land far from the
> home of palm-trees. So I said, this resembles
> me, for I also live in distant exile and sepa-
> rated by a great distance from my children
> and my family. Thou hast grown up in a
> foreign land and we are both exiled far from
> home.[10]

The poem reveals to us that memories of ʿAbd al-Rahmān I's homeland had permeated the very heart of the emergent emirate as well as its political vocabulary. The lost Umayyad caliphate had quickly taken on both symbolic and emotional importance for the Umayyads of the emirate; it served not only as a political tool that demonstrated their heritage and right to rule but also as a source of identity in a frontier far from the familiar center of the Islamic world.

So we can see in the extraordinary prayer hall of the Great Mosque of Córdoba as it appeared at the time of ʿAbd al-Rahmān I a vigorous and spirited architectural solution that on many levels reflects the creative tensions of a new culture. On one hand, the use of indigenous materials and models signals that the Umayyads had early come to terms with both the gifts and the limitations of an existing architectural tradition. They in fact employed this tradition with enormous freedom and applied it in innovative ways in their ongoing search for an aniconic vocabulary of form. On the other hand, the conscious symbolic meanings of the mosque design were based in an artistic dialogue with the centers of Islam: with Umayyad Syria of the past and with ʿAbbāsid Baghdad of the present. Poised on the frontier of the Islamic world, ʿAbd al-Rahmān I used the design of his most transcendent architectural commission to create a visual symbol of his usurped authority as the last Umayyad and of the survival of his family in a faraway land.

If the immediacy of the first emir's experience of exile was not felt by succeeding Umayyad princes, they continued to share his sense of identity with an Umayyad past. In each of the subsequent additions to the mosque, we can at once read an unswerving reverence for the raucous but meaningful forms introduced under ʿAbd al-Rahmān I. Under ʿAbd al-Rahmān II in 836 (A.H. 222) the prayer hall was extended eight bays to the south: This elongates the plan, while it respects the elevation of ʿAbd al-Rahmān I's mosque. ʿAbd al-Rahmān II's reverence for his predecessor's plan was not compromised, even though many new columns and capitals were fashioned expressly for the mosque. The willingness to make new architectural parts to correspond in proportion to those of the older prayer hall, which was composed of *spolia*, reminds us of the strong appeal exerted by consistency with the older scheme. This addition was completed by ʿAbd al-Rahmān II's son Muḥammad, who is said also to have constructed a

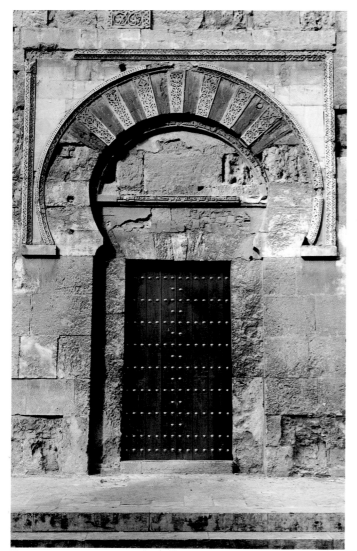

Fig. 6 Great Mosque of Córdoba, Puerta de San Esteban

maqṣūra, or reserved space in which the emir prayed, and to have restored the west door of the mosque, the Bāb al-Wuzarāʾ,[11] popularly known as the Puerta de San Esteban, in 855/6 (A.H. 241) (Fig. 6).

In the Bāb al-Wuzarāʾ we can also discern tensions between the creation of forms that gesture to the central Islamic lands and Muslim identity in particular and the use of indigenous materials and techniques and the new solutions they spawn. This door is dominated by a large blind horseshoe arch inscribed in an *alfiz*, a molding in a rectangular format. The arch itself is covered with false voussoirs that are alternately stucco reliefs and brick—a more elaborate version of those in the arcades within. Above the entranceway is a design of three horseshoe arches, the whole crowned by a projecting cornice of crenellations supported by a row of roll corbels. The

horseshoe arch here becomes the center of a theme that exploits both the traditional disposition of the mosque's interior and carved stucco decoration in a style identifiable with the Umayyad world.

Al-Mundhir, Muḥammad's son, added a treasury to the mosque, and ʿAbdallah, his successor, constructed a *sabat*, or covered passage, leading directly from the palace to a door of the mosque.[12] Ibn Ḥayyān's story of this addition is fascinating for the picture it offers of the delicate balance among ruler, populace, and mosque construction. He relates that the construction of the arched passage was necessary only because ʿAbdallah wanted to "go unseen by the people when he wished to pray [so that] no one was obliged to stand up or watch his going out."[13] The account carefully crafts a narrative that sees ʿAbdallah commissioning the passageway in response to the pious reproach of a doctor of law, who, upon seeing that the people rose when the prince entered the prayer hall, admonishes him to show more humility. ʿAbdallah constructs the passage only after he is unable to keep his subjects from standing upon his arrival. Of course, the theme of the text is humility, but I wonder if it does not subconsciously voice a displacement of the controversy concerning humility as it relates to such constructions and the person of the prince. ʿAbdallah's *sabat* not only would prove extraordinarily convenient for the ruler but would also allow him to pass privately with his entourage "screened from the eyes of the people until he reached the maqsura," according to another account,[14] thereby separating him from the populace and releasing him from the pressure of direct contact with his subjects. I think there is a good possibility that the elaborate justification offered by the text masks nascent tensions concerning the growing isolation and insistence upon the dignity of the prince, as well as his license to make costly additions to the mosque.

The Caliphate

It is with the next patron of the mosque, ʿAbd al-Raḥmān III, that the fullest exploitation of princely dignity is put into play, as the emir declares himself caliph. This is an act accompanied most importantly by an impressive wave of patronage centered upon the palatine city of Madīnat al-Zahrāʾ but also marked by significant additions to the mosque by ʿAbd al-Raḥmān III. In 951 (A.H. 340) this ruler re-

furbished the mosque's courtyard, alternating piers and columns in a sequence that recalled the Great Mosque of Damascus, now two centuries old, and affirming for us the constant renewal of links with the Umayyad world as a source of Islamic identity and now of caliphal authority as well.

Possibly more significant, however, is his construction of the mosque's first true minaret, of which the lower portion survives in the present cathedral bell tower (Fig. 7). Hishām I had already built a minaret in 793/4 (A.H. 177), but Jonathan Bloom has recently demonstrated that this was most likely a *ṣawmaʿa*, or staircase, minaret, which projected very little from the mass of the mosque itself.[15] ʿAbd al-Raḥmān III's minaret of 951–52 (A.H. 340) was a true tower, a fact later chroniclers celebrate in elaborate descriptions. Of particular interest are its height —some claim it reached one hundred cubits—and its two independent internal staircases. The minaret was topped with a "domed pavilion" and "golden and silver apples."[16] Perhaps most important, as Bloom has shown, it was one of the first such structures to establish the tower minaret as a symbol of the presence of Islam.[17] Initially developed under the ʿAbbāsids, in their own search for monumental forms to enhance the authority of their newly proclaimed caliphate, the tower became a potent symbol of the presence of Sunni Islam when the Spanish Umayyads appropriated it. In particular, Bloom sees this minaret as the physical manifestation of a defiant stance against the Fāṭimids, for whom such towers were unacceptable. Indeed, when the Umayyads took Fez from the Fāṭimids, ʿAbd al-Raḥmān III himself commissioned the replacement of short *ṣawmaʿa* minarets with tower minarets in the Spanish style in the city's two principal mosques.[18]

By the death of ʿAbd al-Raḥmān III, then, strong symbolic meanings that interwove the Spanish Umayyads with both the past and the present of the Islamic world had been associated with acts of patronage in the main congregational mosque of Córdoba. By the ninth century, however, another cultural group had begun to have an effect on Spanish Muslims and the way they constructed a visual identity for themselves, and this dialogue seems to have had an impact, albeit subconscious and indirect, on the use of tower minarets.

During a moment of extreme social and political stress in Córdoba in the ninth century, a number of churchmen embarked on a dramatic movement of voluntary martyrdom, aimed at consolidating Christian resistance to the cultural juggernaut of Islam. In response, Muslim authorities took measures to suppress the aspects of Christian worship that had a rhetorical power over the Islamic cityscape.[19] Christian polemic writers complained that they were obliged to shield their ears from the cries of the muezzin from his minaret and lamented in particular that, in violation of earlier practice, the towers of their churches were torn down. The power of the minaret was seen as comparable to that of a church tower. Albar of Córdoba describes Muslims who hear the sound of Christian bells from bell towers: "They wail out repeatedly unspeakable things" and, as Eulogius of Córdoba says, "begin to exercise their tongues in all kinds of swearing and foulness."[20] Perhaps the tower minaret was adopted in the tenth century as a reaction to the perceived power of the bell tower in the Christian communities of al-Andalus. Three generations after

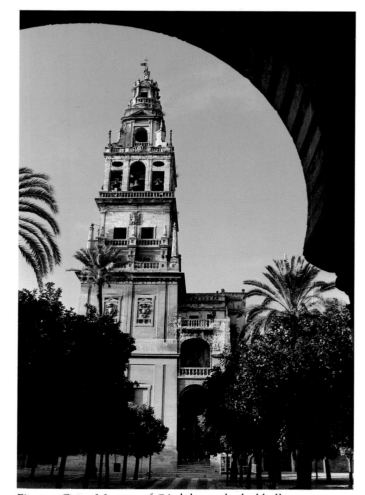

Fig. 7 Great Mosque of Córdoba, cathedral bell tower (minaret with additions)

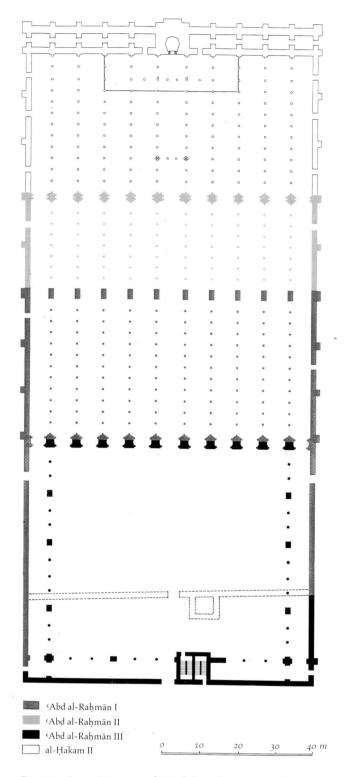

0 10 20 30 40 m

Fig. 8 Great Mosque of Córdoba, plan after additions of al-Ḥakam II

Christian church towers were destroyed because they appeared to threaten Muslim religious predominance, ʿAbd al-Raḥmān III appropriated the tower minaret from the architectural vocabulary of ʿAbbāsid Iraq to serve as a universal Sunni Muslim form: a symbol of the new caliph's transcendence within the Muslim

world, on one hand, and a subconscious competitive reinvention of the church tower, on the other.

The dialogue between Christians and Muslims was to have a long history in al-Andalus: In 997 (A.H. 387) al-Manṣūr sacked and burned the Christian shrine at Santiago de Compostela, bringing the bells to Córdoba, where they served as lamps in the mosque. When Ferdinand III conquered Córdoba for the Christians in 1236 (A.H. 634), he returned the bells to Santiago on the backs of Muslim prisoners. Many of the extraordinary lamps that are today in the Qarawiyyīn mosque in Fez are made from the silent bells of Christian churches, captured in battle by the Almohads and Marīnids and carried to the mosque as trophies of a victorious religion (see Nos. 55, 58). These incidents remind us that the forms that had the most impact or rhetorical force were those that became the most powerful symbols of triumph and sovereignty as appropriated booty, even if they were not exploited for their original purposes.

The Additions of al-Ḥakam II

During the reign of ʿAbd al-Raḥmān III's son al-Ḥakam II, the Great Mosque of Córdoba received the mark of caliphal dignity that had distinguished the palace of Madīnat al-Zahrāʾ under the first caliph—it became the primary focus of royal patronage. Indeed, chroniclers recount that a mandate for additions to the mosque was the first order given by the new caliph upon taking the throne in 962 (A.H. 351). These additions were enormous in scope: He lengthened the existing arcades twelve bays in the direction of the qibla, converting a short, wide prayer hall into an extended longitudinal one (Fig. 8) and adding a number of doors that followed the earliest portal design (Fig. 9). The prayer hall now culminated in an elaborate new *maqṣūra* surmounted by ornate ribbed domes and forming a grid of three bays in front of the mihrab. The aisles extending from these three bays are distinguished at the entrance to the *maqṣūra* and the beginning of al-Ḥakam II's addition itself by two screens of wild meandering polylobed interlacing arches (Fig. 10).[21] This mihrab is the first to take the shape of a room, and to either side of it, doors open onto a treasury and a new *sabat*, which originally·led to the caliphal palace. The three doors on the qibla wall, as well as the mihrab dome, are covered with mosaics in which inscriptions and abstract and vegetal

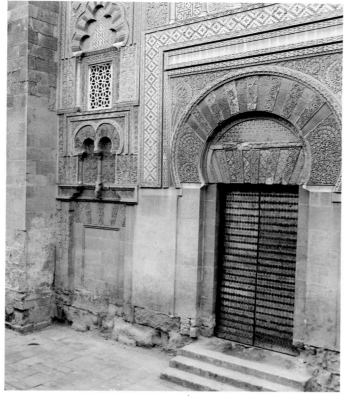

Fig. 9 Great Mosque of Córdoba, portal, addition of
al-Ḥakam II

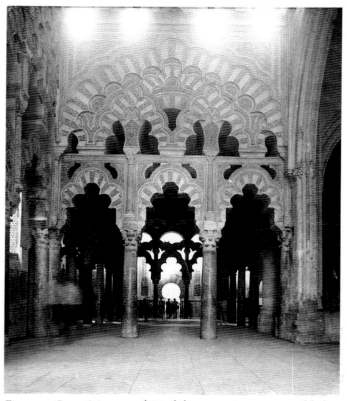

Fig. 10 Great Mosque of Córdoba, *maqṣūra* screens added
by al-Ḥakam II

motifs that recall the mosque's history are picked out
in luminous green and gold glass cubes (Fig. 11).

Al-Ḥakam II's addition is a costly and luxurious
version of the original, traditional plan for the Great
Mosque: The prayer hall repeats in all but the small-
est details the sections built since the time of ʿAbd
al-Raḥmān I. However, the elaborate interlacing
stage-set arches of the three mihrab aisles, the exqui-
site mosaics of the mihrab, its adjacent doors, and its
dome create a privileged space laden with the tensions
and concerns developed in a more restrained way in
earlier moments of the mosque's history.

A first level of meaning of this most ostentatious
addition to the mosque involves its costliness, which
did not escape the scrutiny of the public, as well as the
uses to which this cost was put. ʿAbd al-Wāḥid al-
Marrakeshī tells us that Cordobáns refused to pray
in this enlargement until they were told how it had
been financed.[22] In light of this account, Ibn ʿIdhārī's
justification for the addition tends to ring with the
same concern for rationalization and legitimization
that informed Ibn Ḥayyān's explanation of ʿAbdallāh's
passage: "The press of the crowd in the mosque, be-
cause of the large number of faithful, was so great

that many fainted and perished, and this is what deter-
mined al-Ḥakam II to order enlargements and
additions. The qāḍi al-Mundhir ibn Saʿīd, accompanied
by the superintendent of the pious foundations, the
jurists and witnesses, came to the mosque to study the
work of enlargement to be executed with the help of
existing funds as well as from pious foundations."[23]
The insistence on the welfare of the public as well as
the consultation of so many representatives (including
the superintendent of pious foundations) hint that the
opulent—and not altogether practical—building pro-
grams that had come to link patronage to the aspirations
of individual rulers had caused unease in the *umma*,
the community of the faithful. These tensions clearly
grew from the disjuncture between the opulence and
cost of the program and the extent to which the cost
actually served the *umma*, as opposed to the consoli-
dation of the power of the ruler.

The second level of meaning of al-Ḥakam II's
addition is a subconscious one.[24] It also grows from
social unrest and concerns the impact of the Mozarabic
turmoil of the century before. The reigns of ʿAbd
al-Raḥmān III and al-Ḥakam II saw a closing of the
rift between Muslims and subjected Christians in

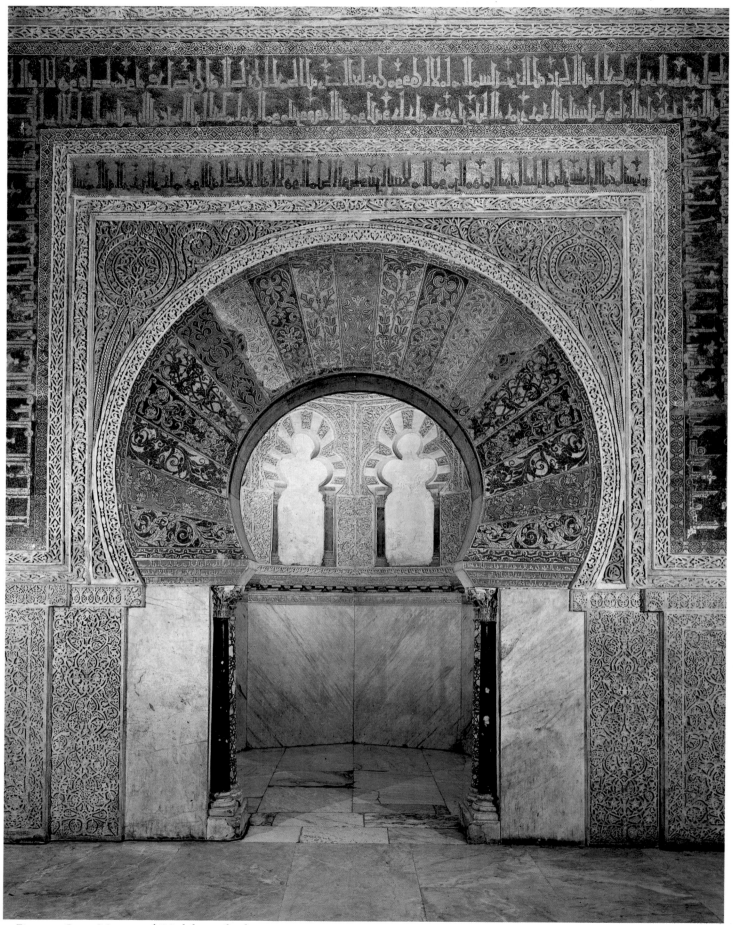

Fig. 11 Great Mosque of Córdoba, mihrab mosaics

al-Andalus, and in fact witnessed a landslide of con-versions to Islam.[25] How did a large population of recent converts and a relatively recent experience of the power of the Christian community's religious fervor affect the secure and consolidated reigns of the Spanish Umayyad caliphs? I believe they inspired an unconscious reactive adaptation of a Christian archi-tectural form in al-Ḥakam II's addition, just as in the case of the tower minaret. Here this adaptation involved the space of a contemporary Mozarabic church, in particular in the three principal aisles that align with the mihrab and its ancillary doors and in the creation of the first mihrab in the history of Islam to take the form of a room.[26] This kind of space was conceived centuries earlier to serve an ancient indige-nous Christian liturgy: three longitudinal aisles and a transverse space culminating in three rooms, the central one of which can be horseshoe shaped. The church of San Miguel de Escalada, completed in 913 (A.H. 301), provides the best parallel for this plan type (Fig. 12).

The dependence of the mosque plan design on a Christian prototype is betrayed in a curious detail: There is no practical reason for the entrances to the sabat and the treasury to be decorated in a way similar to the mihrab; this is totally unprecedented and even functionally misleading, explicable only in the context of a formal parallel with three-apsed Christian churches. It has even been suggested that a procession that re-flected the Mozarabic liturgy might have taken place in this space.[27]

Clearly, however, no conscious allusion to Chris-tianity was intended here. As a matter of fact, the elevation is transformed with an artistic vocabulary unique to the Islamic architecture of al-Andalus. The impossible intertwining of the screens of polylobed arches is a complex mannerist interpretation of ideas we traced in the original mosque, whereby a visual puzzle is created and architectural form fashions a de-sign that seems logically inconceivable. Further, the strongest visual associations here are not with Chris-tian churches but with the palace of Madīnat al-Zahrāʾ; indeed, some of the elaborate decorative vocabulary and variations on the basilical axial space that appear in al-Ḥakam II's additions to the mosque were de-vised at Madīnat al-Zahrāʾ. And it is no wonder that the parallels with this palace are so close: The addi-tions of al-Ḥakam II represent but one development

in a movement throughout the Mediterranean that saw palatial forms imposed upon hypostyle mosque plans as a means of sanctifying the authority of rulers. The important issue to grasp is that, in the search for forms with rhetorical and authoritative force, Spanish Muslims not only mined the basilical spaces of secular palaces but also elaborated the effects and the ritual that inhabited those spaces through an understanding of the rhetorical force of a Christian liturgical build-ing.[28] This was a language of forms the Muslims of al-Andalus learned from the Christians, with whom they were constantly in contact, but it was a language they emptied of any Christian meaning. To what end this extraordinary appropriation was used, I will re-turn presently.

The third and final level of meaning to be drawn from the additions of al-Ḥakam II is both conscious and symbolic: It concerns the renewal of historical and visual links with the Umayyad caliphate, connections pursued with particular energy by the Spanish Umayyads in support of their own caliphate, which they had established only a generation before. Though this interpretation is the most obvious and well known of those discussed, it takes on a new texture against the backdrop of the more subconscious social tensions outlined above. The legends concerning the founding

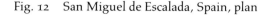

Fig. 12 San Miguel de Escalada, Spain, plan

of the mosque might well have developed at this moment, for the notion that the earliest Muslim inhabitants of al-Andalus might have shared a church with Córdoba's Christian inhabitants presents a striking literary parallel to the early histories of the Great Mosque of Damascus, the centerpiece of early Umayyad patronage in the first years of the eighth century.[29]

In terms of the mosque design, Christian Ewert has outlined for us a number of ways in which the axiality of the additions of al-Ḥakam II forms a dialogue with the Umayyad past.[30] It is, however, in the qibla wall constructed by al-Ḥakam II that we find the strongest support for the political idea that the Spanish caliphs sought to forge such connections.[31] One of the striking and curious aspects of the qibla of al-Ḥakam II is the presence in it of mosaic decoration. Mosaics had been unknown on the Iberian Peninsula for centuries and were little used in the contemporary Islamic world. Once again Ibn ʿIdhārī supplies a justification for a feature of the mosque, now providing the official explanation for the mosaics, as well as their official meaning: "Al-Ḥakam had written to the king of the Christians on the subject [of the mosaic incrustations] and had ordered him to send a capable worker, in imitation of that which [the Umayyad caliph] al-Walīd had done at the time of the construction of the Great Mosque of Damascus."[32]

The use of mosaic decoration was intended, then, to create a strong visual evocation of the Great Mosque of Damascus. It was not only another in the continuing series of links created between this mosque and the memory of the early Umayyads but also a fascinating gesture in which the caliph reminds the viewer of his presence as patron: Al-Ḥakam II negotiates with a Christian king (in this case, the Byzantine king) in an almost ceremonial repetition of what his ancestor, the Umayyad caliph in Damascus, had done over two hundred years earlier.

The qibla wall combines other, more familiar forms, such as quartered marble and carved stucco inspired by both the early history of the Córdoba mosque and the early centers of the Islamic world. The qibla's associations are with the mosque's own past as well as with the Great Mosque of Damascus: We are told that al-Ḥakam II himself supervised the conservation and transferal of the columns that support the mihrab arch from the mihrab of ʿAbd al-

Raḥmān II, which had to be destroyed to accommodate this addition. The principal innovation in the qibla, however, was the introduction of Qurʾanic inscriptions as the carrier of meaning for this opulent focal point. The inscriptions weave a path through the densely composed jungle of vegetal and geometric forms of the mosaic, adding to their cacophony and horror vacui; at times their status as writing is obscured by their integration into the overall abstract schema. In this way the writing becomes part of the visual dialogue present everywhere in the mosque: If we read it, it carries one kind of meaning; but as an abstract form, it also plays a role as part of the complex and meditative design of the mosque as a whole. Once again the viewer is engaged by an ambiguity in the relationship among parts. This time, however, what the puzzle reveals to the meditative viewer is something more profound: the word of God, written in the language in which it was spoken. So the elusive script of al-Ḥakam II's qibla wall is sanctified both in its content and as part of a vast schematized puzzle of form.

In the Qurʾanic citations that embrace the three openings of the qibla, Oleg Grabar has seen evidence of a thematic development around the practice of prayer.[33] For those who were able to read the inscriptions, this first use of Qurʾanic writing to embellish a qibla linked an aniconic formal resolution with religious meaning literally to create a kind of Muslim iconography: an engaging visual drama that carries a message without dependence on narrative. It is an iconography that communicates through intellect rather than empathy. Once again I think it is possible to interpret a new development in religious art as the result of contact with an active and vibrant Christian community, and perhaps now also stimulated by the recent absorption of large numbers of former Christians into the Muslim community. The idea of creating an aniconic iconography—a nonfigurative art that carries a specific religious message to its public—can be seen as a concept learned from generations of living side by side with Christians, for whom religious art was a message conveyed through figural iconography. It is, however, borrowed across a cultural barrier, without any memory of or association with the figural religious iconography that was the catalyst for its development. What we find, then, is that the presence of a strong Christian community stimulated the development of a number of new forms in the Great

Mosque of Córdoba — forms that lie at the heart of the uniqueness and creativity of the mosque without once betraying any association with Christian practice or identity. Part of the strength and originality of the Great Mosque of Córdoba as a monument grew from the presence of an other — the challenge presented by confrontation with another culture.

In the case of the qibla inscriptions, the taking over of such forms served not only the subconscious goal of appropriating certain powerful rhetorical features from Christian arts; it also buttressed the conscious program of the creation of a new caliphate, which sought to underline the hierarchy and legitimacy of the new caliph. For the immediate model for the inscriptions, the model that transformed the Christian idea into a Muslim one for the builders of the mosque, was to be found in an Umayyad public monument—the Dome of the Rock. Here seventh-century inscriptions conveyed lessons about the Muslim religion and an image of Muslim victory to another lively non-Muslim community.[34]

The introduction of inscriptions and their integration into the most lavish part of these additions to the mosque can be seen as an attempt to galvanize a measure of public investment in a program designed primarily to consolidate the authority of the new caliphate. Their use can on one level be seen as a redirection of the opulent qibla program to prayer, the primary activity of the community in the mosque, an appropriate gesture in view of the earliest public reaction to the additions of al-Ḥakam II. This hypothesis is supported by one of the non-Qurʾanic texts that wraps around the mihrab: "Praise be to God, master of the worlds who favored al-Ḥakam II, the servant of God, the prince of the faithful . . . for this venerable construction and helped him in the building of this eternal place, with the goal of making this mosque more spacious for his subjects, something which both he and they greatly wanted."[35]

Though the additions of al-Ḥakam II are teeming with conscious references to the political agenda of the caliphate—an agenda recognized and celebrated by later chroniclers—in the mosque inscriptions he states his purpose to be service to his subjects, a goal that might have been accomplished with significantly greater economy. Clearly the tensions between the needs of the *umma* and the license and exclusivity of the caliphate were great and not yet resolved when al-Ḥakam II's subjects refused to pray in the new mosque.

Despite a disjuncture between the political and public programs of the additions of al-Ḥakam II, even this new religious iconography of prayer, as well as the other inscriptions on the qibla, takes inspiration from a model that buttresses the links between the old Umayyad caliphate of Syria and the new one of Córdoba. The catalysts for the development of this first Qurʾanic calligraphic program in a mosque may have been experience of the power of Christian didactic arts and the need for a way to justify the expensive arts of authority to a skeptical general public. As we have seen, the immediate model that provided an acceptable heritage for these goals was the Dome of the Rock in Jerusalem.

The additions of al-Ḥakam II to the Great Mosque of Córdoba bear witness to the peculiar set of circumstances that created the Islamic society of al-Andalus. They demonstrate the need in a frontier peninsula to create a Muslim identity with links to the center of the Muslim world and also evidence the rich creativity that results from the challenge provided by the dialogue with a divergent religion and culture. Finally, the hierarchical architectural vision nurtured in this atmosphere exasperated the growing tensions between the caliph and the community, between the use of patronage as a means of asserting the power and exclusivity of a caliph and the community's dawning awareness that those pretenses diminish both the pluralistic nature of their worship and their community coffers. The mosque becomes our document of the social tensions that are created by, and hover about, opulent hegemonic display.

The Additions of al-Manṣūr

In the reign of Hishām II, under the administration of his despotic and powerful minister al-Manṣūr, the entire character of the mosque was transformed. In 987/8 (A.H. 377/8) al-Manṣūr added eight aisles to the east along the entire length of the mosque to provide room for the large number of Berber tribes that had settled in the capital. This addition, which repeats both the prayer hall elevation and portal type consistently used in the mosque, widens the prayer hall once more, disrupting the symmetry of the mihrab of al-Ḥakam II and dislocating the axis and hierarchy of the caliph's long directional plan (Fig. 2).

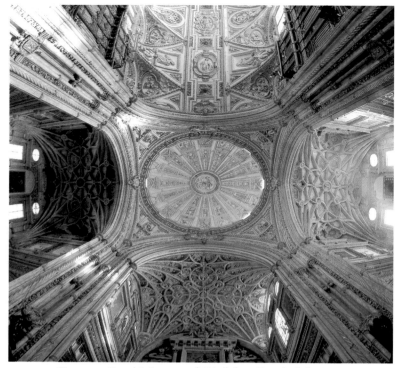

Fig. 13 Great Mosque of Córdoba, Catedral de Santa María, dome

Texts that speak of this last addition, executed on the eve of the fall of the caliphate, describe a more restrained insular attitude toward patronage than had existed earlier: Ibn ʿIdhārī, for example, says curtly that what al-Manṣūr sought in his work was above all solidity and finish, but not ornamentation, though his enlargement is not inferior to the other enlargements in the edifice, except the work of al-Ḥakam II.[36] Historians also chronicle with evident approbation both al-Manṣūr's more conservative polarized attitude toward the Christian kingdoms of the peninsula and the way in which this position becomes part of his myth as a patron of the Great Mosque. For it was at this moment that al-Manṣūr "ordered the bells of the church [of Santiago] be removed to Cordoba on the shoulders of Christian captives, to be suspended [as lamps] from the ceiling of the Great Mosque."[37] Al-Maqqarī, who transmitted this remark of Ibn Ḥayyān's, goes on to say that al-Manṣūr's addition was "rendered still more meretorious by the circumstance of Christian slaves from Castile and other infidel countries working in chains at the building instead of the Moslems, thus exalting the true religion and trampling down polytheism."[38] This severe approach to both patronage and Christians as a group suggests that a reaction was in force against the perceived excesses of a new caliphate under al-Ḥakam II.

From Mosque to Cathedral

On June 29, 1236 (A.H. 634), Córdoba fell to the hands of Ferdinand III, king of Castile. In that same year Ferdinand and a number of bishops purified the Great Mosque of Córdoba for Christian worship, consecrating it as the Catedral de Santa María. At first alterations to the building constructed for Muslim worship were few and insignificant: The incorporation of occasional chapels and burials subtly transformed corners of the Muslim space. Later in the thirteenth century the Capilla Real, a pantheon for the kings of Castile, was constructed in the Mudejar style. The building of this chapel, which was decorated with Arabic inscriptions and carved stucco ornament, must have constituted an attempt to appropriate the potency of the vanquished Muslim caliphate by inserting Castilian royal burials within its most formidable monument. The Great Mosque of Córdoba was part of the myth of Córdoba as a world capital, as the center of a powerful, apparently invincible culture; its visual forms had come to embody the Islamic presence on the peninsula in all of its intriguing and threatening implications. The Christians who conquered Córdoba understood that there was much more power to be gained from appropriating this extraordinary metaphor of their conquest than from destroying it.

By the end of the fifteenth century, a Gothic nave and choir, the Capilla Mayor, subtly defined a Christian space for worship. However, no act more clearly illustrates the need of the Cordobán ecclesiastical hegemony to harness and transform the meaning of the former mosque than the construction of a vast cathedral at its center starting in 1523 (Fig. 13). Despite the opposition of the city council, which vociferously promoted the preservation of the mosque in its original form, the canons won their suit to build a church within it and began a construction campaign that would not be complete until the end of the eighteenth century. Designed primarily by three generations of the Hernán Ruiz family, the cathedral sprouts impertinently from the mosque's flat prayer hall and uses a dome and a clearly defined nave to proclaim its Christian identity to all who view the mosque from without, visually appropriating the minaret as a bell tower. Its interior reveals a vast, radiantly lit space,

featuring Gothic tracery, classical orders, and an enormous array of Renaissance sculpture. These figures are at times inscribed in the earlier horseshoe arches with polychrome masonry, as if to give the Islamic architectural decoration the focal points and narrative subjects the Christian viewer misses. On the other hand, many of the vaults and walls are executed in the Plateresque style, in which abstract patterning of Gothic tracery reminds us that even architectural styles appropriate to Spanish churches contain digested Muslim forms, the mark of over seven hundred years of cohabitation with Islamic culture.

The emperor Charles V, who had originally supported the canons in their petition to build within the mosque, is recorded to have remarked upon seeing the new cathedral: "You have taken something unique and turned it into something mundane."[39] And yet we must not forget that this was the same man who carved a massive Renaissance palace into the site of the Alhambra. The ambiguous meanings that clung to the Muslim and Christian visual languages did not disappear with the Christian conquest; instead they provided fertile ground for the definition, this time, of a new Christian artistic identity. The Great Mosque of Córdoba was a strong statement of Muslim identity, one conceived to link the Muslims of al-Andalus to Syria and the ancient center of the Islamic world. But on some level it was also understood by Christians and Muslims alike as an intrinsically Spanish monument, one that reflected the peculiar interchanges and tensions between Islamic and Christian visual cultures. Appropriation of such a building meant that sixteenth-century Christians had begun to incorporate a part of the Muslim visual world into their own, making it a sign of all that was powerful and elegant for a new Christian hegemony.

1. Cited by Ibn ʿIdhārī 1901–4, vol. 2, p. 378.
2. Creswell 1940a, p. 139.
3. Ibid.
4. For a discussion of the development of early mosques, see Grabar 1987, pp. 99–131. An absence of hierarchical organization characterizes the earliest mosques, though in a number of important prayer halls, pronounced central axes appear. Grabar discusses the particular way in which early mosque design uses the components of church architecture but subverts the natural hierarchy of its axial form, so that elements like aisles can appear without the culminatory effect they have in a Christian basilica (pp. 118–19).
5. On the issue of the relationship between the Great Mosque of Córdoba and the aqueduct of Mérida, see Marçais 1926, p. 231; Gómez-Moreno 1951, p. 36. For an excellent technical analysis, see Ewert 1966, pp. 12–14.

6. The history and meaning of the horseshoe arch have been widely discussed since Gómez-Moreno set the tone for its careful historical study (1906). Camps Cazorla examined proportion and technique (1953). More recently, Caballero Zoreda has rewritten the history of the form in light of discoveries of the last forty years (1977–78). Finally, I attempt to understand the meaning of the form on the Iberian Peninsula through the year 1000 (Dodds 1990).
7. The idea that the inspiration for the Great Mosque of Córdoba might derive from the elevation at Damascus was developed by Franz (1958).
8. For a review of the literature concerning this problem, see Dodds 1990, p. 164, n. 50.
9. For bibliography on this issue, see ibid., p. 163, n. 47.
10. Cited in Ibn ʿIdhārī 1901–4, vol. 2, pp. 95–96, trans. in Creswell 1940a, p. 139.
11. Brisch 1965.
12. Ibn ʿIdhārī 1901–4, vol. 2, pp. 380–81, cited in Creswell 1940a, p. 140.
13. Ibn Ḥayyān, "al-Muqtabis fī Taʾrīkh Andalus," Oxford MS, fol. 27a, b, cited in Creswell 1940a, pp. 140–41.
14. Ibid., fol. 28a, cited in Creswell 1940a, p. 141.
15. Bloom 1989, chap. 7.
16. Al-Maqqarī 1840–43, vol. 1, pp. 224–25, cited in Creswell 1940a, p. 141.
17. Bloom 1989, p. 106.
18. Ibid., chap. 7.
19. This argument is developed in Dodds 1990, pp. 102–4.
20. Albar of Córdoba, Indiculus luminosus, 6, trans. in Colbert 1962, p. 276; Eulogius of Córdoba, Memorialis, Lib. I, 21, this author's trans.
21. For a discussion of the interlacing arches, see Ewert 1966.
22. Al-Maqqarī 1840–43, vol. 1, p. 219, cited in Creswell 1940a, p. 143.
23. Ibn ʿIdhārī 1901–4, vol. 2, p. 390.
24. Dodds 1990, pp. 94–106.
25. See Glick 1979, p. 187; Bulliet 1979, pp. 117–26.
26. Kroeber describes "the idea of the complex or system which is accepted, but it remains for the receiving culture to develop a new content" (1940, p. 1). A text that is important for the application of such methods to the study of Spain is Glick and Pi-Sunyer 1969.
27. Grabar 1988; Dodds 1990, pp. 94–106.
28. Dodds 1990, pp. 94–106.
29. For analysis of the possible relationship between the establishment of the Great Mosque of Damascus and that of the Great Mosque of Córdoba, see Terrasse 1932, p. 59, n. 2; Creswell 1969, pp. 187–96; Creswell 1940a, pp. 138–39; Gómez-Moreno 1951, pp. 24–29; Ocaña Jiménez 1942.
30. Ewert and Wisshak 1981.
31. This has been recognized by a series of scholars, not least among them Stern (1976).
32. Ibn ʿIdhārī 1901–4, vol. 2, p. 392, this author's trans. from the French; see also Stern 1976, pp. 1, 28.
33. Grabar 1988, pp. 116–17.
34. Grabar 1987, pp. 46–70; Grabar 1959, pp. 33–62, reprinted in Grabar 1976, II.
35. Lévi-Provençal 1931, no. 12, pp. 15–16.
36. Creswell 1940a, p. 144, citing Ibn ʿIdhārī 1901–4, vol. 2, p. 392.
37. Al-Maqqarī 1840–43, vol. 2, p. 196.
38. Ibid., vol. 1, p. 228.
39. Ramírez de las Casas-Deza 1837, p. 197.

Madīnat al-Zahrā':
The Triumph of the Islamic State

ANTONIO VALLEJO TRIANO

In the year 929 (A.H. 316) the eighth Umayyad emir of al-Andalus, ʿAbd al-Raḥmān al-Nāṣir, proclaimed himself caliph and adopted the institutional title of the caliphate, *amīr al-muʾminīn* (Commander of the Faithful). The political and ideological reasons for this rupture with his predecessors are complex. ʿAbd al-Raḥmān first consolidated the Islamic state in al-Andalus by subduing the marginal territorial lords who were in open competition with it and integrating them into an already complex administrative apparatus. However, at this time, he was most interested in controlling the economic forces that supported this state, for example, the supplies of cereals and gold from North Africa, which were being threatened by rapid Fāṭimid expansion. Thus, when the Fāṭimid ʿUbaydullāh adopted the title of caliph in 910 (A.H. 298) and thereby increased his influence over the groups of tribal Berbers acting as intermediaries in the struggle for control of that commerce, ʿAbd al-Raḥmān's proclamation was a significant countermeasure.

From this perspective, the architectural representation of the triumph of the state now headed by an *amīr al-muʾminīn* would be the creation of a new city, Madīnat al-Zahrā', whose fortunes would be tied to those of the dynasty that created it.[1] ʿAbd al-Raḥmān's city was located some five kilometers to the east of Córdoba, on a straight line with its western walls, in a place where the slopes of the Sierra Morena project into the countryside, offering the advantage of an enormous natural spur between two ravines. Neither to the east nor to the west, where the mountains meet

the valley in more precipitous formations, do we find a prospect affording such an unobstructed command of the surrounding landscape. The topographical uniqueness of this site on the southern edge of the sierra, so close to Córdoba, is crucial when we assess the placement of Madīnat al-Zahrā'. This geographical uniqueness links it to earlier ʿAbbāsid palaces such as Jawsaq or Bulkawara in Samarra, which were also situated on high ground to take advantage of a view over the land below.[2]

On this site, carefully chosen to exalt the image of the caliphate and employing a hierarchical scale that began with his own residence, ʿAbd al-Raḥmān III erected an authentic medina—in the true sense of the word. He was following a long tradition in eastern Islam that associates sovereigns with the construction of great urban centers, allying, in a way as yet insufficiently analyzed, the building of cities with a caliph's stature.[3]

The rectangular layout of Madīnat al-Zahrā', in theory a plan based on a double square of approximately 1,506 longitudinal meters running east and west, is interrupted on the north by a necessary adjustment to the topography (Fig. 1). Aerial photography reveals a perfect enclosure surrounded by a double wall on the east, south, and west, and fortified by square towers, wider at the corners, except on a section of the north, which is bounded by a single, partially excavated, wall (Frontis.). There are also ruins outside that wall that may correspond to a small defensive area.[4] Between the wall and the ruined buildings runs one of the roads to the

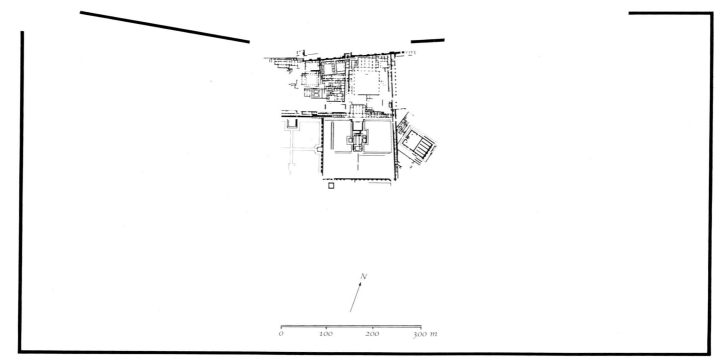

Fig. 1 Madīnat al-Zahrāʾ, plan

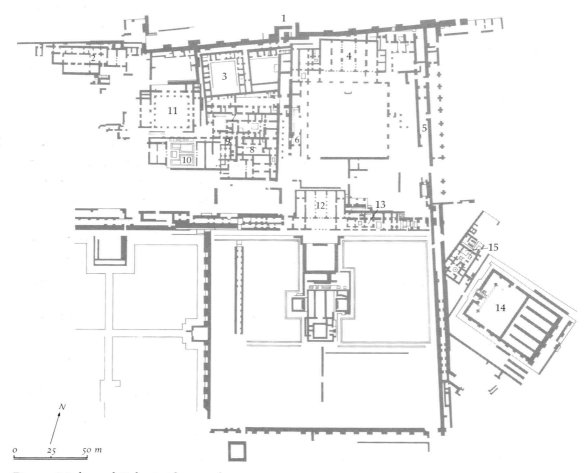

Fig. 2 Madīnat al-Zahrāʾ, Alcazar, plan

1. Northern road and access to the Alcazar 2. Dār al-mulk 3. Large courtyards 4. Dār al-jund 5. Portico and access to the "official" sector
6. Access the residential sector and stables 7. Service quarters 8. Residence of Jaʿfar 9. Bath 10. Residence of the Patio of the Pool
11. Court of the Pillars 12. Hall of ʿAbd al-Raḥmān III 13. Annexes and bath 14. Mosque 15. Ablution rooms

Alcazar. A second nucleus of buildings south of the southern walls has recently been identified as pertaining to one of the outlying areas mentioned by contemporaneous sources.[5]

Recent scholarship seems to offer us the image of a city with a network of roads, relatively independent of Córdoba, that disappeared along with the urban center they served. Of the three roads that have been clearly identified, two enter from the east side, probably through the same gate, and at least one, the road proceeding from Córdoba through an area of aristocratic residences near the Guadalquivir, must have entered on the south, below the Bāb al-Ṣūra (Gate of the Statue) of written accounts.

Although data related to building the city—the number of workmen employed, the quantity and origin of building materials, the time and costs of construction—appears repeatedly in various historical and literary sources, especially later ones, there is little agreement among them. At times, moreover, the information stands in direct contradiction to particulars provided by archaeological investigation.[6] The same lack of accord is found in regard to the date construction started. Ibn Ḥayyān records the year 940/1 (A.H. 329), while other authors state that work was begun in 936 (A.H. 325).[7]

These same sources offer a partial record of the process of creating the city and of the gradual transfer of bureaucratic and administrative departments of the state completed when Madīnat al-Zahrā' was established as the capital of al-Andalus. The principal mosque (aljama) was completed in 940/1 (A.H. 329), although the few remaining epigraphic traces on the main commemorative tablet in the courtyard near the minaret give the date as 944/5 (A.H. 333).[8] The path that joined the former residence of al-Nāṣir, his munyat (country home), al-Naura, was constructed in 942 (A.H. 330).[9] Four years later, in 946 (A.H. 334/5), it is recorded that ʿAbd al-Raḥmān was residing in Madīnat al-Zahrā'. In 947/8 (A.H. 336), the mint, the Dār al-sikka, was moved to the new city, a transfer corroborated by the numismatic register, which implies the existence of a technical and service infrastructure capable of supporting those enormous workshops.[10] In these first years, the Dār al-ṣināʿa, the official center for artisans, also must have been moved, at the same time that ʿAbd al-Raḥmān was encouraging construction and settlement of the new

city through major financial incentives: Four hundred dirhams were offered to anyone who constructed a dwelling at the sovereign's new location, which explains the rapid growth of the city observed by Ibn Ḥawqal in the middle of the tenth century.[11]

This building activity must have continued at a significant pace during the reign of ʿAbd al-Raḥmān's son al-Ḥakam II, who later enlarged the mosque in Córdoba. After al-Ḥakam's death, Ibn Abī-ʿAmir (al-Manṣūr), the hajib, or chamberlain, of the new caliph Hishām II, founded a new city east of Córdoba, Madīnat al-Zāhira. He installed himself there in 981 (A.H. 370), along with his court and the administrative services transferred from al-Zahrā'.

The series of internal struggles that prompted the disintegration of the caliphate and, with it, the state—a period chroniclers refer to as the fitna, or civil war (1010–13 [A.H. 401–4])—implies the beginning of the sacking and subsequent destruction of Madīnat al-Zahrā'. The concentrated pillaging of precious materials—first lead pipes and marble capitals, shafts, and bases, and later masonry —helps explain the rapid effacement of the city, whose ruins would not again be identified with al-Nāṣir's mythic structures until the nineteenth century.[12]

Arab authors who describe the city emphasize its physical plan: There were three large terraces, of which the two upper levels were devoted to the palace and its attendant functions; the Alcazar, as Félix Hernández observes,[13] stood in a prominent position overlooking the third terrace occupied by the medina itself. Placing the palace city on the slope of the mountain at times necessitated the removal of natural rock and at other times required raising the grade by means of major landfills. As a result, the buildings are set on a variety of levels: a physical representation of the hierarchical image desired for each individual building in the whole of the urban plan.

To a greater degree than in the ʿAbbāsid palaces of Samarra, topography assumed a major role, as demonstrated in the more than seventy meters' difference in elevation between the highest level, presumably occupied by the Dār al-mulk—the residence of ʿAbd al-Raḥmān III—and the lowest of the city's three levels, which is still to be excavated. The exhaustive process of work toward the recuperation of Madīnat al-Zahrā', which has been underway since 1911, has revealed, in an area covering more than nine

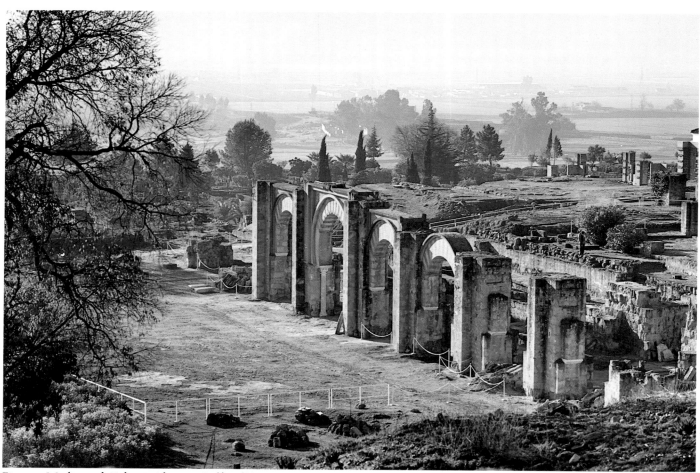

Fig. 3 Madīnat al-Zahrāʾ, Alcazar, "official" sector, entrance gate

hectares, a part of the central sector of the Alcazar and two corresponding elements on a lower terrace. These latter elements—the principal mosque on the east and the lower garden on the west—are linked to the Alcazar by proximity and function. All we know about the remainder of the city is the evidence obtained in aerial photographs, which show an orthogonal urban ordonnance in the southwest sector and traces of a small rectangular building that is out of alignment with regard to the overall ordonnance and that may be a mosque.

As a first observation on the Alcazar (Fig. 2), we may note the absence of the rigid symmetry that characterizes ʿAbbāsid palace complexes and the substitution of an ordonnance that favors placement of the founder's residence on the highest elevation of the city, above the areas devoted to diplomatic delegations, as in the Fāṭimid city of Mahdia.[14] The Alcazar is the result of a profound transformation whose scope is yet to be determined. However, a reading of the principal buildings and spaces that accompany this

transformation—basically, the hall for political functions, along with the facing garden and large portico —indicates a process of exaltation of the sovereign and of the city that must be assigned to the last years of the reign of ʿAbd al-Raḥmān.

The central nucleus of this Alcazar is divided into two sectors created by the two parallel north-south oriented structures occupied by the stables and lined up with the north gate. The "official" sector is to the east of this double axis and the "private" residential sector to the west, establishing a clear separation between residential spaces and those used for government or diplomatic purposes. Access is similar in both sectors: An open space with a portico, acts as a monumental antechamber, or vestibule, for a smaller gate that marks the beginning of a street or fāṣil (covered passageway) with set-in benches that leads to the ceremonial halls.

The entrance gate to the "official" sector serves as background to a veritable stage set located in front of and integrated into an arcade with a portico of

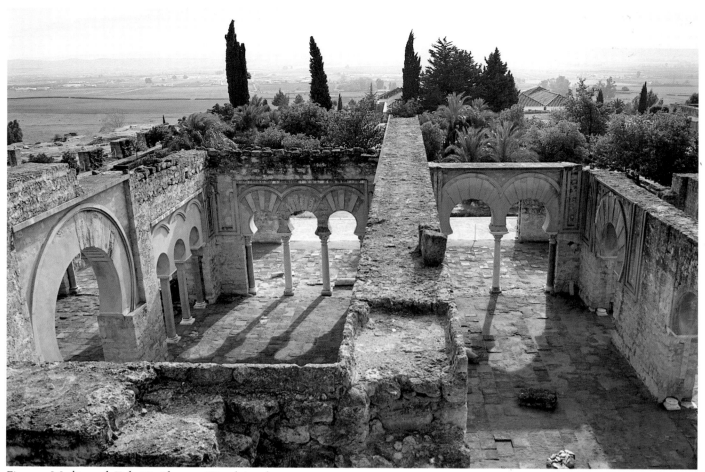

Fig. 4 Madīnat al-Zahrāʾ, Alcazar, Dār al-jund

probably fifteen arches (a central horseshoe arch and fourteen segmental ones), of which four, with alternating voussoirs of brick and stone, have been reconstructed (Fig. 3). The whole, aligned in a series of arches running from north to south, beginning at the north wall, filled the entire eastern face of the terrace. This spectacular, purely theatrical organization, lacking any relationship to the space behind it, must have been the authentic east facade of the Alcazar. Before it stretches an enormous open courtyard flanked by galleries of rooms on the north and south.

This space suffered still another transformation that altered its status as a ceremonial gate and upset both the symmetry of the whole and its original purpose. The north part of the portico was filled in, in order to accommodate a gate for the north road, closing the first four arches by the addition of small rooms, probably guard posts. This renovation must have been related to a cessation of diplomatic functions in the city after the death of al-Ḥakam in 976 (A.H. 365).

The terminus of the ramped street that begins at the portico arcade was the Dār al-jund (army headquarters) (Fig. 4), an edifice constructed on the basilical plan of five longitudinal aisles and a tranversal with portico excavated by Ricardo Velázquez Bosco in 1912.[15] The theme of this construction is similar to that of the Hall of ʿAbd al-Raḥmān III: a central nucleus of three deep aisles opening through an arcade to an entry portico; the wider central aisle and portico form an inverted T. The scheme is completed by two flanking aisles that, with the transept, form a protective U-shaped space around the central nucleus, thereby converting it into the privileged and hierarchical space of the building.[16] In the Dār al-jund, this concept is confirmed by doors that isolate the block of the three central aisles from the outer aisles and by the discrepancy in height of the entrances between them. The discrepancy suggests the possibility of two levels in the latter aisles—a thesis supported by archaeological evidence. The complex is completed by a wide walkway and a vast, perceptibly square court, converted in the 1960s

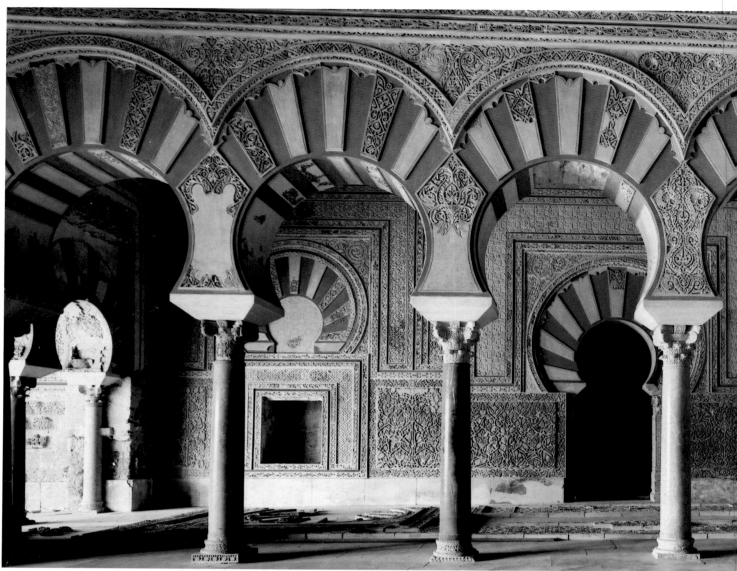

Fig. 5 Madīnat al-Zahrāʾ, Alcazar, Salón Rico

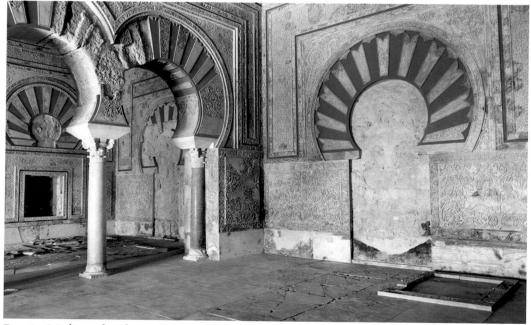

Fig. 6 Madīnat al-Zahrāʾ, Alcazar, Salón Rico, mihrab at right

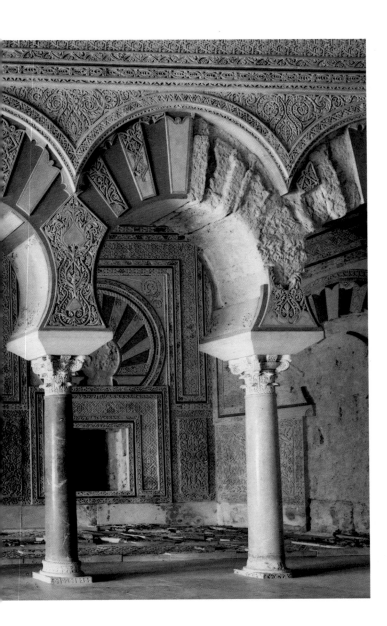

West Hall and the East Hall, both with associated gardens. It is difficult to identify the East Hall with the building excavated and reconstructed by Hernández because it is located almost mathematically in the center of the east-west axis of the city. Nevertheless, important archaeological and topographic arguments permit a prudent identification of this space as the setting where most of the political receptions and religious activities recorded in the *Anales Palatinos* for the years 961 to 976 (A.H. 350–66) were celebrated.

This building, also presently known as the Salón Rico (Rich Hall) (Fig. 5) because of the extravagant decoration of the walls, was ordered constructed by ʿAbd al-Raḥmān III between 953/4 and 956/7 (A.H. 342–45), as attested by plentiful epigraphical evidence.[18] Facing the Dār al-jund, the building was devoted solely to audiences. Its space is unified in concept: Two series of horseshoe arches of magnificent caliphal proportions separate three principal aisles that terminate, at the upper end, in blind arches, of which the central arch is a true mihrab (Fig. 6), as is recorded in written sources.

The hall's uniqueness is determined by two essential characteristics. The first of these is the development of a new decorative technique consisting of elaborate carving on stone different from the stone used in construction—it is as if the carved stone were a skin (Fig. 7). The second, the extension of the decoration to all the walls of the building, follows a well-defined concept that consigns the large panels flanking the openings—whether false or real—to the lower portion of the composition; the horseshoe arches themselves, with their corresponding decoration, to the middle zone; and a frieze that comes in contact with the wood ceiling to the highest section.

It is in this building that the characteristics of the caliphal horseshoe arch are formalized: the extrados stilted in relation to the intrados; the division of the voussoirs aligned with the imposts instead of with the center of the arch; and, above all, associated lavish decoration in which the molding of the arch becomes a protective frame. The decorative program of the interior panels is outstanding, filling entire surfaces with the theme of the tree of life. These panels, whose influence will reach into the Almohad period, signify the definitive emergence in Madīnat al-Zahrāʾ of eastern ʿAbbāsid elements, imposed upon a very firm Umayyad artistic base.[19]

into a garden that closes the east and west sides with porticos of arches contained in lintellike construction.

At this juncture it is difficult, given the military-administrative activities we assume from its identification, to explain precisely how the building was used.[17] The architecture suggests an official purpose, to which must be added the use of some of the halls (*majālis*) as reception rooms for diplomatic delegations waiting for the caliph. Farther to the west, accessed by a ramp ascending toward the Dār al-jund, a residence still stands that repeats the basilical scheme, although with variations; this edifice must have been occupied by a high official.

The final destination for arriving delegations was always one of the reception halls devoted to the affairs of the caliphate. During the time of al-Ḥakam, there were two such halls, called, according to sources, the

The Hall of ʿAbd al-Raḥmān III is but the centerpiece of a large architectural complex that includes the Upper Garden with four parterres watered by irrigation ditches and a building on the garden's axial hub with a central pavilion surrounded by four pools that repeats the basic structure of the hall. However, the relative formal simplicity of the plan maintains a rigorous sense of proportion and design that ties the hall with the garden, so that both form a unifying concept that has as its objective the magnification of the caliph. The throne room (symbol of the heavenly palace) and the garden (symbol of paradise) are interrelated through a precise geometry of equilateral triangles that begin at a central source—the mihrab, the hieratical focus of the ensemble—and define, as they lengthen, the interior space of the basilical building and the external perimeters of the garden, with strange and surprising precision.

An analysis of the protocol that evolved in the edifice[20] demonstrates a process of aggrandizement of the sovereign, as in the ʿAbbāsid and Fāṭimid worlds. Here, however, the sovereign has not as yet reached the total veiling that will characterize his public audiences in those two courts. In contrast to Fāṭimid protocol, in which the caliph's throne was set behind a veil, completing an effect of evanescence and affirming his unique nature—"being," without being seen—the Umayyad sovereigns still "showed" themselves in their actual physical body, making themselves "manifest" to the remainder of the state, which was represented by different religious and political ceremonies enacted by hierarchic public officials. In short, because of the brevity of their dynasty, the Umayyads seem never to have reached the final stages of processes consolidated in other courts.

On the east side of the building was a major

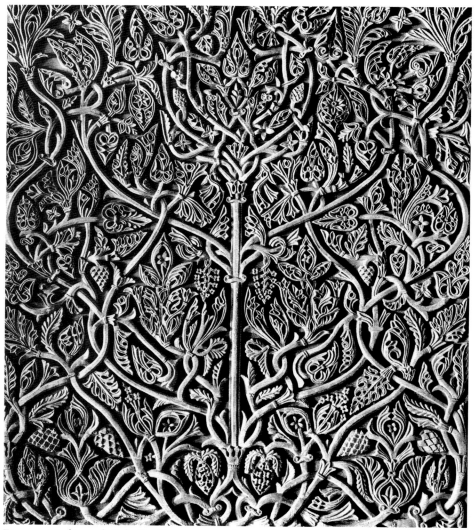

Fig. 7 Madīnat al-Zahrāʾ, Alcazar, carved stone from Salón Rico

complex of rooms paved with white marble and terminating in a small bath. This complex must have been related in function to the reception halls. A *sabat*, or covered hallway, bordering the east side of the garden allowed the passage of the caliph between that area and the principal mosque. As in Córdoba, the mosque had a double qibla wall connected to the *maqṣūra* (a wooden screen around the mihrab), which was approached by a bridge spanning the significant difference in the level between the qibla and the street.

The plan of the mosque is laid out on a rectangle oriented toward the southeast; it has a prayer room of five aisles perpendicular to the qibla wall and is separated by arcades with a succession of horseshoe arches.[21] The *alminar*, or minaret, in the interior of the patio in the northern *riwāq*, or gallery, is placed off center, allowing a direct line of access between the entrance door and the mihrab. This plan anticipates the placement of the minaret erected by ʿAbd al-Raḥmān III in the Great Mosque of Córdoba. The rooms facing the principal facade were intended for ceremonial ablutions.

The residential section of the Alcazar was contained in a group of buildings of varying typology located west of the alignment of the stables. The entrance to the area basically repeated the model of the east ramps, although it was later modified. In this nucleus of buildings, some constructions, such as the large upper courts, were laid out on a parallel with the north wall. Others were adapted to the perpendicular ordonnance of those basic alignments and do not necessarily relate to subsequent remodeling but to prior divisions that defined zones of buildings that came much later. Information about the city wall provided by Ibn Ḥawqal (d. 966 [A. H. 356]), indicating that it was not yet complete at the beginning of the reign of al-Ḥakam II, may be very instructive in this respect and finds support in archaeological evidence in some sectors of the Alcazar. The large upper courtyard on the north terrace is made up of two important residential entities formed by galleries of rooms disposed around an ashlar-tiled courtyard with surrounding and crossing footways, as is the norm in al-Zahrāʾ.

The original organization, based on large rooms with adjacent alcoves—probably no more than three to each gallery, with attached latrines (Fig. 8)—was modified by an extreme compartmentalization based on a downgrading of the space that seems to corre-

Fig. 8 Madīnat al-Zahrāʾ, Alcazar, latrine

spond to a more intensive use and lower category of residents. In some of these rooms there is an indication of two stories, with a terraced roof, in contrast to the usual peaked tile roof used in the rest of the Alcazar. A ramp with *poyetes*, or set-in benches, connects these two dwellings with the gate of the Alcazar and, on the lower terrace, with a trapezoidal space to their south, where differences in orientation are resolved.

As it was the true communication and control center for the upper and lower residential areas, it seems certain that this trapezoidal space was used by the palace guard. Departing from that space, and to the south, was a block consisting of two substantial dwellings, and to the north there is an area with a street for internal traffic; we believe that area was devoted to services.

The east dwelling, tentatively identified as the residence of Jaʿfar ibn ʿAbd al-Raḥmān, the hajib of al-Ḥakam II, was begun in 961 (A. H. 350) and was adapted to preexisting limitations of space (Fig. 9).[22]

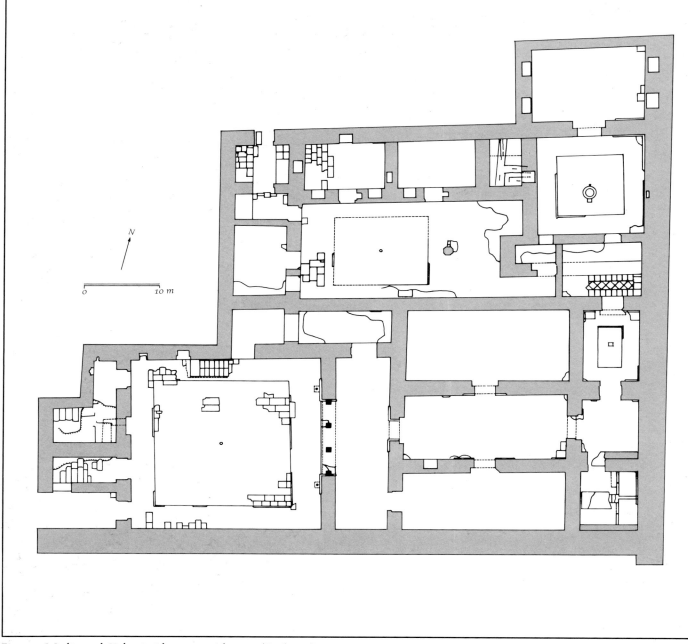

Fig. 9 Madīnat al-Zahrāʾ, Alcazar, residence of Jaʿfar, plan

It is composed of three interconnected areas, separated by facing doors for security: the "official," or work, area, built on the basilical plan, in which the correspondence between the longitudinal aisles and the facade has been broken by the need to adapt the facade to the space of the previously constructed adjacent bath, epigraphically dated 960/61 (A.H. 350); the private, or "personal," area terminating in an alcove whose space has been borrowed from the dwelling to its north, and preceded by a patio with a circular basin and fountain aligned with the alcove (Fig. 10); and an attached area for the servants attending the tenant. Nothing in this structure intimates that this was a

family dwelling; it seems, instead, to have been the quarters of a high-ranking official who lived alone.

The dwelling to the east is the only one as yet found to be organized around a central open-air court containing a small garden with bordering and center paths. At the extreme west two gardens enclosed a small pool fed by a fountain— probably in the form of a small bronze animal—which was connected by two spillways to the perimetrical irrigation ditch. On the north side a covered stairway with a double flight of steps of some monumentality established communication with buildings on the upper level, that is, with the previously mentioned internal street, the

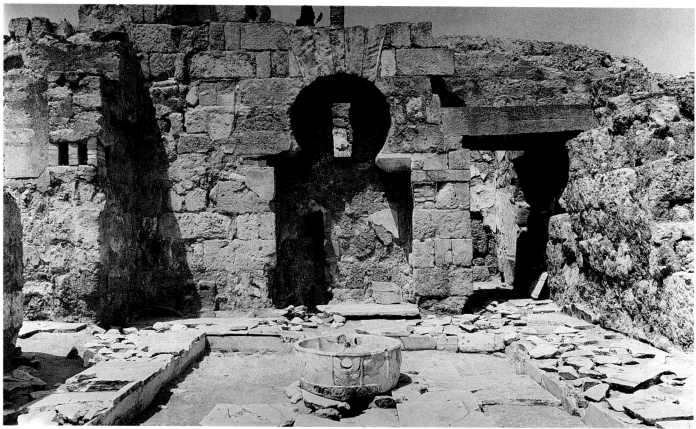

Fig. 10　Madīnat al-Zahrāʾ, Court of the Pool

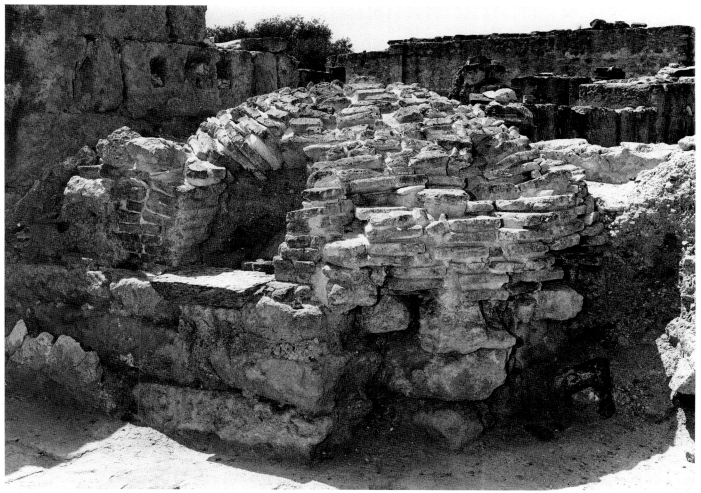

Fig. 11　Madīnat al-Zahrāʾ, Alcazar, service area, oven

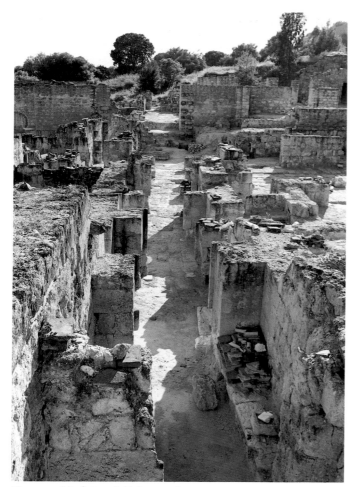

Fig. 12 Madīnat al-Zahrāʾ, Alcazar, service area, internal street

Court of the Pillars, and, through it, the Dār al-mulk. Two parallel rooms open through triple arches with *ataurique*, or entwined vine and leaf, decoration onto each of the shorter sides of the garden, signaling a model that after the eleventh century would spread throughout al-Andalus and North Africa.

A bath, apparently for one person, was originally located on the east side of this dwelling, repeating, both in organization and in the arrangement and type of decoration, the bath attached to the Hall of ʿAbd al-Raḥmān III. Only one note differentiates it: the reduction in size of the dressing room or hall near the frigidarium, where the indication of a long bench, not present on the lower terrace, equates it with the dressing rooms of the eastern Umayyad baths.

The block in which Jaʿfar's dwelling is located is closed off to the north by what we have defined as the service area, meaning the space where those members of the domestic corps who were responsible for the

meals and housekeeping in the noble residences we have referred to lived and worked. Of the two buildings that constitute this area, the one to the east is the more interesting because of its complexity and because it is more representative of the character and function of the buildings of the Alcazar. In it we find a hierarchically disposed residential unit, autonomous in relation to the other dependencies and characterized by the basilical plan (a portico-gallery with two rooms perpendicular to the gallery); this arrangement is found only in official spaces and thus indicates preeminent status. Status is inferred not only from the architectural form but also from the presence of a private latrine for each of the two rooms. In contrast, the rest of the dwelling is organized as an intensely utilized work area. The presence of major culinary accoutrements, such as an oven (Fig. 11), and the unit's precise placement in the center of the intermediate terrace, connected by means of an internal street with important residential dependencies (Fig. 12), confirms that it housed service personnel and not a family.

We know little about the organization and nature of the palace servants. Sources consistently refer to different classes of ṣaḥāba (singular, ṣāḥib) that must have corresponded to the different strata of functions, administrative and palatine, almost exclusively performed by slaves. Despite the fact that no supervisor or chief of cuisine is among the positions noted during the existence of the palace city, we are familiar with the position held by the ṣāḥib al-maṭbakh (head confectioner or chef de cuisine) in caliphal palaces.[23] It must have been an official of this rank who lived in this prestigious space, so clearly intended for supervising activities carried out in the building.

The Court of the Pillars, so-called because of the gallery with lintel-porticos mounted on square bases, is situated to the north of the dwelling with the pool. Its two principal rooms were on the west and were paved with white marble, in contrast to the violet limestone used in the rest of the complex. Where the north alcoves should have been was a stairway in the minaret style that spanned the seventeen-meter difference between the two areas and connected these dependencies with the private rooms of ʿAbd al-Raḥmān III.[24]

In the fashion of a true balcony, the Dār al-mulk, located on the highest site of the Alcazar, has an unobstructed view over the city and country below. Three parallel galleries of rooms, set side by side with

alcoves at the end, occupy the center of a larger space, of which at least the east section was renovated during the time of al-Ḥakam in order that his heir, Prince Hishām, could be tutored in tasks of governing.

This remodeling also affected the stone decoration that embellished the exterior facade and interior portals, where "archaic" effects were combined with effects typical of the work in the expanded mosque in Córdoba, for which al-Ḥakam was responsible. A novel treatment in floor paving also points to the importance of these rooms: The clay floor tiles are inlaid with limestone, creating various geometrical motifs in borders around the rooms.

The depredations caused by wholesale plundering of stone and the total destruction of the exterior facade impede our appreciation of the precise image of his private quarters that the first caliph of al-Andalus projected to the rest of the city. Similarly, given the present state of the excavations, we can offer a coherent explication of only a minimal part of the city of Madīnat al-Zahrāʾ. With 90 percent of the city still buried, the period of the apogee of the Umayyad state and its dissolution remains a great mystery, although one we hope will be resolved in the near future.

1. Acien Almansa 1987.
2. Ruggles 1991.
3. Acien Almansa 1987, pp. 14–15.
4. López Cuervo 1985, p. 64.
5. García Gómez 1967a, p. 141.
6. For example, in data relative to the origin of certain building materials. As for the abundance of imported marble cited by sources—from Africa, Byzantium, and the land of the Franks—the chemical analysis of the paving of the Hall of ʿAbd al-Raḥmān III and adjoining rooms indicates that they were quarried in Estremoz (Portugal), relatively near the city.
7. The problems inherent in contradictory chronology in sources on al-Zahrāʾ and the need for a historiographical critique of those sources have been mentioned on several occasions by Manuel Ocaña Jiménez; Labarta and Barceló 1987 is an excellent update on this subject.
8. Ocaña Jiménez 1970, p. 31.
9. Ibn Hayyan 1981, p. 359.
10. Barceló Perello forthcoming a.
11. Ibn Ḥawqal 1971, p. 64.
12. Although various scholars had, since the seventeenth century, associated Madīnat al-Zahrāʾ's vast ruins with the project of ʿAbd al-Raḥmān III, it was not until the nineteenth century, specifically in the publication in 1840–43 by Pascual de Gayangos of al-Maqqarī's *Nafh al-Tib . . .*, that a definitive identification was made.
13. Hernández Jiménez 1985.
14. Acien Almansa 1987, p. 17.
15. Velázquez Bosco 1912.
16. Ewert 1986, pp. 117–20.
17. Because of the limited area of excavation, the difficulties of identifying structures with those described in written sources must be apparent.
18. Ocaña Jiménez 1945, pp. 154–59.
19. Ewert 1987.
20. Barceló Perello forthcoming b.
21. According to the sources, the mosque of Madīnat al-Zahrāʾ was "correctly" oriented, in terms of the principal mosque in Córdoba, whose obvious astronomical deviation presented the necessity of changing the qibla wall during the renovations undertaken by al-Ḥakam II. See Samso 1990, p. 210.
22. Vallejo Triano 1990, pp. 131–32.
23. Lévi-Provençal cites the name of one such person in 930 (A.H. 318), taken from the *Bayan* (1932, p. 54, n. 4).
24. Hernández Jiménez 1985, p. 73.

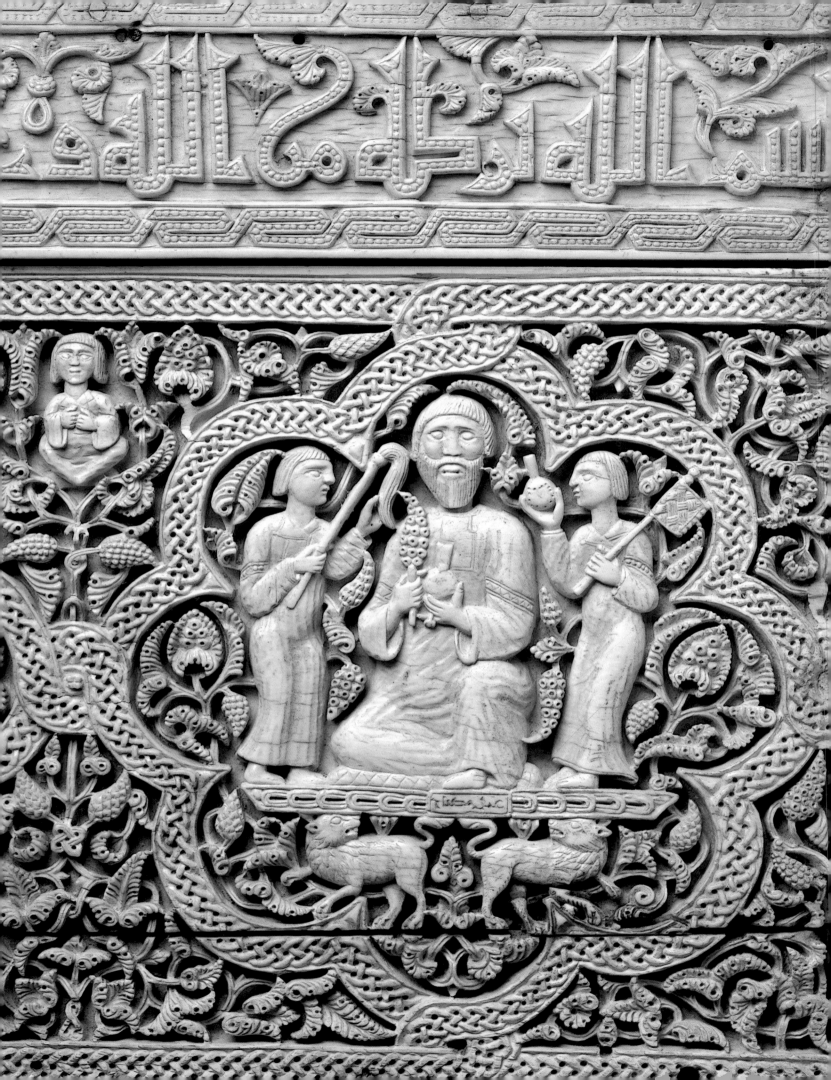

Luxury Arts of the Caliphal Period

RENATA HOLOD

The ultimate example of the luxury arts of the Umayyads is the palace city of Madīnat al-Zahrāʾ. Madīnat al-Zahrāʾ was begun by ʿAbd al-Raḥmān III in 936 (A.H. 325) and over the next forty years was built continuously by this caliph and his son al-Ḥakam II. It survives only as a field of ruins spreading down a hillside in the Cordobán countryside, yet in its day it was conceived to be the epitome of the Islamic palace.[1] Every luxury art imaginable in the caliphal period—work in gold, silver, and other metals, marble, textiles of wool, silk, and cotton, containers for jewels and precious substances, as well as books—was used in the construction, embellishment, and furnishing of the reception halls, pavilions, residential units, and gardens of the palace city. Although few objects and materials remain that can be associated specifically with the site itself, or even with the Umayyad period in Spain, a perusal of the histories reveals a high level of interest in and manufacture of objects that were highly prized and considered precious or luxurious at the time. The concepts of luxury and the arts of living had been developed over the preceding two centuries on many estates, particularly those in the countryside around Córdoba.[2] The estate, with its fields, gardens, and pavilions, the basis of well-ordered private and public life, had formed a prosperous unit for investment and for consumption of nonsubsistence production. The markets of the main center, Córdoba, and their specialized section for luxuries, al-qayṣariyya (alcaiceria), produced goods and catered to the wants and tastes of the landowners and inhabitants of this increasingly wealthy suburban zone.[3] The princely court itself, first at Córdoba and various smaller estates and then chiefly at Madīnat al-Zahrāʾ, was the apogee of an opulent and refined style of life and was the primary locus of luxury production and consumption.

In some years the entire contents of ʿAbd al-Raḥmān III's treasury was expended on the construction and embellishment of the new palace city—a witness to the ambition and scope of the enterprise as well as to the quantity and quality of materials utilized.[4] To this site the caliph moved his court, his chancery, his army, and the means for their provisioning, together with the mint (Dār al-sikka), a specialized textile manufactory (Dār al-ṭirāz), and other workshops (Dār al-ṣinaʿa). Having assumed the caliphal title of amīr al-muʾminīn, ʿAbd al-Raḥmān III built with the intention of surpassing the almost mythical ʿAbbāsid capitals of Baghdad and Samarra and the emergent city of Fāṭimid Cairo. Ultimately, however, the new palace paid these centers a compliment by emulating them. The life-style and luxury of the earlier Persian and Byzantine, as well as the Indian and Chinese, royal courts were known from memory and legend and had been elaborated and broadcast by the ʿAbbāsids; their opulent ways were sought and practiced avidly in the far west of the Islamic world in the tenth century.[5] Yet, as sophisticated and as rich as Córdoba and Madīnat al-Zahrāʾ may have seemed to their inhabitants and observers, together at their apogee they did not constitute even a quarter of the area of Baghdad, which was the world's largest and wealthiest metropolis in the ninth and early tenth centuries.[6] With this in mind, the few surviving pieces that are dated or securely datable to the caliphal period in Spain and are not subsistence-level material such as common ceramic ware[7] must be viewed through the lens of the taste and production of the great eastern capital.

The story of a taste for the east begins in Spain

Detail of Pamplona Casket (No. 4)

Fig. 1 Incense burner, 10th century, bronze,
Museo Arqueológico Provincial de Córdoba, 30.146a

before the caliphal era. First it is built on the senti-
mental attachment of the earliest Umayyads of al-
Andalus to their homeland, Syria and the eastern
Mediterranean.[8] Then it proceeds in earnest with the
arrival in the ninth century of a remarkable individual
who almost singlehandedly transformed the Umayyad
court of ʿAbd al-Raḥmān II: the legendary Ziryāb. A
freedman of the ʿAbbāsid caliph al-Mahdī, Ziryāb
spent his early years and received his musical training
at the ʿAbbāsid court. When he lost favor there, he
ventured to the west as a young adult in 821/2 (A.H.
206/7). Ziryāb was to spend the better part of his long
life as a favorite at the Umayyad court, where he estab-
lished a school of music and trained his many sons and
daughters to succeed him. To the far west he brought
not only the courtly music traditions of Baghdad but
also the art of elegant living, with its manners,
fashions, and etiquette. Aspects of dress, food, groom-
ing, hygiene, and ambience were all revamped accord-
ing to the more sophisticated standards of the ʿAbbāsids.
At the very moment Ziryāb arrived in al-Andalus, the
Umayyad court, with its new sovereign and a new
sense of power and prosperity, was ready for change.[9]

Because of the direct influence of Ziryāb and,
even more importantly, the increasing presence of
merchants and merchandise from the east, styles of
dress and furnishings changed in the next decades.
Fine textiles and textile workers were imported from
Egypt, Iran, and Byzantium. Spain began to produce
silk, first at Córdoba and then at Almería.[10] In emula-
tion of the royal manufactories in Iraq, Egypt, and
Constantinople, ʿAbd al-Raḥmān II established a *dār
al-ṭirāz* to produce fine textiles of silk, wool, and
cotton inscribed with his name to be bestowed on

officials at court, ambassadors, and other individuals
as gifts or "robes of honor." The customary winter
and summer wardrobes, which changed from dark to
white and from heavy to lighter-weight fabrics with
the change of season, were enhanced by fashionable
variations for spring and autumn introduced by Ziryāb.
The new spring costume was a *jubba*, a colored silk, or
mulham, gown with wide sleeves. Cloaks from Merv
and quilted but light-colored clothes were the height
of fashion in the fall.[11] The art of coiffure came into
its own; for men short hair baring the neck and ears
became fashionable, and beards were tinted with henna.

The introduction of deodorants and fragrances,
particularly for men and women of high rank, was
crucial to the new ideas of well-being. Perfumed
substances were sprinkled on guests of honor, as the
depiction in the medallion on the right front of the
Pamplona casket, which includes an attendant with a
perfume bottle or sprinkler, shows (Frontis.). Cham-
bers were scented by burning fragrant candles or
incense.[12] The art of using aromatic substances was
developed from the aesthetic, sensual, and medicinal
viewpoints. The importance of this art is indicated in
the encyclopedic treatise on medicine written in Spain
by al-Zahrāwī a century after Ziryāb arrived at the
Umayyad court.[13] This treatise includes a two-part
section on cosmetics that makes clear that these sub-
stances were considered integral to the healing sci-
ences. Aromatic substances were used for colds and
sore throats, and precious aromatics, such as amber-
gris, musk, and camphor, were recognized as thera-
peutic for brain, heart, and geriatric diseases. Clothing
was scented for medicinal as well as sensual purposes,
fumigation kept pests away, and storing scented cloth-

ing in chests or even in earthenware pots helped preserve its benefits. The discussion of cosmetics also deals with hair and skin treatments, hair removers, and deodorants. These desirable cosmetic and therapeutic compounds were prepared in pharmacies, the most noted of which was the pharmacy (the Khizānat al-adwiya) at Madīnat al-Zahrāʾ.[14]

Ambergris, musk, and camphor, the bases for many of these concoctions, were imported at high cost[15] and were considered to be the most luxurious and generous of gifts, on a par with large amounts of gold or silver, elaborate textiles and furnishings, slaves, or thoroughbred animals.[16] These substances were often presented in earthenware vessels or baskets, in precious containers such as golden goblets or filigree gold nets, or molded into the shapes of fruits or statues. Statuettes of ambergris are known to have been attached to golden trays and decorated with precious jewels.[17] An incense burner now in the Museo Arqueológico Provincial de Córdoba (Fig. 1), attributable on the basis of its domed shape and other details to northeast Iran, may well have been included in a gift of such substances from the east.[18] There were also gifts of all-night candles made with precious aromatics and meant for use on special occasions. We can imagine that a candle of this sort perfumed events such as the feast at Munya al-ʿAmiriyya in the spring of 986 (A.H. 376) celebrating the wedding of Ḥabība and the son of the hajib al-Manṣūr, ʿAbd al-Malik, who would be named Sayf al-Dawla and come to own an ivory casket and an ivory pyxis that are included in the present exhibition (Nos. 4,5).[19]

The ivory pyxides and boxes made in the workshops of Madīnat al-Zahrāʾ and Córdoba (see Nos. 1–6, Fig. 2) were containers for gifts of these highly valued substances. Ivory itself at one time had been a rarity as well as a luxury in the Mediterranean region.[20] By the middle of the tenth century, however, as a result of flourishing trade contacts between North Africa and Spain, it again became abundant there. The Umayyads had access to a supply channeled from sub-Saharan Africa through the Aghlabids of Tunisia.[21] In the tenth century ʿAbd al-Raḥmān III extended his control across the Strait of Gibraltar into North Africa, and the close relations between Córdoba and Tahert ensured a constant and ample flow of the material. In fact, there is a record of a gift or tribute in 991 (A.H. 382) from the Berber emir Zuhayrī ibn

ʿAṭiyya to Hishām II of eight thousand pounds of ivory.[22] Even when ivory became more plentiful, it was thought of as a luxurious material, and it is clear that skill at ivory carving was highly prized. The ivory pieces themselves were not considered mere containers, even though as receptacles they were ornamented with carvings, colored and set with gems (see No. 6, which has remnants of color and inlays of stones). They were the carriers of the many meanings of the gift and often bore the names and titles of the givers and recipients as well as the dates of presentation. The signatures of their carvers appeared just as prominently as the other names and served to confirm the high value of every piece.

Gastronomy and style of food presentation were altered profoundly by Ziryāb's presence and influence. Both an order of service and individual dishes were introduced from the east: The single, laden table from which diners chose whatever they wanted was replaced by an exquisitely staged and served event. The consumption of food now involved elaborate table

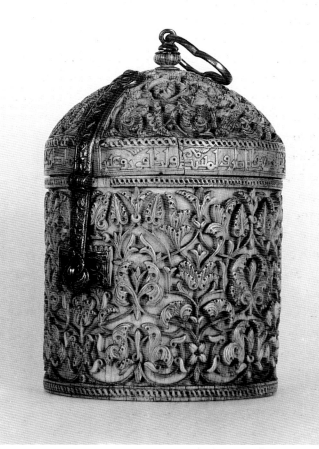

Fig. 2 Pyxis, ca. 966, ivory, Hispanic Society of America, New York, D752

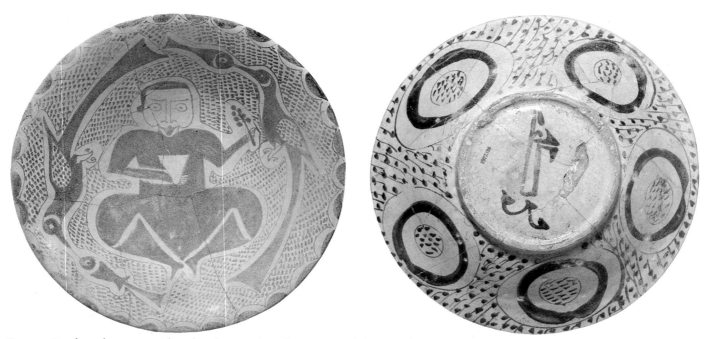

Fig. 3 Bowl, 10th century, glazed and painted earthenware with luster, The Metropolitan Museum of Art, New York, Gift of Edwin Binney, 3rd, and Purchase, Richard S. Perkins Gift, 1977, 1977.126

manners, a menu with a sequence of courses, and a variety of platters and bowls. Cold courses and meats and fowls with garnishes of pickles and other condiments were succeeded by an array of baked pasties, followed by soups, asparagus, and other vegetables. Sweets, nuts, cakes, and fruits in syrup completed the meal.[23] The menu was structured according to the calendar and the rank of the guests.

The furnishings, dishes, carpets, curtains, cushions, and low tables covered with leather tablecloths and napkins (*mandīl*) were all carefully chosen to impress. Social rank of diners was designated by the location of their mats within the room and in relation to the other guests, and by the size, quality, and number of cushions granted to them.[24] Color brought further richness to these stylized surroundings. A splendid silk with an inscription referring to al-Hishām II, now at the Real Academia de la Historia in Madrid (No. 21), might have been used in such a setting. This is a tapestry of high color, with gold-wrapped silk threads woven in white, mauve, green, blue, yellow, black, and beige.[25] Fine textiles of this sort were traded to the east and used as diplomatic gifts. For example, after a victorious campaign in 997 (A.H. 387), the hajib al-Manṣūr presented his allies with 2,285 pieces of varieties of *ṭirāzī* silk, 21 pieces of sea wool, two *anbārī* (ambergris-perfumed) robes, 11 pieces of *siqlatun* (scarlet) and 15 pieces of striped material, 7

carpets, 2 robes of *rūmī* (Byzantine) brocade, and 2 marten furs.[26] By the eleventh century textile production had reached such a high level that it could compete with the famous older manufactories of Egypt, Iran, and Byzantium. In 1060 (A.H. 452) examples of "the most beautiful and amazing fabric of pure silk with gold" were sent as part of a diplomatic gift to the Fāṭimid caliph al-Mustanṣir bi-llāh.[27] So sure were the Hispano-Muslims of the quality of their textiles, and so pervasive was the emulation of the luxury goods of the east, that they produced a silk cloth with an inscription identifying it as made in Baghdad.[28]

It is in the context of sophisticated dining that the inhabitants of al-Andalus used luster ceramics of Iraqi origin (see Fig. 3)—shards of such pottery were found at Madīnat al-Zahrāʾ—and developed their own high quality ceramics. Plates, bowls, and cups, bottles, jugs, and jars of Hispano-Islamic production were covered with a white slip and decorated in green and manganese with patterns inspired by eastern ceramics and textiles.[29] Rock crystal from Egypt and cut or mold-blown glass from the eastern Mediterranean or Iran (see Fig. 4) appeared on their elegant tables.[30] As a result, a new taste for transparent vessels spread, and glassmaking flourished in Almería, Murcia, and Málaga after the middle of the ninth century.

Madīnat al-Zahrāʾ was more than the sum of the Umayyad estates that had preceded it; the Umayyad

caliphs sought to make it a major capital of the known world. The image of the caliph as the powerful ruler who was available to the *khāṣṣa*, or nobility, but removed from the public and visible only on rare occasions emerged fully at the palace city.[31] ʿAbd al-Raḥmān III and, even more self-consciously, his learned son al-Ḥakam II attempted to re-create the mythic court at Madīnat al-Salām. ʿAbbāsid court ceremonies, with their ranks of uniformed and bedecked pages and soldiers, caparisoned animals, textile hangings, processions through myriad courts, corridors, pavilions, gardens of nature and artifice, and their special effects manipulated to dazzle ambassadors and petitioners alike, were echoed at Madīnat al-Zahrāʾ. Descriptions of Umayyad pageantry are numerous; they tell, for example, that the entire route from Córdoba to Madīnat al-Zahrāʾ was lined with double rows of soldiers holding silken hangings in order to astound the ambassadors from the Christian north. They also relate that when King Ordoño of León was received at al-Ḥakam II's court, protocol indicated that he ride on horseback, accompanied by his own courtiers and those of the caliph, between files of uniformed and armor-clad honor guards through a succession of palace gates and, finally, pass mounted, alone, to the threshold of the reception hall. An account of the reception of the commander al-Ghālib, when he returned victorious from North Africa, makes clear that presentation at court was also carefully staged: Courtiers, family, eunuchs, slaves, and soldiers, magnificently dressed, armed, and bejeweled and disposed in order of rank, lined the entire approach from the palace portals to the reception hall—overlooking the garden—where the most privileged were ranged around al-Ḥakam, who sat on a raised throne.[32]

Just as description must suffice in the main to convey the impact of the textiles and dress on their audience, so the details of the magnificent animal trappings, of the musk- and ambergris-stuffed saddles, the palanquins, and the litters must be left to our imaginations. On the other hand, evidence of the tradition of jewelry-making, as it was practiced in the Islamic world, and in al-Andalus particularly, survives in a small number of pieces. Although none of this material is securely dated, the Charilla hoard (see No. 17) has been attributed to the tenth century and examples from the Victoria and Albert Museum in

London (No. 18) and The Walters Art Gallery in Baltimore (No. 19) to the eleventh.[33] This gold jewelry, mostly bereft of its precious stones and pearls, still exhibits a high level of craftsmanship, which is closely allied to eastern Mediterranean techniques and habits of manufacture. The most accomplished extant object produced by caliphal silversmiths is the silver gilt Gerona casket made by Badr and Tarif for al-Hishām II with an inscription naming him heir apparent (No. 9).

Other metalworking shops, whether located within the confines of Madīnat al-Zahrāʾ or elsewhere in al-Andalus, produced bronze mortars, incense burners, lamps, spouts, and candlesticks (see Nos. 8, 10, 11). The elaborate spouts enlivened the fountains of the palaces and estates. Al-Maqqarī leaves us descriptions of marble basins with such spouts and tells us of one made of a green marble that was brought from Constantinople and set by ʿAbd al-Raḥmān in the eastern reception hall of Madīnat al-Zahrāʾ. Around this basin he placed twelve statues of gold, each encrusted with pearls and other jewels and spewing water from its mouth. These were fashioned in the Dār al-sinaʿa at

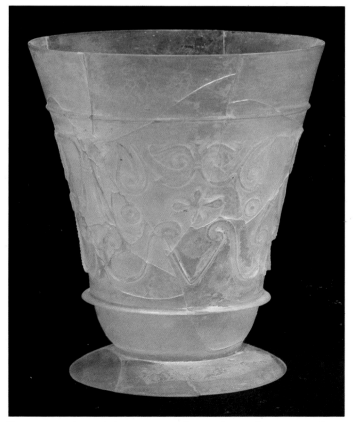

Fig. 4 Beaker, 10th century or later, glass, The Metropolitan Museum of Art, New York, Purchase, Rogers Fund and Jack A. Josephson, Dr. and Mrs. Lewis Balamuth, and Mr. and Mrs. Alvin W. Pearson Gifts, 1974, 1974.45

Córdoba, and they included a lion, gazelle, crocodile, snake, deer, dove, giraffe, kite, hen, cock, an elephant, and an eagle.[34] No golden or silver animal spouts are extant, but there survive large bronze animals such as the Córdoba stag and the so-called Pisa griffin (Nos. 10, 15) that may have functioned as spouts.[35] Although the stag and the griffin are not made of precious metal or inlaid with jewels, their ornament of incised rondels would have recalled for their viewers the gold-threaded caparisons of animals in court processions.[36]

We know that some marble decoration was imported: The green marble basin in 'Abd al-Raḥmān's reception hall came from Constantinople, as we have seen, and accounts of the construction of Madīnat al-Zahrā' mention that marble columns for the palace were collected from all regions of the Mediterranean.[37] However, there was an active marble-carving workshop in Córdoba and another was located on the premises at Madīnat al-Zahrā'. These establishments prepared pilasters, plaques, and basins for fountains carved with vegetal ornament that was sometimes interspersed with human figures and animals. Their products embellished the halls of the great palace as well as of other mansions (see Nos. 34–40, 42). They also provided the carved marble components of the new *maqṣūra* and mihrab of al-Ḥakam II in the Great Mosque of Córdoba. Although columns were often scavenged from other sites, artisans from the local workshops decorated the capitals and the bases, which had to be fashioned in place. Often the carver of these elements inscribed his name in a highly visible area, along with the names of the supervisor and the patron, the date, and the place of manufacture (see No. 39).[38] The appearance of such signatures indicates that the work of the carvers in this prized medium was esteemed.

Luxurious appointments were carved in wood, but none from the caliphal period survive. There were wooden roofs and ceilings, balconies, and stairs in the palace and in the pavilions, large storage closets and chests of wood,[39] such as those in which al-Ḥakam II's huge library was stored, and myriad paired wooden door leaves, sometimes inlaid with a marquetry of ebony and ivory.

We have a picture of Madīnat al-Zahrā' from the writings of al-Maqqarī; among his various descriptions of the palace units, that of a key reception pavilion, the Qaṣr al-Khilāfa, stands out because it presents an image of the ultimate in luxurious appurtenances for a building:

> Its ceiling was of gold and a marble pure in color and of many hues; its walls were the same. In the center hung a magnificent pearl which Leo, the Emperor of Constantinople, has presented to al-Nasir. The roof tiles of the pavilion were of gold and silver. In the middle there was a large tank of mercury. The hall had eight openings formed by interlacing arches of ebony and ivory inlaid with gold and all manner of precious gems. The arches were supported on columns of colored marble and pure beryl. When the sun came through these openings and its rays rebounded off the roof and walls, the hall sparkled with light, and confounded all vision. When al-Nasir wished to impress visitors, he would signal one of his slaves to disturb the mercury. Then there would appear in the chamber a brilliancy like lightning which would fill their hearts with fear.[40]

The world of artifice manipulates the world of nature for heightened effect. Precious materials take the place of ordinary ones. Gold, mercury, and marble replace the brightly colored wooden ceiling and the basin of water. Yet the simpler materials, the stone, brick, and wood of the terraces, walls, and roofs create a built environment that, in its own way, is a luxury. Cooled by the summer breezes, warmed by the south sun in the winter, this environment overlooks a well-ordered nature, the gardens and the natural landscape beyond.[41]

The luxury arts sought to enhance the experience of the senses. Gastronomy and its measured pace expanded the range of taste and smell. White ceramics allowed for greater visual enjoyment of food. Cosmetology brought both hygiene and sensuality, covering all with fragrance. Textiles, perhaps the premier manufactured art, provided comfort and, as importantly, transformed the draped objects by creating new effects for beauty and enhanced status. Jewelry embellished those who wore it and announced their worth. Carved, figured, and inscribed containers enlarged the meaning of the gift. The surface of the carvings gave immediate tactility to each piece as it was presented. Objects with mundane functions such as water spouts

were turned into precious sculptures in otherworldly gardens, where artifice in metal and stone reigned and beasts of opposing natures drank together in peace. Simple shelters for work, rest, and prayer, elaborated through the art of architecture, attained mythic character. The crucible in which the luxury arts, as well as the arts of music and poetry, were realized was the Umayyad court, first at Córdoba and ultimately at Madīnat al-Zahrāʾ. The achievements of this era formed the basis for the subsequent flowering of all the arts in al-Andalus.

1. For a reading of the site, see the essay by Antonio Vallejo Triano in this catalogue, pp. 26–39.
2. Among the numerous estates and mansions (munya, dar, qasr) of the area are those owned by ʿAbd al-Raḥmān I, ʿAbd al-Raḥmān II, the poet and vizier Ibn Shuhayd, and the several belonging to ʿAbd al-Raḥmān III. For a discussion of country mansions, estates, and gardens in al-Andalus, see Ruggles 1991, pp. 129–52. In this dissertation Ruggles has proposed a new way of understanding the development of the Hispano-Islamic landscape and the construction campaign of Madīnat al-Zahrāʾ as the major factor in the shaping of this tradition. I am indebted to her work in the shaping of this essay.
3. On the composition of the Cordobán markets, see Torres Balbás [1971], pp. 174–76.
4. Accounts of the construction of Madīnat al-Zahrāʾ can be found in al-Maqqarī 1855–61, vol. 1, pp. 370–74, and in Ibn ʿIdhārī 1948, vol. 2, p. 246.
5. On the myth of architecture in the Islamic world, see Rubiera 1988.
6. On the primacy of Baghdad in the ninth and tenth centuries, see the cogent presentation of Hodges and Whitehouse 1983, pp. 123–57.
7. For a discussion of common ware, see Lister and Lister 1987, pp. 25–37.
8. Among the products and natural resources sought by the Umayyads were textiles and, as importantly, plants. On ʿAbd al-Raḥmān I's estate, named al-Ruṣāfa after the Syrian Ruṣāfa of his grandfather al-Hishām, imported plants and trees were cherished in a setting built to remind him of his grandfather's estate. On textiles, see below, p. 44. On agricultural innovation, see Watson 1983, p. 101; on al-Ruṣāfa, see al-Maqqarī 1855–61, vol. 1, p. 304.
9. Farmer 1938, pp. 266–67; al-Maqqarī 1855–61, vol. 2, pp. 83–90.
10. Lombard 1978, p. 98; Serjeant 1951, pp. 33–34. Almería continued to be an important textile center for several centuries, and Murcia, Málaga, Granada, and Seville were also known for their specialized textile products.
11. On the introduction of cotton and mulham, see Lamm 1937, p. 144ff.; Golombek 1988, pp. 27–28.
12. On incense burners and the custom of thurification, see Baer 1983, pp. 45–60.
13. Abū'l-Qāsim Khalaf ibn ʿAbbās al-Zahrāwī, known as Abulcasis in Latin (936–1013 [A.H. 325–404]), was personal physician to al-Ḥakam II at Madīnat al-Zahrāʾ (see Hamarneh 1962 and 1965). I thank Anuradha Sharma, my student in the spring 1990 seminar on al-Andalus at the University of Pennsylvania, for her exploration of cosmetology in al-Andalus.
14. Hamarneh 1962, p. 62. For a discussion of pharmaceutical wares that could have been used in the establishment at Madīnat al-Zahrāʾ, see also Lister and Lister 1987, pp. 30–31.
15. Musk and camphor were imported from Tibet, India, and China, and ambergris came from Atlantic whales.
16. Adab literature, or belles lettres, included a separate genre of works that recorded and commented on diplomatic and celebratory gifts for all occasions. There survives only one partial example of this genre, an account by qaḍi Aḥmad ibn al-Rashīd ibn al-Zubayr known as Kitāb Al-Hadāya wa'l-Tuhaf and also as Kitāb al-Dhakhāʾir wa'l-Tuhaf, henceforth Ibn al-Zubayr 1959. Although this text pertains mainly to gifts and rarities at the ʿAbbāsid and Fāṭimid courts, the range of materials and characteristics of the objects discussed would also have been found at the Umayyad court. For the most recent work on this text, see Qaddumi 1990.
17. See Ibn al-Zubayr 1959, sections 65,309,395; Qaddumi 1990, pp. 64, 224, 259.
18. Melikian-Chirvani 1982, pp. 31–333, figs. 7, 8.
19. Conde 1874, vol. 2, pp. 67–69, after Ruggles 1991, p. 341. An ambergris candle weighing forty mann was lit during the feasts connected with the marriage of al-Maʾmūn to Burān, the daughter of al-Ḥasan ibn Sahl. See Ibn Zubayr 1959, section 116; Qaddumi 1990, p. 108.
20. Cutler 1985, p. 29; Cutler 1987, pp. 454–55. Plentiful amounts of ivory had been available in the Mediterranean area from the fourth to sixth century; the supply was cut short, however, by the Persian wars and the Islamic conquest of Spain. An ample flow appears to have been restored by the ninth and especially the tenth century.
21. ʿAlī ibn Ḥamīd, vizier of the Aghlabid emir Ziyādat-ullāh I (r. 817–38 [A.H. 202–24]), became extremely wealthy by trading raw ivory. See Dyer 1979, pp. 12–13; Talbi 1966, p. 223. I am grateful to Michael Morony for making Dyer's paper available to me.
22. Al-Maqqarī 1840–43, vol. 2, p. 191, after Cutler 1985, p. 51.
23. Bolens 1990, pp. 27–36.
24. Sadan 1976, pp. 14–17. On the napkins, see the classic study by Rosenthal [1971].
25. Grohmann 1938.
26. Al-Maqqarī 1855–61, vol. 1, p. 271; Serjeant 1951, p. 33.
27. Ibn al-Zubayr 1959, section 83; Qaddumi 1990, p. 84.
28. This inscription cites the informal name of the city, Baghdad (the equivalent of using L.A. for Los Angeles), rather than the formal Madīnat al-Salām, which was used in official inscriptions. The silk was preserved in Burgo de Osma and is now in the Museum of Fine Arts, Boston; see Day 1954, pp. 191–94.
29. On the finds at Madīnat al-Zahrāʾ, see Pavon Maldonado 1966a and 1972; for a characterization of ceramics produced under the caliphate, see Lister and Lister 1987, pp. 33–49. For what may be signatures of the makers Naṣr, Mubārak, and Yāsmīna, see Soustiel 1985, pp. 170, 185, no. 214.
30. For examples found at Madīnat al-Zahrāʾ, see Gómez-Moreno 1951, p. 342, fig. 404c, d, e, f; for a summary of the glassmaking industry, see Imamuddin 1981, pp. 118–19.
31. Lévi-Provençal 1953, pp. 116–17.
32. Al-Maqqarī 1855–61, pp. 252–53; for a reconstruction of the environs of this reception hall, or dār al-jund, see also Ruggles 1991, pp. 235–40; Ibn al-Zubayr 1959, sections 161–64. For a description of the arrival of the Byzantine ambassadors at the court of the ʿAbbāsid Muqtadir bi-llāh, their tours of the treasuries, courts, gardens, and pavilions, and their appearances before the vizier and the caliph in 917 (A.H. 305), see Qaddumi 1990, pp. 137–47.
33. For the most recent discussion of this material, see Jenkins 1988, pp. 39–57.
34. Al-Maqqarī 1855–61, vol. 1, p. 374.
35. The Pisa griffin may have been a fountain decoration at Madīnat al-Zahrāʾ. See Jenkins 1978.
36. Golombek suggests a similar interpretation of other ornamented animal sculptures (1988, p. 34).
37. For instance, al-Maqqarī 1855–61, vol. 1, pp. 372–73.
38. The signed capitals have been studied by Ocaña Jiménez 1931; 1936–39; 1945.
39. On storage chests, see Sadan 1976, pp. 142–53.
40. Al-Maqqarī 1855–61, vol. 1, p. 346.
41. Ruggles explores the idea of the mirador (1990 and in her essay in this catalogue, pp. 166, 169, 170).

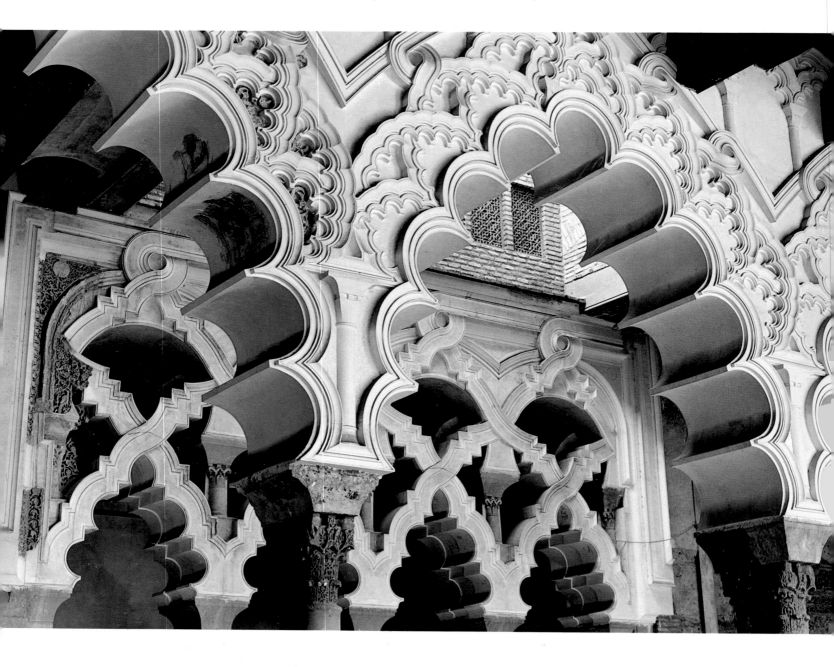

Arts of the Taifa Kingdoms

CYNTHIA ROBINSON

The *Taifa*, or *mulūk al-Ṭawāʾif*, period, when minor regional kingdoms developed throughout the Iberian Peninsula during and after the collapse of the caliphate in Córdoba, is one of the least understood eras in the history of Islamic Spain. This period of about one hundred years, which roughly corresponds to the eleventh century A.D., traditionally has been slighted by historians or analyzed inappropriately in terms of European cultural phenomena such as feudalism. Until recently *Taifa* history and culture were often interpreted in terms of decline and fall after the caliphal era, which was perceived as a glorious time of unity, plenty, and tolerance orchestrated by a series of wise statesmen. The decentralization of power, the shifting boundaries, and seeming disorder intensified by pressure from increasingly powerful Christians to the north that characterized the *Taifa* period were seen to constitute a degeneration that, fortunately, was halted by the ascent to power of the Almoravids.[1]

Today, however, thanks to a new generation of scholars, the history of al-Andalus and of the *Taifa* states in particular is emerging in more realistic perspective. When the *Taifa* states are considered in the context of the history of the wider Islamic and Mediterranean world—the Norman conquest of Sicily, the Crusades, as well as the dissolution of the ʿAbbāsid caliphate in Baghdad and the subsequent proliferation of separatist states of Fāṭimids in North Africa and Egypt, Umayyads in Spain, and Turkish dynasties in Iran—it becomes apparent that many parallels can be drawn between al-Andalus and other societies in the region. Thus, the unique character of Spain's historical situation, so often insisted upon by scholars, is shown to be spurious. Moreover, recent work in the fields of economic history and the history

of science and technology makes it clear that the *Taifa* era cannot be described in terms of decline. Especially during the first half of the eleventh century, despite destructive internecine strife and the gathering forces of the reconquest, trade and travel, both international and throughout the peninsula, continued apace. Indeed, aspects of culture, such as science, poetry, building, and decorative arts, gained new life as the result of an explosion of patronage that occurred after new ruling dynasties and capitals were established.[2]

A consequence of the outmoded historiography that misunderstands the *Taifa* period is a tendency to evaluate the architecture and decorative arts created after the fall of the caliphate only in relation to the Great Mosque of Córdoba and the caliphal palace of Madīnat al-Zahrāʾ, the two monuments that are traditionally considered to represent the zenith of Islamic Spain's artistic achievement. Such analyses often denigrate the visual arts produced between the eleventh and thirteenth century and fail to take into account or even perceive the social and cultural phenomena they express. Thus, Manuel Gómez-Moreno cursorily dismisses *Taifa* arts as degenerate. Asserting that the Aljafería was "primitive" and inspired by Córdoba and "the east," he describes the interlacing arches of the palace as "without any other law than fantasy, nor other structure than carved gesso, they reach a... delirious development in the gallery facade.... There is nothing new in the component elements; the spirit of caliphal Cordobán art maintains its virtuosity here, but it is brought to absurdity. The regression was inevitable."[3]

Henri Terrasse characterizes *Taifa* Spain as "withdrawn into itself," stating that diplomatic exchanges with Byzantium were completely curtailed, that

influences from without diminished, and that the oriental influences that did reach al-Andalus arrived "directly from Mesopotamia and from Persia without the intermediaries of Egypt and North Africa." Terrasse justly affirms that cultural life continued in the new provincial centers in the face of political disintegration yet maintains that this culture was achieved largely through the reworking of Cordobán themes and motifs: He sees no development in the architecture of the mosque, the quintessential embodiment of Islamic civilization, or of the palace and perceives no changes in decorative themes.[4]

Caliphal themes certainly had a powerful impact on the architecture and decorative arts of the *Taifa* states, but foreign influences also left their mark on al-Andalus in the eleventh century. These influences reached the peninsula through trade and scholarly exchange with North Africa, Egypt, Sicily, and the Islamic countries of the Near East, although diplomatic contact with other Mediterranean powers was drastically curtailed after the caliphate dissolved. In an effort to legitimize their newly acquired power, the *Taifa* kings sought not only to appropriate some of the glory of the caliphate by emulating Cordobán prototypes but also to respond to the latest and most sophisticated Pan-Islamic expressions of courtly art. In this regard it is important to note that artists of the *Taifa* kingdoms did not necessarily produce close copies of architectural or decorative arts models but sometimes adapted them freely. As Richard Krautheimer and Terry Allen have pointed out, approximations of prototypes in which allusions to the original object may be oblique were considered copies and were recognized as such by educated audiences during the eleventh century.[5]

It is useful to conceive of the *Taifa* arts as involving two levels of interchange or dialogue, both of which can sometimes be observed in the same object or monument. The first level of dialogue took place primarily within the Iberian Peninsula among the *Taifa* kingdoms themselves, pertained mainly to architecture and its decoration, and entailed the exchange of specific local ideas and techniques. Such information flowed freely from court to court, thanks to rapidly shifting political alliances and boundaries, to traveling poets and scholars and presumably artisans, and to intermarriage on the court level. The effectiveness of this dialogue is witnessed in a unity of

spirit that informs *Taifa* architecture despite regional differences in many individual details and motifs.

The second level involves exchanges with other Islamic and Mediterranean cultures and is reflected mainly in objects or minor arts. These exchanges were effected largely by means of travel and trade carried out by merchants from al-Andalus throughout the Mediterranean[6] and embraced the transmission of objects as well as techniques, styles, and motifs. For example, trade in luxury items, especially textiles—which are among the most easily transportable of goods—widely disseminated certain images associated with royalty, prosperity, and well-being; these motifs included heraldic animals and particular types of vegetal ornament, which were adopted by both the wealthy bourgeoisie and court patrons in the *Taifa* states. The spread of decorative idioms across international frontiers has often made it difficult for scholars to identify the provenances of objects attributed to this period: The mysterious Pisa griffin (No. 15) is a case in point.

The two levels of dialogue often coincided in architecture and architectural decoration, meeting first in the palace and later in the mosque. These levels confronted each other as the *Taifa* kings reached out to a highly developed international royal aesthetic (the second level), resulting in the application of motifs drawn from the luxury arts to architectural decoration. Here they were combined with elements of a distinctly local nature (the first level) to produce a regional variant of the international palace aesthetic. This is a subject that will be returned to later in the essay, the remainder of which examines the art of three *Taifa* states, Málaga, Denia, and Saragossa.

These kingdoms have been selected because they were located in widely different areas of the Iberian Peninsula and serve to illustrate the curious mixture of regionalism, expressed in a diversity of specific motifs and tastes of individual patrons, and unity of spirit that characterized *Taifa* civilization. (In fact, this mixture was apparent not only in *Taifa* culture but also in the cultures of other Islamic areas after ʿAbbāsid control collapsed.) Unity was brought about in al-Andalus by the first level of dialogue, which took place among individual courts, and was encouraged as well by influences from other parts of the Islamic world—influences that entered the peninsula through ports, such as Denia and Almería, that were engaged

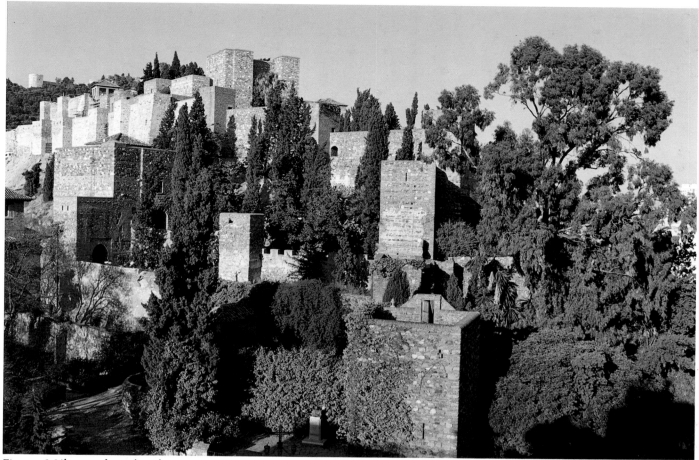

Fig. 1 Málaga, palace, fortifications

in international trade. The regionalism that marked the period is a more complex phenomenon and was determined by geography and by the resurgence of specialized local economies after Córdoba ceased to function as the cultural and economic center of al-Andalus.

It is difficult to reconstruct the background of this picture and the full panorama of *Taifa* art because of what might be called negative evidence—there are few archaeological remains and those that do exist are unevenly distributed. For example, no *Taifa* architecture survives from Seville or Denia, two of the most powerful kingdoms. The architectural remains at Badajoz, Almería, and Granada are fragmentary, mere hints of what must have been an impressive series of palaces and fortresses. In addition, a key monument from the caliphal period that might shed interesting light on *Taifa* arts has disappeared. This is the palace of Madīnat al-Zāhira, built by the powerful ʿAmirid hajib al-Manṣūr. It would be interesting to compare the architecture and decoration of Madīnat al-Zāhira with eleventh-century examples—as the *Taifa* kings

would surely have responded to it, particularly in view of the fact that al-Manṣūr, like each of them, was a newly established ruler. Unfortunately, Madīnat al-Zāhira was destroyed at the end of the tenth century, and all that remains of it is a basin preserved in the Museo Arqueológico in Madrid.

Another kind of negative evidence for the *Taifa* period is the curious position of Córdoba after the fall of the caliphate. Córdoba was the main center of luxury arts production and building in al-Andalus during the emirate and the caliphate. Yet there are no records of construction of any note in this city after 1010 (A.H. 401), when Madīnat al-Zahrāʾ was destroyed, although the *Taifa* kings were active patrons of architecture. Remodeling and embellishment of the Great Mosque of Córdoba had been virtually obligatory for rulers who wished to manifest their power and legitimacy in visual terms, but contemporary chroniclers record no such renovations carried out in the eleventh century. Neither the Banū Ḥammūd dynasty, which aspired to the caliphate, nor the Banū Jawhar, who ruled the *Taifa* of Córdoba from 1031 to 1075 (A.H.

423–68), nor al-Muqtadir, the *Taifa* sovereign of Toledo who subsequently conquered Córdoba, attempted to reconstruct Madīnat al-Zahrāʾ or Madīnat al-Zāhira. Al-Muqtadir did not even decorate his own buildings in Toledo with spoils from either of the two ruined palaces. Furthermore, the *Taifa* kings who attempted to revive the caliphate during the first half of the eleventh century did not take what would seem to have been the logical step of establishing themselves in Córdoba, the ruling seat of the old caliphal domains. Finally, when it was a *Taifa* state, Córdoba did not expand or play a particularly active part in territorial disputes within the peninsula, and it no longer attracted the most gifted poets and scholars of al-Andalus. In light of Córdoba's peculiar status, then, the subject of caliphal influences on *Taifa* arts should be approached with caution.

This is not meant to imply that the *Taifa* kings rejected Cordobán inspiration. They certainly looked to Córdoba, but they did not imitate it slavishly. The new patrons of science, literature, architecture, and luxury objects were ruled by feelings of nostalgia for the lost Córdoba that was once a great center of princely culture, a Córdoba perceived to be connected to Baghdad, the greatest center of all. The *Taifa* attitude toward Córdoba is epitomized in the work of the Hispano-Islamic poet Ibn Zaydūn, who describes Córdoba and Madīnat al-Zahrāʾ impressionistically and selectively, never literally, remembering it with yearning, indistinctly, and in hazy vignettes. It is in just this same manner that Cordobán architectural and decorative arts prototypes were approached. Certain features of caliphal buildings, architectural decoration, and the ornament of luxury objects were adapted, albeit sometimes obliquely and in combination with contemporary Hispano-Islamic and foreign influences, by *Taifa* artists. These include decorative details from the addition commissioned by al-Ḥakam II (r. 962–76 [A.H. 351–66]) for the Great Mosque of Córdoba and from Madīnat al-Zahrāʾ (particularly those of the Salón Rico [Rich Hall]), and a style of vegetal ornament seen on late caliphal ivory caskets and pyxides.

Málaga

During the first half of the eleventh century, the *Taifa* of Málaga was ruled by the Banū Ḥammūd, a Berber dynasty that for a time aspired to the caliphate. In 1056 (A.H. 448) it was annexed by the Zīrids of Granada, who were also Berbers. About the middle of the eleventh century, one of the dynasties—it is uncertain which—built a palace atop a hill. All that remains of the structure is a double ring of defensive walls and towers, which together with its hilltop location made the palace almost unassailable (Fig. 1), and the Cuartos de Granada (Granada Rooms), which include a restored portico and an open pavilion, in the eastern area of the palace.

Scholars have long debated the date of the construction of the palace of the Alcazaba and, hence, its patron. Like Gómez-Moreno, Christian Ewert believes that the palace itself was built by Yaḥyā (r. 1026–35 [A.H. 417–27]), the first of the Banū Ḥammūd emirs, and that the double wall was probably an addition made by Bādīs (r. 1057–63 [A.H. 449–56]), the Zīrid ruler of Granada whose troops conquered Málaga.[7]

Because of its ruined state, the entire plan of the Málaga complex cannot be assessed; clearly, however,

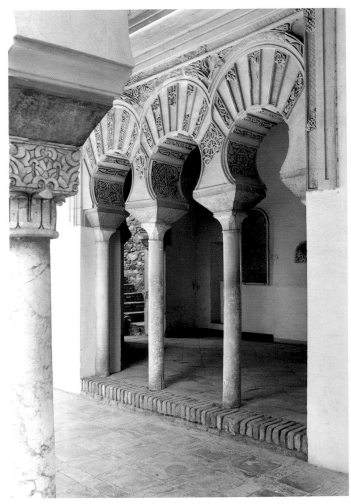

Fig. 2 Málaga, palace, portico

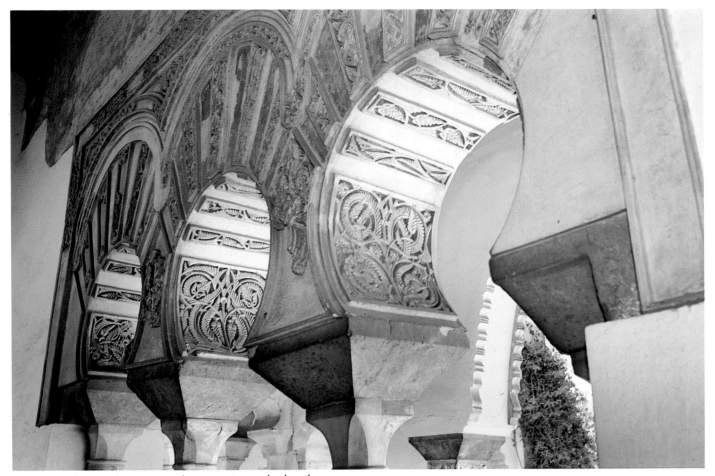

Fig. 3 Málaga, palace, stucco from portico arch, detail

the hilltop site and enclosure within heavy walls distinguish it from Madīnat al-Zahrāʾ, which was a series of pavilions and gardens spread out on the slope of a mountain. Although the caliphal aesthetic was in some respects in evidence at Málaga, defense, or the desire to present an appearance of impregnability, seems to have been the most pressing concern in terms of the exterior profile here. David Wasserstein has shown that this type of heavily fortified palace construction, which is also seen at Aleppo and Cairo, is favored by rulers who belong to ethnic minorities in their domains.[8]

The surviving elements of the palace within reveal striking parallels with the portion of the Great Mosque of Córdoba commissioned by al-Ḥakam II as well as with the Salón Rico of Madīnat al-Zahrāʾ. The layout of the extant room, which opens onto the portico attached to the pavilion, is very similar to that of the Salón Rico, and the alternating areas of plain and sculptured stucco above the arches through which the room is entered are inspired by caliphal prototypes

(Fig. 2). Ewert points out, however, that the intersecting arches of the pavilion betray a method of construction unlike that used in the arches at Córdoba. He also notes that the arches at Córdoba served a structural purpose, whereas those at Málaga are essentially decorative. An inclination to differentiate between the skeleton and the covering of a building, which was to become more pronounced in the Aljafería in Saragossa, has already become apparent.[9]

The architectural decoration has also evolved: The stucco reliefs at Málaga are flatter and more uniform in texture, and their motifs are less varied than those of Madīnat al-Zahrāʾ. The pulpy stems, fruits, and leaves of the caliphal stuccowork have been transformed into delicate, attenuated, elaborately curved leaves and stems, and relatively naturalistic disposition has been replaced by geometric organization (Fig. 3). In view of these clear stylistic differences, the often repeated notion that Cordobán workers might have constructed and/or decorated the palace at Málaga is unlikely. Moreover, it is probable that there

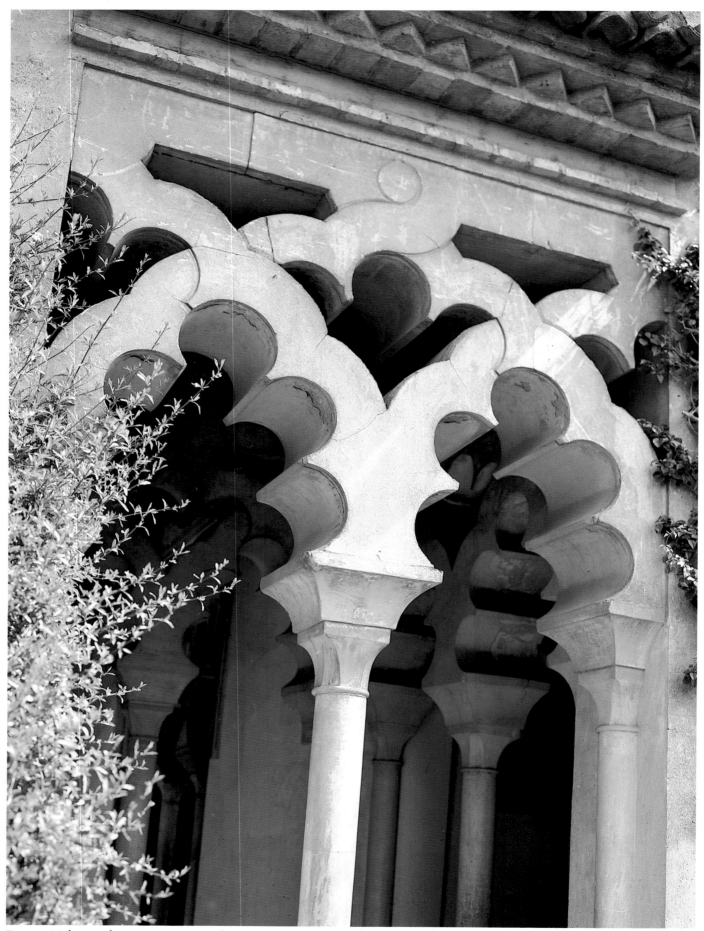

Fig. 4 Málaga, palace, intersecting arches

were few or no workshops for the production of architectural ornament in Córdoba in the eleventh century, as building activity had ceased there.

The changes in the nature of the intersecting arches and of the decorative stuccowork visible in the palace at Málaga have traditionally been considered degenerations of caliphal forms (Fig. 4). It is perhaps more correct and certainly more enlightening to see them as early intimations of a new *Taifa* aesthetic that was to evolve more fully in later buildings in Saragossa and elsewhere. Certainly it is clear that the Málagan palace was inspired by a memory of Cordobán princely culture and equally clear that the architecture and decoration represent a reinterpretation of that culture. In this reinterpretation lies the key to our understanding of *Taifa* art and architecture.

Denia

Denia was established as a *Taifa* kingdom by Mujāhid (r. 1012/3–1044/45 [A.H. 403–36]), a Slavic *fatā*, or high-ranking slave, who had served at the court of al-Manṣūr. Mujāhid was succeeded by his son ʿAli, who reigned until the city was taken by al-Muqtadir of Saragossa in 1075/6 (A.H. 468). Denia's location on the east coast of the peninsula between Valencia and Alicante made it an ideal port (Fig. 5). Moreover, from 1015 to 1076 (A.H. 406–69) the *Taifa* of Denia controlled the Balearic Islands, which were important both strategically and economically.

It is known from archaeological evidence and the Cairo Geniza documents, a compendium that includes many letters and commercial documents relating to merchants from al-Andalus, that Denia was a prosperous center of trade. These sources indicate that the kingdom flourished in particular during the first three-quarters of the eleventh century. Imports from Egypt, North Africa, Sicily, and the Levant passed through Denia en route to cities throughout the peninsula, and goods from Spain left its port for the east. Although no *Taifa* architecture survives in Denia, other

Fig. 5 Denia, aerial view

archaeological remains uncovered by Rafael Azuar Ruiz have yielded a picture of a flourishing and distinctively regional economy based on agriculture and trade in the city and its ʿamal, or surrounding region, beginning in the first quarter of the eleventh century.[10] That almost no products of local manufacture datable to the eleventh century have been uncovered supports Azuar's suggestion that Denia functioned primarily as a distribution center. The similarity of Denia's material culture to that of other cities throughout al-Andalus, which has been noted by Azuar, also gives credence to this theory.

Azuar's excavations brought to light facts about Denia's contacts with other *Taifa* states and with foreign powers that carry implications for the whole of *Taifa* civilization. For example, he discovered a group of bronzes that are almost certainly of Egyptian provenance and datable to the eleventh century, as well as fragments of eleventh-century ceramics. The majority of the ceramics seem to be imported from Toledo; a notable exception is a particularly interesting fragment of an *ataifor*, or shallow bowl, bearing the image of a peacock and decorated in the complete *cuerda seca* technique, which Azuar believes to have been imported from North Africa (No. 33). He cites several other ceramics with strikingly similar decoration that have appeared throughout the peninsula, noting that some may be of Hispano-Islamic manufacture. These ceramics demonstrate a flourishing commerce between al-Andalus and North Africa and also indicate the receptivity of the artisans and patrons of al-Andalus to international decorative trends.[11] The commercial activity and attendant cultural and artistic interchange of Denia, and of other *Taifa* states as well, to some extent functioned independently of the political sphere: Although Denia was allied with Seville throughout most of the *Taifa* era, its most intense commercial relations were maintained with Toledo (as the presence in Denia of Toledan ceramic fragments and other archaeological remains shows). The *Taifa* kingdoms clearly were able to sustain strong commercial and cultural links with one another and with the rest of the Mediterranean world despite the somewhat precarious political situation. Thus, unity and regionalism coexisted within the framework of *Taifa* political and commercial relations.

Denia's great prosperity during the first half of the eleventh century resulted in the flowering of a cosmopolitan culture with links to other important centers. A school of Qurʾanic commentary flourished, and with royal patronage the famed Cordobán thinker Ibn Ḥazm completed a large part of his treatise on love, Ṭawq al-Ḥamāma. However, the coming of the Almoravids to the peninsula and increasing pressure from the Christian kingdoms to the north in the late eleventh century brought about the rupture of Denia's commercial and cultural ties to other regions of al-Andalus as well as to the Mediterranean basin. This is manifested archaeologically by the disappearance of several ceramic types and by clear evidence of depopulation that began in the final decades of the eleventh century. Although the late twelfth and thirteenth centuries would witness the return of economic prosperity to the region, Denia's cultural life, which had been based on its exchanges with the rest of the peninsula and with the wider Mediterranean world, had been extinguished.

Saragossa

Saragossa, which was ruled by the Banū Tujībī from 1010 to 1040 (A.H. 401–32) and by the Banū Hūd from 1040 to 1110 (A.H. 432–504), was one of the longest-lived and largest of the *Taifa* states. Because it was a *thagr*, or frontier kingdom, located far from stronger *Taifa* powers, it was strategically important in terms of the Christian governments to the north. Far from the center of power in Córdoba, it had a tradition of at

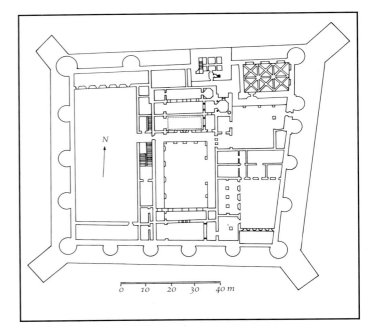

Fig. 6 Saragossa, Aljafería, plan

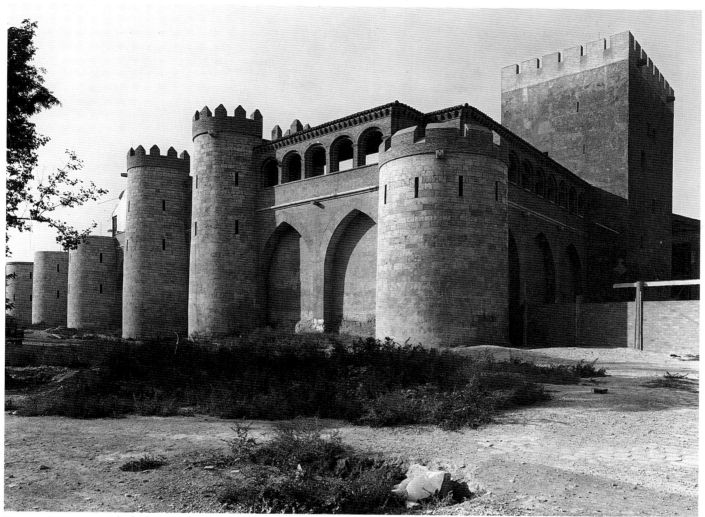

Fig. 7 Saragossa, Aljafería, exterior view

least semiautonomy, and, despite Christian advances and frequent skirmishes with Toledo and Balaguer, it maintained a relatively secure independence for a longer time than most *Taifa* states.

Saragossa is the site of the Aljafería, the best-preserved palace complex of the *Taifa* period (Fig. 6).[12] The Aljafería was constructed under the patronage of al-Muqtadir, the most powerful of the kings of the Banū Hūd. Its enclosed, fortresslike aspect (Fig. 7) sets it apart from Madīnat al-Zahrāʾ and has inspired Ewert to propose that al-Muqtadir was attempting here to emulate the late seventh- and early eighth-century Umayyad desert palaces of Syria and Jordan.[13] Oleg Grabar disputes this contention, however, observing that such desert palaces were only symbolic fortresses, not made for actual defense, and that their patrons may not have been royal.[14] The Aljafería, on the other hand, was probably a functioning fortress,

since Saragossa was often involved in battles with Christians and with other *Taifa* states. Moreover, it seems unlikely that al-Muqtadir would have wished to imply a relationship with the Umayyads, since the Banū Hūd did not claim descent from them.

The mosque of the Aljafería is noteworthy in more than one respect. The octagonal plan is atypical in Hispano-Islamic architecture and, especially in comparison with the mosque at Madīnat al-Zahrāʾ, it is unusually small, so small that it might be considered an oratory. It is located within the palace complex, adjoining the area that is thought to have been al-Muqtadir's audience hall, and the intricate vegetal stucco decoration (Fig. 8) is repeated in the palace itself. For these reasons it appears likely that the king wished to emphasize the association of his newly established dynasty with the religion he proposed to defend. This supposition is given credence

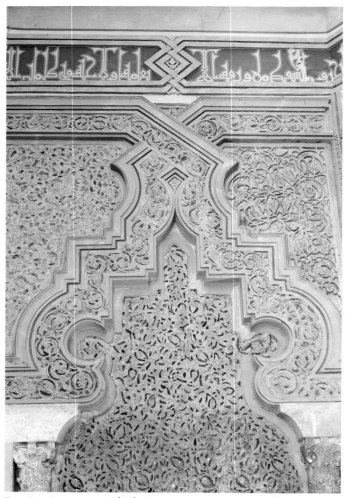

Fig. 8 Saragossa, Aljafería, mosque, stucco panel

by the fact that the Saragossa mosque's ornamentation seems to be inspired in particular by the decoration of the Great Mosque of Córdoba's *maqṣūra* region and mihrab, which were associated with caliphal authority. For example, the Aljafería mosque's plan and elevation resemble those of Córdoba. In addition, architectural features of the Great Mosque are converted into highly charged decorative elements at Saragossa: The intersecting arches that support the dome of the Capilla de Villaviciosa, the area immediately preceding the Great Mosque's mihrab, are transformed into ornamental motifs that articulate wall surfaces at Saragossa, and the domes of the Cordobán mihrab are referred to in two curious dome-shaped medallions in the Aljafería mosque's mihrab arch.

The small size, as well as the location, of the Saragossa mosque implies that it was intended for the exclusive use of the king and his inner circle of family and courtiers. This assertion of royal privilege, meant to underscore the power and legitimacy of the reign-

ing dynasty, has parallels throughout the *Taifa* kingdoms and is reflected in a variety of art forms. The exaggerated use of titles in the inscription on the Palencia casket (No. 7) is one such example. Although a number of allusions are made at Saragossa to the royal exclusivity, wealth, and luxury that characterized caliphal culture, they do not appear to have been aimed at reestablishing the defunct Umayyad caliphate: The Banū Hūd never attempted to annex Córdoba, and many of the artistic statements at the Aljafería are inspired by local models.

Thus, architecture and embellishment of the Aljafería illustrate the first level of dialogue discussed in the earlier part of this essay, since they are primarily related to Hispano-Islamic prototypes. As Ewert notes, both the vegetal motifs of the Aljafería and its intersecting arches (Fig. 9), which are ultimately based on Cordobán models, were probably directly inspired by the decoration of the Alcazaba at Málaga (Fig. 4).[15] However, the Saragossan forms have evolved: The leaf and vine motifs are more varied, delicate, and attenuated. The circular forms of the vines, the elegantly curved leaves that hang from them, and the carefully designed spaces these leaves fill constitute arabesques in their pure form.

The intersecting arches at Córdoba were structural; at Málaga they appeared to be linked to structure but were essentially decorative; at Saragossa their decorative aspect is more pronounced—in fact, they are so fantastic that they could not be mistaken for structural elements. Moreover, these arches are part of a decorative program in the Aljafería: Motifs based on their shapes are substituted for the volutes on a number of capitals in the palace.

It is possible that the decorative reliefs of the Aljafería reflect a taste for precious courtly arts like the renowned caliphal ivories. Indeed, because they obscure the underlying skeleton and in their minute and mannerist detail deny all architectonic logic (Fig. 10), the reliefs suggest the skin of a delicate ivory casket more than an architectural monument with structural tensions. Perhaps even the intimate proportions and concentrated octagonal shape of the mosque of the Aljafería recall such objects. The architectural associations of the domelike covers of several caskets have often been noted; their shapes seem to be reflected in the plan and elevation of the Aljafería mosque and may be the source for them. Here the allusion to

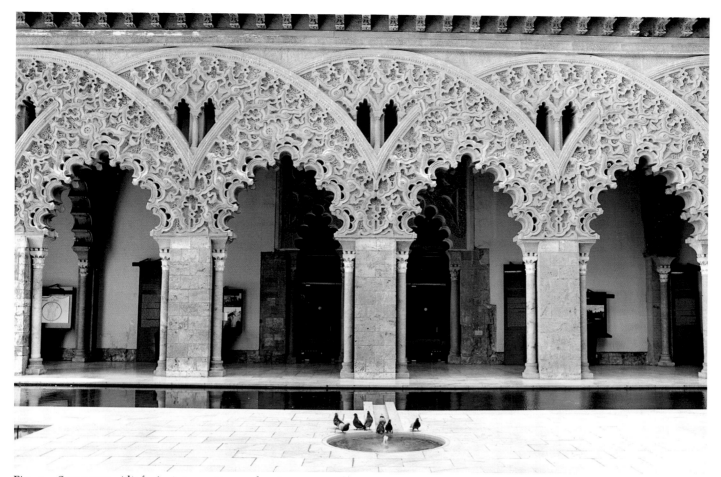

Fig. 9 Saragossa, Aljafería, intersecting arches in courtyard

ivory boxes would represent a reversal of the usual appropriation of architectural motifs for use in luxury objects. Thus, it is likely that the decoration of the Aljafería contains a veiled allusion to Cordobán luxury arts. References of this kind make sense, for we know that the production of ivories and other luxury arts, as well as the patronage of additions and embellishments to the Great Mosque of Córdoba, which also were emulated by the *Taifa* rulers of Saragossa, were royal monopolies. Moreover, the very act of patronage of such objects or enterprises was considered an expression of princely position and authority.

Although the palace and mosque of the Aljafería certainly exemplify the first level of dialogue posited above, they may also represent an instance of the second, or international, level. Because little remains of the Aljafería's decoration, this can be deduced only from evidence uncovered at a comparable site. Fragments of painted stucco ornament that show developed heraldic imagery have been found at the palace of Balaguer, which was built by a relative of al-

Muqtadir in response to the palace complex at Saragossa (the Aljafería's surviving decoration is strikingly similar to reliefs at Balaguer [Fig. 11]). For this reason, it is possible to suggest that the heraldic imagery of Balaguer might also have appeared at Saragossa. This imagery included a harpy of a type common in textiles and ceramics throughout the Mediterranean. In addition, the tapestrylike effect of the painted stucco at Balaguer is similar to that of painted wooden panels from the Fāṭimid Eastern Palace in Cairo.[16] A direct source for *Taifa* architectural ornament in Fāṭimid wooden panels is not suggested here, but it may well be that these or similar Fāṭimid prototypes found ready acceptance in eleventh-century al-Andalus. Clearly, the *Taifa* kings were sensitive to current international trends as well as to the shadowy image of Umayyad Córdoba.

The fragments of painted decoration excavated at Balaguer imply that the *Taifa* states reached out to the architectural milieu as well as to the luxury arts of the larger Islamic and Mediterranean world. It is

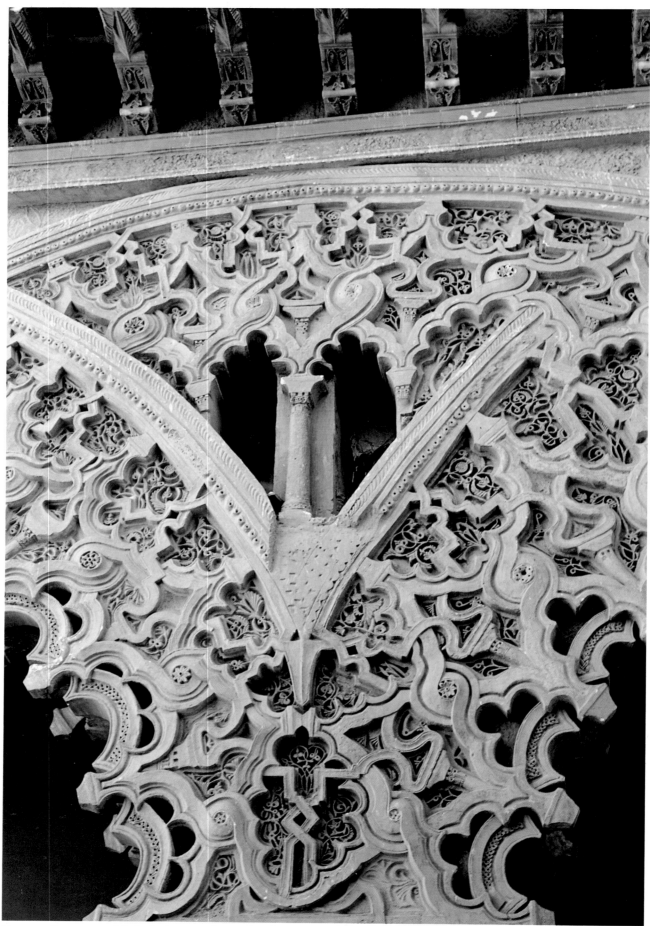

Fig. 10 Saragossa, Aljafería, intersecting arches in courtyard, detail

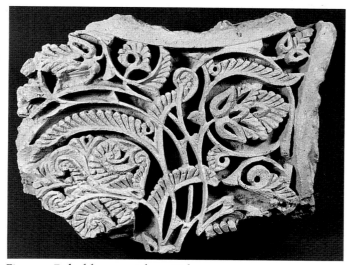

Fig. 11 Relief fragment from Balaguer

unfortunate that more architectural ornament does not
survive from other kingdoms to confirm the existence
of this impulse. Such evidence might begin to alter our
perceptions of the context and character of the art and
architecture of al-Andalus during the *Taifa* period.

1. For a discussion of these interpretations, see Wasserstein 1985, pp.
 98–153. As Wasserstein points out, Islamic Spain did not develop
 as a unified entity ruled by a succession of powerful dynasties that
 experienced intermittent periods of disorder. Rather, medieval
 al-Andalus was an amalgam of regional cultures, held in fragile
 unity by central authority when strong rulers emerged (p. 290).
2. For cultural, political, economic, and social background for the
 eleventh century, see Guichard 1977; Miquel 1967–88; Glick 1979;
 Goitein 1966; Wasserstein 1985.
3. Gómez-Moreno 1951, pp. 221, 237, 241–43.
4. Terrasse 1965b.
5. Krautheimer 1969, pp. 115–39; Allen 1988.
6. Through his work with the Cairo Geniza documents, Goitein has
 demonstrated that many merchants from al-Andalus were highly
 educated and that they lived with their families in all corners of the
 Mediterranean world (1966, pp. 296–307).
7. Ewert 1966.
8. Wasserstein 1985.
9. Ewert 1966, pp. 238–53.
10. See Azuar Ruiz 1989, esp. pp. 13–20, 48–57, 411–16.
11. Ibid., pp. 48–49, fig. 20, pl. 5. The peacock enclosed in a rondel is
 similar to motifs on eleventh-century ivories, textiles, and metals
 from Spain and elsewhere in the Islamic world and thus illustrates
 the role of minor arts in the diffusion of decorative styles.
12. For a detailed discussion of the palace, see Ewert 1978–80.
13. Ibid., part 1, pp. 1–26.
14. Grabar 1987, pp. 132–77.
15. Ewert 1966, p. 242.
16. For a full discussion of Balaguer, see Ewert 1971; idem, 1979–80.
 For the wooden panels of the Fāṭimid palace in Cairo, see Pauty
 1931, pls. XLVI–LIX.

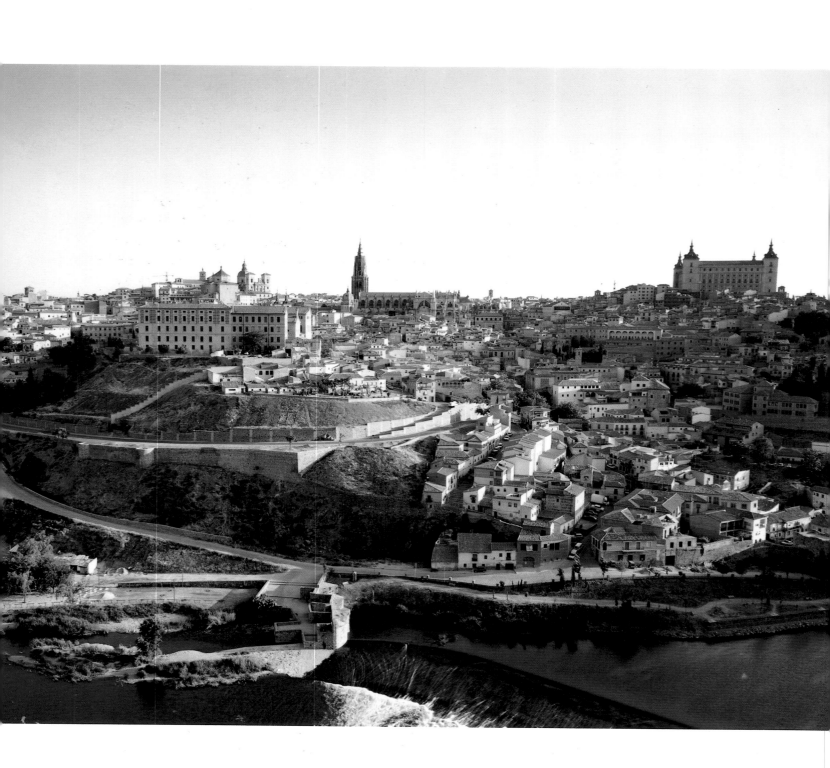

The Fortifications of al-Andalus

JUAN ZOZAYA

The English expression "to build castles in Spain" seems to refer to the fantasy of which we Spaniards are capable and, of course, to a time when castles, a general term for defensive structures, had begun to form part of our history. In fact, of the more than four thousand military structures of various kinds remaining in Spain, more than one-fourth are of Muslim origin, which gives one an idea of their importance. Of these, approximately half were constructed between the eighth and the eleventh century.

At the beginning of Islamic rule on the Iberian Peninsula and the Balearic Islands, from the middle of the eighth century, the building of fortifications was widespread and fairly intensive. This construction was rich and varied and, to an unusual extent, conformed to homogeneous ideas of geography,[1] above all in the early stages and until the ninth century, when the demographic importance of Muslims was not very great. However, from the ninth century on, and especially beginning in the twelfth century, conditions would change with the great advance of the Christians toward the south, the arrival of the Almohads in al-Andalus, and the large concentrations of displaced peoples in their territory.

The complex world of the multiple traditions of al-Andalus has begun to reveal its mysteries, as the scholars who have studied the field for many years have gradually begun to understand the defense mechanism or mechanisms created by those who fought for another social and religious system on the peninsula. We tend to think of castles as independent defensive systems, but this elementary understanding does not take into account a world that was heir to Rome and Byzantium and to the idea of the nation as more than a reflection of spiritual cohesion. The Islamic world had a clear notion of geographical unity. Scientific advances up to that time clearly show this, and the world of politics was not a series of chance incidents but of carefully planned moves with clearly defined orientations that always took into account the society or societies in which they occurred.

In the case of the Iberian Peninsula, we can appreciate this total vision as something truly revelatory of the military and strategic points of view held by the new rulers of the land. By paying careful attention to their systems of settlement and to their control of communications and urban centers, we can reach a thorough understanding of the politics of territorial occupation, although this was certainly not consolidated as quickly as the new rulers desired.

If we have some understanding of geography and of the significance of military architecture, we will realize that there is a great line of communications. This line stretches from Lisbon and Faro through Évora to Mérida, Trujillo, Condeixa-a-Velha, Idanha-a-Velha, or Coria in the western territory, Alija, Talavera de la Reina, Vascos, Maqueda, Toledo, Madrid, Talamanca del Jarama, Alcalá de Henares, Guadalajara, Peñafora, and Medinaceli in the central zone, to Ágreda, Calatayud, Saragossa, Lérida, Huesca, and Navarre along the upper frontier,[2] roughly following what can be considered the spinal column of mountains that divides the peninsula in two.[3]

But this reading of geography may not be entirely accurate: The placement of fortifications may have been less precise, with the upper frontier somewhat reduced in size. In the first half of the ninth century, this line of communications probably also followed a path north of the central range of mountains, leaving behind ancient cities like Segovia and Sepúlveda[4] in the central zone north of Guadarrama

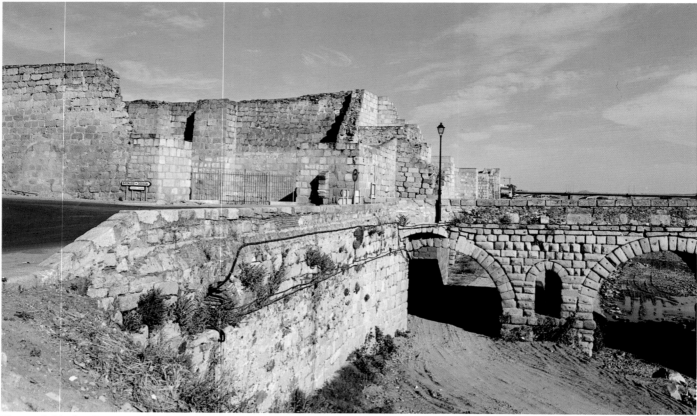

Fig. 1 Mérida, Conventual

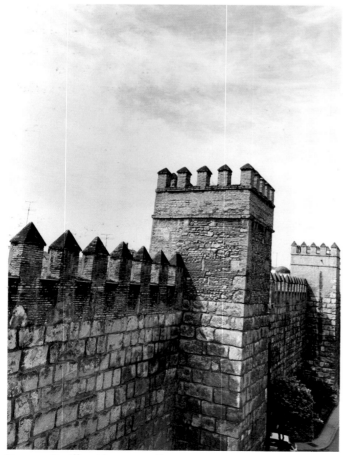

Fig. 2 Seville, Alcazar, walls

and Somosierra. New sites need to be considered, such as Nájera in Rioja or Falces in Navarre,[5] reaching Balaguer in the east[6] and extending farther to the north and east. The Sorian zones in north-central Spain have not been explored fully, although I have made some attempt to do so.[7] The references by Ibn Ḥayyān,[8] when he cites the attacks against Soria in 868 (A.H. 254) and 870 (A.H. 257), give us early dates that justify the existence of these fortifications and augment the typological data provided by the walls.

This brief overview indicates the need to consider the importance of territorial occupation. Territories had to be defended right from the start by fortified systems, since there was not yet sufficient demographic strength to accomplish defense through full economic occupation. Consequently, we have an occupied zone and a tenuous unifying network that stretch from Sepúlveda to Soria and Nájera to the region of the Ebro (Falces and Tudela in Navarre), proceeding from an area that even in the early ninth century extended as far west as Condeixa-a-Velha, near present-day Coimbra in what is now Portugal. In the zone that includes Sepúlveda, Soria and Nájera, toponyms such as Almarza or Alberite must be noted[9] (both begin-

ning with the definite article "al" characteristic of Islamic settlements).

The commonality of systems and their arrangement in this area, together with historical data, lead to the assumption that these structures were built in the period 800 to 875 (A.H. 184–262). The basic dates are provided by the founding of the Conventuals of Mérida in 838 (A.H. 224) (Fig. 1), of Madrid, Salamanca, and Peñafora in 856 (A.H. 242), and of Huesca in 875 (A.H. 262).[10] Another point of reference is supplied by the construction of the walls around Seville (Fig. 2), following the Viking attack of 848 (A.H. 234). The other walled structures mentioned above should be similarly dated, to judge by the typology of their layout, which apparently has parallels in the eastern world.[11] But it does not seem logical to assume that these and other cities had no connection with each other or with the central seat of authority. (Frontier cities were not the only ones that were fortified.) Urban fortification signified defense of the cities and control of the inhabitants.

Rural areas, however, remained separate from the state as it was conceived and lay outside the centralist system of the Umayyads. A link was needed that would help to keep these jewels within the network. Undoubtedly the first link would be structures built more as caravansaries than as castles. They constituted a relatively infrequent system of communication in the middle and upper frontier areas before the time of the caliphate and were used to protect roads and routes until a fairly late period. The castles of El Vacar, Baños, Guadalerzas, or the magnificent caravan city of Calatrava la Vieja[12] seem to confirm this.

Along with castles of the usual size and garrison towers, small castles called *sajra*[13] made their appearance in the tenth century. These consisted of small fortifications, generally at the top of a low hill, with a cistern, a wall, and a small settlement outside the wall. They were usually situated so as to guard valleys and help to cut off possible enemies, as in Paracuellos de Jarama (Madrid) or in Alboer and Alarilla, which, along with Oreja and other sites along the Tagus River, became part of the network.[14]

The next link is the towers that helped to maintain territorial control in the countryside. Some served as military posts and can be characterized by their large storage capacity and potential to maintain a permanent garrison. Typologically they follow a quad-

rangular plan, are extremely high, and are topped by a crenulated component.[15]

Depending on the period, they were designated as *qubba*, *qal'a* or *qulay'a*, or later *bury* (tower), and they remained fairly unchanged. In my opinion the oldest archetype of fortification (not a watch post on a hill) of all is the *qubba* (in Spanish *alcoba* [alcove; bedroom]); the diminutive is *al-qubayba* (in Spanish *alcubilla*; in Catalan *cubells*). In Soria the toponym is reflected in villages such as Alcoba de la Torre, Cubo de la Solana, and Alcubilla del Marqués (cited in *The Poem of the Cid*);[16] the latter probably followed a square plan but was topped by a dome (*qubba*). An example that remains is the structure in Cogolludo, identified by Pavón Maldonado[17] as a *morabito*, or Muslim hermitage, because of the dome. However, I believe it is not a religious monument (its semantic and functional development is much later) but a military one. An interesting structural parallel is the Torre del Andador in Albarracín.[18]

The *qubba* type must have had the appearance of a fortress; the tower in Aguilera near Berlanga de Duero (Soria), described by Silense as an *oppidum*,[19] probably resembled the one in Cogolludo; its remains on the upper part of the hill are similar to those found in Alcubilla del Marqués. Both seem to correspond to this first stage, in the ninth century, when the frontier passed through areas that were farther north than those stabilized in the region of the Douro River at the beginning of the tenth century.

This kind of tower made way for a type built on a rectangular plan, with or without an antecastle. Those

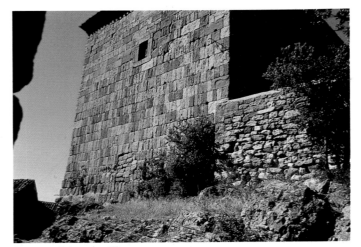

Fig. 3 Mezquetillas, tower

with an antecastle or walled enclosure, or *qilāᶜ* (singular *qalᶜa*; Spanish *alcalá*), give rise to toponyms such as Calatañazor (Soria). Elsewhere I have explained the translation of the word *qilāᶜ* into the "Aguilares" that are dispersed throughout the topography of Spain and Portugal, among them the *oppidum* in Aguilera cited above.[20]

Towers on a rectangular plan without an antecastle were designated *bury* (plural *buruy*). This term is also applied to a kind of castlelike fortification that has not been totally defined but whose prototype might be the isolated tower of Idanha-a-Velha in Portugal, from which are derived the structures in Covarrubias (Burgos), Noviercas, or Bordecores (Soria),[21] and that will develop in places such as Mezquetillas (Fig. 3) and Bujalaro, giving rise in general to toponyms such as Bujalaro, Butarque, Bujarrabal, or Bordecores. They were possibly controlled by a garrison of regular troops.

The practice of using rectangular towers garrisoned by the army continued until very late, and in the Valencian community there are still several remains, perhaps the best known being the tower of Bufilla in Bétera (Valencia). Dating from the Almohad period, made of tabby, and higher than those from the Umayyad period, it can be considered an archetype.

The type of tower built on a circular plan plays a more complex role despite its humbler appearance. I am referring to what are called watchtowers,[22] or *atalayas* (from Arabic *al-ṭalᶜīyya*) (Fig. 4). Besides their circular floor plan, they have a cylindrical body with relatively little capacity to garrison the troops provided by a system of militias drawn from the local inhabitants. This is what the Silense chronicle seems to refer to when it describes the destruction by Ferdinand I of a series of these structures between Berlanga and Bordecores: *"Prosternit etiam turres omnes vigiliarum, barbarico more supero montem Parrantagon eminentes atque municipia in valle Horcecorex ob tuitione arantium boum per agros passim constructa."*[23] (He also destroyed all watchtowers standing in barbaric fashion over Parrantagon Mountain and the settlements in the Horcecorex Valley that were built to shelter the animals that tilled the fields.)

The warning mission of these watchtowers allowed the extremely rapid transmission of messages to a control center by means of fires and smoke signals. It has been calculated that a coded message could be sent from Gormaz (Soria) to Córdoba in approximately five hours. The system's method of operation has left behind toponyms such as Humanes, Humera, or Humosa (*humo* means smoke). This kind of watchtower would continue to be built, especially in the area of the Mediterranean coast, until the time of Philip II in the sixteenth century, when they served to help warn against incursions by pirates from the Barbary Coast.

The extension of this system of watchtowers is evident in the fact that they can be found, in partial ruins, throughout al-Andalus. The group offers elements that help to delineate the network and thereby enhance our general concept of these towers. This delineation can be accomplished, for example, by studying toponyms, the antiquated designations of primitive places that have been destroyed (for example, *cubo, alcubilla, alcoba, alcolea, qalᶜa*). Of course, one must also take into account Spanish place-names of Arabic origin that may have been partially Romanized. (An example is Castillejo de Mesleón, which is formed from Castillejo, a Roman diminutive probably translated from the Arabic *qulayᶜa*, and Mesléon, which is derived directly from Mas al-ᶜUyūn.) Trans-

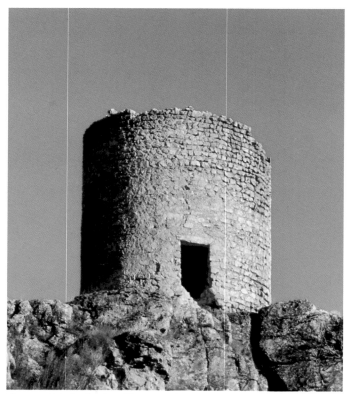

Fig. 4 Madrid, El Vellon watchtower

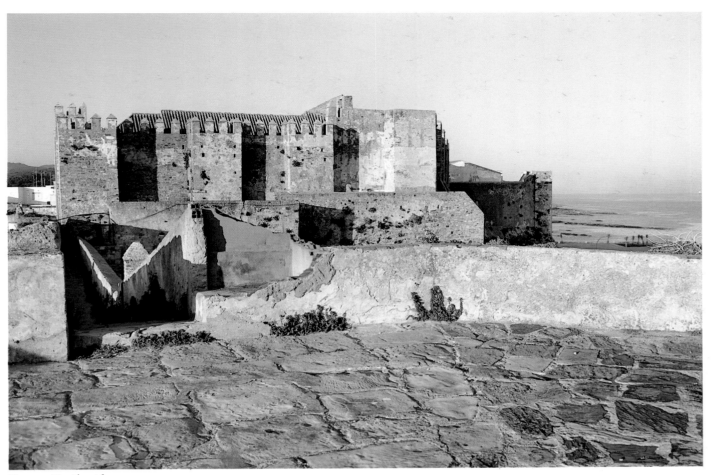

Fig. 5 Tarifa, Alcazar

lated toponyms (probably including Aguilera, Aguilar, Humera, *tor-* and *tar-*, *tordehumos*, la Humosa, Humanes, and Humera) seem to indicate the existence of signal towers that have disappeared in modern times. The entire group would be a function of the great nuclei of population, which enjoyed various types and kinds of fortifications, combining and adapting elements according to the terrain on the one hand and the needs of an expanding population on the other. This is described below.

In the group ordinarily called castles, those with a quadrangular floor plan are of special interest. Extremely common during the Umayyad period, they are particularly varied in their layout and appear to derive from eastern types that originated in Sasanian, Parthian, and Byzantine models. Their significance seems to be associated with magical elements emanating from power, which, according to an ancient Hindu numerical theory adapted by the Arabs, represents power as the center of the world.[24] Transmission of the theory must have occurred by means of manuals containing formulas for building this kind of structure.

Representations of castles with quadrangular floor plans and towers appear in miniatures in the Mozarabic style. These include examples in the Morgan (MS. 644, fol. 222v),[25] Gerona (MS. 7, fol. 230v), Saint Sever (MS. lat. 8878, fols. 207v–208r), and Fernando I (Cod. Vit. 14-2, fol. 253v) Beatus manuscripts, just to cite the best-known cases in which they signify the heavenly Jerusalem. In the Aemilianensis Codex (33, fol. 205v) there is also a representation of a castle, although its two-dimensional bird's-eye perspective is different from the examples previously cited, which present a kind of diagrammatic floor plan.

In al-Andalus the examples constructed according to a quadrangular floor plan prior to the twelfth century and still extant today are El Vacar, Mérida, Trujillo, Guadalerzas, Alora, Toledo in the Hizam, Reliquias in Portugal, the Alcazaba in Bobastro, Castillo Real in Majorca, Castell Formós in Balaguer, Tarifa (Fig. 5), Aljafería,[26] and possibly Madrid, to judge by the remains of the topographical conformation

in the area in which the Alcázar de los Austrias was situated, as well as its possible floor plan. This type of plan survived, possibly with the same significance, into the period of the Christian kingdoms of the thirteenth century; a splendid example is Villareal (Castellón), founded by James I the Conqueror.[27]

The source of inspiration is eastern, from sites such as Dār al-Imāra in Kūfa (644–56 [A.H. 24–36]), Qaṣr al-Minya (712 [A.H. 94]), Castillete de ʿAmra (714 [A.H. 96]),[28] Qaṣr al-ʾAnyar (714–15 [A.H. 96–97]), Qaṣr al-Ḥayr al-Gharbī (724–43 [A.H. 106–26]), Qaṣr al-Ḥayr al-Sharqī (728–29 [A.H. 110–11]), Qaṣr Kharana, the Umayyad palace in Jerusalem, Qaṣr al-Tubba (734–44 [A.H. 116–27]), Khirbat al-Mafjar (739–50 [A.H. 122–33]), al-Qasṭal (possibly 743–44 [A.H. 126–27]), Ukhayḍir (764–68 [A.H. 147–51]), and Mshatta (743–50 [A.H. 126–33]).[29] All are characterized by a quadrangular floor plan and by towers that follow a semicircular plan in the case of the eastern examples and those in North Africa, with special attention to their proportions and numerical values; in the examples from al-Andalus their floor plan is quadrangular, with the exception of the Aljafería in Saragossa,[30] which reverts to the eastern model that has semicircular towers.

Their real splendor is reflected in this short poem from the time of the *Taifa* kingdoms:

When kings wish to leave behind a memory of their high thoughts, they do so in the language of [beautiful] buildings.
A building, when it has beautiful proportions, indicates the majestic rank [of the builder].[31]

In fact, the idea of the quadripartite interior patio present in the Castillejo de Monteagudo,[32] an interesting Almoravid work, is further proof of this interior-exterior conformation of symbols.

Systems of fortifications conceived within a network suggest an issue that has been debated at length but has not yet been resolved. I am referring to the question of the meaning of the term *ḥuṣūn* (singular, *ḥiṣn*), which translates into the Spanish prefix *azn-* (for example, Aznalfarache or Aznaltoraf). Talamanca and Peñafora are referred to as *ḥuṣūn* in Ibn Ḥayyān's *Muqtabas* (II). Other *ḥuṣūn* cited in this compilation are Ayedo, Esteras (Medinaceli?), Amaya,

Andújar, Orihuela, Badajoz, Soria, and Madrid. A clear example from a later date is in Gormaz.

It seems obvious that the defensive district would have a military character. According to Ibn Ḥayyān's text, a *taʾa*, or demarcation, was determined by the *ḥuṣūn*, which had overseers whose succession to office is cited frequently in this text. The *ḥuṣūn* seem to have been state military foundations under civilian rule that were perhaps not directly dependent on the government of the *cora*, or province. Their proximity to a frontier suggests the idea of fortifications; in present-day terms they would be command posts or garrisons, although this point is still debatable.

There were also civilian cities, or *mudun* (singular *madīna*), such as Madīnat al-Faraj (Guadalajara) or Madīnat Sālim (Medinaceli), which included a fortified area that could be enlarged considerably. This occurred in particular because of the southerly migrations caused by the Christian advance in the late twelfth century; examples include the Almohad expansions of cities such as Córdoba, Seville, and Granada. In contrast to the Umayyad society of the tenth century, when the countryside was very urbanized, this migration produced a greater ruralization of the countryside and an increased urbanization of the city.

Consequently, a *ḥiṣn* could eventually be termed a *madīna*. As such it had the structure of a city with districts and suburbs, with clear urban interconnections, and with a *qaṣba* (Spanish *alcazaba*), or residential area for those who had taken over governance, such as the Alcazaba *qadīma* in the Granadan Alhambra or the Alcazaba in Málaga.

Finally, one needs to explain the term *qaṣr* (Spanish *alcázar*), which apparently refers to the military redoubt of the governor of a *madīna* or, in exceptional cases, of an isolated building such as the Alcázar of San Juan. In any event, doubts that need to be clarified surround the term. It is probably derived from *al-quṣayr*, the diminutive of *al-qaṣr*, the source of the Spanish word *alcocer*; for the moment, concrete examples are lacking, but it probably corresponds, in its primitive stages, to systems similar to those of the *bury*, as the Alcocer in Soria, to the west of San Esteban de Gormaz, seems to indicate. The *qalʿa* as well as the *ḥuṣūn* and the *mudun* had complex systems of fortification. An example is Calatrava la Vieja, which I have described elsewhere.[33]

The fortifications could be constructed of various

materials that can be described generically as of two basic types: stone and tabby. The use of stone was fairly intensive in the great fortifications of the Umayyad period. During the Umayyad emirate, large rows of stone, approximately fifty to fifty-five centimeters high, were typical. The rows often reutilized Roman ashlars, as was the case in Mérida, and were leveled with gravel and brick. Shortly afterward, intensive use was made of a layer connected to two or three headers as the model for width, especially in official constructions. Generally exceeding two meters in width, these rows were made lower and facing ashlar was employed.

Tabby is made from a mixture of earth and other elements, including branches, straw, bones, and lime; it allows the rapid building of a strong and generally highly resistant wall. It was used from the very first, for example in the castle of El Vacar (Córdoba),[34] where one can still see large ashlars covered by plaster to conceal the seams between blocks. It was also employed at other sites such as Talamanca del Jarama (Madrid), in this case with brick sheathing, and it

would become an element commonly used by the Almohads, in the castles of Corbera or Cullera (Valencia), for example.

The system of construction was fairly rapid, especially in the case of tabby, in which a trough was dug for the base of ashlar masonry. A series of blocks held on transverse "needles" that followed the line of the wall were positioned on the low foundation wall, establishing the base for the adobe blocks and at the same time serving as scaffolding. As the construction progressed and the tabby dried, the wooden block molds were reutilized. At large sites, several crews might work at the same time under the direction of military engineers. The system of construction with ashlars was slower but still fairly rapid. The stone from existing buildings was reutilized or was obtained from nearby quarries or even from the site itself, as was the case in Balaguer (Lérida) or Gormaz (Soria) (Fig. 6).[35] At this latter site, small tubs used for cooling lime, for sand and earth, and for water have been found at regular intervals in the interior. This means that the crews, under the direction of their

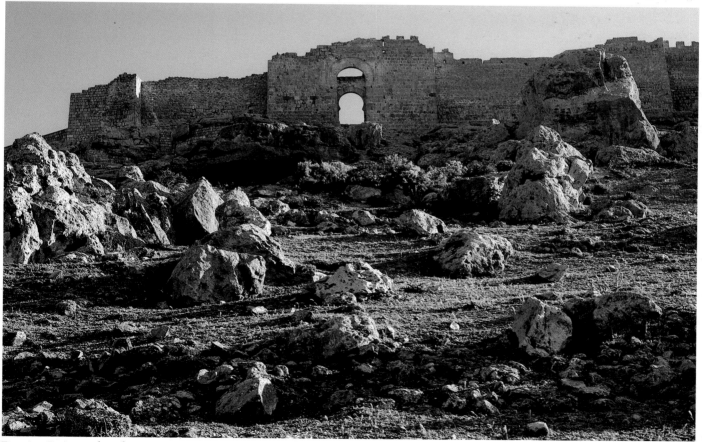

Fig. 6 Gormaz, fortifications

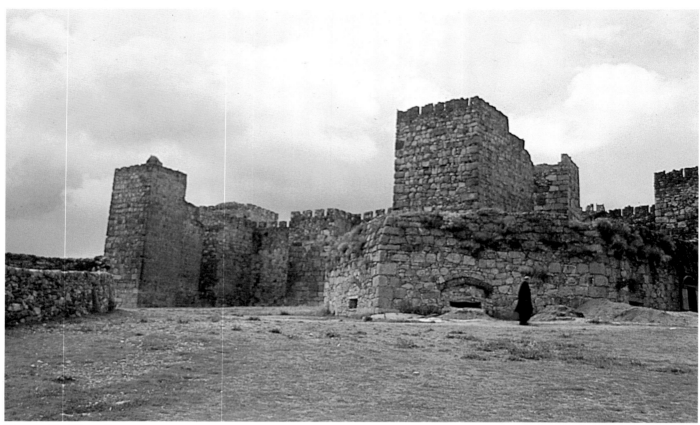

Fig. 7 Trujillo, *albarranas*

overseers, worked quickly, preparing their mixtures and placing their rows of stone. Mule trains must have replaced the materials as needed. Observing the walls of constructions at such sites as Talavera de la Reina and Vascos (Toledo), Calatrava la Vieja (Ciudad Real), or Gormaz (Soria), one can see the sections built by each crew and how the seams were made between portions of wall built by different crews. Throughout the entire Umayyad period, walls of either adobe or ashlar stones were built on a footing, which became one of the characteristic elements from the ninth century on. The footing began to disappear with the Almoravids and was utilized only in the first stages of the Almohad period.

The great fortifications were articulated by means of diverse elements that were added as needed. Among these elements were *albarranas*, or towers separate from the principal area but joined to it by an elevated bridge. Very likely they have their origin in the *castella acquae* in Calatrava la Vieja and may well be an original creation of al-Andalus, since their use outside the country is restricted and late.[36]

They could be exterior to the area, as in Mérida (Badajoz), Trujillo (Cáceres) (Fig. 7), or Marbella (Málaga), or interior, as in Gormaz (Soria).[37] In each of these cases, they are primitive and follow a quadrangular plan. This type of plan endured, but an innovation in the twelfth century, during the Almohad period, meant that they were also built according to a polygonal plan, as in the Torre del Oro (Seville), Espantaperros (Badajoz), or the tower of Guzmán el Bueno in Tarifa (Cádiz).

Doors in these fortifications were flanked by towers, generally maintaining a spatial proportion of 1:1:1. Frequently they were supported by a nearby postern, as in Madrid, Toledo, or Trujillo. We know from documents that they could be direct-access doors, as was the case in the Vega tower in Madrid, which has disappeared, and in the towers in Visagra Vieja in Toledo (also from the ninth century) (Fig. 8) and Baños de la Encina (Jaén), from the tenth century. In the late eleventh century they began to be irregular, and asymmetrical doors appeared. The tower might have had a *buhereda*, or small balcony, overhanging the door for defense from above in the case of attack.

In the late eighth century the flanking towers

followed a type of semicircular plan, with a solid wall, clearly of late Roman origin, for example in Condeixa-a-Velha (Portugal), which included a *rastrillo*, or portcullis. Shortly afterward they coexisted with towers following a square floor plan, as in Talavera de la Reina.[38] By the first third of the ninth century, they followed a quadrangular plan, as in the frequently cited Alcazaba of Mérida, a design that would continue to be used until the fall of al-Andalus, except that beginning in the late eleventh century, under the Almoravids, they were also hollow. From the thirteenth century on, under the kings of Granada, towers were made larger and could even be inhabited, as in the Peinador de la Reina (Queen's Dressing Room) in the Alhambra at Granada.

The doorways could also be angled or bent, a device of clear Byzantine origin.[39] That is, access was at a right angle in order to weaken the cavalry attack that would ensue once the threshold had been crossed. This angling could be indicated as one break, two breaks, as a compound of two, or as a partition. The first two seem to be Umayyad, from the mid-ninth century. One break was employed in the Alcazaba at Marbella (Málaga) and two breaks in Calatrava la Vieja (Ciudad Real), in the Puerta de Alcántara in Toledo, and in Talamanca de Jarama (Madrid), where there was a portcullis. The above-mentioned Puerta de Alcántara in Toledo was the precedent for the angled entrances with two breaks that are evident in the Umayyad period. Its variant with two complex breaks, consisting of a passageway through the angled door to an embrasure area and then passage through another door of the same type into the interior was introduced by the Almoravids, who employed it in the Ribat de Fuengirola (Málaga) (Fig. 9);[40] it is a system that was used extensively by the Naṣrids. The partition type presents a wall in front of the door opening and two lateral openings that could be closed or opened as needed; an example is the Almohad door of Santa Eulalia in Murcia.[41] Other doors are even more complex; the Alhambra has numerous examples of these.[42]

Other important elements in fortifications were those related to water. Among them were *corachas*, or sections of an exterior wall that extended inward to provide protected access to water from a nearby river in the event of a siege. Calatrava la Vieja (Ciudad Real) has what may be the oldest known *corachas*,

examples dating from the ninth century; one of them is almost one hundred meters long.[43] The type functioned successfully and continued to be used. Possibly dating from the eleventh century, a more complex variant, which offers many clues as to how such systems operated, is the well-known Puente del Cadí in Granada.[44] But the most beautiful and famous example is the Torre del Oro, a magnificent Almohad work that was intended to control the port of Seville on the Guadalquivir.

Another element, not invariably related to water, is the moat. The first known example following eastern systems is the ninth-century one in Calatrava la Vieja,[45] which turns the great walled complex into an island, with the Guadiana River to the north and the moat that connects with the river to the south. Another early example is the moat to the east in Balaguer (Lérida), dated somewhat later but presumably also from the ninth century.[46] Moats were used

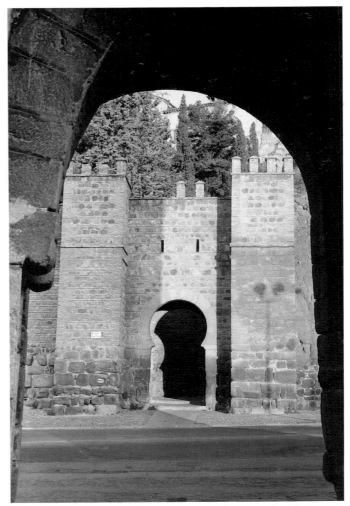

Fig. 8 Toledo, Visagra Vieja, towers of Puerta de Alcántara

Fig. 9 Málaga, Ribat de Fuengirola, passageway

in fortifications would continue to be employed by the Almoravids and Almohads;[50] an outstanding example, which has not yet been published, is the beautiful Almohad *aljibe* with elegant arcatures in the castle of Jimena de la Frontera (Cádiz). The system came to an end with the great examples in the Alhambra.[51]

Briefly, then, we have touched on the characteristics of the world of castles in al-Andalus, castles that were the sources for many innovations in Europe. They were extraordinary in size and concept, especially in the ninth and tenth centuries. Most of them now lie in complete ruins after being used in the nineteenth century as municipal jails or as sanctuaries for Carlists or Liberals during the civil wars of the time. The majority languish in a sad state of deterioration, but they still represent some of the most outstanding examples of the art of fortification. Today they are the real "castles of Spain."

continually from that period on and could be reinforced, sometimes in a very classical manner with leather sacks, as is the case in the Almohad castle in Corbera (Valencia).[47]

The other well-known element, used from about the mid-ninth century, is the *aljibe*, or reservoir, an immense basement dedicated to storing rainwater, both for ordinary needs as well as in cases of siege. Rainwater was collected because it could be stored for long periods of time. The interior of the reservoir was faced with hydraulic lime mortar to waterproof the walls, then covered again in red ocher to seal it completely. A noteworthy example is the *aljibe* in Alcalá la Vieja.[48] At times, especially in the early periods, these were carefully worked constructions. An example is in Trujillo.[49] The system of large *aljibes*

1. Azuár Ruíz 1981; Bazzana et al. 1988.
2. Zozaya 1984a, 1984b.
3. Hernández Giménez 1965.
4. Martín et al. 1990.
5. Cabañero Subiza 1985, 1991.
6. Díez-Coronel i Montull 1963–65; Ewert 1979–80; Giralt 1991; Senac and Esco 1991.
7. Zozaya 1984a.
8. Ibn Hayyan 1974, fols. 268, 269 verso.
9. Asín Palacios 1944; Gaya Nuño 1952.
10. For Mérida, see Hernández 1940; for Huesca, see Esco and Senac 1987.
11. Lekvinadze 1959; Müller-Wiener 1961, 1962.
12. For the castle of El Vacar, see Zozaya 1984a; for Baños, see Ruibal 1985; for Guadalerzas, see Viada Rubio 1987; and for Calatrava la Vieja, see Retuerce Velasco and Lozano García 1986.
13. Dallière-Benelhadj 1983.
14. Larrén 1989.
15. Almagro Gorbea 1976, 1979–81, 1987; Gaya 1932, 1935; Iñiguez Almech 1934; Llull Martínez de Bedoya et al. 1987; Pavón Maldonado 1984; Sánchez Trujillano 1976.
16. Michael 1973, verse 399.
17. Pavón Maldonado 1984.
18. Almagro Gorbea 1979–81.
19. *Historia Silense*, p. 92.
20. Zozaya 1984a.
21. Llull Martínez de Bedoya et al. 1987.
22. Caballero Zoreda and Mateo Sagasta 1988, 1990; Zozaya 1988.
23. *Historia Silense*, p. 91.
24. See Nasr 1964; Albarn et al. 1974; Critchlow 1974; Brentjes 1981.
25. For manuscripts, see Williams 1977 and Mundo and Sánchez Mariana 1976.
26. Numerous authors have written about these castles. For the castle at El Vacar, see Zozaya 1984b; for Mérida, see Hernández 1940; for Trujillo, see Lafuente and Zozaya 1977; for Guadalerzas, see Viada Rubio 1987; for Alora, see Pavón Maldonado 1986; for Toledo, see Delgado Valero 1987; for Bobastro, see Mergelina 1927; for the Castillo Real, see Rosselló Bordoy 1985; for Balaguer, see Ewert 1979–80; for Tarifa, see Terrasse 1932 and Torres Balbás 1957; for Aljafería, see Ewert 1976 and Ewert 1979–80.

27. Madrid 1989.
28. Almagro et al. 1975.
29. Stern 1946.
30. Ewert 1976.
31. Pérès 1953, p. 120.
32. Torres Balbás 1934a.
33. Retuerce Velasco and Zozaya forthcoming; Zozaya and Fernández
 Uriel 1983.
34. Zozaya 1984b.
35. Banks and Zozaya 1984.
36. Retuerce Velasco and Zozaya forthcoming.
37. Banks and Zozaya 1984.
38. Martínez Lillo 1987.
39. Monneret de Villard 1935; Presedo Velo 1964.
40. Román Riechmann 1986.
41. Jorge Aragoneses 1966.
42. Torres Balbás 1960.
43. Retuerce Velasco and Lozano García 1986.
44. Torres Balbás 1934c.
45. Retuerce Velasco and Zozaya forthcoming.
46. Ewert 1979–80.
47. Bazzana et al. 1988.
48. Zozaya and Fernández Uriel 1983.
49. Lafuente and Zozaya 1977.
50. Ribera i Gómez 1986.
51. Bermúdez Pareja 1955.

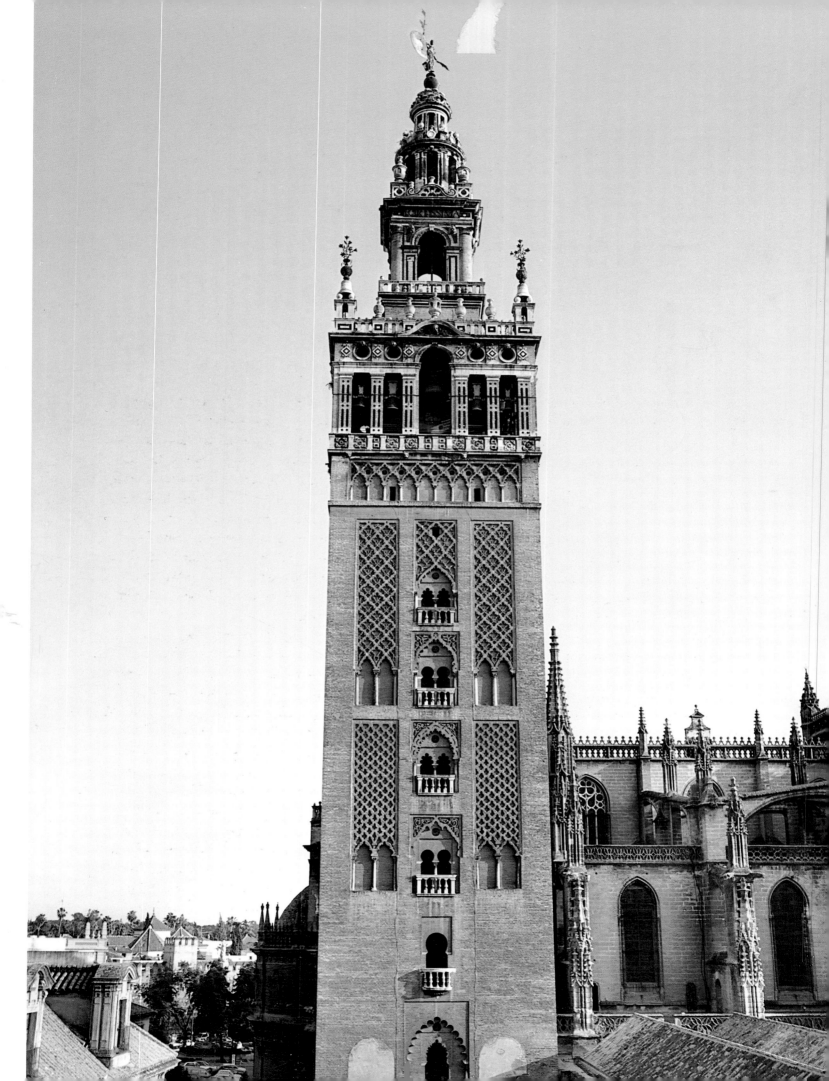

The Almoravids and Almohads
An Introduction

MANUEL CASAMAR PEREZ

The Almoravid Empire

The fall of the caliphate of Córdoba after the war, or *fitna*, that took place between 1010 and 1013 (A.H. 401–4), rekindled old struggles and tribal rivalries, not only among the leaders of the various resulting kingdoms but also among the subjects occupying the regions that constituted the territorial and economic support of the new states. These kingdoms were given the name *Taifa* in combination with the name of the principal city of the territory, and their boundaries generally obeyed geographical, political, and economic determinations. The *Taifa* states were extremely unstable, both because of the disputes and ambitions of the clans to which their dominant monarchs and classes belonged, and because they lacked firm political and social bases. The arrival of the Almoravids in al-Andalus, with their peremptory usurpations at the end of the eleventh century, signaled the end of these states.

The initial motivation for the presence of the Almoravids in al-Andalus was the growing pressure of the expansionist policies of King Alfonso VI, who was skillful in exploiting the quarrels dividing the *Taifa* rulers. When these so-called party kings were no longer able to overlook the Castilian threat and feared their imminent obliteration—with the fall of Toledo, they heard Alfonso pounding at their very doors—they called for help from the powerful warriors from the south who had surged across the Sahara and the Maghrib in an uncontainable wave.

Like many of the *Taifa* rulers, the Almoravids, who dominated North Africa from 1059 to 1147 (A.H.

451–539) and the south of Spain from 1070 to 1146 (A.H. 412–541), were Berbers. They belonged to a movement that, although religious in origin, like others soon became military and political, achieving major conquests under the flag of puritanism. In fact, the appellation *al-Murābiṭūn*, from which the word *Almoravid* derives, refers specifically to the faithful who lived in ribats, or frontier fortresses, and followed a religious-military life, dedicating themselves to holy war. While the existence of such Murābiṭs was nothing new in Islam, in this period the institution of ribats reached its apogee.

The Almoravid empire and its capital, Marrakesh, were founded between 1058 and 1060 (A.H. 450–52) by Yūsuf Ibn Tāshufīn. It was Ibn Tāshufīn whom the *Taifa* rulers summoned and with whom they united to inflict a crushing defeat upon Alfonso VI in 1086 (A.H. 479) in the Battle of Zallaka, in which the king was wounded as well as vanquished. In addition, Alfonso lost all the territory he had conquered along the Tagus, with the exception of Toledo.

Ibn Tāshufīn returned to al-Andalus in 1089 (A.H. 482) to assist in the siege of the castle of Aledo, from which Alfonso's troops were harassing the *Taifa* rulers of Murcia and Almería. Discord among the latter, as well as between the *Taifa* rulers of Seville and Granada, caused the Almoravid emir to abandon the siege and go back to Africa. Ibn Tāshufīn returned to al-Andalus once again, however, in 1090 (A.H. 483), armed with *fatwas*, or theological law, to declare the remaining *Taifa* rulers outside religious teaching and

Seville, La Giralda

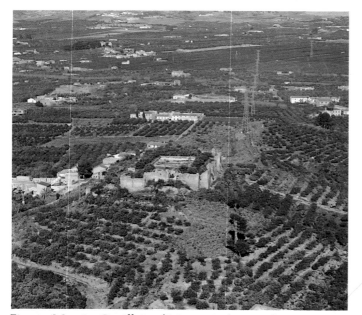

Fig. 1 Murcia, Castillejo of Monteagudo, aerial view

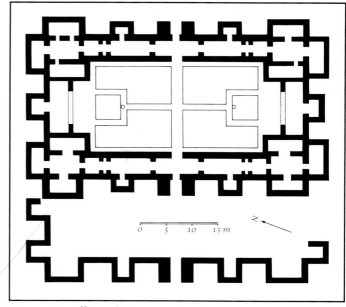

Fig. 2 Castillejo of Monteagudo, plan

to occupy Tarifa, Córdoba, Seville, Almería, Murcia, Játiva, Denia, Badajoz, and Lisbon—all between 1090 and 1094 (A.H. 483–87).

In Valencia the Cid had come to power, and during his lifetime he succeeded in resisting the Almoravids and in establishing a balance of power by uniting Muslims and Christians. The Cid, as well as the *Taifa* rulers of Saragossa and Albarracín, and the Catalans and Aragonese, halted the Almoravid reconquest long enough for Aragon in particular to prepare bases for future battles.

Before he died in 1106 (A.H. 500), Ibn Tāshufīn named his son ʿAlī ibn Yūsuf governor of al-Andalus and designated him as his successor with a seat in Córdoba. In 1115 (A.H. 509) Ibn Yūsuf conquered the Balearic Islands, which, under the Banū Ghāniya, had been independent of Denia since 1076 (A.H. 469), but the kingdom of Saragossa did not submit to him until 1111 (A.H. 505). He ruled Saragossa for only a brief period, however, for in 1118 (A.H. 512), only three years before the Almohads began a war against the Almoravids, Alfonso I, called the Battler (r. 1104–34 [A.H. 498–529]), retook the city, this time definitively. In 1125 and 1126 (A.H. 519 and 520) Alfonso marched through part of al-Andalus, passing through Valencia, Alcira, Játiva, Denia, Murcia, Baza, Granada, Motril, Málaga, Lucena, Córdoba, Alcaraz, Cuenca, and Albarracín. In 1134 (A.H. 529), however, the Almoravids dealt Alfonso a grave defeat in Fraga.

Almoravid Art

In the Almoravid Maghrib and al-Andalus, the first third of the twelfth century marked a brilliant renaissance in Islamic letters, culture, and arts. Córdoba enjoyed a new splendor, continuing the tradition of learning of the caliphate and the *Taifa* kingdoms. Ibn Quzmān is one of the most representative figures of that moment; his collection of poems—of exceptional value in understanding his society—was made famous by the modern-day controversy it provoked over the Arabic origins of European troubadour poetry and by the immense impression it left on Spanish lyric poetry.

A school that would prove long-lived was created in the Maghrib, where artists from al-Andalus contributed to the decoration of Almoravid buildings. Three notable examples of the work of this school are the facade of the mihrab of the largest mosque in Tlemcen, the Qubbat al-Bārudiyyīn in Marrakesh, and Ibn Tāshufīn's 1135 (A.H. 530) addition to the Qarawiyyīn mosque in Fez. The interwoven arches of the latter derive from those in the *maqṣūra* of al-Ḥakam II in the Great Mosque of Córdoba, as do its vaults. However, the columns traditional in al-Andalus are here replaced by brick piers that provide neither the visibility nor the economy of space afforded by columns.

On the peninsula, the finest example of Almoravid architecture is the rural villa of the Castillejo, located at the foot of the castle of Monteagudo on the Murcian

plain (Fig. 1). Only the plan (Fig. 2) and a smattering of decoration have survived, both of which are highly interesting. The Castillejo was an elegant rectangular residence surrounded by a wall punctuated with square towers. The perimeter of the villa itself, reached through one of the outer wall's long sides, was also defined by square towers. Corridors along the long sides of the villa led to rooms at its corners; each of these rooms had alcoves at its rear and sides. At each of the short ends of the residence, a small room with its own alcove opened to the court, completing this very impressive composition. The court contained a garden with intersecting paths and two small pools at the ends of the longitudinal spans. The decorative traces that have survived are socles with red geometric scrolls painted on white plaster and very beautiful plasterwork with single and double digitate palm leaves arched above slender, twisted trunks. In the decorative elements at the Castillejo, which was the precursor of other palaces and gardens in Seville, Granada, and the Maghrib, we see new developments alongside Cordobán features that continue to evolve.

In Almoravid art the Cordobán tendency toward the baroque, which had been accentuated during the period of the *Taifa* states, diminishes slightly in favor of an emphasis on linear values, so that a greater harmony between volume and decoration is created.

The Almohad Empire

Ibn Yūsuf's last years were clouded by the growing power of the Almohads. Like the Almoravids, the Almohads were Berbers, but they belonged to an enemy tribe originating in the Atlas Mountains. Inspired by their religious and political leader Ibn Tūmart (1089–1128 [A.H. 482–522]), and swayed by his rigorous ideas and practices, the Almohads declared the Almoravids infidels and, under a banner of puritanism similar to that raised by the Almoravids for their own conquests, waged a holy war against them in 1121 (A.H. 515). The Almohads established their capital in Tinmal and made their first attempt to take Marrakesh. Ibn Tūmart spent his last years in study and prayer in Tinmal, where he died and was buried. ʿAbd al-Muʾmin (1094–1163 [A.H. 487–559]), Ibn Tūmart's former lieutenant, was then proclaimed caliph. By 1147 (A.H. 542) he had taken Oran, Tlemcen, Fez, Aghmat, Tangier, Seville, and Marrakesh, conquests that marked the end of the Almoravid

empire. In al-Andalus the decline of the Almoravids prompted an uprising of the inhabitants in 1143–44 (A.H. 538–39). The next thirty years, from 1143 to 1172 (A.H. 538–68), constituted a late *Taifa* period—an interval characterized by a succession of factions and struggles for independence during which cities were passed from hand to hand.

The position of the Almohads in al-Andalus was consolidated under Abū Yaʿqūb Yūsuf (1139–1184 [A.H. 534–580]), who succeeded his father, ʿAbd al-Muʾmin, in 1163 (A.H. 558). Yūsuf had already served a long term in Seville as governor, surrounded by scholars and literati, and once he was caliph, he returned to that city as often as he was able. He died during a siege of Santarem and was buried in Tinmal. His successor—and son—Abū Yūsuf Yaʿqūb (r. 1184–99 [A.H. 580–96]) was proclaimed caliph in Seville. He defeated Alfonso VIII at Alarcos in 1195 (A.H. 592) and eventually commanded the basin of the Tagus, laying siege to Toledo, Madrid, Alcalá, and Guadalajara. His son, Abū ʿAbdallah Muḥammad (1181–1213 [A.H. 577–610]), conquered the Balearic Islands in 1202 (A.H. 599) but was in turn defeated at Las Navas de Tolosa in 1212 (A.H. 609). That battle was a reverse from which the Almohads would not recover. ʿAbdallah Muḥammad's successors governed only briefly, during which time the Marīnids were gaining control of the empire. In 1269 (A.H. 668), the Marīnids entered the capital of Marrakesh, ending the Almohad dynasty.

On the peninsula, this was a time of reconquests and uprisings, of the establishment of the Naṣrid kingdom in Granada in 1238 (A.H. 636) as a vassal of Castile, and of the loss of Almohad Seville in 1248 (A.H. 646) to the Castilian king Ferdinand III.

Almohad Art

The Almohads were active builders of religious, civilian, and military structures in al-Andalus and in the Maghrib. While Córdoba maintained its prestige as the city of learning, Seville became the center of power when chosen by the second ruler of the dynasty, Abū Yaʿqūb Yūsuf, as the peninsular residence of the Almohad caliphs. Abū Yaʿqūb Yūsuf constructed the most important mosque of his caliphate in that city, an edifice about which we have considerable information. The mosque, begun in 1172 (A.H. 568), was finished in 1176 (A.H. 572), although some authorities give a later date for its completion. Because

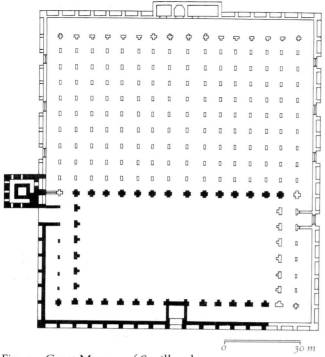

Fig. 3 Great Mosque of Seville, plan

of political complications, it was not until ten years later that the first khutba, or sermon, was given in it. The mosque was built in the form of an enormous rectangle, nearly coincident with the outlines of the cathedral measuring 150 by 100 meters that today replaces it. A prayer hall featuring seventeen naves opened onto the court through thirteen doors; the two outermost naves on each side continued to the transverse, which closed the court to the north (Fig. 3). To the south, in front of the qibla wall, was another transverse nave, with a cupola at each end, that terminated the aisles of the naves of the hall. Before the mihrab three additional cupolas with skylights signaled, as in the Great Mosque of Córdoba, this most important spot in the oratory. (We can see a replica of those cupolas in the one covering the Capilla Real in Córdoba [Fig. 4].) The mosque was constructed of plastered and whitewashed brick, and its ceiling, supported on piers and pointed horseshoe arches, was embellished with carved plaster. On the exterior the

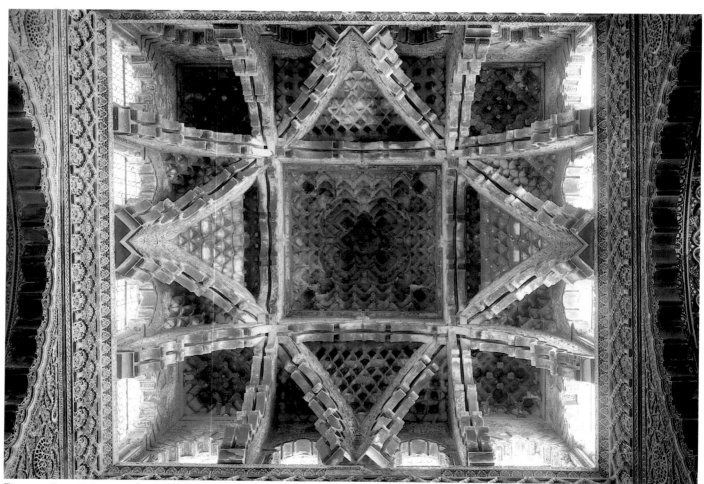

Fig. 4 Great Mosque of Córdoba, Capilla Real, cupola

building gave the appearance of a smooth wall interrupted by square buttresses, which were placed according to the module that marked the width of the naves and aisles and which, again as in Córdoba, had crenellated tops (Fig. 5). The axis of the mihrab is still indicated by the Puerta del Perdón (Gate of Pardon), which, like the doors of the gate at the Qarawiyyīn mosque in Fez, is ornamented with bronze plates in a knot design. The large door knockers, a typical element of Hispanic art, are without rival (Fig. 6). Their decoration of double-palms recalls classical compositions.

On the east, marking the division between court and prayer hall, rises the minaret, which was once topped by four famous gilded spheres. Today known as La Giralda, this structure is directly indebted to the Kutubiyya minaret in Marrakesh, the Ḥassān minaret in Rabat, and through them to the minaret in Córdoba, on which the others were modeled. In its elegance of proportion and variety within apparently uniform decoration, La Giralda is one of the glories of Islamic art. It is composed of two rectangular units, one upon the other; the larger measures 50.51 by 13.61 meters and the smaller 14.39 by 6.83 meters. Within this structure is a nucleus of similar proportions containing seven rooms, one above the other, with groined vaults. The access to the tower, a ramp with intermittent horizontal sections, rises between this nucleus and the outer wall. As in Córdoba, the minaret was crowned with crenellations that were lost in later alterations. The tiled dome and the *yamur*, or minaret finial, built to commemorate the victory of Alarcos also disappeared in renovations.

A major portion of the minaret's exterior decoration (Fig. 7) has been conserved. Upon a large, smooth foundation of stone and brick, barely broken by windows lighting the interior ramp, rise three vertical rows divided by a transom into two distinct sections, one atop the other. The outer rows of each section feature double arches, whose lobes continue upward, interweaving and forming a network of carved brick,

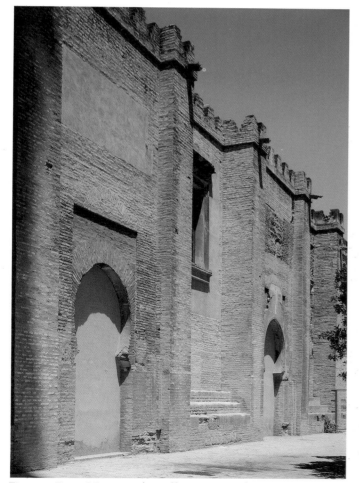

Fig. 5 Great Mosque of Seville, exterior elevation

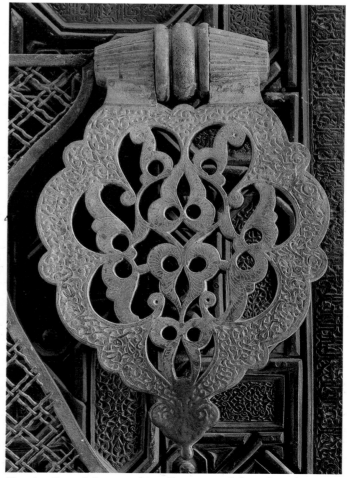

Fig. 6 Great Mosque of Seville, Puerta del Perdón, door knocker

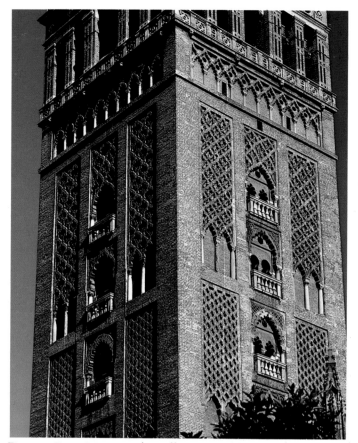

Fig. 7 Great Mosque of Seville, La Giralda, detail

different in each section, against the smooth background. In the central rows, twin lobed arches, today sheltered behind balconies, are framed by blind polylobed arches. The sides of each arch meet at a central oculus. The space above the arches is filled with ornamental plasterwork. The twin arches rest on columns with marble capitals, which were reclaimed from caliphal-period examples. The decoration of the lateral zones is divided into registers of disparate heights determined by the height of the arches themselves, which are disposed according to need for lighting the interior ramp. In this way the monotony of equal, repetitive panels is avoided. Above this sexpartite composition is an arcade of blind arches on columns and capitals. The treatment is descended from the minaret of Córdoba, but here the arches are lobed and interwoven with felicitous results that would become indispensable in minarets, towers, and facades to follow.

For the comfort and protection of the caliph, who visited through a passageway, the mosque was constructed beside the Alcazar, which always served Se-

ville's governors as their residence. Renovations and additions made by the Almohads are still visible in that complex monument. The best-known addition is the Patio del Yeso (Court with Plaster Carving) (Fig. 8). One of its facades is composed of an arcade consisting of a large arch flanked by smaller triple arches; all are pointed and have the typical Almohad lobed profile. The central arch rests on brick piers, and the triple arches on tenth-century columns and capitals. The lobes of the lateral arches, formed by interwoven palms, are prolonged and reticulated until they reach the height of the central arch; the spandrels of the latter are faced with similar, although blind, ornamentation. Such networks of interwoven arches, characteristic of Almohad architecture, are called *sebka*, like the lacework in the luxury arts, and would be adopted by Naṣrids, Mudejars, and Moroccans.

Another Almohad court was discovered when the old Casa de Contratación (House of Trade) was demolished, revealing a large garden-court with intersecting elevated paths aligned along the transverse axes (Fig. 7, p. 168). These paths delimit four sunken plots filled to the height of the paths with flowers and small shrubs composed to resemble beautiful rugs. The gardens were framed by painted and stuccoed brick arcades. Irrigation channels ran down the center of the raised paths and formed a circular pool where they crossed in the middle of the court. Along the shorter sides of the court were porticoes with a central arch and tripartite openings similar to those in the Patio del Yeso.

The wall of the Alcazar extended to the river, and at that juncture stood a large defensive construction, called the Torre del Oro (Golden Tower) (Fig. 9). This single tower was erected with a fourfold purpose: to cut off movement along the riverbank, to defend the river port by means of a recently constructed pontoon bridge and a small fort on the right bank, to cut off access by river, and to ensure communication with the west. The tower is twelve-sided; within it a hexagonal space houses stairs that offer access to a terrace and an element with three stories, which again is twelve-sided. Both the tower and the three-storied element are crenellated. Each of the three hexagonal stories is covered by, alternately, triangular and square arris vaults. The upper structure offers an innovation: The spandrels of the blind arches on the facades are faced with green-and-white glazed ceramic plaques forming rhombuses. This is a device that will be more

frequently and more widely employed. Other tiles, which appear to be gilded, covered the tower, giving it its name.

Abū Yaʿqūb Yūsuf ordered other constructions in Seville, such as the now-lost suburban palace of the Buhayra, so called to allude to its large well-irrigated garden (*al-buhayra* means "lake"). For the garden, called the Huerta del Rey (King's Orchard), Abū Yaʿqūb Yūsuf converted a preexisting Roman aqueduct into what is known today as Los Caños de Carmona (Carmona Water Pipes) (Fig. 10). Recent, still uncompleted excavations have revealed water pipes, a large reservoir, and indications of the layout of the palace that stood there. Chroniclers of the time wrote in detail of the palace's construction and of its gardens and orchards, which although not equal to those of Mādinat al-Zahrāʾ, were nevertheless praised by the ambassador from La Serenissima, the Republic of Venice, Andrea Navaggiero, at the time of the marriage of Charles V in 1526.

In Abū Yaʿqūb Yūsuf's epoch major portions of the fortifications of Seville were repaired, as were those in Cáceres and Badajoz. The Almohad section of the Alcazaba of Badajoz, built from 1169 to 1170 (A.H. 565–66), has survived nearly intact. The main entrance is through the Puerta del Capitel, a gate whose name derives from the large Roman capital that tops a marble pilaster embedded in a prominent spot in its facade, as if to symbolize the power of its builders. The entry to the Alcazaba was constructed with a dog-leg angle and a patio and was defended by a tower and a stretch of wall, as well as, one presumes, by a barbican.

There are many major Almohad monuments in Marrakesh, the most outstanding of which is the great Kutubiyya mosque (see Frontis., p. 84). It was constructed by the first Almohad sultan, ʿAbd al-Muʾmin, from 1146 to 1162 (A.H. 541–58), and underwent a second building phase that ended in 1196 or 1197 (A.H. 593 or 594). ʿAbd al-Muʾmin summoned craftsmen to

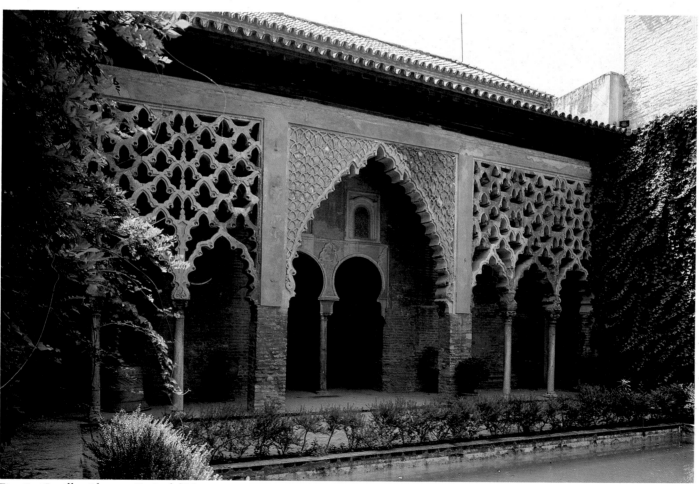

Fig. 8 Seville, Alcazar, Patio del Yeso

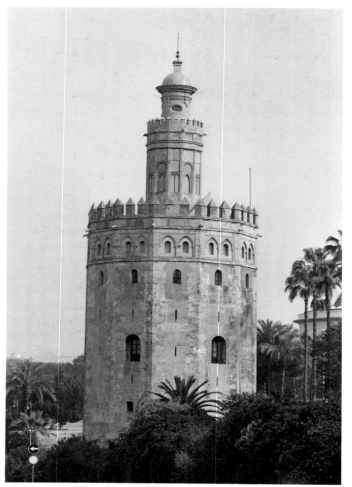

Fig. 9 Seville, Torre del Oro

maintained, as was logical and necessary for use, especially on Fridays.

Kutubiyya's elevation is significantly different from that at Córdoba. Here there are no columns—it was very expensive to make new ones, as al-Manṣūr had done—but, rather, brick piers; nor are there superimposed arches. To achieve height, the exaggerated semicircular arches of Córdoba here became sharply pointed horseshoe arches. This allowed a considerably higher ceiling, which, as always, was flat. The minaret at Kutubiyya conserves the general line and composition of that in Córdoba, although with less decorum and beauty. The stairways of Córdoba were replaced here by ramps, and the ceramic decoration begins with a frieze of glazed tiles between the series of interwoven arches and the crenellation.

Almohad decoration advances the Almoravid style. It is increasingly hierarchical, becoming simpler and more rigorous, with more empty space and uncomplicated floral forms. Plaster continues to be the most common material for ornamentation. With it, columns were joined to piers and half columns to new capitals. There, acanthuses could be linked to form sinuous ribbons, on the one hand, while, on the other, everything else could be simplified and converted into austere double palms; sometimes pinecones appear, or a fine fillet among the leaves. The Marīnid and Naṣrid capitals would not add significantly to this type. In the cupolas, *muqarnas*, or stalactite ornamentation, reigned, as it would later on in Marīnid and Naṣrid monuments.

In Rabat, the great Ḥassān mosque, begun in 1195–96 (A.H. 592–93), was never completed because of its extraordinary size. It is the second-largest mosque in Islam, measuring 180 by 140 meters, and its twenty-one naves with twenty-five or twenty-six aisles open onto three courtyards. Before the mihrab and the qibla was a triple transverse nave, apparently without cupolas. The minaret is on the axis, also marked by a wider nave cut by the three transverse naves. As in Marrakesh, each face of the mosque has a different decoration. On each of the several stories, the windows of which are sheltered beneath lobed arches of differing design, unique unfinished *sebka* panels spring from triple arches. The composition is clearer and more harmonious than in Marrakesh and marks yet one more step toward the perfection of the minaret of Seville.

his service and was not disappointed. Although the influence of the Great Mosque of Córdoba is patent in Kutubiyya, there are more than a few innovations in plan, elevation, and decoration. A nave—this one wider than that in Córdoba—still marks the axis toward the mihrab, which, like the one in Córdoba, was preceded by a cupola. Here, however, the contiguous rooms of the Great Mosque are replaced by two naves on either side, wider than their caliphal precedents, as dictated by the cupolas in which they terminate. This model was repeated, with corresponding cupolas, at the extremes of the prayer hall. The width of the nave determined by the five cupolas also affected the courtyard, which was reduced in width as the four outer naves were prolonged and the number of aisles reduced. The minaret was neither on the building's axis nor positioned at the entrance, but was displaced toward the east corner—a device that would be repeated in Seville, although there the building would be outside the wall. The side entrances were

The al-Ruwaḥ and Oudaia gates in Rabat and the Agna gate in Marrakesh are considered to be among the most handsome monuments in the Islamic west. These magnificent gates stand between towers and are manifestations of the power of the Almohad empire. They are outstanding in their majesty of proportion and in the beauty of their carved stone, which is usually executed on two planes. These gates follow the overall design of the mihrab of al-Ḥakam II in the Great Mosque of Córdoba—an exaggerated semicircular arch framed within an *alfiz*—but they vary in their details.

The Decorative Arts
Outstanding among the few examples of Almoravid and Almohad furniture that remain is the pulpit of the Kutubiyya mosque in Marrakesh (No. 115). This minbar is considered by some to be the finest piece of furniture in Islamic art, and it is through it that we know the state of cabinetry and marquetry in al-Andalus. While the minbars of Córdoba and Seville were famous and acclaimed, they no longer exist, and we must turn to the Kutubiyya example as evidence of their beauty. If the composition of the Kutubiyya minbar is less than perfect, its manufacture is exemplary: The beauty of the woods, the exquisite carving, and the polychrome marquetry all justify the praise for works now lost. Another outstanding example of the decorative arts is the banner of Las Navas de Tolosa (No. 92), a tapestry of silk with gold thread housed in the Monasterio de Santa María la Real de Huelgas in Burgos. Among manuscripts, there is a little-known series of small Qurʾans in parchment, attributable to a Valencian workshop active at the end of the twelfth and beginning of the thirteenth century. Their beautiful illuminations make these books small jewels. And again, if one may be forgiven the repetition, the large door knockers on the Puerta del Perdón in Seville are unique. Those on the Qarawiyyīn mosque in Fez and, even more clearly, the Mudejar imitations in the mosque of Córdoba cannot compare to them.

In both architecture and decorative arts, the Almoravids and Almohads brought a new dignity and restraint to the arts of al-Andalus, while drawing them into the orbit of North Africa.

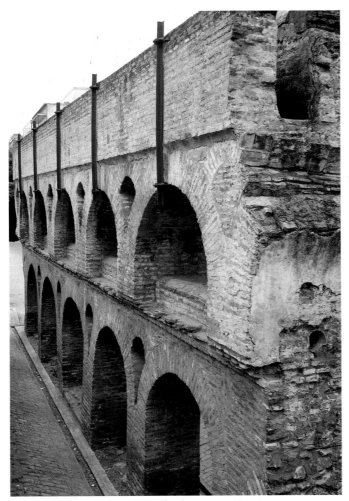

Fig. 10 Seville, Los Caños de Carmona

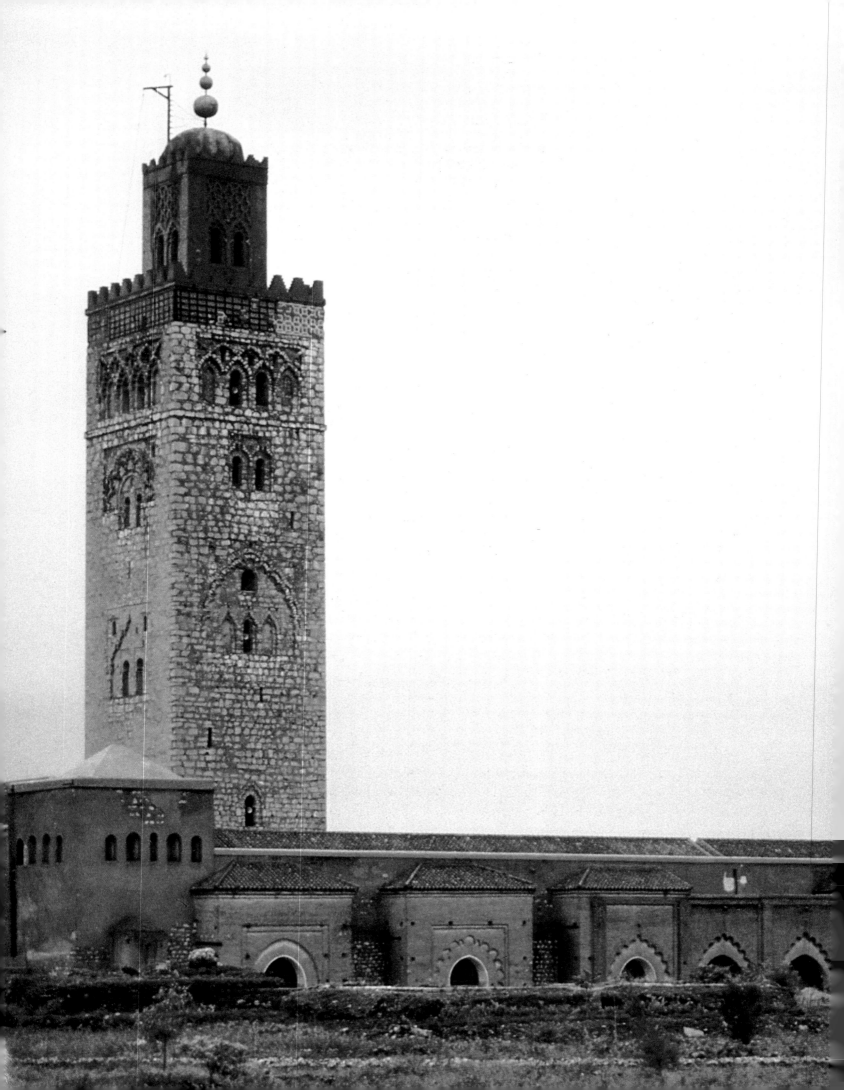

The Architectural Heritage of Islamic Spain in North Africa

CHRISTIAN EWERT

Even after the fall of the Cordobán caliphate in 1031 (A.H. 422) and the later transfer of the political fulcrum south into Morocco, Islamic Spain, though dwindling under the blows of the Christian reconquest, remained dominant in the artistic sphere. The political unification brought about by the Almoravids and Almohads favored the dissemination of the western Umayyad inheritance.

The Almoravids

The Almoravids were of Berber origin, as were their conquerors, the Almohads. In 1060 (A.H. 452) they founded Marrakesh in the south of Morocco, at the foot of the Atlas Mountains, and the city remained a metropolis under the Almohads as well. Called in at the close of the eleventh century to help the *mulūk al-Ṭawāʾif* withstand the pressure of the reconquest, the Almoravids ended by crushing those helpless petty kingdoms. They then united a considerable part of the Maghrib and al-Andalus. In this way, the Maghrib, before the end of the eleventh century, was laid wide open to influences from Islamic Spain that were still deeply impregnated with the artistic heritage of the Umayyads. Spanish artists, perhaps whole workshops, went as far as southern Morocco. Marrakesh became a center of Andalusian art. The Islamic far west was an artistic as well as a political unit, and here was elaborated the repertoire from which in the mid-twelfth century the puristic Almohads filtered the essential elements of their use of forms. This transition can be understood best in mosque architecture.

The mosque with aisles perpendicular to the qibla had found acceptance in the leading monuments of western Islam as a hall of columns. Examples include the Great Mosque of Córdoba, begun about 785 (A.H. 169) and the Aghlabid rebuilding of the Great Mosque of Kairouan from 836 (A.H. 222). As the easily obtainable supplies of classical stone spoils became exhausted, the pillared hall now penetrated into the Maghribī mosque with brick architecture. Ṭūlūnid and Fāṭimid Cairo (the mosque of Ibn Tūlūn, built between 876 and 879 [A.H. 263–66]; the mosque of al-Ḥākim, founded in 990 [A.H. 380]), served as the transmitter between the ʿAbbāsid east (for example, the Abū Dulaf mosque in Samarra of about 860 [A.H. 246]) and the Maghrib. However, the overheavy ʿAbbāsid pillar profile, perhaps deriving from a continuance of ancient oriental tradition, was considerably reduced in the Maghrib, providing a formula for the almost standard dimensions of the Almohad workshops.

The Great Mosque in Algiers, built about 1097 (A.H. 491),[1] gives the clearest illustration of how the Almoravid prayer hall leads from the Umayyad tradition to the Almohad mosque (Figs. 1, 2). The narrow court, the T-type of oratory, the profiles of the pillars, and the arches of the arcades and their hierarchic distribution point toward the Almohads. But the hegemony and inertia of the Umayyad elements show astonishingly strongly here: not the purified stage of the T-type found in the Great Mosque of Kairouan but the type of the extension of al-Ḥakam II in the Great Mosque of Córdoba, with interpenetrating longitudinal and transverse arcades, persisting probably in the tradition of

Marrakesh, Kutubiyya mosque

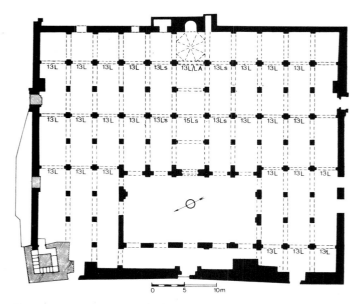

Fig. 1 Great Mosque of Algiers, plan

the al-Aqṣā mosque of Jerusalem, was adopted. In comparison with the Almohad type, which represents the classical stage of the west Islamic prayer hall, the articulation in the qibla area in Algiers is indecisive in effect. Not only do the arcades of all ten side aisles of the eleven-aisled hall run right through to the qibla, but their separate roofs do as well. The compartments of the transept do not stand out as pyramids as they do in Córdoba.

This unusually strong longitudinal movement is countered by four transverse arcades. These make the transept along the qibla appear in the ground plan (Fig. 1) of the whole layout as merely the outermost narrow band of a rhythmic compartmentalization in depth. However, it is distinguished from its counter-part, the northwest *riwāq*, by the greater depth of the single bay. The nave is stressed by its greater width and by its fragmentation into single cells a bay in depth, that is, by the densest possible gradation in depth of an alignment of arches. Its width is transmitted to the qibla transept. An approximately square compartment in front of the mihrab was to result from the interpenetration of nave and transept; here, too, a T-type is realized.

The distribution of the arch types (Fig. 1) antici-pates the Almohads much more strongly: pointed horseshoe arches in the longitudinal arcades and around the court, and distinctive, more fragmented, lobed

arches in the transverse arcades of the interior (Fig. 2), which are further enriched in the area of the three central aisles and most strongly in the central nave. A principle first observed in the mosque at the Bāb al-Mardūm in Toledo, built from 999 to 1000 (A.H. 391),[2] is here expanded and even more nuanced. In the side aisles the optical flow to the qibla is once more supported by congruent arches, but the distances between the transverse arcades are narrowed toward the qibla (Fig. 1), and the "wavelength" of the flow is abbreviated and reaches the density of the central nave only in the final bay in front of the qibla, in the transept. This mannerist refinement of the Umayyad legacy had no future in the purified prayer hall of the Almohads.

The other two most important new Almoravid buildings to be preserved, the Great Mosque of Tlemcen, completed about 1136 (A.H. 531), and the considerably smaller construction in Nedroma (also in western Al-geria), are typologically reduced. There is no transept along the qibla; only a compartment in front of the mihrab is developed.[3] It is true that the Qarawiyyīn mosque in Fez was extended and embellished, but there was no attempt to alter the original scheme of the ninth-century mosque; this solution was probably influenced by the Umayyad mosque in Damascus—a transverse-aisled prayer hall with a perpendicular central nave cutting through it.[4] Only outbuildings remain of the Almoravid Great Mosque in Marra-kesh, the most important being the central *qubba* of the ablution complex, an outstanding example of Almoravid decoration (Qubba of ʿAlī ibn Yūsuf; also called Qubbat al-Barūdiyyīn).[5]

The Almohads

The Almohads took over the artistic as well as the polit-ical inheritance of the Almoravids in the mid-twelfth century, but they stamped the art, especially mosque architecture, with the mark of their role as religious reformers. They clarified the types of buildings and disciplined the exuberance of the decorators, who were still predominantly from al-Andalus or Hispano-Muslim-trained workshops. The pacifying power of the Almohad caliphate fused the outer Maghrib and al-Andalus into a totally unified artistic sphere. The two political centers, Marrakesh and Seville, became the two main centers of artistic life as well.

*The Characteristics of the Classical **T***-*Type in Mosque Architecture*

Two works of the metropolitan artistic circle of Marrakesh resume all the characteristics of the classical Almohad type: the double structure of the Kutubiyya mosque (Figs. 9–11), which was erected in two stages (the first building phase, directly after the occupation of the city, 1147 [A.H. 542]; the second phase, an almost exact repetition of the initial building scheme, set against it at a slight angle, probably already finished in 1158 [A.H. 553],[6] although opinions about these dates differ) (ground plan: Fig. 9); and the mosque built in honor of Ibn Tūmart, the founder of the Almohad movement, at the site of his activities and of his death, the Atlas village of Tinmal (about one hundred kilometers south of Marrakesh), commissioned in 1153–54 (A.H. 548–49) (Figs. 3–8). The much smaller up-country construction site (Tinmal halves the type of the Kutubiyya: nine instead of seventeen aisles in the qibla *riwāq*; two instead of four aisles in each side *riwāq*) was evidently entrusted to an elite of master craftsmen from the ruler's workshop in the capital (ground plan: Fig. 3; ruin: Fig. 4; reconstruction model: Fig. 5).

The longitudinal aisled, pillared mosque that developed under the Almoravids (for example, the Great Mosque of Algiers: Fig. 1) was clarified and enriched, particularly in the area of the qibla: the longitudinal arcades of the standard side aisles end at the transversal arcade in front of the qibla (Fig. 3: A–K,1) as they already do in the Aghlabid rebuilding of the Great Mosque of Kairouan. A wider central nave and qibla transept give rise to the familiar T-form in the ground plan characteristic of Kairouan, Córdoba, and Algiers. In the prolongation of the nave and the outermost of each group of four side aisles are compartments vaulted with *muqarnaṣ* (stalactite) domes (Fig. 8) to stress the qibla transept.

In the elevation, the hierarchy of arches[7] for which the Almoravids had provided the prototype (Fig. 2) was perfected: for the normal aisle arcades, pointed horseshoe arches (Fig. 10); around the domed

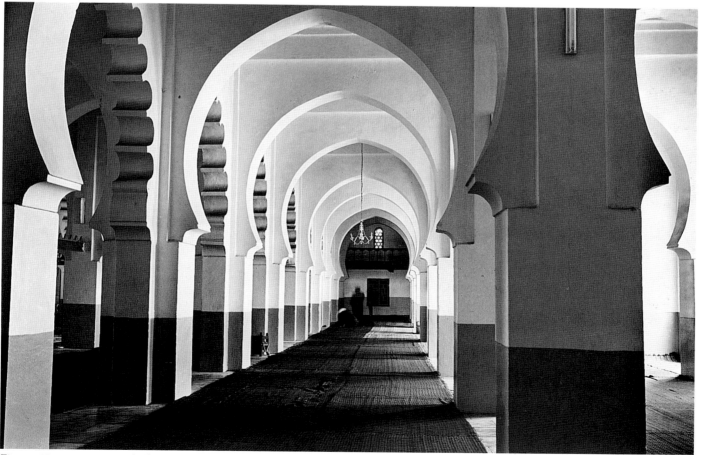

Fig. 2 Great Mosque of Algiers, prayer hall, transverse view

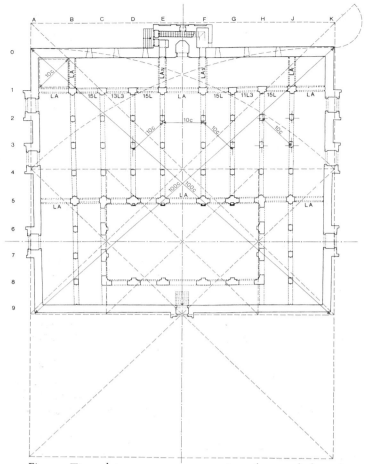

Fig. 3 Tinmal, mosque, reconstruction of ground plan with geometric scheme

compartments, lambrequin or *muqarnaṣ* arches (Fig. 11); in the intermediary bays at the transverse arcade along the qibla, lobed arches, while the lobes in the central bays of the two oblong compartments between the dome fronting the mihrab and the corner domes are, uniquely to Tinmal, again broken up into trefoils (Fig. 6; Fig. 7: background).

The new Great Mosque of Seville, built between 1172 and 1198 (A. H. 568–95), now replaced by the cathedral, repeated the type of large mosque like the Kutubiyya in Marrakesh, with seventeen aisles.[8] Its famous minaret, La Giralda, converted into a bell tower, is largely preserved. It is closely related to the two other great Almohad minarets, both in Morocco: the second Kutubiyya mosque in Marrakesh and the Ḥassān mosque in Rabat (Fig. 16).

*The Enrichment of the **T**-Type: The Motif of the Three-Sided Ambulatory in the Mosque of Tinmal*
In Tinmal the qibla transept is extended to become a three-armed walk down the whole depth of the mosque on either side. It surrounds the prayer hall: The outer aisles repeat exactly the width of the transept. In the elevation, lambrequin arches stress the unity of this ambulatory. They are reserved solely for it, apart from

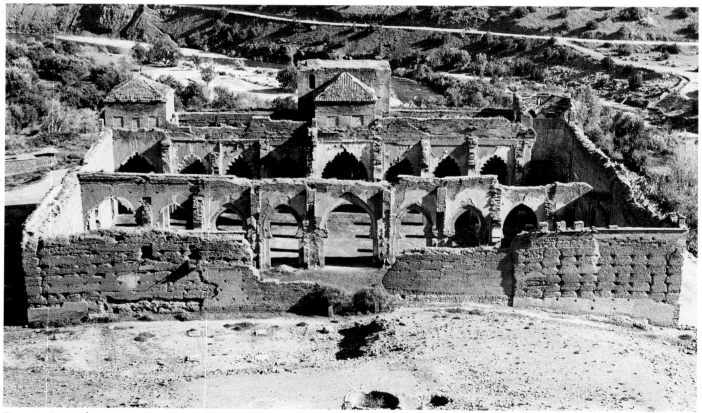

Fig. 4 Tinmal, mosque, ruin, view from north

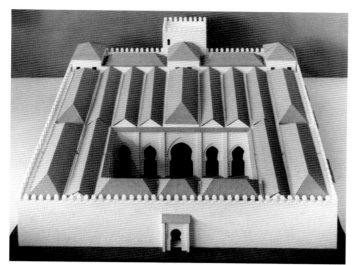

Fig. 5 Tinmal, mosque, reconstruction model by J. P. Wisshak

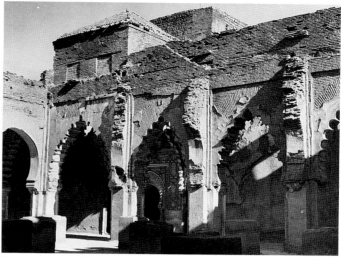

Fig. 6 Tinmal, mosque, transverse arcade in front of south (qibla) wall

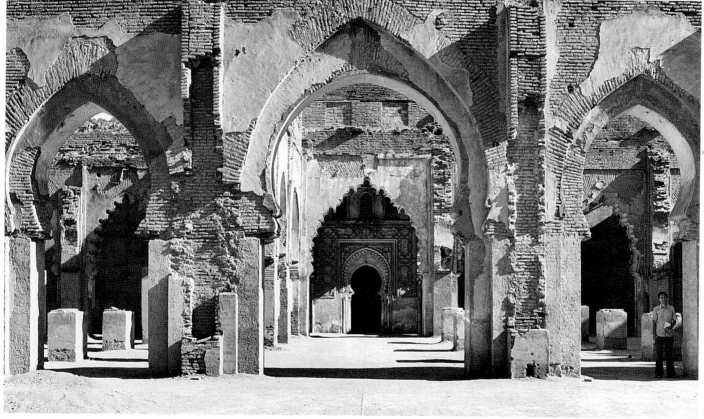

Fig. 7 Tinmal, mosque, view from court toward mihrab

a blind projection at the start of the central nave.[9] It seems likely that a smaller three-legged squared U-motif was planned to interlock with the larger one. In fact, the typically profiled corner piers had been laid out (Fig. 3:c8, H8), and we were able to prove by excavation that they were original, but the third arm of the figure, the north *riwāq* (Fig. 3:c8–H8), was evidently never built.[10]

A three-sided screening motif enclosing a core space is anticipated in the Islamic west in the principal buildings of the Umayyad caliphate.[11] We shall here restrict ourselves to the example of the two multiaisled halls in Madīnat al-Zahrā'. They show an identical basic structure of ground plan that is comparable with that of the western type of prayer hall we are now discussing. The almost square three-aisled core with a

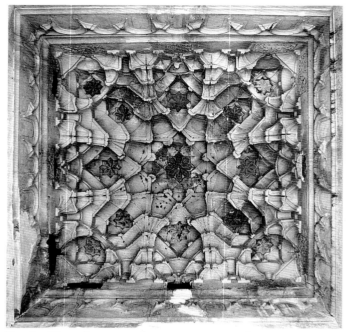

Fig. 8 Tinmal, mosque, eastern *muqarnas* dome

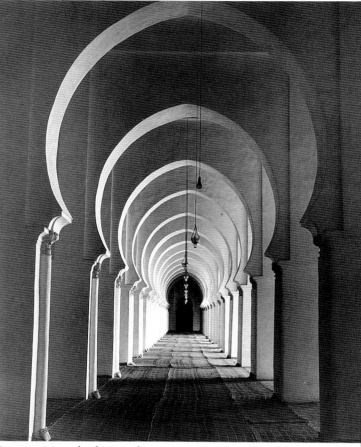

Fig. 10 Marrakesh, Kutubiyya mosque, second building phase, transverse view with normal pointed horseshoe arches

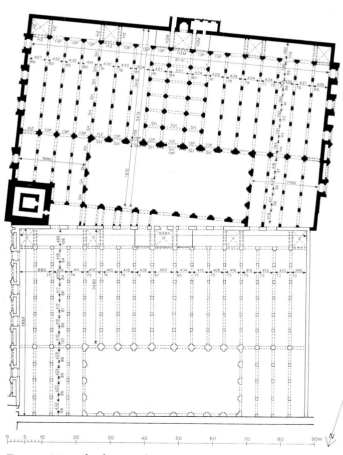

Fig. 9 Marrakesh, Kutubiyya mosque, plan

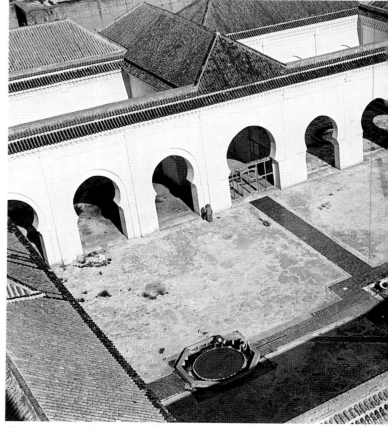

Fig. 13 Marrakesh, Qaṣba mosque, main court seen from minaret

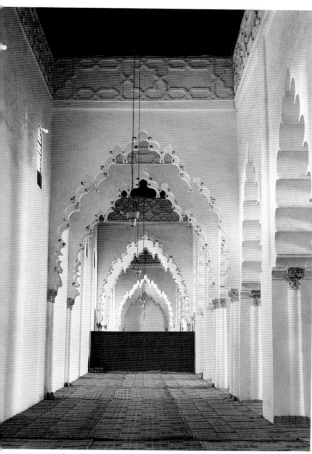

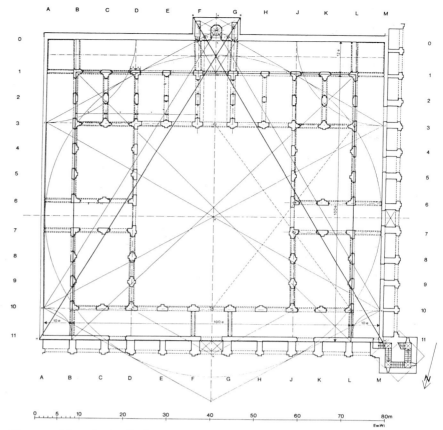

11 Marrakesh, Kutubiyya mosque, second building e, qibla transept

Fig. 12 Marrakesh, Qasba mosque, reconstruction of Almohad plan with geometric scheme

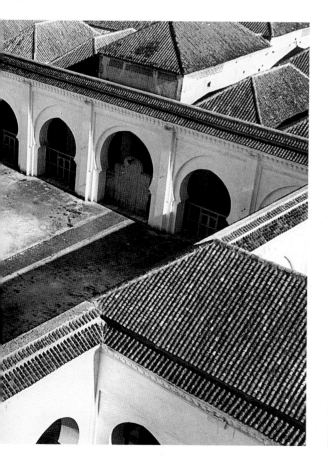

Fig. 14 Marrakesh, Qasba mosque, transverse view from northwestern court

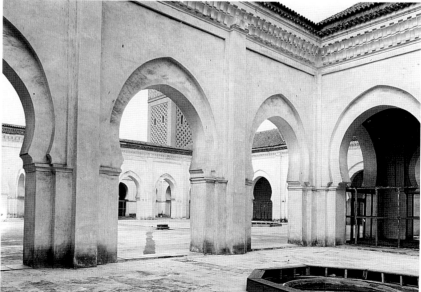

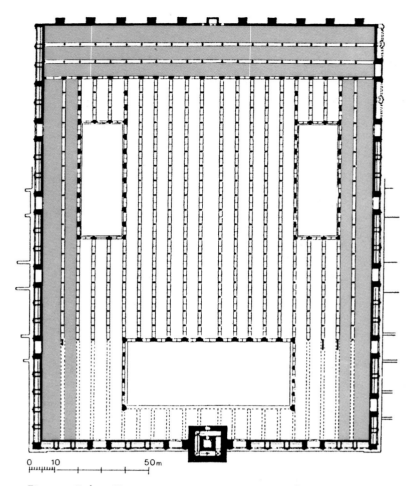

Fig. 15 Rabat, Ḥassān mosque, reconstruction of ground plan

Fig. 16 Rabat, Ḥassān mosque, minaret

wider central aisle is flanked down its whole depth by side rooms; a portico runs transversally, like a transept, across the front. In essence the plan anticipates the scheme at Tinmal: A wider central aisle and a three-sided ambulatory form the extended T. As early as in Madīnat al-Zahrā', it can be seen that the essential typological features that distinguish the Almohad mosque have their roots in pre-Almohad palace architecture.

The Almohad Mosque as "God's Castle":
The Mosque of Tinmal
The increased emphasis on the mihrab as an architectural as well as a cult focus is a west Islamic trend that saw its first culmination in the Great Mosque of Córdoba. There the prayer niche had become an almost independent central chamber. In Tinmal the mihrab is spanned by a *muqarnaṣ* dome, in the apex of which can be read the module unit utilized throughout the building.[12] The mihrab exercised an unusually

strong power of attraction. The minaret left its usual location on the north side of the mosque and was made into a shell or covering for the mihrab; the call to prayer and the focus of its consummation are made one in the prominent projecting tower on the qibla. However, the central significance of the mihrab-minaret block[13] is demonstrated further in the geometric and metrological scheme (Fig. 3). Only this great projecting block, and not the seven smaller gates, is included in the almost exact square that circumscribes the ground plan of the mosque.

But this architectural form, which is so ideally adapted to the requirements of the mosque, is no innovation conceived for the sacred building. From the tenth century on in the Islamic west, castle buildings can be instanced with rectangular outer walls that are interrupted by similarly rectangular salients. The close approximation of building dates gives us reason to consider particularly a comparison to one of the strongly Islamicizing Norman palaces in

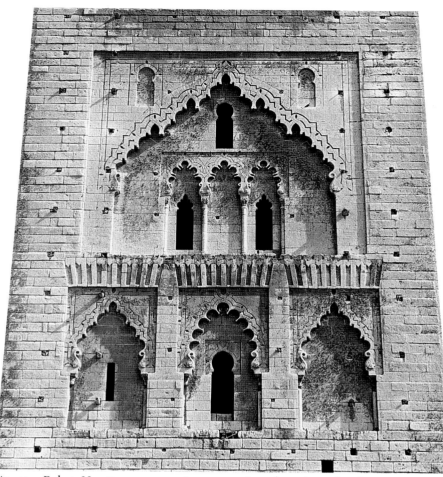

Fig. 17 Rabat, Ḥassān mosque, minaret, portion of northern facade

Palermo. The Zisa (Fig. 18) was begun only some ten years after the mosque of Tinmal, in about 1165 (A.H. 561). Ursula Staacke has discovered that its rectangular scheme of outer walls repeats the proportions of the Zīrid castle in Ashīr, Algeria (probably dating from the second half of the tenth century),[14] and she has also reconstructed the common geometric scheme of the ground plans (Fig. 18). The external articulation in Palermo is crucially modified. Two rectangular salients of identical plan and elevation are intruded into the long axis, symmetrical to the short. A biaxial symmetrical figure arises that is divisible into two: In Tinmal what we have is the half-figure of this scheme, distinguished by only a single salient. The identity of the geometric scheme of both ground plans confirms their typological identity.

The Qaṣba Mosque in Marrakesh[15]
At the end of the great period of Almohad hegemony, in the late twelfth century, arose two sacred buildings

with such unusual designs that the classical Almohad type is only apparent as a substratum: the gigantic Ḥassān mosque in Rabat and the Qaṣba mosque in Marrakesh.

The later restorations[16] did not affect the scheme of the ground plan of the Qaṣba mosque (Fig. 12). Its geometrical skeleton, too, is related to Tinmal (compare Figs. 3, 12) and argues strongly for an Almohad design. Like the exterior architecture of Tinmal, the interior articulation in the Qaṣba mosque stands outside any satisfactory typological classification in the realm of sacred architecture. It is dictated by the accumulation and grouping of five courts (Figs. 12, 13), which is a very unusual phenomenon in a mosque.

The central, main court (Fig. 12: D–J, 3–10) demolishes the typically Almohad reduced depth; the relation of roofed to unroofed spaces is reversed. In the main part of the prayer hall, in the qibla *riwāq*, the eight aisles, only two bays deep, end with their arcades at the usual transverse arcade in front of the qibla

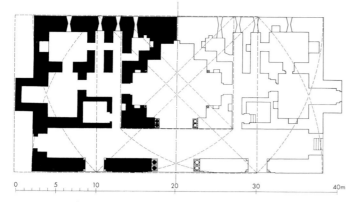

Fig. 18 Palermo, La Zisa palace, plan and geometric scheme

(Fig. 12: A–M, 1). The depth of seven bays in the main court is explained by the paired arrangement of four subsidiary courts. Each of these is separated from the main court only by an open arcade. Between two courts at each side is inserted an aisle (Fig. 12: A–D, 6–7, J–M, 6–7; Fig. 13). Running along the transverse axis of the main court, it corresponds to the central aisle of the qibla *riwāq* (Fig. 12: F–G, 1–3; Fig. 13), which can be sensed on the opposite side of the court as a flat "echo" (Fig. 12: F–G, 10–11): There the north *riwāq* consists of only the fourth arm of the ring walk surrounding the whole mosque.

These four spatial elements on the two axes of the main court are reflected on its facades, each being given a wider and slightly higher central arch. To stand in the main court is to be reminded of a mosque with four iwans. The proportions are, however, much toned down, and the spatial elements leading into depth lack the monumental weight so characteristic of the oriental type. However, this auxiliary interpretation serves its purpose by stimulating our thoughts to look further afield.

The pre-Islamic models of the four iwans layout are to be found not in sacred but much more in palace architecture (for example, the Parthian palace in Ashur).[17] Did this sphere also contribute the motif of the pairs of courts flanking the main one, as we find, for example, in the already cited Zīrid castle in Ashīr? Did the ruler allow the idea of a palace to permeate the design for his palace mosque, which, relieved of its worldly functions, became sublimated? The arcades, the only elements of partition in this mosque, afford the visitor deep vistas of almost esoteric beauty (Fig. 14). With all due caution we advance a hyperbolic

interpretation: Might the diaphanous image of a heavenly palace in paradise, such as had already perhaps been held up to the eyes of the faithful in the mosaic decoration of the Umayyad mosque in Damascus,[18] have been here intensified to three-dimensional monumentality?

The Last Great "Copy" of the Great Mosque of Córdoba: The Ḥassān Mosque in Rabat[19]
The main characteristics of this largest, uncompleted western Islamic mosque can be summarized as follows (Fig. 15): in all, twenty-one aisles—a three-aisled qibla transept that probably joined the two outer aisles at each end to form a higher three-sided ambulatory and very much reduced the importance of the central longitudinal nave, which was only of normal height; a disproportionately small horizontal oblong court in the north; and two longitudinal subsidiary oblong courts perpendicular to the qibla, to give the gigantic prayer hall additional light in the vicinity of the transept.

The dominant feature of the exterior is the minaret (Figs. 16, 17). It retains the square ground plan usual in western Islam and is not united with the mihrab, as it is at Tinmal, but, as there, is set exactly in the long axis of the building, and, again like Tinmal, a prospect is set to face the down slope of the valley with a strict symmetry dictated by a mighty salient block (here, however, not kept short, so that the association with a castle is not suggested). The tower and flanking curtain walls are in the exact proportions of 4:1:4, which are those anticipated in the Kutubiyya mosque in Marrakesh (compare Figs. 9 and 15). There the minaret is aligned on the second building phase, to which it belongs, but it stands in the middle, between the facades of the two phases. These, at a slight angle to each other, were, in fact, each a half facade; in Marrakesh, too, the effect of the symmetrical prospect was evidently taken into account: It faces the medina. (It follows that the demolition of the first prayer hall of the Kutubiyya was not in the original plan.) Tinmal seems once again to be playing the role of a half scheme: In comparison with the Kutubiyya, the halving of the number of aisles corresponds to the halving of the length of the curtain walls in relation to the minaret; the proportion has been worked out as 2:1:2 (Fig. 3).

Henri Terrasse[20] has pointed out the anomaly of

the supports in the prayer hall of the Ḥassān mosque. There we find columns composed of dressed stone drums of markedly varied heights, instead of the usual brick pillars that suited the Almohad tendency to standardize architectural elements, a tendency that under normal circumstances might have been considered essential on a site of this size. What could be the reason for this exceedingly irrational and laborious technique, which must certainly have held up the flow of work to no small extent? The only explanation to be found is in the light of the other unusual factor, the uncommonly large dimensions of the mosque.

No sacred building in western Islam had hitherto come near to rivaling the Great Mosque of Córdoba, which, over a period of two hundred years, had grown into the most important and largest oratory in the whole region. Now it was not merely equaled but surpassed. Was the intention to recall its hall of columns? The historical situation speaks for this interpretation. Yaʿqūb al-Manṣūr, the last Almohad caliph of importance, was preparing for the campaign in al-Andalus that culminated in the battle of Alarcos (1195 [A.H. 592]), the last great victory of Islam on the Iberian Peninsula. In the fortress of conquest (Ribāṭ al-Fatḥ = Rabat), he was conjuring up before the eyes of the troops he had assembled for the holy war an image of the chief sanctuary of Islamic Spain, the land so sorely pressed by the Christian advance.

1. Ewert and Wisshak 1981, pp. 103–7, pls. 34, 35.
2. Ewert 1977, pp. 287–354, esp. fig. 3, which is a plan of the intermediate story with the distribution of arch types.
3. See Bourouiba 1973, figs. 23, 25.
4. See esp. Terrasse 1968.
5. See esp. Meunié, Terrasse, and Deverdun 1957.
6. See esp. Ewert and Wisshak 1981, pp. 1–7.
7. For the distribution of arch types in Tinmal, see Ewert and Wisshak 1984, fig. 3; for the elevation of the arcade in front of the qibla, see ibid., plans 10, 11.
8. Terrasse 1928, pp. 249–66.
9. See n. 7.
10. Hassar-Benslimane et al. 1982.
11. Ewert and Wisshak 1984, pp. 7–13, fig. 7.
12. Ibid., pp. 76–79, 124–25, plans 23–25, pls. 74, 75.
13. Ibid., pls. 6–9.
14. See esp. Golvin 1966, pp. 47–76, ground plan: pl. 5.
15. See esp. Ewert and Wisshak 1987, pp. 179–210, ground plans: plans 1–3.
16. Basset and Terrasse 1932, pp. 274–76.
17. Pope 1938, pp. 432–35, figs. 106, 107.
18. See esp. Finster 1970–71, pp. 82–141.
19. See esp. Caillé 1954.
20. Terrasse 1932, p. 315.

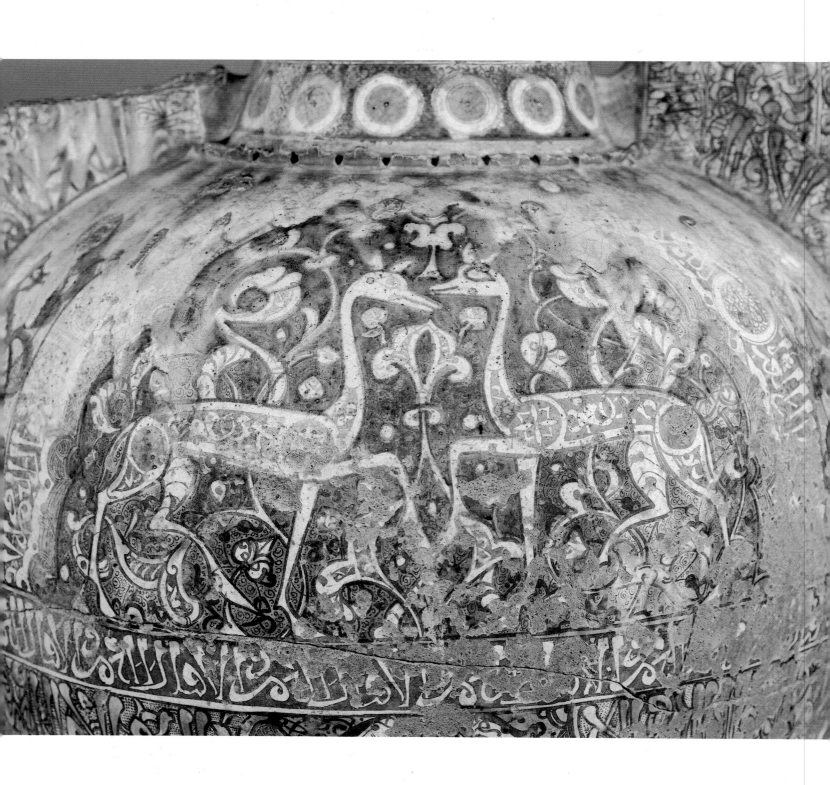

The Ceramics of al-Andalus

GUILLERMO ROSSELLÓ BORDOY

To understand any civilization and the way of life of its men and women, a knowledge of its ceramics is useful. During the Islamic period in Spain, which lasted almost eight centuries, pottery took many forms and sustained many changes. There were articles of tableware, storage containers for food and beverages, kitchen utensils, such as cooking pots and braziers, as well as objects of domestic necessity and convenience, including lamps, candle holders, funnels, sugar molds, inkwells, and piggy banks. With the passing of time, shapes changed and decorative motifs underwent important evolutionary processes. We are now looking at this evolution in a new way.[1] Much progress has been made, but many aspects of the problem remain to be investigated.

Pottery making in al-Andalus cannot be understood without an analysis of its pre-Islamic antecedents on the Iberian Peninsula. The work of the late Roman potters of the peninsula was highly developed. The forms they used evolved throughout the high Middle Ages, when the Visigoths and then the Byzantine peoples, who held political control of the peninsula and consequently influenced its cultural development, brought about specific changes in the shapes and methods of manufacture of earthenware utensils for domestic use. The emergence of the Arabo-Berber civilization in Spain at the beginning of the eighth century was to create a strange mixture of indigenous and Roman techniques with North African and oriental influences, a symbiosis that lent new dimensions to art. Out of this amalgam would be born the ceramics of the Islamic epoch, within the new political and cultural entity known as al-Andalus. Al-Andalus is an elastic term used to designate the territory occupied by the Arabo-Islamic civilization—a term that was to assume various meanings with the developing vicissitudes of the political world. In the caliphal period al-Andalus would embrace practically the entire Iberian Peninsula and the Balearic Islands, but at the close of the fifteenth century it would encompass only the small area under Naṣrid rule.

We can postulate an initial phase—the emirate or paleo-Andalusian period—when autochthonous techniques were continuing to develop and a revitalization of ceramics shaped by hand or on the slow wheel took place. These practices gradually changed as outside influences, especially decorative and functional ones such as the application of glazed finishes, brought modifications of style and advances in craftsmanship. Studies carried out in southern Alicante[2] and southeastern Andalusia[3] have thoroughly documented these developments.

During the Islamic era glazes were a fundamental technical resource. A glossy coating, vitrified by firing in a kiln, not only waterproofed the vessel but also kept the clay from absorbing the odors of food and giving off an unpleasant taste. Characteristic techniques were adopted to create the ceramic decoration of the time: painting, stamping designs in relief, as well as glazing. Highly diverse styles evolved as various substances were used to achieve an impermeable glazed surface. Oxides of copper and manganese, for example, produced the green and purple typical of the caliphal period. The use of cobalt oxide could result in a broad spectrum of blues, while copper, by means of a complex secret process employed by specialized artisans, was given a metallic luster or golden sheen. Thus human ingenuity produced the famous Hispano-Muslim golden pottery as a substitute for the gold and silver vessels proscribed by the Qurʾan.

These glazing techniques were not discoveries

made in the Islamic era. We can find green glaze in the time of the Roman Empire, although it was not popular then. The techniques that produced luster, green, manganese, and cobalt blue ware were oriental ones (Byzantine, Persian, and Chinese) that came to be widely used in Spain. It was these techniques, however, that gave rise to the particular characteristics of the ceramics of the Islamic culture in al-Andalus.

The pottery made in the palatine city of Madīnat al-Zahrāʾ near Córdoba, when al-Andalus reached its political and cultural apogee in the middle of the tenth century, suggests an extraordinary advance in the ceramics production of al-Andalus as a whole. The introduction of white tin and lead glazes for sealing the surface and of oxides of copper and manganese for decoration generated a special type of tableware, the production of which spread rapidly throughout the entire country.[4] Political unification and caliphal prestige supported this diffusion, along with that of the monumental Kūfic writing of the same period. Manuel Ocaña Jiménez observes: "At first, there was an indisputable uniformity of Kūfic style throughout Muslim Spain. It was a reflection of the political unity that had been tentatively established at the level of the wālī [district governor] and subsequently solidified by the Banū Umayya, as well as by the existence of a single directive cultural center in the metropolis of Córdoba."[5] This concept can be extended, certainly, to apply to the manufacture and especially to the decoration of ceramics.

In the tenth century pottery in green and manganese began to appear not only in Madīnat al-Zahrāʾ but also in other places in Spain. There were marked differences in the pottery produced at the same time in ancient Ilbira, or Elvira (Granada), and other local workshops.[6] This leads us to suppose a very early proliferation of schools of design. Already in caliphal times, in compliance with directives from the court of Córdoba, workshops were beginning to produce pottery that was distinguishable in its various decorative schemes and possibly in the shapes of the most common forms: plates or trays for serving food, vessels for storing and dispensing liquids, lamps, small food containers, and cooking utensils.

The Madīnat al-Zahrāʾ style is sober and quite austere. The decoration, in green set off by dark outlines in manganese, seems to stand out against the white background. Is there a particular symbolism in this chromatic contrast? White was the color that stood for the Umayyads, while green represented Islam. Can we see in this duality a special meaning wherein Islam prevails under the Umayyads?[7] The most common epigraphic expression found on the ceramics of this period is الملك (al-mulk). It occurs in great profusion, and its meaning is quite clear: power represented by the Umayyads. From an analysis of the writing on Madīnat al-Zahrāʾ ceramics, we may be able to deduce a chronological sequence. When the decoration is austere, so is the calligraphy; this is a relationship that has been substantiated.[8] The later appearance of Foliated Kūfic in the decorated epigraphy of al-Andalus marks a clear distinction between the different periods of activity of the palatine workshops; this matter, however, has not been studied thoroughly.

While the pottery from Madīnat al-Zahrāʾ leans toward austerity, that of Ilbira does not. The two-valued coloration is retained, but the designs spread out to occupy the entire decorative field. There is a greater feeling of gaiety in the combined geometric and floral motifs, and animal figures appear more often. It is safe to affirm that provincial workshops in other mediums had already become active by the tenth century. The existence of the ivory workshop in Cuenca, on the northern frontier, supports this hypothesis—since the only other explanation for its presence in this area, so far from the center of power, would be that specialized artisans happened to live there. Such shops, even though they still imitated the palatine products, maintained an artistic independence that would be more openly manifested after the fitna, or the period of political confusion, that followed the caliphate and gave rise to the first mulūk al-Ṭawāʾif, or Taifa, kingdoms.

The enormous diversity of the ceramic centers, with their individual variations in form and decorative schemes,[9] leads us to speculate about when the proliferation of potters began and when local differences started to appear.[10] If at the time of the fitna the rulers of the dismembered al-Andalus took under their protection statesmen, scholars, ulāmāʾ, and fuqahāʾ, or alfaquís (Muslim jurists and theologians), why could they not support specialized artisans as well? A skilled ceramist would have been as desirable in the court of an enlightened local ruler as a good poet or a famous calligrapher.[11] Such a development would have encouraged the evolution of local schools.

There can be no doubt that the era of the first *Taifa* kingdoms, which occupied most of the eleventh century, was one of the most prosperous times for local potteries in centers such as Toledo, Saragossa, Valencia, Majorca, Badajoz, and Murcia. These workshops not only produced green-and-manganese ware but also ventured into the areas of *cuerda seca* and lusterware. *Cuerda seca*, which evolved from the green-and-manganese ware of the caliphal period, is a technique in which areas of different colors are separated by a painted line of manganese mixed with grease;[12] its effect is similar to that of cloisonné enameling. Both *cuerda seca* and lusterware techniques had been used at Madīnat al-Zahrā', but only sporadically. The pieces found at Madīnat al-Zahra, given the conditions of excavation there, could very well have been from a period later than the splendid era of the caliphs, or could even have been imports from the east; the new technique of *cuerda seca*, therefore, could have been a discovery made during the time of the *Taifa* kingdoms.[13] At any rate, ceramics decorated in this manner that date from the *Taifa* era are to be found at sites over the entire peninsula. Although they also appear occasionally in the Balearic Islands, this has little significance.

Our information about lusterware is rather scanty. That of Madīnat al-Zahrā' seems to have been imported from sources outside al-Andalus, and we have only documentary evidence, unsupported by archaeology, concerning the manufacture of lusterware during that period.[14] From notarial papers drawn up by Ibn Mugīth of Toledo, we know that this type of pottery was sold in that city; however, in eastern al-Andalus his contemporary al-Buntī makes no mention of it. Although Ibn Mugīth's testimony, which is probably the earliest we have, is documentary proof of the existence of this ware, we possess no reliable evidence regarding its characteristics. A text by al-Idrīsī, from the twelfth century, speaks of the manufacture of lusterware in Calatayud. This reference, recorded by later writers like al-Ḥimyarī, has had a curious status in the study of ceramics. There was no tangible evidence to confirm it until the discovery in Tudela, Navarra, of a gold-decorated bowl (No. 30), which has no parallel from other periods or at other sites.[15] Was this bowl made by the potters of Calatayud? It is possible, but an isolated piece is not a sufficient basis for a hypothesis. On the other hand, absence or scarcity of material

remains of al-Andalus lusterware from the period before the late *Taifa* era, when it was plentiful, does not mean that this product did not exist during earlier times.

By the eleventh century *cuerda seca* had deteriorated to a poorer technique known as partial *cuerda seca*, or work decorated with *verdugones*, or welts. In partial *cuerda seca*, portions of the pottery surface are left unglazed, and the decorated areas stand out in weltlike relief. This was the result of an economic decline that impelled a search for cheaper, more salable artistic solutions. The new process became common throughout al-Andalus, with specific local variations in Málaga,[16] Valencia,[17] and Majorca.[18]

This was the time of greatest activity for local workshops specializing in green-and-manganese decoration. Ornamentation became extremely complicated, and caliphal sobriety gave way to a veritable baroque in which floral and geometric motifs abounded. It was an evolution marked by an accompanying proliferation of shapes that deviated from earlier prototypes. Such plastic luxuriance was especially significant in the ceramics production of Majorca, where bowls with a characteristic broken profile began to appear. This complexity was not exclusive to al-Andalus; it appears in North African work of the same period, some of which was brought to Majorca, Mértola, and Málaga, and even to Italy. Imports of this kind could easily have influenced local forms.

The call for help sent out at the end of the eleventh century by the *Taifa* sovereigns to the Islamized Berber tribes of North Africa brought about political and cultural changes in al-Andalus. First the Almoravids (during the second half of the eleventh century and first half of the twelfth) and then the Almohads (during the second half of the twelfth century) left their mark on peninsula ceramics, opening an era that we do not yet completely understand. The doctrinal rigidity preached by the Almoravid religious leaders resulted in a Qur'anic austerity that was reflected in the ceramics of the day. This austerity can be seen in the degeneration of decorative motifs into monochromatic surfaces with green and occasionally honey-colored glazes that have a purely functional value and in which ornamentation has no place. This is a little-known epoch, although it embraced practically all of the twelfth century. Fantasy was permitted only in the survival of partial *cuerda seca*, which gradually

became more and more stylized, until it was reduced to an absolute minimum.

During this period the greatest possible variety of shapes appeared. We have gleaned knowledge of this through documents that reveal a truly surprising increase in the lexicon of domestic utensils. By examining glossaries and cookbooks dating from the end of the twelfth century and the beginning of the thirteenth, we learn that there were more names for the various types of ceramic vessels at this time than ever before. The number of names reached a peak in the first third of the thirteenth century, when we know that ceramics production displayed a formal and decorative variety that was decidedly spectacular. By the end of the fifteenth century, when Hispano-Muslim ceramics production ceased, the lexicon had become greatly impoverished.[19] Does this diminution correspond to a reduction in the variety of shapes? This is a question we cannot answer at present for lack of evidence.

In any case, it is a fact that we know little about the production of ceramics during the Almoravid era. Of the centers that had flourished previously, as far as we know, only Denia still seemed to function vigorously enough to spread the products of its potteries into neighboring countries. Stamped designs under glaze, which was common in the period before the caliphate, reappeared now. Among the decorative motifs used most frequently in this technique were geometric patterns of flowers.

Under the rule of the Almohads—a politico-religious group that endeavored to attain a Qurʾanic purity even stricter than that dictated by the Almoravids—the panorama changed. Despite the Almohads' fundamentalist goals, there appeared a previously unknown decorative and plastic splendor. The newly embellished ornament was based on geometric, plant, and floral motifs that incorporated epigraphic designs in both cursive and Kūfic writing. Figural themes are seen as well, for instance in Valencia and Murcia, and even the human form occurs.[20] Examples discovered in Andalusia, eastern Spain, and the Balearics have amply demonstrated the extraordinary wealth of ornamentation that developed, involving two fundamental techniques: sgraffito and *estampillado*, or designs stamped in relief. Both had been used in earlier times, but it was at this moment that they reached their greatest refinement.

We can follow a complex evolutionary process in Almohad pottery, beginning with sgraffito work. The partial *cuerda seca*, in obvious decline, came to be combined with broad unglazed areas in manganese. These unglazed areas were decorated with simple geometric designs in sgraffito executed before firing. The firing was carried out at a temperature that fixed the colors but was not high enough to vitrify the oxides on the bands of sgraffito. Geometric elements were complicated by the introduction of new motifs consisting of flowers, plants, and inscriptions. At a certain point sgraffito supplanted the *cuerda seca*, which was now reduced to simple lines that separated the sgraffito bands or isolated more complex motifs. It is in Murcia that the most perfect examples of sgraffito are found. Here the technique reached its culmination, when sgraffito was applied to the entire surface of the vessel, which was embellished with finely detailed work in imitation of metal prototypes. The appearance of this mode can be dated precisely: It emerged between 1229 (A.H. 627), when Majorca fell into Christian hands, and the third quarter of the thirteenth century, when the Murcia area came under Castilian rule.[21]

The *estampillado* technique evolved fully at the height of the Almohad era. It had been carried out by making small punch marks that left geometric and plant designs on the surfaces of plates before they were glazed. The Almohad artists used the punch marks in profusion to form bands that covered the entire surface of the piece—usually a large jar meant to store liquids or solids. Incidentally, a special type of large container with a sturdy, robust neck was developed at this time. When such a jar was empty, it was easier to store in an inverted position than if its opening were narrow; if the vessel had a conical base designed to fit into a saddlebag, it could be stored in a vertical position, since it could rest upside down on its strong neck. There was a broad range of *estampillado* decoration, all of which remained within the canons of al-Andalus art: the *ataurique*, or intertwined leaf and flower design; Kūfic and Naskhī inscriptions, sometimes combined with one another; small arches and stylized architectural elements; magic signs and talismanic devices, such as the hand of Fāṭima and Solomon's seal. Occasionally, animal figures took on special importance. Sometimes *estampillado* and partial *cuerda seca* were used together; the bodies of the ceramics in which these techniques were combined are red and

yellow, emphasizing the green tones of necks with glazed relief in the form of arabesques or epigraphic texts. Regional variations were common, as each center produced its own shapes and decorative schemes. The *estampillado* was extraordinarily popular and survived for centuries into the Mudejar period.

Green-on-white table service was revived, although its designs never attained the intricacy of those of the caliphal and *Taifa* periods. However, the most singular characteristic of the tableware of the period is the use of metallic luster in combination with sgraffito under the glaze. Pieces found in Pisa, Murcia, and Majorca place the rebirth of tableware at the middle or end of the twelfth century. Sometime before the Christian conquest of Murcia in 1243 (A.H. 641), Ibn Sacīd al-Maghribī observed that high-quality glass and luster ceramics were being made in Murcia, Málaga, and Almería. This reference is not a clear indication that these cities were the principal production centers of lusterware, however, because the Arabic terms for glass and glazed ceramic ware are very similar and because gold-tinted glassware was a common product at that time. Ceramics with molded relief decoration in gold over a white ground also date from this period. Of these we have fragments found in Málaga and Mértola and nearly complete pieces that have lost their golden tones, such as the little Málaga pitchers in the Instituto de Valencia de Don Juan.[22]

Archaeological investigations of recent years have revealed the immense variety of ceramic shapes and decorative techniques that existed during the Almohad era. It is relatively easy to reconstruct the ordinary pottery of the Almohad period and to identify the principal centers of production because the territory of al-Andalus was gradually shrinking, along with Muslim zones of influence, as the Christians advanced. In the middle of the thirteenth century, however, what we know today as Naṣrid ceramics appeared. These represent the last and perhaps the most splendid, if the least known, stage of al-Andalus production. In its initial stages, Naṣrid pottery is no more than a continuation, in both form and decoration, of the Almohad tradition. We find our first evidence of this in the Castillejo de los Guájares excavations in Granada.[23] In the earliest pieces the punch marks in the technique of *estampillado* have become smaller, there is a preciosity and minuteness

of detail reminiscent of architectural prototypes, and a splendid resurgence of the use of gold occurs. The introduction of cobalt oxide added blue to the spectrum of glazes; indeed, blue and gold would be the characteristic colors of Naṣrid ceramics. This ware was not only widely distributed but also quickly imitated by Valencian potters.

The two and a half centuries of ceramics manufacture in the kingdom of Granada have not been systematically investigated. Exceptional pieces, from great jars to bowls adorned with geometric designs and widely diversified glazed tile work (Fig. 1), have attracted more attention and study than the domestic products, which are sometimes coarser but always of the highest artistic quality.

The supremacy of Málaga as a port of distribution for this production has led us to believe—too hastily, in my view—that that city was not merely the most important center of manufacture, but the only one. The fact that we have found kilns in the Alhambra, although little is known about them and they are imprecisely dated, suggests that there were other ceramic centers turning out diversified products: These could have been Málaga and possibly Almería as well as Granada.

Recent investigations,[24] some of which are still in progress, have enabled us to construct a formal typology and a chronological evolution for Naṣrid ceramics. We have not yet studied the different stages of production and the incidence of its decoration, which embraces luster, luster and blue, green and luster, and green ground with manganese embellishment. These groupings have been verified through excavations and museum holdings, but they have not yet been properly appraised. Some prestigious earlier conclusions regarding lusterware[25] must be revised, in view of information brought forward by new archaeological finds that have not yet been recognized by the scientific world.

Ceramics from the potteries of the kingdom of Granada very soon had their imitators in the Christian world—especially in Valencia, where Málaga ware was copied. (Since Málaga was the principal Granadine port from which this precious commodity was exported, it gave its name to all of the production, which the Christians knew as Málaga ware.) It is difficult to distinguish the genuine articles from the imitations made in Valencia.[26] We must look for

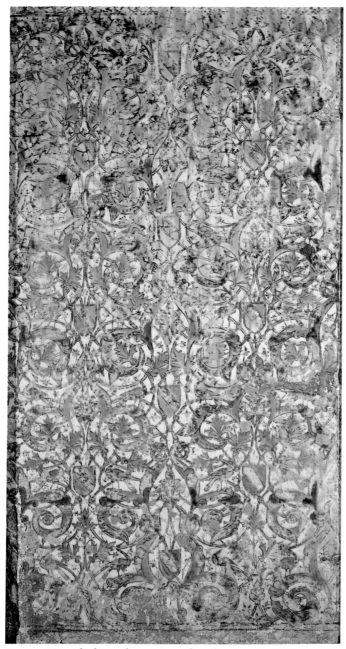

Fig. 1 Naṣrid tile, 15th century, glazed and painted blue and manganese earthenware with luster, Museo Arqueológico Nacional, Madrid, 1948–31

subtle nuances of color, delicacy of drawing the arabesques, and artistry in the development of decorative themes that generally characterize the products of Granada. Muslim potters may have worked in Valencia, shaping and decorating tableware in their traditional styles. In some cases Valencian ceramics surpassed their Granadine prototypes, as witness the bowls at the Hispanic Society in New York and in the Musée National des Thermes et de l'Hôtel de Cluny in Paris. However, small Valencian pieces, where there was limited space for complicated decoration, were of a lower quality.

Naṣrid ceramic art culminated with the creation of great jars, the so-called Alhambra vases, in luster and blue or luster alone. Because of their size and the delicacy of their decoration, they enjoyed extraordinary fame; they were exported to such faraway places as Cairo, where they have been discovered at archaeological sites. If the kingdom of Granada, the last flowering of Islam in Spain, left its unparalleled monument in the Alhambra, it was these extraordinary vases that brought to a close the long era of ceramics production in al-Andalus and sealed it with a golden clasp.

1. Our first knowledge of the pottery that was fabricated and used in al-Andalus during the Islamic period came in 1924 with a series of lectures by Manuel Gómez-Moreno at the University of Barcelona (Gómez-Moreno 1924). New systematic studies, based essentially on aesthetic criteria that prevailed in the field until 1970, appeared subsequently.

 The first overall view in the context of this approach was the work of Luis M. Llubiá, who published the results of his long experience in a single fundamental volume in which he analyzed the entire field of Spanish medieval ceramics, including both the Islamic tradition and its development in Christian territories (Llubiá 1968, 2nd ed., 1973). Similar important studies, particularly in the field of lusterware, have been presented by other investigators (Frothingham 1951; Martínez Caviró 1983).

 In the 1970s a new generation of scholars in the field of archaeology brought their discipline to these issues, contributing analyses of the stylistic aspects of the ceramics (Rosselló Bordoy 1978b; Zozaya 1980; Casamar 1981). This movement was to introduce a radical change in the study of ceramics from the Islamic era. Many investigators have amplified and extended these researches to apply them to the entire geography of Spain. Their shared efforts have modified our knowledge, especially in terms of chronology, and have brought our investigations into a more coherent framework of time and place.
2. Gutiérrez Lloret 1988.
3. Acién Almansa and Martínez Madrid 1989, pp. 123–35.
4. Bazzana, Lemoine, and Picon 1986, pp. 33–38.
5. Ocaña Jiménez 1970, p. 19.
6. Retuerce and Zozaya 1986.

7. Barceló Perello forthcoming.
8. Ocaña Jiménez 1970.
9. Retuerce and Zozaya 1986, pp. 125–26; Valdés Fernández 1985, pp. 281–99; Kirchner 1990, p. 97.
10. Aguado Villalba 1983, p. 23.
11. Rosselló Bordoy 1987, p. 127.
12. Casamar 1981, p. 419.
13. Ibid., p. 420; Casamar and Valdés Fernández 1984, pp. 400–401.
14. Martínez Caviró 1983, pp. 46–49.
15. Bienes Calvo 1987, p. 138; Esco, Giralt, and Sénac 1988, p. 71.
16. Puertas Tricas 1989, p. 30.
17. Bazzana et al. 1983, pp. 11–21.
18. Rosselló Bordoy 1987, pp. 115–20.
19. Rosselló Bordoy 1991, p. 159.
20. Navarro Palazón 1986a, pp. 66–73.
21. Navarro Palazón 1986b, p. xix.
22. Martínez Caviró 1983, p. 48.
23. Cressier, Riera Frau, and Rosselló Bordoy forthcoming.
24. For example, Flores Escobosa 1988, pp. 11–12; Serrano García 1988, p. 127.
25. Frothingham 1951, pp. 83–87; Caiger-Smith 1985, pp. 86, 192.
26. Blake 1986, pp. 368–72; Porcella 1988, pp. 177–79.

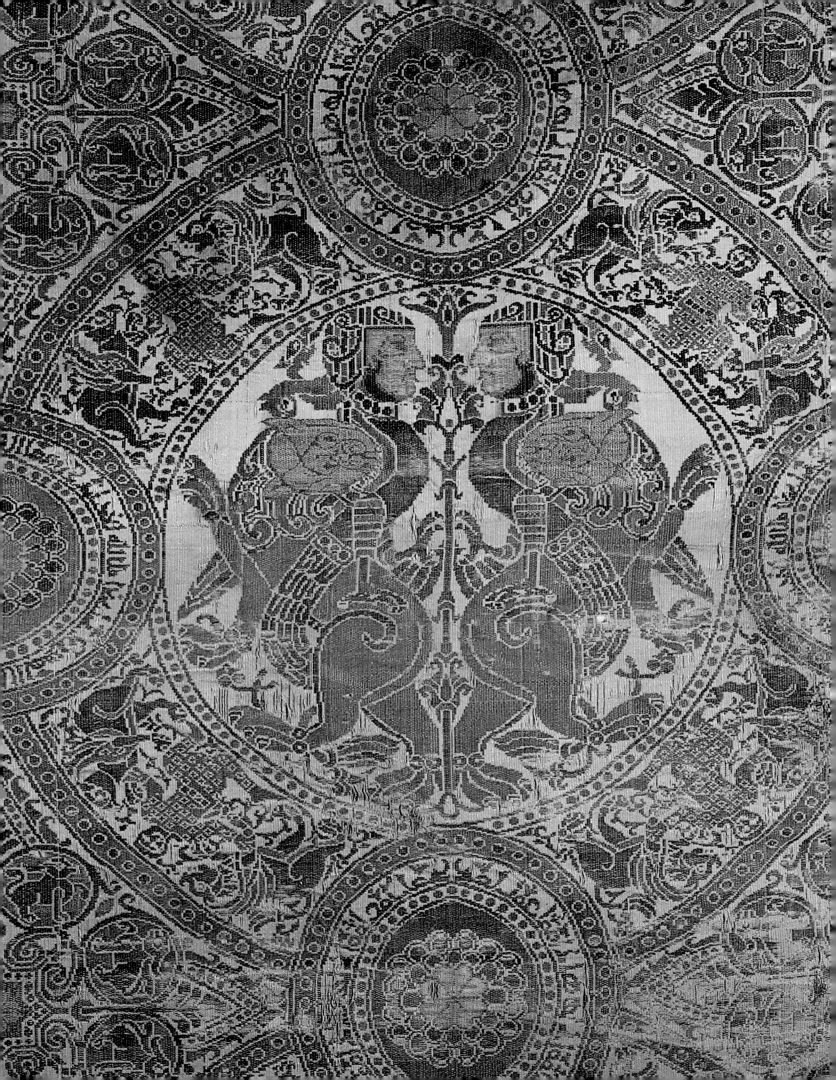

Almoravid and Almohad Textiles

CRISTINA PARTEARROYO

One of the splendors of power and sovereignty, and one of the customs of many dynasties was to inscribe (rasama) their names or certain signs (ʿalāmāt), which they had adopted specially for themselves, in the borders of garments (thawb) designed for their wear, made of silk (ḥarir) or brocade (dībādj) or ibrīsm-silk. The writing of the inscription was to be seen in the weave of the warp and woof of the cloth itself, either in thread of gold, or colored thread without gold, different from that of the thread composing that of the garment, according as the workmen decide to arrange and introduce in the process of their weaving. Thus, the royal robes (al-thiyāb al-mulūkīya) are bordered (muʿlama) with a ṭirāz. It is an emblem of dignity reserved for the sovereign, for those whom he wishes to honor by authorizing them to make use of it, and for those whom he invests with one of the responsible posts of government.[1]

From the very beginning, the manufacture of textiles in Islam was associated with the court and specifically with the ruler. This was especially true of the caliphate in Córdoba. Weavings and embroideries were executed in the royal workshop, or ṭirāz, located in the palace. Al-Maqqarī recounts that the caliph Hishām, whose power was overshadowed by that of his chamberlain, al-Manṣūr, "was not left with any more insignia of the caliphate other than the prayer in his name on the mimbars, and the inscription of his name on the coinage, and the ṭirāz-strips."[2] Hishām's name on the border of luxury garments was a sign of authority and is a reminder of the expense and power associated with manufactured textiles in al-Andalus in particular.

In the Almoravid period, however, the city of Almería became the center of textile production, indeed one of the first great manufacturing cities of the Iberian Peninsula. Contemporary chroniclers exhaustively recounted the large numbers of factories and diverse types of textiles manufactured there, suggesting a level of production and quality that outstripped Córdoba during the caliphate. Yāqūt notes: "Merchants sail from it, and their ships anchor there.... Figured washi-stuff and brocade of excellent manufacture are made there. This was first made in Cordova but then Almeria outstripped it. In the land of Andalus there is not to be found a people who make more excellent brocade than those of Almeria."[3]

The nature of this new, vigorous development of textile production in the Almoravid period and its transformation in the Almohad era are the subject of this essay. The text centers on some of the finest extant Islamic textiles: those whose aesthetics are expressed in the beauty of silk and gold by designers and weavers, and those whose rich, even exotic, phenomena include Arabic inscriptions, interlacery, and *ataurique* decoration.

Almoravid Period

The most prosperous and brilliant Almoravid period fell within the first quarter of the twelfth century, that is, during the reign of ʿAlī ibn Yūsuf (1107–43 [A.H. 500–538]). The Almoravid silks that stand out above all others are those often referred to as the "Baghdad group," or, following translations and research pertaining to the shroud of San Pedro de Osma,[4] one might more accurately call them "the Baghdad imitations."

Almoravid textiles of the first half of the twelfth century share many characteristics and exhibit a special technique favoring fine woven lines between two juxtaposed colors and accentuated outlines. This inclination to stress lines rather than masses of color was developed with such precision and to such a

Detail of fragment of shroud of San Pedro de Osma, 1st half 12th century, silk and gold thread, Museum of Fine Arts, Boston, 33.371, Ellen Page Hall Fund

degree by Spanish weavers that the intricate and delicate product tends to resemble a painted miniature more than a textile.

The uniformity of execution in these textiles suggests a single locality for their manufacture—the city of Almería—and a defined period of time—from the reign of ʿAlī ibn Yūsuf to the period of Ferdinand II of León (r. 1157–88 [A.H. 552–84]).[5] In Almería textiles were made that were called, by chroniclers of the time, tabby, from Attabi, the name of a textile district in Baghdad where this weaving was done. Manuel Gómez-Moreno[6] called these textiles *baldaquíes*, in reference to their having come from Baghdad. Otto von Falke[7] and Dorothy Shepherd[8] prefer the classification "diaspers" because the textiles employed the technique of this name, which was recorded in medieval inventories. These are brocaded lampas textiles. The colors are dull orange-red for the decoration, with green or blue on an ivory ground, and touches of gold to highlight certain motifs.

Technique

The diaspers[9] of Hispano-Islamic workshops are characterized by the use of two sets of warps and wefts, of which one set produces the ground fabric and the second, interwoven with the first, yields the design. What distinguishes these weaves from those of Europe or the Near East is the fact that the warps of the foundation are disposed in groups of 2-2-4-2-2-4 and the warp that joins the weft of the design is run in with each group of four background warps. This creates a pronounced ribbed effect on the right side of the background weave. A second technical characteristic found only in this group of Hispano-Islamic silks is a unique system of joining the strands of *oropel*, or thin threads of gilded leather, to produce the brocade, in an unusual honeycomb effect. According to the designation of the technical vocabulary of CIETA (Centre International d'Études des Textiles Anciens) in Lyons, this is a lampas brocade, since the term "diaspers" is not a technical word.

Almoravid Textiles

Approximately fifty examples of these textiles have survived, of which we shall refer to only the most representative. They all share features of technique and decorative style based on large rondels with ribbons of pearling, tangent or linked, disposed in rows and enclosing pairs of animals: lions, griffins, sphinxes, harpies, heraldic eagles, peacocks, and others, confronted or addorsed and separated by a slender palmette. In some examples they clasp small prey—such as antelopes or gazelles—in their claws. The band of the rondel is usually decorated with animals on a reduced scale, forming a characteristic circular frame. The interstices are filled with four palmettes that spring from a central star. These are Persian-Sasanian themes, widely used since ancient times.

Some of the textiles bear horizontal bands with Arabic inscriptions showing typical Hispano-Kūfic ornamentation and certain letters terminating in vegetal elements. An example is seen on the chasuble of San Juan de Ortega (Fig. 1), which reads, *Victory from God the emir of the Muslims, ʿAlī, the work of...*, alluding to the Almoravid sovereign ʿAlī ibn Yūsuf. Since this chasuble eventually belonged to San Juan de Ortega, who died in 1163, the piece is essential in establishing the Spanish provenance of this entire group of textiles, as well as the date of manufacture as the first half of the twelfth century. The principal theme of the decoration is addorsed lions with deer beneath their feet.[10]

Similarly outstanding is a fragment of the shroud of San Pedro de Osma (Frontis.), decorated with pairs of lions and harpies encircled by small male figures holding griffins. The most interesting aspect of this piece is the inscription, which reads, *This was made in Baghdad, may God watch over it.* Based on this evidence some authors believe that the textile was executed in Baghdad, but Shepherd[11] is of the opinion that it is a copy of textiles from that city and that even the inscription may have been falsified to make the product more valuable. We are informed by al-Saqaṭī of Málaga,[12] for example, that during the eleventh and twelfth centuries there were indeed regulations prohibiting falsified inscriptions. The characters, nevertheless, are typically Hispanic; even more conclusive, the technique and colors are exactly like those of other pieces in this group. We therefore concur with Shepherd that the shroud was woven in the same center or even the same workshop as the chasuble of San Juan de Ortega, surely in Almería, where, according to al-Maqqarī and al-Idrīsī, figured textiles with rondels were woven during the time of the Almoravids.

Another important piece is a textile fragment of the "lion strangler" (No. 88), found in the tomb of

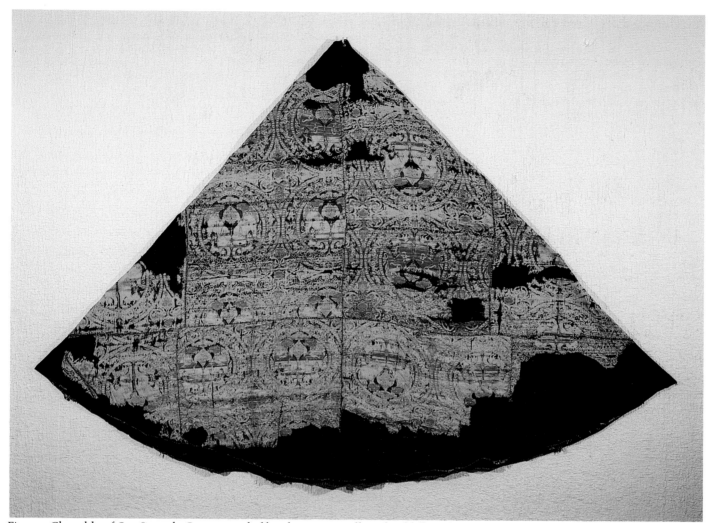

Fig. 1 Chasuble of San Juan de Ortega, 1st half 12th century, silk and gold thread, Parochial Church, Quintanaortuño, Burgos

San Bernardo Calvó in Vich and named after the principal figure of the design. Of the same provenance and quality is another textile in this series in the Vich museum; it is decorated with confronted sphinxes. Both may have been obtained as booty in 1238 (A.H. 636) in the capture of Valencia, in which San Bernardo fought by the side of James I.

Two further examples were discovered wrapped around the relics of Santa Librada in the cathedral at Sigüenza, brought there, according to tradition, by Alfonso VII in 1147 (A.H. 542), on the occasion of the victory over the Almoravids and the capture of Almería. In one, the rondel contains addorsed griffins and in the second, an eagle with outspread wings. Similar to the latter are textiles from a reliquary in Quedlinburg, Germany, and from the church of San Pedro de Cercada in Gerona.

The textile featuring paired eagles in the cathedral at Salamanca is one of the finest examples of Almoravid weaving. It was found binding a document from the time of Ferdinand II, king of León, and thus first appeared in the second half of the twelfth century. Closely related is the chasuble in the cathedral of Provins; in this case, the garment is complete and in an excellent state of preservation.[13]

A tunic of the infante Don García (d. 1145 or 1146 [A.H. 540 or 541]) (Fig: 2), son of the emperor Alfonso VII, was discovered in 1968 in his tomb in the Panteón Real of the parochial church of Oña (Burgos).[14] This garment, which was worn for riding, fit the body closely down to the hips, where it flared out in four pleats like a tunic or split skirt. It has long tight sleeves terminating in a semibelled opening, a novelty in the twelfth century. The textile features large double-headed eagles with necks decorated in zigzag and with pearl collars. On the upper portions of their outspread

ornamented with exquisite vegetal elements. Kūfic inscriptions adorn the peacocks' breasts. The feathers of the tails end in "eyes" that recall those of peacocks on the chasuble of Saint Sernin in Toulouse (No. 87) and on Cordobán ivories.

Other examples related in technique to those we have discussed offer the same vegetal and epigraphic themes in horizontal zones symmetrically disposed; among these is the pillow cover of Alfonso VII in the cathedral in Toledo. Of this same period, although from a different workshop, is the cope of King Robert d'Anjou, decorated with confronted peacocks standing on a plinth bearing the inscription *perfect blessing*.

In the disposition of motifs and other shared elements, these textiles bear a certain similarity to those of contemporaneous Luccan and Sicilian workshops. The ornamental motifs are closely related to tenth- and eleventh-century ivories from caliphal workshops and the *Taifa* kingdoms, which had been influenced by eastern currents already assimilated in al-Andalus. According to Christian inventories, these textiles were known as *pallia rotata*, that is, panels with wheels or rondels, and *cum rotis mayoribus*, or with large wheels, to distinguish them from those with small-circle decoration. The distinction is significant, for the large rondels were necessary to contain the animal and figural decoration that is central to this style.

There is also a small fragment from the first part of the twelfth century, in the Museu Tèxtil i d'Indumentària in Barcelona decorated with pearl rondels

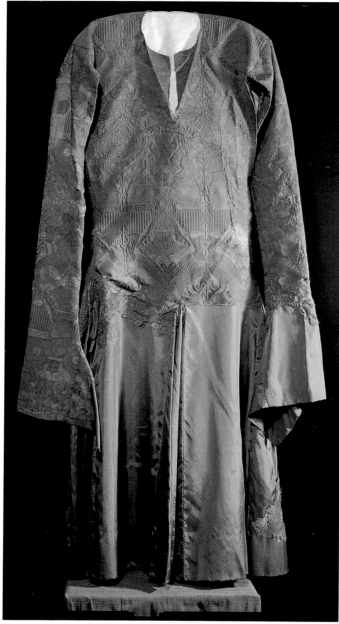

Fig. 2 Tunic of Infante Don García, 1st half 12th century, silk and gold thread, Parochial Church, Oña, Burgos (top); detail (right)

wings are rondels with imbrications and eight-petaled rosettes and cartouches with Kūfic inscriptions. The wings are outlined with feathers in the form of curls or small hooks. The bodies are decorated with rosettes and lozenges. Each of the extended tails springs from a ribbon of gold pearls and is arranged in three zones of parallel lines ending in a row of gold rosettes. Confronted peacocks held in the eagles' claws decorate the lower portion of the textile. Each pair of peacocks stands on a small tree, from which it is separated by a stem that springs from the tree to create a pear-shaped palmette

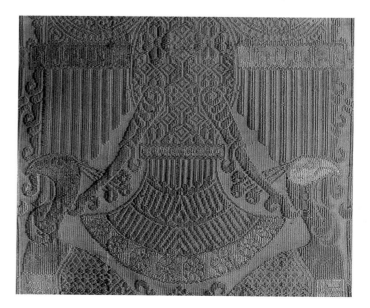

containing pairs of addorsed birds with heads turned toward one another and separated by vegetal elements, with four-petaled flowers in the interstices. The heads of the birds, the beads or pearls, and the flowers are brocaded in gold, creating a honeycomb effect. The textile was wrapped around relics dated 1147 (A.H. 542) that were found in the Romanesque sculpture of Christ, or *La Majestad Batlló*, in the Museu d'Art de Catalunya in Barcelona.

Such Christs were usually dressed in tunics patterned with rondels and pairs of birds, like those we have been analyzing, and bordered with a broad band or design of Arabic inscriptions or pseudo-inscriptions. Thus it is clear that the makers of these images, so characteristic of Romanesque art, were well acquainted with the aforementioned textiles, which confirms their abundance and diffusion.

The last Almoravid textile we wish to mention is a triangular fragment of worked silk and gold brocade (Fig. 3). It is embellished with rondels, not tangent, enclosing pairs of addorsed lions with turned heads; between them is a fine palmette executed in the manner of a tree of life. The spaces between the rondels are filled with eight-pointed stars that in turn contain disks. Completing the decoration are stylized *ataurique* motifs distinguished by asymmetrical leaves. The pattern is pale red on an ivory ground. The lions' heads and disks in the stars are gold brocade.[15]

The decoration of this textile is composed of diverse, dense, schematized motifs, a development of the small-circle, or small-rondel, group. These characteristics make this group of textiles of the Almoravid tradition transitional in nature. At least one style of textile manufacture seemed to be turning away from Almoravid types, which had been linked to traditions that favored figural and animal decoration in large medallions. The small-rondel ornament looks to a more schematized, abstract Almohad style.

Almohad Period

According to Ibn Khaldūn, the first Almohad monarchs did not have a *ṭirāz*, or royal workshop, for manufacturing silk-and-gold cloth, nor for fabricating ceremonial and ornate court robes or diplomatic gifts:

> When, at the beginning of the sixth century, after Umayyads of the West had lost their power, the Almohads founded their empire,

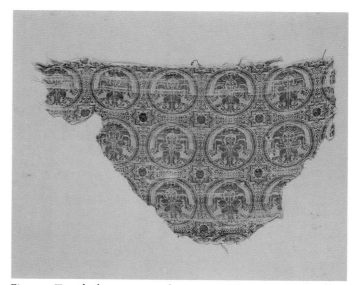

Fig. 3 Textile fragment, 12th century, silk and gold thread, Instituto de Valencia de Don Juan, Madrid, 2059

in the early period of their domination they did not adopt this institution because they followed the ideal of piety and simplicity that they learned from the Imam Muhammad al-Mahdī ibn Tūmart. For they scrupled to wear silk (ḥarīr) or gold. So thus the office of the inspector of the ṭirāz fell into abeyance at their court. However, in the latter part of this dynasty, their descendants adopted something of this usage, but it did not have the same fame as it had in former times.[16]

These facts surely explain why there are so few examples of textiles from the Almohad period. In addition, Abū Yūsuf Yaʿqūb al-Manṣūr, victor of the Battle of Alarcos, issued an edict prohibiting luxurious silk garments and forbidding women to wear sumptuously embroidered gowns; at the same time he ordered the sale of silk-and-gold cloth customarily held in the state storehouses. Nevertheless, there are indications, as suggested by Ibn Khaldūn, that over a period of time the Almohads, like the Almoravids before them, succumbed to the longstanding tradition of luxury arts in al-Andalus, despite their cultural and religious conservatism. Rich textiles were produced, although generally with less figural decoration.

In Almohad textiles rondels containing pairs of confronted animals gradually disappear and circles decorated with interlacery are substituted for them. Pattern is distributed on the basis of medium bands

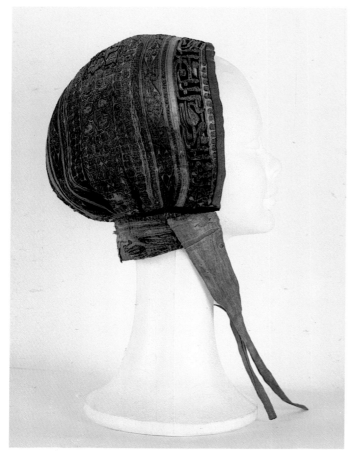

Fig. 4 Cap of Infante Fernando of Castile, late 12th–early 13th century, silk and gold thread, Museo de Telas Medievales, Monasterio de Santa María la Real de Huelgas, Burgos, Patrimonio Nacional 007/001 MH

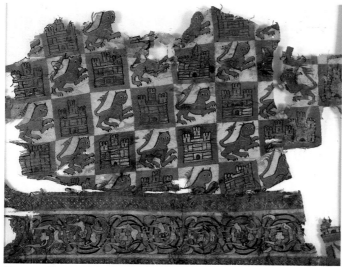

Fig. 5 Fragment of mantle of King Ferdinand III, 13th century, raw silk and gold thread, Armería del Palacio Real, Madrid, N9

filled with reticulated lozenges, rosettes, stars, starred polygons, and other figures borrowed from caliphal marbles. *Ataurique* decoration features pepper leaves and pods, as well as asymmetrical leaves or palms. Epigraphic ornamentation is in Kūfic or cursive script; such epigraphy is one of the most reliable sources for classifying a textile.

Technique

They used figured *taqueté*, a term that designates antique patterned textiles with obverses and reverses constituted of floats of wefts interlaced in tabby by structural warps. In these textiles the repeat of the structure is composed, in principle, of four threads: two threads of the main warp and two of the binding warp. The floats of the regular wefts in tabby give the textile the look of flat decoration, as much for the background as for the ornamentation. The only areas that stand out are those with *oropel* or gold threads of Chipre, which are thicker than wefts of silk without twist. The filaments of silk of the warps, on the other hand, are always twisted and rendered invisible, since their function is binding, not decoration.

Almohad Textiles

The examples from the Almohad period are few in number but high in quality and almost all feature tapestry embroidery. The point of departure for this group of textiles, which belongs to a single workshop or school, is the cap of Infante Fernando of Castile (Fig. 4). It is among the most interesting pieces in Hispano-Islamic textile art.

Fernando was the son of Alfonso VIII, founder of the Monasterio and Panteón Real de Santa María la Real de Huelgas. The cap, according to Gómez-Moreno,[17] was the richest of the infante's burial garments. Tailored from a length of tapestry, it is heavy with gold and decorated in parallel bands, of which the center and widest band is the most lavish. The piece is made up of four types of eight-pointed stars worked between bands of double spirals bordered by interweaving ribbons of two strands and another band with long, simple Almohad-type leaves. Framing the cap is a cursive Almohad inscription of gold and white on a blue ground that Gómez-Moreno translated as *In the Lord is our solace*. It is edged in ribbons of pearling, and the wefts are strips of gilded membrane wrapped around silk thread and untwisted silk floats of wefts of white, sky and navy blue, cream, and light green. The shape of the cap itself is simple and is seen in innumerable miniatures in the *Cantigas*

de Santa María. The textile dates from the end of the twelfth or beginning of the thirteenth century.

Another example is a fragment of the mantle of King Ferdinand III, the Saint (d. 1252 [A.H. 650]) (Fig. 5). The mantle was found in the king's tomb in the cathedral at Seville; much of it gradually disappeared, since textiles were considered relics—a notarial certificate of 1676 confirmed their status—and were thus highly prized. Fortunately, in 1729, a representative piece of the mantle was sent to the king of Spain, Philip V. This is the only surviving fragment; it is exhibited in the Armería of the Palacio Real, alongside the monarch's spurs.

The fragment is composed of two textiles stitched together by old but not very skillful work. Both pieces are tapestry weave. The upper piece is decorated with castles and lions disposed on a grid and may have been commissioned specifically for the king from workshops in al-Andalus. According to Gómez-Moreno,[18] the lower band is unique; it is decorated with Almohad *ataurique* based on spiraling stems from which spring double palms with asymmetrical and divergent lobes, often with truncate endings, curling back upon themselves. This *ataurique* is executed in white and sky and navy blue on a gold ground. It is bordered by an interwoven ribbon of four strands: gold wefts on a crimson ground, with white dots. The warp is raw silk, joined two by two.

Closely related in its tapestry technique and Almohad *ataurique* to this fragment from the mantle of King Ferdinand are remnants of the vestments of the bishop of Bayonne, Bernardo de Lacarre, who died in 1213 (A.H. 610). Found in his tomb, these two wide bands are in a poor state of preservation; they are now in the Musée National des Thèmes et de l'Hôtel de Cluny in Paris. According to Carmen Bernis, they had not been published until the time of his 1956 study. She believes the fragments are "exceptional not only among extant Hispano-Islamic tapestries, but among all medieval tapestry."[19] The tapestry weave is extraordinarily fine, worked on silk with a gold ground. It is decorated with a blue Kūfic inscription outlined in white and very elegant, stylized Almohad *ataurique* in blues and white with curling red stems limned in white. The gold of the ground is composed of threads of gilded membrane that totally cover the "core" thread of silk. The tapestry stitch is very small and dense.

The culmination of this type of weave, which

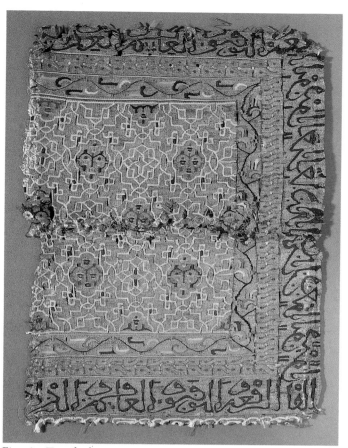

Fig. 6 Textile fragment, 13th century, silk and gold thread, Instituto de Valencia de Don Juan, Madrid, 2067

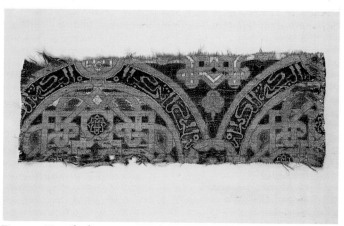

Fig. 7 Textile fragment, 13th century, silk and gold thread, Instituto de Valencia de Don Juan, Madrid, 2093

was produced throughout the thirteenth century, is a unique and exceptional series utilizing very fine strips of gilded membrane wrapped around a silk "core" and producing the effect of wrought gold; typical decorations were orles of extremely fine interlacery and cursive inscriptions with characters in Andalusian *thuluth* form surrounding a central compartment also decorated with interlacery. Ornamentation of this type

is found on the pillow cover of Leonor of Castile in the Monasterio de Santa María la Real de Huelgas (No. 93); the vestments of San Valero in Barcelona (No. 95); the garments of the Infante Alfonso in the Museo de Valladolid; and various fragments (Fig. 6) from the Soto Posada Collection of Cangas de Onis in the Instituto de Valencia de Don Juan in Madrid.

Finally, there is a series of pieces with medallions of Hispano-Islamic tapestry containing pairs of human figures on a smooth ground of crimson taffeta. Among them are the pillow cover of Queen Berengaria in the Monasterio de Santa María la Real de Huelgas (No. 89), and several pieces of the vestments of Bishop Gurb found in the cathedral of Barcelona and housed in various museums.

An Almohad textile in the Instituto de Valencia de Don Juan (Fig. 7) is a fragment of worked silk and gold. On a navy blue ground are circular medallions (the fragment contains only quarters or halves of a complete medallion) formed by gold ribbons outlined with red. The medallions are filled with the same ribbons, creating curving interlacery. Around the medallions is a frame of cursive Naskhī inscription in gold on a blue ground, reading *perfect blessing*. The medallions are joined by smaller medallions containing eight-pointed stars. The interstices are filled with interlacery and *ataurique* in gold and touches of white.

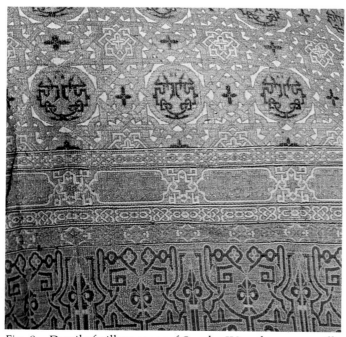

Fig. 8 Detail of pillow cover of Sancho IV, 13th century, silk and gold thread, Catedral de Toledo

The technique is *taqueté* worked in silk and gold. The piece is typical of thirteenth-century textiles, although the color is more intense, a foreshadowing of Naṣrid stuccowork.

The decoration of medallions with curving knots and eight-pointed stars of gold ribbons is very similar to that of a medallion on a vase from the Alhambra dating from the last third of the thirteenth century and now in the Instituto de Valencia de Don Juan. Even though the technique is different, there are obvious ornamental and, especially, epigraphic analogies to the banner of Las Navas de Tolosa (No. 92), a thirteenth-century Almohad tapestry. This banner was traditionally considered to have been from the tent of the Almohad sultan al-Nāṣir, who was defeated by Alfonso VIII in the Battle of Las Navas de Tolosa in 1212 (A.H. 609). However, studies, particularly one by Bernis,[20] with whom we are in agreement, identify the standard as one of the trophies acquired by Ferdinand III in his campaign to recover territory from al-Andalus and later donated by him to the Monasterio de Santa María la Real de Huelgas during renovation of the cloister, sometime between 1212 and 1250 (A.H. 609 and 648).[21] The banner, with its impressive inscriptions in a bold geometric pattern, is a tour de force of the style of the Almohad tradition: aniconic, glorifying the word of God as its primary aim.

Opulent textiles used as coffin linings also made their way to Christian tombs—remote from mourning as they were: silk and gold cloth and heavily textured, twilled half-silks, richly decorated and complemented with magnificent galloon. Several of the textiles in the Monasterio de Santa María la Real de Huelgas were decorated with parallel strips of cursive inscriptions, such as that found in the tomb of Fernando de la Cerda. María de Almenar's coffin cover (No. 91) bore the inscription *Faithfulness to God*. Perhaps this legend was commissioned expressly for her burial.

The pillow cover of Sancho IV, the Brave, who died in 1295 (A.H. 695) (Fig. 8), is decorated with wide bands on the upper and lower ends, with Kūfic inscriptions, interlacery, and *ataurique* decoration; there are also four narrower borders of interlacery, one of them with cartouches containing inscriptions. The field of the cover is also decorated with interlacery, as well as with rows of oval disks with stylized inscriptions alter-

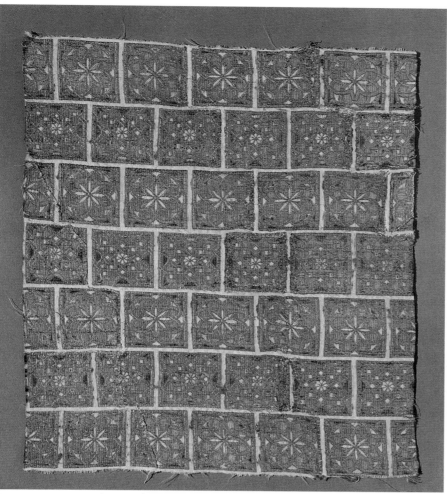

Fig. 9 Fragment of cape of San Valero, 13th century, silk and gold thread, Instituto de Valencia de Don Juan, Madrid, 2062

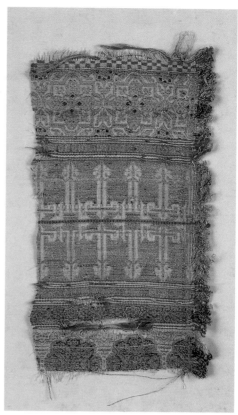

Fig. 10 Fragment of mantle of Don Felipe, 13th century, silk and gold thread, Instituto de Valencia de Don Juan, Madrid, 2069

nating with rows of eight-pointed stars. The textile is red, green, and blue on a white ground, a gold worked silk of superior quality. Its technique, *taqueté*, is similar to that of the cape of San Valero (Fig. 9), although the latter is a lampas weave of double cloth with a tabby ground and is the same technique as that of the coffin cross of the infante Enrique I, son of Alfonso VIII, and the pelisse and mantle of Don Felipe (d. 1274 [A.H. 673]) (Fig. 10).[22]

The textiles placed in Christian royal burials remind us of the extent to which the textiles of al-Andalus established the fashion for richness and opulence and reflected the power of those who ruled. Clearly, the possession of textiles maintained some of the same associations with wealth and authority for Christians that they had had since the era of the earliest rulers of al-Andalus. Although some of the examples discussed above were actually made after the Almohad period, they continue to express the spirit

and tradition of Almohad textiles. Such textiles are well represented in the burials of the Monasterio de Santa María la Real de Huelgas.

1. Serjeant 1972, p. 7.
2. Ibid., p. 169.
3. Ibid., p. 170.
4. Day 1954; Elsberg and Guest 1934; Shepherd 1957.
5. Shepherd 1957.
6. Gómez-Moreno 1951.
7. Falke 1922.
8. Shepherd 1955.
9. Ibid.
10. Shepherd 1957.
11. Ibid.
12. Serjeant 1951.
13. Shepherd 1958.
14. Lázaro López 1970.
15. Partearroyo 1982.
16. Serjeant 1972, p. 8.
17. Gómez-Moreno 1946.
18. Gómez-Moreno 1948.
19. Bernis 1956a, p. 95.
20. Ibid.
21. Ibid., p. 110.
22. May 1957.

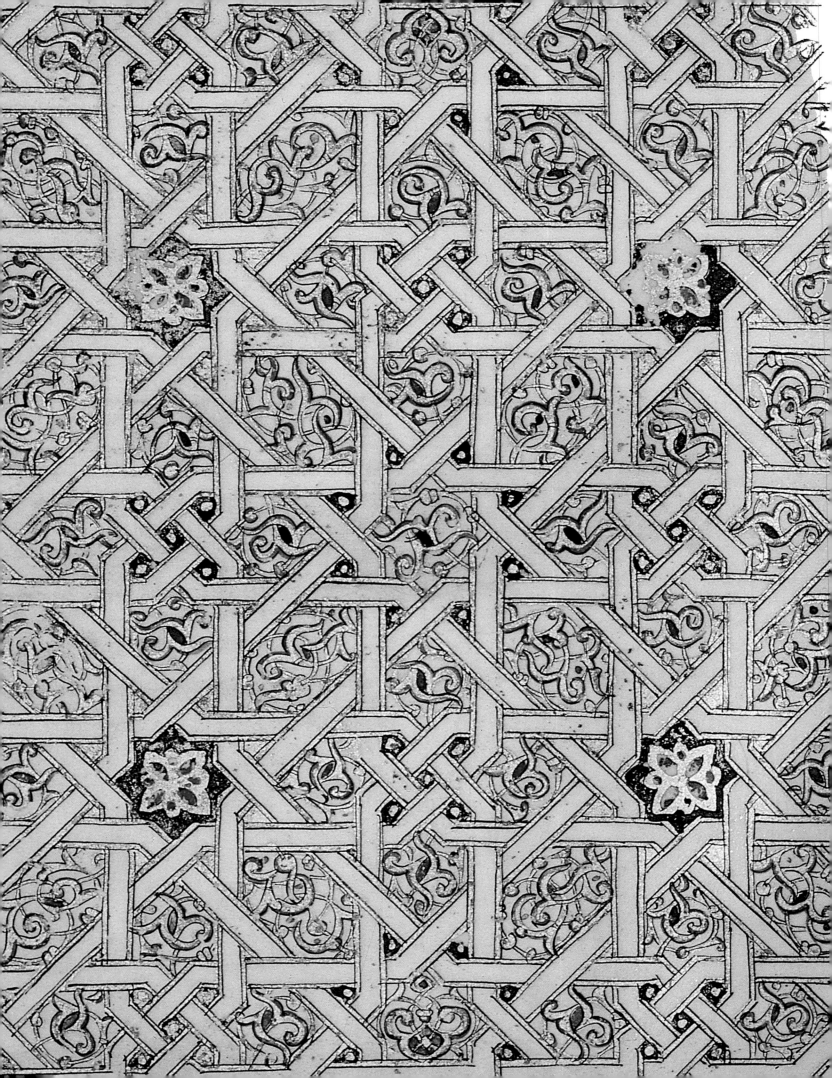

The Arts of the Book

SABIHA KHEMIR

اقرأ باسم ربك ... الذي علم بالقلم

"Recite: In the name of thy Lord . . . who taught by the Pen. . . ." (Qurʾan 96:1–4)

These words, the first spoken to the Prophet Muḥammad by Gabriel, messenger of God, established the great importance that reading and writing were to be given within Islam. Indeed, the name Qurʾan is transliterated from the Arabic word derived from the verb *qaraʾa*, to read, and a complete chapter within the Qurʾan is titled "The Pen" (sura sixty-eight).

The role of calligraphy in Islamic art need not be stressed here. Arabic script as a pictorial form carries in itself an important message for Islam. The choice of Arabic by God as the language of the Qurʾan endowed it with sacredness. Awareness of such significance prompted its use in the first major Islamic building erected, the Dome of the Rock in Jerusalem, completed in 691 (A.H. 72) by the Umayyads, who thus declared a religious and political victory for Islam.

The Qurʾan was transcribed soon after the death of the Prophet; copies were sent to the main Islamic cities, securing the text and spreading the faith. Books were seen as powerful tools through which knowledge was to be disseminated, and numerous libraries were established throughout the Muslim world. Two hundred fifty thousand volumes, for example, were said to have been housed in the library at Córdoba, a truly impressive phenomenon considering that this was at a time when all books were copied by hand. The Almohads founded public libraries; the Almohad sultan Yūsuf ibn ʿAlī, in fact, had such a passion for books that he acquired whole private libraries, paying their owners handsome prices. Unfortunately, most early Islamic libraries did not survive—as the storehouses of knowledge and influence they were often destroyed. The renowned Fāṭimid libraries in Cairo, for example, were sacked in 1068 (A.H. 461), during a period of general disorder.

From its early stages, the form of Arabic script manifested two distinct styles: One, with an angular and monumental geometry of rectilinear forms and vertical divisions, is known as Kūfic, its name derived from Kufa in Iraq, a great early center of Islamic culture; the other, Naskhī, is a rounded, cursive, and flowing script. Naskhī was employed for commonplace topics, whereas Kūfic was mainly reserved for religious purposes. Kūfic may be said to have reached its perfection, in Qurʾan manuscripts, during the late eighth and early ninth centuries.

Western Kūfic evolved directly from standard Kūfic. The predominantly rectangular forms of the earlier Kūfic were gradually transformed into the definite curves and almost perfect semicircles that are Western Kūfic's main distinguishing features (Fig. 1). It is known as Western Kūfic because it developed in the Maghrib (modern Morocco, Algeria, and Tunisia), the western part of the Islamic world. Kairouan, a town in present-day Tunisia first established by the Arabs in 670 (A.H. 50), played an important role in the evolution of western Islamic calligraphy. The Great Mosque at Kairouan became a center for learning, and a large number of Qurʾans were copied there.

Qurʾan manuscript (No. 85, folio 129v)

The only cursive script derived directly from Kūfic is Maghribī, which reached its full development by the beginning of the twelfth century in Spain and North Africa; the script owes its name to the region, the Maghrib. Two main derivatives from this style can be discerned. The smaller and closer-knit of the two is known as Andalusī; it is delicate and more compact, with fine letters and dense lines. Although the letters that come below the line, such as *nūn*, are drawn in a round, semicircular shape, those that come above, such as *ṣād* and *kāf*, are composed of straight parallel lines that generate the sense of horizontality present in Kūfic. The other derivative style is monumental and rounder than the Andalusī script, with deep sublinear flourishes; it is considerably less compact, with as few as five lines per page, compared to perhaps twenty-seven lines in Andalusī script.

By the sixteenth century these two styles had converged into one average-size script, in which Qur'ans produced in the western Islamic world have been written ever since. Unique to Maghribī script is the way in which the letter ق, *qāf*, is written, with only one dot above it instead of the customary two of the eastern ق, *qāf*; in Maghribī the single dot of ب, *fa*, is marked below the letter to differentiate between the two letters.

Because Qur'ans were and are intended to be read aloud, orthographic marks in Qur'anic manuscripts are usually indicated in different colors; Abū'l-Aswad al-Du'alī (d. 688 [A.H. 69]), the legendary founder of Arabic grammar, devised the system of using large colored dots to indicate those vowels not represented by the letters. Called *tashkīl* (vocalization), this system was closely associated with Kūfic and its derivatives. All western Islamic manuscripts, whether produced in Spain or in North Africa, follow the same rule: *hamzat al-qaṭʿ* (disjunctive hamza) is marked by an orange dot, whereas *hamzat al-waṣl* (connective alif) is noted by a green dot. Only occasionally does yellow replace orange or is *hamzat al-waṣl* indicated in the same ink as that used for the calligraphy. In rare cases only *hamzat al-qaṭʿ* is marked.

Although the large swinging curves of the Maghribī script suggest noble grace while reflecting a sense of the solemnity retained from Kūfic, fine and delicate curves, oriented toward the left, that come close to touching the adjacent letters give it a distinctive quality of integration. The entire line rather than the individual letter is more valued; the eminent fourteenth-century Maghribī historian Ibn Khaldūn informs us that calligraphers from the western Islamic world were trained from the start to write whole words rather than separate letters, as was the case in the east.[1]

An innovative stage in cursive calligraphic script was introduced in the east at the beginning of the tenth century by Abū ʿAlī Ibn Muqla, a master renowned for his competence and knowledge of the science of geometry. The cursive script he devised was mathematically proportioned and became the basis for subsequent generations of calligraphers. Notable among these was Ibn al-Bawwāb from Baghdad (d. 1022 [A.H. 413]), whose handwriting displays a remarkable sense of proportion and a regularity suggestive of printing. Although no such exact rules were followed in the Maghribī style of calligraphy, master calligraphers were emulated, and the clear and decisive lines of the script reveal an intrinsic awareness of proportion. The relative freedom allowed within Maghribī calligraphy generated personal and creative contributions from calligraphers that enriched the style. Maghribī, performed with a light, free, elegant, and graceful rhythm, plays a different tune within the Islamic calligraphic repertoire.

Maghribī script was never used outside North Africa and Spain. Even today there is a distinct difference between handwriting from North Africa and that from the Middle East. Unlike Kūfic, Naskhī, or other cursive scripts, it was rarely employed in architecture or on objects and was instead reserved almost exclusively for manuscripts. Manuscripts from the western Islamic world (produced during the period of common rule) treat a wide range of topics, such as law, love, chivalry, grammar, science, and particularly Hadith. The primary manuscripts copied, however, were Qur'ans.

Several Qur'anic manuscripts in the so-called Andalusī style, in which the relation to Kūfic is still noticeable, have survived; they all have the same general characteristics and are written predominantly on vellum. Most of these are relatively small and square in format. A number of them contain colophons declaring the date they were copied and giving Valencia as the place of origin (No. 76). Two of these were copied by the same calligrapher, Muḥammad ibn Ghaṭṭūs.[2] Other Qur'ans of the same type do not

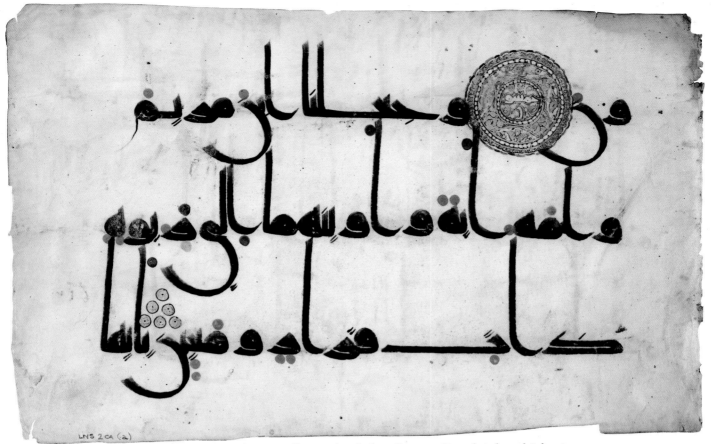

Fig. 1 Qur'an manuscript, 1st half 10th century, vellum, Al-Sabah Collection, Dar al-Athar al-Islamiyya, Kuwait National Museum, Kuwait City

contain information about their place of origin but are clearly attributable to Valencia on stylistic grounds and can be dated to the twelfth century.[3]

A number of manuscripts written in the rounder and more openly spaced Maghribī style, which creates an impact different from that of the Andalusī calligraphy described above, can be attributed to Granada. Several volumes, housed in various collections, can be identified as belonging to one Qur'an originally comprising sixty volumes. The thirty-ninth volume of this Qur'an is now in a private collection in Tétouan, Morocco (Figs. 2, 3).[4] The full-page illuminations in this Qur'an show similarities to illuminations in a Qur'an dated A.H. 703 (1304) and now in the Bibliothèque Nationale in Paris (No. 85). Both use the same type of interlacing pattern departing from a central eight-pointed star, and the medallions in the margins as well as the arabesque motifs filling them are very similar.

Some of the decorative motifs of these volumes can also be seen in the Alhambra. Specific analogies can be drawn between the interlacing designs used for the full-page illuminations and those of the ceramic decoration of the Sala del Trono, while the framing bands based on the knotted motif in these manuscripts can be found, for example, in the stucco capitals of the Sala de los Reyes.

Although there can be no doubt that a significant number of manuscripts must have been produced in Granada during the two hundred fifty years of Arab rule, of the few that survived the Christian reconquest of this city at the end of the fifteenth century, none are dated. The volumes in the British Library that were originally part of the sixty-volume Qur'an mentioned above are believed to have been taken from Spain to Morocco by a princely family at the time of the reconquest of Granada.[5]

A magnificent two-volume Qur'an now in the Museum of Turkish and Islamic Art in Istanbul (No. 83) shows a remarkable resemblance to the surviving parts of the sixty-volume Qur'an. Not only is the handwriting similar in every respect, but the general layout and the manner in which the ornamental Kūfic of the sura headings is rendered (in gold and outlined

in places with red) are also virtually identical (for comparison, see Fig. 2). The two volumes of the Istanbul Qur'an are monumental in scale (53.5 x 60.5 cm), yet there are only seven lines to the page; the effect is one of stately elegance and sophisticated simplicity. It is very likely that both the two-volume and the sixty-volume Qur'ans were produced in al-Andalus, most probably Granada, in the late thirteenth to early fourteenth century.

This sense of simplicity, so characteristic of Maghribī calligraphy, in fact conceals the complexity of the art and the history behind it. One variation found in western Islamic manuscripts is achieved by a costly and meticulous technique that consists of tracing the contours of letters with a very fine pen and an ink composed of a resin-and-burned-oak-gall base, then filling the letters with gold ink; in time the fine line turns black, as it has in a manuscript now in the Bibliothèque Nationale in Paris (No. 84). This technique was sometimes used for sura headings or to highlight particular words inserted within the text.

We find it in manuscripts produced in al-Andalus as early as the thirteenth century. The type of handwriting in the Bibliothèque Nationale manuscript closely resembles the light, elegant Maghribī calligraphy in both the two-volume and the sixty-volume Qur'ans discussed above. In one of the sixty volumes (Fig. 4), this technique was used to emphasize the words لا إله إلا الله (*There is no god but God*). It is most likely that this type of calligraphy, as seen in the Bibliothèque Nationale manuscript, should be attributed to late thirteenth- to early fourteenth-century Spain.

A close study of western Islamic manuscripts reveals that the various styles of Maghribī calligraphy do not seem to follow a linear development. Not only do we find different styles practiced in the same towns, we also see the same style practiced in towns far apart. This variety in styles, occurring more or less simultaneously throughout the region, reflects a propitious period of intense creative activity.

Although Valencia is known for a particular type

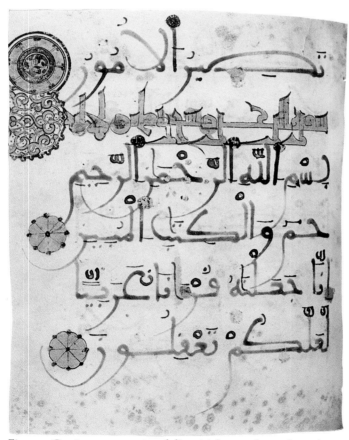

Fig. 2 Qur'an manuscript, folio 28r, late 13th–early 14th century, vellum, Dawed Collection, Tétouan

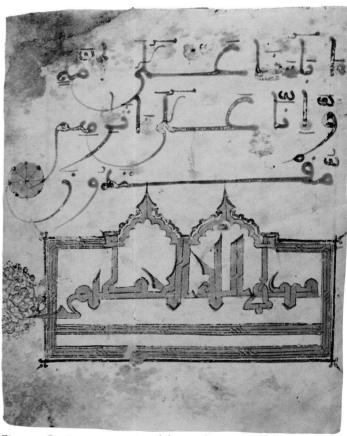

Fig. 3 Qur'an manuscript, folio 34, late 13th–early 14th century, Dawed Collection, Tétouan

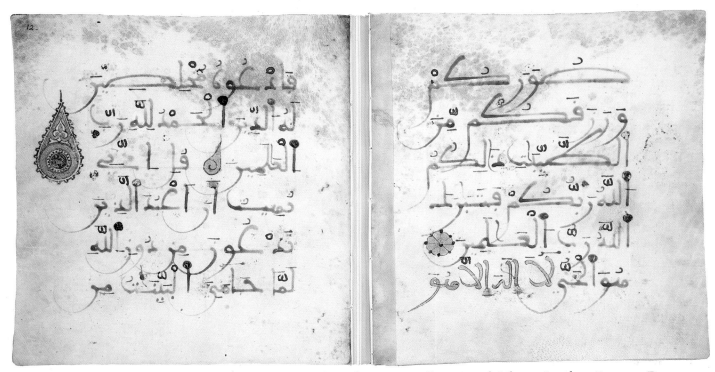

Fig. 4 Qurʾan manuscript, folios 11v–12r, late 13th–early 14th century, vellum, British Library, London, Or. 12523D

Fig. 5 Qurʾan manuscript, folio 58r, 1256 (dated A.H. 654), vellum, British Library, London, Or. 13192

of manuscript, such as a Qurʾan now in the General Egyptian Book Organization in Cairo (No. 76), dated A.H. 557 (1161/2) and written in a close-knit Andalusī script with light brown ink, a style altogether different was produced there as well. A manuscript now in the Bibliothèque Royale in Rabat (No. 77), written in Maghribī script with dark brown ink and well-spaced lines, contains a colophon stating that it was copied in Valencia in A.H. 568 (1172/3). This information brings new light to our knowledge of manuscripts produced in Valencia during the second half of the twelfth century. The contrast in styles is obvious, and yet both manuscripts were completed in the same town a mere eleven years apart.[6]

The eighth volume of a Qurʾan produced origi-nally in twenty volumes, now in the Bibliothèque Ben Youssouf in Marrakesh (N.430), contains a colophon indicating that it was copied in the town of Málaga in A.H. 620 (1223). It is written in Maghribī script with large letters and only two or three words to the line, five lines to the page. Extremely similar to this particu-lar manuscript in its style of calligraphy and general layout is another Qurʾan, also originally in twenty volumes. The sixteenth volume of this Qurʾan, now

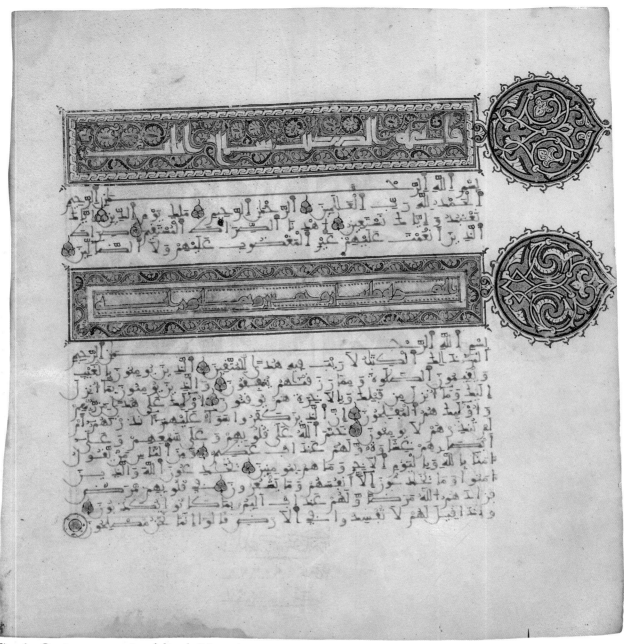

Fig. 6 Qur'an manuscript, folio 3b (No. 75)

also in the Bibliothèque Ben Youssouf in Marrakesh (N. 429), is dated A.H. 632 (1234) and inscribed with the name of Seville. If we compare this manuscript to a Qur'an now in Munich (No. 80), also copied in Seville and dated A.H. 624 (1227), we again notice a different style. The Munich Qur'an is written in the close-knit Andalusī script with twenty-five lines to the page.

A number of Qur'anic manuscripts from Marrakesh indicate that it too appears to have been an important center for calligraphy in the western Islamic world. Although manuscripts produced there during the period of common rule generally conform

to those styles of calligraphy found in al-Andalus, they tend to show variations in their illumination. The close-knit Andalusī script can be seen in a Qur'an copied in Marrakesh in 1202/3 (A.H. 599) (No. 79); we also find the larger Maghribī script used in the ten-volume Qur'an copied in Marrakesh by the penultimate Almohad emir Abū Ḥafṣ ʿUmar al-Murtaḍā, in 1256 (A.H. 654) (Fig. 5).

The variety of illumination in manuscripts from the western Islamic world is considerable. In Qur'ans, for example, the sura headings, which consist of the title of the sura and the word *Makiyya* (Meccan) or *Madaniyya* (Medinese), indicating the location of its

revelation to the Prophet, are nearly always written in an ornamental style of lettering developed from Western Kūfic for the purpose of illumination only, different from the script of the text itself. The lightness and grace of the Maghribī script are often in contrast with the weight of the ornamental Kūfic chosen for the titles.

Other devices of illumination include the medallion, which appears in a number of styles, both within the text and in the margins. In addition to their functional role of marking the passage of verses, medallions enhance the overall visual aspects of the manuscript. An examination of their colors, motifs, and positions reveals a conscious adherence to the spiritual coherence of the text itself. Medallions in the margins with a root- or trunk-shaped base, for example, are suggestive of trees growing from the sura headings; their pointed ends, directed toward the edge of the page, allude to infinity.

Red strokes, often applied to parts of the letters in sura headings, and echoed in the medallions and the leaf-shaped ornaments, are said to evoke the flame of candles, symbolizing the divine light. The stylized upright palmette, often called the tree of life and usually placed in the margin, frequently contains at its base a rondel decorated with a radiating motif. In one example the rondel is topped with a stylized palmette resembling a candle flame, the whole design reinforcing the concept of light. Verses are often simply marked by little trefoils rendered in gold. In other cases, verse markers are solar in form and decorated with finials that create the effect of rays (Fig. 2). The use of gold emphasizes the spiritual importance of the concept of light.

Originality in the use of conventional motifs may also serve to communicate spiritual values. An example of this can be seen in the Tétouan volume (Fig. 3) of the sixty-volume Qur'an discussed earlier. The words صدق الله العظيم (God is all truthful or Amen), written in highly ornamental Western Kūfic, are incorporated within an architectural frame that appears to have two multilobed arches, a type familiar in Islamic buildings; these forms might also be intended to suggest a mihrab structure. We find exactly the same design in the stucco decoration of the Alhambra.

The connections between manuscripts produced in different cities in Islamic Spain are most noticeable in their illuminations. The motifs and the layout of the medallions that decorate the margins of a Qur'an from Córdoba dated A.H. 538 (1143), now in the Istanbul University Library (No. 75), bear an especially close similarity to those in the manuscript produced in Valencia and dated A.H. 557 (1162), now in the General Egyptian Book Organization in Cairo (No. 76). In these manuscripts the medallions are, as usual, placed in the margin to coincide with the sura

Fig. 7 Qur'an manuscript (No. 76)

Fig. 8 Qur'an manuscript (No. 76)

نبرأنه أصفر منه يصلح لكل ما يصلح له النسيأمين

عنعقسلى وهو السلجم

ظله إذا اطبخ وأكل كان معتداً من أخذى الرتاج مولداً ا

جوّ مجرماً لشهوة الجماع وطبخته يصّ على البقر

السقاوا العارض من البقر وينفع مغلاً وإذا اصمر

Fig. 9 Detail of *Materia medica*, Pedanius Dioscorides, folio 73, late 12th–early 13th century, vellum, Bibliothèque Nationale, Paris, Arabe 2850

headings; in the case of short suras, parts of them are superimposed, resulting in a series of medallions that fill the margins in a vertical line (compare Figs. 6, 7). In addition, both manuscripts are written in the same type of Andalusī script. One further similarity can be seen in the interlacing motifs; the circles and semi-circles used in the manuscript from Córdoba, both in the decorative border framing the colophon and in the full-page illuminations, are also present in the manuscript from Valencia (Fig. 8).

Only three illustrated western Islamic manuscripts are known to survive from the period of common rule, a condition thought to result from the orthodoxy of the western part of the Muslim world, and one that raises the enigmatic question of iconoclasm in Islamic art. It is important to state at once that figural representation appeared at all times in all secular Islamic art; it was, of course, more favored in some periods than in others. The presence in the Biblioteca Apostolica Vaticana in Rome of a profusely illustrated manuscript, *Ḥadīth Bayāḍ wa Riyāḍ* (No. 82), which can be attributed to the thirteenth century, is proof that such representation existed in manuscripts from the western Islamic world. The high quality of the miniatures in this manuscript suggests that if one such superlative example exists, there must have been others that have not survived. *Ḥadīth Bayāḍ wa Riyāḍ* is a love story of a well-established literary genre. The manuscript contains fourteen miniatures that display a remarkable grace of forms and refined details. Though the connection with miniature tradition in the east is clear, elements of pure Hispano-Islamic character are present. In art in other mediums from al-Andalus, especially ivory

Fig. 10 Qur'an binding, 1256 (A.H. 654), leather, British Library, London, Or. 13192

carvings, there is also abundant use of figures, further refutation of the claim that figural representation was prohibited in the western Islamic world.

A different style of drawing can be seen in *Kitāb Ṣuwar al-Kawākib al-Thābita* (Treatise on the Fixed Stars) by al-Ṣūfī, completed in Ceuta, North Africa, in 1224 (A.H. 621) and now in the Biblioteca Apostolica Vaticana in Rome. The illustrations in this manuscript demonstrate that various forms of artistic expression did indeed exist in the western Islamic world during the thirteenth century. The linear aspect of the drawings, traditional in the eastern al-Ṣūfī manuscripts, is preserved here, although some new interpretations are introduced in the subjects illustrated.

The first-century Greek physician Pedanius Dioscorides compiled the ancient world's most famous medicinal herbal book, the *Materia medica*, which

came into Arabic via the Syriac. A copy of this book now in the Bibliothèque Nationale in Paris (Fig. 9) is written in Maghribī script and probably dates from the late twelfth or early thirteenth century. In this instruction manual the explanatory drawings of medicinal plants inserted within the text are clearly based on earlier Greek images. It is said that the Byzantine emperor Constantine Porphyrogenitus sent an illustrated copy of the *Materia medica* to the court of the Umayyad caliphate in Córdoba in the early tenth century so that botanists there could correct the available Arabic translations.

A considerable amount of information concerning the art of bookmaking in the western Islamic world can be found in two Arab manuscripts in particular. One, titled *ʿUmdat al-kuttāb wa ʿuddat dhawī al-albāb* (Staff of the Scribes and Implements of

the Discerning), articulates the merits of calligraphy and analyzes the components of inks and their colors, the mixing of dyes, gilding, paper, and binding. It was written for al-Mu'izz ibn Bādīs (1007–61 [A.H. 398–453]), a royal patron of the arts born in Manṣūriyya, Tunisia. The other treatise, Ṣinā't tasfīr al-kutub wa ḥall al-dhahab (The Arts of Bookbinding and Gilding), was written in Fez in 1619 (A.H. 1029) by Abū'l-'Abbās Aḥmad ibn Muḥammad al-Sufyānī, a master binder.

The fabrication and use of paper, which had been borrowed from the Chinese by the Arabs as early as 750 (A.H. 133), spread rapidly in the Muslim world, and paper manufacture was introduced into Morocco and Spain in the tenth century. Ceuta was renowned for its papermaking, and Fez was an important center from the eleventh century. Játiva in al-Andalus was also prominent; in fact, the paper made there was said to be without equal in the civilized world and was exported to both the east and west.[7] It was from Játiva that knowledge of papermaking was disseminated to the rest of Europe.

The papermaking techniques developed at these centers included the production not only of papers in various shades of white but also in different colors. Yellow, for example, was created by adding saffron, blue by adding indigo or aloe, and red was achieved by using a wax made from insects. A Qur'an manuscript now in the Topkapi Museum in Istanbul is a masterpiece of creative richness, containing particularly enhancing blue pages with finely executed text written in gold.

In spite of its costly price, vellum (raqq in Arabic) remained the primary material used throughout the Muslim empire until the middle of the eleventh century. It continued to be employed for a notably longer period—though not to the exclusion of paper—in the western part of the Islamic world, up to the end of the fourteenth century; its extended use applied especially to religious texts.

Vellum was made mainly from goat or sheep skins, less frequently from gazelle skins. We know that, according to a jurisconsults' precept, the skin for vellum had to come from an animal killed according to Islamic rite; an act of purification was also necessary before any vellum could be used for Arabic, considered sacred in Islam. For Qur'anic texts these requirements were of profound significance.

The binding of a manuscript was considered a very important event. A description of the celebration organized by the Almohad king 'Abd al-Mu'min for the binding of a Qur'an imported from Córdoba is recorded by the historian al-Maqqarī in Nafḥ al- Ṭīb: "For this great occasion, he brought together the best artisans from all over the country—jewellers, specialists in setting precious stones, engineers, carpenters, decorators, engravers, binders, illuminators, calligraphers, heads of guilds."[8] The leather most commonly used for book covers was goatskin, and the decoration was accomplished with a variety of tools; the basic design was laid out by means of a compass and rulers.

It was during the Almohad period that the art of bookbinding reached a new height. Several Almohad bindings have survived;[9] they display designs of predominantly polygonal interlacing with goffering, heightened with gold dots. Stamping was also used. A remarkable Qur'an binding from this period, now in the Bibliothèque Royale in Rabat (No. 78), is square in format and magnificently engraved, gilded, and colored. The central motif is an eight-pointed star integrated into a surrounding square of strapwork, itself enclosed by three decorative borders, separated by thin bands left in reserve. This central design continued in use and became a characteristic feature of fifteenth-century Spanish and Mudejar bindings. Still applied by Moroccan artisans today, it is called Muthamman (which means composed by the number eight) because its basic element is the eight-pointed star. Another binding, long believed to be the earliest known western Islamic binding of its kind, exhibits the same kind of interlace pattern (Fig. 10). Here, however, the strapwork design appears reserved against a richly tooled background pattern, the whole again constructed around an eight-pointed star.

As one examines the concept of the "beautiful book" in Islamic culture, it becomes apparent that Islamic aesthetics cannot be separated from a way of being and a way of life. Before proceeding with his writing, the calligrapher performs his prayers, which end with an invocation that his art be worthy of the texts he is about to copy. The aesthetic value of manuscripts is not merely as "beautiful objects"; the praised qualities of writing, such as balance, elegance, and clarity, are directly connected, on several levels, to a particular code of behavior, from the actual sitting position to such attributes as patience, devotion, and

the search for inward perfection. The purity of writing reflects the purity of the soul. On each page the calligrapher seeks an intrinsic harmony of space, which in its turn seeks to be in coherence with the harmony of Creation. Because the Qur'an occupies a sacred place within Islam, the arts of the book—calligraphy, illumination, binding—have acquired a significance that elevates them above other Islamic decorative arts. So meritorious is the act of copying the revealed text that Muslim calligraphers would willingly devote their lives to it; the calligraphic pen, so much a part of the calligrapher's soul in life, was sometimes buried with him when he died.

Despite the printing press, Qur'an manuscripts are still copied by hand today, and a remarkably high standard of calligraphy has been maintained. Manuscripts of stunning magnificence end with a colophon expressing the humility and modesty of the calligrapher, mentioning, for example, that it was ''written with the perishable right hand of the servant of God.'' This is not only an expression of the relationship between the calligrapher and the manuscript but also a direct reflection of the calligrapher's relationship with his Creator.

1. Ibn Khaldūn 1967, vol. 2, p. 378.
2. One Qur'an, now in the Bibliothèque Nationale in Tunis (Al-Ahmadiyya 13727), is signed and dated Muḥammad b. Ghaṭṭūs, A.H. 564 (1168) in Valencia; the other Qur'an copied by the same calligrapher, now in the University Library in Istanbul (A 6754), is dated A.H. 578 (1182/3) in Valencia. Other surviving Qur'ans giving Valencia as the place of origin include one in the General Egyptian Book Organization in Cairo (No. 76), dated A.H. 557 (1162), and one in the library of the Great Mosque in Tétouan, Morocco (N.01), dated 1163 (A.H. 559).
3. These include a Qur'an in the British Library (Or. 1270) and another, on paper, dated A.H. 534 (1139/40), sold at Christie's, London, October 9, 1990, sale catalogue, pl. 46.
4. Other volumes that must be part of the same Qur'an include one in the Bibliothèque Générale in Tétouan, Morocco (Ms 884); one now in the Instituto de Valencia de Don Juan in Madrid; and two others in the British Library (Or. 12523 C, Or. 12523 D).
5. Lings and Safadi 1976, nos. 45, 46, p. 39.
6. The Qur'an in the Bibliothèque Nationale in Tunis (Al-Ahmadiyya 13727; see n. 2), written in the close-knit Andalusī script, was copied in Valencia only four years earlier than the Maghribī Qur'an, in 1168 (A.H. 564).
7. According to the Moroccan historian and traveler Al-Idrīsī (1100–1165 [A.H. 494–561]), as quoted by Sijelmassi 1987, p. 36.
8. Ibid., p. 37.
9. See Ricard 1933, pls. II–VIII.

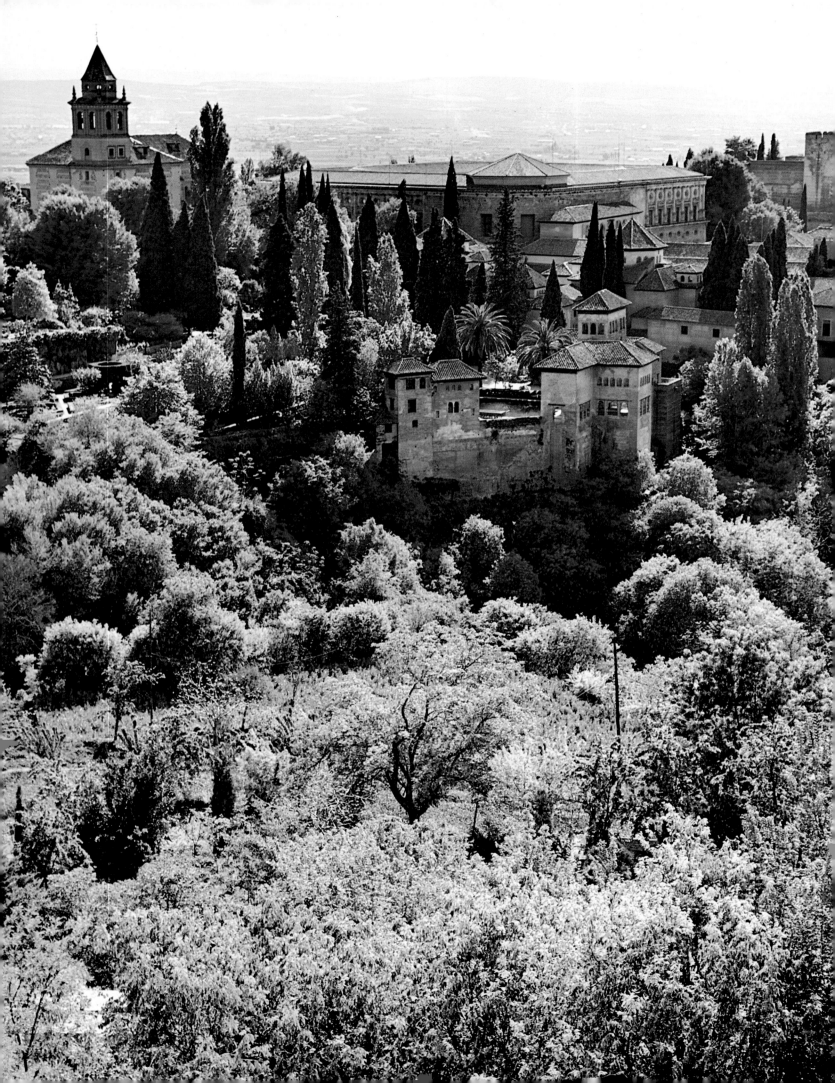

The Alhambra
An Introduction

DARÍO CABANELAS RODRÍGUEZ

Early History

The toponym "Alhambra" appears for the first time toward the end of the ninth century in the expressions *maꜤqil al-Ḥamrāʾ*, "refuge of the Alhambra," *ḥiṣn al-Ḥamrāʾ*, "fortress of the Alhambra," and *al-qalꜤa al-ḥamrāʾ*, "the red castle," a designation deriving from the color of the clay that was taken from the hill on which the building stood and that was used in constructing its walls.[1] Like all the walls of the Naṣrid Alhambra, these would initially have been whitewashed, although with the passing of time, the paint flaked to reveal the rusty color of the clay. The historical circumstances that prompted the first references to the Alhambra were the battles between the Arabs and the Muladies begun during the rule of the emir of al-Andalus ꜤAbdallah (r. 888–912 [A.H. 275–300]) and waged in the region of Elvira, a medieval entity roughly corresponding to the contemporary province of Granada. During one of those encounters, the Muladies defeated the Arabs under the command of Sawwār ibn Ḥamdūn al-Qaysī and forced them to take refuge in the red castle.

We may deduce from the number of combatants able to take shelter there that the proportions of the castle or fortress were relatively modest. Similarly, we know that its walls were not sufficiently solid to protect its defenders or, on several occasions, to prevent their defeat. It is reasonable to believe that the castle stood on the spot where the Torre de la Vela (Watchtower) is found today, that is, at the far west end of the hill the Arabs called the Sabīka, which later was entirely occupied by the Naṣrid Alhambra. The castle was for the most part abandoned during the first half of the eleventh century, but between 1052 and 1056 (A.H. 444–48) it was rebuilt, enlarged, and joined to the precinct of Granada by the Jew Samuel ibn Naghralla, vizier to King Bādīs of the Zīrid dynasty, for the purpose of protecting the Jewish quarter on the slopes of that same hill. The fortress was later improved by Bādīs's grandson and successor, Emir ꜤAbdallah, as he called himself in his memoirs.

The old Alhambra castle, reconstructed and enlarged, is mentioned throughout the twelfth century in Arab texts and Christian chronicles that recount battles waged by the emirs of al-Andalus against the Almoravids and, later, the Almohads. It is interesting to note that all those who laid siege to Granada succeeded in penetrating the castle of the Alhambra with little difficulty, whereas the combatants installed around the Alcazaba *al-qadīma* across the Darro confronted their attackers and successfully defended themselves. This evidence would seem to confirm that the latter complex, constructed by sovereigns of the Zīrid dynasty, was the larger and more efficacious stronghold.

The Naṣrid Alhambra

The founder of the Naṣrid dynasty, Muḥammad ibn Yūsuf ibn Naṣr ibn al-Aḥmar, was the scion of a noble Arab line established in Arjona (a province of Jaén). In 1232 (A.H. 630), with the support of family members, Ibn al-Aḥmar proclaimed himself sultan and rebelled against Ibn Hūd, a leader of humble

Alhambra, aerial view

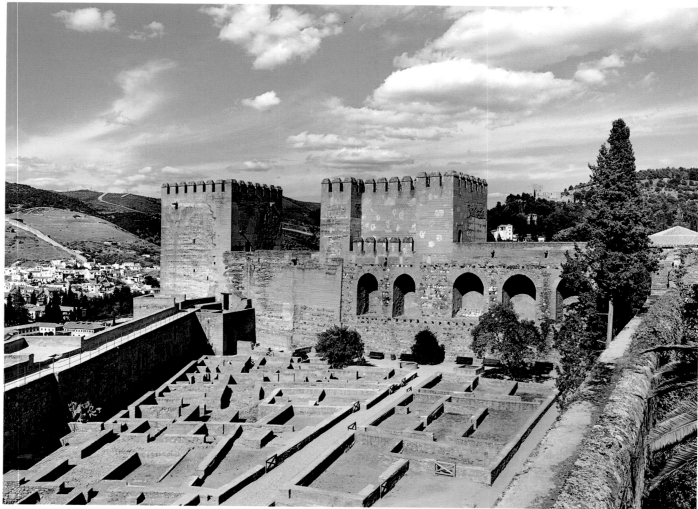

Fig. 1 Alhambra, Alcazaba

origins who had in part displaced the Almohads of al-Andalus. After seizing cities like Jaén, Guadix, Baza, and Córdoba—even, for a few days, Seville—from Ibn Hūd, Ibn al-Aḥmar declared himself a vassal of Ferdinand III of Castile and dedicated himself to consolidating the domains that were to become the basis of the Naṣrid kingdom.

When Muḥammad I ibn al-Aḥmar (r. until 1273 [A.H. 672]) peacefully entered the city of Granada in May 1238 (A.H. 636), he adopted as official residence the Palace of Bādīs near the Alcazaba al-qadīma in the area that later would be called the Albaicín. After only a few months, however, he undertook the construction of the new Alcazaba of the Alhambra, which, in its dimensions and fortifications, would be very different from the old red castle located there (Fig. 1). According to an Arab manuscript published as the Anónimo de Madrid y Copenhague, "This year [1238] ʿAbdallah ibn al-Aḥmar climbed to the place called

'the Alhambra,' inspected it, laid out the foundations of a castle, and left someone in charge of its construction. Before the year was ended, the building of the ramparts was concluded and water from the river had been brought to the site by means of a watercourse."[2] With remarkable vision, then, at the same time that work on the new Alcazaba was begun, an aqueduct that the Moriscos of the sixteenth century called the sultan's trench was constructed; water was channeled from a distant part of the Darro, at the necessary elevation, and descended to the Generalife (the summer villa), where it would serve both the Alhambra and the city below.

The project as conceived by Muḥammad I probably was not limited to the construction of a bulwark larger than that of the old red castle, with imposing defensive towers to the east and west. Drawing, perhaps, on the experience of earlier battles, and with a clear eye to the future of Granada, he must have had

in mind not merely a stronger fortress but also a true palatine city, recalling the examples of Madīnat al-Zahrāʾ and Madīnat al-Zāhira in the Córdoba of the caliphs. It is likely, however, that at the death of Muḥammad I, the Alhambra complex was not yet complete and, in particular, that a residence had not yet been built in the palatine zone—these are achievements attributed to the son of Muḥammad I, the emir Muḥammad II (r. 1273–1302 [A.H. 672–702]). We have reason to believe that the father may have lived in the Torre del Homenaje (Tower of Homage) (Fig. 2) of the Alcazaba itself and that he later occupied a relatively modest house on the site of the present Palacio de Carlos V.

There is little question that during the reign of Muḥammad II the Alhambra was steadily transformed from a fortress into a palatine city (Fig. 3), an undertaking completed with the addition of buildings constructed by his son Muḥammad III (r. 1302–9 [A.H. 702–9]). We suppose that the Alcazaba and a good part of the upper city, along with the Puerta del Vino (Wine Gate) (Fig. 3, p. 156)—which was subsequently remodeled—the house to the south of the Palacio de Carlos V, the Rauda—the royal necropolis conceived by Muḥammad II—and the Palacio de los Abencerrajes, had already been planned in the thirteenth century. Amplification and renovation later undertaken by Muḥammad III, Ismāʿīl I, Yūsuf I, and Muḥammad V, however, greatly changed that primitive Alhambra, which unquestionably was not as grand as the Alhambra we know today.

It is not always easy to establish the chronology for each of the parts of the Naṣrid Alhambra. Most of the ornamentation that adorns the walls and false arches is of plaster. Because this material deteriorates easily, it was often patched or replaced. Consequently, the inscriptions and the style of the embellishments help us to date only the superficial layers of the plaster on which they appear. Thus, we cannot accept the names of sultans that we see in the inscriptions as authentication of the dates of the walls but only of the ornamentation itself. Moreover, the walls themselves, particularly those built during the period that Naṣrid art was at its apogee, do not vary appreciably in appearance.

The Partal, which was constructed on ramparts that had already ringed the precinct of the Alhambra for a century, seems to be the oldest residential retreat of any of those surviving in the Casa Real (Royal Palace). As Basilio Pavón Maldonado has demonstrated, the Partal is the work of Muḥammad III.[3] Yūsuf I (r. 1333–54 [A.H. 734–55]) later added the small Muslim houses and the nearby Oratorio, which were also erected on the outer wall of the complex.

From evidence found in the poetry of Ibn al-Khaṭīb, we know that Muḥammad III was also responsible for the Mezquita Real (Royal Mosque) of the Alhambra, with its beautiful decoration of mosaics and silver lamps, and for the bath facing it, which he financed with tribute imposed upon the non-Muslim subjects of his kingdom. The mosque—in which Yūsuf was murdered by a slave on the last day of Ramadan (October 19, 1354 [A.H. 755])—occupied the site on which the church of Santa María de la Alhambra was later built, although the church did not share the same orientation. The bath was partially destroyed in 1534 (A.H. 941) and was reconstructed by the architect Leopoldo Torres Balbás in 1934.

A number of architectural projects of Ismāʿīl I would later be modified or totally replaced by his son Yūsuf I and his grandson Muḥammad V (r. 1354–59; 1362–91 [A.H. 755–61; 764–94]). Among them is the primitive Mexuar, or the administrative and judicial seat, according to an inscription that survived his son's alterations and the total remodeling and enlargement carried out by Muḥammad V when he built his new Mexuar. Muḥammad's Mexuar was constructed on the site of the present Mexuar, and not where the Sala de las Dos Hermanas (Hall of the Two Sisters) is located, as Emilio García Gómez has argued.[4] In fact, the verses inscribed in the wood frieze above the

Fig. 2 Alhambra, Torre del Homenaje

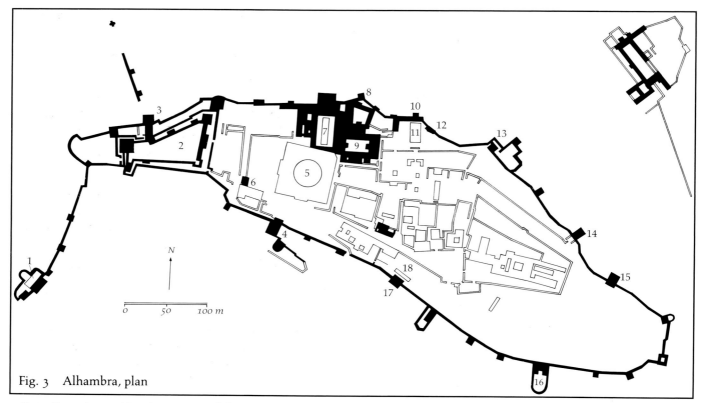

Fig. 3 Alhambra, plan

1. Torres Bermejas; 2. Alcazaba; 3. Puerta de las Armas; 4. Puerta de la Justicia; 5. Palacio de Carlos V; 6. Puerta del Vino; 7. Patio de Comares (Palacio de Comares); 8. Torre del Peinador de la Reina (Torre de Abū'l-Ḥajjāj); 9. Patio de los Leones (Palacio de los Leones); 10. Torre de las Damas; 11. Partal; 12. Oratorio; 13. Torre de los Picos; 14. Torre de la Cautiva; 15. Torre de las Infantas; 16. Puerta de Siete Suelos; 17. Torre de los Abencerrajes (Torre de la Contaduria) 18. Palacio de los Abencerrajes

entrance to the present Mexuar clearly allude to Muḥammad V. Similarly, the bath in the Comares palace is the work of Ismāʿīl I, although it underwent major renovations at the hands of Yūsuf I and minor changes by Muḥammad V.

The remaining buildings of today's Alhambra were the responsibility of the two great builders of fourteenth-century Granada, Yūsuf I and Muḥammad V. The epoch of the latter was unquestionably the more brilliant, refined, and receptive to influences outside the Naṣrid reign.

The works of Abū'l-Ḥajjāj Yūsuf I, who is called the wise king of the dynasty because of his superb education and broad culture, are distinguished by their solidity and evident majesty. The best representation of their style is found in important towers he enlarged and improved along the Alhambra wall, such as the Comares, which houses the splendid hall of the same name, and the Picos (Spiked), Cadi, also called Candil, and Cautiva (Captive) towers. Characteristics of their construction and ornamentation, rather than the texts of the inscriptions found on them, identify them as Yūsuf's work. In fact, the Puerta de

la Explanada (Gate of the Esplanade), today called the Puerta de la Justicia (Gate of Law) (Fig. 4), is the only structure from Yūsuf's era that can be dated with precision, since it has an inscription above the interior arch that clearly indicates that it was completed in June 1348 (A.H. 749).

The gate today known as the Siete Suelos (Seven Floors) also was built during the reign of Yūsuf I. It is located on the south of the Alhambra hill and is related in structure to the Puerta de la Justicia. The Siete Suelos was seriously damaged by French troops as they retreated from Granada in 1812 but recently underwent a restoration that incorporated all its extant elements. Yūsuf I was responsible as well for the Torre de Abū'l-Ḥajjāj (Fig. 5), a tower that houses what is today called the Peinador de la Reina (Queen's Dressing Room), which Muḥammad V completed after reclaiming his throne in 1362.

A problem arises regarding the attribution of buildings credited to the initiative of Muḥammad V during his brief first and his longer second reign. We must determine which works begun by his father he merely completed (some are alluded to above) and

which he razed—he preserved only the most structurally sound—and entirely rebuilt. To aid in clarifying this question, we have three dates that serve as points of reference.

We know that when Muḥammad V regained his throne in 1362, he completed the Torre de Abū'l-Ḥajjāj, a tower nearly finished by his father. Second, we learn from a poem written by Ibn al-Khaṭīb and inscribed on the new Mexuar that its construction was concluded in 1365 (A.H. 767). (It survives today, although with a number of modifications, and, to repeat, in the location occupied by what we now call the Mexuar and not the Sala de las Dos Hermanas.) Third, certain verses by Ibn Zamrak, such as those carved in the wood frieze of the Comares facade, or the poem inscribed in the north and south galleries of the Patio de los Arrayanes (Court of the Myrtles), further refine our chronology because they allude to the taking of Algeciras, in 1369 (A.H. 771), by Muḥammad V. From the evidence of the above dates, we may suppose that the works begun by Muḥammad V with a view to creating a new Alhambra of his own design were pursued with increasing rapidity in the Patio de los Leones (Court of the Lions) and the four halls that surround it.

We may, then, conclude that the Alhambra complex acquired its present outlines during the last third of the fourteenth century, perhaps by October of either 1369 or 1370 (A.H. 771 or 772), as Muḥammad V completed his principal architectural projects at about that time. In 1369 King Peter of Castile, who had enjoyed a long alliance with the sultan of Granada, was killed on the field of Montiel by his stepbrother Henry, thus ending the years of peace that had permitted Muḥammad to devote himself completely to construction within the Alhambra.

The resources available to the successors to Muḥammad V for the renovation of palaces gradually dwindled. Moreover, the Naṣrid dynasty declined apace throughout the fifteenth century, during which there were twelve sultans—some of whom took the throne at least four different times. These factors, together with the presence of internal strife and constant danger on the frontiers, explain why work on the Alhambra was not continued after the reign of Muḥammad V. Of the twelve sultans, we call attention only to Muḥammad VII (r. 1392–1408 [A.H. 795–811]), who inaugurated his reign with the construction of the Torre de las Infantas (Tower of the Princesses). In this tower Naṣrid art, which had achieved its supreme flowering in the fourteenth century, readily reveals its decadence.

The magnificent fortified complex of the Naṣrid Alhambra, which Torres Balbás likened to "an enormous boat anchored between the mountain and the plain,"[5] was never directly attacked. The incursions that had approached Granada for more than two centuries had always stopped short of the city walls. With the campaign begun in 1491 by the Catholic sovereigns, however, Granada itself fell under siege, and on January 2, 1492 (A.H. 898), Muḥammad XII (Boabdil) surrendered the city to Ferdinand and Isabella.

The Christian Alhambra
The Alhambra is the only palace that has remained from the Muslim Middle Ages nearly intact and

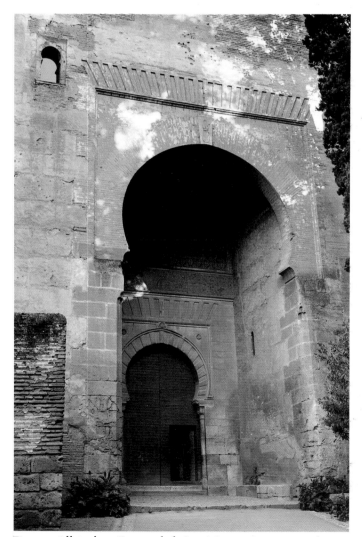

Fig. 4 Alhambra, Puerta de la Justicia

relatively well preserved. It survived because the entire complex became a part of the royal patrimony; the king and queen declared it a Casa Real, a royal residence, and took it upon themselves to preserve its fragile buildings. Had that not been the case, the Alhambra quickly would have been reduced to a pile of ruins. It was the wish of the triumphant Catholic sovereigns to keep the Alhambra intact as eternal testimony to the conquest. They not only ordered intensive repairs, calling upon the services of Morisco artisans well trained in their crafts, but also placed the Alhambra under special jurisdiction, with its own garrison, and appointed as warden Iñigo López de Mendoza, the count of Tendilla, who claimed the office as a hereditary privilege of his house. With zeal matching that of her parents, Queen Joan issued a royal decree from Segovia dated September 13, 1515, and directed to the rulers of the kingdom of Granada; in it she assigned to the Alhambra fines collected by the Cámara y Fisco of Granada to be applied to the conservation of its walls, towers, and palaces. "The Casa Real," reads the document, "this sumptuous and excellent edifice, shall so remain because the wish of my lords the said king and queen [Ferdinand and Isabella], and my own, has always been, and is, that the said Alhambra and Casa be well repaired and maintained, in order that it stand forever as a perpetual memorial ... and that such an excellent memorial and sumptuous edifice as this not fall into disrepair and be lost." It is not only the royal family, however, but also the faithful workmen and craftsmen who generation after generation have provided exceptional care for this singular monument. It is they who have assured that the Alhambra not fall into ruin but remain a living organism, despite the unstable circumstances of its history during the Christian epoch.

When Emperor Charles V arrived in Granada in 1526, following his wedding in Seville to Isabel of Portugal, he decided to construct his palace within the Alhambra. To do that, it was necessary to remove from the south part of the Patio de Comares a room similar in structure to that of the Sala de la Barca (Hall of the Blessing) on the north. After the Moriscos rebelled, the *farda*, the tax the emperor had set aside to fund the conservation of the Alhambra, became for all practical purposes null and void. In 1581, therefore, Philip II ceded six thousand ducats of the revenues

from Sevillian sugar, as well as income from several properties located in the old kingdom of Granada, for that purpose.

The monarchs of the house of Austria continued to demonstrate their concern for the Alhambra until the arrival of the eighteenth century and its attendant change of dynasty. In 1717 Philip V stripped the marquess of Mondéjar—a descendant of the count of Tendilla's—of his ancestral privilege as punishment for his support of Archduke Charles of Austria in the war for succession to the throne of Spain. The Alhambra was soon thereafter deprived of more than the authority and concern of that custodial family; in 1750 Ferdinand VI claimed for himself the resources that had been levied for its maintenance. Later, however, Charles III ordered a review of the status of the Alhambra and of the state of its stewardship. Ultimately, Charles IV determined that it should be the responsibility of the crown to levy an annual sum for the most urgent repairs.

When Napoleon's troops occupied Granada, they established their barracks in the Alhambra and, although they made certain improvements, when they were forced to flee the city in 1812, they dynamited all the towers. The total destruction of the towers was prevented only by the daring of a Spanish soldier who severed the fuse that linked all the defensive constructions along the ramparts. Pleas for repair of those damages, as well as of the ravages of time, were submitted to the government by, among others, the writer Washington Irving, who set up residence in the Alhambra upon his arrival in Granada in 1829. A year later, Ferdinand VII assigned a fixed sum for the upkeep of the buildings; this money subsequently was augmented by the queen regent María Cristina and, in turn, by her daughter, Isabella II.

The revolution of 1868, in which Isabella II lost her throne, marked an important change in the legal status of the Alhambra: The state attached all the assets of the Patrimonio Real and transferred the jurisdiction of the Alhambra from the crown to itself, declaring the entire complex a national monument in 1870. As a consequence of this change, a fixed sum was appropriated for the care of the Alhambra as part of the operating budget of the state; this sum, which has been increased steadily over the years, has provided the necessary support to ensure its preservation.

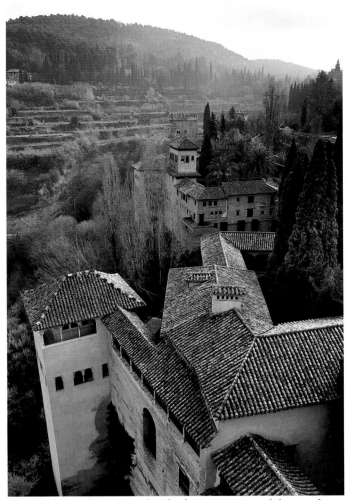

Fig. 5 Alhambra, Torre de Abū'l-Ḥajjāj (Torre del Peinador
de la Reina)

1. It is not possible to say whether buildings existed on the site of the
 present Alhambra during the time of the Romans and Visigoths.
 Although scattered architectural fragments and a few stones with
 Latin inscriptions have been found, they probably were brought
 there from the hill on the other side of the Darro River, the location
 of the forum of the Roman municipality of Iliberri, which became
 the seat of an ecclesiastical province in Visigothic Spain. During the
 period of Arab domination, the name Iliberri was adapted to Ilbira
 (Elvira). In the eleventh century the emirs of the Berber dynasty of
 the Zīrids maintained a residence there; Elvira was also the location
 of the Alcazaba that the sixteenth-century Moriscos called *qadīma*,
 that is, "old," to differentiate it from the Alcazaba built during the
 era of the Naṣrid Alhambra.

 Few traces of the pre-thirteenth-century Alcazaba are visible
 today. There remain only portions of foundations and patches of
 masonry in walls— especially on the northeast side—that served as
 the base for new fortifications erected by the Naṣrids. These traces
 of walls are made of hard mortar and contain rounded stones
 (vestiges of construction employing these same kinds of stones with
 framing bricks are found in towers near the present wall of the
 Alhambra). The remnants suggest that the primitive fortress must
 have projected a sense of impressive austerity.
2. Huici Miranda 1917.
3. Pavón Maldonado 1975b, pp. 115–95, esp. p. 120.
4. He presents his thesis in his commentary on a 1362 text of Ibn
 al-Khaṭīb, which he edited and translated in García Gómez 1988; see
 esp. pp. 75–81.
5. According to Terrasse 1965a, p. 1016.

In 1905 the maintenance of the Alhambra was
consigned to a special commission, which in 1913 was
replaced by a Patronato within the Dirección General
de Bellas Artes del Ministerio de Instrucción Pública
(later the Ministerio de Educación Nacional). In 1944 a
new Patronato was formed; this operated, with slight
modifications, as a dependency of the Ministerio de
Cultura until it was disbanded in 1985. At that time
responsibility for cultural events and services, in-
cluding those pertaining to the Alhambra and the
Generalife, was transferred to the Comunidad
Autónoma de Andalucía. Finally, after a commission
established for the purpose temporarily performed
these functions, an autonomous body, administrative
in nature, was appointed in December 1985. This is
the Patronato de la Alhambra y Generalife, which
today discharges all the responsibilities that have been
transferred to the Comunidad Autónoma de Andalucía.

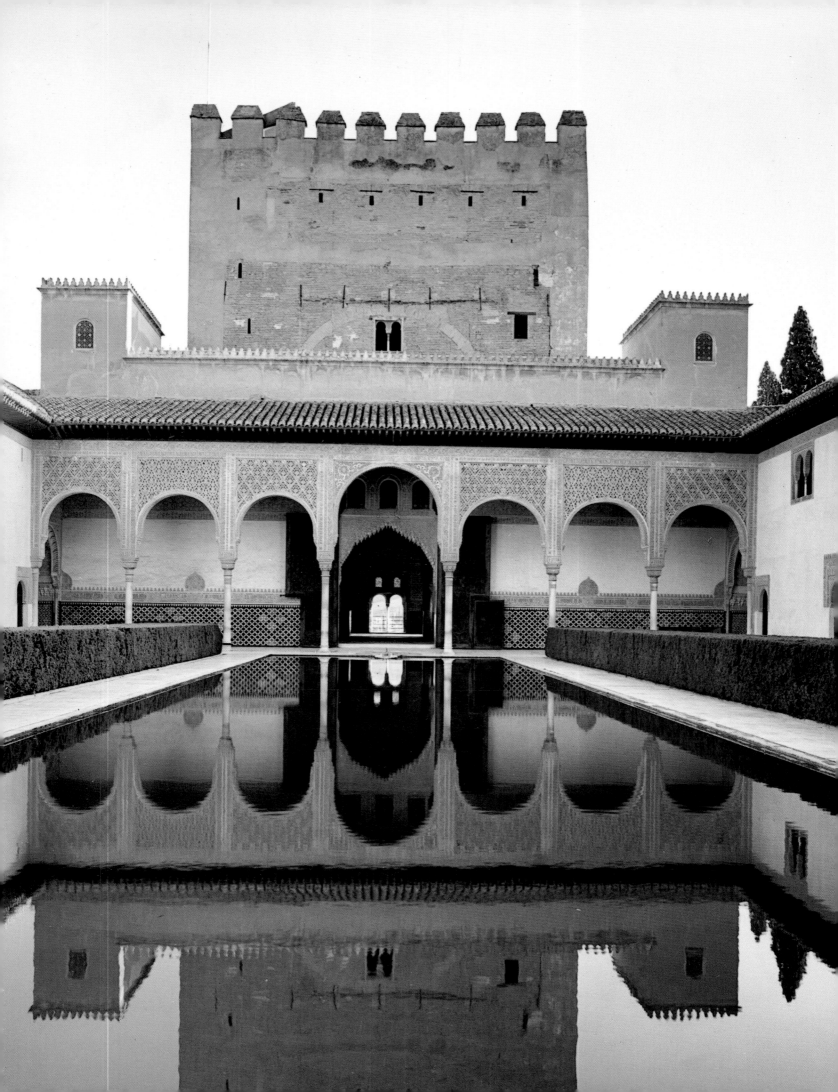

The Palaces of the Alhambra

JAMES DICKIE
(YAQUB ZAKI)

The Alhambra was a palatine city (Madīnat al-Ḥamrāʾ) that embraced a diversity of functions, only one of which was residential. It was the royal city, as distinct from the bourgeois city (Madīnat Gharnāṭa) on the plain beneath, and represents the world of power as much as the world of beauty: the plastic arts, poetry, and music. Viewed in terms of function, the Alhambra becomes a text that demands interpretation.

The enclosure contained no fewer than six palaces, in addition to two circuit towers adapted to domestic use. Of these palaces, five occupied by the Naṣrid dynasty were grouped in the northeast quadrant, forming a royal quarter. All five had a northern aspect and were either perched on the edge of the escarpment to avail the view or crowned rises in the terrain where the circumvallation dipped to reveal a view. Four of the six palaces were virtually demolished between 1492 and 1812, while the two that substantially remain, the Palacio de Comares and the Palacio de los Leones (Palace of the Lions), survived as an annex (the Casa Real Vieja [Old Royal Palace]) to a Renaissance palace that was never completed, the Palacio de Carlos V.

With the exception of a few open spaces within or adjacent to the palaces, the entire area was congested, like Granada itself, with narrow, twisting streets and labyrinthine alleyways; indeed, the Alhambra was even more densely urbanized than any part of Granada save the medina because it lacked suburbs into which to expand. These streets and lanes communicated with the palaces, which were seldom visible from without since they focused on an internal courtyard, or system of courtyards, depending on the complexity of function.

Palacio de Comares

The formal approach to this palace is now obscured by the transformations the site has sustained over five centuries, and the route the visitor takes today is not the original one but a misleading sequence of rooms, courtyards, and galleries arranged with little thought to archaeological accuracy. Windows have been converted into doors and beds used as passageways. Even the original mode of entry into the Mexuar (Arabic mishwār: council [chamber]) (Fig. 2), the first room the visitor enters, cannot now be determined with accuracy.

Begun by Ismāʿīl I, continued by Yūsuf I, and completed by his son Muḥammad V in 1370 (A.H. 772), the Palacio de Comares was the official seat of the sovereign, although the dynasty had other palaces, inside and outside the Alhambra. As the main palace, Comares's primary function was to house the executive power, which was closely linked to the judicial and administrative functions. Both of these functions were accommodated in the ancillary courtyards arranged as an enfilade forming grades of ascent toward the royal gate on the south side of the Patio del Cuarto Dorado (Court of the Golden Room). The purpose of this latter court was to separate the regnal and the administrative functions.

Thus the main courtyard of the palace, the Patio de Comares, alternatively known as the Patio de los Arrayanes (Court of the Myrtles) (Fig. 3), was the nucleus of a series of courtyards accommodating specific functions with their corresponding bureaucracies. Taken in sequence, these courtyards made up a parade, marking stages in a progressive disclosure culminating in the sultan's presence. The Presence manifested itself in two ways: publicly in one of the

Alhambra, Patio de Comares, looking north

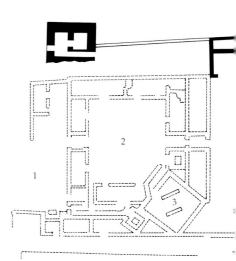

courtyards, the Patio del Cuarto Dorado (Court of the Golden Room) (really a courthouse) (Fig. 4); and privately in an audience hall, the Salón de los Embajadores (Hall of the Ambassadors) (Fig. 5), attached to the sultan's private apartment in the palace, which opened off the main courtyard. Thus the Patio del Cuarto Dorado forms a transition between public dependencies and a private place of residence, so that the palace proper begins only after this point and is entered through an example of the crooked gateway that is characteristic of Naṣrid military planning.

This gateway opens in a facade intended as a dramatic backdrop for the sultan's occasional presence, when he was within sight and reach of his subjects while hearing a legal case in person. Routine litigation was left to the qāḍī (judge) of the Alhambra, whose apartment lay adjacent to the Cuarto Dorado, with stairs leading up to it from where the porter's lodge now stands. The qāḍī's jurisdiction was limited to the royal city; the city of Granada enjoyed a separate jurisdiction, except for the Alcaicería (textiles market), which, as a royal (industrial) estate, was administered by a sub-qāḍī appointed by the qāḍī of the Alhambra.

Contrary to all popular belief, the Palacio de Comares has a facade, but it is an internal one.

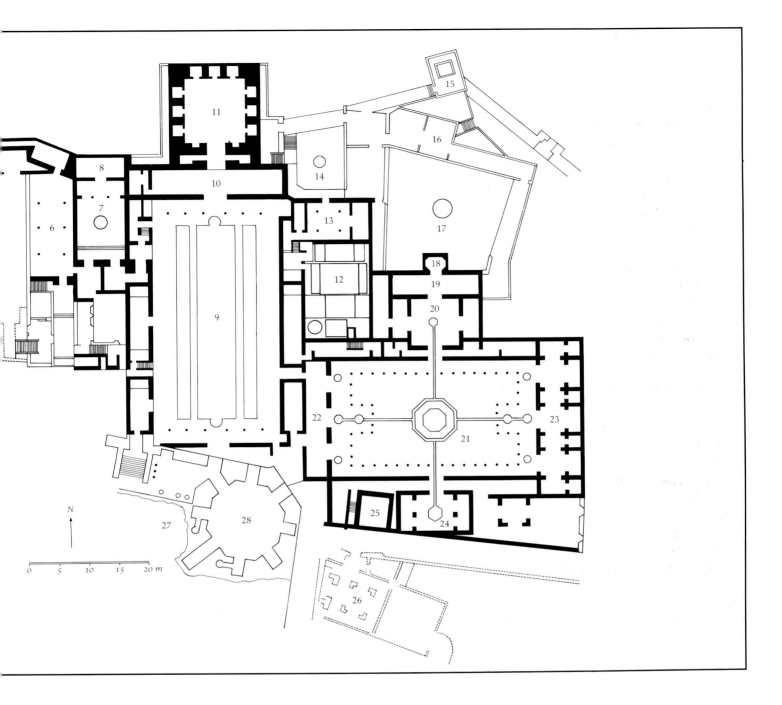

Occupying the south side of the Patio del Cuarto
Dorado, this facade is the most highly decorated wall
in the entire Alhambra. The three remaining walls are
plain so as to focus attention on the facade and the
importance of the person seated in front of it. The
twin doors in this facade were designed to confuse an
assailant. Originally, the right door led nowhere,
while the left one led to the sultan's private quarters.
A feature of Hispano-Arab architecture, the bifur-
cated entrance, rather than a bifurcation of the
entrance, is a bifurcation of the route. Equidistant
between the two doors and canopied by the widest
eave in the Alhambra stood a temporary throne,

probably a scissors-type chair of the style preserved in
the Museo Nacional de Arte Hispanomusulmán in the
Alhambra. The axiality of the sultan's position re-
peats the axiality of more formal occasions in the
Salón de los Embajadores, where the throne, as con-
firmed by an inscription, occupied the central
embrasure in the north side.

In the east a canopy is an attribute of divinity
or of royalty. The depth of the canopy in this case
corresponds to the lowermost of three steps that
suppliants would approach to present a petition or
address the sultan, whose throne was thus elevated
above the level of the courtyard. The wide eave

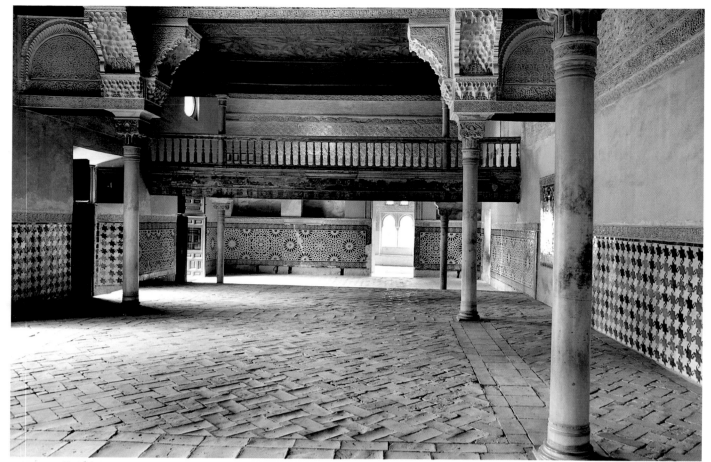

Fig. 2 Alhambra, Mexuar

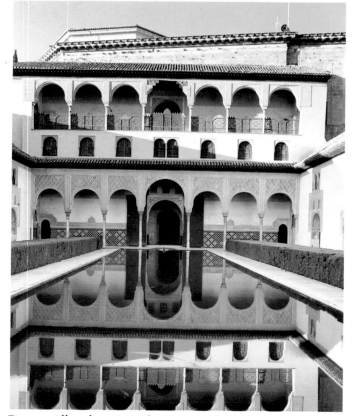

Fig. 3 Alhambra, Patio de Comares, looking south

functions practically as well as symbolically, to shade the sultan and to protect the plane surface of the facade that supplied the dramatic backdrop to his presence. Beside him would stand the hajib, or chamberlain (the court dignitary in charge of the *hijāb*, a screen, physical or metaphysical, that interposed between a ruler and his subjects). Petitioners or litigants stood in the Cuarto Dorado, which had the function of a waiting room. Designed to overawe the petitioner, visually impressing him with the power of royal authority, the facade also operates symbolically: It is a royal porch, the entrance to the seat of power, overwhelming a suppliant in the same way that the Puerta de la Justicia, or Puerta de la Explanada (Gate of the Esplanade)[1]—the entrance to the Alhambra city from the countryside—overwhelmed the stranger because it straddles the route taken by foreign embassies.

The Salón de los Embajadores is contained within the Torre de Comares (Comares Tower). It was reserved for state occasions, such as the reception of envoys or other persons of rank. The hall is based on the conventional 3 x 3 module; it is, in fact, simply a

dilated mirador. Paved in blue and white tiles garnished with gilt, the floor originally gleamed like porcelain, matching the brilliant polychromy of the walls and dado. No floor tiles remain in situ, but some surviving specimens are in the Alhambra museum and still gleam like porcelain when immersed in water; a few even retain a delicate gold arabesque.

Unique to the Muslim world, as far as we know, were floor tiles in the Alhambra inscribed with the name of God. They bore the dynasty's motto, *There is no conqueror but God*, which is reiterated in faience or plasterwork all over the Alhambra. These tiles, on which no one would ever stand, occupied the center of the floor, directly under the apex of the ceiling. Dario Cabanelas Rodriguez's researches have established that the ceiling of the Salón de los Embajadores is a schematic representation of the seven superimposed heavens of the Muslim cosmos (Qur'an 67:3), above which stands the throne of God.[2]

Whenever the earthly sovereign seated himself on the throne occupying the central bay on the north side of the hall, he was covered and protected by this canopy. A proper Muslim ruler never styled himself "king," which would be an encroachment on God's sovereignty, but only "sultan" (the root s-l-t conveys the notion of *delegated* authority). He recognized that his power derived from the Sharīʿa, the divinely revealed Law; indeed it was the application of this law that legitimized his rule. There extended, therefore, an axis from floor to ceiling, the vertical axis of the spirit (as opposed to the horizontal axis of the phenomenal world), making this huge interior a microcosmic reflection within which the ruler had his place. The Salón de los Embajadores was intended as a setting for monarchy. The symbolic allusion in the design of the ceiling to the sixty-seventh chapter of the Qur'an, the sura *al-Mulk*, "The Kingdom," is the Naṣrid equivalent of the Umayyad dynasty's use of the word *mulk* on the walls of Madīnat al-Zahrāʾ outside Córdoba.

The main court contained five houses, or self-contained dwellings, in addition to a service block and throne hall. The sultan's private apartments were on the north side of the patio and comprised summer quarters on the ground floor and winter quarters in the tower above, with a window on the main axis. The name of the ground-floor apartment, the Sala de la Barca (Hall of the Blessing), derives from the repetition

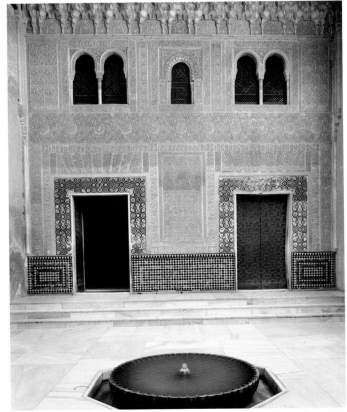
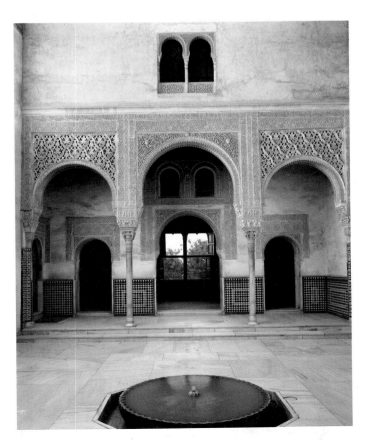

Fig. 4 Alhambra, Patio del Cuarto Dorado: left, south wall; right, north wall

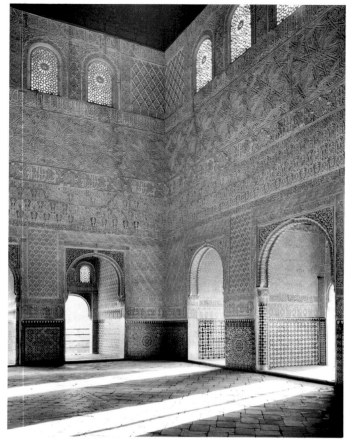

Fig. 5 Alhambra, Salón de los Embajadores

of the word *baraka* (blessing) on the walls.[3] Folding doors, now restored, closed off the room and ensured privacy. At either end of this room is an alcove (*al-qubba*), or bed recess. Originally the alcoves had flat roofs; the present arrangement, which includes the two turrets whose windows light the alcoves through pierced ceilings, dates only from the restoration by Rafael Contreras after the fire of 1890. The alcove on the west was equipped with a privy, whose long disuse has been the secret of its preservation, for the walls retain their original painted dadoes. The corresponding alcove (*jawāb*) on the east had its function disguised by the later insertion of a door giving access to another courtyard, the Patio de la Reja (Court of the Screen), and to the baths.

Further problems of restoration are evident in another doorway in the east side of the wall separating the Sala de la Barca from the Salón de los Embajadores. This doorway was, in fact, the mihrab (prayer niche) of the sultan's private oratory (*muṣallā*). Mistaking it for a blocked-up doorway, the archaeologist Leopoldo Torres Balbás cut through the wall at this point. Sub-

sequent restorers, recognizing the mistake, closed it off again by inserting iron bars across the opening. The result is that it now functions as neither a mihrab nor a doorway.[4] Opposite this oratory a stairway leads to the sultan's winter quarters upstairs.

The tower on the perimeter wall of the palace that houses the Salón de los Embajadores also functioned as the mirador of the sultan's suite. The name of this tower, and the palace, comes from the Arabic place-name Qumārish (Comares). In a work published in 1608, Francisco Bermúdez de Pedraza claimed that the artisans who worked on the tower may have come from the fortress town of that name; the same story was repeated by Hurtado de Mendoza in 1627.[5] Externally, the tower operates, like the Puerta de la Justicia, as yet another symbol of royal authority, while internally, its bulk is aestheticized by being reflected in the large pool in the Patio de Comares (Fig. 3). This vast expanse of water served to cool the important apartments bordering the courtyard, while the garden kept the atmosphere fresh. Only the myrtle bushes (replanted by Contreras) remain, but there were citrus trees as well, exactly as in the courtyard of the Palacio de los Leones.[6]

The facilities most in use by the sultan—an oratory for his devotions, a washroom for his personal hygiene, a bathhouse for his relaxation, a separate courtyard (the Patio del Cuarto Dorado) for his adjudication, and a hall for his audiences (the Salón de los Embajadores)—all lay adjacent to his private apartment. The courtyard of tribunals is small because the number of litigants was restricted, whereas the throne hall had to be large to accommodate an entire court as well as, on occasion, an ambassador and his suite. The arrangement is a curious and not entirely satisfactory one, considering that the hall is only accessible from the sultan's private quarters, which would have to be traversed by anyone attending an audience. One would like to know more, but too little of the palace architecture of Muslim Spain survives to enable us to trace antecedents or make comparisons. The fact that one and the same court accommodated private and official functions must have posed numerous problems of protocol.

Symmetrically disposed on the east and west sides of the Patio de Comares were apartments for the sultan's four wives (the maximum number permitted by Islamic law). The south side was reserved for service

and concubinage. Like the sultan's apartment, each of the wives' apartments comprised two floors, one summer and the other winter quarters. Each room terminated in lateral alcoves, and each apartment had three doors: a large one in the center and two smaller ones off to one side, one admitting to the stairs, the other to a privy concealed in the hollow of the staircase. In the harem quarters on the south side, the doors have been replaced, but in the four lateral chambers not even the sockets in which the doors turned survive to show that these were private apartments, although the apartment in the southeast corner still has the wooden sockets on the wall.

To the northeast of the Patio de Comares, in an extensive underground annex, are the baths. Although their chronology is confused, they probably go back to the time of Ismāʿīl I (r. 1314–25 [A.H. 714–26]). The epigraphic evidence is inconclusive. A misleading reference to Muḥammad V in the Sala de las Camas (Hall of Repose) proves on examination to date from the nineteenth century, when a restorer substituted a calque of a contemporary inscription for an original Qurʾanic one. The gaudy polychromy was added in 1866. This hall probably dates from the time of Yūsuf I (r. 1333–54 [A.H. 734–55]), whose name appears on a marble plaque framing a niche in the east wall of the caldarium.

Torres Balbás attributes the hall to Yūsuf on stylistic grounds but assigns the vaulted portions of the complex to Ismāʿīl on the basis of the style of the capitals.[7] While it seems reasonable to credit Ismāʿīl with the baths, their proper relationship to the remainder of that monarch's palace cannot now be determined, for they communicate with the Patio de Comares through an addition (the Sala de las Camas) dating from the time of Yūsuf. The junction between baths and courtyard is so adroitly handled as to leave little doubt that the latter is also the work of Yūsuf, albeit modified by his son, for the upper level of the part of the baths added by Yūsuf corresponds to the ground level of the courtyard.

Islamic baths were modeled after Roman baths, but they lacked a frigidarium; because of the immodesty involved, swimming never became a Muslim sport. The Sala de las Camas forms an apodyterium, which is followed by a tepidarium and two caldaria, the second with hypocaust beneath. The last compartment, separated from the others by a flimsy partition,

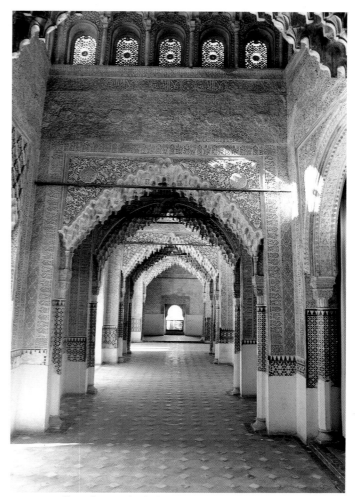

Fig. 6 Alhambra, Sala de los Reyes

is the furnace room, where a great copper boiler sat atop a stove.[8] The partition kept out the smoke, and the boiler supplied the tanks. Both hypocaust and hot-water system were wood fired. The baths were Turkish, that is, vapor, baths but with tanks that were converted to immersion usage after the conquest.[9]

A small doorway set inconspicuously into the northeast corner of the Patio de Comares, matching the doorway of a sultana's apartment directly opposite, admitted to the bath attendant's humble abode; a somewhat larger one a few paces south served persons of rank. This entrance fell into desuetude after the conquest, when a new one from the Patio de la Reja (Court of the Screen) was inserted on the subterranean level in the time of Charles V. Since a bath is one of the amenities missing from Charles V's palace, it may be that the Muslim baths were a factor in that monarch's decision to retain the conjoined palaces as an annex.

Palacio de los Leones

Unlike the Comares palace, the Palacio de los Leones did not conclude a parade but was entered through a gateway opening inconspicuously off a street, since it was never intended for ceremonial purposes. It dates from the second reign of Muḥammad V (1362–91 [A.H. 764–94]). The Leones complex cannot be dated with the same precision as Comares, but work on it would not have started until the main palace was finished in 1370, and 1380 has been plausibly advanced as the date for its completion.[10] The architect chose for it a ground plan resting on organizational criteria altogether different from those of the Comares palace. Here the main architectonic elements are grouped around a courtyard based on two intersecting axes. The arcaded court represents a fusion of the Ancient peristyle and the Persian *chār-bāgh*. This court includes such amenities as pavilions, water channels, and a fountain, the supports of which have provided the name by which the complex has become known to the world, the Patio de los Leones (Court of the Lions). The fountain recovered its original appearance in June 1965 with the removal from the haunches of the lions of the dwarf columns that had been added by Diego de Arcos in 1708. Torres Balbás had already removed the upper basin.

The plan of the palace, whereby one enters a peristyle directly, is that recommended by Vitruvius for a villa. Although furnished with sleeping facilities in the usual form of alcoves, apart from a small, self-contained house on the upper floor totally invisible from without, this palace was not intended for anything like permanent occupation. It was a *villa rustica* transposed to an urban setting so that the inmates of the official palace (Comares) alongside could relax away from the constraints of protocol. Thus only the essence of villa living survives, shorn of the economic apparatus that normally makes such a life-style feasible; consequently, the ground plan and overall arrangements reflect the informality of country life.

A villa in the heart of a city cannot have a serious purpose, and the Leones palace is a simple pleasure

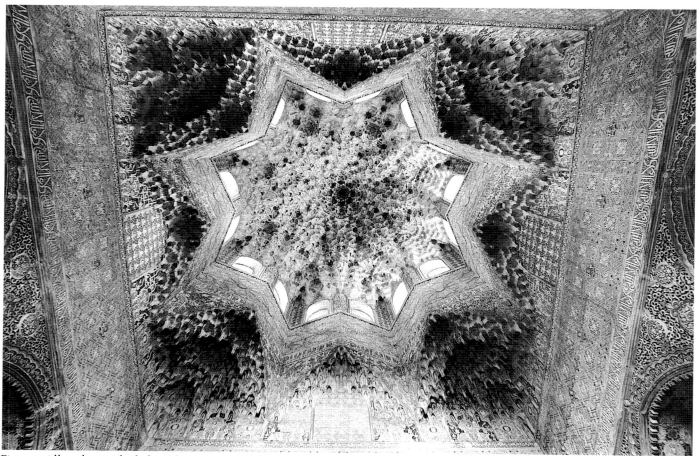

Fig. 7 Alhambra, Sala de los Abencerrajes, ceiling

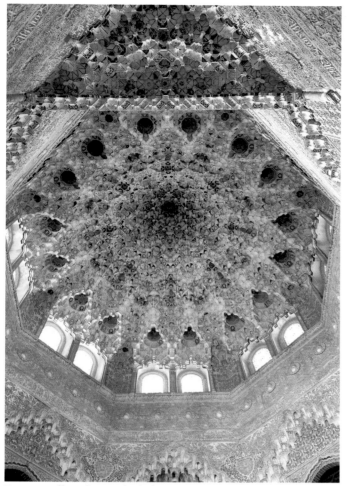

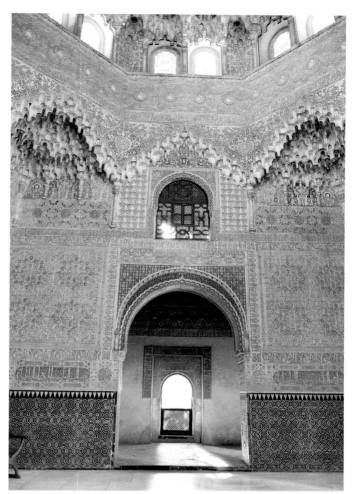

Fig. 8 Alhambra, Sala de las Dos Hermanas, ceiling

Fig. 9 Alhambra, Sala de las Dos Hermanas

dome with four reception halls, all for entertainment purposes, one doubling as a residential unit. These four halls—the Sala de los Reyes (Hall of the Kings), the Sala de las Dos Hermanas (Hall of the Two Sisters), the Sala de los Mocárabes (Hall of the Muqarnas), and the Sala de los Abencerrajes— compose a balanced arrangement determined by the axiality underlying the design of the courtyard. The grid plan imposes a formal unity on the varied functions and forms, linking up elements such as the terminal pavilions with the three tabernacular cupolas on the east as well as with the main masses to the south and north.

The Sala de los Mocárabes and the Sala de los Reyes (Fig. 6), on the west and east sides respectively, were intended for parties or feasting; both were summer rooms. Most likely, the Sala de los Abencerrajes and the Sala de las Dos Hermanas, on the south and north sides respectively, were for musical soirées. This would account for the acoustic ceilings (Figs. 7,

8), although such ceilings are a feature of the whole courtyard. Both halls have doors, which the two other daytime reception rooms lack; but the Abencerrajes is for winter, the Dos Hermanas for summer, use. No one actually lived in the Leones palace except the people occupying the house over the gateway. Even the sultan would only camp there overnight when in the mood for pleasure or when he wanted to relax with poets and commensals. In short, the function of the Palacio de los Leones was therapeutic.

Epigraphic evidence is important for dating Islamic architecture anywhere, but in Muslim Spain it takes on added significance, since part of the job of being a court poet was to compose occasional poems appropriate to the positions on the buildings that they were intended to occupy. Therefore, poems will sometimes allude, in a metaphorical or hyperbolic way, to extant or vanished features; in such cases, poetry becomes an interpretive tool. Crucial to the correct interpretation of the Leones complex is the famous

qaṣīda (ode) that Ibn Zamrak composed to adorn the walls of the palace's principal apartment, the Sala de las Dos Hermanas (Fig. 9). This ode helps to explain not only the structure but also the underlying aesthetic of the room. The third of twenty-four verses inscribed on the walls of this chamber reads:

> *And if they [the Gemini] were to appear in its [the hall's] two courtyards, they would vie with each other in serving him [the sultan] as concubines in such a way as to leave him gratified with them.*[11]

This audacious hyperbole plays on the duality of the constellation referred to: The heavenly twins correspond to two courtyards, even though only one is visible today.

The plan of the Leones palace is a Greek cross; all four arms are of equal length. The two main halls—the Sala de los Abencerrajes and the Sala de las Dos Hermanas—are defined by domes crowning the ends of a transverse, north-south axis, which extend it so that it is equal to the east-west axis. Nondomical, rectangular halls lie beyond the point at which the main, east-west, axis ends in small fountains. To compensate for the bulk of the two principal halls, pavilions emphasize the east-west axis; the tabernacular cupolas of these pavilions complement the cupolas of these two principal halls (see Fig. 1). On the upper floor these halls have miradors that overlook the courtyard. These miradors perform the same function for the Leones courtyard that the balcony on the south side of the Comares palace does for that courtyard.

As a hall reserved for winter use, the Sala de los Abencerrajes is less open than the Sala de las Dos Hermanas. The Dos Hermanas hall retains its original doors, from which all others elsewhere in the Alhambra have been copied. The passage behind the doors communicates with a privy on the left and stairs leading to an upper floor on the right. This arrangement, which also obtains elsewhere (Abencerrajes and Barca halls), allows service personnel to pass without having to enter the hall and risk disturbing the occupants.

The drum of the Abencerrajes cupola is a rotated square, producing a star-shaped interior profile. The contrast between this dome and the one in the Dos Hermanas is particularly striking when the two are viewed from outside the palace on the south. Both halls have upper floors, that of the Dos Hermanas equipped with *mashrabiyyas* (lattices of turned wood), one of which, that on the south, was original until it was removed to the Alhambra museum, where its fine craftsmanship can more easily be admired. The Dos Hermanas retains its original tilework intact, in sharp contrast to the Abencerrajes, where the dado has been replaced with Sevillian tilework of the seventeenth century. In the courtyard, not even a vestige of the original faience survives.

Originally the Palacio de los Leones occupied two terraces, an upper and a lower, with the principal apartment, the Sala de las Dos Hermanas, projecting into the lower terrace, where its basement formed a cool cryptoporticus in the now-vanished garden. From a mirador entered on the upper level, the sultan could relax and absorb the beauties of the scene, with the Albaicín and Sacromonte for backdrop. This arrangement would explain how the Palacio de Comares and the Palacio de los Leones came to be built on different axes. Although an urban villa by virtue of its location, yet embowered amid gardens, the Leones unit partook somewhat of the nature of a real, that is, rustic villa.

The Palacio de los Leones took up all the space between a still-extant street and the curtain wall. The street separated the living space of the quick from the dwelling space of the dead. Such proximity should not startle: In Islamic palaces the dead and the living form a symbiosis. The Rauda (royal necropolis) was a garden in actuality as well as in metaphor, but a myrtle, not a water, garden. The term rauda (garden) was used in allusion not only to the Prophet's *rawḍa* (necropolis) at Medina, but also, since paradise is a garden, to sanguine anticipation of the deceased's posthumous condition. To the poetic imagination of the Arabs, the sight of dewdrops adhering to plant stems and leaves meant that the heavens were weeping for the one buried beneath.

Inside, marble recumbent slabs were used in conjunction with headstones of the same material, but in the ancillary burial space outside, each grave plot was enclosed with curbs so as to form a miniature garden liberally bedewed overnight, a privilege denied the more consequential burials under cover, which could thus only envy the sympathy nature bestowed on their lesser brethren outside. The epitaph of Yūsuf III, preserved in the Alhambra museum, hesitates

between the advantages of outdoor and indoor burial:

> *May the clouds' downpour refresh his sepulcher and revive it; and may the garden carry to him its sweet-smelling fragrance.*[12]

Outdated guidebooks and maps have created confusion by referring to a domed structure of uncertain purpose in the southeast corner of the Leones quadrangle as the Rauda. The confusion dates back to 1807, when Argote de Molina published a book[13] in which he identified this structure with the ancient pantheon of the Naṣrid sultans, presumably because four royal gravestones were discovered there in 1574; after 1807 the error assumed a life of its own. There should never have been any doubt, for in 1600 Luis del Marmol had clearly stated that the Rauda lay behind the Palacio de los Leones to the south.[14] Finally, at a date prior to 1898, Contreras demolished a house that adhered to some Naṣrid ruins on the other side of the street that ran behind the palace, and he found four burial loculi.[15] The site was explored in 1925–26 by Torres Balbás, who found seventy additional crowded graves inside and outside the mausoleum in three parallel rows facing the qibla.[16] All but one were empty,[17] for Muḥammad XII, the last sultan of Granada, had received permission to transport the bodies of his ancestors to Mondujar, the site of which awaits excavation.

In the Middle Ages the sultan most likely would be found ensconced in the Mirador de Lindaraja (Fig. 10), a protrusion from the Sala de los Ajimeces (Hall of the Geminated Windows) overlooking the patio of the same name. Here an inscription acclaims him its central adornment: the pupil of an eye that regards the landscape. This perfumed bower represents the sensuous climax of the Alhambra; the Naṣrid craftsmen who fashioned it reserved it for their most intricate patterns, whether of faience or stucco.

Washington Irving professed to believe that Lindaraja was a Moorish beauty. Lindaraja, however, is a corruption of the Arabic ʿayn dār ʿĀʾisha, "the eye of the house of ʿĀʾisha," and, to function as an eye, needed mashrabiyyas, which, thrown open, would disclose the landscape beyond. An opulent decor mirrors the sultan's presence; doubtless this was his favorite retreat, whence cares of state were banished,

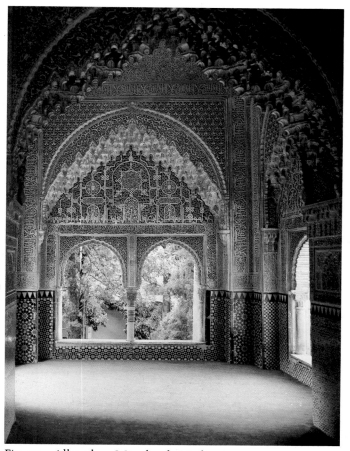

Fig. 10 Alhambra, Mirador de Lindaraja

and joy reigned unconfined in the adjacent rooms or somewhat more decorously in the hall, as dancers took the floor to the sound of bittersweet *muwashshaḥāt* (ballads in classical Arabic) sung by skilled performers. ʿĀʾisha was doubtless some favorite after whom the palace was named in the same way that ʿAbd al-Raḥmān III immortalized one of his concubines by calling the palatine city he founded Madīnat al-Zahrāʾ after her.

Should this hypothesis be correct, it means that the original name of the Leones palace must have been Dār ʿĀʾisha, the House of ʿĀʾisha, just as the original name of the Comares palace would have been Dār Qumārish, rendered into Spanish as the Cuarto de Comares, while the Leones palace metamorphosed into the Cuarto de los Leones.

The "Daraxa" (or Daraja) is how the Sala de las Dos Hermanas and adjoining rooms are referred to in the documents in the Alhambra archives. The visual climax of the Leones complex is the *muqarnaṣ* dome in the Dos Hermanas, where the exuberant qualities of Granadine art achieve a positive effervescence.

Upward of five thousand cells cascading downward produce in their disciplined descent domes within a dome, the most complex ceiling in the Muslim world and the apogee of Islamic art on the peninsula.

Palacio de Comares and the Palacio de los Leones
These two palaces, which were combined in the sixteenth century, represent distinct types of Hispano-Arab domestic architecture, the town house and the urban villa. The Comares palace follows a standard plan that is very rigid: a rectangular courtyard with porticoed ends and the side walls plain. The Leones palace follows a villa plan but shorn of its dependencies. As a formal composition, the Leones complex lacks the coherence and symmetry of Comares, but the arcaded courtyard articulates a screen that binds and unites the disparate elements behind it. The principal elements are disposed along two intersecting axes, as opposed to the single axis of the standard plan. The Palacio de los Leones is unique only in terms of its survival. We can but guess how many of this type of palace may once have existed, but in the Vega of Murcia there was a palace similar in plan, the Castillejo, close to Monteagudo.[18]

The two structures form a study in contrasts: Comares is official, ceremonial, pompous; the Leones is intimate, nuanced, conducive to relaxation. Comares, linear and monoaxial, stands at the opposite remove from the Leones, with its daring asymmetries and multiple axes.[19] The conflation of the two to meet the needs of a different society has completely distorted their respective functions and given rise to numerous misinterpretations. The standard explanation is that the two palaces formed two different parts of a single palace and that one courtyard represented the public part and the other the private portion of one and the same palace. Nothing could be further from the truth: the so-called courts served separate palaces standing back to back with a party wall between them. The palaces were built at different times and on different axes and had independent entrances. It would be interesting to know precisely when and how the confusion arose; it ought all the time to have been clear from Marmol, who wrote unequivocally in 1600: *"Estos alcázares o palacios reales son dos, tan juntos uno de otro, que solo una pared los divide"* (These alcazars, or royal palaces, are two [and are] so close to each other that only a wall separates them).[20]

During Arab times the two palaces were separated on the north by a street, which provided access to the furnace of the bath complex. Flanked by blank walls on either side, the street was designed in such a way as to prevent the menials who used it from catching even so much as a glimpse of the inmates, whether *en déshabillé* in the baths or relaxing in the garden. Once again, today's visitor has to use his imagination, for, when the two palaces were combined, the street became a vaulted undercroft supporting a vital link in the new circulation system. On the subterranean level it became a loggia by the simple expedient of having openings cut in its east wall so that it communicated with the newly formed Patio de Lindaraja.

The marriage of the two contiguous structures posed no serious problems on the south side, where only a party wall divided them (inserting a couple of doors produced a single palace with an L-shaped ground plan), but the north side was a different matter. About the year 1530 Charles V decided he needed a Renaissance dwelling en suite with both palaces, which would make them into one. The work, comprising six new rooms, was completed by 1537. The only space where such a suite could be constructed without entailing wholesale disturbance was the lower terrace of the Leones complex, and some gimcrack structures on the north uniting the two palaces to the formerly independent Torre de Abū'l-Ḥajjāj represent the work of Charles V. This tower had stood isolated on the perimeter wall until Muhammad V built the lower terrace of the Leones palace, after which time it related to the gardens of that palace.

The Patio de Lindaraja was cannibalized out of demolition material from the suppressed garden and helped out with material yielded by the Palacio del Convento de San Francisco, which lay to the east of the other palaces and was the first part of the Alhambra to be destroyed. Encased in reused columns and demolition materials, Abū'l-Ḥajjāj's tower became practically unrecognizable in its Renaissance guise as the Torre del Peinador de la Reina (Tower of the Queen's Dressing Room) (Fig. 5, p. 133). The southernmost window on the east side of the Torre de Comares palace became a door onto a veranda leading to the transmogrified tower. The same veranda admitted to the Renaissance suite, which led to the Sala de las Dos Hermanas via a corridor erected over the now defunct

street of the furnace attendants, so that once again a window, this time belonging to one of two flanking bedchambers, has been pressed into service as a door.

On the north side, the suite ended in another corridor turning right, then right again, to meet up with the Sala de los Ajimeces on the south side of the Patio de Lindaraja. As a result, a claustrophobic little courtyard replaced a spacious garden. The corridor connects with the Sala de los Ajimeces by means of yet another converted window, while the two doors, which are cut through the party wall referred to earlier, complete the circulation system on the south. In this manner two palaces became one, under the title of the Casa Real Vieja (to distinguish it from the Casa Real [Nueva], built by Charles V).

The entrance to the Leones palace, rendered redundant by these transformations, was suppressed, which accounts for the incongruous window in the southwest corner: This window was really a door into a room that came down at the same time as the entrance underneath it (in 1537–38) and so had to be balustraded off for safety. The room it admitted to formed part of the Patio del Harén (Court of the Harem)[21] house, which was built over the cistern that fed the baths of the Comares complex.

Since the function of the Palacio de los Leones has been so widely misunderstood, it is worth reflecting on the ambience from which both it and the Comares palace spring. In Spain and North Africa, the Roman tradition, to which the Arabs fell heir, had never entirely died out. The Roman instinct for civilized society produced a variety of life-styles not possible except under a Pax Romana. One of these styles was villa living, eulogized by Andrea Palladio in a variation on the *Beatus ille* theme: "The ancient sages commonly used to retire to such like places; where being oftentimes visited by their virtuous friends and relations, having houses, gardens, fountains, and such like pleasant places, and above all, their virtue, they could easily attain to as much happiness as can be attained here below."[22]

Palladio places virtue at the apex of the advantages such a life enjoys over its rivals precisely because it is the possession of so rare a quality that enables one to benefit from all the others. A villa also offers practical advantages, for it is a place where, for a gentleman, "the remaining part of the time will be passed in seeing and adorning his own possessions, and by industry, and the art of agriculture, improving his estate; where also by the exercise which in a villa is commonly taken, on foot and on horseback, the body will the more easily preserve its strength and health; and, finally, where the mind, fatigued by the agitations of the city, will be greatly restored and comforted, and be able quietly to attend the studies of letters, and contemplation."[23]

But virtue in the Renaissance sense was a luxury medieval man could seldom or never afford. In feudal times brigandage combined with centrifugal authority ensured that the only alternative life-style open to the rich, if they were not to reside in cities, was castle living. In this respect, al-Andalus was blessed beyond the wildest dreams of its European neighbors; villas formed part of the great agricultural system that made Muslim Spain prosperous at a time when most European countries languished in poverty.

We are fortunate to have in the Generalife, on the opposite side of the gorge separating the hill of Santa Elena from the Sabīka hill (on which the Alhambra stands), a surviving nucleus of this system. The Generalife could be enjoyed by the sultan in any one of the ways described by Palladio with no more effort than it took to slip out by the postern at the foot of the Torre de los Picos (Spiked Tower) and cross the Cuesta de los Chinos (Slope of the Pebbles). Marmol says the Naṣrid monarchs spent the summer in extramural villas and gardens "round about the Alhambra," to get away from the heat and, presumably, the smells as well as the danger of infectious diseases.[24] But the dream of *rus in urbe* remains and produces the *villa urbana*, of which the Alhambra city boasted at least two: the Palacio de los Leones and the Palacio del Convento de San Francisco, where gardens substituted for the missing estates, producing an atmosphere conducive to relaxation.

The Partal

To the east of the Palacio de los Leones and separated from it by what in the Middle Ages would have been streets and houses (of which four survive, complete down to interior frescoes in one case), there lay a third palace known as the Partal (Fig. 11). Of this structure, there remains one of the original four sides and a mosque with a house adjacent. The mirador corresponds typologically to the Salón de los Embajadores in the Comares palace, whose monoaxial plan the Partal

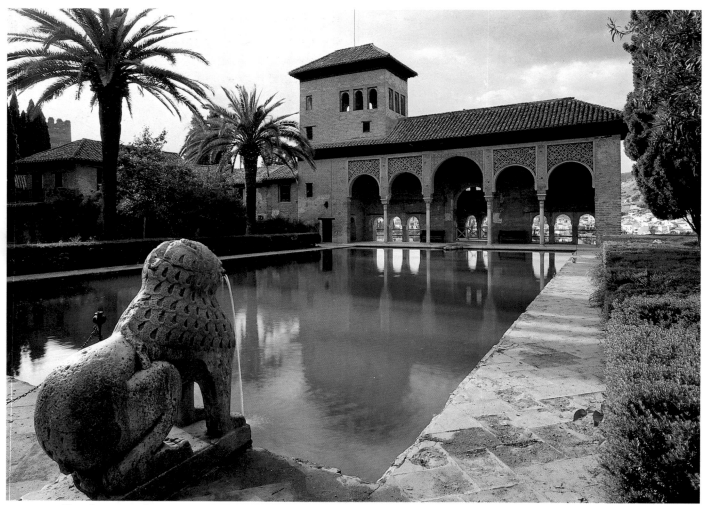

Fig. 11 Alhambra, Partal

duplicates, although the Partal, which was built by
Muḥammad III (r. 1302–9 [A.H. 702–9]), is older.[25]

The Partal is the innocent cause of many a
popular misconception. Because it retains only one
of its four sides, its open appearance belies its real
nature; people mistake it for a garden pavilion and so
relate it to the gardens extending south and east, ig-
noring the fact that these gardens were conjured out
of a wilderness by Gómez-Moreno in the 1920s. There
never was nor could have been a garden here in Arab
times, because a palace occupied the site. The formal
Renaissance parterres of box could not, in fact, be
more incongruous, and it takes all the exuberance of
an Andalusian summer to render them tolerable,
softening their hard outlines with torrents of blos-
soms. Like Comares, the Partal palace, in its original
form, was another instance of the town house; as a
city, the Alhambra could not admit any other type of
construction except, of course, the urban villa.

Palacio del Conde de Tendilla
This palace is the sprawling complex, now reduced to
foundation level, lying to the southeast of the Partal.
It dates from the reign of Yūsuf III (r. 1407–17 [A.H. 810–
20]) but owes its present name to the count of Tendilla,
whose residence it became after the conquest. Its plan
follows the conventional model, exactly like Comares
or the Partal. Typologically, the tower, of which only
the foundations are visible, corresponds to that of
Comares or the mirador of the Partal. Because of its
ruined condition, the hypocaust system whereby the
baths were heated in this palace is very conspicuous.
Hygiene throughout the Alhambra is impressive by
any standards. Even the garrison was clean; it had its
own baths in the Alcazaba.

The Palacio del Conde de Tendilla was demol-
ished by Philip V after 1717, when the office of a
separate *alcalde* (mayor) for the Alhambra was sup-
pressed and an official residence for him therefore

became redundant. The count lost his job because he sided with the losing side in the War of the Spanish Succession, and the Alhambra lost a palace in consequence of his dismissal.

Palacio del Convento de San Francisco

Only scant portions of this early fourteenth-century palace, built by Muḥammad III and remodeled by Muḥammad V, survive.[26] Now the site is the Parador Nacional de San Francisco, established in a former Franciscan friary that Ferdinand and Isabella had installed in one of the six palaces the Alhambra at one time boasted. The surviving portions—comprising a mirador, rather less than half the water channel that ran the length of the courtyard, and one of the two principal chambers located at either end of the watercourse—suffice to show that this particular palace conformed to the Generalife model. Both the former palace and the Generalife were built by the same monarch (Muḥammad III), and in both cases the basic town house plan had a courtyard elongated to a degree impossible in a normal urban context.

The Generalife is a *villa rustica*; its twin inside the Alhambra, the Palacio del Convento de San Francisco, becomes a *villa urbana* by virtue of its location, exactly like the Palacio de los Leones. The two miradors, that of the Generalife and that of the San Francisco palace, confronted each other from opposite sides of the gorge separating the Sabīka hill from that of Santa Elena. The San Francisco palace was the first building in the Alhambra to be demolished; it succumbed only a year after the conquest.

Two towers of the precinct wall, the Torre de la Cautiva (Tower of the Captive) and the Torre de las Infantas (Tower of the Princesses) (Fig. 12),[27] are miniature palaces, complete in the latter case even down to a minuscule courtyard. They date respectively from the reign of Yūsuf I and of Muḥammad VII (1392–1408 [A.H. 795–811]).

Palacio de los Abencerrajes

The sixth and last major palace, called, after the Abencerraje family, the Palacio de los Abencerrajes, focused on an unusually large pool, located on a no less unusual east-west axis adjoining a tower (Torre de la Contaduría [Tower of the Counting House]) on

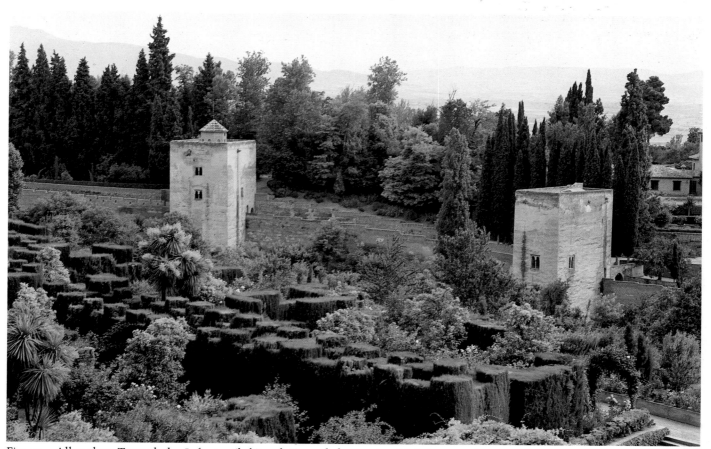

Fig. 12 Alhambra, Torre de las Infantas (left) and Torre de la Cautiva (right)

the southern side of the Alhambra city. The Torre de la Contaduría is now referred to in plans as the Torre de los Abencerrajes in consequence of the recent excavation of the palace of that name. Blown up by the French in 1812 at the same time as the Puerta de Siete Suelos (Gate of Seven Floors), this palace sustained further damage in 1957, when the site was used to quarry material for a parking lot at the public entrance to the Generalife.[28] What remained was eventually excavated by Antonio Fernández-Puertas, revealing what appears to be a two-hall palace. Taken in conjunction with the anomalous pool, this palace indicates a plan compatible only with the Palacio de los Leones type, of which it may have been the immediate precursor and therefore yet another instance (the third) of a *villa urbana*.

With the exception of the Palacio del Conde de Tendilla, which dates from the fifteenth century, and the two residential towers—the Torre de la Cautiva and the Torre de las Infantas—most of these palaces predate the first two; like the Generalife, they belong to the early fourteenth century. The exception is the Abencerrajes palace, which was built in the thirteenth century.

1. "Puerta de la Justicia," or "Gate of Justice," is a mistranslation of Bāb al-Sharʿī (or al-Shurayyʿa, the diminutive form), signifying "little street," which refers to the esplanade where the Palacio de Carlos V now stands. The real Puerta de la Justicia is the facade of the Comares palace before which the seated sultan dispensed justice. Research has shown that this facade was completed on or just before October 4, 1370 (12 Rabiʿ al-Awwal, A.H. 772). See Fernández-Puertas 1980, vol. 1, p. 7.
2. Cabanelas Rodríguez 1988b.
3. The name does not refer to any resemblance on the part of the roof to the upturned hull of a boat, as has often been alleged.
4. In view of this and other mistakes in restoration he made in the Alhambra, it is amusing to read Torres Balbás's own strictures on his predecessors, Rafael Contreras and Modesto Cendoya (1960b). He can, however, plead extenuating circumstances for having misread a vital piece of archaeological evidence: The back of the mihrab had already been broken through in Christian times, but by the seventeenth century, when the south side of the Torre de Comares evinced signs of subsidence, doorways were filled in and the one cut through the mihrab suffered the same fate, being blocked off with stone between 1672 and 1674, which accounts for Torres Balbás's error when he reopened it at the end of May 1923. See Torres Balbás 1934b.
5. See Bermúdez de Pedraza in Simonet 1872, p. 267; Hurtado de Mendoza 1979, p. 99.
6. The presence of citrus trees both here and in the Generalife was remarked by Andrea Navaggiero, the Venetian ambassador, when he visited Granada in 1526. See his fifth letter, reproduced by Simonet 1872, p. 239.
7. Torres Balbás 1959.
8. This boiler of superfine copper was valued in 1752 at 14,305 reales, which probably sealed its fate, as it was sold off during the reign of

Charles III (1759–88) to defray the costs of repairs elsewhere in the Alhambra.
9. Arabs never immersed themselves, but stood outside the tank and slopped water over themselves. The instant the water touched the floor, it was converted into steam (bathers wore pattens to protect their feet and to avoid slipping on the floor). In the outer caldarium a wall fountain in the southeast corner supplied the necessary moisture for what was essentially a zone of acclimatization. A progressive adjustment took bathers from tepidarium to caldaria, whereafter the cycle would be reversed, so that they ended up on the beds in the apodyterium to recover.
10. Bernis 1980, pp. 21–50.
11. Lafuente y Alcántara 1859, p. 128.
12. Text in Lévi-Provençal 1931, pp. 161–62.
13. Argote de Molina 1807.
14. In Simonet 1872, p. 255. The full passage, unaccountably omitted by Simonet, who does not even indicate its omission with ellipses, reads as follows: "At the back of the apartment of the lions, toward the south was a rawda, or royal chapel, where were found the year of the Lord one thousand, five hundred and seventy-four some alabaster [*sic*] slabs which appear to have been placed at the head of the graves of the [*sic*] four kings of this house, and the part not buried in the earth, because they were stood upright, bore on both sides epitaphs in Arabic characters, gold on blue, in prose and in verse, in praise and memory of those who lay there, a translation of which we had made for inclusion in this history; but, written [in a style] different from ours and in order not to interrupt the description of the city, we are consigning them to a chapter apart" (Marmol Carvajal 1600, f. 7).

The four epitaphs, translated by Alonso de Castillo, figure on folios 9v to 12v and are followed by an account of the Muslim dating system intended to explain the dates on the headstones. The four are Muḥammad II, Ismāʿīl I, Yūsuf I, and Yūsuf III. Of these, only the first and the last survive, but the lost stele of Yūsuf I resurfaced in 1901 when the Palacio de Sitti Maryam was demolished at the time the Gran Via was being built. Lévi-Provençal is mistaken in saying that the stele is lost (1931, pp. 147–48); it is in the Alhambra museum. The museum also conserves the stele of Prince Yūsuf, Mulay Ḥasan's brother.
15. Contreras himself credited Argote's story as late as 1878 (1878, pp. 250–51). The structure is a tower with four arches and sixteen windows, open on all four sides, and seemingly nonfunctional. Although we know that the tower in question is not the Rauda, it is less easy to say what it was. It adjoins a postern, but the tower is too large for the protection of a mere postern. Nor can it be for latrines, for drainage would be visible if it were; moreover, unlike their Roman equivalent, Arab latrines were never sumptuous. The style of decoration in the dome is one encountered in gateways and vestibules. There is a gadrooned dome in the Puerta de las Armas (Gate of Arms), which this tower structurally resembles. It is, therefore, presumably of the same date, that is, early fourteenth century. Clearly, the structure is a tower that Muḥammad V adapted as a vestibule to the postern in the palace he was building. This form of dome treatment first appears in the mihrab of the Great Mosque of Kairouan (836–37 [A.H. 222–23]), is repeated in Córdoba, and proliferates under the Almohads. The tower is evidently some preexisting structure that the ingenious architect chose to incorporate, unlike other structures that had to be demolished and traces of whose walls lie under the Patio de los Leones (see Gómez-Moreno González 1892, vol. 2, pp. 30–31). By and large, the functions of the different parts of the Leones palace are much less easy to ascertain than those of the Comares palace.
16. Torres Balbás 1926. Poking around in a vault in the southwest corner of the Rauda in 1965, the present author found the bottom left-hand corner of a stele overlooked during the excavation forty years before and transported it to the Alhambra museum.
17. This grave's occupant now reposes in the storerooms of the Alhambra museum. The identity of the skeleton is a mystery. It could even be Christian, as burials took place in the Alhambra after

it was Christianized. When the skeleton was found, its posture was not that of sideways burial, which the Muslims of Spain always practiced.

18. See Torres Balbás 1934a.

19. On the axial complexities of the Patio de los Leones, see Marçais 1938, pp. 64–69, reprinted in Marçais 1957, vol. 1, pp. 99–102.

20. In Simonet 1872, p. 254. See also p. 255, where he repeats it: *"Demás destos dos ricos alcázares, tenian aquellos reyes infieles otras muchas recreaciones en torres, en palacios, en huertas y en jardines particulares, ansi dentro como fuera de los muros de la ciudad y de la Alhambra"* (Aside from these two sumptuous palaces, these infidel kings had many other places of pleasure in towers, palaces, orchards, and private gardens alike, inside and outside the walls of the city and the Alhambra).

21. This patio formed part of a house whose function will probably remain a mystery. It may have been a janitor's house, the lodging of a man who kept the keys for both the palace and the mausoleum. The luxury of painted dadoes within would seem to point to a less humble occupancy than that of a mere janitor, however, and a harem seems a less untenable hypothesis than most because, like the baths, its entrance was vigilated.

22. Palladio 1738, p. 46.

23. Ibid.

24. In Simonet 1872, p. 256.

25. Cabanelas Rodríguez and Fernández-Puertas 1974–75, esp. pp. 124–25.

26. See Torres Balbás 1931, pp. 126–38.

27. The many who fancied they could discern decadence in the Torre de las Infantas received a rude shock in 1958, when Luis Seco de Lucena published his research into the history of this building. He showed that it was a full half-century earlier than anyone had thought, dating not from the time of Sa'd (r. 1445–61 [A.H. 840–66]) but from that of Muḥammad VII (see Seco de Lucena Paredes 1958). It had been fashionable to find in the designs evidence of an impoverishment of the artistic imagination and decry this building as proof of the decadence of Naṣrid art.

28. Details of this and other scandals have been aired outside Spain; see Shepard 1972. This palace, which is included on the plan of the Alhambra prepared by the Academia de San Fernando in the eighteenth century, is also shown on Gómez-Moreno's own plan published in 1892 (see Gómez-Moreno González 1892, vol. 1, pp. 24–25).

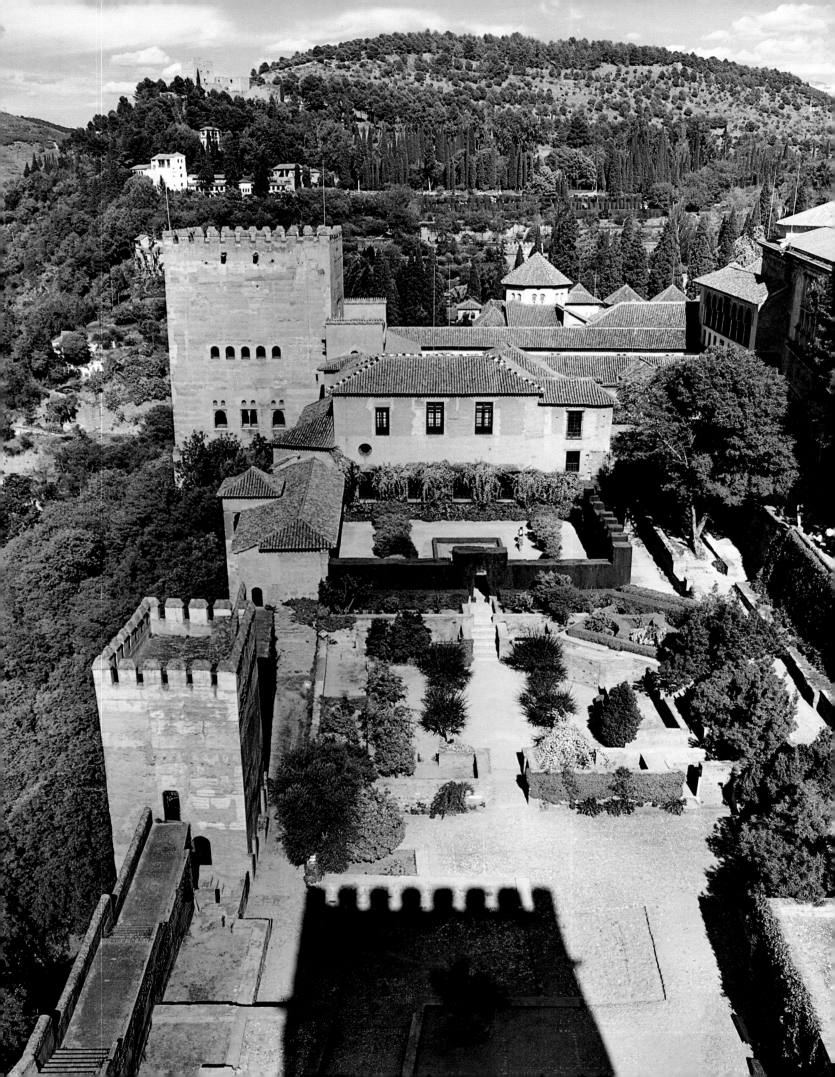

The City Plan of the Alhambra

JESÚS BERMÚDEZ LÓPEZ

There are three principal areas within the walls of the Alhambra: the Alcazaba, which was reserved almost exclusively for military use; the palace and its surroundings, which was not planned as a single entity, although it enjoys a conceptual unity based on symbolism and its function as a royal residence, an area in which up to seven distinct palaces can be traced or recognized; and the medina itself, a residential and artisans' city, a *qaṣba*, in which administrative and commercial activities were at the exclusive service of the court (see Fig. 3, p. 130).

When we speak of the plan of the Alhambra, we must not overlook the areas that lie outside the walls but are nonetheless an integral part of the whole: the Generalife, a semiurban, semirural residence, with its exquisite palace and especially its four luxuriant terraced gardens—Mercería, Grande, Colorada, and Fuentepeña—that served the palace and even functioned as a pasture for its livestock; and the edifice today called the Castillo de Santa Elena, which is popularly known as the Silla del Moro and is located on the north side of the Cerro del Sol (Hill of the Sun) protecting the rear of the Alhambra hill. The latter building must originally have played an extremely important role as guardian or sentinel over the place where the Acequia Real (Royal Aqueduct) entered the Alhambra, as well as related constructions scattered about the hill. Among the buildings on the hill, and presiding over its summit, is the Dār al-ʿArūsa, the Palacio de la Desposada (Palace of the Bride), which is integrated into the whole through aquatic elements (wheels for drawing water, pools, and cisterns) distributed at various points over the slopes. The Torre de las Damas (Ladies' Tower) and its complicated water systems of conduits and pools—the Albercones (Reservoirs)—were vital to the creation and continued existence of the Alhambra, since they were the key to the supply and control of water for the entire complex.

The mythic and virtually unknown Palacio de los Alijares, an estate, or *almunia*, of considerable size, was built on the hill behind the Alhambra and continued down to the banks of the Genil River some distance away. This celebrated, legendary residence occupied the heart of the area that is today the cemetery of the city of Granada.

El Campo de los Mártires (Field of the Martires), another spot near the Alhambra that is the subject of myth, was a field for military maneuvers and jousts and was dotted with dungeons and caverns. Supposedly, it was the scene of the most bitter battles of the Christian reconquest, and it is one of the areas of the Alhambra about which we know least and still have much to learn.

To the southeast of the Alhambra is another important building, the last of those outside the walls we shall mention here: the Torres Bermejas (Vermillion Towers), which stand watch over the ancient Mauror Jewish quarter and serve as connecting link and checkpoint between the wall of the city and the exterior fortifications of the Alhambra.

These features and structures, for all practical purposes, surround the Alhambra wherever it is not in direct contact with the city of Granada below, functioning as a kind of physical belt, a natural moat, that protects it and isolates it from any possible assault. The Alhambra was never conquered militarily in any battle at its walls; rather, it was surrendered through a signed accord.

Let us return to the walled heart of the Alhambra. A basic element of any palatial medieval establishment was that area destined for the sultan's guard or his elite army. As we have noted, in the Alhambra

Alhambra, view from west

the guard was quartered in the Alcazaba, which was constructed on the highest point of the Sabīka hill, the most forward spur of the Sierra Nevada on the Vega and inside the city of Granada.

Nevertheless, the Alcazaba of the Alhambra—*al-jadīda*, or new Alcazaba, in contrast to *al-qadīma*, or old Alcazaba, which occupied the top of the Albaicín quarter—is different from other medieval fortresses. In most of these alcazabas, the interior, or Plaza de Armas, was an open space free of buildings, occupied only by tents, or *khaymas*, or other shelters that could be quickly dismantled and transported to facilitate troop movements at the moment of battle. But as the Alcazaba of the Alhambra is itself integrated into a defensive structure—the larger fortified area of the Alhambra—its Plaza de Armas is occupied by a series of buildings that lend it a specific character, one that gave rise to the plaza's name: Barrio Castrense (Military Quarters). Seventeen small houses for the elite guard and their families fill the north half of the Alcazaba, which was laid out in the characteristic Islamic urban pattern: Some buildings abut one another and are joined and separated by narrow corridors or alleyways that lead only to the interior of the houses themselves. In each of these dwellings—behind the small entrance set at an angle to safeguard domestic privacy—is a courtyard (a skylight is in the smallest); in the center of each courtyard, space is reserved for some display of water. In the case of the principal dwelling, the area contains a small pool; all the rooms of the house open onto this courtyard, and each has a water closet with running water. At one time all these structures had a second level.

The south half of the Barrio Castrense was occupied by constructions laid out on a regular plan very different from that of the houses; these rooms probably were barracks for the junior troops or, possibly, storerooms. This urban space is completed to the east by two indispensable elements in an Islamic habitat: a cistern for providing water to the area and a bath opposite for the use of the military. It is also characteristic that this arrangement of buildings follows a hierarchical plan, that is, the size and surely the importance of the dwellings increase as they advance from east to west toward the Torre de la Vela (Watchtower) along the principal, though small, street that splits the barrio into the previously mentioned divisions.

However, one traditional element of Muslim urban centers, otherwise found throughout the Alhambra, is not present in the Alcazaba: a place for common prayer, a mosque. We should not be unduly surprised by this absence, since by its very nature the Alcazaba was intended to house only the elite. There can be little doubt that most of the soldiers, or certainly a large portion of them, camped outside the walls, where space for a *muṣallā*, or open-air mosque, was reserved for them and prayers were shared at the prescribed times. In any case, in Islam all places are conducive to prayer. We need only think, as a possible point of reference, of the ribat, a kind of fortress-monastery occupied by volunteer soldiers on the frontiers and front lines of battle after the proclamation of a jihad, or holy war.

One last feature of the complex of the Alcazaba should be mentioned: the Torre del Homenaje (Tower of Homage), which is the keep. It is by no means the largest tower of the Alhambra, nor is it one of the most outstanding in regard to construction or ornamentation; it is not even the best known. It is, however, the highest tower in the precinct. In medieval fortresses, the keep was the most important tower, since the command post was located there as the center for intelligence and strategy equivalent to today's high command; it was, therefore, the tower that commanded the best view of the surrounding terrain and was the last to be abandoned in a battle. The upper level of the Torre del Homenaje at the Alhambra, in fact, contained the quarters of the chief of the guard, a residence with a central courtyard following the plan of the previously mentioned homes. This points to another characteristic feature of domestic space in Islamic countries—rooms with multiple functions. Perhaps it was in that elite tower that the founder of the Naṣrid dynasty first lived while the Alhambra was under construction.

The plan of the Alcazaba suggests the outlines of a triangle with unequal sides, the north and south sides being the longer ones. The curtains of the north wall, particularly, with its small, massive towers, and even the *adarve* (the upper part of the wall), must, at least in their foundations, date back to the compound constructed by the Zīrids, the dynasty that preceded the Naṣrids, in the eleventh century. The Naṣrids reinforced the complex by building the impressive east curtain formed by the Torre del Homenaje, the

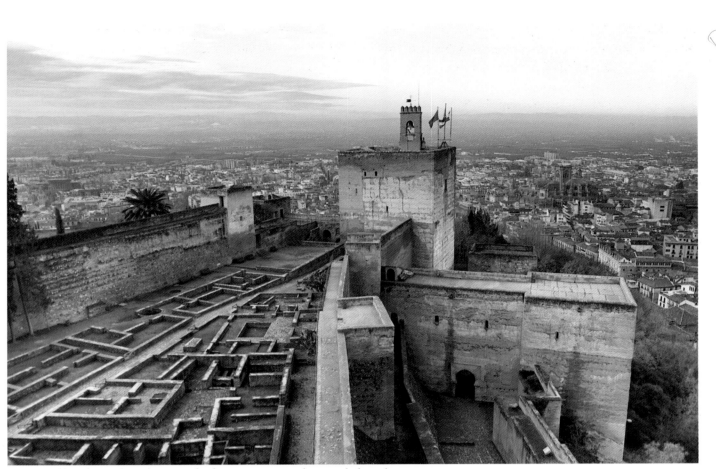

Fig. 1 Alhambra, Alcazaba, view looking west toward Torre de la Vela

Torre Quebrada (Broken Tower), and the Torre del Adarguero or Torre Hueca (Shieldmaker's Tower or Hollow Tower). To the west, at the apex of the longer sides, stands as reinforcement the imposing mass of the Torre de la Vela, which guards, presides over, and symbolizes the city of Granada (Fig. 1).

The Alcazaba is at once separated from and joined to the rest of the Alhambra by a natural ravine at the base of its eastern curtain. That area today is nearly filled in because after the Christian conquest, López de Mendoza Tendilla, first captain general of Granada, ordered a reservoir to be constructed for supplying his troops, thereby creating a platform that makes a visual appraisal of the site difficult. The platform extended to the north curtain of the exterior wall of the Alhambra until the early 1950s, when an archaeological excavation of the sector was undertaken. This excavation, which represented the culmination of several exploratory digs and rubble removal begun at about the beginning of the century in the area between the Palacio de Carlos V and the Alcazaba, has probably been the most important to date in the Al-

hambra, providing information about the interior plans of its various dependencies.

Beneath this platform in the Plaza de los Aljibes (Plaza of the Cisterns), in its extension toward the north wall, an esplanade of modest proportions with the original and traditional paving of round stones was revealed; this area was, in fact, a public plaza. The esplanade was important in the city plan of the Alhambra because it functioned as a place of interchange between the several areas of the fortress. It was the traffic hub for people who came in from the city and its environs after passing through the outer gates of the wall.

The fortress of the Alhambra has four large exterior gates: Armas (Gate of Arms) (Fig. 2), Arrabal (Outer Gate), Siete Suelos (Gate of Seven Floors), and Justicia (Gate of Law) or Explanada (Gate of the Esplanade) (Fig. 4, p. 131). The first two gates open toward the north, and the remaining two toward the south. Of them, only one, the Puerta de las Armas, originally communicated with the center of Granada and was the gate normally used by residents

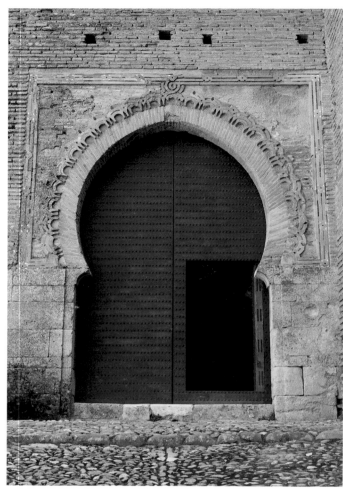

Fig. 2　Alhambra, Puerta de las Armas

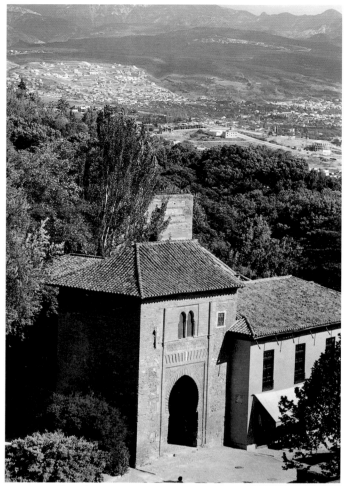

Fig. 3　Alhambra, Puerta del Vino

of the city for direct access to the Alhambra when they had to resolve administrative problems, request an audience, or pay their taxes. In the fifteenth century, with the increase in population that occurred, the walls and fortifications of Granada were considerably expanded, modifying to a significant degree the inter-related urban patterns of the city and the Alhambra. The construction of the exterior gates of the Alhambra followed the Almohad tradition, to which the Alhambra was direct heir: As was appropriate to their defensive function, the entrances were built at an angle, which prevented them from being easily penetrated.

After entering the Puerta de las Armas, one may proceed in two directions: to the right, toward the interior of the Alcazaba, after following a rampart to the foot of the Torre de la Vela and passing several control points; to the left, toward the heart of the Alhambra and the above-mentioned courtyard, leaving behind a small courtyard, a broad rampart under the shadow of the north curtain of the exterior wall of

the Alcazaba, and the Puerta de la Tahona (Bakery Gate) at the foot of the tower of the same name, now buried beneath the superimposed Christian Torre del Cubo (Water Bucket), which is circular in structure. This small courtyard surely was similar to those still found in the markets of traditional North African cities, and was a place where moneylenders and itinerant merchants of all kinds offered their services to people entering the palace.

The most monumental of all the gates of the Alhambra, the Puerta de la Justicia or Puerta de la Explanada, was also reached through this courtyard after crossing the rampart street and passing through the now-vanished Puerta Real (Royal Gate) and the Puerta del Vino (Wine Gate) (Fig. 3)—which was the entrance to the medina—and descending a steep street. The Puerta de la Justicia was built in the middle of the fourteenth century, just as the age of greatest splendor of the Naṣrid sultanate was beginning. With time it became the most important

entrance into the Alhambra, surpassing even the Puerta de las Armas because of its aulic symbolism and also because, as the population increased with the advance of the Christian conquest and the protective walls of the city were enlarged, the city of Granada continued to grow in the direction of the Alhambra.

Partly because of the sizable expansion of this area of the city and partly as a political stratagem, even Ferdinand and Isabella encouraged access to the Alhambra through the Puerta de la Justicia, then, as today, approached by ascending the Cuesta de Gomérez. As we climb this hill toward the Alhambra, we find ourselves before the Renaissance Puerta de las Granadas (Pomegranate Gate), which gives us the sensation that we are entering a walled enclosure when, in fact, we are leaving behind the walls of the city.

The Puerta de Siete Suelos, also monumental in proportions, has been reconstructed following its nearly total destruction by Napoleon's withdrawing occupation troops. This gate was once the principal entrance to the medina of the Alhambra in the upper zone of the fortress, which was occupied by residences and by industries serving the court. Some accounts speak of the gate as presiding symbolically over the military parades and jousts, or knightly tournaments, held on the esplanade located at its foot. On one occasion this gate was identified as the mythic "postern of betrayal" used to "negotiate" the surrender of the Alhambra to the Catholic sovereigns. While it undoubtedly played some role in that episode, research suggests that the infamous postern must have been a small gate located nearby.

The Puerta del Arrabal (Fig. 4) offers access to the northeast sector of the Alhambra. Located in the shadow of the warlike Torre de los Picos (Spiked Tower), it has undergone numerous transformations through time. The most recent was the addition or alteration during the Christian epoch of a kind of *coracha*, or precinct wall, with stables and with the Puerta de Hierro (Iron Gate). The Puerta del Arrabal opens onto the Cuesta de los Chinos (Slope of Pebbles), a natural ravine separating the hill of the Alhambra from the terraced gardens of the Generalife and connecting the Darro River at the foot of the Sacromonte with various properties situated around the Alhambra. Thus, if one left the Alhambra through the Puerta del Arrabal, it was not necessary to pass through the city of Granada. In the Christian epoch, in fact, one of the

established enterprises inside the Alhambra was a posthouse where travelers lodging inside the walls could change horses; at that time the Alhambra was free of the burden of taxes, and anyone who entered the fortress by the Puerta de Siete Suelos could leave through the Puerta del Arrabal without having to go through the city, which amounted to a considerable savings for the traveler.

The most important, or at least the most attractive area in a city like the Alhambra, which served as the residence of sultans, is that of the palaces. The fact that over a period of two hundred and fifty years, this throne was occupied by at least twenty-three sultans gives some idea of the complexity of the administration of the court, and also of the transformations the residences of its rulers must have experienced. We shall not undertake an analysis or description of the palace complex that exceeds the boundaries of this essay. Nevertheless, for simple purposes of orientation, we shall repeat the statement offered at

Fig. 4 Alhambra, Puerta del Arrabal

the beginning: that the palace area of the Alhambra must be taken as a unit, even though the palaces—the "quarters," as they have traditionally been called—are many and were independent of one another. We must remember, too, that the Alhambra that has come down to us is the Alhambra of the second half of the fourteenth century, with important subsequent modifications. The major construction that took place in the thirteenth and first third of the fourteenth centuries was significantly altered, both structurally and in ornamentation, and, given the almost total absence of contemporary chronicles or descriptions, it is only with difficulty that the profile of grounds and edifices can be traced.

As many as seven discrete palaces can be identified in the Alhambra. Their names allude to some fact of their construction: the sultan who ordered the palace to be built; the one who decorated or remodeled it; the last sultan to live in it; its most striking feature; and so on. Thus we speak of the Palacio de Ismāʿīl, the

Palacio de Comares, the Palacio de los Leones (Palace of the Lions), the Partal, the Palacio de Yūsuf III, the Palacio del Convento de San Francisco, and the Palacio de los Abencerrajes.

Before these palaces were built, there existed a well-defined administrative area and the Mexuar, where audiences and ceremonies were held, which opened directly onto the main courtyard of the Alhambra. The Mexuar occupied the area that today is called the Patio de la Madraza de los Príncipes (Court of the Madrasa of the Princes), the Patio de Machuca, and the Mexuar itself with its dependencies. In this context we find fascinating a recently discovered, brief account of a festival in the Mexuar celebrating the *mawlid*, or birth of the Prophet. This account, which is virtually the only extant text from the period, was written by Ibn al-Khaṭīb, vizier of Muḥammad V, who built the Palacio de los Leones.

Although the three areas inside the walls of the Alhambra listed at the beginning of this essay belong

Fig. 5 Alhambra, Calle de Ronda

to a single urban complex that has come to be called the palatine city of the Alhambra, they are completely independent of one another. This independence and their interdependence, which derives from sharing the space within the walls, are achieved by means of a perfectly planned and executed urban system of streets and gates that both separates and links the areas of the complex.

There are three principal streets within the Alhambra: the Calle Real Baja (Lower Royal Way), the Calle Real Alta (Upper Royal Way), and the Calle de Ronda (Fig. 5), which surrounds the hill. They must be placed in a historical context based on an oral and written tradition of many years' standing.

The Calle Real Baja might actually be called the Street of the Palaces. Little was known about it until the middle of the present century, when the first digs and archaeological explorations were undertaken. Because of the many transformations sustained following the Christian conquest, the urban plan of the Alhambra was substantially modified and the original layout hidden beneath rubble and new buildings—especially of the Palacio de Carlos V. As a consequence, the street cannot be seen in its entirety.

This Calle Real Baja had more than one function. It served as the principal access to the palaces and dependencies of the sector we have called the palace zone. In addition, in moments of emergency such as times of siege, when more security and control than usual were needed once the gates had been closed by the guard, the street became a moat between the medina and the palace area, isolating it completely from the remainder of the Alhambra. It begins with an entrance gate that provides direct access to the southeast corner of the main courtyard of the Alhambra, at a small but extremely important structure that connects with at least two other gates: one that opens onto the courtyard itself and one that leads along a steep narrow street toward the Puerta del Vino (the main entrance to the medina) and then through the now-vanished Puerta Real toward the Puerta de la Justicia and the exterior wall. It is important to remember that in the Alhambra the openings of the interior gates that were public or semipublic in nature are all unobstructed, unlike the exterior gates with angled entrances.

The street continues, slowly ascending, toward the east, passing the palaces on the north and to the south bordering the wall defining the medina. When it reaches the Palacio de Carlos V, it is abruptly interrupted. It emerges at the opposite side of the palace, just in front of the octagonal chapel, and provides access to the main entrance of the Palacio de los Leones, today half-hidden, and to the Rauda, the royal necropolis. (The sultan must have followed this street to reach the mosque located beyond the Rauda in the medina.)

The street continues eastward until it comes to the present-day Partal gardens, where, apparently, it disappears. Modifications in this zone, including those effected during Muslim reigns but especially during the excavations of the 1930s and the addition of the modern gardens, make it very difficult to follow, though it must have connected the Partal and the Palacio de Yūsuf III (or Muḥammad II) and perhaps continued even farther east.

The Calle Real Alta is the principal street in the medina. It begins at the Puerta del Vino and continues upward and eastward until it disappears inside the upper level of the Alhambra in the place traditionally known as the Secano (Wasteland) (Fig. 6). Its path, although modified for practical reasons over the course of centuries, more or less coincides with the present-day street except that as it reaches what is today the Parador de San Francisco, it disappears.

To understand the development of the Alhambra, it is important to study this street. It obviously follows a preestablished plan, which with time developed and adapted to the available physical space and to the demands of use. If we follow the Calle Real Alta, we gain insight into the plan of the medina itself: The lower level near the southern side of the Puerta del Vino is lined with important dwellings, while the area close to the palaces is occupied by buildings of a more public nature: cisterns, surely a madrasa, the mosque —with the Rauda to the south—and the bath of the mosque. Curiously, as the street ascends, it reveals a strict obedience to a hierarchical plan. Today the street stops when it reaches two now-vanished palaces: the palace of the former Convento de San Francisco and the Palacio de los Abencerrajes.

From this point forward, the upper zone of the Alhambra is artisanal in character, the site of industries supplying the court. We find a tannery for processing hides and furs, a mint, and several ceramics and glass workshops with ovens and muffle kilns.

Fig. 6 Alhambra, the Secano

Where these industries once stood, there are now only ruined walls or no archaeological evidence of their existence—we must rely here on documentary evidence—for following the Christian conquest, there came to live in this area of the Alhambra a different population, with a different concept of space and different domestic customs, causing a major modification of the urban texture. These changes eventually created the layers of debris that resulted in the fills and neglect that created the Secano.

The Calle Real Alta must originally have continued, perhaps dividing into a series of smaller streets, to the eastern extreme of the fortress near the Torre del Agua (Water Tower). One of the characteristics of the street is that almost for its entire length—at least in the area explored archaeologically—it parallels the main line of the aqueduct that supplied the Alhambra. We should not forget that the hill of the Alhambra had no water source of its own, and that the Naṣrid sultans had to devise a complex and ingenious engineering system to divert water, higher on the mountain, from the Darro River through a network of pipes, communicating reservoirs, sluices, waterwheels, and other components. The most visible of these ele-

ments are the Albercones on the slopes of the Cerro del Sol, which are the key to the water-supply system of the Alhambra and thus to the plan and development of the entire area.

The Torre del Agua itself stands over the point at the extreme eastern side of the Alhambra where water enters the complex; only the ruins of a *partidor*, or cistern, which distributed water to the sluices, and part of a reconstructed aqueduct remain of that tower. This is the section of the Alhambra that was most badly damaged by Napoleon's retreating troops in 1812.

All along the Calle Real in the medina of the Alhambra are a series of intersecting streets and secondary passageways. As we saw in the Barrio Castrense of the Alcazaba, the majority of the thoroughfares succumbed to the new urban plan of the Christian conquest and a sequence of later vicissitudes. Some of them may still exist but lie hidden beneath new constructions; some survived in a way when newer streets were laid over them. The best example of the latter is the small street that must have run in a fairly straight line between the easternmost gates of the Alhambra, the Puerta de Siete Suelos, and the Puerta del Arrabal. Today all that remains of it is the Callejón del Compás (Alley of the Compass), which begins at the Puerta del Compás (a part of the Convento de San Francisco) and leads down through the terraces of the Partal toward the Torre de los Picos, where it runs into the Puerta del Arrabal. This street, along with the Calle Real, vividly recalls the plan of the Roman *cardo* and *decumano* (intersecting streets in a municipality).

Farther west there is an alleyway perpendicular to the Calle Real called the Callejón del Guindo, clear evidence of the earlier existence of a small street laid with remnants of another cobbled street—perhaps even this same street—that is linked to the lower terrace of the Partal. Finally, the street that today runs parallel to the east face of the Palacio de Carlos V and ends at the gate called the Cauchiles (Water Basins) must have been laid over another at right angles to the Calle Real, where the building near the mosque and the Rauda, which may have been the madrasa endowed by Ibn al-Khaṭīb, is located. Because of the relationship it may have had with the Palacio de los Abencerrajes or its surroundings, it is equally interesting to note the small and curious overpass that links the Calle Real

with the Placeta de las Pablas in front of the mosque (today a church).

Perhaps the most important street in all the Alhambra, however, is the Calle de Ronda, also known as the Calle del Foso (Street of the Moat). This was the true Calle Mayor (Main Street) of the complex, affording rapid communication among all its dependencies. The name is well taken, for the street did become a moat in time of siege: The gates were closed, and the Foso acted as a separating and protective space between the dependencies of the fortress and the outer wall and also facilitated rapid movement of troops from one end of the area to the other when they were called upon to repel an assault or attempted breach of the gates or wall. Last, the circuit of the *adarve* atop the exterior wall was constantly patrolled by sentinels.

As we have seen with so many dependencies of the Alhambra, the Calle de Ronda, too, underwent important changes, even during the Muslim era. The street begins beside the main courtyard and follows the entire perimeter of the complex, within the walls, to the Puerta de la Justicia at the opposite side, where it ends. Originally it passed in front of the palace area, sometimes using tunnels or overpasses; however, the expansion of these palaces, especially in the mid-fourteenth century, hid or modified the street to such an extent that today it is nearly unrecognizable until it reaches the level of the Puerta del Arrabal. The *adarve* in this sector was also displaced by the construction of new palaces, which transformed it into a semihidden gallery that runs the entire length of the buildings on a lower level. From the Torre de los Picos standing above the Puerta del Arrabal, the street continues uphill without interruption to the extreme eastern tip of the area, to the Torre del Cabo de la Carrera (End of the Path Tower). The destruction wrought by Napoleon's troops caused it to disappear between this tower and the Torre del Agua—although it is barely visible where it passes beneath the point of entry of the aqueduct, the Acequia Real.

This street also suffered from Napoleon's destruction and from modifications—with attendant dumping and rubble fill—in the Secano, specifically in the sections between the Torre del Agua and the Puerta de Siete Suelos and on the gentle descent from the latter gate to the Palacio de los Abencerrajes. The street is also interrupted as it passes the present Puerta de los Carros (Carriage Gate), undoubtedly because of transformations necessitated during the construction of the Palacio de Carlos V. Nevertheless, it continues from the small Torre de la Barba (Beard Tower) to its end at the Puerta de la Justicia, where it is hidden by a modern tunnellike covering.

From time to time along the Calle de Ronda, we find signs of old communication with dependencies of the fortress, whether direct or through smaller cross streets. As we follow the original plan of the street, one of the interesting features we see along the way is the variety of towers. In fact, there are several classifications of towers within the walls of the Alhambra, classifications as varied as their role in the plan of defense or the other uses for which they were intended.

Apart from towers that housed or protected the exterior gates of the area and those that are part of the palaces, we can identify two additional types. First, there are tower dwellings, even tower palaces, the rather luxurious residences for people closely connected with the sultan or the court for family or institutional reasons. These towers are completely independent of the defensive system; the *adarve* of the guard passes through a tunnel beneath the main entrance without breaching their privacy, and the Calle de Ronda is bridged by a gate or overpass. The Torre de la Cautiva (Tower of the Captive) and the Torre de las Infantas are significant examples of this category.

The other type of tower is military in nature, smaller and apparently without special importance. These towers are situated at irregular intervals along the perimeters of the wall, strategically interrupting the course of the *adarve*, which must pass through them as if through a checkpoint. The Torre de Muḥammad and the Torre del Candil, among others, belong to this classification.

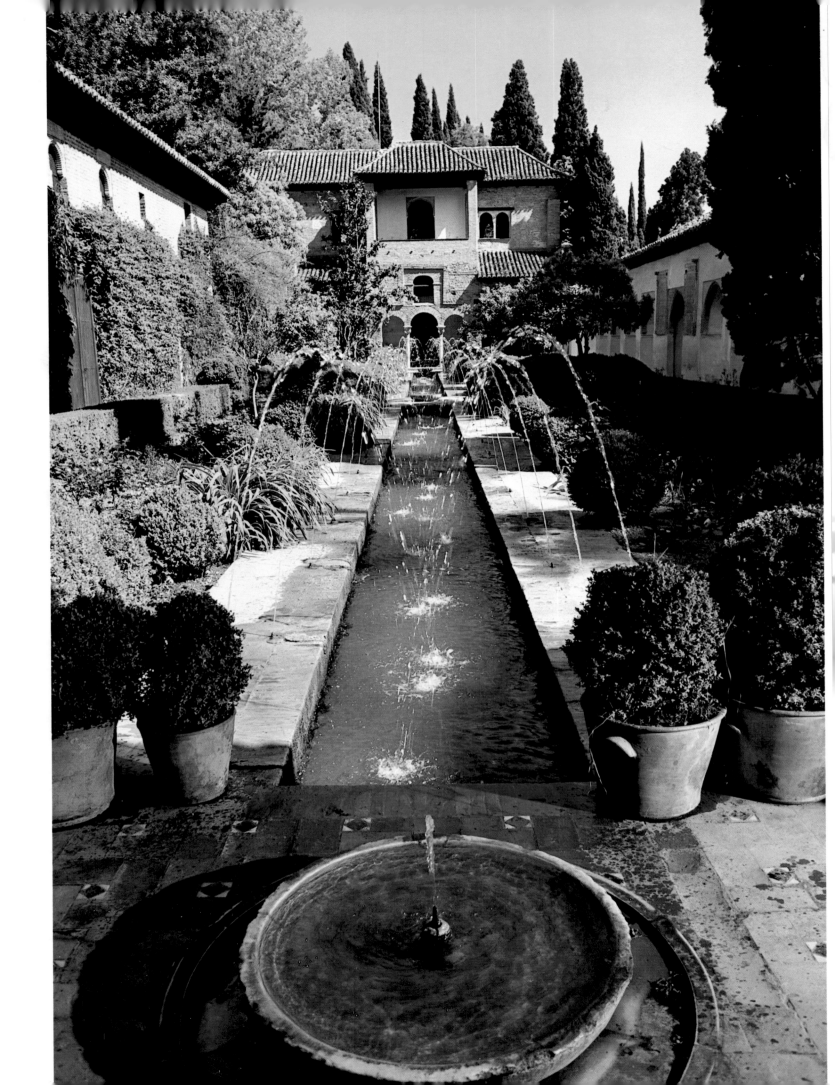

The Gardens of the Alhambra and the Concept of the Garden in Islamic Spain

D. FAIRCHILD RUGGLES

The Alhambra gardens represent the culmination of a long line of gardens and garden estates that began in Córdoba in the middle of the eighth century with the founding of al-Ruṣāfa by the first Umayyad ruler of al-Andalus.[1] Such estates, in which agricultural enterprise was combined with the cultivation of nature for the sake of its beauty, proliferated throughout the ninth and tenth centuries, and the Umayyad kingdom of al-Andalus reaped the benefits of their fruitfulness. Since the economy of the medieval Islamic world was based almost entirely on agriculture and the trade of its products, agricultural changes had a profound effect on al-Andalus. As a result of the importation of new cultivars and the concerted application of already known techniques of fertilization, grafting, and water management, production increased in quantity and quality. This set off a cyclical process in which agricultural surpluses led to flourishing urban markets, which encouraged capital investment in the countryside, where farms were located, which in turn contributed to greater yields. The two factors of agricultural transformation and economic development reverberated within the medieval consciousness, affecting the way landscape was used and perceived and inspiring a new awareness of the landscape's potential for economic yield and inhabitability, with tremendous ramifications for the design of landscapes and gardens.

To some extent both the medieval Christian and Islamic worlds were preoccupied with the relationship between humankind and God and between the transitory realm of the flesh and the eternal realm of heaven; nonetheless both societies had powerful secular dimensions. Particularly in the context of Islamic garden making and landscape transformation, which previous studies have explained solely on the basis of the Qurʾanic theme of paradise, it is critical to recognize the extent to which environmental, economic, and political factors played a role.

In al-Andalus a language of landscape developed that was a code for a system of social, political, and economic values placed on land. These values were articulated by a set of visually organized objects intended for a prescribed audience—the caliph and his court. They sprang from the agricultural exploitation of ever-expanding areas of land but were expressed artistically in the highly artificial environment of palace gardens. Water was the conceptual underpinning of the garden, for the fountains and pools that were fundamental elements of its morphology represented the respective methods for the acquisition and collection of water in the irrigation networks of Spain. Decorative channels and raised or sunken flower beds displayed in miniature the process by which water was transported and distributed. The geometrical layout of the garden, in which axes and intersections are marked by channels, fountains, and pools, gave physical structure to the performance of water as the politico-economic foundation of the irrigated society. The presence of water and its dependent vegetation implied the prosperity, luxury, and ease provided by the abundance of water. And finally, the act of creating a

superb garden symbolized the appropriation of the kingdom's territories and referred to the leadership required to implement a hydraulic system capable of literally supporting a royal garden and, by conceptual extension, an entire agricultural landscape.

The Umayyad gardens were representations of landscape as well as actual landscape—essential parts of the surrounding environment. On the one hand, the garden was acted upon by that environment, for gardens are shaped by current agricultural technique, plant species, soil, water, and climate. On the other hand, the environment was acted upon by the garden, for the increase in available cultivars and botanical knowledge in the first two centuries of Umayyad rule in al-Andalus was facilitated by royal patronage and gardens, which were repositories for exotic plant species and testing grounds for new techniques that in turn stimulated agricultural expansion into hitherto unarable areas.[2]

The earliest recorded mention of the acquisition and deliberate transplantation of exotic plants into Andalusian soil is in a reference to the palace of al-Ruṣāfa. Dating to the beginning of ʿAbd al-Raḥmān I's reign (756–88 [A.H. 139–72]) and built three kilometers northwest of Córdoba in the area known even today as Arruzafa, al-Ruṣāfa was the first garden state in al-Andalus. The historian Ibn Saʿīd praised its beautiful irrigated gardens, saying that ʿAbd al-Raḥmān had sent a messenger to foreign parts in order to obtain special plants, so that "al-Ruṣāfa became famous for the excellence of its plant varieties."[3] Al-Ruṣāfa contained within its extensive gardened grounds a superior pomegranate that had been sent especially from Syria by ʿAbd al-Raḥmān's sister. The courtier Safar planted its seeds in an experimental garden near Málaga and, when the young tree grew and bore fruit, he brought the pomegranates to ʿAbd al-Raḥmān.[4] Ibn Saʿīd noted: "The Emir admired his discovery, appreciated his efforts, thanked him for the work he had done, and recompensed him generously. He then planted that pomegranate in Ruṣāfa and in his other gardens. That pomegranate species spread and the people planted groves of them."[5] This is the first reference to a botanical garden in al-Andalus where exotic species could be cultivated in a controlled manner and acclimatized. It not only demonstrates the precocious interest in botany and practical agronomy that existed in the eighth century, but also indicates that royal patronage promoted the spread of improved plant species.[6]

The concept of the garden continued to develop in Córdoba for the next two centuries, a particularly important expression of which was realized in the palace city of Madīnat al-Zahrāʾ. Al-Zahrāʾ emerged from the Cordobán tradition of building farm and recreation estates in the agricultural zone surrounding the city, yet it was an architectural type new to al-Andalus. Like al-Ruṣāfa, Madīnat al-Zahrāʾ was built well apart from Córdoba in a landscape made green and fertile through the introduction of water from the mountains for irrigation and through the planting of gardens and orchards for both enjoyment and profit. However, Madīnat al-Zahrāʾ was larger and more architecturally complex than previous estates, for it unified the typology of the Cordobán garden estate with the sophisticated palace architecture of the ʿAbbāsid court in Samarra in Iraq, which was more cosmopolitan than that of the Umayyads.

Madīnat al-Zahrāʾ was built in a series of stepped levels cut into the southern slope of a mountain, the highest level being roughly sixty meters above the lowest. Because of the site's steep incline, the elevated position of the upper structures afforded views onto the palace gardens, and from these gardens toward the landscape beyond. Both the topographic situation and the design of the architecture itself were new, for the gardens and countryside were seen through the controlled lenses of miradors—literally places for viewing—in the form of terraces, framing windows, and pavilions.[7]

Only three of al-Zahrāʾ's gardens are known from archaeological remains: the Prince's Garden, the Upper Garden, and the Lower Garden. On the highest level is the so-called Prince's Garden, a small, elegant residence that was conceived on an intimate scale and probably served as a private dwelling for the heir apparent, the wife of the caliph, or another important member of his family.[8] Rectangular in plan, it is contained at its east and west ends by halls stretching almost the entire width of the garden and on its south side by a blind wall (Figs. 1, 2). The northern wall has steps leading to structures on higher ground. A paved walkway bordered by water channels forms a longitudinal axis that divides the garden into two almost equal parts, and an axially aligned square pool occupies the space in front of the western hall.

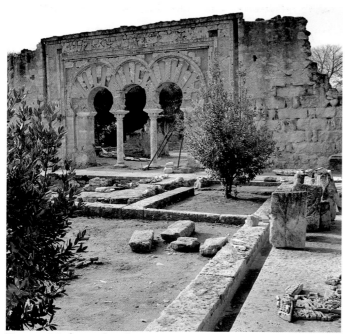

Fig. 1 Madīnat al-Zahrāʾ, Prince's Garden

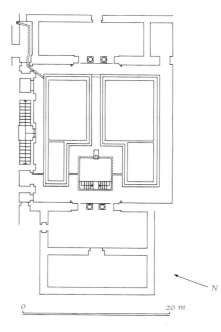

Fig. 2 Madīnat al-Zahrāʾ, Prince's Garden, plan

On the middle level, facing the Salón Rico (Rich Hall), or reception hall, is the Upper Garden, an enormous enclosed space in the form of a four-part composition (Fig. 3). The garden's axes are determined by paved walkways bordered by water channels used for irrigation. This is the earliest surviving quadripartite garden in the Maghrib and al-Andalus, predating the Castillejo of Monteagudo by two hundred years.[9] The north arm of the crossed axes was made up of a small pavilion surrounded by rectangular pools. Although the elevation of the pavilion is not known, it almost certainly had windows on all four sides so that to a viewer looking out of the building would seem to be surrounded by water. This was a remarkably early instance—the earliest surviving example of which I am aware—of a floating pavilion in Islamic architecture.[10]

The Lower Garden, located approximately fourteen meters below the Upper Garden, was an extensive walled quadripartite garden with paved walkways and pools marking the termini of its axes. A rectangular expansion of pavement along the southern arm may have been the foundation of a garden pavilion, but this attribution is speculative because the area has not been thoroughly excavated.

The position of the spectator in Madīnat al-Zahrāʾ's gardens was fixed in three points. The first was the central pavilion in the Upper Garden, from which there were four possible views of the surrounding

water and vegetation. The second was the presumed mirador in the west wall of the Upper Garden, from which one looked toward the Lower Garden, another large quadripartite garden approximately twelve meters below, and across to the fertile cultivated plain of the Guadalquivir River valley.[11] The third was the Salón Rico, which overlooked the Upper Garden from

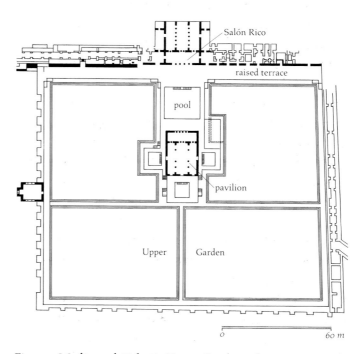

Fig. 3 Madīnat al-Zahrāʾ, Upper Garden, plan

an elevated position (Fig. 4). Cut into the stepped terrace, this hall was windowless on three sides but opened through the south wall to the garden, with five arches framing the view (Fig. 5). According to medieval descriptions of the court ceremonies and feast days celebrated in the Salón Rico and Upper Garden, on formal occasions of state, the caliph sat on a raised throne in the middle of the hall; family, government officials, palace staff, and members of the military were positioned in rows, diminishing in rank as they radiated away from him, out of the hall, and across the garden terrace. The uniqueness and primacy of the caliph's person were asserted by this enactment of social hierarchy. Likewise, the hall's focused space and dominant position over the garden in which the event took place underscored the centrality of the viewer, who was the caliph.

At all three of the Upper Garden's viewing points, the placement of architecture in landscape emphasized not just the view of nature but also its view from a particular location. The mirador, whether a pavilion or a projecting window in an enclosure wall, fixes the direction of vision and dictates what is seen. For this reason the mirador is invariably located at the intersection of two crossed axes or at one of the axes' terminal points, and it is always elevated, directing the gaze downward to the garden. The mirador, as the origin of seeing, denotes the beholder—who is understood to be the caliph or king—and the view is seen from his perspective. Landscape panoramas, especially,

were seen through the ruler's eyes, for in the medieval period, the all-encompassing view of landscape and domain was the ruler's exclusive prerogative because he alone was responsible for conceptualizing and shaping the structure of the kingdom.

Madīnat al-Zahrāʾ became the model for subsequent palace estates built in Córdoba until the civil war of 1010 to 1013 (A.H. 401–4), when the Umayyad-ʿAmirid government was overthrown. Thereafter, in the period of the mulūk al-Ṭawāʾif, the idea of the garden was disseminated to the capital cities and royal palaces of the Taifa kingdoms in the rest of Spain. The largest and most powerful of these kingdoms was Seville, which had a palace zone that sprawled on either side of the city wall, as well as a number of suburban palaces (Fig. 6). In the eleventh century the Taifa ruler al-Muʿtamid (r. 1069–91 [A.H. 462–84]) ordered the planting of the area of Seville called the Buḥayra, today the Huerta del Rey. He placed a pavilion in the center of the Buḥayra's orchards and gardens, so that their productive aspect was commingled with the enjoyment of their aesthetic qualities.[12] In 1171 (A.H. 567) the Almohad ruler Abū Yaʿqūb Yūsuf added a magnificent group of palaces to the Buḥayra, supplying them with water via a renovated Roman qanāt (underground aqueduct).[13] According to Ibn Ṣāḥib al-Ṣalāt, in the twelfth century:

> The Caliph commanded Abū al-Qāsim Aḥmad ibn Muḥammad, the qāḍī, and Abū Bakr Muḥammad ibn Yaḥyā, the imām of the mosque, because of his trust in their knowledge of surveying, soil preparation, and cultivation, to design for him everything concerning his palace constructions, and with respect to the barren land surrounding them, to use treasury money to plant olive trees, fig trees, vineyards and fruit trees of all the most delicious and rarest species.... He charged the people of the Aljarafe to dig up roots of a variety of select olive trees which were bought with treasury money, and to take them to the Buḥayra to be planted. They were brought from miles away, a task in which the most qualified folk assisted. The shoots were planted in rows in order to facilitate tending them. The Caliph used to ride out from his palace in Seville

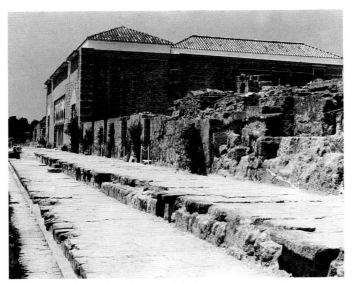

Fig. 4 Madīnat al-Zahrāʾ, Salón Rico, exterior view

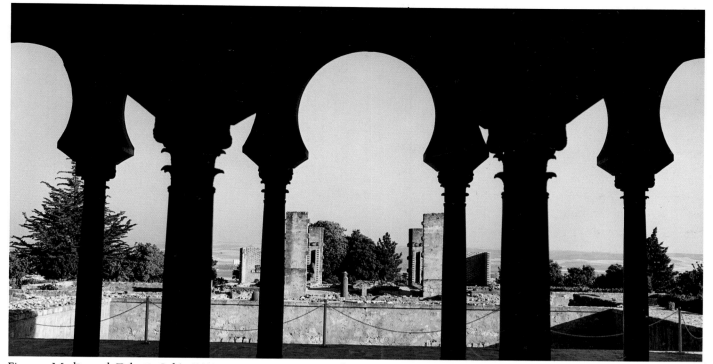

Fig. 5 Madīnat al-Zahrāʾ, Salón Rico, view onto Upper Garden

with his principal followers for the enjoyment of watching the olives being planted. Aḥmad ibn Bāṣu, the foremost architect in al-Andalus, had no equal in his work on these palaces of the Buḥayra.[14]

The description of men skilled in the surveying and cultivation of the land is particularly significant because it is the first medieval Hispano-Islamic reference to a landscape architect.

Rebuilding in the Almohad and Christian periods erased most of the original fabric of al-Muʿtamid's al-Mubārak Palace, which stood within the city walls, but we have some idea of its gardens from verses that praised the variety of its colorful flowers: roses, narcissus, lilies, anemones, jasmine, stock, violets, poppies, daisies, and other flowers that "attract the gaze and make the eyes dally with delicate buildings that seem like spider webs."[15] A small portion of one of al-Mubārak's courtyard gardens was discovered by Rafael Manzano in the course of excavating a twelfth-century garden.[16] The latter, called El Crucero, follows a cross-axial plan formed by walkways dividing the space into four sunken quadrants that are approximately five meters deep.[17] A third garden, also of the twelfth century and probably built by the Almohads, has been thoroughly excavated by Manzano's team.[18] This garden is almost square, measuring 12.25 by 11 meters, and is divided by walkways into four quadrants that are two meters deep and decorated with stucco and intersecting blind arches of brick (Fig. 7). Pollen analysis has determined that orange trees were planted in the corners of each sunken quadrant. At one end of the courtyard, there still survives the facade of a brick portico consisting of central arches flanked on each side by additional arches (Fig. 8). At the other end were excavated three sunken flower beds from the al-Mubārak Palace.

There were other important palaces with gardens in al-Andalus, some of which have been excavated. The Aljafería of Saragossa was organized around a central gardened courtyard, but all of its plantings and pavements visible today are modern. The Castillejo of Monteagudo, Alcazaba of Málaga, and Alcazaba of Almería, like al-Zahrāʾ, were built on elevated sites. All of them had interior views of gardens with water channels, pools, fountains, and colorful flowers. Additionally, the hilltop locations of the Castillejo and the Alcazaba of Málaga yielded vistas of an irrigated landscape of productive fruit orchards. The Alcazaba of Almería, which was situated in arid terrain, included interior gardens with axial walkways, a central pavilion, and irrigation channels (Fig. 9). Its exterior prospect, however, was not of landscape but of the sea, which

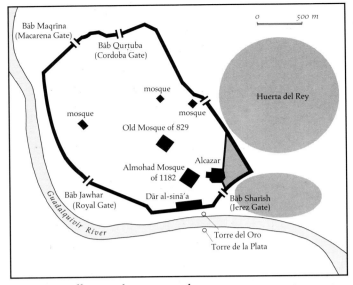

Fig. 6 Seville in 11th century, plan

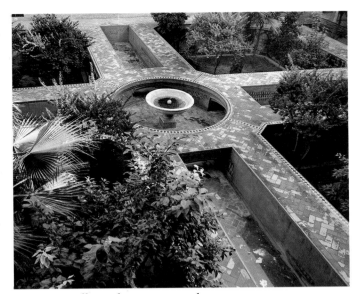

Fig. 7 Seville, 12th-century garden

made possible the trade that was the basis of the port city's economy.

Like Córdoba and Seville, medieval Islamic Granada was situated in a fertile landscape irrigated by streams and rivers that provided abundant water for its palace and agricultural estates. According to the historian Ibn al-Khaṭīb, called Lisān al-Dīn, the Alhambra, as well as Granada itself, was densely planted with so many verdant gardens that the light-colored stone of the palaces' many tall towers shone like bright stars in an evening sky of dark vegetation.[19]

The Alhambra is a complex layering of Zīrid, Naṣrid, baroque, neoclassical, and modern conceptions of nature and landscape. Although the extant palaces at the Alhambra date largely from the Naṣrid period, they probably followed the foundations of the eleventh-century palaces of the Zīrid rulers' influential vizier, Samuel ibn Naghralla. Samuel, whose family had fled Córdoba in 1012, brought Cordobán artistic taste to Granada in the eleventh century.[20] Descriptions of the vizier's sumptuous residence on the Alhambra hill mention gardens and fountains, as well as theatrical effects achieved with water and vegetation. When Samuel died in 1056, his son Yūsuf inherited the post of vizier as well as the father's penchant for dramatic garden and architectural effects, and he built a magnificent palace on the hill where the Alhambra now stands. The parallels between Yūsuf's palace and Madīnat al-Zahrāʾ are many: Each sat on an elevated site overlooking a flat plain and was embellished with

luxurious materials and adorned with flower gardens and fruit trees. Moreover, the emphasis in Yūsuf's palace complex on water in the form of large tanks, fountains that were like natural springs, and channels that traversed the courtyards reflects the Cordobán prototype. The poet Ibn Gabirol wrote:

> There is a large pool, similar to the Sea of Solomon, but it does not rest on bulls; such is the expression of the lions, at the pool's edge, that the cubs seem to roar through their jaws; and like springs, they spill their guts through their mouths, flowing like rivers. Next to the channels are sunken hollows so that the water may be decanted to spray the plants in the garden beds with it and to sprinkle the stems with pure water and to water the garden of myrtles with it.[21]

These eleventh-century lions, which were moved to the Patio de los Leones (Court of the Lions) when it was built in the fourteenth century, are not the first animal figures used in fountains. One of ʿAbd al-Raḥmān III's Cordobán palaces had a golden lion fountain with sparkling jewel eyes that spewed water through its mouth;[22] and the Zāhira palace, built by al-Manṣūr in 978 (A.H. 368) to supplant the caliphal palace of Madīnat al-Zahrāʾ, included a lion fountain of black amber with a necklace of pearls.[23] Furthermore, in the hills well above Córdoba, there is a fountain in the form of a large stone elephant that

may have been part of the irrigation system of a tenth-century agricultural estate (Fig. 10).

The Alhambra became the Naṣrid seat in the second quarter of the thirteenth century and was continually augmented and embellished throughout the fourteenth. The Patio de los Leones, the Generalife, and most of the other constructions visible today date to this period. At the Alhambra, as at Madīnat al-Zahrā², Monteagudo, and the alcazabas of Málaga and Almería, the eye is constantly invited to look through and beyond the garden walls (Fig. 11). Although spaces such as the Patio de los Leones and the Generalife's Patio de la Acequia (Court of the Channel) are enclosed by architecture, their walls are pierced with miradors that overlook the palace gardens on the lower slopes of the Alhambra hill and the more distant landscape of the Albaicín hill. Such vistas are often framed by arched polylobed windows, as in the Salón de los Embajadores (Hall of the Ambassadors) or the elegant Cuarto Dorado (Golden Room). The windows of the latter look outward to the hills and streams of the "natural" exterior countryside and inward toward the enclosed paved courtyard, where the only reference to nature is a single water basin at the center. The all-encompassing vistas of garden and landscape at the Alhambra belie the traditional conception of the Islamic garden as an entirely self-contained private space; instead they show that different visual perspectives were incorporated into garden design by manipulating the direction of the gaze and the distance it traversed.

Inscribed on the walls and fountains of the Alhambra are verses referring to the gardens and landscape. In the Patio de los Leones and the Sala de las Dos Hermanas (Hall of the Two Sisters), for example, verses by the poet Ibn Zamrak celebrate the watercourses and vegetation, the architecture and space surrounding the garden, and the view onto the more distant countryside, as well as Emir Muḥammad V, for whom the garden was built.[24] A verse in the Mirador de Lindaraja reads: "In this garden I am an eye filled with delight and the pupil of this eye is none other than our lord."[25] The statement is absolutely clear in its identification of the viewing place—the mirador—with the viewer/king, and the art historian is extraordinarily fortunate to have it. Although the architecture at Madīnat al-Zahrā², Monteagudo, Almería, and Málaga makes evident the conflation of power with view, the Alhambra is the only palace in al-Andalus with an inscription explicitly articulating the relationship. Indeed, it is the only palace in al-Andalus known to have been inscribed with an epigraphic program that accompanies and explains its architecture and gardens.

The Patio de los Leones is a quadripartite garden divided axially by paved walkways and surrounded by a columnar arcade on all four sides. Pavilions projecting from the middle of the courtyard's east and west sides contain water jets; likewise there are basins in the Sala de las Dos Hermanas on the south side and the Sala de los Abencerrajes on the north. The water from these jets and basins flows in channels toward the central fountain, uniting the disparate spaces. Although the garden's original plantings are not known with certainty, a visitor in 1602 observed six orange trees in each quadrant. The surface of the soil

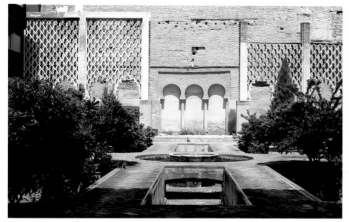

Fig. 8 Seville, 12th-century garden, portico

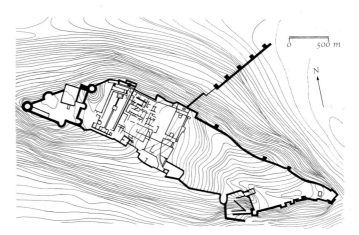

Fig. 9 Almería, Alcazaba, plan

was initially eighty centimeters below the level of the pavement.[26]

The Alhambra contains several post-Islamic gardens, such as those of the Patio of la Daraja, below the Mirador de Lindaraja, and the Partal. The former was originally an open garden with views from a projecting mirador called the ʿAyn Dār ʿĀʾisha (Eye of the Sultana's Palace), but it was enclosed when it was converted into private quarters for Emperor Charles V. The Torre de las Damas (Ladies' Tower) in the Partal also functioned as a mirador, with windows on the ground floor and a tower on the left side providing far-reaching views across the exterior landscape to the Albaicín hill. Although the orientation of the Partal pavilion to the landscape outside the walls of the Alhambra remains exactly as it was conceived by the Muslim builders of the palace, the Partal gardens themselves are twentieth-century restorations.

The Generalife Palace was built in terraces on the slope of a hillside on the side of the ravine opposite the Alhambra. When the Generalife's Patio de la Acequia was excavated and restored in 1959 following a fire, a thirteenth-century Islamic garden was discovered with both its original soil level, half a meter below the surrounding pavements, and its original irrigation system intact—neither of which was retained in the restorations.[27] The garden is organized along a central axial watercourse, the water for which is supplied from mountains via the same aqueduct that serves the Alhambra. The water channel is bordered by plant beds and intersected by a short, narrow walkway. The north and south ends of the garden are each marked by a longitudinal pavilion; both offer pleasant views of the garden and watercourse below, and from the southern pavilion panoramic views of the Alhambra and surrounding countryside can be enjoyed. The west wall is pierced by arches and a projecting mirador that looks over the lower gardens, which are modern restorations, and across the ravine to the Alhambra with the Sierra Nevada in the distance. Although this mirador appears to be an alteration made by Isabella and Ferdinand, it is likely that it replaced an Islamic mirador from the late thirteenth or early fourteenth century.[28] The gardens on the elevated terrace above the Patio de la Acequia were largely redesigned after 1492.

James Dickie has noted that the Patio de los Leones and the Generalife's Patio de la Acequia constitute two distinct types of gardens. The Patio de los Leones is of the expansive four-part kind (an early example of which was Madīnat al-Zahrāʾ's Upper Garden), and the Patio de la Acequia is of the self-contained, longitudinal type (like that of Madīnat al-Zahrāʾ's Prince's Garden and domestic house courtyards in al-Andalus). However, the typologies are inverted: The cross-axial plan of the Patio de los Leones is realized in a contained domestic space, whereas the Patio de la Acequia is expanded literally, as well as visually, through its vistas onto the gardens and hillside below.[29]

The skillful manipulation of topographical elevation and vision that took place in al-Andalus began at Madīnat al-Zahrāʾ and was developed further at Monteagudo, Málaga, Almería, and the Alhambra. Architecture, garden, and landscape were united by the mirador so that they gave structure to the relationship between nature and humankind. Although the meaning of the landscape and the way it was perceived changed considerably from the time of the Umayyads and Madīnat al-Zahrāʾ to the time of the Naṣrids and the Alhambra, the formal typology of the garden became a fixed element in royal palatine architecture, an indispensable aspect of the language of luxury and prestige. Even after the reconquest the Islamic taste for architecture oriented to landscape and for elevated views was continued in the *carmenes* (villas) and aristocratic palaces of Granada and elsewhere in Spain.

Fig. 10 Elephant fountain, 10th century, stone

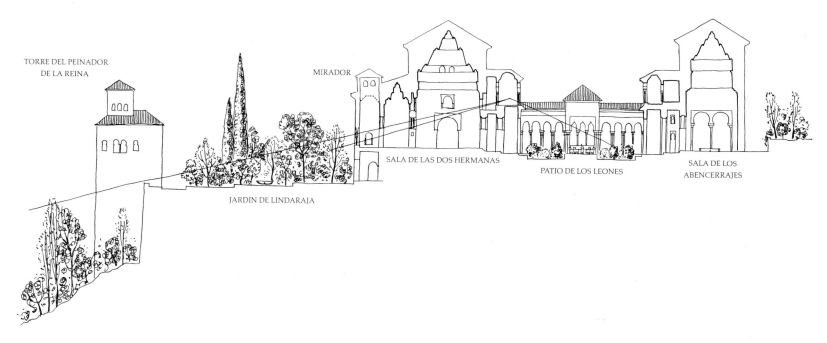

TORRE DEL PEINADOR
DE LA REINA

MIRADOR

SALA DE LAS DOS HERMANAS

PATIO DE LOS LEONES

SALA DE LOS
ABENCERRAJES

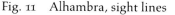

JARDIN DE LINDARAJA

Fig. 11 Alhambra, sight lines

1. For an extensive analysis of the relationship of gardens and land-scape to architecture, see Ruggles 1991.
2. Watson 1983.
3. Al-Maqqarī 1967, vol. 1, p. 304.
4. Samsó 1981–82, p. 135.
5. Al-Maqqarī 1967, vol. 1, p. 305.
6. Samsó 1981–82, pp. 138–39; Watson 1983, p. 89 and passim.
7. The typological sources for palace architecture organized to provide views are discussed in Ruggles 1990, pp. 73–82.
8. The women in the household traditionally resided in the harem. However, such an important dwelling might well have belonged to a woman as powerful as Ṣubḥ, who was al-Ḥakam's wife, Prince Hishām's mother, and al-Manṣūr's coconspirator.
9. Torres Balbás believed that the Castillejo in Murcia and the Almoravid palace excavated beneath the Kutubiyya mosque in Marrakesh contained the two earliest cross-axial gardens in the Islamic west, but the Upper Garden at Madīnat al-Zahrāʾ, which was excavated in the 1950s, changes his chronology (1958, pp. 171–92).
10. Ruggles 1990, pp. 75–76.
11. In fact, the existence of a mirador in this position cannot be proven from archaeological remains. But a view as encompassing as the one that such a mirador would have provided was offered from the ramp that led from the Upper to the Lower Garden (ibid., pp. 76–78).
12. The palaces outside the Bāb al-Jahwar (Gate of Jahwar) were located in a place popularly known as the Bocados de Faraón (from Luqam Firʿawn, meaning Pharaoh's Tidbits), where there were orchards (huertas) named for their former owner, Ibn Maslama (Ibn Ṣāḥib al-Ṣalāḥ 1965, pp. 464–65 [Arabic], p. 188 [trans.]); Bosch Vilá 1984, pp. 273–83.

 Torres Balbás first suggested that the Huerta del Rey might be the site of al-Buḥayra (1945b, pp. 89–96), and his theory was confirmed by excavations carried out there in 1972 by F. Collantes de Terán and Juan Zozaya (1972); Moreno Menayo 1987, vol. 3, pp. 43–51.
13. Ibn Ṣāḥib al-Ṣalāḥ 1965, pp. 468–69 (Arabic), pp. 190–91 (trans.); Bosch Vilá 1984, pp. 227–30.
14. Ibn Ṣāḥib al-Ṣalāḥ 1965, pp. 464–66 (Arabic); trans. in Rubiera 1988, pp. 139–40. For a discussion of the architect Aḥmad Ibn Bāso, see Dodds 1982.
15. Rocío Lledó Carrascosa 1986, pp. 191–200.
16. Unfortunately, the results of the excavation have not been published. Although Manzano had promised a paper on the subject for the ICOMOS colloquium on the Islamic garden in November 1973, he did not produce a text.
17. Dickie 1976, pp. 97–98.
18. In lieu of Manzano's excavation report, the best discussion of the garden is ibid.
19. Simonet 1872, pp. 46–47.
20. Bargebuhr 1956, p. 196.
21. Ibn Gabirol 1978, pp. 174–79; this translation by Bargebuhr 1956, p. 198. Ibn Gabirol was from a Cordobán Jewish family, which, like Samuel's family, had fled during the civil war to Málaga and from there to Granada.
22. Al-Maqqarī 1967, vol. 1, p. 371.
23. Rubiera 1988, p. 92, citing Continente 1969, p. 131.
24. These verses are part of a longer poem reproduced in al-Maqqarī 1967. See García Gómez 1985, pp. 111–20.
25. Translated by James Dickie (1981, p. 134).
26. Dickie 1976, p. 100.
27. Bermúdez Pareja 1965, pp. 9–40, esp. p. 28.
28. Dickie 1981, p. 139.
29. Ibid.; also Ruggles 1990, p. 70 and n. 17.

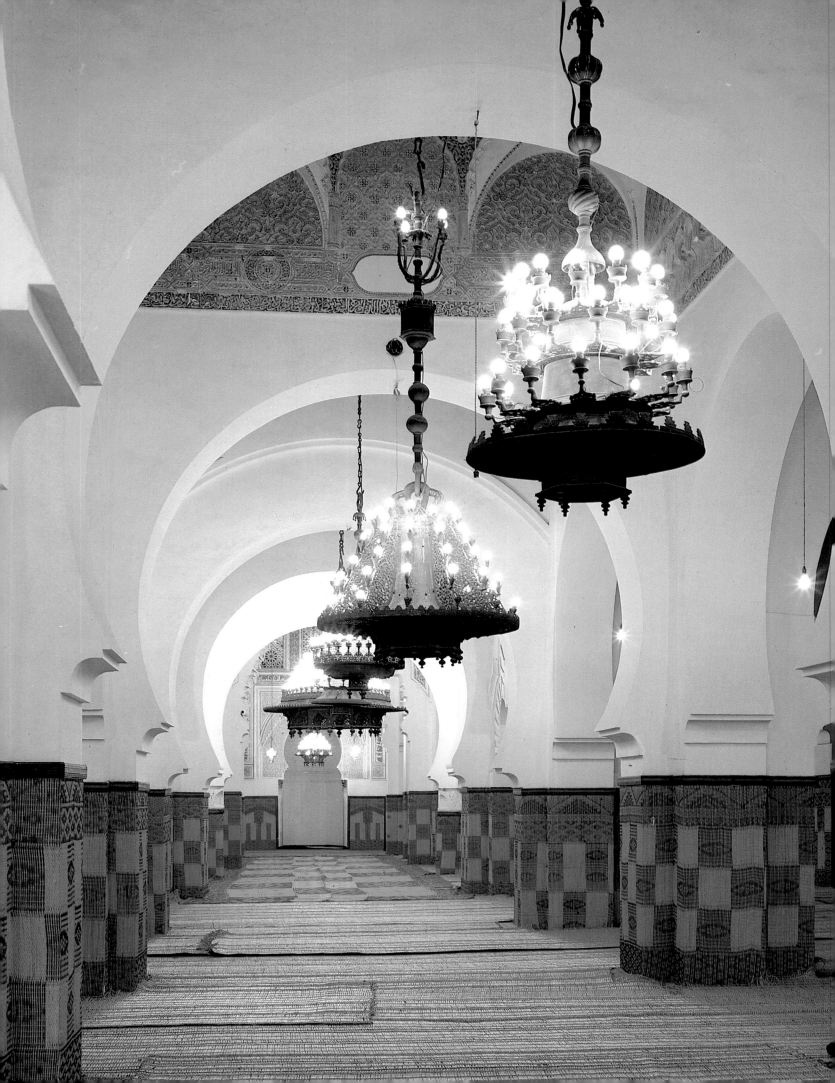

The Legacy of Islam in Spain

JUAN VERNET

The Evolution of Islam in Relation to al-Andalus

Muḥammad's rise to power with the propagation of Islam brought about the joining together beneath his aegis of the sedentary and nomadic peoples of the Arabian Peninsula. By 750 (A.H. 133), a little more than a century after his death in 632 (A.H. 11), his successors, the caliphs, had extended the dominion of Islam from the Indus and the Amu Darya rivers to the Pyrenees Mountains. And within the second hundred years, Arabic had become the language of culture in these lands, as later, from the thirteenth to the sixteenth century, Latin would be in Europe. About 1000 (A.H. 391) Baghdad and Córdoba were the two poles that drew the attention of all the peoples—whether Muslim or not—who lived in the regions stretching from China to the Atlantic Ocean and from the Sahara Desert to the Rhine and the Danube rivers.

The word "Islam," like "Judaism" or "Christianity," is the name of a religion. The "Book" of Islam is written in Arabic. We often forget that in Muslim Spain, where Arabs, Jews, Christians, Berbers, even Slavs, lived together, Arabic was the language of science and literature as well as of administrative affairs.

Soon after the Arab conquest of 711 (A.H. 92), the Muslims called the area of the Iberian Peninsula they controlled al-Andalus. Its population was composed in great part of descendants of the Hispano-Romans and the Christian Visigoths who had been subdued in the Battle of Guadalete by an army of Berbers, themselves also newly converted and under Arab command. The indigenous converts were materialistic (as Muslims they paid less in taxes than nonconverts) and opportun-istic (they were more likely to serve in administrative posts). In regard to religious matters, the most recent arrivals, following the counsel of the Qurʾan, did not involve themselves in the debates of the Christian theologians, nor were they concerned with the quarrels of non-Muslim subjects. In addition, their own religion had not yet been petrified by scholastic summas of Muslim ritual—that is, books of laws—and so they had an extraordinary capacity for adapting to everyday life.

Islam in Spain, more accurately, on the Iberian Peninsula, remained strong for eight centuries, and between 711 and 1091 (A.H. 92–484) Muslims in Spain were masters of their fate. However, toward the latter date the Christian lords to the north, who occupied the high valleys of the Cantabrian-Asturian and Pyrenees mountains and who had never yielded to the new religion, were beginning to make inroads into the territory of Islam. The Christians occupied Toledo, the ancient capital of the Visigoth kingdom, in 1085 (A.H. 478), after which they considered themselves the emperors of Spain. The loss of Spain, symbolized by the loss of Toledo, caused the Muslims to close their circle more tightly around the ever-diminishing al-Andalus. To contain their enemies, the Muslims sought the assistance of African allies; thus the dynasties of the Almoravids and the Almohads were able to establish themselves in al-Andalus (1086–1232 [A.H. 484–630]). They in turn succeeded in checking the Christian advance and in inflaming the ideological battle that before the fall of Toledo had been more rhetoric than reality. The clash of ideologies resolved itself on the one hand as the spirit of the Spanish

Fez, Qarawiyyīn mosque, mihrab aisle with bell lamps

Fig. 1 Mozarab manuscript, folio 117v, 9th century, vellum, Biblioteca Nacional, Madrid, case 14, no. 3

Crusades and on the other as the expulsion from al-Andalus of the Christian and Mozarab minorities (by the Almoravids) and the Jews (by the Almohads)—or as the adoption of extremist positions in religion and politics. The extremism that resulted, for example, in the exile of Ibn Rushd, known popularly in the west as Averroës, was only temporary and was intended to galvanize the population into confronting the danger from without while the Christian king Alfonso VIII—invoking a kind of *union sacrée de la patrie*—continued to advance. Upon the defeat of Alfonso at Alarcos in 1195 (A.H. 592), this stance softened, allowing the Muslim philosopher to be reinstated. However, in the end, the Almohads were only the predecessors of the last Muslim dynasty to rule on the Iberian Peninsula: the Naṣrid dynasty of Granada (1238–1492 [A.H. 638–898]). On January 2, 1492, their last sovereign, Muḥammad XII (Boabdil), surrendered the keys of the city of Granada to King Ferdinand and Queen Isabella. On March 31 of the same year, the Catholic sovereigns promulgated an edict expelling the Jews, and on October 12 Columbus landed in America. These surely were three landmark events to take place within the period of one year, and—considering how far removed our contemporary mentality is from the attitudes of the fifteenth century—celebrations of the quincentenary in 1992 will demand that their various sponsors perform true tours de force of historical exegesis.

The surrender of Granada did not announce the end of Islam in Spain, however. Despite the awareness that the struggle against Islam was a reconquest, many Muslims stayed to live under the protection of Christian authorities in the same way that Mozarabs had survived for four centuries in al-Andalus. From the thirteenth century on, colonies of Mudejars (publicly professed Muslims) and Moriscos (converts to Christianity, whether or not sincere) continued to live in Spain until 1609 and 1610 (A.H. 1018, 1019), when they were expelled by Philip III for political reasons.

The Birth of Islamic Arts and Science

It is within this historical framework that we find the cultural transition from the late Latin Mozarab world to the world of Spanish Islam and then, during the following centuries of impressive creativity (the tenth to the thirteenth century), the dissemination of the culture of al-Andalus not only to Europe but to the east as well. Let us review for a moment.

The major scientific and philosophical works of antiquity were assimilated rapidly in the east, in part from the original Greek texts and in part through intermediary translations in Syriac. Before the end of the tenth century, therefore, Aristotle, Archimedes, Ptolemy, and other principal scientific writers of the past could be read almost in their entirety in Arabic. The same was not true, however, of literature. Even though philosophy was held in high regard, the *Iliad*, the *Odyssey*, and the broad heritage of classical literature attracted the attention of the new lords of the world only occasionally.

Late Roman Heritage

In the west, that is, in al-Andalus, the situation was different. Here, there was a more limited knowledge of the classical sciences. The late Roman heritage had been comprehensively summarized by Saint Isidore (ca. 560–636) in the *Etymologiae*, a work that was a major contributor to the survival of the culture of the Mozarabs while they were a conquered people and as their language fell into disuse. (This language was an emerging Romance that until the end of the tenth century was the only language other than Basque that

the Christians of the Iberian Peninsula spoke before Romance branched into Catalan, Castilian, and Galician.) Scientific works in Latin were beginning to be used principally by Christian but also occasionally by Jewish physicians as the basis for their training and for the treatment of patients belonging to the three religions of the peninsula. Not the least among these patients were the emirs—either dependent on or independent of Damascus—and, later, the caliphs of Córdoba.

Fragments of the works of Saint Isidore were translated into Arabic, as was an astrological study entitled in Spanish *El libro de las cruces* (Book of the Crosses). We can follow the complex transmission of this book from one language to another and from one culture to another beginning in the eighth century, when al-Ḍabbī translated it into Arabic. It was not until the thirteenth century that Alfonso X, known as Alfonso the Learned, ordered it translated into Latin and Castilian. In the case of these works, and possibly in the area of agriculture, we can prove the phylogenetic relationships of certain texts. Unfortunately, that relationship is not as clear as we might wish with respect to technical knowledge whose importation is traditionally attributed to the Arabs. The introduction of irrigation systems, or *qanats* (in Spanish *matriz*, the origin of the name of Madrid), of mining techniques, and of siphon pumps contributed to the expansion of the arable lands of al-Andalus without threatening the existence of its great forests.

Introduction of Eastern Culture

During the reign of the Umayyad ʿAbd al-Raḥmān II (822–52 [A.H. 206–38]), who was independent of the ʿAbbasīd caliph of Baghdad, the whole of eastern scientific learning became available in al-Andalus. Arabic astronomical tables of Indian origin appear. We also find the game of chess, of which the oldest extant

Fig. 2 *Commentary on the Apocalypse*, Beatus of Liébana, folio 34v, 35r, 8th century, vellum, Catedral Burgo de Osma Soria, Ms. 1

pieces, carved in rock crystal and now located in the collegiate church in Ager,[1] date to the eleventh century and may owe as much to importation from Fāṭimid Egypt as to the work of local craftsmen.

Some ideas contained in Saint Isidore's *Etymologiae* gave rise to the development of T-shaped maps, one example of which is now in the Biblioteca Nacional of Madrid (Fig. 1). This particular map is of special interest, given the fact that the inscriptions are in Arabic, which suggests that it must have been used by Islamized Mozarabs. The *Commentary on the Apocalypse* by Beatus of Liébana (d. 789), which had a wide distribution and of which there are today some thirty examples, is illustrated with numerous miniatures, among them a mappemonde that details the travels of the apostles (Fig. 2). This map was frequently reproduced between the tenth and thirteenth century in a number of variations deriving from the two prototypes drawn by the Mozarab monk Maio, who had taken refuge in Asturias. The earlier of these prototypes is the Escalada map (926), and the later, commissioned by the monastery at Tábara and illuminated by Maio himself shortly before his death in 968 was already showing strong eastern influences. Comparison of these two examples demonstrates that the flow of scientific information—uninterrupted in the tenth century—spread from the east to al-Andalus and from there northward.

Paper followed the same route, originating in the east and moving toward Europe through al-Andalus and Christian Spain. From China, through Samarkand and Baghdad, it reached Córdoba. It initially appeared as loose sheets intercalated between sheets of parchment in manuscripts. Similarly, the numerals that we today call Arabic or Indian correspond to what were positional ciphers; we find them used this way, undoubtedly for the first time, in the *Codex Vigilanus* of 976. The numbers that appeared a century earlier in the margin of a folio of an Oviedo manuscript written by Saint Eulogius are known as Fez, or Notary. The last bit of evidence that documents the passage of eastern learning to Europe is MS. 225, dating from the beginning of the eleventh century, now in the monastery of Ripoll, which contains a series of Latin summaries of Arabic treatises on astronomy and mathematics. Some of them are the work of Maslama de Madrid (Maslama ibn Aḥmad al-Majrīṭī), and they circulated throughout Córdoba during the tenth

century. These translations, summaries, or commentaries rapidly spread to the monasteries in Lorraine, Reichenau, and Saint Gall.

Tolerance in Islam

Some Mozarabs took issue with the tolerance Muslim authorities displayed toward them and the Jews, a tolerance based on two Qurʾanic verses: "No compulsion is there in religion" (2:256) and "If thy Lord had willed, whoever is in the earth would have believed, all of them, all together. Wouldst thou then constrain the people until they are believers?" (10:99). This concept of respect for other religions revealed by Abraham clashed with the teachings of 2 Timothy 4:2–4: "Preach the word: be instant in season, out of season: reprove, entreat, rebuke in all patience and doctrine. For there shall be a time, when they will not endure sound doctrine; but, according to their own desires, they will heap to themselves teachers, having itching ears: And will indeed turn away their hearing from the truth, but will be turned into fables." Muslim tolerance undoubtedly contributed to the absorption of Arab culture, if not its religion, by the Christian faithful, who reacted in two ways to the conquest: Some immigrated to Christian lands in the north, toward the kingdom of León, as Christians living in Mérida explained in a letter they sent to Louis the Pious in 828; others remained in al-Andalus and soon divided into two groups, zealots and moderates. The former, led by Albar of Córdoba and the cleric Eulogius, incited their followers to dishonor Muḥammad publicly in 850 (A.H. 236), knowing that such conduct would mean execution. This behavior outraged the emir Muḥammad I, who drew on his theoretical right to confirm elected bishops and, with the backing of the moderate Mozarabs, convened a council composed of the Christian hierarchs of al-Andalus. This council decreed that from that time on, the church would not bestow martyrdom on anyone who provoked his own death, since such action was tantamount to suicide. The remains of the executed zealots, however, came to be venerated in Christian Europe, and to the journeys of merchants and ambassadors between Córdoba, Aachen, and other places were added the travels of monks searching for relics in Saragossa, Valencia, Córdoba, and other Spanish centers.

The tolerance of the emirs of the period extended

to questions of Jewish and Christian civil and penal law; they intervened only when the fortunes of a Muslim were involved. Jews and Christians, such as Hasdai ben Shaprut (or Gómez), for example, held high administrative positions, although they apparently made an effort never to exercise their authority over Muslims. Jews and Christians were ambassadors and heads of various administrative offices, but they did not, in the beginning, have direct contact with the masses.

Muslim authorities, on the other hand, were very sensitive to transgressions committed by their own subjects in departing from the predominant Malikī doctrine in al-Andalus. Ibn Hāniʾ (al-Andalusī), an excellent poet, was branded depraved because of his leanings toward Fāṭimid ideas and had to flee to Egypt. Ibn Masarra, viewed with suspicion because of his esoteric teachings—a possible threat to public order—fled and took refuge in the mountainous terrain around Córdoba. Books by Baqiyy ibn Makhlad, Ibn Ḥazm, al-Ghazzālī (Algazel), and Ibn Rushd were burned, destroyed, or expurgated. Some of these events recall happenings in Europe of the last fifty years.

Birth of the Culture of al-Andalus

Although books were destroyed, some survived, which implies the existence of private libraries and perhaps even a public library in Córdoba. Arab authors tell us that the Visigoths had a *bayt al-ḥikma* (house of wisdom) in Toledo that evidently had nothing to do with the later *bayt al-ḥikma* in Baghdad. It must have been an ecclesiastical library with classical Latin and, eventually, Greek works. Other texts refer to the libraries of the emirs ʿAbd al-Raḥmān II and Muḥammad I, and especially to the library of the caliph al-Ḥakam II al-Mustanṣir (r. 961–76 [A.H. 350–66]), of which, so far as we know, only one book has survived (Fig. 3). Al-Manṣūr expurgated al-Ḥakam's library for political reasons, and it was sacked by the masses and sold in lots later, during the *fitna*, or civil war, of the early eleventh century, which put an end to the Umayyad caliphate and gave rise to the *Taifa* kingdoms. Many works—especially those referring to the sciences—found homes in Toledo and Saragossa, where they were studied, to great advantage, by both Muslims and Jews. For two centuries Jews wrote their sacred books in Hebrew and their

Fig. 3 Manuscript from library of al-Ḥakam II, folio 347, 970 (A.H. 359), parchment, Bibliothèque de al-Qarawiyyīn, Fez

profane works in Arabic, as this was a time when Arabic was consecrated as the tongue of world culture.

The century of the caliphate of Córdoba (929–1031 [A.H. 317–432]) witnessed not only successive additions to the mosque-cathedral of that city but also the construction of many other mosques, along with a group of palaces in the foothills of the Sierra Morena. Excavations of the ruins of those palaces have revealed to archaeologists not only massive walls but modest artifacts, such as small pipe bowls, as well (Fig. 4). The shape of the bowls and the fact that similar ones have been found in cities of the east suggest that the inhabitants of these castles smoked hashish in pipes like those still seen in Morocco. One quote lost in the enormous lexicological seas of the *al-Mukhaṣṣaṣ* of Ibn Sīdah of Murcia (d. 1064 [A.H. 458]) offers clear proof that this practice was commonplace—in part for

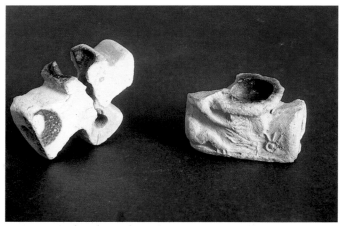

Fig. 4 Pipe bowls, 10th–11th century, ceramic, Badajoz, Alcazaba

pleasure and in part to combat seasickness. The Cordobán fleet was the master of the western Mediterranean and ruled the Atlantic from the coasts of the Río de Oro to Brittany. The caliphs achieved supremacy of the seas using typically Mediterranean ships and ships modeled after captured Norman vessels.

The Golden Age of the Culture of al-Andalus
As the caliphate deteriorated, it was replaced by many small "caliphates." Several petty regional lords had coins minted bearing their names and the prestigious title *amīr al-mu'minīn*, that is, Commander of the Faithful, or caliph. If under the caliphs of Baghdad, Cairo, and Córdoba there had been a tripartite division within Islam—not unlike the situation in the west caused by schisms among fourteenth- and fifteenth-century Christians—now Islam was even more splintered. Titles that had been highly esteemed during the Umayyad caliphate rapidly lost their meanings—for example, the designation "vizir" (*wazir*) began a process of dilution that has continued until in present-day Spain it has become the word for "bailiff" (*alguacil*). Currency, too, rapidly depreciated because coins contained ever-lower grades of precious metal. Soon they were rejected by northern Christians as payment for the protection they afforded various *Taifa* kings. Instead, each of the northerners, to the degree he was able, coerced or seized portions of *Taifa* lands.

What is truly significant, however, is the survival of those petty kingdoms today as political entities, which are recognized by the constitution of 1977 and may serve as the basis for a future federation. The king of Spain is, in fact, the king of all the cities recognized by the Cordobán chancery at the apogee of the caliphate's political and military power: Asturias (today Principado), Galicia, León (today Castile-León), Pamplona (today Navarre), and Barcelona (today a *condado*, or a county, but a kingdom in the tenth century). He is also the king of other territories that were the property of the *Taifa* kings and that gradually passed into Christian hands: Saragossa (Aragon), Valencia, Murcia, Toledo (today Castile-La Mancha), Seville, Córdoba, Granada (Andalusia), and others.

Another consequence of the twenty years of war and destruction that led to the collapse of the caliphate and left its capital, Córdoba, nearly demolished was the emigration of many scholars, merchants, and affluent citizens who wanted to live tranquilly in more secure regions. These desirable citizens were welcomed with open arms by Seville, Denia, Toledo, and Saragossa. The poet of al-Manṣūr's court, Ibn Darrāj al-Qasṭallī, took refuge in Saragossa. Ibn Darrāj has left us a series of *qaṣā'id* (poems) of unequaled beauty, comparable only to those al-Mutanabbī of Syria dedicated to Sayf al-Dawla. As poets were the journalists of the time, his verses shed light on many events in the ancient kingdom of Saragossa and in bordering Christian states. One poem, for example, was written for the wedding of Sancha of Castile and Count Berenguer Ramón of Barcelona, which was celebrated in 1018 (A.H. 409) in Saragossa. According to the author, the *Taifa* lord of Aragon, al-Mundhir, negotiated the marriage with the goal of enlisting the two *condados*, Castile and Barcelona, to help protect his lands, which were under constant attack from Sancho the Elder of Navarre. I question whether any Christian European sovereign ever received an honor so exalted as having his personal life immortalized by one of the greatest Arab poets of all time.

Another émigré who settled in Aragon was the Cordobán physician Ibn al-Kattānī. We have little information concerning how he exercised his profession; we do know, however, about his activities as a teacher of song and probably dance to female slaves, because the text used for their training has survived until today. Once they had learned those graces, the women were sold at exorbitant prices. This venture was probably the basis of Ibn al-Kattānī's enormous fortune, and we know that in pursuing his affairs he

visited Pamplona, where he saw Muslim slave women singing for Christian lords.

Other refugees were artisans. One group of ivory carvers settled in Cuenca, where they lived from 1026 to at least 1049 (A.H. 417–41). Although they utilized an imagery of living subjects (from plants to caballeros fighting singular duels) similar to that of their tutors—the artisans who worked under the caliphate—the refugees exhibited an inferior taste and technique. Workshops of architects were also reestablished in safer locations, and to them we owe construction of the splendid Aljafería palace in Saragossa and the Alcazar of al-Mubārak in Seville. (A long poem was written by another émigré to Seville, the Sicilian Ibn Ḥamdīs, to honor the al-Mubārak Palace.) Even in cities as near the border as Balaguer, an industry that produced beautiful objects flourished, and artists were never loathe to represent the human figure. The freedom to depict the human form and the consumption of wine are not explicitly prohibited in the Qur'an, even though a majority of the faithful believe the contrary.

Two very important texts written in the eleventh century give us details of the political and cultural development of that period. (The historical works of Ibn Ḥayyān allude to these subjects, but I prefer to leave them aside.) Pertinent political observations are found in the *Memoirs* of the last Zīrid king, 'Abdallah of Granada, which were written to justify his performance as ruler and which have been translated into both Spanish and English. During his reign a pogrom that culminated in the execution of the vizier Jehoseph ben Nagrella was carried out against the Jews of the capital. However, this pogrom was an exception in al-Andalus, where tolerance toward Jews was the norm.

Developments in science were related in great detail, although with occasional inaccuracy, in the second text, *Kitāb ṭabaqāt al-umam* (The Book of the Nations), by the *qāḍī* (magistrate) Ibn Ṣā'id of Toledo (d. 1070 [A.H. 462]). This work discusses schools of the sciences established by the astronomer Maslama al-Majrīṭī and the physician Abū'l-Qāsim al-Zahrāwī (known in Latin as Abulcasis) during the period of the caliphate; it describes how the schools continued to thrive in different locations around the Iberian Peninsula after they assimilated Greek science, represented by the *Almagest* by Ptolemy and the *Materia medica*

by Dioscorides (Fig. 5). Ibn-Ṣā'id demonstrates that he is cognizant of young scholars beginning their careers, those whom today we would say showed promise, and he outlines the texts by Jews who wrote in Arabic on scientific topics. One of many such authors was Ibn Gabirol, known among thirteenth-century Latin writers—who thought of him as a Christian—as Avicebron. We also know that around the Saragossan king al-Mu'taman (r. 1080–85 [A.H. 475–78]), himself an outstanding mathematician, there was a group of scholars and philosophers who developed the ideas of the *Rasā'il Ikhwān al-ṣafā'*. Al-Kirmānī carried these concepts to the Pyrenean frontier, and through them Ishmaelite gnosticism was introduced into al-Andalus. The esoteric teachings of this work would have been adopted on the basis of two verses of the Qur'an (24:35 and 23:20). These verses may have served as the source of things Arab in *Perceval*, or the *Conte du Graal*, by Chrétien de Troyes (fl. 1159–90) and the *Parzival* by Wolfram von

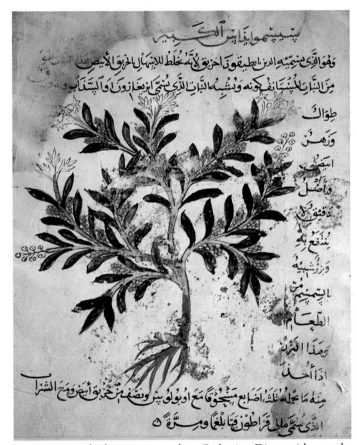

Fig. 5 Detail of *Materia medica*, Pedanius Dioscorides, 10th century, vellum, Private collection, New York

Eschenbach (ca. 1170–ca. 1220), and possibly influenced the development of the heresy of Catharism.

The Originality of the Arabic Sciences

I have left until now the topic of the scholarly value of Arabic thought. The best explication, I believe, is one given by the eastern writer Ibn al-Haytham in his *Doubts Regarding Ptolemy*, which was known in eleventh-century al-Andalus. He affirms that truth must be sought after in the books of scholars but cautions that the reader must always keep in mind that God did not make scholars impervious to error, blindness, or confusion. Had he done so, he explains, there would be no differences among them when addressing the same question, and all men would possess the truth. As experience demonstrates, scholars do differ in opinions, and so it must be conceded that they also err.

Such arguments were less common in the abstract field of pure mathematics as it was presented in the first European treatise exclusively devoted to trigonometry, a work by Ibn Muʿādh of Jaén. It must be noted that this writer knew how to state and prove the problem of the polar triangle, which was so basic to navigation, and he also established a number of trigonometric relationships that were honored for centuries. Regiomontanus, for example, benefited from his theories, which were superseded only at the end of the sixteenth century by François Viète of France (1540–1603).

However, those who gave most credence to discrepancies between theory and practice were astronomers, who sought to predict with their tables the future position of stars in the heavens. As it was easily proved that their predictions were not fulfilled, they continued to make more observations and to compile new tables (Toledan, Jaén, and Alfonsine), and at the same time they attempted to perfect the precision of astronomical instruments. Thus Ibrāhīm ibn Saʿīd al-Sahlī (of Castellón de la Plana) constructed two celestial spheres in which the constellations are well delineated (see No. 121); he was also the designer of several astrolabes. Responding to the great demand for these instruments by astrologers—sovereigns like al-Qādir of Toledo and al-Muʿtamid of Seville believed in the pseudoscience of astrology—astronomers contrived lighter instruments that could be used anywhere in the world; that is, they were universal.

Al-Zarqāllu (Azarquiel) drew the tympan, or plate, of the Saphea astrolabe; ʿAlī ibn Khalaf conceived the universal disk; and Ibn al-Samḥ, al-Zarqāllu, and Umayya Abū'l-Ṣalt constructed the instrument that today we call the equatorium, which allowed the positions of the planets to be calculated with a certain accuracy and without employing astronomical tables.

Planispheres and geared astrolabes were the most obvious precedents for these instruments. A major scientific breakthrough occurred when al-Zarqāllu realized that he achieved greater exactitude in determining the position of Mercury if, in a departure from the Ptolemaic model, he represented the deferent of that planet by an oval. Al-Zarqāllu's graphic representation constitutes the first clear and indisputable case of progress away from the Aristotelian-Ptolemaic astronomy based on circles and toward an astronomy utilizing a different class of curves. Both Georg von Peuerbach (1423–1461) and Erasmus Reinhold (1511–1553) knew al-Zarqāllu's work, and thus the Arab scientist contributed to the concept of the oval that Johannes Kepler (1571–1630) drew for Mars before conceiving of the ellipse.

To determine the position of a star, one must make calculations at a given moment, and to fix this moment, one must rely on a clock. The scientists of classical antiquity and the Arabs of the independent emirate (ʿAbbās ibn Firnās, for example) were familiar with gnomons, or sundials, and with clepsydras. A further evolution of the latter can be credited to the work of an artisan of the *Taifa* epoch from al-Andalus, Aḥmad, or Muḥammad ibn Khalaf al-Murādī, who invented a complicated mechanism, a number of examples of which have been reconstructed. He added mercury to the activating flow of water in his mechanism. Inside the beam of a balance, the mercury initiates the system through the law of hysteresis, setting subsidiary mechanisms in motion. This new method of constructing automatic clocks was independent of systems already known to Banū Mūsā and al-Jazarī.

The Muslims of al-Andalus had been toying with the science of agronomy as early as the reign of ʿAbd al-Raḥmān I. During the period of the *Taifa* states, major treatises on agronomy were written, the precedents for which have been attributed to Ibn Wāfid, whose work has survived in Spanish. However, it appears that this information should have been attrib-

uted to Abū'l-Qāsim al-Zahrāwī, transmitted by treatises by Ibn Baṣṣāl, who carried out experiments in the acclimatization of plants and intensive cultivation in the royal gardens of Toledo; by al-Tignarī; by Ibn al-ʿAwwām in the thirteenth century; and finally by Ibn Layūn, who worked in the botanical gardens of Granada in the fourteenth century. We must emphasize that al-Zahrāwī decisively influenced Gabriel Alonso de Herrera (d. 1539 [A.H. 946]) when, during the High Renaissance, he wrote his *Agricultura general*.

Other writings that were passed on to the western world were the *Lapidario*, attributed to Abolays, in which there are indications that the author knew the work of Dioscorides, and Ibn Wāfid's *Pharmacologia*, which was translated into Catalan.

As we can see, at the end of the eleventh century, al-Andalus was at the forefront of European science. The status that Heidelberg, Paris, Oxford, and Harvard enjoy today was accorded then to Saragossa, Toledo, Seville, and Barcelona. These Hispanic sites have been compared to Palermo and other cities in Sicily, which was also occupied by Muslims during the Middle Ages. The cultural function of the centers of that island, however, were of secondary importance and differed from those of the Iberian Peninsula, facts recognized by most contemporary Italian historians. Two centuries of foreign domination in Sicily did not create the breadth and scope of culture that resulted from eight centuries of Arab influence in Spain. Two centuries were, however, sufficient for Norman sovereigns to be superficially arabicized, and for that purpose they summoned to their service such Muslim scholars as al-Idrīsī. We should not forget, however, that in Sicily material interests were involved, one of them being the exploitation of Sicilian Mudejars, whose unenviable situation was noted by the Valencian traveler Ibn Jubayr in 1185 (A.H. 580). One last difference between Sicily and Spain should be noted: In Sicily, in addition to Arabic, Greek continued to function as the language of culture, and when a sovereign of the Norman dynasty was drawn to one culture or another, he could satisfy his whim only in relative terms, since he lacked specialized libraries.

African Invasions of the Peninsula
When Alfonso VI took Toledo in 1085 (A.H. 478), the Muslims were left as unwelcome guests at the feast. For once, the petty kings of the Iberian Peninsula

were able to reach an accord, and they sought outside help in containing the tide of the Christian advance. They turned to an African, Yūsuf ibn Tāshufīn, who had just constructed a vast empire stretching from the Niger River to the Strait of Gibraltar. Yūsuf agreed to come to their aid: He transported his army to Algeciras and marched toward the north. Camels served as the beasts of burden as the horses' energy was too depleted to work under harness. An infantry of Tuaregs and blacks was met on the battlefield of Zallaka (Sagrajas, in Romance) by Alfonso and his nobles. The skittish horses in Alfonso's cavalry forgot that their ancestors had once before seen aggressive camels in those lands, and they bolted and ran. Regiments of Almoravid infantry, acting as one, following orders transmitted by drums, broke the ranks of the Christian foot soldiers. The king rode from the battlefield with an enemy dagger buried in his thigh. The danger that Islam might be snuffed out abruptly on the peninsula was eliminated, and subsequently the Africans expelled all non-Muslim minorities remaining in al-Andalus. This included the Christians, who fled primarily to the north of Spain. Thereafter, the Almohads, who succeeded the Almoravids, expelled the Jews. Many Jews emigrated to Castile; others relocated in the valley of the Ebro River and then within a few generations moved on toward Provence, in southern France. There they sparked a cultural renaissance by translating into Hebrew, and then from Hebrew into Latin, the principal Arab works they had brought with them from their longed-for Sefarad (Spain). Another group of Jews emigrated to the east. The most illustrious of that group were Maimonides (Moses ben Maimon) and Ibn ʿAqnīn.

For their part, Muslims in Palestine and Spain were having to combat the increasingly forceful and purposeful attacks of the Christians, who were beginning to speak of crusades and reconquest. To offset this development, Muslim intellectuals devised a plan to instruct their rulers in a particular genre of ancient Muslim literature—dating back to the Persian convert Ibn al-Muqaffaʿ in the eighth century. This literature of moral instruction for rulers is known by the name "mirrors of princes," a genre with a broad tradition in the west, including such works as *Sirāj al-Mulūk* (The Lamp for Kings) by Abū Bakr al-Ṭurṭūshī and *Wāsiṭat al-Sulūk* (The Pearl Necklace) by Abū Ḥamū Mūsa of Tlemecen. Meanwhile,

as Christians came to realize that conquest of the Muslims by arms lay far off in the future, they attempted to delve more deeply into their enemies' thoughts and beliefs. During a visit to Spain in 1142, the great abbot of Cluny, Peter the Venerable (ca. 1092–1156), ordered Robert of Chartres, Herman of Dalmatia (Hermannus Dalmata), Pedro of Toledo, and a Muslim named Muḥammad to translate the Qurʾan into Latin. These men, who lived in the Ebro Valley, quickly carried out their task, creating a literary version less faithful than the pedestrian and more literal translation effected fifty years later by Marcos of Toledo. Although the Marcos translation is still relatively unknown, the former version enjoyed wide distribution well into the Renaissance.

Something similar—although in a different field—happened to Gerard of Cremona (d. 1187), who, eager to study Ptolemy's *Almagest*, traveled to Spain to translate it from Arabic, not realizing that it had been translated directly from Greek in Sicily in 1169 (A.H. 554). Italian was not widely known in that period, however; in the twelfth century the west learned its classical sciences through Arabic translations. A century would pass before the "Latins" took their versions directly from the Greek.

The Internationalization of the Science of al-Andalus
The Jews forced to emigrate from al-Andalus either entered the service of Arab chanceries of peninsular Christian domains (Ibn al-Fajjār, in the service of Alfonso VIII of Castile, and members of the Abenmenasse family, in the courts of Peter III and James II of Aragon) or devoted their lives to translations from Arabic into Hebrew or Latin that were disseminated throughout Europe. The most important of the twelfth-century translators is, without doubt, Abraham ben Ezra. Others took with them to the east manuscripts recording the advances achieved in al-Andalus by the school of Aristotelian scholars that had sprung up in Saragossa in the second half of the eleventh century. Abū Yūsuf Hasdai ben Shaprūṭ, who lived his last years in Cairo, had probably brought with him the *Encyclopedia* written by his king, al-Muʾtaman. From Egypt he corresponded with Ibn Bāja (Avempace). It was Ibn Bāja and his followers, Ibn Ṭufayl, Ibn Rushd, and al-Biṭrūjī, who noted that the epicycles and eccentrics employed in Ptolemy's world system contradicted the Aristotelian presump-tion that in their rotations around the earth, stars followed circular orbits.

In the hands of Ibn ʿAqnīn and other Jews, the works of a number of these authors reached Maimonides, who by then was living in Cairo. Maimonides accepted the ideas of some (such as Ibn Rushd) and disputed those of others (Jābir ibn Aflaḥ, al-Biṭrūjī). Some concepts reelaborated in Egypt, especially those relating to metaphysics, returned without intermediary to the west and took root in Jewish communities in Catalonia and Provence. There a dialectic arose between Maimonidists (rationalists) and anti-Maimonidists (idealists, mystics, and cabalists). Ideas in the field of science continued to move eastward, to Baghdad, for instance, where they were known to the great astronomer Naṣīr al-Dīn al-Ṭūsī (1201–1274 [A.H. 598–673]). Those ideas influenced the development of al-Ṭūsī's thought and that of his successors and later, by paths that today escape us, came to the attention of Copernicus.

The peace established by Genghis Khan in Mongolia enabled the Castilian Alfonso X, who aspired to be Holy Roman Emperor, to establish relations with Genghis Khan's descendants and with the sovereigns of the only great power that stood between them: the Mamluks of Egypt. In the years between 1262 and 1282 (A.H. 661–81), along with political ambassadors, scientific emissaries were exchanged. One result was that the ideas of the great Chinese cartographer Chu Ssu-pen became known to the west, leading to the first step toward the flat rectangular map, of which the primary Arab example is the Granada map, known as the Maghreb chart (Fig. 6). Comparison of the hours at the beginning and at the end of various eclipses of the moon, seen concurrently in Marāgheh (Persia), Toledo, and Peking, led to reducing the world's measurements to its true dimensions. The fruits of this frenzy of scientific activity were the Alfonsine tables. A century later these were being used, at least in part, in Byzantium and in Central Asia, since an astronomer named al-Sanjufīnī (1290–1366), in the khanate of Chagatay, compiled tables in Arabic, some of which are based on parameters of the Alfonsine tables. The manuscript—dedicated to the prince of the region (then part of China)—has notations in Mongolian.

In the fields of mechanics and architecture, we have known for many years of two collections of drawings with brief notations; only now, however, are

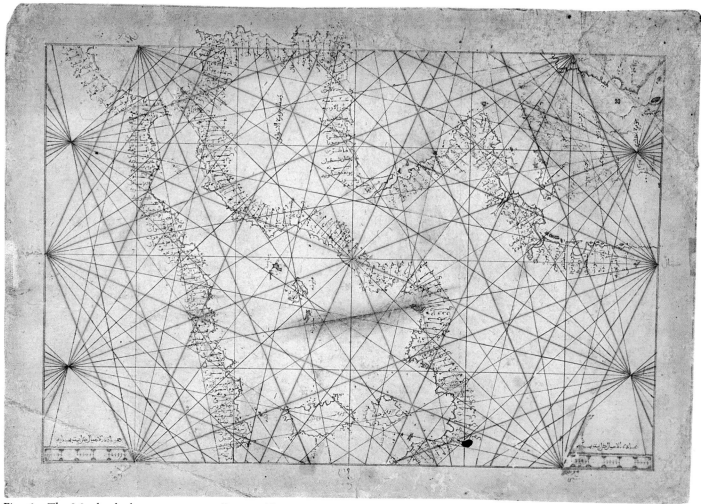

Fig. 6 The Maghreb chart, ca. 1330, vellum, Biblioteca Ambrosiana, Milan

they being presented and classified by theme, offering opportunity to draw interesting conclusions. An analysis of the technical illustrations in Villard de Honnecourt's album[2] and of the miniatures that embellish the almost contemporaneous works of King Alfonso X demonstrates many fascinating facts.[3] It seems that through the whole of the Mediterranean basin, from the Danube and the Rhine rivers to the southern coast, engineers of the period used very similar procedures in constructing buildings and machines. Villard's notebooks reveal that he had contact with Muslim scholars—he seems to have known Muslims in Hungary, as well as in al-Andalus—and tell us that there were circuses, zoos, and tightrope walkers at that time. They record that fresh water was piped beneath arms of the sea and illustrate an infinite variety of screws. We also learn from them that waterfalls were harnessed as sources of power for mountainside mills and smithies and that dams were constructed. Both

eastern and western cultures were striving to master nature, with the goal of reducing the need for physical labor. In search of that objective, perpetual motion machines were invented in both the east and west, and in some of their principles, Arab texts and Honnecourt concur.

Granada, the Last State of al-Andalus
The reign of Alfonso X permitted the consolidation of the last Muslim kingdom on the Iberian Peninsula: Granada. During the Naṣrid dynasty, the device ''There is no conqueror but God'' was emblazoned on all buildings, most notably in the Alhambra. The first moments of the dynasty, under the leadership of Muḥammad I, who reigned from 1232 to 1273 (A.H. 630–72), were politically precarious. However, the dynasty survived and established an independent state in the region today known as Andalucía Oriental (Almería, Málaga, and Granada) as a base where Islam

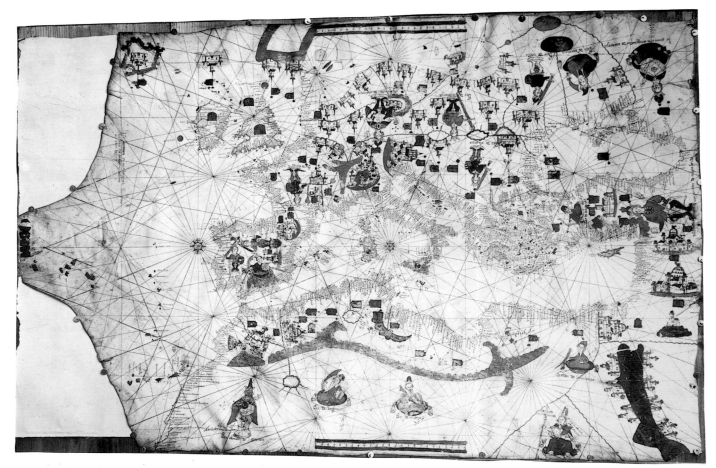

Fig. 7 Chart of the Mediterranean, Jacobo Bertrán, 1482, vellum, Archivio di Stato, Florence, 7

was allowed to endure for an additional two and a half centuries.

It was in the thirteenth century that two eastern institutions were introduced into al-Andalus (though not through Granada, as traditionally maintained): the *māristān*, or hospital, and the madrasa, or university college. Hospitals, which had first appeared in Sasanid Persia and which evolved and were institutionalized in ninth-century Baghdad, were known about in tenth-century Córdoba but were actually introduced into al-Andalus only in the thirteenth century via Valencia. Certainly, the institution of the *māristān* was in existence by then, since the word *marestan/malestan* appears in the *Vocabulista in arabico*, compiled by Ramón Martí of Barcelona (1230–1284). There is also the curious fact that James I the Conqueror is credited with having built the hospital of San Vicente in Valencia immediately following his conquest of that city in 1238 (A.H. 636). We have documentation in Latin from soon thereafter that describes how there was one room for men and another for

women in that hospital, and how doctors did not sleep in the building but came only in the morning or afternoon to visit their patients, just as their Arab colleagues did in the east. Therefore, it is safe to conjecture that James I merely ordered the renovation of an old hospital that had existed in the time of the Almohads. We have records of another hospital in Granada a century later, and before 1450 these establishments, along with asylums for the mentally ill— another institution of eastern Arab origin—had spread throughout Christian Spain.

From early times many hospitals had as an annex a garden in which plants were cultivated for the use of physicians in preparing their magisterial formulas (some of which are recorded), thus preventing, at least theoretically, the possibility of adulterated medications. The pharmacy (apart from the hospital) had already existed in the caliphate; there was one in the dependency of the Alcazar of Córdoba. We know that compounds were sold to a wealthy public and distributed without cost to the poor. But the work of the

physician was perilous then, as it is now, since an error might cause the death of a patient. For that reason, in tenth-century Baghdad candidates were required to take examinations before they were allowed to exercise their profession; this custom was in place in al-Andalus by the eleventh century. A group of distinguished physicians, the major Arab doctors of the Middle Ages, practiced during the reign of the Almohads: the five generations of the Avenzoar family, Ibn Rushd, and, somewhat later, Muḥammad ibn al-Shafra of Granada. Many of their works were translated into Latin, and twelfth-century Spanish translations of the *Qānūn* (Principles of Medicine) by Ibn Sīnā (Avicena) were still being used as medical texts in European universities of the sixteenth century.

The madrasa was institutionalized by the grand vizier of the Seljuk Turks, Niẓām al-Mulk (d. 1092 [A.H. 485]), and was thought to have been introduced into al-Andalus in the thirteenth century through Granada. As in the case of the hospital, however, the city was not Granada: The first such school appeared in Murcia, under the sponsorship of Alfonso X, who was thoroughly conversant with Islamic contributions in the realm of science and seems to have placed Abu Bakr Muḥammad al-Riqūtī in charge of it in 1243 (A.H. 641). Our information comes from the great historian of the Naṣrids, Ibn al-Khaṭīb, who states that Muslims, Christians, and Jews all attended the school. The experiment was of short duration, but the institution later reappeared as a permanent entity and as a center for religious training in Granada.

Rulers of Granada, menaced on all sides by Moroccans, Castilians, and Aragonese who wanted to divide Granada's territory among them, had to practice Machiavellian political measures that resulted in a constant shifting of alliances. With regard to internal politics, the Malikī *fuqahā* (students of Islamic law) opposed any kind of religious change. The growing attention to astrology was viewed with more alarm each day, even though its practitioners vowed that their predictions could be modified by God whenever he wished and employed arguments similar to those of Saint Thomas Aquinas with regard to maintaining man's liberty. Mujahidun installed themselves in ribats (religious and military forts) on the frontiers, hoping to do battle with Christians and thus—or so they believed—gain heaven. The great plague of 1348–51 (A.H. 749–52) decimated the population.

Yet despite all these troubles, the Alhambra was constructed (the debate over its early plan is being renewed), and the sultan's fleet often controlled passage through the Strait of Gibraltar. This fleet was composed of extremely skillful seamen who had the finest nautical charts—the Bertrán (Fig. 7) and the Maghreb—and the compass at their disposal.

Mudejars and Moriscos

Everything changed on January 2, 1492, with the official entry into the city of the Catholic king and queen. Ferdinand and Isabella agreed to respect the religion of the Muslims remaining in Granada, who from then on were called Mudejars. They did not keep their promise for long, however, but instead pressured Muslims to adopt the Christian faith.

In the Islamic world expressions of anger against specific segments of the population—Jewish, Christian, or rebellious Muslim—such as the previously mentioned pogrom in Granada or the prohibition of the sale of scientific books to Jews and Christians at the beginning of the twelfth century were sporadic and violent explosions; in the Christian world such aggression was methodical and well planned. In the thirteenth century the failure of the Crusades (when we look at events from the perspective of the twentieth century, we may ask if they were in fact crusades); the founding of the Dominican Order, which coincided with the creation of the papal Inquisition; and the fourth Lateran Council of 1215 all led to the interpretation of the passage of 2 Timothy mentioned earlier in this essay as an injunction to force Mudejars and Jews to hear the Scriptures. There were no further religious polemics since, as Vajda observes, he who is forced to listen or debate is no longer free but coerced. A doctrinaire period had begun.

Furthermore, there were those who wanted to force captive scholars to share their knowledge with them. This was the procedure of the priest who captured ʿAbd al-Raḥmān ibn Ruwayṭ in 1146 (A.H. 541) and of Ramón Lull with his Muslim slave in 1315 (A.H. 715). Others, like Ramón Martí, were more restrained and traveled to North Africa or to al-Andalus to supplement their learning. But the Spanish Christians who persisted in studying mathematics, astronomy, and the other sciences were extremely limited in number if not nonexistent. The Spanish left these enterprises to students from northern Europe[4]

while they devoted their energies to the struggle against the infidel. Their commitment bore obvious, although unrecognized, similarities to the policy of the Romans, who had relegated the cultivation of the sciences to the Greeks while they pursued their ambition to rule the world. This was the example followed by the Spanish, who from the eleventh century copied the *Aeneid* and absorbed the political attitudes of Rome with the following lines etched in their minds:

> Let others fashion from bronze more lifelike,
> breathing images—
> For so they shall—and evoke living faces
> from marble;
> Others excel as orators, others track with
> their instruments
> The planets circling in heaven and predict
> when stars will appear.
> But, Romans, never forget that government
> is your medium!
> Be this your art: the imposition of peace as
> the norm,
> Generosity to the conquered, and firmness
> against aggressors. [5]

These ideas accentuated the social differences among the Spanish, and during the sixteenth century those who were and had always been Christians were set apart from the new converts from Islam (Moriscos) or Judaism (Marranos). Christian, Jew, and Muslim alike, however, when under suspicion or denunciation, were subject to the new Inquisition established by the Catholic sovereigns in 1478, an entity whose initial excesses terrorized all of Europe. After 1492 the only minority tolerated was that of the Mudejars, who were allowed to continue practicing the religion of Islam without interference. Even within that tolerance, however, there existed degrees and variations in terms of assimilation: The Castilian Mudejars who lived in Segovia, for example, had forgotten their Arabic, and only a *faqīh*, such as Isa ibn Gebir, might know his native tongue; Muslims in Granada, who had only recently been conquered, still spoke Arabic; and between these two extremes there were many gradations.

Many Moriscos continued to be Muslims at heart and merely assumed the external appearance of Christians. If the Inquisition could prove their heresy—find a Qurʾan or books written in Arabic among their belongings—they were subjected to torture, forced to confess, and then, as "lapsed" infidels, handed over to secular authorities charged with burning them at the stake. The Spanish kings, engaged in continuing battle with the Ottomans, were unsure what the reaction of their Mudejar and Morisco vassals would be to a sea assault on the peninsula by the Ottomans or Moroccans. A drastic solution was reached: All Muslims were expelled in 1609 and 1610 (A.H. 1018 and 1019).

In the interval between 1492 and 1610 (A.H. 898–1019) the *fuqahāʾ* had continued to copy the Qurʾan and other religious books and also books of law. Their successors, having lost command of Arabic, created texts in Spanish, including novels in the style of the European Renaissance, but these were written in Arabic script (and referred to as *aijamiada* literature). This literature, of which from time to time we still find an example, apparently constituted the last echo of al-Andalus in Europe.

Conclusion: The Legacy of Islam in Spain
Whoever regularly reads a major contemporary Spanish newspaper often comes across notices of discoveries of Roman and Arab archaeological remains spanning the length and breadth of the Iberian Peninsula. Roman ruins are more common than Arab, whereas evidence of the presence of other ancient inhabitants of the country—Greeks, Phoenicians, Carthaginians, Goths—appears only infrequently. For that reason we may believe that in today's Spain the influence of Roman and Arab civilizations weighs more heavily than that of any of the others.

The appreciation of the contributions of Muslims—today we speak of Arabs—has not, however, been consistent during the course of the centuries. In the seventeenth century, there were still crypto-Muslims despite expulsions, but it was only during the Age of Enlightenment that we began to assess, ever more positively, the influence of Arabic culture on Spain. When at the end of the nineteenth century the question arose, in unsophisticated terms and within a political context, of whether at any time in their history the Spanish had contributed to the advance of science, liberals (laymen or leftists) and conservatives (Catholics or rightists) could agree only that advances had

been made during the ascendancy of al-Andalus. This age-old polemic, which was reopened about 1955, shows the strength, even today, of Arabic culture in contemporary Spain.

1. Fité y Llevot 1984–85.
2. See Villard de Honnecourt 1986.
3. See Menéndez-Pidal 1986.
4. See Vernet 1975, pp. 71–87.
5. Virgil, *Aeneid* 6, 847–54.

Catalogue

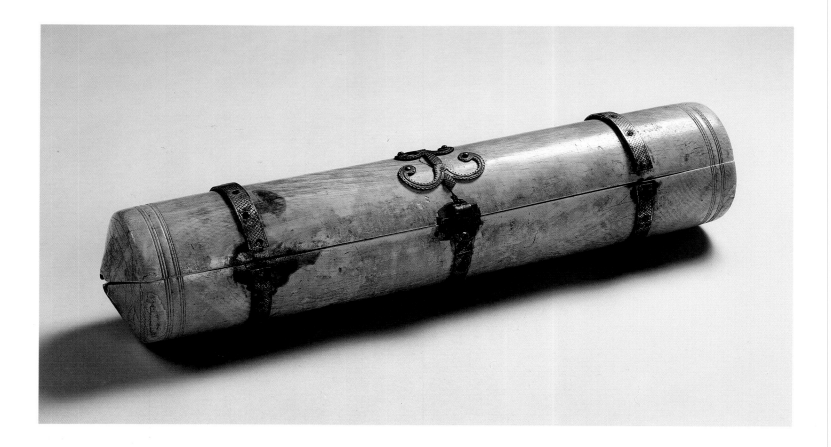

I

Game Box of the Daughter of ʿAbd al-Raḥmān III

Caliphal period, before 961
Ivory and metal
L. 18¼ in. (46.5 cm), diam. 3½ in.
(9 cm)
Museo de Burgos
244

A slightly curved shape and an undecorated exterior distinguish this hinged cylindrical box. A crack has been repaired with a metal clamp. Each half of the box contains five round, concave receptacles and four small holes that alternate with one another, and there originally were four cylindrical slots, two at either end. The interstices between the receptacles are embellished with vegetal ornament. The ends of the box have been damaged; each bears an identical but not identically spaced inscription. It reads:

هذا ما عمل للـ[إبنة] السيدة إبنة عبد الرحمن
أمير المؤمنين

This is what was made [for] Noble [Daughter], the daughter of ʿAbd al-Raḥmān, Commander of the Faithful.[1]

While the container has been published as a cosmetic box,[2] because of the interior configuration and the cylindrical slots it appears more likely that this was a box for one of the games in the *manqala*, or mancala, group. The *manqala* group of games is very old and widespread and is known from examples from both Pharaonic and Islamic Egypt, as well as India, Indonesia, and throughout sub-Saharan Africa.[3] Two rank *manqala* games usually have six holes in two

rows and storage pits at the ends for seeds or marbles used as game pieces, though games are still played with five holes in contemporary North Africa.[4]

Another, later ivory container (No. 2) was also made for the daughter of ʿAbd al-Raḥmān III. As this lady is referred to nowhere but in the inscriptions on these two boxes, they are the only witnesses to her existence. It is possible that these two (or more)[5] containers were ordered as a set at the same time, but the wording of their inscriptions indicates that the game box was completed before ʿAbd al-Raḥmān's death in 961 (A.H. 350) and that the other was not finished until after he died. The two are very similar in the nature of their ornament, which is purely vegetal, and in their technique of deep undercutting. While we do not know what occasioned these pieces, the fact that they have almost identical inscriptions, presumably referring to the same person, could indicate that they were made as gifts for a major social event, such as the lady's marriage.

Both receptacles have been attributed to the ivory carving workshop at Madīnat al-Zahrāʾ because their motifs and techniques are closely related to those of three pieces with inscriptions that identify them as products of this work-

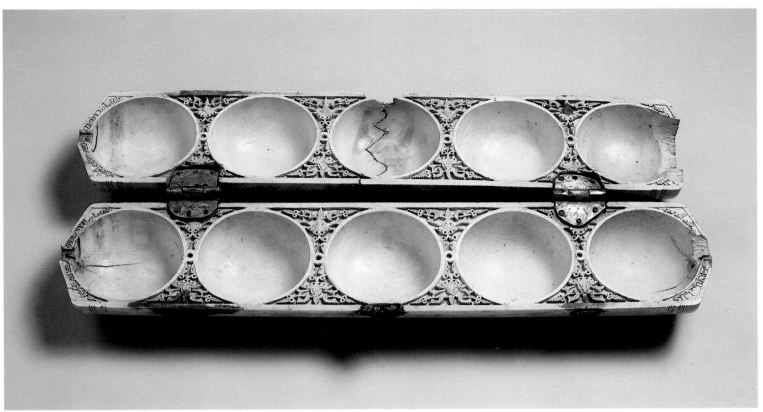

shop. These objects, all made for the favorite Ṣubḥ, are the box in the parochial church at Fitero in Navarra and a box at the Instituto de Valencia de Don Juan in Madrid, which are inscribed for Wallāda, and a pyxis inscribed for the mother of ʿAbd al-Raḥmān, the first son of al-Ḥakam, now in the Museo Arqueológico Nacional in Madrid (2.113).[6] Like the ivories made for Ṣubḥ, the containers ordered for or by the daughter of the caliph ʿAbd al-Raḥmān III bear no specific figural motifs. Though all display the finest workmanship,[7] they lack the rich visual allusions of the pyxis of al-Mughīra (No. 3) or the pyxis of Sayf al-Dawla (No. 5). Perhaps more ornamental, less specific imagery than that carved for men was considered appropriate for women recipients. In addition, the fact that cloistered women patrons did not enjoy the same direct access to the agents and carvers available to men may have determined the character of these objects, which are more generalized though no less artistically accomplished than those made for men.

According to tradition, this box was the gift of Count Fernán González to the monastery of Santo Domingo at Silos. An inventory dated 1440 describes it as a reliquary. RH

1. This reading is based on the more legible inscription on the box discussed in entry No. 2. The inscriptions on both containers can be understood in the active voice: *This is what the Noble daughter made.* While this might make better sense grammatically, it would imply that this Umayyad princess was herself a carver of ivories. Since this ivory can be closely associated with the Durrī al-Ṣaghīr/Khalaf workshop at Madīnat al-Zahrāʾ and little is known about the activities of elite women in the society of al-Andalus, it is preferable to assume that the word *for* was left out of the inscription and that the verb should be read in the passive voice. See Roxburgh 1991, appendix 1.

2. For example, Beckwith 1960, pp. 6–7.

3. For a discussion of *manqala* games, see Bell 1969, pp. 71–77; Rosenthal 1986, pp. 615–16.

4. Personal communication, Adel Allouche.

5. In the Victoria and Albert Museum, London, is another box (580-1910) that might have been part of the set, which Beckwith has identified as a nineteenth-century copy (1960, pp. 32–33, 34). Kühnel, however, includes it in his corpus (1971, p. 33).

6. Kühnel 1971, p. 34, pl. X, no. 23, no. 24, pp. 34–35, pl. XI, no. 22, pp. 33–34, pls. XII, XIII.

7. The pieces inscribed for Wallāda and for ʿAbd al-Raḥmān's mother are signed by the supervisor of the workshop, Durrī al-Ṣaghīr, or the carver, Khalaf.

LITERATURE: Lévi-Provençal 1931, no. 193; Gómez-Moreno 1951, p. 298, fig. 373; Beckwith 1960, pp. 6–7, pl. 1; Kühnel 1971, pl. VIII, no. 19; Córdoba 1986a, p. 92, no. 150; Roxburgh 1991, appendix 1.

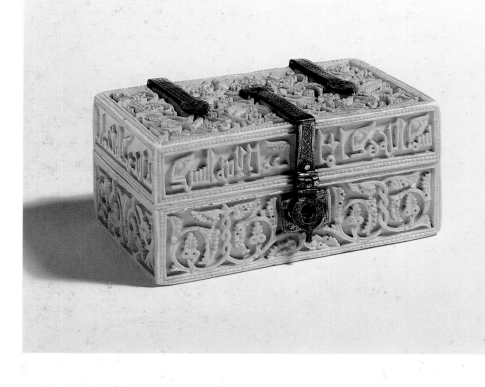

3

Pyxis of al-Mughīra

Caliphal period, 968 (dated A.H. 357)
Ivory and metal
H. 5⅞ in. (15 cm), diam. 3⅛ in.
(8 cm)
Musée du Louvre
(Section islamique), Paris
4068

*O*ne of a series of Cordobán pyxides with domed covers from Madīnat al-Zahrāʾ/Córdoba,[1] this container, or *ḥuqqa*, has a lid that was once topped by a knob. The hinges of the lid do not have the long supports visible in similar pieces.[2]

The pyxis is a very well known form in the history of Mediterranean ivory carving. It utilizes the natural cylindrical shape of the tusk and, unlike boxes or caskets, does not require piecing together. Most pyxides have flat, pieced-together lids, as late antique, Byzantine, and Sicilo-Arabic examples reveal.[3] The domical cover is unique to the tenth-century Spanish series that includes the present pyxis and is probably more wasteful of ivory than the flat one. Its shape was chosen for particular reasons, as we shall see.

The body of this pyxis is completely covered with ornament. Four sizable eight-lobed medallions are the largest elements. Their borders, rendered as garlands of leaves, are intertwined with one another and form small knots between the medallions. Each medallion contains a large figural scene, and the interstices are filled with smaller figures inhabiting a vegetal environment. The representations within the medallions are notable for their vividness and have been included in virtually every discussion of early Islamic art.[4]

The first medallion is the most conventional: Its subject is the well-known royal motif of lions attacking other animals, in this case bulls. The second ostensibly shows a typical throne scene, although several features indicate an intention to convey a special meaning. In the more standard throne scenes, the crowned king is flanked by two servants. Here, however, the attendant, a lutanist, stands in the center of the throne and he is flanked by two youths who are equal to each other in rank. The young man to the right holds a round (probably foldable) fan,[5] and the one to the left holds a bottle[6] and a flower

2

Casket of the Daughter of ʿAbd al-Raḥmān III

Caliphal period, after 961
Ivory and metal
1¾ x 3¾ x 2¾ in. (4.5 x 9.5 x 7 cm)
Trustees of the Victoria and Albert
Museum, London
301-1866

*T*he very small rectangular box, or *safat*, has a cover with hinges in their original location. At the edge of the cover is an inscription that reads:

بسم الله هذا ما عمل للابنة السيدة إبنة عبد الرحمن
أمير المؤمنين رحمه الله عيله ورضوانه

Bismillāh, this is what was made [for] the Noble Daughter, daughter of ʿAbd al-Raḥmān, Commander of the Faithful, may God's mercy and goodwill be upon him.

The formula of ʿAbd al-Raḥmān's epithet indicates that the inscription refers to the late caliph, thus making it possible to date the box to a time after his death in 961 (A.H. 350). The carving technique of the vegetal ornament that covers the entire surface allows us to attribute the box to the Madīnat al-Zahrāʾ workshop (see No. 1).

R H

LITERATURE: Beckwith 1960, pp. 6–7, pls. 2–4; Kühnel 1971, pp. 32–33, pl. VIII.

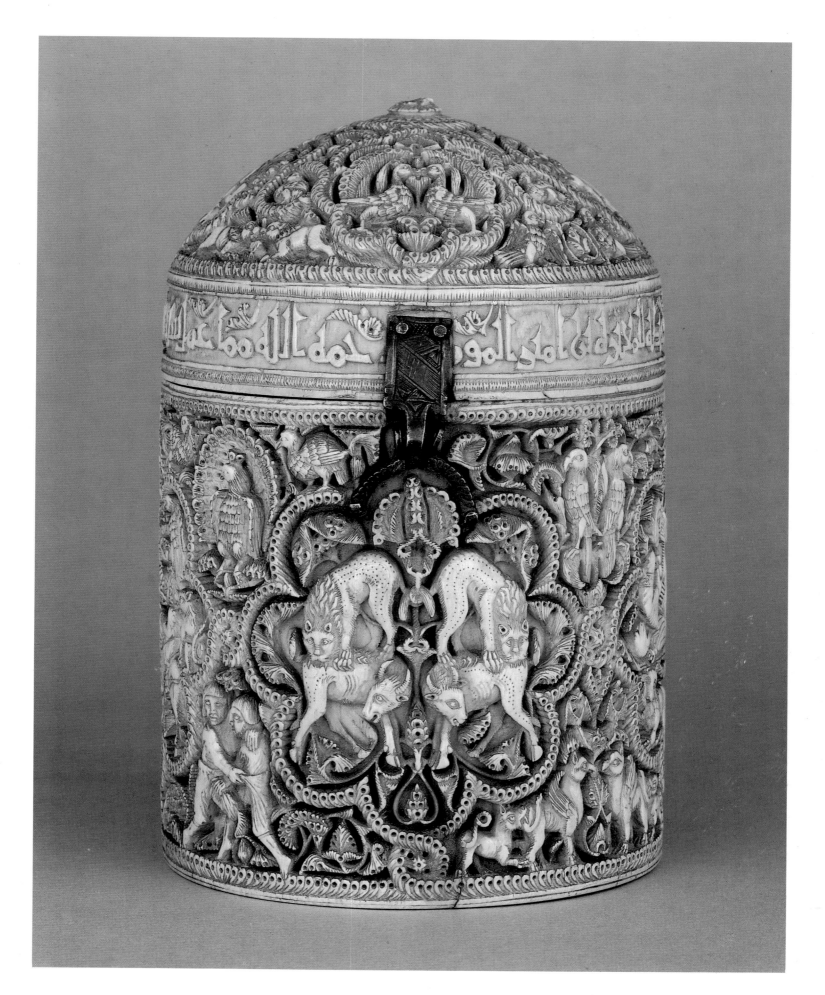

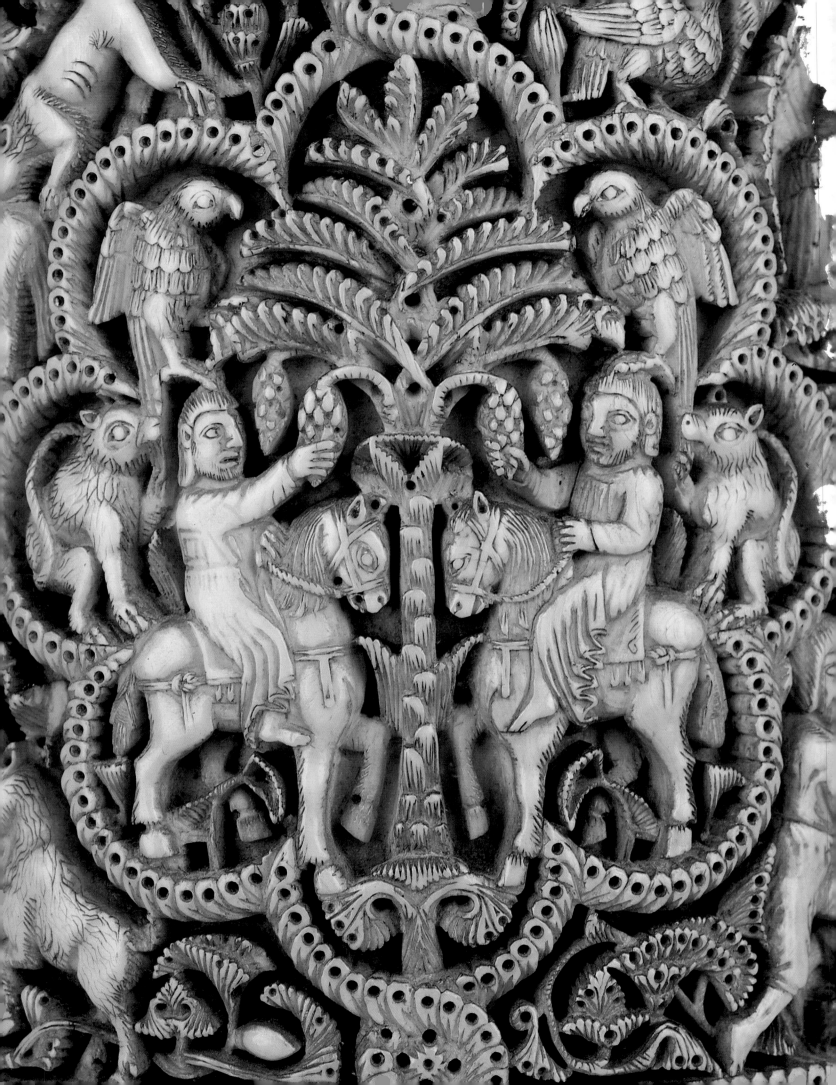

on a long stalk. Both youths sit cross-legged and barefoot, the one on the left with a sole showing.[7] They have straight hair cut short and are bareheaded, without the headgear usually associated with individuals of high rank.[8] Although all are on a lion throne, their poses and dress imply that this is an informal scene rather than a formal presentation of a reigning monarch sharing his throne with his heir.[9]

In the third medallion a thicket of intertwining vines shelters three eagles' nests. The central nest is filled with four fledglings, and an eagle still hatches the eggs in each of the flanking ones. Two bareheaded, beardless youths who are gripped at the ankles by dogs(?) stand back-to-back, reaching up to steal the eggs. The youths are wearing long, flowing robes with decorative (embroidery or tapestry?) squares on the back. The scene represents a springtime activity or may even recall a specific moment in the life of al-Mughīra, who received this pyxis as a gift.

The fourth medallion shows two bareheaded, beardless riders picking dates. They are accompanied on their "hunt" by two cheetahs that have caught two birds (parrots or falcons?) by their tail feathers. The riders are dressed in long, flowing robes decorated on the back with (embroidery or tapestry?) squares. The bilaterally symmetrical composition of the design here and in the other scenes recalls the medallions of contemporary textiles. Such medallions have usually been explained as ornamental vignettes, part of the princely visual vocabulary of well-being.[10] The subject here, however, is unusual. The mixture of hunting and agricultural motifs may have a specific and as yet undiscovered meaning: Perhaps the picking of the dates refers to a particular calendrical festival celebrated in the Islamic world and especially in al-Andalus.[11]

The figures in the vegetation between the medallions are of various kinds: In the lower register there are two dogs biting the tails of two confronted griffins, two wrestlers, two butting rams, and two confronted stags. The upper register shows two addorsed eagles, a peacock flanked by two peahens, two wolves(?) attacking an onager, and two addorsed falconers. The falconers are bareheaded, bearded, and dressed in short tunics and boots. Many of the motifs are similar to those seen on textiles, although the wolves(?) and the onager and the peacock with peahens may derive from other contexts.[12]

The cover of the pyxis, like the body, is divided into four eight-lobed medallions with interwoven borders; here they intertwine to form four small rondels. The medallions contain, respectively, two confronted gazelles, two addorsed lions, two addorsed peacocks, and a mounted falconer in a short, belted tunic. Partridges or peahens inhabit all four rondels. The lower interstices are filled, respectively, with two facing doves, two facing birds, two confronted lions, and two confronted jackals or dogs. The location of the missing knob is marked by a circlet of leaves. The knob itself, judging by the knobs of other domed pyxides, would have been rendered as a fruit. It may have been a pomegranate or, more probably, an Indian *amalaka*, the fruit shown on some of these pyxides, in particular the example in the Hispanic Society in New York (D752) and the openwork container made for al-Ḥakam at the Victoria and Albert Museum in London (217.1865). *Amalaka* finials appeared commonly in India on the domes of Hindu temples and, later, on Islamic domes and may have been used on small objects, although there are no extant early examples of the latter.[13]

A Kūfic inscription is located at the base of the cover. The inscription is mutilated by a hinge and clasp, which presumably are later additions. (This pyxis, unlike others such as those at the Hispanic Society and the Victoria and Albert Museum, did not originally have a hinge, since no space seems to have been left for one.) The inscription reads:

بركة من الله ونعمة وسرور وغبطة للمغيرة بن أمير المؤمنين
رحمه الله عم [ـل] سنة سبع وخمسين وثلا ثمائة

Blessings from God, goodwill, happiness, and prosperity to al-Mughīra, son of the Commander of the Faithful, may God's mercy be upon him; made in the year three hundred and fifty-seven.

The nature of this inscription, together with its inhabited medallions, may reveal the purpose for which the pyxis was intended. It is the only inscription on a Hispano-Islamic ivory in which the title *amīr al-muʾminīn* is used without the full name of the caliph. Here the caliph referred to is the late ʿAbd al-Raḥmān III, who died in 961 (A.H. 350). The reigning caliph when the pyxis was made was al-Mughīra's brother al-Ḥakam. When al-Ḥakam acceded to the throne in his forties, he did not have a son, and al-Mughīra, who was born in 950/1 (A.H. 339), was considerably younger and would have had some hope of gaining the throne. Within the following four years, however, al-Ḥakam did have two sons—the first died almost immediately and the second, Hishām, was born in

965 (A.H. 355). Two years later the pyxis was made for al-Mughīra, who was then nineteen. Presumably the fact that the new contender for the throne survived informs the inscription's declaration that al-Mughīra is a son of the late caliph and, therefore, still a contender even though he is not named as heir apparent (*walī al-ʿahd*).[14] The absence of the full name and title of the father, as well as the informal aspects of the visual program, makes it unlikely that al-Mughīra ordered the piece for himself. Rather, it should be understood as a gift of affirmation, presented in a humorous, or even ironic, vein.[15]

The domical shape of the cover turns the pyxis into a miniature piece of architecture. The architectural aspects of its form are not as fully developed as those of the later Braga pyxis (No. 5), where they are accentuated by the framing of the figures in arcades. In fact, the entire Braga pyxis could have been considered a pavilion. The polylobed frames of the medallions of the present pyxis do, however, recall the polylobed arches of Madīnat al-Zahrāʾ and Córdoba. Late Roman and medieval objects from the Mediterranean and western Europe in the form of miniature architecture are well known.[16] Examples survive rendered as Christian reliquaries and, notably, as containers for aromatic substances from both religious and secular contexts.[17] Particularly in the early Islamic world censers and incense burners were used in secular, palatial settings.[18] A five-domed incense burner in the Freer Gallery in Washington, D.C. (52.1), and a single-domed one in the Musée du Louvre in Paris (E11708) are elaborate examples of objects in the shape of pavilions that are connected with the burning of or censing with precious substances.[19] The domed ivory pyxis in the Hispanic Society bears an inscribed poem that identifies it as a container for musk, camphor, and ambergris, which were considered precious substances.[20] The vessel in the form of a pavilion, with its palatial and paradisiacal connotations, served as a container for storing or burning precious aromatics. Thus, through its form, the pyxis made for al-Mughīra announced its contents and the actual worth of the gift contained in it. RH

1. The others are one made for the mother of ʿAbd al-Raḥmān in the Museo Arqueológico Nacional, Madrid (2.113), one in the Hispanic Society, New York (D752), one made for al-Ḥakam in the Victoria and Albert Museum, London (217.1865), one made for Ziyād ibn Aflaḥ in the Victoria and Albert Museum (368-1880), and one made for Sayf al-Dawla in the treasury of the cathedral in Braga (No. 5).

2. The first, second, and fourth examples cited in n. 1.

3. An example of a caliphal ivory pyxis with a flat lid, datable to the early eleventh century, is in the Kuwait National Museum, Kuwait City (LNS 19 I) (Atil 1990, no. 22, pp. 90–91).

4. For example, Grabar 1987, pp. 165–66, and Ettinghausen and Grabar 1987, pp. 145–53.

5. For an earlier, Carolingian example, see the liturgical fan (*flabellum*) from the second quarter of the ninth century preserved in Tournus (Gaborit-Chopin 1978, p. 56, pls. 66–69).

6. Roux identifies this as a small vaselike glass goblet similar to those used in Morocco (1982, pp. 87–88).

7. The cross-legged posture has been associated clearly with northeast Iranian, Soghdian, or Turkish models (Roux 1982; Otto-Dorn 1967, pp. 82, 89; Gelfer-Jørgensen 1986, pp. 31–67; Marschak 1986, pp. 76ff.). However, in early Islamic art individuals are commonly depicted shod, if their feet are shown at all. The display of the sole is unusual.

8. There is little information about head coverings in al-Andalus before the Naṣrid period (Arié 1990, pp. 80–89). Apparently the turban was worn in Spain primarily by legal scholars and judges (Stillman et al. 1986, esp. pp. 742–47); a fashion for bare heads existed in Byzantium until the eleventh century (see "Headgear" in Kazhdan et al. 1991, vol. 2, p. 904).

9. For examples of contemporaneous throne scenes, see Marschak 1986, pls. 30, 33.

10. See in particular silk textiles made in al-Andalus, such as Nos. 23, 24.

11. Dozy 1961; on Egyptian/Coptic calendars, see Pellat 1986; Ruggles 1991, pp. 50–55. A reference to a comparable though later agricultural festival in Yemen involving the harvesting of dates (*subūt al-nakhīl*) is found in Ibn Mujāwir's *Mustabir* (see Sadek 1990, p. 155).

12. It is possible that these scenes were included because of the popularity of animal stories derived from Persian or other sources, such as the *Kalīla wa Dimna*. See Imamuddin 1981, pp. 149, 183.

13. Kramrisch 1946; Coomaraswamy 1964. See n. 19 for a reference to the stupalike incense burners of northeast Iran.

14. Hishām was named heir apparent sometime later, as the inscription on the casket of Hishām II (No. 9), made in 976 (A.H. 365/66), demonstrates.

15. For a discussion of the humorous and parodistic intent of the decoration of ninth- and tenth-century Byzantine ivory caskets, see Cutler 1987, pp. 456–57.

16. In his forthcoming Mellon lectures Oleg Grabar addresses the uses of architectural frames as evocations of architecture, although his interpretation is different from that presented here (chap. 4).

17. For numerous examples of miniature models of the heavenly Zion and terrestrial Jerusalem, the Holy Sepulcher, and the Temple of Solomon, see Nice 1982, esp. pp. 45–52. The silver and gilded pavilion with pierced domes in the treasury of the basilica of San Marco in Venice, which has been attributed to Byzantium or Venice but recalls a Sasanian pavilion, is an important example of a series that includes objects of both a secular and religious nature. See Gaborit-Chopin 1984, pp. 237–43.

18. For the uses of censing and fragrances in the Islamic world in al-Andalus, see my essay in this catalogue, pp. 42–43. No particular religious use appears to have been identified for such objects within the Islamic sphere, but for the rather anomalous dedica-

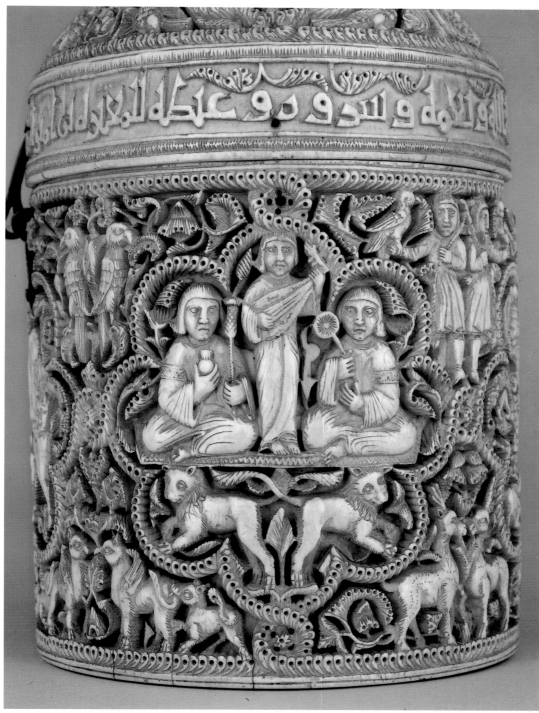

3, detail

tion ceremony of the Qurʾan of ʿUthmān in the *maqṣūra* of al-Ḥakam in the Great Mosque of Córdoba, which apparently mimics aspects of a Christian ceremony, see Dodds 1990, pp. 100ff.

19. These are attributed to Egypt and dated eighth to ninth century in Atil, Chase, and Jett 1985, pp. 58–59. Melikian-Chirvani has indicated the existence of a group of pavilion-shaped incense burners from northeast Iran and Afghanistan, which he dates from the ninth to the eleventh century and sees as echoes of the Buddhist stupas in the area

(1982, pp. 32–33, 49). For an architectural incense burner attributed to eleventh-century Spain, see Jenkins 1983, pl. 40.

20. Kühnel 1971, no. 28, pp. 36–37, pls. XIII, XIV.

LITERATURE: Lévi-Provençal 1931, pp. 25, 188; Beckwith 1960, pp. 16–20, pls. 14–17, 22A; Kühnel 1971, no. 31, pp. 38–39, pls. XVII, XVIII; Roux 1982, pp. 87–88; Ettinghausen and Grabar 1987, pp. 145–53; Grabar 1987, pp. 165–66.

Pamplona Casket

Caliphal period, 1004/5
(dated A.H. 395)
Ivory
9¼ x 15⅛ x 9⅜ in.
(23.6 x 38.4 x 23.7 cm)
Museo de Navarra,
Comunidad Foral de Navarra, Pamplona

*L*ocations for hinges and a lock were carved on this rectangular casket with a truncated pyramidal lid, but the original hinges and lock have not survived. The casket is composed of nineteen ivory plaques, each 1.4 cm thick. Seventeen of the plaques are carved. The entire surface is covered with ornament, most of which is presented in twenty-one eight-lobed medallions—eight on the body and thirteen on the lid. The remainder of the decoration consists of vegetal motifs interspersed with birds, animals, and two busts,[1] all enclosed in the same braided interlacing border that frames and connects the medallions. A band of inscription at the base of the lid completes the program.

The three medallions on the front of the body present court scenes. In the medallion at the right, a bearded, bareheaded figure, perhaps the reigning caliph, Hishām II,[2] is seated on a lion throne. He sits on his right foot, with his left knee raised, has a signet ring on his left ring finger, and holds a raceme of a flower or fruit. Flanking him are two attendants, one holding a fly whisk, the other a perfume bottle or sprinkler and a woven fan. The throne bears the signature of the carver Miṣbāḥ. Because the central medallion accommodates a place for an element of the lock, the individuals depicted in it, three youthful musicians seated in informal poses, are considerably smaller than the figures in the other medallions. The medallion on the left shows a tree flanked by two men seated on a lion throne. The back panel is centered on a medallion with a hunter who is defending himself against two lions. His shield is inscribed with benedictions and the signature of Khayr. Heraldically arranged scenes of combat fill the flanking medallions: On the right are two elephant riders with drawn swords, on the left, two horsemen, one with a spear, the other with a sword. The signature of the carver . . . *md ʿĀmir[ī]* appears on the hindquarters of the horses.

Either side panel of the casket presents two medallions, and each pair echoes the other: The medallions at the front have similar facing, mythical beasts (griffins and unicorns),[3] and those at the back show confronted horned quadrupeds (deer, antelopes, or gazelles) attacked by lions. A deer in each medallion bears a carver's signature on its hindquarters: Saʿāda or Saʾabadha on the right, Rashīd on the left. Not only the signatures but also variations in composition and carving style attest to different hands. In addition, the panel on the right has a vignette in the interstices between the medallions showing a pair of lions attacking a figure in a tree. The other panel has only vegetal motifs in this area.

The ornamentation of the lid echoes that of the panels of the front, back, and sides in only a general way. The two central medallions on each of the long sides of the lid enclose men on mounts, and the flanking medallions on both sides show animal combat. On the front panel one horseman spears a lion, the other, a falconer, sits with his bird on his arm, and victorious lions with singularly twisted heads grasp gazelles by their necks. On the back one elephant rider shoots with a bow and arrow, another defends himself with a shield, and in each flanking medallion a heraldically disposed frontal eagle grasps two quadrupeds in its claws.

Each of the cover's side panels has at its center a single medallion inhabited by a peacock. The space at each side of the medallion on the right-hand panel is filled with lion slayers. The signature of Faraj is located on the calf of the lion slayer at the right. On the left-hand panel the area on either side of the medallion is embellished with two lions attacking a gazelle. The top of the box carries three medallions, all showing animal combat: an eagle grasping a hare in the central medallion, a lion tearing at the neck of a gazelle in each of the flanking ones.

The casket's main inscription is framed with a meandering pearl border and carved in pearl decorated in Foliated Kūfic. It reads:

بسم الله بركة من الله وغبطة وسرور و بلوغ أمل
في صالح عم[ـل] وانفساح أجل للحاجب
سيف الدولة عبد الملك بن المنصـ[ـو]ر وفقه الله
مما أمر بعمله على يدي الفتى الكبـ[ـير]
[ز]هير بن محمد العامري مملوكه
سنة خمس وتسعين وثلث مائة

In the name of God. Blessings from God, goodwill, happiness, and attainment of expectations from pious works, and respite from the appointed time of death to the hajib Sayf al-Dawla ʿAbd al-Malik, son of al-Manṣūr, may God grant him success. From that which was ordered to be made under the supervision of the chief page Zuhayr ibn Muḥammad al-ʿĀmirī, his servant in the year three hundred and ninety-five.

There are at least seven other inscriptions on the casket (six have already been referred to),

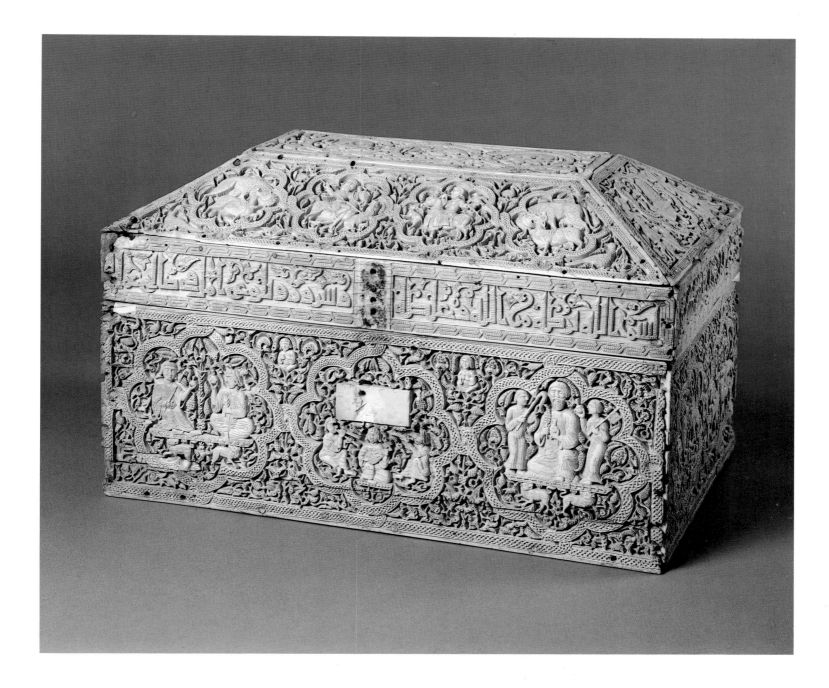

all of which appear to be signatures of the carvers who ornamented it.[4] Since the casket was made of many separate panels that were joined together after they were embellished, it would be reasonable to propose that it was a collaborative effort. The inscription on the interior of the lid reads: عمل فرج مع تلامذته (*The work of Faraj and his apprentices*).

The workshop headed by Faraj was active some forty years later than the enterprise associated with Khalaf and Durrī that produced the earliest Hispano-Islamic pieces (see Nos. 1, 2). Nevertheless, Faraj's workshop continued to employ many of the compositional and icono-

graphic conventions of its predecessor. The appearance on the Pamplona casket of the same eight-lobed medallions and vegetal ornament that characterize the pyxis of al-Mughīra (No. 3), which was made more than thirty-five years earlier, as well as a pyxis made for Ziyād ibn Aflaḥ in 967 (A.H. 359), indicates a continuity of workshop practice, even though no objects can be securely dated to the intervening years.[5] Motifs relating largely to the princely imagery of well-being, feasting, and hunting, traced by many scholars to textile patterns, formed the basis of the workshops' visual language, though specific choices of imagery and manipulation of

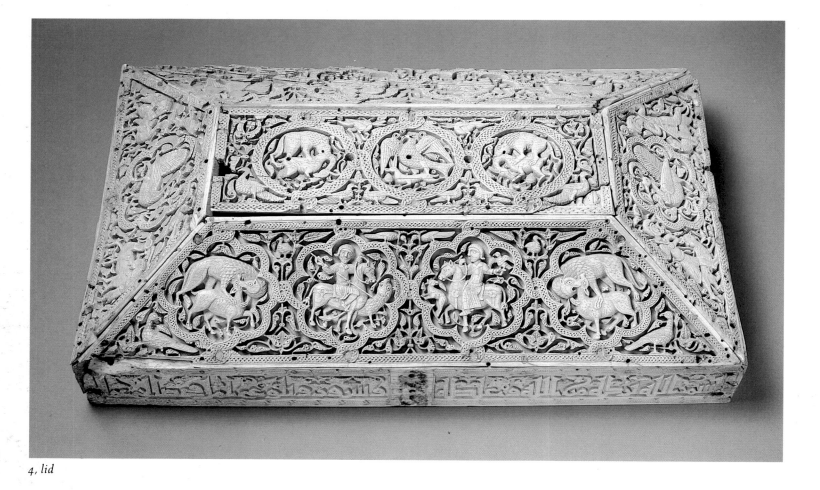

4, lid

components individualize the meanings of the decorative programs of particular objects. Thus, for example, this casket produced for ʿAbd al-Malik appears to have been made to celebrate his conquest of León, for which he was given the title Sayf al-Dawla by the caliph al-Hishām. The depiction of the caliph in one medallion underscores the official validity of the new title, and the majority of the scenes in the other medallions and in the vignettes in the interstices involve battle or victorious animals.

While the earliest carved ivories were produced at Madīnat al-Zahrāʾ and a group has been assigned to Córdoba,[6] this casket and the pyxis of Sayf al-Dawla (No. 5) could well have been made at Madīnat al-Zāhira, the actual seat of power of al-Manṣūr and his son ʿAbd al-Malik. However, there is no proof that there were ivory carvers at Madīnat al-Zāhira.

The casket was used for many centuries in the monastery at Leyre as a reliquary. It was transferred later to the church of Santa María de Sangüesa and then to the treasury of the cathedral in Pamplona. R H

1. For similar decoration, see a pyxis in the Kuwait National Museum, Kuwait City (LNS191) (Atil 1990, no. 22, pp. 90–91).
2. Navascués y de Palacio 1964b, p. 246. Even though Hishām II was being kept by al-Manṣūr and his son ʿAbd al-Malik as a virtual prisoner in the old palace city of Madīnat al-Zahrāʾ, away from the center of power at Madīnat al-Zāhira, he was named on coins and ṭirāz as ruler. As caliph he would have granted diplomas for titles and received embassies. See also al-Maqqarī 1855–61, vol. 1, pp. 257–58.
3. On unicorns, see Ettinghausen 1950.
4. Beckwith is the only scholar who does not agree that these are signatures, but takes them as "polite invocations" (1960, p. 29). For opinions that these are the workshop signatures, see Kühnel 1971; Navascués y de Palacio 1964b; Fernández-Ladreda Aguade 1983.
5. Kühnel 1971, pl. XIV. Kühnel places the pyxis in the Museo Nazionale di Firenze to this interim period (p. 40).
6. The existence of a Cordobán workshop was proposed by both Kühnel (1971, pp. 38–46) and Beckwith (1960, pp. 6–8) to account for pieces carved in a somewhat less refined style than ivories from Madīnat al-Zahrāʾ. However, only the workshop at Madīnat al-Zahrāʾ is identified in inscriptions on extant objects; the supposition that there was one at Córdoba, or even at Madīnat al-Zāhira, is based entirely on a perceived difference in the quality of products.

LITERATURE: Beckwith 1960, pp. 26, 29, pls. 23, 24; Navascués y de Palacio 1964a; Navascués y de Palacio 1964b; Kühnel 1971, no. 35, pp. 41–43, pls. XXII–XXVI; Fernández-Ladreda Aguade 1983, pp. 4–17.

4, detail

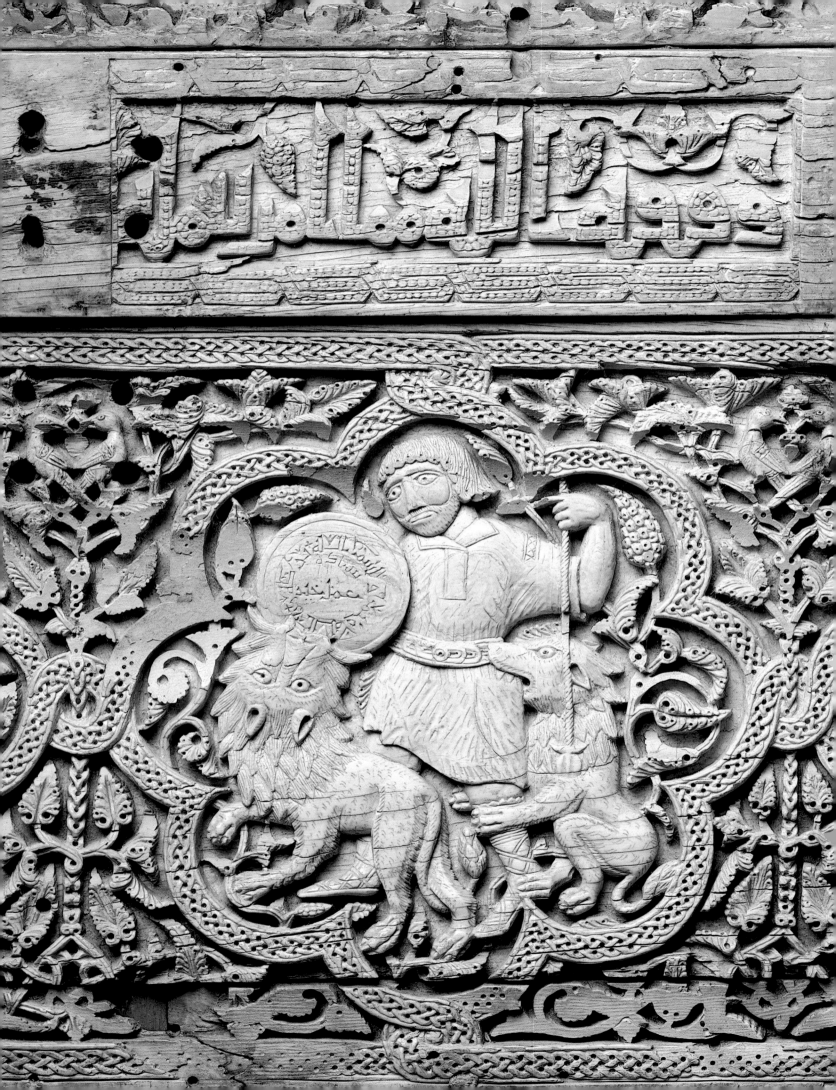

Pyxis of Sayf al-Dawla

Caliphal period, 1004–8
Ivory and metal
H. 7⅞ in. (20 cm), diam. 4⅛ in.
(10.4 cm)
Braga Cathedral Treasury,
Portugal

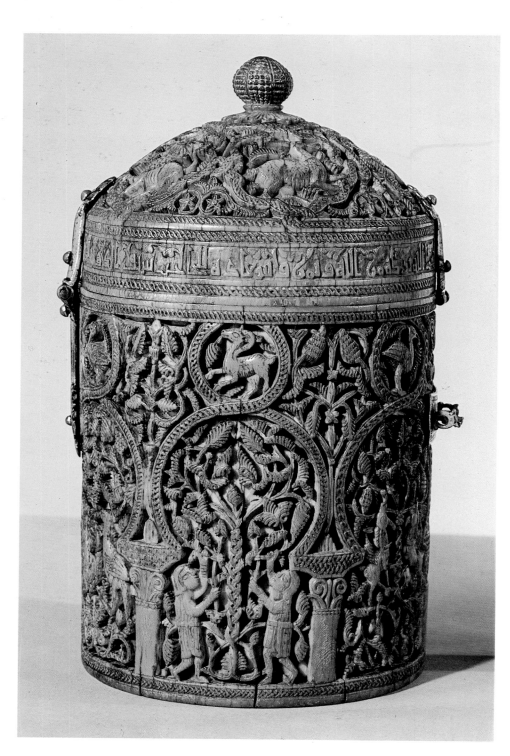

*F*ive eight-lobed medallions, each enclosing a single animal, ornament the dome of this pyxis. Two lions, a peacock, and two deer are shown. The cover has double hinges and is damaged in the area of the inscription band located at its bottom. The finial knob is rendered as an *amalaka* fruit (see No. 3) set in a rondel of leaves. The interstices between the medallions are filled with pinecones, star-shaped flowers, and leaves.

The dome-shaped cover gives the pyxis an architectural aspect, a theme that is carried out in the arcaded frieze on its body. The arcade consists of six horseshoe-shaped arches resting on impost blocks, capitals, and columns. Each arch loops up into a small rondel that contains birds or an animal: a pair of quails(?) in the one adjoining the lock, a pair of peacocks in the one next to the hinges, and a stag or deer between each of the others. Paired animals, birds, and humans eating and harvesting fruit (dates?) inhabit the thicket of vegetation that fills the arcade and spills out above and beyond it.

The inscription on the bottom of the cover reads:

بسم الله بركة من الله ويمن وسعادة للحاجب
سيف الدولة أعزه الله مما أمر بعمله على يدي الفتى
[الكبير زهير بن محمد] العامري

In the name of God. Blessings from God, good fortune and happiness to the hajib Sayf al-Dawla, may God increase his glory. From what was ordered to be made under the supervision of the chief page [Zuhayr ibn Muḥammad] al-ʾĀmirī.

The pyxis is datable to a period between 1004, when the hajib ʿAbd al-Malik received the title Sayf al-Dawla, and 1007 (A.H. 395–98) when he received the additional title al-Muẓaffar, or 1008 (A.H. 399) when he died in battle. In contrast to the Pamplona casket (No. 4), which commemorated a military victory and the granting of a new title, Sayf al-Dawla, to ʿAbd al-Malik and includes scenes of combat, this pyxis has only peaceful figures and animals. Thus it could have been made for a specific personal celebration, such as a marriage, or an occasion of a calendrical observance, such as a summer or fall harvest festival (see No. 3). R H

LITERATURE: Lévi-Provençal 1931, no. 205; Beckwith 1960, p. 29, pl. 25; Kühnel 1971, no. 36, pp. 43–44, pls. XXIX, XXX.

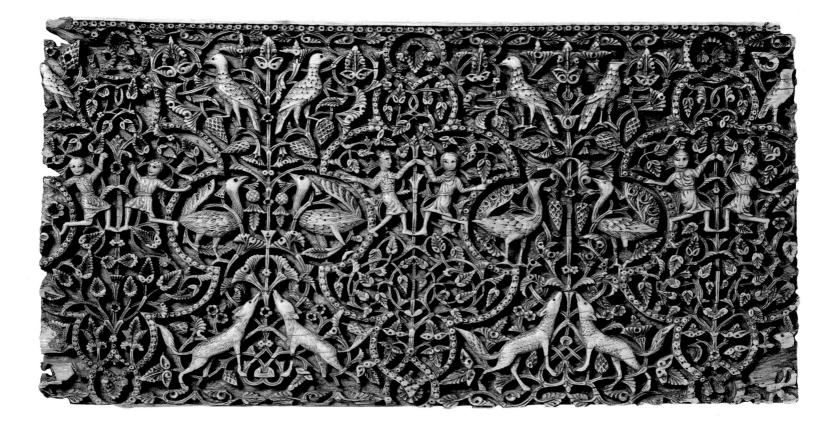

Here the lush but delicately executed repeating pattern of paired birds, foxes, and dancing human figures set against a background of graceful arabesques probably reflects a strong connection to patterned textiles. In this respect the panel may be associated with several other boxes from al-Andalus decorated with textile patterns, including the pyxis of al-Mughīra (No. 3).

The panel, carved from a single piece of elephant ivory, surely was made for a rectangular casket. It must have been cut down, as only the top edge has the expected decorative border and finish. Significant traces of pigment remain: red and green paint on the foliage throughout, blue pigment on one flower, and green paint on the tails of birds. There is no pigment on the figures, however. The eyes of the humans and animals were drilled and inlaid with a clear stone, possibly quartz, surrounded by a dark material.[1]

Such color and inlay were typically used on ivories made for the court—they must indeed have been of spectacular richness. An inscription on a contemporary cylindrical box reads in part: *beauty has invested me with splendid raiment, which makes a display of jewels.*[2] Clearly the allusions here to textiles and jewels were not mere hyperbole. DW

1. Conservation report by Dorothy Abramitis, The Metropolitan Museum of Art, May 30, 1991.
2. Beckwith 1960, p. 14.

LITERATURE: Glück and Diez 1932, fig. 633; Ferrandis 1935, pp. 18, 36, no. 6, p. 61, pl. VI; Gómez-Moreno 1951, p. 298, fig. 359; Beckwith 1960, p. 13, pl. 5; Kühnel 1971, pp. 2, 3, 5, no. 39, pp. 45–46, pl. XXXI; Jenkins 1975, p. 9; Metropolitan Museum of Art 1987, p. 29, no. 17.

6

Panel from a Casket

Caliphal period, early 11th century
Ivory, stones, and traces of pigment
4¼ x 8 in. (10.8 x 20.3 cm)
The Metropolitan Museum of Art,
New York, John Stewart Kennedy Fund,
1913
13.141

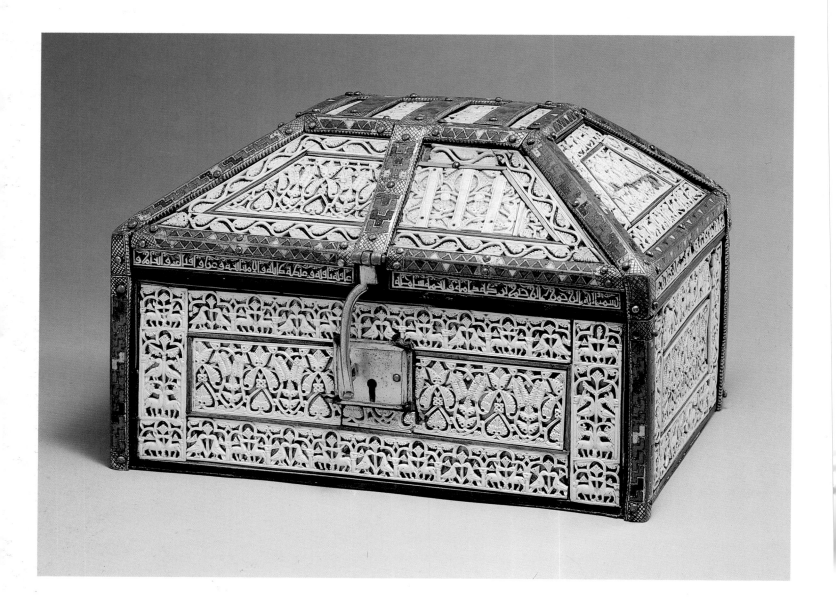

7

Palencia Casket

Taifa period, 1049/50 (dated A.H. 441)
Ivory, leather, and gold
9 x 13⅛ x 9¼ in. (23 x 34 x 23.5 cm)
Museo Arqueológico Nacional, Madrid
5737[1]

*T*his casket is the most important piece
known to have been produced in the ivory
workshop at Cuenca under the patronage of the
Taifa kings of Toledo, the Banū Dhūʾl-Nūn.[1]
The elaborate inscription tells us that it was
made for al-Ḥājib Ḥusām al-Dawla Ismāʿīl,
son of the *Taifa* king al-Maʾmūn, in the year
A.H. 441 (1049/50).[2] The title hajib indicates
that Ḥusām al-Dawla was the designated suc-
cessor to the throne of the *Taifa* of Toledo; he
never assumed power, however, because he met
a premature and violent death. The use of
honorary titles, such as *husām al-dawla* and
qaīd al-quwwād, in addition to a very long list
of prosaic blessings and good wishes, in the
inscription reflects the king's efforts to establish
the legitimacy of his son's claim to the throne
and thus to secure the continuation of the dy-
nasty. Al-Maʾmūn was also attempting to

glorify the new dynasty through the patronage
of architecture that engaged the decorative styles
of caliphal Córdoba and of Saragossa, a rival
Taifa kingdom's capital.

The panels of vegetal ornament on the front
and back of the Palencia casket reveal the inspi-
ration of earlier caliphal and *fitna*-period ivories
as well as of contemporary Saragossan and
Toledan architectural decoration. The vegetal
imagery combined with pairs of confronted and
addorsed birds and gazelles enclosed in architec-
tural motifs may represent paradise, which
would reinforce both the good wishes conferred
upon Ismāʿīl by the inscription and the apotro-
paic qualities traditionally ascribed to the
animals. Hunting scenes, griffins, and lions attacking
gazelles, such as those shown on the sides of the
casket, are usually associated in a general sense
with royalty and courtly art.

7, detail, lid

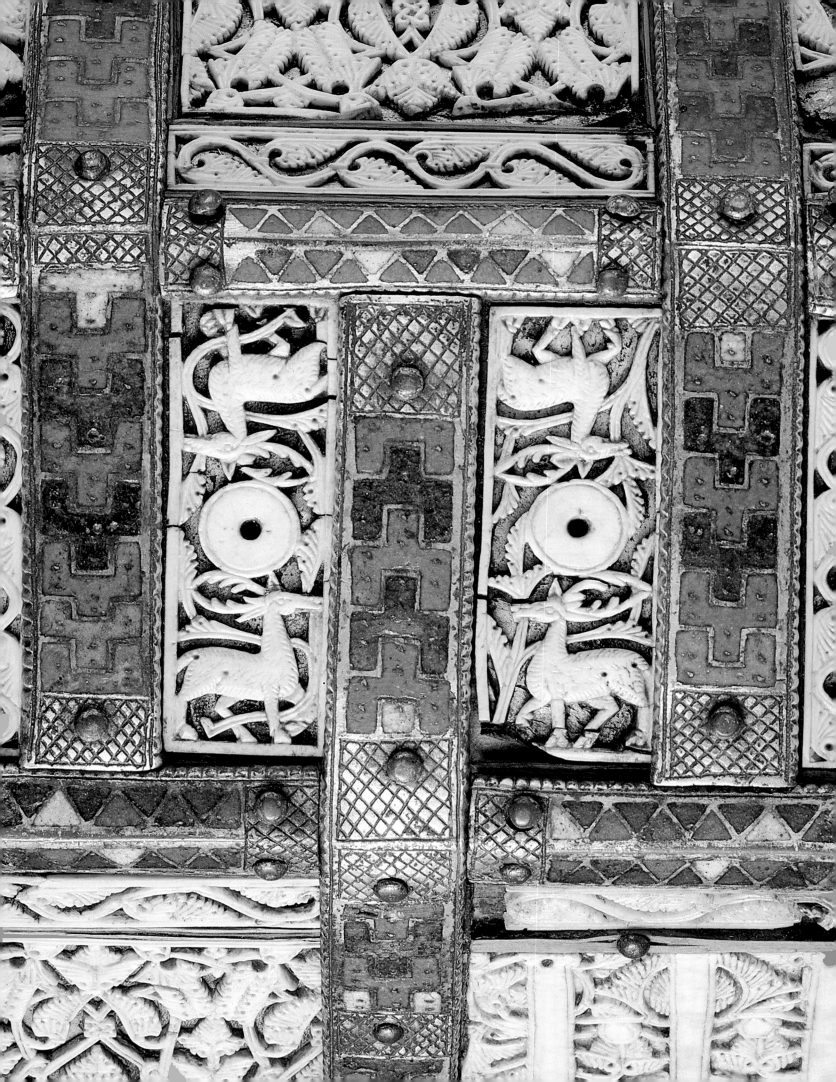

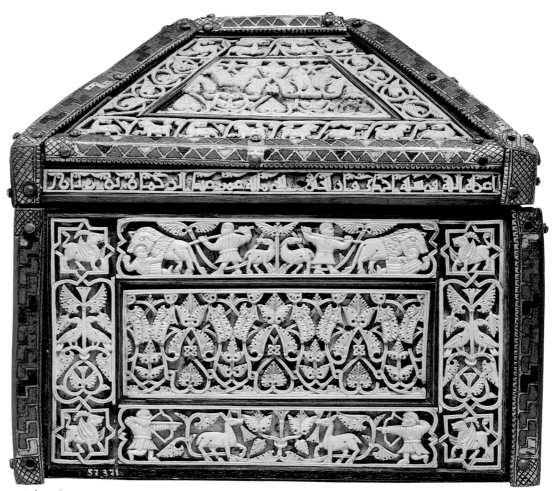

7, right side

The Cuenca workshop was particularly active about the time the Palencia casket was made, producing ivories for patrons who all appear to have been members of the Toledan royal family. Other ivories commissioned by King al-Maʾmūn include the pyxis in the cathedral of Saint Juste in Narbonne and plaques for the casket of Bienaventuranzas, which is in the Museo Arqueológico Nacional in Madrid (2.092).[3]

C R

1. Each *Taifa* king controlled an ʿ*amal*, or region that surrounded his capital city. During most of the eleventh century, Cuenca was part of the ʿ*amal* of Toledo.

2. The inscription reads:

<div dir="rtl">

بسم الله الرحمن الرحيم بركة دائمة ونعمة شاملة [و]

عافية باقية وغبطة طائلة آلاء متتابعة وعز وإقبال وإنعام

و[أمصال] و بلوغ آمال لصاحبه أطال الله بقائه عمل

بمدينة قونكة بأمر الحاجب

حسام الدولة أبو محمد إسماعيل بن المأمون ذي المجدين بن

الظافر ذي الرياستين [إبن] محمد بن ذي النون أعزه الله

في سنة إحدى وأربعين وأربع مائة [عمل] عبد الرحمن

بن زياد

</div>

In the name of God, the Merciful, the Compassionate, continuous blessing, complete bounty, [and] lasting health and prolonged[…]glory, total happiness, continuous favor, and support, and the achievement of the hopes of the owner, may God prolong his life! Completed in the city of Cuenca by order of the hajib Ḥusām al-Dawla abī Muḥammad Ismāʿīl ibn al-Maʾmūn Dhūʾl-Majdayn (?) [he of the glories] ibn al-Zāfir Dhūʾl-Riyāsatayn Abū Muḥammad ibn Dhūʾl Nūn, May God bring him glory. [Completed] in the year 441. Work of ʿAbd al-Raḥmān ibn Ziyādn.

3. For the Narbonne pyxis, see Ferrandis 1935, no. 30, pp. 98–99, pl. LX; for the Bienaventuranzas casket, see ibid., no. 28, pp. 95–96, pl. LIX.

LITERATURE: Prieto y Vives 1926, pp. 51–55; Migeon 1927, vol. 1, p. 357, fig. 144; Ferrandis 1928, p. 87, pl. XIX; Ferrandis 1935, pp. 92–95, no. 27, pls. LIII–LVII; Gómez-Moreno 1951, p. 310, fig. 369; Beckwith 1960, pp. 30, 32, pl. 32; Kühnel 1971, pp. 48–49, no. 43, pls. XXXV–XXXVII.

8

Hanging Lamp from Medina Elvira

Emirate or Caliphal period,
9th–10th century
Bronze
H. 30⅜ in. (77 cm), diam. 17⅜ in.
(44 cm)
Museo Arqueológico de Granada

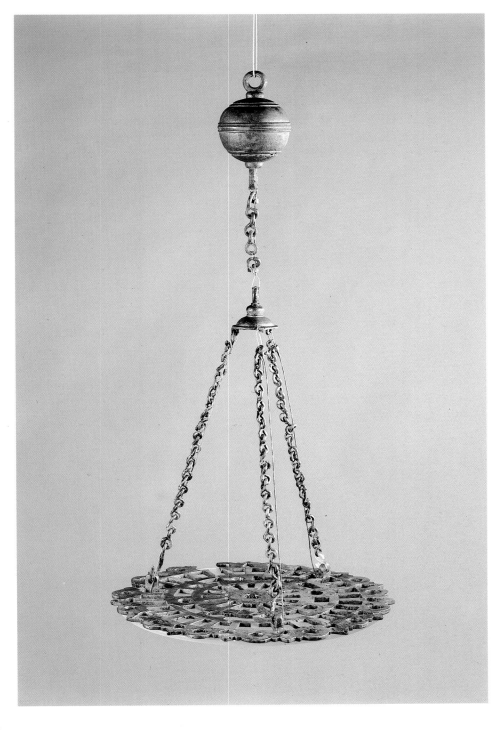

A disk or flat plate suspended by three chains from a hemisphere that is capped by a ring constitute this cast-bronze lamp. A single chain connects the ring to a sphere that is also topped with a ring, this one used to hang the lamp. The most interesting feature of the lamp is the plate, which contains numerous circular openings, disposed in concentric circles, that held small oil lamps made of cones of blown glass filled with a mixture of two parts water and one part oil in which a wick floated. The remaining perforations in the plate were arranged in diverse patterns, according to the necessities of both economy and aesthetics.

The lamp was found in 1874, along with as many as six similar pieces, by Manuel Gómez-Moreno at a site in the old city of Medina Elvira (Atarfe, Granada) where construction materials were being salvaged from the ruins of an ancient, burned building. It was supposed, and is generally believed today, that the ruins were those of the mosque of Elvira, perhaps because the area in which the discovery was made was called the Secano de la Mezquita (Mosque Wastelands). (We have documentation that the building was reconstructed in 864/5 [A.H. 250].) Such lamps, or polycandela, are known to have been used in mosques since the eighth century and believed to have been used in churches as early as the sixth century. As they are known to have been manufactured by Coptic Christians, we cannot be certain that the ruins of the building explored were those of a mosque and not a church. Unfortunately, there was no possibility of performing a survey that would offer information about the plan or the orientation of walls destroyed in the salvage operation. Such pieces and the ambiguities they pose remind us of the forms shared, even in the religious arts, by Muslims and Christians.

MCP

LITERATURE: Oliver Hurtado 1875, p. 618; Gómez-Moreno González 1888, nos. 41, 50, pp. 8–9; Gómez-Moreno González 1892, vol. 2, p. 192; Gómez-Moreno 1919, pp. 390–94. pls. CLXIX, CL; Gómez-Moreno 1929, no. 3362, pp. 71–72; Marçais and Poinssot 1948, pp. 454–55; Gómez-Moreno 1951, pp. 324–25, fig. 385; Torres Balbás 1957, p. 752; Valdés Fernández 1984, p. 215.

9

Casket of Hishām II

Caliphal period, 976
Silver, wood, gilt, and niello
10⅝ x 15⅛ x 9¼ in.
(27 x 38.5 x 23.5 cm)
Tesoro de la Catedral de Gerona
64

*T*his wooden box with vaulted lid is covered in repoussé silver and decorated in silver, gilt, and niello (a black alloy of sulfur with lead and silver). The casket has a rectangular base and sides, four trapezoidal shoulders that slant inward, and a rectangular top with attached handle. The top of the handle forms three shallow arches; as the handle's sides descend from the outer arches they curve inward and then loop up, terminating in striated acorns. Where the lid joins the body of the casket there is a dedicatory inscription in heavy Kūfic lettering:

بسم الله بركة من الله ويمن وسعادة وسرور دايم لعبدالله
الحكم أمير المؤمنين المستنصر بالله مما أمر بعمله لأبي الوليد
هشام ولي عهد المسلمين تم على يدي جودر بن ٠٠٠

In the name of God. Blessing from God, prosperity, fortitude, and perpetual joy and happiness for the servant of God al-Ḥakam Commander of the Faithful al-Mustanṣir bi-llāh. Among those things ordered for Abū'l-Walīd Hishām the successor to the caliphate. Completed under the direction of the official Gaudar.

As Hishām was declared al-Ḥakam's heir on February 5, 976 (A.H. 366), and al-Ḥakam died in the arms of his eunuch Gaudar on October 1 of that same year, we may assume that the casket was made between those two dates.

Lines of pearls initiate the decorative scheme, forming volutes that enclose double, forked palms; the space between the palms is occupied by small bunches of symmetrical leaves. (We see volutes ending in double palms in the stuccowork at Medina Elvira, which was abandoned about 1010 [A.H. 401], on the San Esteban gate in the Great Mosque of Córdoba, and in abacuses at Madīnat al-Zahrāʾ.) These volutes end in heart-shaped leaves and in rosettes of four and eight petals beside the metal strapping for the closing. This strapping is actually false, hammered in the silver itself. The hasp of the hinge that closes the casket has a slot that slips over a fixed ring; that ring, along with one on either side, forms the fixed element of the closing. The moving piece is a threaded bolt with a nut at each end. On the back of the hinge is engraved: عمل بدر وطريف عبده (*Work of Badr and Ṭarīf, your servants*).

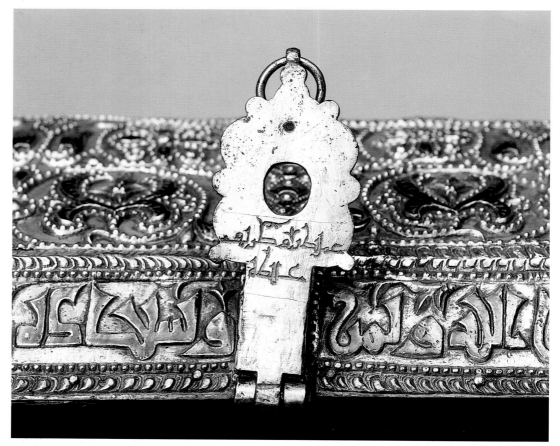

detail, back of hinge

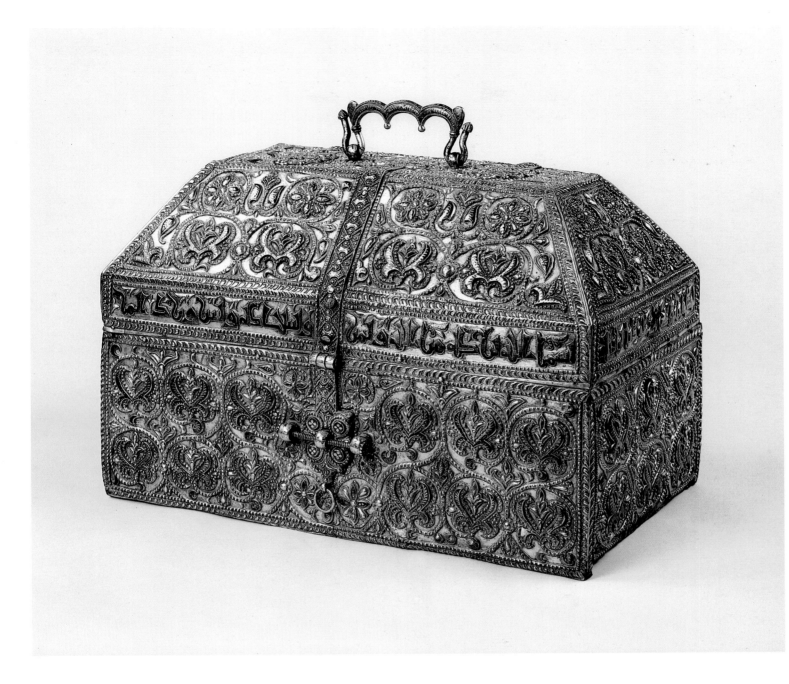

The casket must have passed into Christian hands during Hishām's lifetime, when Catalan mercenaries recruited by Wāḍiḥ, the governor of La Marca Superior, on behalf of Muḥammad al-Mahdī, fought in Córdoba. Commanded by Armengol of Urgel and Ramón Borrel III of Barcelona, they were in Córdoba between May 22, 1010 (A.H. 401), the date of the victory of El Vacar, and July 23, 1010, when Muḥammad al-Mahdī died. The contract between Wāḍiḥ and the counts stated that all booty would be theirs. It is, therefore, not unreasonable to suppose that like other contemporaneous pieces of Islamic art located in old churches of the Spanish Marches, this casket may have been among the spoils of the battle. This supposition is substantiated by wills and deeds of gift executed throughout the eleventh century.

MCP

LITERATURE: Girbal 1877, pp. 331–36; Davillier 1879, pp. 17–18, fig. 4; Gómez-Moreno González 1888, p. 18, no. 20, pl. V; Madrid 1893a, sala VIII, no. 85; Madrid 1893b, pls. LIII–LIV; Vives 1893, pp. 99–100; Artiñano 1925, pp. 38–39; Lévi-Provençal 1931, no. 191, p. 185; Gómez-Moreno 1951, p. 337, fig. 399a; Font 1952, p. XXXIII, no. 141; Bagué 1953, pp. 275, 542, fig. 122; Torres Balbás 1957, p. 764, figs. 623, 624; Scerrato 1966, no. 32, pp. 72, 78; Gerona 1981, p. 16.

Córdoba Stag

Caliphal period, 2nd half of 10th century
Bronze
H. with plinth 24¼ in. (61.6 cm)
Museo Arqueológico Provincial
de Córdoba
500

The well-known Córdoba stag is perhaps the surviving masterpiece of the caliphal metalworking atelier at Madīnat al-Zahrāʾ, the palace constructed by ʿAbd al-Raḥmān III and his son al-Ḥakam II between the middle and the end of the tenth century. Although the object bears no dedicatory inscription, its provenance is fairly certain: It was found among the ruins of Madīnat al-Zahrāʾ.[1] The patron who commissioned it surely was a member of the royal family or someone else highly placed in the administrative or military hierarchy, because during the caliphate most of the luxury arts industries, such as textile manufacture (especially *ṭirāz*), stone and ivory carving, and metalworking, were royal monopolies. This is known from

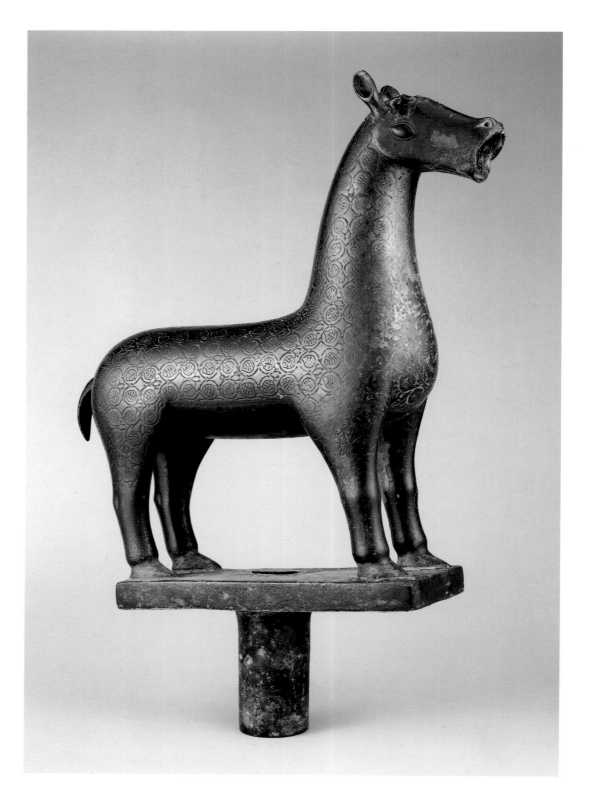

inscriptions, particularly those found on textiles, ivories, and capitals, which often identify patrons, places of production, and workshop chiefs, and sometimes artists responsible.

This sculpture probably served as a fountain—there is a hole on the animal's underside to allow for the passage of water, which would have spouted from its mouth and cascaded into a shallow pool at its feet. Fountains were an important part of the aesthetic program of the Islamic—especially the western Islamic—palace, and they are mentioned in the writings of travelers, chroniclers, and poets, which suggest their special meanings within Muslim Spain. The present stag may well have been accompanied by other bronze animals of the same or different species, perhaps arranged in a circle like the lions of the fountain of the Patio de los Leones in the Alhambra.

Most of the production of the Madīnat al-Zahrāʾ metalworking atelier is lost, but there are two extant pieces that are similar to the Córdoba stag that may have been produced there. The first, an animal of somewhat uncertain species, belongs to the Museo Nazionale del Bargello in Florence.[2] This sculpture's rather generic inscription conveys wishes of good fortune to an unspecified owner and bears no date. Umberto Scerrato assigns it to the eleventh century, probably on the basis of the handling of its incised decoration, which is broader (and perhaps less adept) than that of the Córdoba piece. The stances of the Bargello sculpture and the Córdoba stag are comparable, as are their simple, rather abstract body parts, and both are adorned with ornament that makes them appear to be draped with a rich fabric. However, the "fabric" of the Bargello piece is bordered by an inscription, whereas the stag's is not. Moreover, the Bargello animal, like the Pisa griffin (No. 15), bears vegetal motifs within teardrop shapes on its joints. This kind of motif does not appear on the Córdoba example, which is covered with delicate, uniform allover ornament composed of leaves within circles. Although the individual decorative elements of the Florence sculpture are greatly simplified in comparison with those of the Córdoba stag, the division of the former animal's incised ornament into distinct zones relates it to later pieces, such as the Pisa griffin and two bronze peacock aquamaniles (see No. 15), for which a Spanish provenance is likely. Whatever the chronological sequence of the Córdoba stag, the Florence animal, and the Pisa griffin, it is clear that these three pieces

have close affinities, especially in comparison with bronze animal sculpture from contemporary Fāṭimid Egypt or Būyid Persia.[3]

The second piece that can be related to the Córdoba sculpture is a stag in the Museo Arqueológico Nacional in Madrid (51.856). The two stags share like facial features, simple body volumes, rigid stance, and a mantle of vegetal ornament. However, the Madrid animal is much smaller and squatter, probably was not a fountain decoration (it has no holes for the passage of water), is gilt, whereas the Córdoba piece is not, and has leaf motifs with different details. The parallels are close enough, nevertheless, to indicate that the two sculptures were produced in the same general area, if not in the same workshop, which was likely in Spain, since both were found there.

Géza Fehérvári has proposed that there was no distinctive metalworking tradition in the western part of the Islamic world until the Fāṭimid dynasty emerged in Egypt.[4] However, the Bargello piece, the Córdoba and Madrid stags, and other related objects seem to constitute evidence of a rich and unique metalworking tradition—and perhaps the existence of several contemporaneously active workshops—in al-Andalus that, if anything, preceded and probably influenced the metal sculpture of the Fāṭimid Empire.[5]

C R

1. Migeon calls it Fāṭimid (1927, vol. 1, pp. 377–78). No other scholar has taken this position, however.
2. Scerrato 1966, pp. 71–73, fig. 30. Scerrato says the figure is a lion, but the feet, which are hoofed, and the presence in the top of the head of holes from which horns conceivably could have sprouted probably place it in the stag category.
3. For Fāṭimid animal sculpture, see Migeon 1927, vol. 1, pp. 376–77, fig. 183; Scerrato 1966, pp. 72–73, no. 31. These pieces reflect a realistic aesthetic at odds with the style of Hispano-Islamic production. Hispano-Islamic sculpture was more monumental than Egyptian and was probably inspired by but not imitative of Persian models. (For comparable Persian examples, see Fehérvári 1976, pl. 37, nos. 109–11.) Persian animal sculpture of this period is related to the Spanish pieces in terms of its simple geometric volumes and textilelike decoration but is distinguished by a peculiar facial scheme, especially apparent in the lions, and by an openwork technique that is not used in Spain.
4. Fehérvári 1976, p. 40.
5. For a discussion of possible Spanish influence on Fāṭimid metalwork, see the entry on the Monzón lion (No. 54).

LITERATURE: Kühnel 1924, pl. 120; Migeon 1927, vol. 1, pp. 377–78, fig. 184; Gómez-Moreno 1951, p. 336, fig. 396b; Scerrato 1966, p. 83.

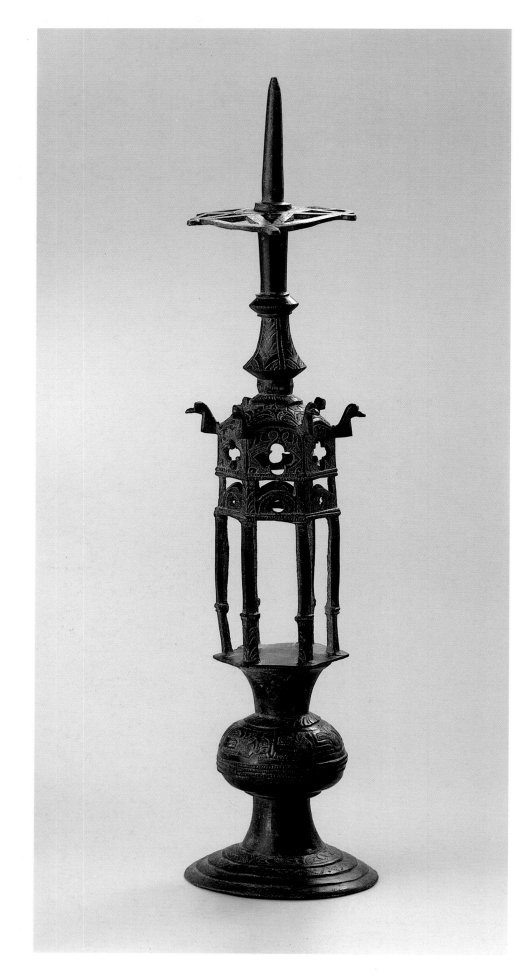

Candelabrum

Caliphal period, 10th century
Bronze
H. 19⅞ in. (50.5 cm)
The David Collection, Copenhagen
11/1987

A typical Hispano-Islamic piece from the epoch of the caliphate, dating from the tenth century, this architectonic candelabrum is composed of three elements. In the center of the boss is an incised epigraphic decoration with the word بركة (*baraka*, blessing).

The architectural structure imitates a temple with cupola supported by six solid, square columns. Atop the columns is a double entablature: the lower of the two features a frieze of semicircular arches with pierced vegetal decoration; the pediments of the second level are pierced with large four-lobed crosses. Modeled bronze birds, perhaps doves, spring from the vertices or intersections of the pediments.

A shaft grows from atop the cupola, sustaining a pierced disk. The disk, typically, is intended to hold a number of oil lamps. The piece is finished with a cylindrical finial with horizontal incised bands and wing-shaped rim or lip.

This complete example is similar to one found in Medina Elvira (Granada), published by Manuel Gómez-Moreno.[1] Juan Zozaya and Guillermo Rosselló Bordoy[2] studied several pieces from the peninsula corresponding to this type of candelabrum, such as an architectonic temple originating in Almería, now in the Museo Arqueológico Nacional in Madrid; a piece in the Museo de Bellas Artes in Valencia; and one in the Pons Soler collection in Minorca.[3] Several isolated knops, including one in the Museo de Bellas Artes in Valencia,[4] are also known, and there is an obvious parallel between the finial of this piece and one found when the mosque in Madīnat al-Zahrāʾ was excavated.[5] RAR

1. Gómez-Moreno González 1888.
2. Zozaya and Rosselló Bordoy forthcoming.
3. Rosselló Bordoy 1978.
4. Zozaya 1967, pp. 133–54.
5. Pavón Maldonado 1966a.

LITERATURE: Gómez-Moreno González 1888; Pavón Maldonado 1966a; Zozaya 1967; Rosselló Bordoy 1978a, pp. 42–44; Allan 1986; Folsach 1990 no. 229; Zozaya and Rosselló Bordoy forthcoming.

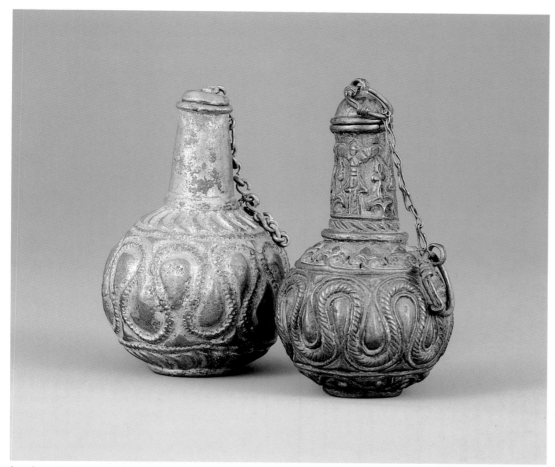

bottle a (left); bottle b (right)

Dating the first perfume bottle shown here presents no difficulty, as it was found in a trove of caliphal coins. The bottle is silver and has a flat base, spherical body, narrow conical neck, and slightly thickened outer rim. The stopper is semispherical and somewhat flattened, with a ring in the top. An S-link chain fastened between this ring and one situated at the base of the neck of the bottle connects the stopper to the body. The neck is plain, but the body is entirely covered with relief motifs simply and schematically treated. Crescents running in opposite directions fill upper and lower bands, which frame a garland that takes the form of a serpentine rope, the loops of which enclose repoussé teardrops.

This vessel has many features in common with typical bronze Cordobán perfume bottles in the Museo Arqueológico Provincial de Córdoba.[1] Among these bronze pieces is the second example shown here, which was published by Manuel Gómez-Moreno as silver.[2] It has a flat, spherical body and narrow conical neck slightly thickened on the outer rim. The

semispherical stopper is topped by an attached ring; a chain fastens this ring to a second placed in the upper quarter of the body of the container.

The relief decoration covers the entire body, including the neck. The lower band displays a garland of acanthus leaves. In the upper quarter of the body, ringing the neck, is a band of vertical trifoliate flowers, linked at the stem. Between these bands of vegetal decoration, on the central portion of the body, a serpentine cord encloses repoussé teardrops—a motif similar to that on the body of the silver bottle. While the composition is much like that of the silver vessel's decoration, the detail is more elaborate and the quality finer. On the neck is a commonly used relief formed by horseshoe-shaped arches surrounding vertical trifoliate leaves. Four incised radii embellish the exterior of the stopper. R A R

1. Córdoba 1986a, p. 90, nos. 140, 141.
2. Gómez-Moreno 1951, p. 337, fig. 398g.

LITERATURE: (No. 12b) Gómez-Moreno 1951, p. 337, fig. 398g; Torres Balbás 1985, p. 765, fig. 625; Córdoba 1986a, p. 90, nos. 140, 141.

12

Two Perfume Bottles

Caliphal period, 10th century
a. Bottle from the Treasure of
La Mora Lucena, Córdoba
Silver
H. 2¾ in. (6.8 cm)
Museo Arqueológico Provincial
de Córdoba
24205
b. Bottle from Olivos Borrachos,
Córdoba
Bronze
H. 2⅞ in. (7.4 cm)
Museo Arqueológico Provincial
de Córdoba
3.772

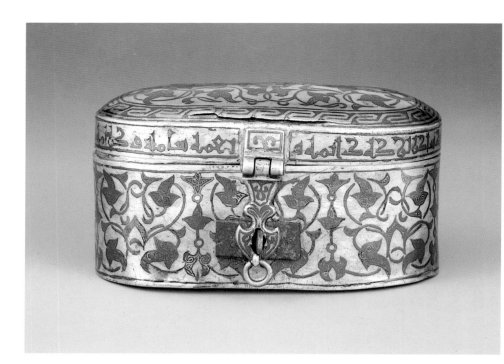

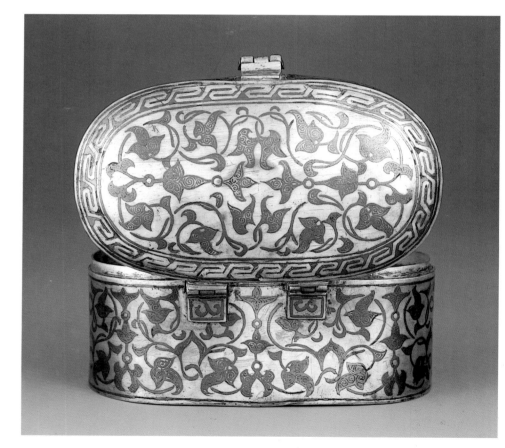

13

Box

Caliphal or *Taifa* period,
10th–11th century
Silver and niello
H. 2⅛ × 4⅜ in. (5.5 × 11 cm)
Museo Arqueológico Nacional, Madrid
50.889

*I*ncised and nielloed decoration distinguishes
this small oval silver box, which was part of a
group of similar precious objects that belonged
to the treasury of the cathedral of León. It may
have been made in the northern *thagr*, or
frontier, *Taifa* of Toledo, which was famous for
the production of precious metalwork. The
formulaic inscription it bears expresses only
good wishes and gives no date or information
about patron, artisan responsible, or place of
manufacture. Thus, it is probable that this box
was produced in a workshop that was not under
strict royal control. The embellishment is rather
simplified in comparison with that of contem-
porary ivories and *Taifa* architectural decoration.
It is possible that *Taifa*-period objects, such as
this box as well as a perfume bottle now in the
Museo de Teruel (No. 16), with inscriptions
that do not identify patrons or artisans were
made for wealthy members of the middle
class who wished to own luxury arts like those
commissioned by royalty. C R

14

Ewer

Taifa period, 10th–11th century
Bronze
H. 8⅝ in. (22 cm)
The David Collection, Copenhagen
5/1990

*A*mong luxury metal objects produced in
the Islamic world during the tenth and eleventh
centuries, this bronze ewer with a spout in the
form of a cock's head is rare. Its shape relates it
to the Basra ewers that were fairly common
during the early Islamic era, but no Basra ewers
with spouts are known. Moreover, cock's-head

spouts are seldom found on early or medieval Islamic ewers of any form. Although this piece is sometimes compared with the eighth-century Marwān ewer, which may have been made in Syria and is now in the Museum of Islamic Art in Cairo (15241), the latter vessel's spout represents the entire bird, and the shape of its body is different.[1]

The present ewer probably predates and is certainly related to two peacock aquamaniles—one in the Musée du Louvre in Paris (1519) and another in the Pinacoteca Nazionale in Cagliari.[2] These three vessels share a distinctive stylization of eyes, beak, and comb, as well as a static, monumental quality. However, the David ewer's pear-shaped body, flaring neck, and splayed foot, as well as its cock's-head spout, set it apart. The David vessel is also related to an unpublished ewer without a spout in the Museo Arqueológico Nacional in Madrid that was probably produced in Muslim Spain during the *Taifa* period: They have similarly shaped bodies and are adorned with fantastic animals inscribed within rondels.

The dates usually proposed for the David ewer (tenth to eleventh century) and for the peacock aquamaniles (twelfth century) separate these objects by as much as two centuries. However, none of them are securely dated by either inscriptions or archaeological evidence, and it is conceivable, given the similarity of their facial features and combs, that they were produced within a much shorter time span.

Not only the dates but also the provenances of the David ewer and the aquamaniles are uncertain. Arguments have been advanced to support attributions to Fāṭimid Egypt, Sicily, which was within the Fāṭimid sphere of influence, and Muslim Spain. It seems to this author, however, that the evidence of shared stylistic characteristics indicates that the David ewer and the peacock aquamaniles, as well as the Pisa griffin (No. 15), were probably produced in the same area. Their geometric, monumental qualities contrast with the generally more realistic aesthetic of objects of secure Fāṭimid provenance.[3] Thus, an attribution to Fāṭimid Egypt seems questionable. It is also unlikely that these pieces were produced in Sicily, since there are very few metal objects of known Sicilian provenance datable to the tenth, eleventh, and twelfth centuries, and those that do exist do not resemble the David ewer or the objects to which it is closely related.

For these reasons, and given its similarity to the vessel in the Museo Arqueológico Nacional, an attribution to Muslim Spain for the David ewer seems most acceptable. The marked stylistic affinities of the David ewer and the Pisa griffin with the aquamaniles also suggest, if not the same provenance for all four objects, at least that the ewer and the griffin strongly influenced the aquamaniles. Considered together and in contrast to examples of metalwork of Fāṭimid Egypt, these four pieces appear to constitute a coherent group that may have been produced in Muslim Spain.

CR

1. London 1976, p. 165, no. 167.
2. Paris 1989, no. 119, p. 148; Scerrato 1966, p. 81, no. 34.
3. For Fāṭimid metal animal sculpture, see Fehérvári 1976, pls. 9–11, nos. 29A, 30, 31, 33, 36; Scerrato 1966, pp. 72–73, no. 31.

LITERATURE: Sotheby's 1990, no. 104, pp. 38–39.

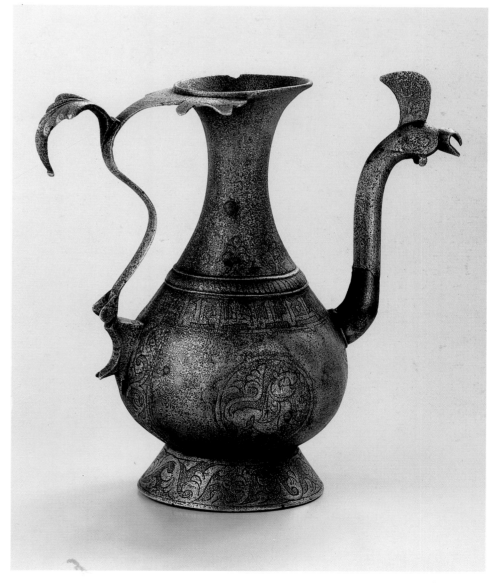

15

Pisa Griffin

Taifa period, 11th century
Bronze
H. 42⅛ in. (107 cm)
Museo dell'Opera del Duomo, Pisa

One of the most important and most problematic masterworks of the Islamic metal arts, the Pisa griffin has puzzled scholars for decades because of its size, unique character, and uncertain provenance. The conclusions of various scholars will be summarized here and a few comparisons will be offered that may, if they do not identify the griffin's provenance, at least clarify its connections to various regions of the Islamic world of the eleventh century.

This puzzling sculpture, which probably served as decoration for a fountain, has been attributed variously to Fāṭimid Egypt, Fāṭimid North Africa, Spain, Sicily, and Iran. The route the griffin traveled in order to reach its resting place atop the cathedral in Pisa is as mysterious as its place of origin. In 1839, in the first scholarly article published on the griffin, J. J. Marcel recorded

Pisans' ideas on the subject.[1] According to one of their legends, the Pisan armies had brought it home as booty when they returned from their conquest of the Balearic Islands.[2] It was said that the triumphant soldiers arrived in Pisa with their treasure at the moment the foundations of the cathedral were being laid. Another Pisan legend reported by Marcel asserts that the griffin was found miraculously when the cathedral foundations were dug. Whatever its origin, this impressive bronze was probably installed atop the cathedral during the late eleventh or early twelfth century; it remained in this place of honor until 1828.[3]

The griffin exhibits characteristics of many of the most important regional styles of its epoch —hence the confusion that surrounds its provenance. The earliest assignment of the sculpture

detail, left hindquarter

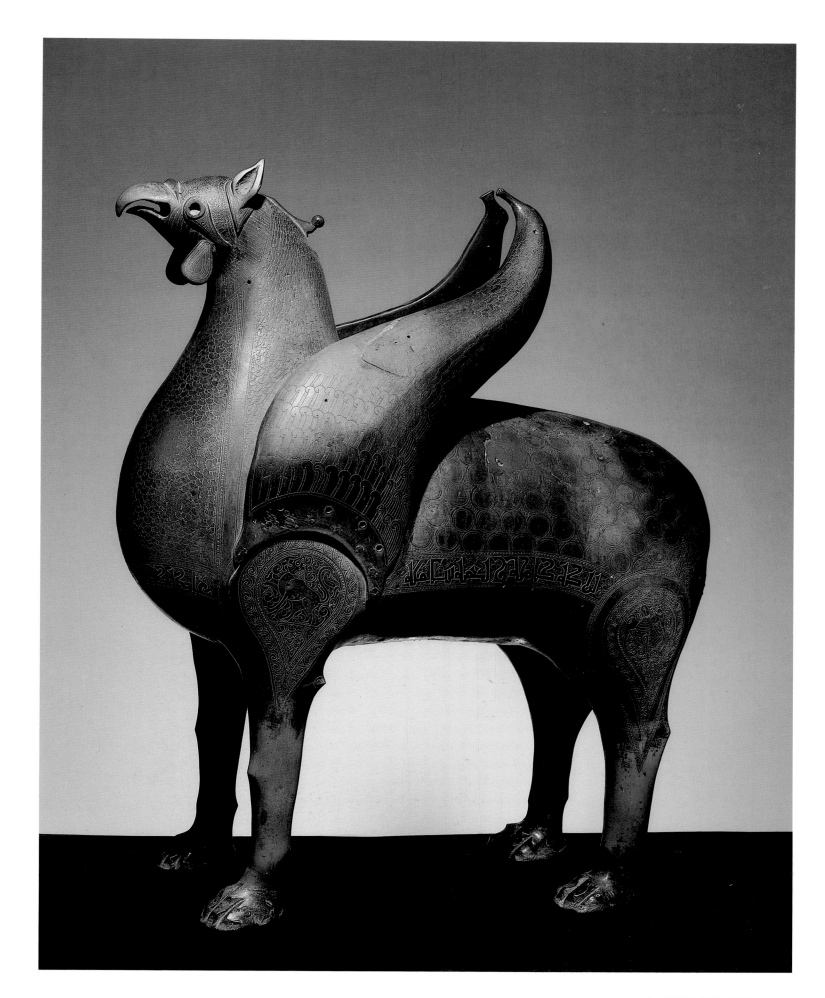

to Fāṭimid workshops was made by Gaston Migeon in 1927, at which time he similarly attributed a bronze stag now in the Bayerisches Nationalmuseum in Munich, the Córdoba stag (No. 10), a bronze goat in the Keir collection,[4] and other bronzes of extremely varied appearance. Migeon's conclusions are based entirely on stylistic evidence, much of which is disputable.

Marilyn Jenkins found citations in a Latin text of an inscription on the facade of the Pisa cathedral regarding the taking of a large bronze statue by Pisan soldiers campaigning in North Africa; because the inscription is cited as transcribed before 1175, Jenkins has suggested that the griffin might have been made under "the Fāṭimid aegis."[5] Although these citations argue strongly for Jenkins's position, it must be noted that no comparable pieces attributed to Fāṭimid North Africa or Egypt have been found.

Umberto Scerrato has argued reasonably, on the basis of style, against a Fāṭimid provenance for the griffin, attributing it instead to Islamic Spain. As Scerrato notes, its monumentality, rigid stance, and incised decoration related to textiles are obviously at variance with the realism of most Fāṭimid animal sculpture.[6]

The most striking features of the griffin are its monumental size and stiff posture, the rounded volumes of its body, wings, and legs, and the incised decoration that covers almost its entire surface. This decoration is divided into clearly distinguished zones of scale and of feather motifs and ornament that resembles tapestry. Bands of Kūfic inscription[7] border the tapestry-like decoration in the manner of a ṭirāz textile, and animals, both fantastic and real, surrounded by vegetal motifs occupy the teardrop-shaped hip areas of the beast.

These characteristics were used as evidence of the griffin's Iranian provenance by Melikian-Chirvani.[8] However, such features distinguish not only Iranian sculpture but also metal objects that have been attributed to Islamic Spain. The most famous of these pieces is the Córdoba stag, whose provenance is reasonably certain because it was found in the ruins of the Umayyad palace Madīnat al-Zahrā'. The stag's rigidity and its overall vegetal decoration that recalls textiles mark it as a likely predecessor of the griffin.

Arguably Spanish pieces of later date also exhibit features that relate them to the griffin. Among these are two bronze peacock aquamaniles, one now in the Louvre (1519), the other in the Pinacoteca Nazionale in Cagliari, that have been attributed to Spain and are generally dated to the twelfth century—although it is conceivable that they were produced in the eleventh century.[9] The aquamaniles and the griffin share overall ornament, rounded volumes, simple geometrical body forms, and an unmistakably similar rendering of eyes and beaks: Thus, a Spanish provenance, if possible for one, is possible for all.　　　C R

1. Marcel 1839, pp. 85–86.
2. Legends of this sort should not be disregarded entirely, as they may contain elements of truth. In the eleventh century the *Taifa* king of Denia ruled the Balearics, which had an important port with connections throughout the Mediterranean world. Thus, an object of Fāṭimid or another provenance could have been brought from the Balearics to Pisa. *Taifa* Spain's participation in the commercial, and thus, cultural, life of the Mediterranean makes understandable the confusion that surrounds the attribution of many portable objects, among them the Pisa griffin. In the caliphal period commercial and scholarly contact among the inhabitants of the Mediterranean area established a visual lingua franca with regional variations, which had roots in the Roman past. This language still existed in most of the Islamic world in the eleventh century. Therefore, although a Spanish provenance for the griffin seems likely, it is important to evaluate this object in the light of the affinities it exhibits with works from other Mediterranean regions.
3. Melikian-Chirvani 1968, pp. 68–69.
4. Migeon 1927, vol. 1, p. 376, fig. 183; Fehérvári 1976, p. 50, no. 30, pl. 9c.
5. Jenkins 1978.
6. Scerrato 1966, pp. 78–80, 83.
7. The inscription, which merely conveys good wishes to an unspecified owner, does not help to resolve the question of the griffin's provenance. It does, however, indicate that the sculpture was secular in nature. It reads as follows:

بركة كاملة ونعمة شاملة

(*Perfect blessing, complete well-being*) (left side)

غبطة كاملة وسلامة دائمة

(*Perfect joy, perpetual peace*) (chest)

عافية كاملة وسعادة

و[عمدة] لصاحبه

(*Perfect health, happiness [support] for the owner*) (right side)

8. Melikian-Chirvani 1968, pp. 71–76.
9. Scerrato 1966, pp. 80–81, no. 34; Paris 1989, no. 119, p. 148. No inscriptions or other evidence support the presumed Spanish provenance or the twelfth-century date.

LITERATURE: Migeon 1927, vol. 1, p. 374, fig. 182; Scerrato 1966, pp. 78–80, 83, fig. 33; Melikian-Chirvani 1968; Sourdel-Thomine and Spuler 1973, no. 194, p. 263; Fehérvári 1976, pp. 42–43; Jenkins 1978; Baer 1983.

16

Perfume Bottle

Taifa period, before 1044–by 1103
Silver
H. 6⅛ in. (15.6 cm)
Museo de Teruel
629

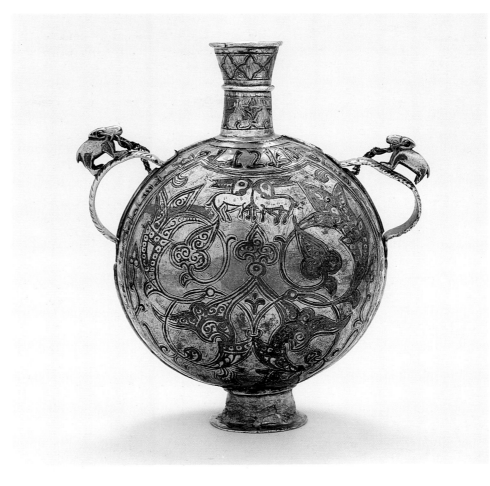

This small gold-washed silver perfume container is engraved and nielloed with sulfur of silver and lead, which colors the decoration black. It was commissioned by Muʾayyid al-Dawla (r. 1045–1103 [A.H. 437–97]), the second independent monarch of Albarracín as a gift for his wife, Zahr.[1] During the *Taifa* period, the title hajib signified a designated successor to the throne. Since Muʾayyid is called hajib in the inscription, it is possible that the bottle was commissioned before the death of his father, Hudayl ibn Razīn, in 1044/5 (A.H. 436). The location of the workshop that produced the bottle is uncertain. It may have been in Toledo,[2] which would mean that the container probably dates to before 1085, when the city was conquered by Christian armies.

Muʾayyid was a member of the Banū Razīn, a Berber family that settled in al-Andalus immediately after it was conquered. Both Muʾayyid and his father emulated the Cordobán court's splendor and its pursuit of high culture. Hudayl, for example, bought slaves from a celebrated Cordobán academy of music for his own court.[3]

The container's beauty and outstanding workmanship give us some idea of Albarracín's prosperity and the refinement of its court in the mid- to late eleventh century —which are striking in view of its politically and militarily insecure position as a *thagr*, or frontier, *Taifa*.

The decoration of the bottle calls to mind a number of *Taifa* prototypes. The circular disposition of vines and the outlines of the leaves resemble elements of contemporary architectural decoration, particularly that of the Aljafería palace in Saragossa. The gazelles near the bottle's neck and the peacocks at its foot are somewhat similar to the animals on the Palencia casket (No. 7), which was produced under Toledan patronage. Finally, the arabesques that fill the leaves show affinities with motifs on eleventh-century ceramics from Denia and with late tenth- and eleventh-century wooden decoration from Fāṭimid Egypt, which traded with al-Andalus during the *Taifa* period and later.[4]

It is noteworthy that the decoration of this bottle and that of a silver box generally presumed to have been made in Toledo (No. 13) are markedly dissimilar. If we suppose that the perfume bottle was also made in Toledo, this dissimilarity would allow us to posit the existence of two distinct metalworking enterprises in Toledo during the *Taifa* period. C R

1. The inscription reads:

بركة دائمة وأنعمة وغبطة باقية ودرجة
صاعدة وعز ورشد
وتوفيق وتسديد للسيدة العالية
زهر زوجة الحاجب مؤيد الدولة
عبد الملك بن خلف وفقه ا [لله]ـه

Perennial benediction, general well-being, continual prosperity, elevated position, honor, assistance, divine help, and good direction (toward the good and the equity) for the most excellent lady Zahr, wife of the hajib Muʾayyid al-Dawla ʿAbd al-Malik ibn Khalaf, may God assist him.

2. Almagro 1967, p. 11.
3. Ibid., pp. 11–12.
4. For ceramics, see Azuar Ruiz 1989, esp. pp. 94–95, pl. 14, fig. 33; for decorative motifs from Fāṭimid Egypt, see Pauty 1931, pls. XXXIV, 6878/I verso, XLII, XLIII.

LITERATURE: Bosch Vilá 1959; Almagro 1967.

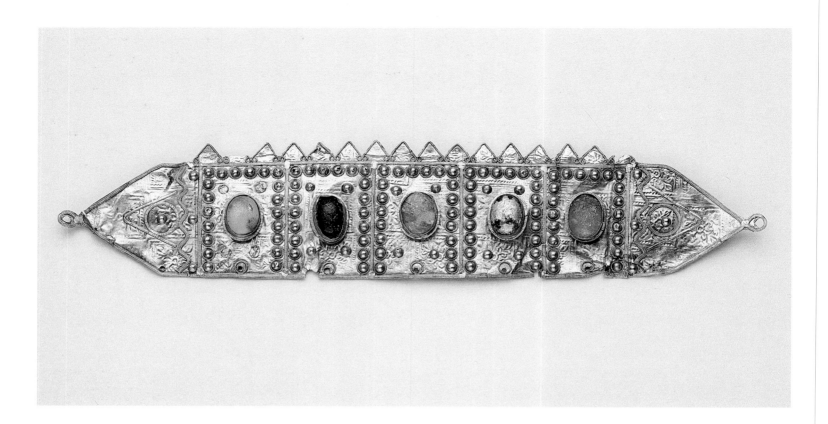

17

Diadem or Belt from the Charrilla Hoard

Caliphal period, 10th century
Gold and stones
1⅞ x 8½ in. (4.6 x 21.6 cm)
Museo Provincial de Jaén
2789

*A*l-Andalus has yielded relatively little jewelry, a fact that Pedro María de Artiñano pointed out in 1925.[1] The find in Charrilla, in the province of Jaén, presents an interesting combination of jewelry, including *bractae*, pendants, rings, and other items. The coins in the same find date the jewelry between 944 and 947 (A.H. 333–36).

This example was probably designed as a diadem, although it may well be a belt: Compare it, for example, to the four belt pieces in the Museum für Islamische Kunst in Berlin (No. 71). It is articulated in seven parts, two of which are intentionally distal, or end, pieces. The distal elements are pentagonal in form and have soldered rings on their ends through which a sash could be passed. In turn the distal elements flank five rectangular plaques garnished in the center with a cabochon of vitreous paste. The upper borders of the plaques are edged with triangles. The plaques, made of metal plates, are hollow. These metal plates are simple, counterpoised, and folded at the edges, which are soldered.

A variety of techniques, occupying specific areas, was employed in the decoration of this piece. Repoussage was used to create a vegetal band on the sides leading up to the apex of the triangular ends of the distal elements as well as on the small triangles of the upper borders of the plaques. The motif of lotus flowers with upward-pointing tips embellishes these zones. Simple rolled filaments frame the vegetal ornament of the distal triangles; double-torso flattened filaments form circles in their centers. An undulate band of double-torso flattened filaments marks the separation between the distal elements and the five central plaques. Inside the circles and three curves of the undulate bands are stamped and soldered annulets, which also frame three sides of the rectangular plaques. Four more surround the cabochon in each plaque. In the lower central portion of each rectangular plaque is a circle made with simple-torso filament. Each circle has a small opening in the center. JZ

1. Artiñano 1925, p. 53.

Among the objects that came to light in Lorca in the last century were these earrings. The hoard at Lorca constitutes one of the most important, original, and complete finds known and includes coins that permit a dating of its material to the first third of the eleventh century. The earrings are outstanding for their originality. They were constructed on a hoop base on which five spheres of gold were mounted. Soldered to the central sphere are two quadrangular plaques arranged so their apexes are on a vertical and horizontal axis—that is, in a diamond shape. Between them hangs a tiny third of a sphere soldered in the center and open to the outside. From its lower portion, another third of a sphere with a small complete sphere in its center projects downward, giving it the appearance of the corolla of a flower. The two spheres at either side of the central sphere each have four gently curving disks, each of which has a raised edge and a small circle soldered in the center.

No similar examples have yet been found in al-Andalus, where earrings tended to adhere to the Fāṭimid model. To judge by the quadrilateral elements that are established by means of rhombuses with circular cabochons, these earrings have more in common with the Roman and Visigothic traditions. 　　　J Z

Literature: Gómez-Moreno 1951, pp. 338–41.

18

Pair of Earrings

Taifa period, 1st third of 11th century
Gold
L. 1⅝, 1¼ in. (4.1, 4.4 cm)
Trustees of the Victoria and Albert Museum, London
1447–1870, 1447a–1870

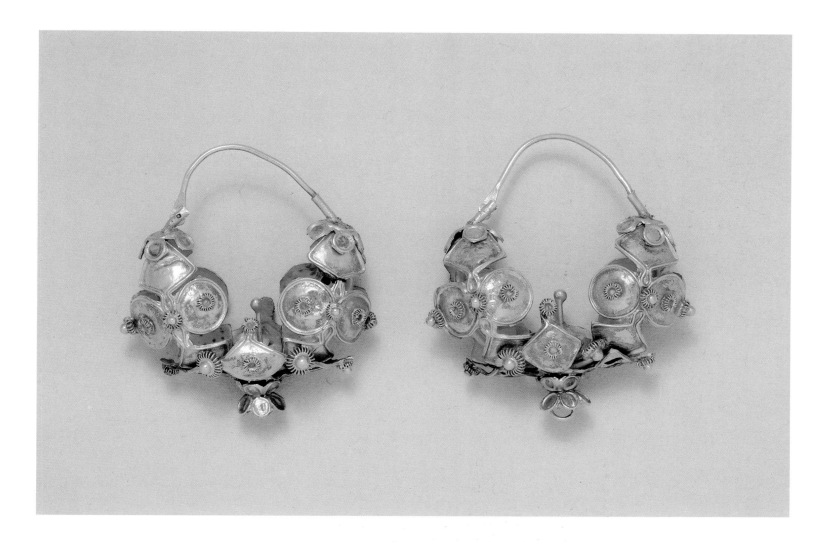

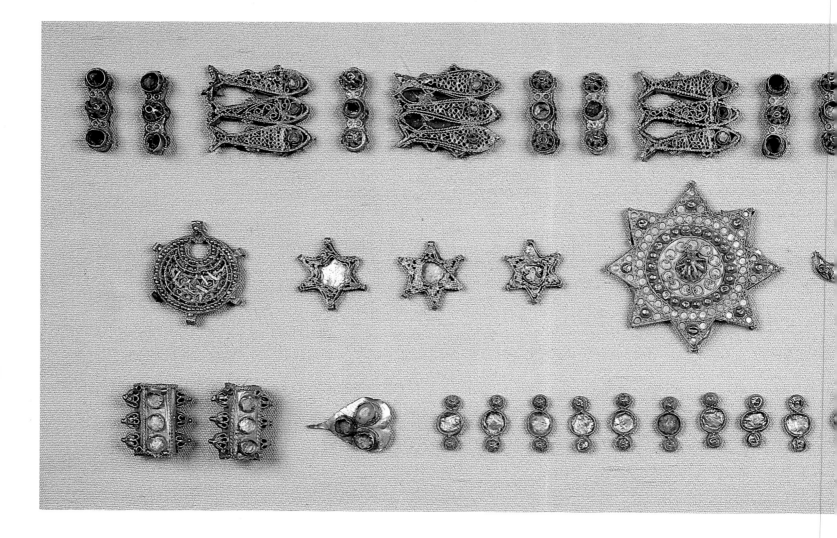

19

Jewelry Elements

Taifa period, late 10th–early 11th century
Gold, stones, and traces of enamel
w. ½ in. (1.3 cm)–2⅛ in. (5.2 cm)
The Walters Art Gallery, Baltimore
57.1596

This group is one of the most spectacular jewelry finds of al-Andalus, clearly its place of origin, judging by its affinities with pieces from such other hoards as Lorca or Charrilla. The group dates from the end of the tenth century or the beginning of the eleventh, which is consonant with the known date for the Charrilla and Lorca (see Nos. 17, 18) hoards and is associated with the Fāṭimid systems.[1]

Among the noteworthy elements of adornment are a series of seven *bractae* in the form of stars, all in varying states of preservation. Four of them finish in six points and have a circular cabochon, seeming to make up one group; two, each having a starred cabochon, appear to belong to another group; the seventh and the largest takes the form of an eight-pointed star, with semispheres marking the points and forming a circle around a central striated semisphere. One *bractea* shows remains of enamel in the form of a bird.[2] Each of two other pieces—circular pendants with pendant hooks at the edges—is embellished with a crescent in its interior. A small element in the form of a half-moon with enamels was possibly intended for mounting on earrings or on a larger element that has been lost.[3]

The other objects in the hoard, a belt and a diadem, are perhaps the most extraordinary examples of jewelry from al-Andalus that survive. The belt is composed of a notable series of pieces with diverse formal characteristics. There

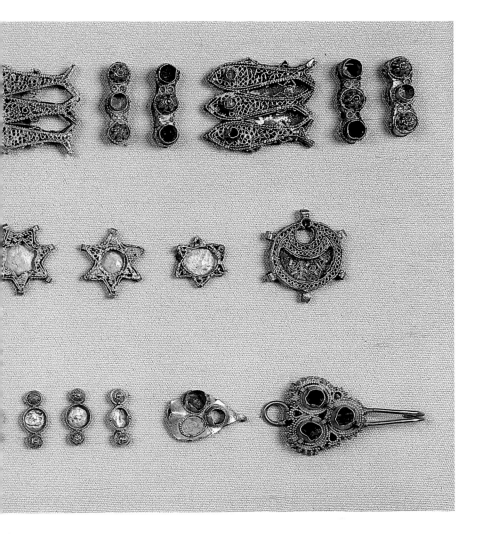

are eleven small units, each made up of three lobules studded with vertically arranged cabochons. Five more elements consist of groups of three fish, some with brass eyes, swimming in the same direction. Finally, there is a buckle with a trilobular part that carries cabochons and a hook for tightening the belt.

The diadem is also composed of trilobular elements: Fourteen of them are made up of two units flanking a larger one with a central cabochon. The smaller lateral elements end in striated half-spheres. The diadem ends in two leaves having three cabochons on their upper surfaces.

In addition, there are two beads with cup-shaped cavities on each side except one, which has three small cabochons. It is not known if these beads formed part of the belt or the diadem, since jewelry from al-Andalus is characterized by interchangeable elements, as hoards from Bentarique and Mondujar exemplify.

In all these elements, the basic decorative techniques used are filigree and granulation. Vermiculate work in the interior of the fish is complemented with stones or vitreous paste, as, for example, in the eyes. J Z

1. Ross 1940, pp. 166–67.
2. González 1990, p. 196, fig. 201.
3. Ibid., fig. 200.

LITERATURE: Ross 1940, pp. 166–67, figs. 2–4; Gómez-Moreno 1951, pp. 338–41, fig. 401; González 1990.

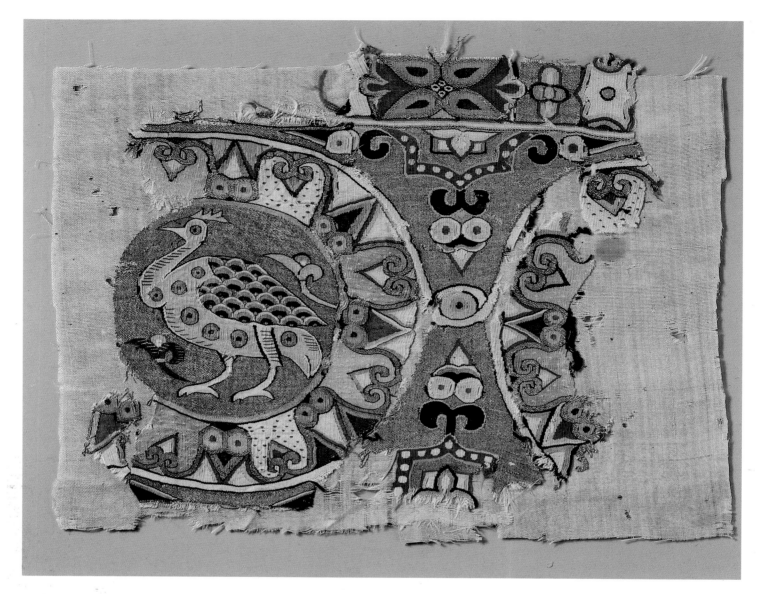

20

Textile Fragment

Caliphal period, 10th century
Silk and gold thread
7½ x 9 in. (19 x 23 cm)
Instituto de Valencia de Don Juan,
Madrid
2071

Discovered in a church in the Pyrenees Mountains, this fragment has traditionally been thought to be part of a Muslim *almaizar*, or headdress. However, recent analysis leads us to suggest that it is an ornamental strip of textile that served as trim for a different piece of cloth, perhaps a tapestry panel such as that belonging to Don Arnaldo de Gurb, bishop of Barcelona from 1252 to 1284 (A.H. 650–83).[1]

The strip consisted of linked medallions, of which one has survived nearly intact, along with part of the border of the next medallion. A peacock, in profile and outlined in white and blue on a gold background, occupies the center of the medallion; feathers are simulated by small gold disks and wings by imbrications in two tones of blue silk. The circular band is decorated with flowers set alternately blossom to stem, as seen on bases of columns in Madīnat al-Zahrāʾ. The interstices are filled with pearl

ribbons that form half of an eight-pointed star and with typical caliphal motifs. Of the two borders that would have framed the medallions, only a fragment of the upper band is preserved; that fragment features a four-petaled flower.

The composition shows the clear influence of Sasanian weavings and also that of contemporary Cordobán ivories. This is the most perfect example we have of the technique of regularly packed silk twist perpendicular to the warp; that technique, combined with the liberal use of gold thread, the range of white, crimson red, marine and sky blue, straw yellow, and olive green silks, as well as the beautiful design, make this weaving the masterpiece of the caliphal textile industry, worthy of the royal *ṭirāz* in Córdoba. Magnificent tapestries similar to this fragmentary one are mentioned in the *Anales Palatinos* (971 [A.H. 360]) of al-Ḥakam II. They were used to decorate royal estates and the throne

room of the caliphal alcazar and Madīnat al-Zahra³.

C P

1. Examining Dorothy Shepherd's hypothetical reconstruction of the tapestry panel formed of pieces employed in Bishop Gurb's burial in the Santa Lucía chapel of the cathedral in Barcelona (1978, pp. 111–34), we can see similarities between this Pyrenees band and strips that may have decorated the upper and lower borders of the Gurb tapestry: medallions with peacocks and four-legged animals, in profile, enclosed by upper and lower borders with stylized floral decoration and pearl ribbons.

LITERATURE: Torres Balbás 1949, p. 786; Gómez-Moreno 1951, p. 347, fig. 404 C; Bernis 1954, pp. 204–5, pl. VIII; May 1957, p. 18, fig. 7; Shepherd 1978, pp. 111–34, figs. 8, 9, 10; Partearroyo 1982, p. 354, fig. 249.

*T*his decorative strip of woven tapestry was wrapped around a reliquary found in 1853 in the church of Santa María del Rivero of San Esteban de Gormaz in Soria. It may have been one of the ends of the *almaizar* belonging to the caliph of Córdoba Hishām II (r. 976–1013 [A.H. 366–404]). The *almaizar*[1] was a long band of extremely fine plain weave with compound tabby, which served as a veil, or headdress; it was wrapped like a turban and fell loosely to the arms. In this example, the ends are decorated with bands of patterned tapestry weave finished with fringe. *Almaizars* like that worn by the horseman in a miniature in the Mozarabic manuscript of the Beatus of Gerona (975 [A.H. 364]) can be found in Sasanian art as well.

The decoration is divided into three horizontal bands. The central band is black decorated with thirteen octagonal medallions, two of which contain very stylized human figures. According to one hypothesis, these figures may be those of Hishām himself and his mother, Princess Subeya, who governed during his minority.[2] In the remaining medallions are quadrupeds and birds, very similar to those in Coptic designs. Alternating with the medallions are stylized vegetal

21

Veil of Hishām II

Caliphal period, 976–1013
Silk, linen, and gold thread
7⅛ x 43 in. (18 x 109 cm)
Real Academia de la Historia, Madrid
292

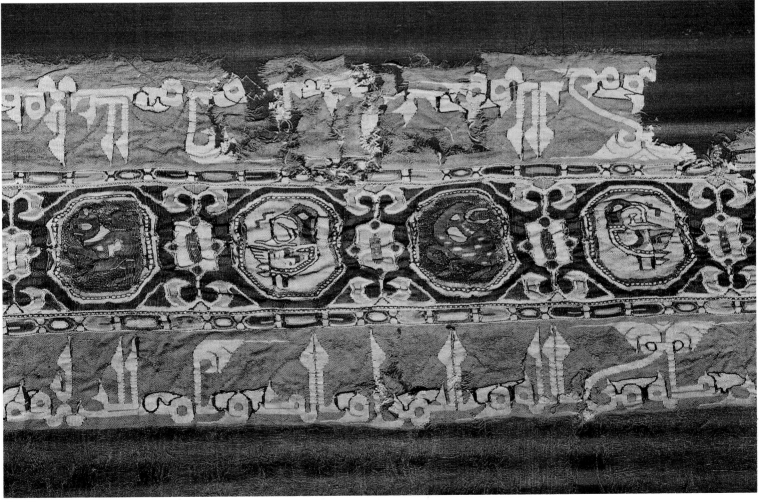

detail

elements typical of the Cordobán caliphate, such as triangular leaves divided by their axis and quatrefoil leaves contained within a rectangle. The background of some medallions and a number of the floral themes are worked in gold thread, and the silks are white, sky blue, straw, yellow, mauve, and bright green outlined in black.

On each side of the central band are two strips of beading. The two outer bands are designed with a Kūfic inscription reading, in white letters on a beige background:

> In the name of a compassionate and merciful God, the blessing of God, and prosperity and long life for the caliph, the Imam ʿAbdallah Hishām, favored of God and Prince of Believers.[3]

The tips of the letters, especially the alif, or first letter, terminate in half-palmettes; this ornamentation is typical of Hispano-Kūfic lettering, as can be seen in the mihrab of the Great Mosque at Córdoba and in contemporaneous ivories.

The left selvedge is preserved and is decorated in the center with parallel colored lines. The tapestry weave is loose, with some weft threads oblique to the warp. The *almaizar* of Hishām II may have been woven in compliance with one of the measures enacted by the unpopular son of al-Manṣūr, ʿAbd al-Raḥmān Sanchuelo, in 1009 (A.H. 399), in which he compelled government dignitaries and functionaries to wear Berber-style turbans in his palace at Madīnat al-Zāhira.[4] However, according to the seventeenth-century historian al-Maqqarī,[5] these *ṭirāz* bands with inscriptions must already have been plentiful during the time of ʿAbd al-Raḥmān's father, al-Manṣūr (r. 976–1002 [A.H. 366–93]), who held power during the greater part of the reign of Hishām II. Fortunately, there can be no doubt that this is one of the Cordobán *ṭirāz* bands produced in the royal workshops that Ibn Khaldūn describes so clearly.[6]

C P

1. Dozy 1845, p. 46.
2. Fernández y González 1875b, vol. 6, pp. 463–75.
3. Archivo R.A.H., file 109.
4. Arié 1982, p. 26.
5. al-Maqqari 1855–61, vol. 2, p. 258; Serjeant 1972, p. 169, notes 14 and 15.
6. Ibn Khaldūn 1967.

LITERATURE: Artiñano [1917], no. 43, pl. 1; Grohmann 1938, pp. 266–68; Bernis 1954, pp. 189–211; May 1957, pp. 14, 17, figs. 3, 4; García Gómez 1970, p. 44; Partearroyo 1982, p. 353.

22

Textile Fragment

Taifa period, 11th century
Silk and gold thread
20⅜ x 23⅛ in. (51.8 x 58.5 cm)
Museo Episcopal y Capitular de
Arqueologia Sagrada, Huesca

The astonishing discovery in 1978 of this weaving in the Colls church in Puente de Montañana in Huesca[1] provides us with a textile that is similar, both in technique and ornamentation, to the *almaizar* or *ṭirāz* of Hishām II (No. 21).

This fragment of plain weave with compound tabby and tapestry weave decoration has a design displayed in three horizontal bands. The central band consists of four complete lozenges and a fifth, partial one that contains the figure of a peacock with back-turned head. Each of the four complete lozenges encloses a central quatrefoil flower surrounded with small lozenges, stylized palmettes, or small budlike decorative motifs. In the interstices are small medallions enhanced with crosses and schematic flowers. Bordering this band are two narrow edgings or beadings. On either side of the central band, symmetrically disposed, is an inscription in Kūfic characters, quoting the *basmala*: *In the Name of God, the Merciful, the Compassionate*.[2] The colors of this fragment are ivory, dark and olive green, yellow, indigo and sky blue, and red with gold thread.

The technique is identical to that of the *almaizar* of Hishām II; here, however, the background silk is more dense and the decoration is the same on both sides, which was the traditional weaving technique for standards—a feature that leads us to believe the fragment did indeed come from a standard. Like the *almaizar*, this piece has a selvedge with small parallel multicolored stripes at the edge. The weft is sometimes oblique to the warp. The influence of Fāṭimid and also Egyptian Islamic weavings in the Coptic tradition is evident, as it is in the *ṭirāz* of Hishām II. On the other hand, in the decoration of the lozenges we see a rather close similarity to ʿAbbāsid weavings and embroideries, especially a ninth-century embroidery in The Cleveland Museum of Art with a network of lozenges.[3]

Is the Colls *ṭirāz*, in fact, a standard? We cannot be certain, although standards and banners are mentioned frequently in the

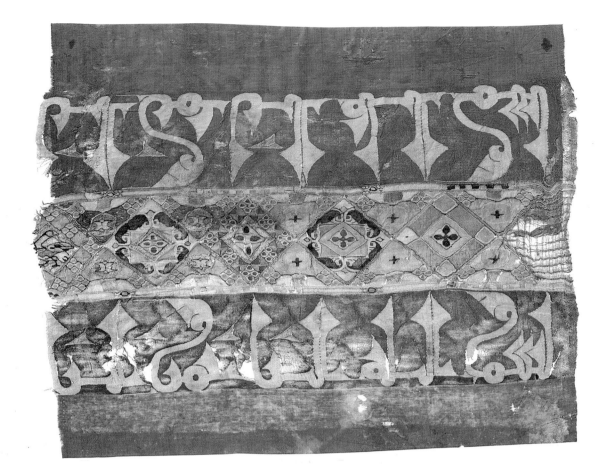

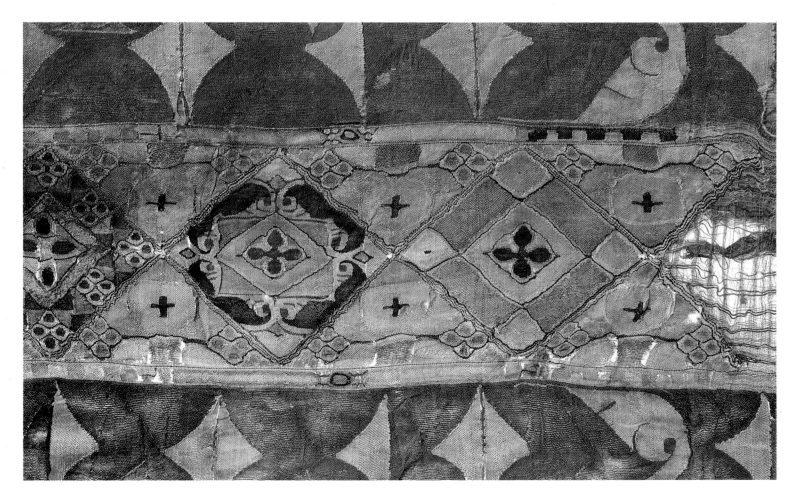

tenth-century *Anales Palatinos* of al-Ḥakam II.[4] We can be sure only that in Muslim Spain there was a tradition of weaving banners in tapestry workshops, and that such banners were portrayed in miniatures in the *Cantigas de Santa María* of Alfonso X, the Learned, in the thirteenth century, and in paintings in the Partal palace of the Alhambra at the beginning of the fourteenth century. In the cathedral at Toledo are banners that were carried by Abū Saʿīd and Abūʾl Ḥasan in the Battle of Salado in 1340 (A.H. 741). These banners, made in Fez, follow the tradition of Hispano-Islamic tapestry making.[5]

C P

1. The weaving was wrapped around a wooden box that had been placed under the communion table at the altar of a small thirteenth-century church in Colls; it was half hidden and in ruins for many years.
2. Translation of Muḥammad Yūsuf, University of Cairo, a specialist in Mudejar and Hispano-Islamic epigraphy.
3. Kühnel 1957, p. 368, fig. 12.
4. García Gómez 1967a, pp. 163–79.
5. Amador de los Ríos 1893.

LITERATURE: Bernis 1954, pp. 189–211, pls. XII, XIII; Bernis 1956a, pp. 112–13, pls. XII–XIV; García Guatas and Esteban 1986, pp. 29–34; Esco, Giralt, and Sénac 1988, p. 171, no. 133; Partearroyo Lacaba 1991, pp. 118, 155, no. 84.

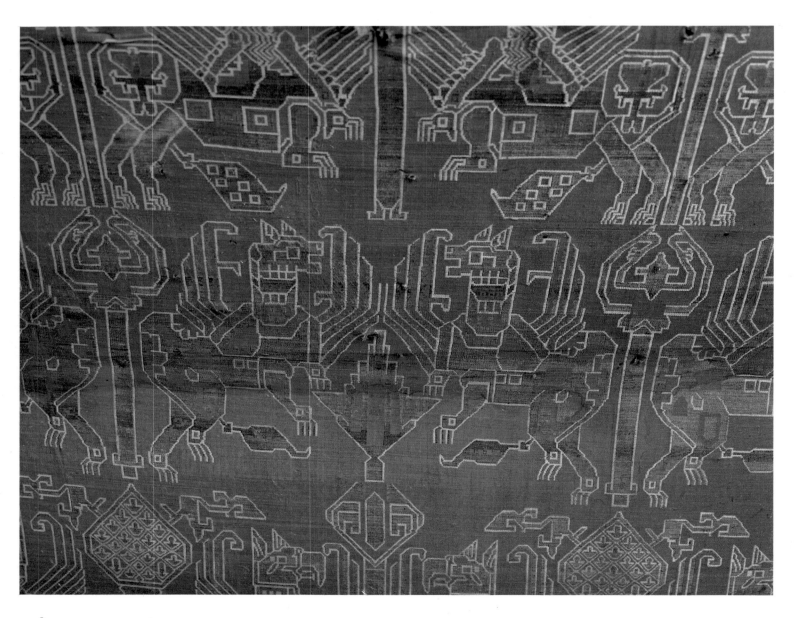

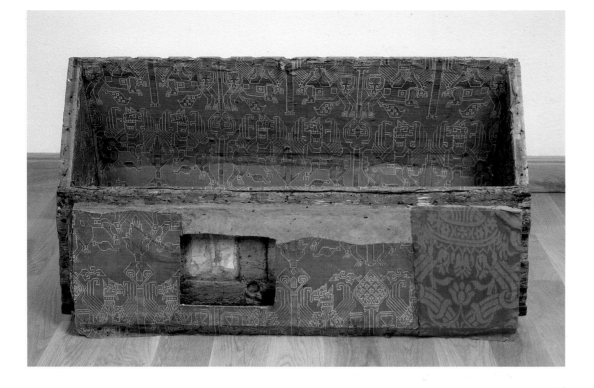

This textile served as a lining for the reliquary of San Millán, a precious wooden casket covered with gold and ivory plaques showing scenes from the life of the saint. Although San Millán died in 574, the coffer that was to hold his relics was not fashioned until 1067 (A.H. 460), according to a Benedictine chronicler.[1] This information is vital in determining the date of the textile.

The silk is crimson with ornamental themes in green outlined with yellow. Pairs of griffins and winged lions confronted on either side of a central axis simulating the tree of life are disposed in alternating, horizontal friezes. In the upper frieze are griffins framed by treelike forms topped with palmettes of differing design. Each beast displays ribbons of pearling around the neck and along both sides of the body, from which spring wings formed by strokes or parallel broken lines. On the body are red squared edges with yellow flecks or spots. One very original detail is the rhomboidal tail with six prominent spots. The lower frieze features confronted winged lions separated by smaller trees than those on the frieze above. In contrast to the griffins' necklaces of pearling, an ornamentation of small squares adorns the necks of these beasts. The spots on the body are irregular. The overall design is geometric and very schematic. The theme of fabled winged beasts originated in ancient Persia. Models were copied from eastern textiles and manufactured in the workshops of Almería and had already appeared, with eastern names, in Christian inventories of the eleventh century.

Based on the technique (worked samite of dark green and yellow on a red ground) and the decoration (beasts disposed in horizontal friezes), this silk exhibits a marked similarity to textiles such as the Witches Pallium (No. 24) in the Museu Episcopal de Vic and the Winged Lion in the Rijksmuseum in Amsterdam.　　C P

1. Peña 1978.

LITERATURE: May 1957, p. 47, fig. 32; Uranga Galdiano and Iñíguez Almech 1971, vol. 1, p. 268, pl. 17; Serjeant 1972, p. 169, n.19; Peña 1978; Hermosilla 1983; Martin i Ros 1987, pp. 399–402; Burgos 1990; Partearroyo Lacaba 1991, addendum to catalogue.

23

Lining of the Reliquary of San Millán

Taifa period, before 1067
Silk
23⅜ x 41 x 13 in. (59.5 x 104 x 33 cm)
Monasterio de Yuso- PP Agustinos Recoletos, Logroño

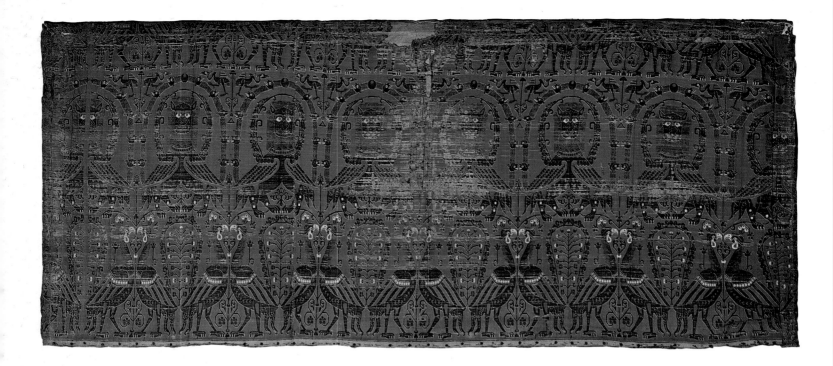

24

Antependium: The Witches Pallium

Taifa period, 11th century
Silk
39¾ x 91⅜ in. (101 x 232 cm)
Museu Episcopal de Vic, Barcelona
557

†

Decoration unfolds in three horizontal friezes on this altar frontal from the Monasterio de San Juan de las Abadesas. In the middle frieze are fantastic animals that traditionally have been called witches. They are half-sphinx, half-harpy(?), composites of lions and eagles. From the upper band of the wings of each symbolic animal springs an orle of palmettes and profiled scrolls surrounding the head. From the tips of the feathers, there originates a second orle, composed of serpents with feline heads, their tongues protruding.

In the lower frieze and in a portion of the upper one are pairs of confronted peacocks; between each pair is a stylized palmette representing the *hom*, or tree of life. From the wing tips of the peacocks spring orles of schematized vegetal elements, each enclosing a stylized tree that serves as an axis for the composition. At the top of the orle of serpents, on either side, is a wading bird in the act of treading upon or attacking the serpents. This bird occupies the interstices between the serpents and the upper frieze.[1] The lions and peacocks wear collars of pearling; feathers are indicated by parallel lines. The background of the frontal is crimson; the ornamentation of the animals and other motifs is blackish green with yellow outlines and details in white.

The technique and the colors are typical of Hispano-Islamic weavings. The iconography, however, has an eastern flavor, with roots in Mesopotamia and Persia. Its symbolism must

have found wide acceptance in the Romanesque world, specifically in Catalonia, where this unique piece served as an altar frontal and as a model for Romanesque capitals in nearby monasteries.

Because of the particularity and uniqueness of the textile in its unique convergence of influences, it is difficult to confirm its attribution to Hispano-Islamic workshops. However, when we compare it to examples similar in color and technique and with animals disposed in friezes, such as the lining of the reliquary of San Millán (No. 23), which was loomed before 1067, we are inclined to date it to about the same time. We should also remember that the workshops of al-Andalus produced imitations of eastern models, among them cloth classified as Iṣfahānī and Jurjānī, which appeared in Christian inventories of the eleventh century.

C P

1. Eva Baer characterizes the sphinxes as follows: ''The creature's tail ... terminates in a plant element, a flower, a tassel, a peacock tail or a snake's or dragon's head which often appears to grasp or attack the creature's wings'' (1965, p. 1). Rosa M. Martin i Ros, on the other hand, maintains that the long-legged bird is an ibis, and this theory fits in well with the iconographic program: The ancient Egyptians venerated this bird because it ate the reptiles that infested the land where they were swept up on the banks of the Nile in the periodic flooding of the river. Therefore, we can look for a symbolism involving guardian sphinxes spared from attack by ibis that ate the predatory serpents (1986, pp. 390–402).

LITERATURE: Baer 1965; Rice 1965, pp. 155–56, fig. 155; Partearroyo 1982, p. 356; Martin i Ros 1986, pp. 399–402.

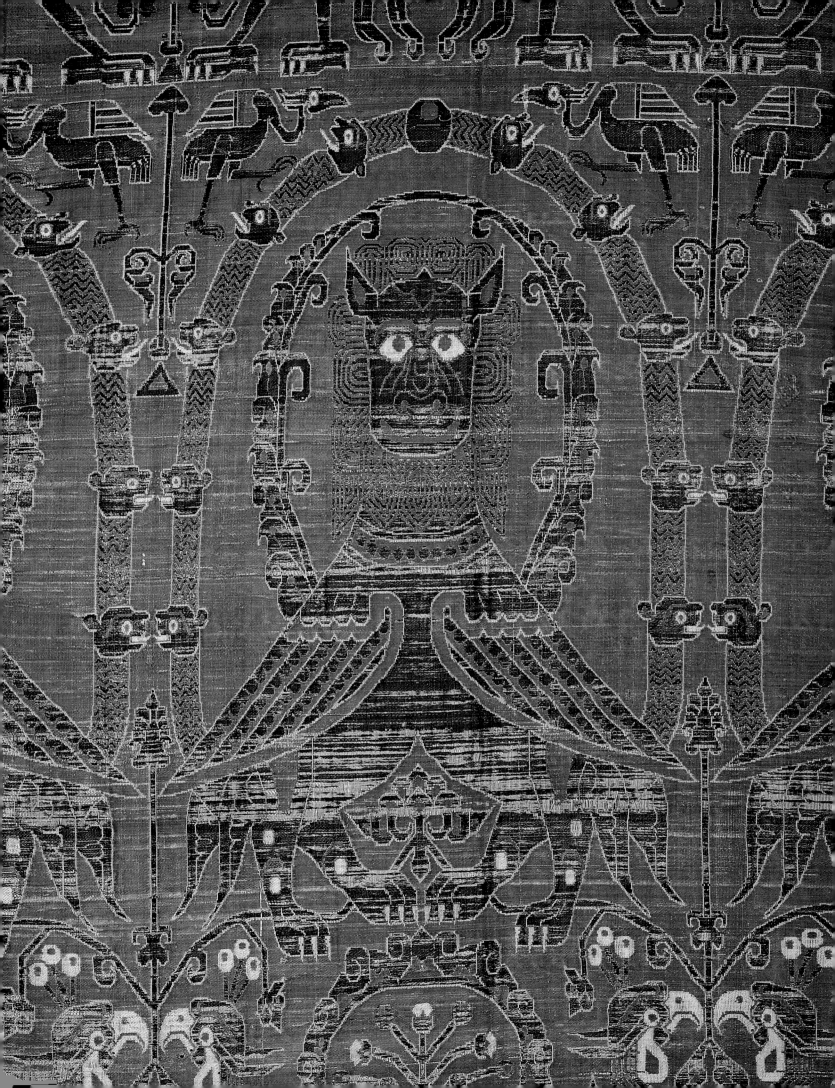

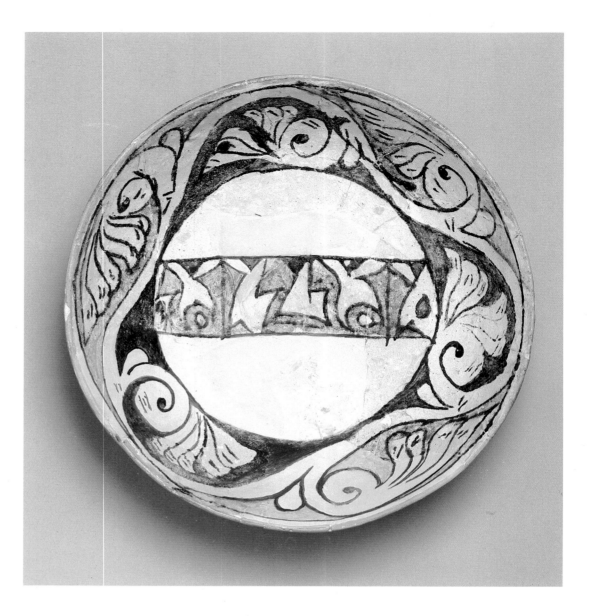

25

Bowl

Caliphal period, 10th century
Glazed and painted green and manganese
earthenware with luster
Diam. 10¼ in. (26 cm)
Museo Arqueológico Nacional, Madrid
63.043

A honey-colored overglaze with greenish yellow overtones covers this *ataifor*, or shallow bowl, which was found at Madīnat al-Zahrāʾ. It has a convex base, rounded walls, and flat edge and is made of a reddish clay containing traces of quartz and gneiss. The inner face bears a decoration in green and manganese on a white ground, constituting a peripheral ring that encloses a diametrical band.

The decorative inscription repeats the word الملك (*al-mulk*, kingship or dominion) in Kūfic script. The style of the script is quite simple, as is appropriate to an early phase in the palatine ceramic production of Madīnat al-Zahrāʾ. The letters are outlined in manganese and filled in with green, so that they stand out against the white background. The circular zone shows white palmettes arranged in groups of three, which contrast with the alternating areas of dark manganese and coppery green.

The contrast of colors, so common in the decoration of the time, contributes to a sense of trilobate organization, which also characterizes the design of other examples from the period. Because of the script, we may regard this piece as belonging to an early period, prior to the reign of Al-Ḥakam II, before Foliated Kūfic became popular.

The fact that the vivid combination of white, green, and black appears often suggests that these colors are symbols: white for the Umayyads, green for Islam, and black for the Prophet. The use of the inscription *al-mulk* reminds us that patronage of fine objects was closely related to issues of power and authority in the caliphate.

G R B

LITERATURE: Camps Cazorla 1947, pp. 148–54; Pavón Maldonado 1981, pp. 115–25; Zozaya 1981b, p. 43; Barceló Perello forthcoming a.

26

Bottle

Caliphal period, 10th century
Glazed and painted green and manganese
earthenware with luster
H. 9⅝ in. (24.5 cm)
Museo Arqueológico Provincial de Córdoba
11.282

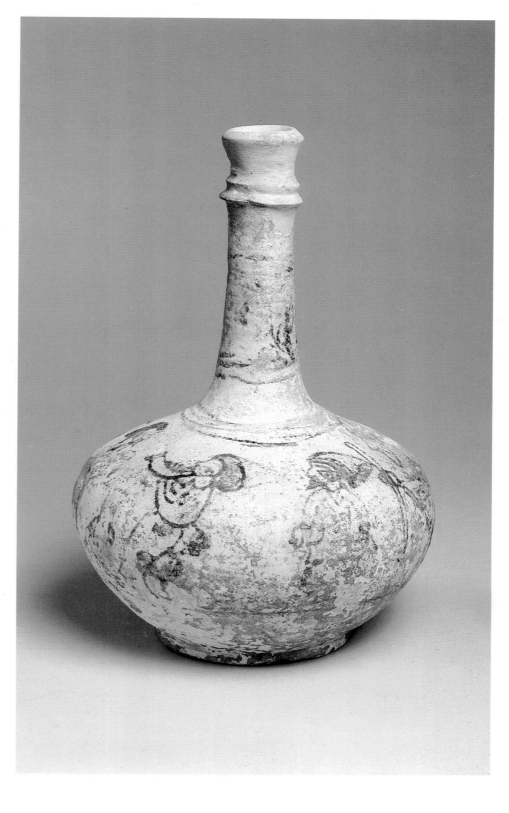

This is a bottle, or *limeta* (from the Arabic *limma*), with a rounded belly on a ringed base and a long, narrow neck that is constricted at the top. It was discovered in Córdoba. Like a bottle with hares found in Ilbira (ancient Elvira), it is unquestionably from the caliphal era.

The embellishment, roughly drawn in manganese on the neck and body, is badly deteriorated, as is the greenish white glaze, which has fallen away in places to reveal a light red fabric similar to the clay that comes from Madīnat al-Zahrāʾ. The central decorative theme is a horizontal row of male figures, most of them bearded, who are looking at an indistinguishable element, which Samuel de los Santos Jener believes to be an animal —perhaps a goat.[1]

The clearest figure, on the left, is a musician playing a horn. He has a beard, wears no turban, and seems to be walking. Opposite him is another bearded and bare-headed man, obscured in the area where the glaze has flaked away. He holds a round object, possibly a tambourine. Behind the first figure sits a bearded man who wears an elegant conical turban and watches the musicians. At his side a fourth man, also bearded and turbaned, holds a long staff bearing a diagonal element. Is he perhaps a chamberlain or bodyguard? A beardless figure with arms outstretched crouches behind the musician with the round instrument. There is a black cross-shaped object above his head. He may be a rope dancer.

Human figures appeared on the pottery of al-Andalus from caliphal times. They have been found on fragments of lusterware and in individualized figures, such as a representation of a drinker on a bowl from Benetússer now in the Museo Nacional de Cerámica "Gonzáles Marti" in Valencia. A recreational scene such as the present one, possibly representing people watching an entertainer, is rather unusual. However, it recalls scenes on caliphal ivory caskets that suggest princely and aristocratic pastimes. GRB

1. Santos Jener 1952, pp. 401–2, pls. 25, 26.

LITERATURE: Santos Jener 1952; Madrid 1966, p. 97, no. 347; Llubiá 1973, pp. 82–110; Córdoba 1986a, p. 97, no. 8.

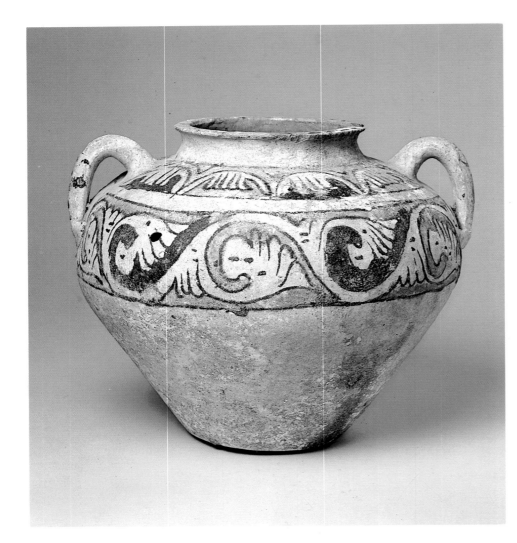

east, had many variants in Hispano-Muslim decoration: for example, a simple palmette in the form of a leaf with undulating stalks, a floriated palmette, and, ultimately, a digitated palmette that enjoyed popularity from the eleventh century. G R B

1. Pavón Maldonado 1981, pp. 111–25.

LITERATURE: Madrid 1966, p. 96, no. 340; Pavón Maldonado 1972, pp. 194–227; Llubiá 1973, p. 44; Pavón Maldonado 1981, pp. 111–25.

28

Bowl

Caliphal period, 2nd half of 10th century
Glazed and painted green and manganese
earthenware with copper sulfite
Diam. 13⅞ in. (35 cm)
Museo Arqueológico de Granada
855

*T*his bowl was found during a systematic excavation of Madīnat Ilbira (Granada). It has a flat base, a continuous profile with the sides joined to the base in a smooth curve, and a straight, uniform rim. The piece is worked in clay that is light brown on the surface and slightly redder in the fabric. The clay is not very fine grained but is well sifted, with small impurities in the paste. Tin glaze with copper sulfite that is slightly yellowed by iron impurities but adheres well covers the exterior. The interior has a lead glaze with a small amount of tin. The glaze is applied unequally, with very slight cracking in some areas, and is not well adhered. In the interior is a painted decoration of copper green and manganese black; the black serves both as outline and as filler; the green is used only for the outline.

The decoration consists of a harnessed and saddled horse. Its long mane falls in strands, and the hair of the tail is tightly bound from the base and knotted toward the tip, ending in three sections. One raised front hoof gives the sensation of forward movement. A bird with outspread wings stands on the saddle holding the reins in its beak. A palmette is depicted beside the horse, and a three-petaled flower is below its belly. An uninterrupted band of scallops circles

27

Jar

Caliphal period, 10th century
Glazed and painted green and manganese
earthenware or terracotta with luster
H. 8⅛ in. (20.7 cm)
Museo Arqueológico Provincial
de Córdoba
24.216

A narrow, flaring neck and small handles characterize this typical round-bellied pot resting on a flat bottom, which was found at an unspecified site in Córdoba. A very thin tin glaze reveals the reddish color of the clay. Two encircling bands, each bearing frets of white palmettes on an alternately green and manganese background, make up the decoration. The upper, narrower band is in two sections, the spaces between which are occupied by the tops of the handles. The pattern of motifs and colors in the lower band is the reverse of that in the upper band, creating an intriguing figure-ground relationship.

Although it is very common in tenth-century Cordobán ceramics, this shape of pot is rare in later periods. The present example has not been published until now; however, objects of similar shape and decorative theme have been described by Basilio Pavón Maldonado, who points out that the palmette is one of the most frequently used vegetal designs in caliphal decoration.[1] This motif, which originated in the

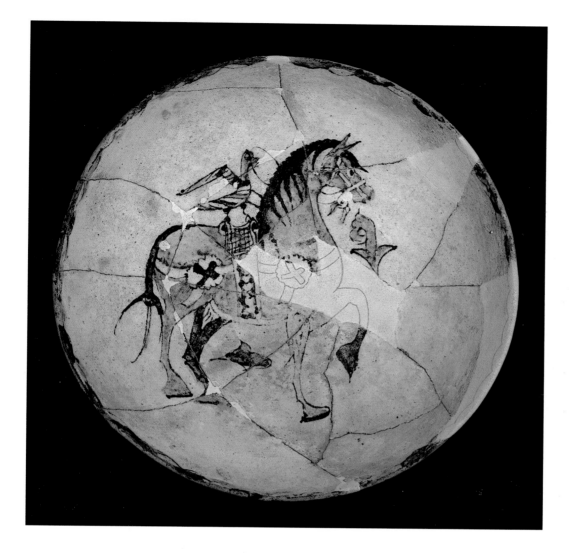

the rim, which is black with touches of green. The scallops are loosely drawn and in places overlap one another.

The figure of the horse, common in eastern Islamic art, is not frequently seen in Hispano-Arabic representations. Few examples are known from this period, and in Madīnat Ilbira itself no other ones have been found. There is a similar bowl with a much more crudely drawn horse from Madīnat al-Zahrā[1] and also a small fragment showing the figure of a horse and rider, from which little can be discerned.[2] On the other hand, the horse as the steed of a warrior or knight is relatively common in eastern art, but the strange association of horse and bird is much less so. In the tenth century, however, pieces were produced in Nīshāpūr in Persia in which, in addition to a warrior, the horse carries a bird on its hindquarters.[3] The bird of the Ilbira piece bears an obvious similarity to the birds of Nīshāpūr.[4]

The horse is surprisingly natural. Gratiniano Nieto, who published this piece,[5] speaks of the Mongolian character of the animal; in fact, it is closer to a Mongolian or Chinese horse in appearance—small in height, with powerful flanks and round hooves—than to the abstractions of horses to which eastern Islamic art has accustomed us. Such naturalism would not be found again until the eleventh century, in a piece made in al-Fustāt (Old Cairo) and today in the Museum für Islamische Kunst in Berlin (I 43/64 in no. 100),[6] or in the more remote Minai pieces of the twelfth and thirteenth centuries.

The Granada provenance of this example is certain. Nevertheless, one may detect in it Persian and Egyptian influences, although leavened with the strong presence of the naturalism that traditionally has lent weight to the classic art of the Iberian Peninsula. MPSF

1. Córdoba 1986a, p. 95.
2. Pavón Maldonado 1972, p. 223.
3. Düsseldorf 1973, pp. 54, 55.
4. Ibid., p. 44.
5. Madrid 1966, p. 97.
6. Düsseldorf 1973, p. 92.

29

Bowl

Caliphal period, 2nd half of 10th century
Glazed and painted green and manganese
earthenware with copper sulfite
Diam. 9⅝ in. (24.4 cm)
Museo Nacional de Cerámica
"Gonzáles Martí," Valencia
2.858

*T*he sides of this shallow circular bowl with a straight uniform rim are joined to the flat base in a smooth curve. The piece was found in a clandestine excavation carried out in Valencia or its surroundings. It is worked in reddish clay, which is not very fine grained but well sifted, with small impurities in the paste. The exterior is covered in a yellowish tin glaze, with dark green areas caused by the addition of copper. The glaze adheres well to the paste. The interior is covered in a lead glaze, with a small amount of tin. The glaze adheres well but is not evenly distributed. A rosy tone is lent by the transparency of the paste. The interior decoration is copper green and manganese black; the manganese is used to outline the forms and the copper to fill them.

The decoration consists of a gazelle seen in profile, with ears pricked and body covered with heart-shaped spots in reserve. Between the body and the neck is a reserve band that seems to be more a device to delineate the area between two parts of the body than a representation of collars worn by fowls and quadrupeds also found in depictions from Madīnat al-Zahrāʾ and related to collars of Sasanian origin indicating royal status. One rear hoof is raised in the attitude of walking. In its mouth the gazelle holds a willowy bough that branches into two stems, each terminating in a three-petaled flower. The rim of the piece is decorated with green scallops, which are divided into five groups.

The figure is drawn with assurance and has great force and expressiveness despite the limited means used to create it. The striking naturalism of the animal is not a very common feature in Islamic representations, although peninsular Islamic art is characteristically more bound to reality than is the art of eastern Islam. Another feature that, like naturalism, has over time been attributed to Madīnat al-Zahrāʾ is the leaving of a significant amount of space free of decoration. More than a characteristic of place, however, this feature typifies a variety of caliphal pottery decorated in green and black.

The figure of the gazelle is one of the most highly favored in Islamic zoomorphic art. Of the same period and characteristics is an example found in Majorca, probably from the workshops of Madīnat Ilbira.[1] We see the gazelle in later ceramic pieces from Portugal[2] and Spain as well.[3] This figure is also reproduced on tenth-century ceramics in Iran and Mesopotamia, although with a different treatment. The closest in conception to our example are a few pieces of gilded pottery from Mesopotamia.[4] M P S F

1. Rosselló Bordoy 1978a, p. 16, pl. 1.
2. Torres 1987, no. 79.
3. Rosselló Bordoy 1978a, p. 23.
4. Lane 1947, pl. 12A, p. 16.

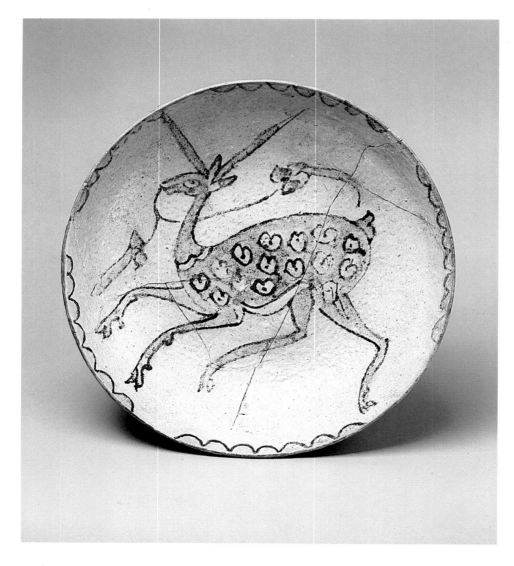

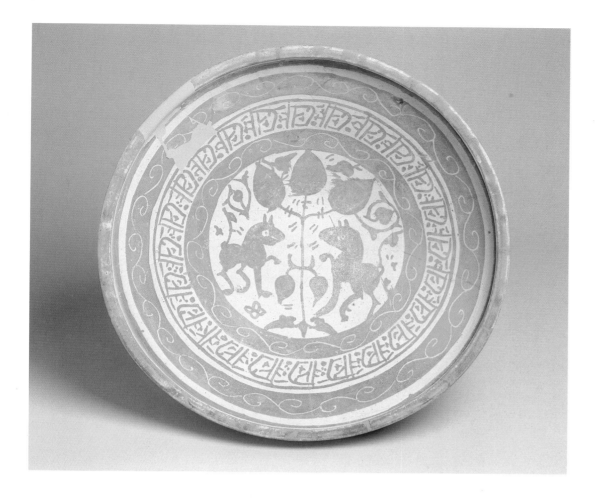

We are reminded of shapes seen in eleventh-century pottery by the form of this shallow bowl, or *ataifor*, with vertical upper walls, turned-down rim, and low, ringed base, although it also displays some characteristics of later periods. It is covered with a tin glaze and decoration in yellowish metallic luster. The design is made up of a series of alternating concentric bands of gold and reserved white glaze. A chain motif is crudely delineated in sgraffito in two bands that enclose a strip of white with purely decorative pseudoepigraphic characters that resemble oriental pictographs. On the bottom of the bowl, a tree of life with three pieces of fruit or heart-shaped leaves, and branches, tendrils, and other vegetal elements appears on a white ground. At the foot of the tree two striding, roughly symmetrical quadrupeds confront each other. These have been interpreted as lions, but could be stylized griffins. The heads and the tips of the tails recall the comparable elements of the bronze Monzón lion, now in the Musée du Louvre in Paris (No. 54). The legs of the animals on the bowl and the Monzón lion are also related to bronze legs found in Ilbira, now in the Museo Arqueológico de Granada.

It is difficult to assign this bowl, which was found in Tudela, Navarra, to a specific workshop or even to the area of Calatayud, for we know little about Calatayud lusterware—no archaeological evidence remains, and we have only written descriptions of it by al-Idrīsī. The sgraffito under glaze seen here is often found on much later bowls, and, although the crude drawing may indicate archaism, it would be rash to make a definitive judgment to this effect. The shape of the piece and the stratigraphic context in which it was found lead us to believe that it can be placed at the end of the eleventh century or the beginning of the twelfth. Thus it would seem to be a rather early example of sgraffito under glaze.

Pottery fragments found in Alberuela de Tubo, believed to be Fāṭimid importations of the second half of the tenth century, show similar tones of gold, but the decorative technique is quite different. It is doubtful that we can relate those fragments or the present bowl with the hypothetical production from Calatayud. GRB

LITERATURE: Bienes Calvo 1987, pp. 115–58; Esco, Giralt, and Sénac 1988, p. 71, no. 33; Barceló Perello forthcoming a.

30

Bowl

Caliphal, *Taifa*, or Almoravid period,
10th–12th century
Glazed and painted green and manganese
earthenware with luster
Diam. 13⅝ in. (34.5 cm)
Archivo Municipal de
Tudela (Navarra), Spain

31

Bowl

Taifa period, 11th century
Glazed and painted green and manganese
earthenware with luster
Diam. 13⅜ in. (34 cm)
Museo Nazionale di San Matteo, Pisa
19

The concave base of this vessel projects slightly where it joins the bottom of the bowl, which has nearly vertical flaring walls and a bifid rim. A thin, yellowish tin glaze reveals the dark fabric of the interior and the reddish tones of the outside. The shape is typical of Majorcan production of the eleventh century. Although it was once believed to be of Tunisian origin, analysis of clay carried out by Enzo Tongiorgi in 1987 has confirmed that this bowl and other examples used as architectural decoration in the church of San Piero a Grado are of Majorcan manufacture. Among these is bowl No. 59 in the Berti Tongiorgi catalogue, which shows a similar ship. The pattern of alternating green and almost black manganese vertical lines on the walls was a common one in the eleventh century and on this type of bowl.

A ship occupies the entire decorative field. It is a round-bottomed sailing vessel, with no indication of oars. The high prow curves backward and the sternpost is inclined forward. The poop has very high sides without openings, creating a solid shape, and displays a square motif that is probably ornamental. Although no lateral steering oars, such as we find in later depictions of ships, are evident, there are some openings below the poop that could accommodate such gear. The lateen-rigged three-master has main and foresail set, and the mizzen sail is furled on its yard in a horizontal position. Alongside lies a long boat with a recurved prow, a crew of oarsmen, and a lateen sail. The poop and the helmsman cannot be seen because of losses in the surface of the bowl, but the long steering oar is visible. These details can be deduced from the evidence of the similar decoration on bowl No. 59, where this zone is in better condition.

This piece can be assigned to the eleventh century on the evidence of the date of construction of the San Piero a Grado church, and through comparison to other archaeological finds. The chronology suggested here does not coincide with that of naval scholars, who find no depiction of this type of boat before the twelfth century. However, it is likely that such sophisticated vessels did exist in the Balearic Islands, whose naval power has been documented in texts since the tenth century. At the time this bowl was made, the fleet headed by Mujāhid, sovereign of Denia and the Balearics, was carrying out vigorous raids along the Italian coast.

GRB

LITERATURE: Berti and Tongiorgi 1981, pp. 191–92; Berti and Torre 1983, p. 43; Berti, Rosselló Bordoy, and Tongiorgi 1986, pp. 97–115; Berti and Mannoni 1990, pp. 100–102, 117–18; Pryor and Ballabarba 1990, pp. 99–113; Pastor and Rosselló Bordoy forthcoming.

32

Bowl

Taifa period, 1035–40
Cuerda seca glazed and
painted earthenware
Diam. 6¾ in. (17 cm)
Museo Arqueológico Nacional, Madrid
74/48/30

This broken and restored ceramic bowl, or *ataifor*, with lightly emphasized incised foot ring is from Alcalá de Henares. It was made from red paste between 1035 and 1040 (A.H. 427–32). Its broken walls are low and end in a flat everted rim with a rounded lip.

A honey-colored glaze covers the exterior of the bowl, and the interior contains a *cuerda seca* decoration in white, honey, and black. In the *cuerda seca* technique painted lines separate areas of different colors. The significant feature of the decoration is a peacock in heraldic pose, its profile set against a black enamel background. Facing left, with wings and tail folded, it occupies the entire inner surface of the bowl. The white-enameled figure of the bird is embellished with center bands of honey-colored enamel schematically applied to wings and tail, as well as two rows of honey-colored dots. The bird's neck ring and eye are the same color. From the bird's head springs a crest or panache that completes the composition with a motif of acanthus flowers.

A surviving portion of the original background decoration consists of an arc, in the lower left angle, defined in white enamel and enclosing a black scroll upon a honey-colored background.

RAR

LITERATURE: Zozaya 1980; Zozaya 1981a, p. 279, fig. 1; Pavón Maldonado 1982; Zozaya and Fernández Uriel 1983; Madrid 1987, p. 166.

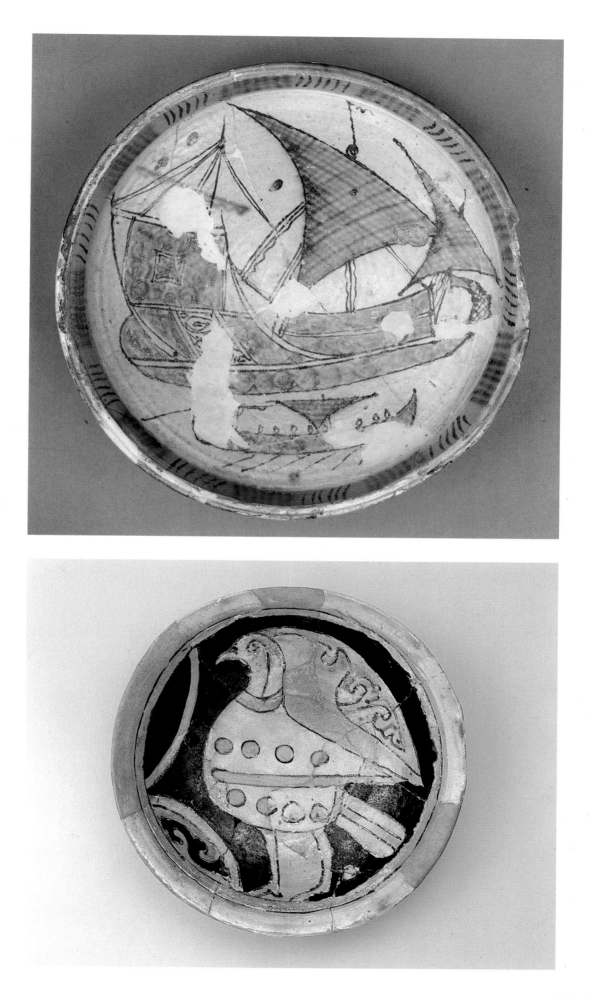

33

Bowl

Taifa period, 2nd half of 11th century
Cuerda seca glazed and
painted earthenware
Diam. 8¾ in. (22.1 cm)
Museu Arqueològic de la
Ciutat de Denia

*M*ade from pale yellowish ocher paste on the wheel, this broken ceramic bowl with foot ring, curved walls with shallow interior well, and flat, wing-shaped rim comes from Denia and dates from the second half of the eleventh century.

The exterior is covered in a honey-colored glaze. The interior, richly colored in white, green, and honey, is decorated in the *cuerda seca* technique and features a peacock in profile —the head is missing—with wings folded. The bird's stance suggests movement toward the right. Executed in all three colors, the figure is outlined in manganese on a white background dotted with small circles filled with either green or honey enamel.

The motif of the peacock, while a classic theme in Islamic iconography, is somewhat rare in *cuerda seca* ceramic pieces. On the peninsula it is found only in an example from Valencia,[1] a piece discovered in Málaga,[2] and a piece from Alcalá de Henares (No. 32).

The interior wall has a honey-colored glaze that has been allowed to drip, creating a decorative pattern, and the lip is similarly treated, but in green on a white background. RAR

1. Bazzana et al. 1983.
2. Casamar 1980–81, pp. 203–9.

LITERATURE: Casamar 1980–81, p. 63; Bazzana et al. 1983; Teruel 1988, no. 45, p. 97; Azuar Ruiz 1989, p. 48, fig. 20, pl. 3.

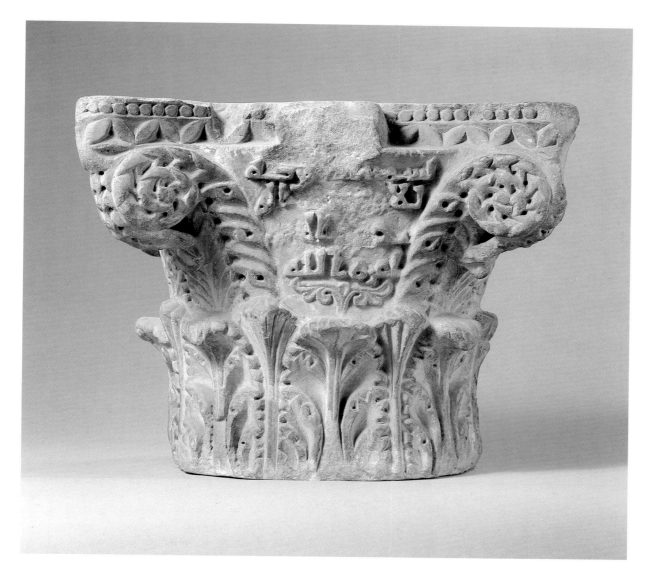

The earliest extant examples of Hispano-Islamic sculpture are among the few capitals executed during the reign of ʿAbd al-Raḥmān II.[1] They were probably all carved for the first enlargement of the Great Mosque of Córdoba, which was realized between 833 and 848 (A.H. 218–34) and was the most significant architectural enterprise of the time. The present Corinthian capital bearing the name of the emir belongs to this group. With it began the tradition of commemorative epigraphic capitals, which became characteristic in Andalusian architecture.

This capital of slender proportions displays very deep, firm, and delicate carving, and a correct and graceful interpretation of acanthus leaves. It thus indicates that by the middle of the ninth century artists had fully absorbed the technical and artistic legacy of ancient Rome. Both stylistically and technically, the piece heralds the splendor that caliphal architectural sculpture was later to achieve.

The inscription reads:[2]

بسم الله بركة من الله للأمير عبد الرحمن بن الحكم
أعزه الله

In the name of God; blessing for the emir ʿAbd al-Raḥmān, son of al-Ḥakam; may God honor him.

This is one of the last instances of the use of Archaic Kūfic script in al-Andalus. During the reign of the next emir, Muḥammad I, the Foliated Kūfic emerged. F-A DE M

1. Gómez-Moreno 1951, pp. 49–51, figs. 58, 59, p. 53; Torres Balbás et al. 1973, pp. 395–98; Terrasse 1961, pp. 426–28; Terrasse 1969, pp. 409–17.
2. See the transcriptions in Lévi-Provençal 1931, p. 85; Gómez-Moreno 1941, pp. 422–23; Revilla Vielva 1932, pp. 58–59.

LITERATURE: Gómez-Moreno 1951, pp. 49–51, figs. 58, 59, p. 53; Torres Balbás 1957b, pp. 395–98; Terrasse 1961, pp. 426–28; Terrasse 1969, pp. 412–13, pl. 15.

34

Capital with Inscription

Emirate, 840–48
Marble
H. 11½ in. (29 cm)
Museo Arqueológico Nacional, Madrid
51.627

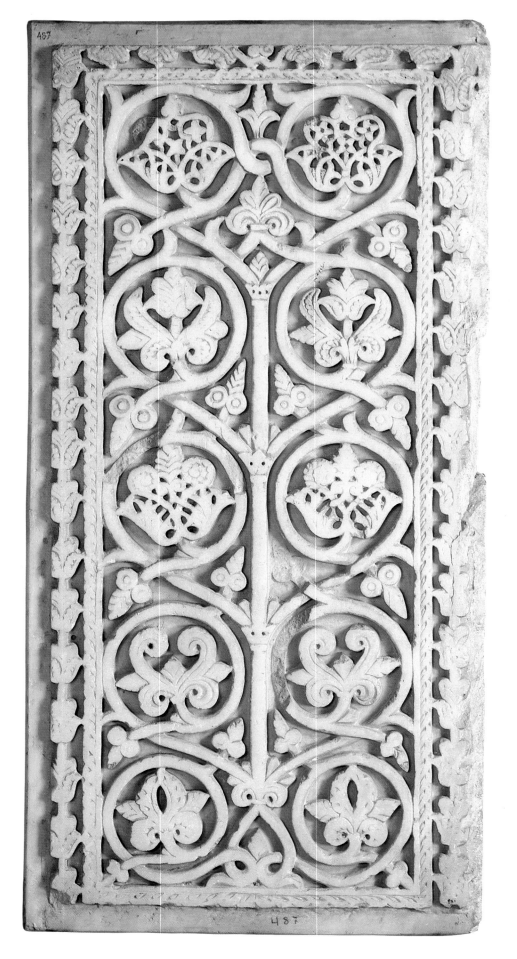

35

Relief from Madīnat al-Zahrāʾ

Caliphal period, 936–76
Marble
41 x 19¾ in. (104 x 50 cm)
Museo Arqueológico Provincial
de Córdoba
487

*I*n the center of this panel, which is from a wall dado or doorjamb, is a carved vegetal design arranged in two rows of five leaf clusters encircled by interlocking vine tendrils that may represent the tree of life. The central section is framed by a continuous border of linked buds. The relief was clearly part of a larger program of architectural ornament and bears close resemblance to other marble panels found in situ.[1] Despite differences in scale and material, the panel's geometricized foliage recalls the carved decoration of certain ivory pyxides made for the Umayyad court during the tenth century. The repeated use of vegetation in such ivories as well as marbles and stuccowork has been considered by some a reference to paradise promised to the faithful by the Qurʾan. However, it might also reflect political meanings connected with the garden and cultivated landscape. DFR

1. For example, see Beckwith 1960, p. 2, fig. 2.

LITERATURE: Gómez-Moreno 1951, pp. 181, 184, fig. 244c; Santos Jener 1951, p. 91, pl. 18.

36

Relief from Baena

Caliphal period, ca. 953–57
Marble
24⅞ x 18¼ in. (63 x 46.5 cm)
Museo Arqueológico de Sevilla
RE4421

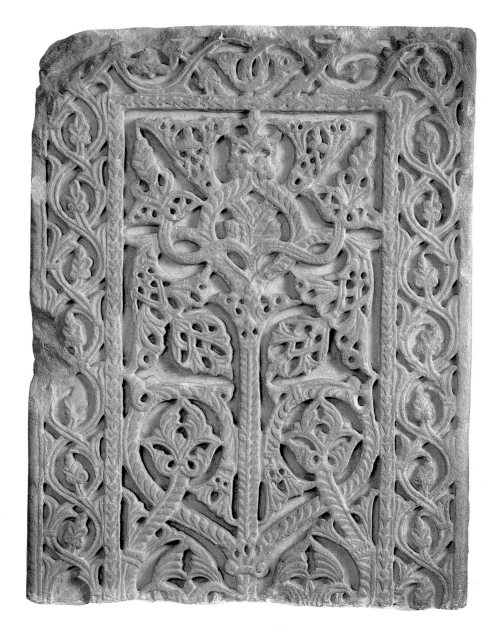

For centuries after Madīnat al-Zahrāʾ was destroyed in 1010 (A.H. 401), its decorative architectural elements, in particular its marble capitals and mural plaques, were dispersed and reused in new buildings. This relief fragment, which was found in a convent in Baena (Córdoba province), may originally have been carved for Madīnat al-Zahrāʾ. The material (marble), excellent carving technique, and superlative design suggest that it was intended as a revetment for the jamb of a doorway in a very important room. The central area of the plaque features a bilaterally symmetrical system of branches that emerges from either side of a major axial stem. These curling and sinuous branches, which sprout palmettes and flowers, fill the rectangular space. The elegant central composition is framed by a band of intertwining vegetal forms, or *ataurique*.[1] The same handling of vegetal embellishment characterizes the workshop responsible for the main public rooms and royal apartments of Madīnat al-Zahrāʾ during the reign of ʿAbd al-Raḥmān III.　　F-A DE M

1. For a thorough study of vegetal ornamentation in al-Andalus, see Pavón Maldonado 1981. See also Gómez-Moreno 1951, pp. 82–90, 180–81; Torres Balbás et al. 1973, pp. 687–716. The influence of the Hispano-Islamic *ataurique* in North Africa is examined in Montêquin 1985.

LITERATURE: Gómez-Moreno 1951, pp. 82–90, 180–81; Torres Balbás 1957, pp. 687–716; Pavón Maldonado 1981; Montêquin 1985, pp. 88–100.

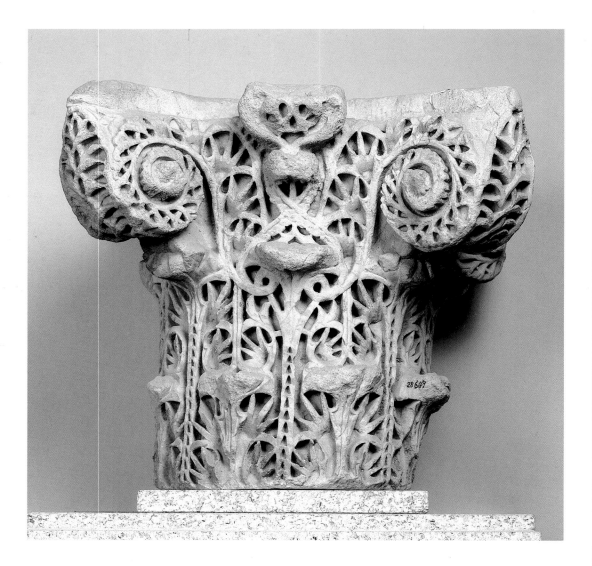

37

Capital from Córdoba or Madīnat al-Zahrā'

Caliphal period, ca. 964–65
Marble
H. 14½ in. (36.2 cm)
Museo Arqueológico Provincial
de Córdoba
28.609

*T*he brilliantly executed ornamentation that characterized the architecture of al-Andalus during the reigns of ʿAbd al-Raḥmān III and al-Hakam II found one of its most important expressions in the virtuoso carving of capitals. Under the exclusive patronage of the court, the major workshops in Córdoba and Madīnat al-Zahrā' set the standards for such ornamentation.[1] This Corinthian capital excels in its harmony of proportions, handling of embellishment, and the refinement and perfection of carving technique. Only the general configuration of the Roman prototype remains. The digitation and venation of the traditional acanthus leaves are treated with great freedom and transformed into vines of *ataurique*. The motifs grow and intertwine in a multitude of directions over the entire cylindrical surface, suggesting a tightly wrapped veil of fine lace.

Artisans relied heavily on the sculptor's trephine to produce the very deep carving and extreme surface fragmentation typical of the style exemplified in this capital. They roughly scored capitals in the workshop and carved their decoration at the site after they were installed. Then they applied the red and blue colors that constituted the final embellishment. F-A DE M

1. For discussions of this type of Cordobán caliphal capital, see Brisch 1961; Domínguez Perela 1981; Gómez-Moreno 1941; Hernández 1930; Kühnel 1928; Ocaña Jiménez 1940; Pavón Maldonado 1966a; Pavón Maldonado 1966b; Pavón Maldonado and Sastre 1969; Terrasse 1963. See also Gómez-Moreno 1951, pp. 89–90; Torres Balbás 1957b, pp. 667–87.

LITERATURE: Kühnel 1928, pp. 82–86; Hernández 1930; Ocaña Jiménez 1940, pp. 437–49; Gómez-Moreno 1940; Gómez-Moreno 1951, pp. 89–90; Torres Balbás 1957b, pp. 667–87; Brisch 1961, pp. 207–12; Terrasse 1963, pp. 212–16; Pavón Maldonado 1966a; Pavón Maldonado 1966b; Pavón Maldonado and Sastre 1969; Domínguez Perela 1981.

38

Two Capitals and Bases from Madīnat al-Zahrāʾ

Caliphal period, 967/8–976
Marble
a. Capital
H. 8⅛ in. (20.5 cm)
Base
5 x 9⅞ x 9⅞ in. (12.5 x 25 x 25 cm)
Museo Arqueológico Provincial
de Córdoba
30.151, 30.152
b. Capital
H. 8¼ in. (20.7 cm)
Base
4⅝ x 9⅞ x 9½ in. (11.8 x 25 x 24 cm)
Museo Arqueológico Provincial
de Córdoba
30.149, 30.150

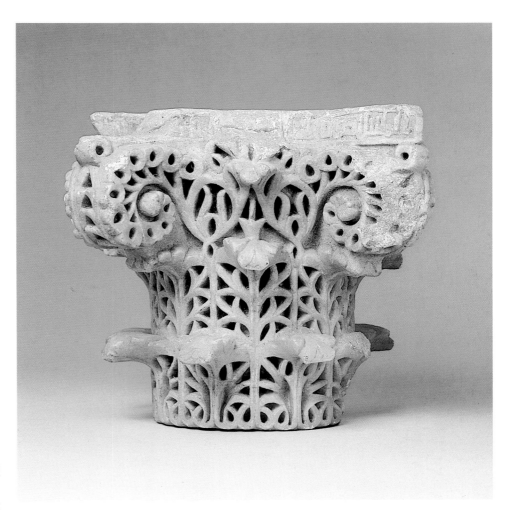

The first capital is of the Corinthian order with two rows of projecting acanthus leaves, its surface deeply drilled in a freely interpreted and uniformly distributed vegetal design. The inscription running along the topmost band reads:

بسم الله بركة من | الله تامة وعافية | شاملة وعز دائم | وسرور متصل للا | مام عبد الله الحكم | المس | تنصر بالله أمير | المؤمنين أطال الله | بقاءه مما أمر بعمله

In the name of God, the complete blessing of God, general well-being, everlasting glory, and eternal joy to the Imām, servant of God, al-Ḥakam al-Mustanṣir bi-llāh, Commander of the Faithful, may God preserve him. [This is] what he ordered done.

The decoration of the base is arranged in bands of floral motifs that alternate with panels of geometric design.

The second capital and base are companions to the preceding ones. The capital is also Corinthian and deeply drilled and has a similar inscription bearing the name of the Imām, servant of God, al-Ḥakam al-Mustanṣir bi-llāh. This column base, like the first, is embellished with four registers of alternately floral and geometric ornamentation.

On the basis of the caliphal titulature of al-Ḥakam, Manuel Ocaña Jiménez dated both examples to between 967 (A.H. 357) and 976 (A.H. 366), the year of al-Ḥakam's death.[1]

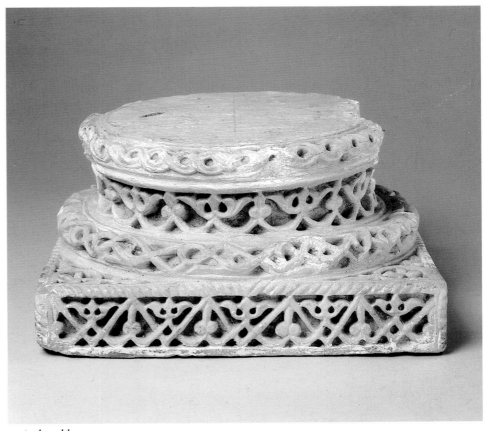

capital and base a

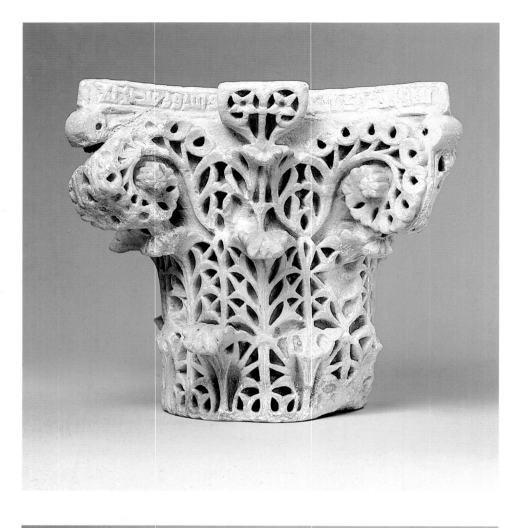

These diminutive capitals recall the delicate work of precious ivory carving, linking architectural parts to the princely taste for luxury objects.

DFR

1. Ocaña Jiménez 1936–39, pp. 163, 165.

LITERATURE: Ocaña Jiménez 1936–39, pls. 1a, 2a; Gómez-Moreno 1951, p. 160, figs. 211, 212.

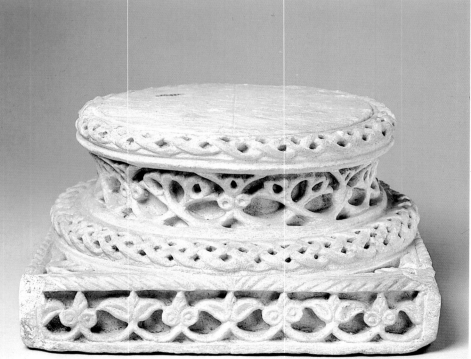

capital and base b

39

Capital from Madīnat al-Zahrāʾ

Caliphal period, 972–73
Marble
H. 15 in. (38 cm)
Al-Sabah Collection, Dar al-Athar
al-Islamiyya,
Kuwait National Museum, Kuwait City
LNS 2 S

†

A narrow band of bead-and-reel ornament and a vegetal design that fills two wide registers of acanthus leaves and the four projecting volutes decorates this deeply drilled Corinthian capital. Atop the capital is a band with an inscription in Kūfic script blessing the Imām:

الامام عبد الله / الحكم المستنصر بالله أمير / المؤمنين

the servant of God, al-Ḥakam al-Mustanṣir bi-llāh, Commander of the Faithful.

It continues:

مما أمر بعمله فتم بعون الله / [على يد]ي
سدق الفتى الكاتب في / سنة اثني وستين وثلث مائة /
عمل فليح (الأسير؟) عبده

From among that which he ordered made, which was done with the help of God [under the direction of] Ṣādiq al-fatā al-kātib, in the year three hundred and sixty-two. The work of Falīḥ the . . . , his servant.

A projecting panel between two of the volutes repeats the name Falīḥ. In technique the drill work surely reflects the hand of Byzantine artisans or Muslims trained by Byzantine masters. Such artisans were invited to the Cordobán court, we know, to work on earlier palaces. DFR

LITERATURE: Jenkins 1983, p. 44; Atil 1990, no. 23, p. 92.

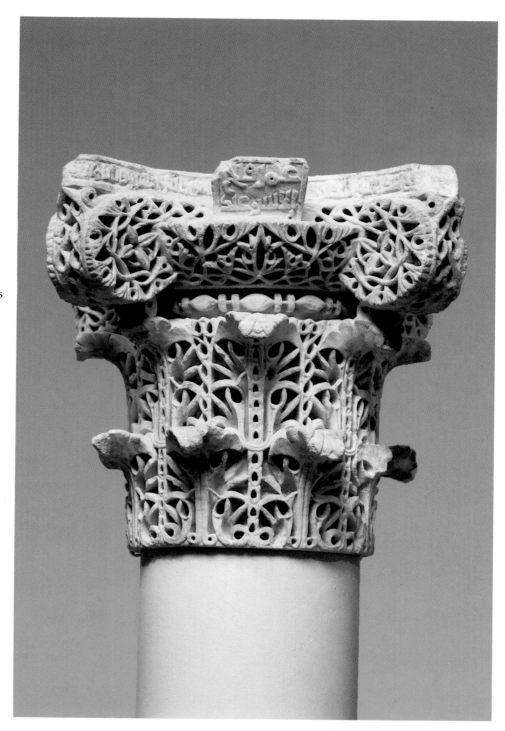

Capital with Four Musicians

Caliphal period, 10th century
Marble
H. 10 in. (25.5 cm)
Museo Arqueológico Provincial
de Córdoba
D/133

This capital, which surely is from an arcade in one of the many palaces in the suburbs of Córdoba, is unusual for the depiction of an elegant musician on each of its faces. The four musicians are frontal and stand on the acanthus that rings the neck of the capital. They are executed in a lively etched style that recalls both indigenous Visigothic reliefs from sites such as San Pedro de la Nave and the more agitated, mannered carving of *Taifa* works like the Játiva Basin (No. 49).

There survive from excavations a number of fragments of figural caliphal marbles; nevertheless, a monumental capital with such prominent figures is unusual. Clearly, their bold and public placement caused discomfort to a later Muslim audience, for the decapitation of all four musicians must surely have occurred in response to later traditionalist aniconism.

The close relationship between the style of this capital and that of Visigothic carvings reminds us that figural capitals were a crucial part of the indigenous artistic tradition when the Muslims first came to the peninsula. It is possible that the type had a structural inspiration in pieces like the Four Evangelists capital (also in the Museo Arqueológico Provincial de Córdoba), which features a single bust on each of its sides. In terms of meaning, however, the present capital is certainly unrelated to works of the Visigothic period. The musicians are doubtless a reference to royal leisure and pastimes that in the early Islamic period became emblematic of princely privilege and authority. JDD

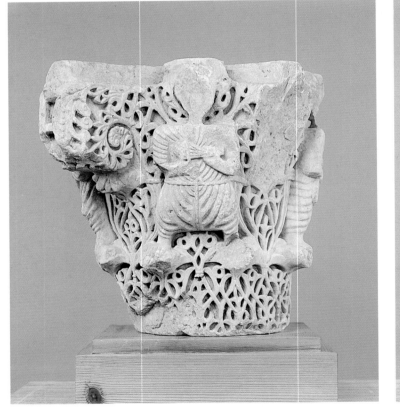

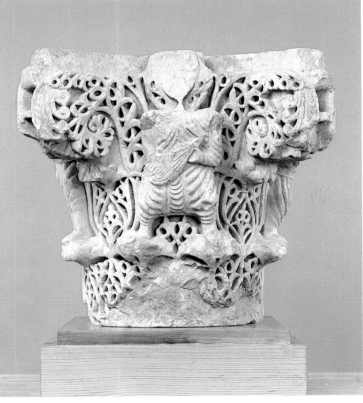

These carved cedar panels come from the oldest surviving minbar, or pulpit, in Morocco, that of the Mosque of the Andalusians in Fez.[1] It is a triangular wooden structure containing seven steps leading to a seat for the preacher. Each triangular side comprises an armature, carved in low relief with geometric and vegetal ornament, of long vertical elements joined with short horizontal ones. Enclosed within the armature, square panels corresponding in height to the risers of the steps are decorated with closely-set turned balusters, half balusters nailed to boards, and shallow carved decoration similar to that on panels a and b, which originally surmounted either side, and to c and d, which were the upper panels of the backrest. The lowest of the backrest panels (e) consists of turned balusters closely set in a rectangular frame. The sculpted panels have several concentric borders of carved epigraphic, vegetal, or geometric ornament surrounding square or round arched fields filled with conventionalized vegetal ornament composed of pinecones, rosettes, and medallions. The relief of the side panels is slightly more modulated than that of the back panels c and d, and the carving is more spacious and somewhat finer in quality. This difference, however, may be more apparent than real, for the panels in the backrest—c, d, and e—have been continuously exposed to wear, while the side panels were concealed when the minbar was remodeled in the thirteenth century.

The foliated letters of the inscription on panels a through d show the impact of contemporary epigraphic developments in the Islamic world to the east, although the ornament shows no hint of the beveled style of carving that had become widely popular beginning in the mid-ninth century. Rather, the subject matter and style seem to derive from Islamic ornament of the eighth century, which itself combined late antique and Sasanian techniques and motifs. The turned balusters on panel e, however, represent a very early example of the technique later known as *mashrabiyya*, in which turned spools and spindles were joined to make screens. This would become one of the most characteristic woodworking techniques for the decoration of Islamic architecture.

In addition to their artistic significance, these five panels are a seminal document in the record of the struggle for political dominance during the second half of the tenth century in northwest Africa: The Shiʿite Fāṭimid dynasty attempted to control the region from Tunisia, and

the Sunni Umayyad dynasty attempted to control it from Córdoba in Spain. The key to the region was Fez, its chief city, which had been divided since the ninth century into the quarters of the Qarawiyyīn (émigrés from Kairouan in Tunisia) and the Andalusiyyīn (Andalusians, émigrés from al-Andalus), each of which had its own congregational mosque. For several years in the middle of the tenth century, the Fāṭimids controlled Fez but they then lost it to the Umayyads. In 955 the Umayyad caliph ʿAbd al-Raḥmān III sent money to build a new minaret for the mosque of the Qarawiyyīn quarter (the tower, which still stands, is a reduced version of the tower he had just added to the congregational mosque of Córdoba). In the following year the Umayyad governor of Fez added a minaret to the Mosque of the Andalusians. The focus of patronage was no accident, for minarets were anathema to Fāṭimids, who, following early Islamic precedent, believed that the call to prayer should be given from either the doorway or the roof of the mosque. In 959/60 (A.H. 348) the Fāṭimids retook Fez, and their client Buluggīn ibn Zīrī held it for them from 979 to 985 (A.H. 369–75).

The inscription on panel a of the minbar states that it was made in 980 (A.H. 369), when Buluggīn ruled Fez. Buluggīn's ordering of a minbar, a traditional symbol of sovereignty, for the mosque is no surprise. Panel b is inscribed with the *basmala* (invocation "In the Name of God, the Merciful, the Compassionate") followed by Qurʾan 24:36:

بسم الله الرحمن الرحيم في بيوت اذن. الله إن ترفع
و يذكر فيها إسمه يسبح له فيها بالغدو والـ[اصال]

In temples God has allowed to be raised up, and His name to be commemorated therein; therein glorifying Him, in the mornings and [the evenings]. . . .

This is a clear allusion to the function of the minbar not only as the place from which the weekly sermon (khutba) was pronounced, but also as the place within the mosque from which the second call to prayer (iqāma) was given. Buluggīn's name, however, does not appear, for the original backrest, on which the patron's name would have been inscribed, was replaced in 985 (A.H. 375) with panels c, d, and perhaps e after the city fell to Askalja, the cousin of al-Manṣūr, vizier to the new Umayyad caliph Hishām II. Askalja immediately took the

Five Panels from a Minbar Made for the Mosque of the Andalusians, Fez

Caliphal period, 980; repaired 985
Wood with traces of paint
a. right panel: 21⅝ x 8⅛ x 1 in.
(55 x 20.7 x 2.5 cm)
b. left panel: 22 x 8 x ¾ in.
(56 x 20.5 x 1.7 cm)
c. backrest upper panel: 26 x 29½ x ⅞ in.
(66 x 75 x 2 cm)
d. backrest middle panel: 14⅜ x
29⅝ x ⅞ in. (36.4 x 75.2 x 2 cm)
e. backrest lower panel: 17½ x
29¼ x 1¼ in. (44.5 x 74.2 x 4.5 cm)
Musée du Batha, Fez

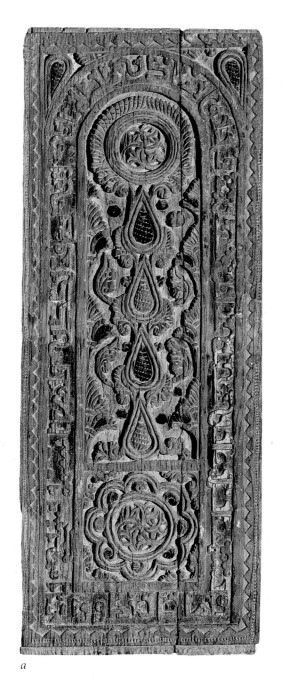

a

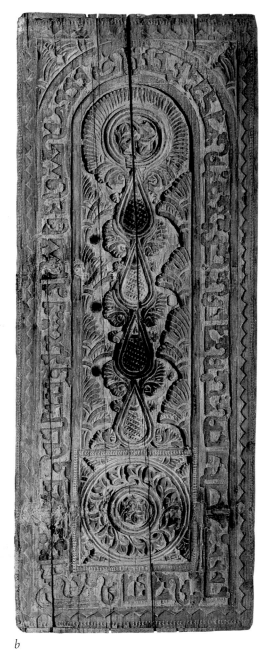

b

Andalusian quarter; in its congregational mosque he undoubtedly saw Buluggīn's minbar, which probably had been damaged in the struggle for the city. Although the Umayyads had no objection to minbars, they probably did object to inscriptions on the backrest that would have included the names and titles of Buluggīn, those of his Fāṭimid suzerain, and Shiʿite formulas and benedictions. Askalja probably ordered Buluggīn's backrest sent as a trophy to Córdoba, much as the backrest of the minbar from Aṣīla had been sent there six years earlier. The damaged minbar was repaired and the new backrest in al-Manṣūr's name carved in a similar style, perhaps by the same workshop that had made the original minbar six years earlier.[2]

JMB

1. Terrasse first untangled the complicated history of this minbar ([1942], pp. 34–52). The tenth-century minbar was completely remodeled at a later date by nailing carved boards to the frame. These boards, laid horizontally, were decorated with a geometric pattern of strapwork bands intersecting to form eight-pointed stars. The similarity of the pattern to that found on Almohad minbars (see No. 115), suggests that the minbar was remodeled when the Almohad caliph Muhammad al-Nasir reconstructed the Mosque of the Andalusians between 1203 and 1207 (A.H. 600–604). Like all the antique woodwork in the mosque, the minbar was later covered with a thick coat of green paint.

2. Bloom 1989, pp. 106–12.

LITERATURE: Terrasse [1942], pp. 34–52; Terrasse 1958, pp. 159–67; Bloom 1989, pp. 106–12; Paris 1990, pp. 188–90.

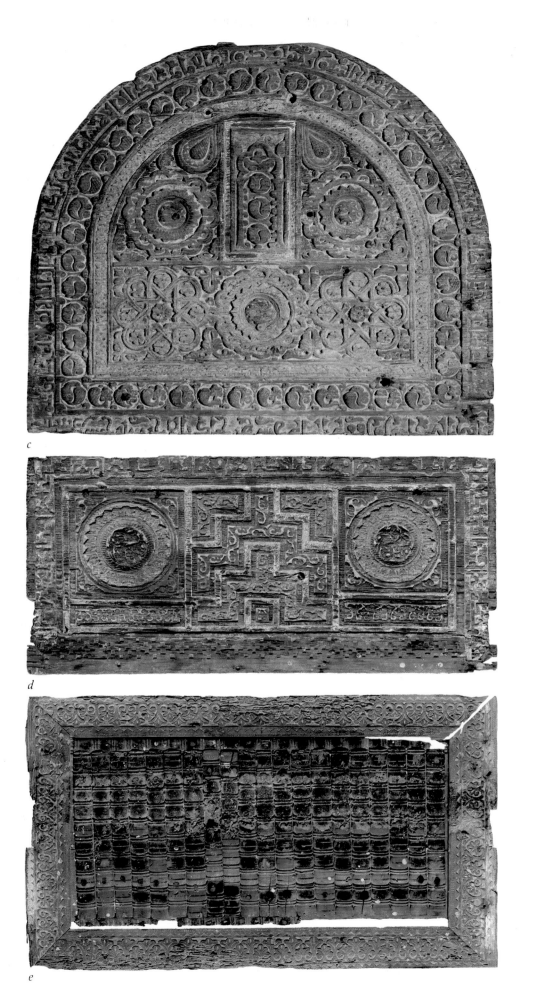

c

d

e

42

Two Window Screens

Caliphal period, 980–90
Marble
a. 69¼ x 38¼ in. (177 x 98.5 cm)
Museo Arqueológico Provincial
de Córdoba
3.468
b. 60¼ x 38⅝ in. (153 x 98 cm)
Museo Arqueológico Provincial
de Córdoba
3.488

*I*slamic window screens (*celosías*) were made of wood unless they were destined for the most luxurious or important structures. *Celosías* have several functions: they form part of the ventilation system of the building in which they are installed, control the amount of light that enters, help create a sense of privacy, and embellish the interior.

These two marble *celosías* are closely related in carving style and design to those made between 987 and 990 (A.H. 377–80) for the qibla of the Great Mosque of Córdoba under the patronage of Hishām II and his chamberlain al-Manṣūr.[1] They were almost certainly produced in the same workshop as part of the same series as the examples at the Great Mosque of Córdoba, though it is unlikely that they were carved for the Great Mosque because their dimensions are at variance with the screens there. They may have been made for country residences of al-Manṣūr near Córdoba, such as Madīnat al-Zāhira, built from 978 to 979 (A.H. 368–69), or al-ʿĀmiriyya, constructed before 980 (A.H. 370).

They follow an open system of design, a pattern that could be expanded infinitely.[2] The individual elements range from small, repetitive shapes to portions of large forms that would surpass the size of the screen if they were complete. Careful use of intense contrasts characterizes the whole: voids and solids, negative and positive shapes, light and shadow, divergent and convergent lines. The contrasts, however, are utilized to create an extremely harmonious composition. The marble has been carved to give the impression of interwoven structural pieces, an effect that is common in carpentry and reflects the wooden origin of *celosías*.

The complex composition of each of the present screens derives from a single geometric form. The basic element of the first screen, a regular hexagon with rectilinear sides, is easily recognizable. It is repeated twenty-one times in a six-member system of interlacing. Only once, however, at the center of the composition, does it appear in its complete form. The regular hexagons meet at their corners, with the interlacing system creating a variety of geometric forms, such as large and small triangles and regular and elongated hexagons.

Only a very careful analysis of the second *celosía* reveals that its complicated design emerges from the repetition of a single shape: a modified octagon that is much larger than the panel. The octagon fits inside a square; its vertical and horizontal sides constitute the center thirds of the sides of the square. Thus, its four diagonal sides each form the hypotenuse of a right triangle, making them 40 percent longer than the horizontal and vertical sides. (That is, the diagonal side equals the horizontal side times the square root of two.) At the midpoint of each side is a semicircle. Relative to the center of the octagon, this semicircle is convex on the diagonal sides and concave on the vertical and horizontal ones. The composition is formed by portions of eighteen octagons, and in no case does much more than one-eighth of an entire octagon appear. The eight-member system of interlacing produces a variety of shapes. Some, such as squares and eight-pointed stars, are easily discernible, but others require detailed analysis. The latter include elongated hexagons intersecting at right angles in the middle to create crosses, which contain a star, and octagonal medallions with alternating pointed and rounded sides. These shapes of varying profile are cut in half by the edges of the screen.

The fact that both of these *celosías* were produced by the same school at the same time reflects the coexistence and balance of classical and anticlassical artistic trends in al-Andalus during the Cordobán caliphate.[3] The classical vision, as exemplified in the first screen, strives for a relative sense of tranquility and stability and for intellectual clarity. The anticlassical approach, reflected in the second *celosía*, wants to involve, puzzle, and excite the viewer, to present a complexity that the mind cannot absorb all at once. Viewers quickly recognize that the decorative program of the first screen is based on the systematic repetition of a hexagon. They may doubt that the extremely complicated second pattern emerges from repetition of a single form and may need assistance to discover that form. Here, full comprehension requires prolonged but rewarding study.

With the accession of Hishām II to the caliphal throne in 976 (A.H. 366), there began a marked and rapid artistic decline, which continued throughout the remainder of the Umayyad era in al-Andalus. This decline was expressed in the production of repetitive, drab, and generally unimaginative decorative art. The superlative design of these *celosías* demonstrates, however, that some of the impulses that drove Andalusian caliphal art at its summit survived at least until the end of the tenth century. F-A DE M

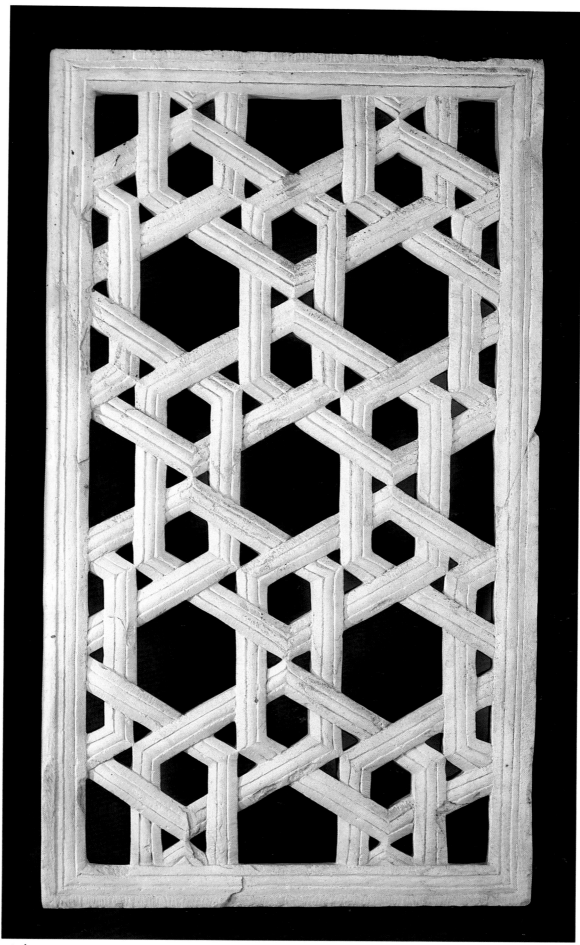

window screen a

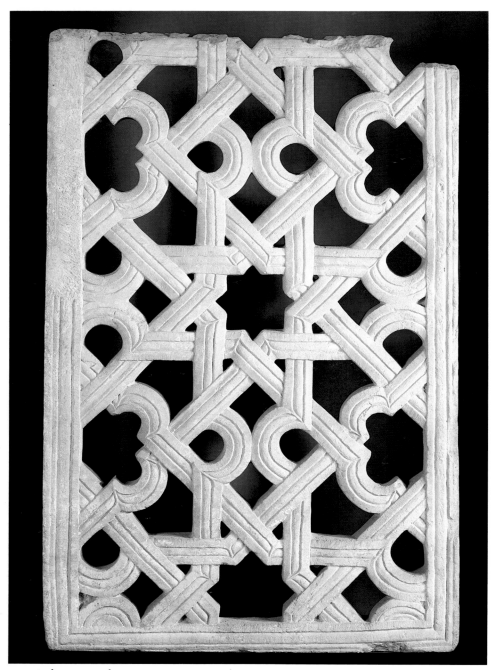

42, window screen b

1. For a major study of the window screens of the Great Mosque of Córdoba, see Brisch 1961; see also Brisch 1966.
2. The technical aspect of geometric interlacing is analyzed in Fernández Puertas 1975. For a thorough study of geometric decoration in al-Andalus, see Pavón Maldonado 1975.
3. These classical and anticlassical currents are studied in Montêquin 1982, pp. 2–5.

LITERATURE: Brisch 1961; Brisch 1966.

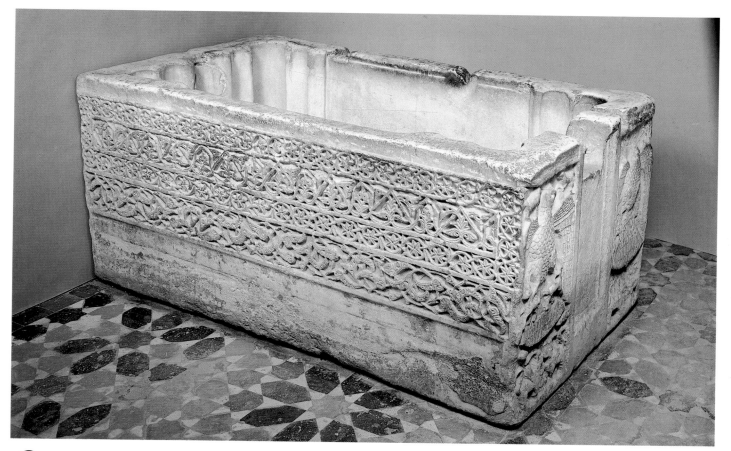

Of all surviving ablution fonts from al-Andalus, this is the largest. It also has the finest interior, featuring a trilobate plant at each corner. Despite the destruction of decoration on two of its sides, it may also be the most spectacular, although it lacks the richness and iconographic interest of the later Játiva basin (No. 49).

The style and disposition of the front are similar to those of the earlier basin dedicated to al-Manṣūr, now in the Museo Arqueológico in Madrid. This face is divided into three tall vertical sections. The central section is blank, to allow for the drainpipe, and the two outer sections contain eagles with outspread wings. Small lions stand on the upper edges of the eagles' wings; beneath the feet of each eagle are two griffins with preternaturally long horns.

The elaborately carved right side is divided into four registers and a superior band that bore an inscription, now destroyed. The lowest and uppermost registers are also destroyed. The second register, contains a horizontal tablet featuring an orle of archaic volutes with six-petaled lotuses, reminding us of the Umayyad palace at Khirbat al-Mafjar; this orle encloses a band of interlacing trees of life. The third register is a forest of palmettes interlaced by marvelously fluid volutes.

The opposite face offers the remnants of an unpublished inscription in the typical Kūfic of the last years of the tenth century; it begins in the classic manner with the *basmala*, imploring the blessing and triumph of God, as well as obedience for al-Manṣūr's son, ʿAbd al-Malik, for whom the basin was made between 1002 and 1007 (A.H. 393–98). Unfortunately, the basin has not been moved in centuries and the face that bears the continuation of the inscription is not visible; the complete inscription, therefore, remains inaccessible. The visible face reveals fragmentary decoration suggesting the presence of a central tree of life flanked by two deer. Two additional trees appear at the sides, behind the deer.

Iconographically, this piece is related to its distant Mesopotamian and Sasanian ancestors, and to the facade of the Umayyad palace in Mshatta (Jordan). The eagles, like others on basins in Madrid and Granada, are an obvious symbol of power; griffins—a solar sign—subjected by eagles are a common theme in Arabic courtly poetry on astrological themes. The basin is a good artistic nexus for understanding panels of the *Taifa* phase of Toledo and Denia.

J Z

LITERATURE: Gómez-Moreno 1951, pp. 181, 188, 191, fig. 246b.

43

Basin

Caliphal period, 1002–7
Marble
28 x 61⅛ x 33⅛ in. (71 x 155 x 84 cm)
Madrasa Ben Youssouf, Marrakesh

44

Relief from the Aljafería

Taifa period, 11th century
Stucco with traces of paint
67 x 59⅞ in. (170 x 152 cm)
Museo Arqueológico Nacional, Madrid
50.440
†

\mathcal{W}e know that this elaborately carved stucco relief was an element in the decorative program of the Aljafería palace constructed by the *Taifa* king al-Muqtadir at Saragossa in the eleventh century. The remains of predominantly red and blue polychrome decoration that cling to it remind us that most of the stucco ornament in the Aljafería and other palaces in al-Andalus originally was painted in brilliant colors. This relief, like much of the architectural decoration of the Aljafería, betrays a specific caliphal source: a relationship with the *maqṣūra* region and the mihrab of al-Ḥakam II's addition to the Great Mosque of Córdoba, rather than with the Madīnat al-Zahrāʾ palace, is evident. Here, the use of the arch motif recalls the transformation of structural forms into decorative elements that is visible at Córdoba. However, at Saragossa,

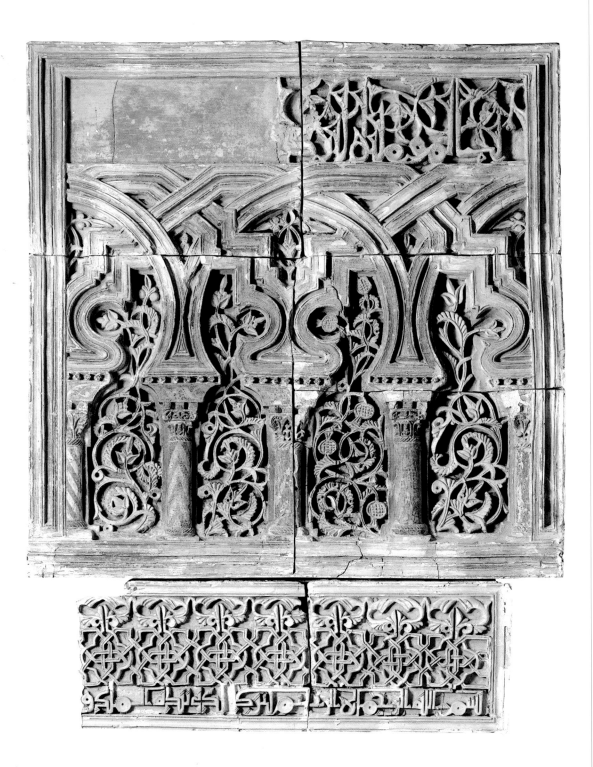

as this relief reveals, the transformation is more fully developed—the geometric and vegetal shapes are more closely integrated and complex.

Because it is so intricate, the decoration of the Aljafería has often been characterized as baroque. This term is also used to imply decadence: The style is often viewed as a debased version of the caliphal model. In truth, however, the *Taifa* ornament at Saragossa represents a specific new taste and a significant and independent style, albeit one with links to the caliphal past. C R

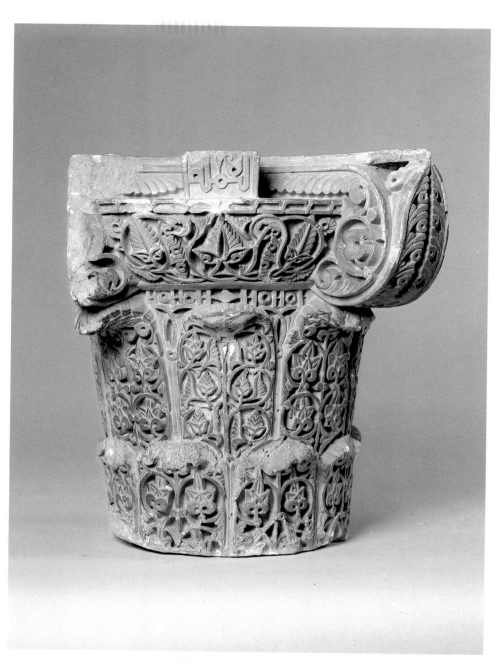

45

Capital from the Aljafería

Taifa period, mid-11th century
Marble and plaster
H. 13⅞ in. (35 cm)
Museo de Zaragoza
7680

The present capital decorated the Aljafería palace of the *Taifa* king of Saragossa al-Muqtadir, whose name appears in the inscription it bears and on coins beginning in 1051 (A.H. 441). It belongs to the group that Manuel Gómez-Moreno calls the first series of capitals from the Aljafería and Toledo.[1] Certain of its characteristics, which it shares with others in the first series, bring to mind the capital from Toledo discussed in entry No. 47 as well as examples in the Great Mosque of Córdoba and parts of Madīnat al-Zahrā᾽ that were commissioned by al-Ḥakam II. These elements are the disposition of the acanthus leaves in two registers with projecting elements alternating with low relief, and the placement of the inscription above the volutes. However,

there are differences that reflect a taste particular to the patron or artisans of the Aljafería: The capital is relatively elongated in comparison with caliphal prototypes, the size of the volutes has been reduced, and the leaves have become compartments into which vegetal motifs are inserted.[2] C R

1. Gómez-Moreno 1951, pp. 226–33.
2. The vegetal motifs and especially their disposition find parallels on certain ivories of the caliphal and *fitna* eras, which suggests that decorative style may have been diffused throughout al-Andalus by means of such luxury objects.

LITERATURE: Prieto y Vives 1926, pp. 45–50; Gómez-Moreno 1951, p. 226, figs. 279, 280; Ewert 1978–80.

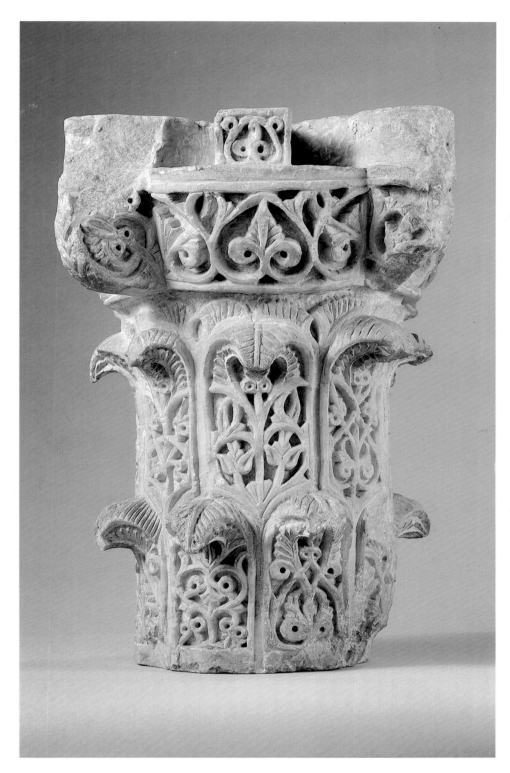

Capital from the Aljafería

Taifa period, mid-11th century
Marble
H. 15 in. (38.1 cm)
Museo Arqueológico Nacional, Madrid
50.482

*L*ike the example in the preceding entry, this capital adorned the Aljafería palace of the *Taifa* king of Saragossa al-Muqtadir, and thus dates to the period of his reign, the mid-eleventh century. It belongs among the capitals Manuel Gómez-Moreno has designated as the second series, which contrast markedly with those of the so-called first series.[1] Gómez-Moreno includes capitals from Toledo as well as from the Aljafería in his first series. In the second series, however, only examples from the Aljafería appear. Although it is possible that similar capitals that are now lost were produced at other sites, their elaborate, fanciful forms seem to have been the exclusive product of Saragossan taste. They bear little resemblance to the capitals of Toledo and no longer betray any direct caliphal influence.[2] As the present piece reveals, the elongation of the first series examples relative to caliphal prototypes is more pronounced, and the acanthus leaves, which are still disposed in two registers, have become increasingly abstract and serve as containers for more intricate, delicate vegetal ornament that includes arabesque forms. Perhaps the most striking feature of this group of capitals is the replacement of the volutes by architectural motifs that resemble the arches of the palace.

C R

1. Gómez-Moreno 1951, pp. 226–33.
2. Ibid.

LITERATURE: Prieto y Vives 1926, pp. 45–50; Gómez-Moreno 1951, p. 226, figs. 279, 280; Ewert 1978–80.

47

Capital

Taifa period, mid-11th century
Marble
H. 12⅞ in. (32.8 cm)
Museo Taller del Moro, Toledo,
Depósito de la Parroquia de Santo Tomé
71

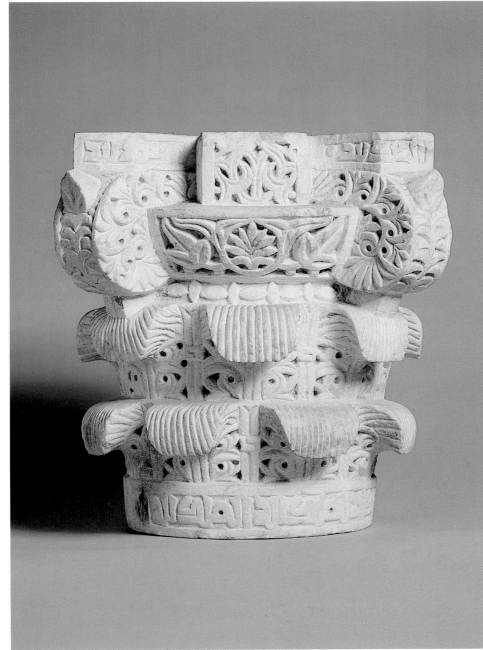

*I*t is probable that this capital came from the royal palace of al-Maʾmūn in Toledo; thus it can with some certainty be dated to the mid-eleventh century, when this king reigned. Al-Maʾmūn repeatedly attempted to conquer Córdoba and may have wished to imitate the decoration of the caliphate in order to effect a symbolic appropriation of some of its power.[1]

Taifa architectural decoration typically reflects both inspiration by and reaction against caliphal precedents, as the present capital demonstrates. Here Cordobán models are recalled in the disposition of the two rows of acanthus leaves with projecting tips and the fully rounded volutes. However, the relief of this piece is lower than in caliphal examples, proportions are somewhat elongated, and the leaves have no relation to their source in nature but rather have become containers for ornament and devices for organizing space. It is likely that this capital shows the influence not only of Córdoba but also of Saragossa, which was a close and powerful neighbor. C R

1. Brisch 1979–81, p. 164.

LITERATURE: Prieto y Vives 1926, pp. 51–55; Gómez-Moreno 1951, p. 214; Brisch 1979–81.

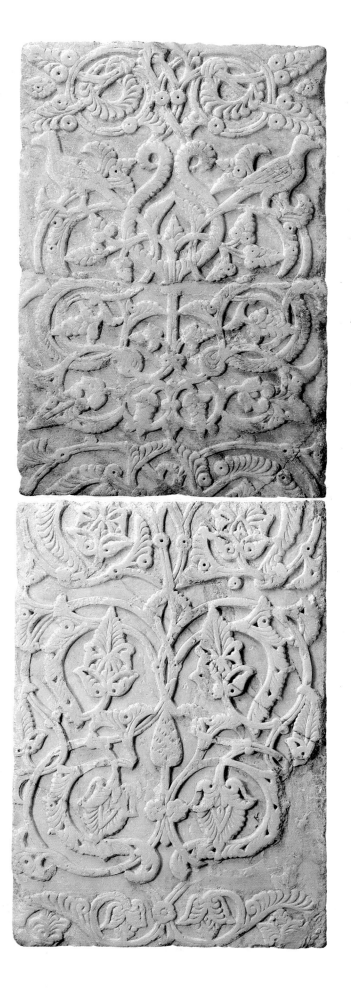

Relief

Taifa period, mid-11th century
Marble
57½ x 19¼ in. (146 x 49 cm)
Museo de Santa Cruz, Toledo
400

*T*his relief probably decorated the palace of the *Taifa* king al-Maʾmūn of Toledo and therefore can be assigned to the middle of the eleventh century, when he ruled. Reliefs of this type adorned various rooms of the caliphal palace Madīnat al-Zahrāʾ, as well as the mihrab commissioned by al-Ḥakam II for the Great Mosque of Córdoba. Some authors maintain that al-Maʾmūn ordered works that followed Cordobán prototypes because he wished to appropriate the power of the caliphate by appropriating its decorative style.[1]

This panel, however, reveals not only caliphal but also Saragossan influence. The symmetrical organization of the tree of life recalls caliphal reliefs, yet specific elements, such as the form of the leaves and their stylized articulation, as well as the circular disposition of the stems, indicate a receptivity to Saragossan taste. In fact, the leaves are remarkably similar to those in architectural fragments from the Aljafería of Saragossa.[2] C R

1. Brisch 1979–81, p. 164.
2. Gómez-Moreno 1951, figs. 286, 290.

LITERATURE: Prieto y Vives 1926, pp. 51–55.

The basin known as the Pila de Játiva is a shallow trough of pinkish marble that is decorated on each of its four sides with animated and textured figural reliefs. It is extraordinary for the boldness of these carvings and for the lively way they evoke a world of aristocratic leisure.

The reliefs are disposed along the exterior of the basin in bands that are separated into panels on the long sides by medallions. The scenes depicted all correspond to established iconographical types, most of which were identified by Eva Baer: a lutanist or ʾud player; a reclining gentleman who drinks in a garden; a drinker with a servant; an entertainment including combatants with staffs and musicians; wrestlers; an offering procession of people carrying deer, fowl, and fruit; a nude nursing woman; combatant lions; confronted lancers; and peacocks with intertwined necks.[1] Drinkers, entertainers, musicians, and animals such as those shown here are among the key images in a caliphal and *Taifa* luxury arts tradition in which representations of princely leisure are seen as emblematic of the license that resides in princely authority. The closest parallels in subject matter can be found on the ivory Pamplona casket (No. 4), which dates from the beginning of the eleventh century.

Many of the Játiva basin's themes are familiar, and figural marbles have been excavated in a number of palatine settings, yet such a lively and densely populated composition is unusual in al-Andalus: Here images of animals and humans are more commonly static, encased in medallions, and woven into a jungle of foliage that serves to neutralize their vitality and verisimilitude. Recognizing the unusual energy and the prominence of the figures in the Játiva basin, scholars have struggled to find in their depictions a literal or narrative meaning. Most recently Baer has suggested that the reliefs represent "rather popular or bourgeois scenes of pastimes" and not aristocratic ones, and that the central themes of drinking and entertainment constitute "a close to life genre scene."[2] Her attempts to negotiate a meaning for the offering bearers and the breast-feeding woman within this interpretation were unsuccessful, however,[3] so the problem of the significance of the Játiva basin's subject matter deserves further scrutiny.

Though the images of princely leisure shown here are more varied and animated than those known from caliphal ivories, they seem to fit squarely within the tradition that equates depictions of elegant princely life with authority and legitimacy. The wrestlers and dancers can be considered extensions of these same themes, if we imagine the kind of entertainment described by Baer. But we must treat the subjects as emblematic—not naturalistic—in order to integrate the more unusual scenes thematically.

49

Játiva Basin

Taifa period, 11th century
Marble
16½ x 66⅞ x 26⅛ in. (42 x 170 x 67 cm)
Museo del Almudin, Játiva
A25

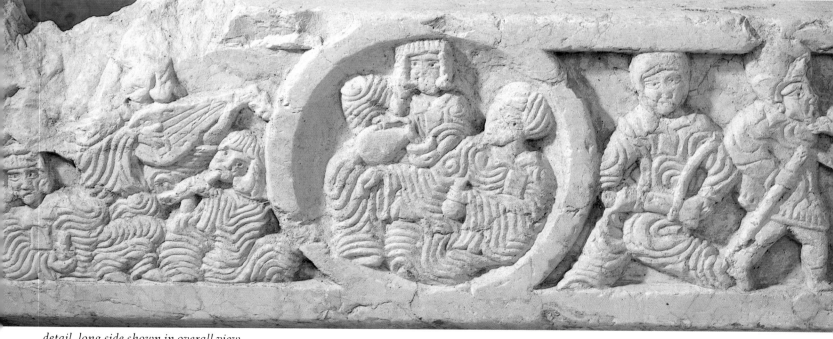

detail, long side shown in overall view

I. ARCHITECTURAL ELEMENTS 261

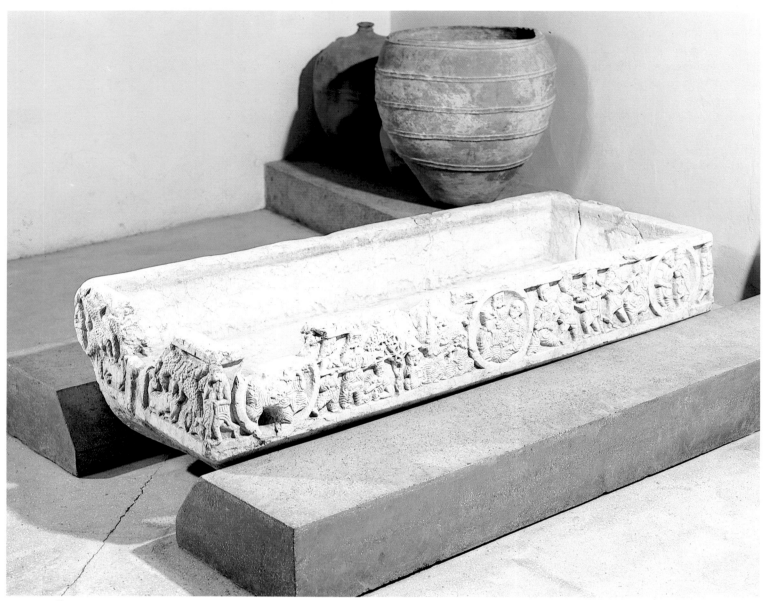

49, overall view

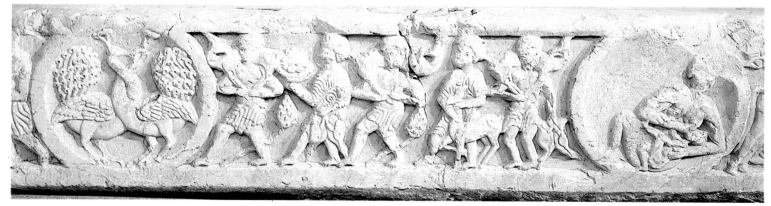

49, detail, long side not shown above

If we see the offering bearers not as peasants who bring food to a particular feast, as Baer suggests, but as part of the ancient emblematic tradition whereby such bearers represent sovereignty over a conquered land, we understand them to be part of the matrix of meaning surrounding the depiction of power and symbols of authority.

The offering bearers signal a particular thematic variation that distinguishes the Játiva basin from the luxury arts to which it is related: They refer to the land and its products. This is our clue to the meaning of the nursing mother, a fleshy and palpable nude, who in this public depiction of private pleasures can only be an allegorical image. As one of the figures enclosed by a medallion, in the manner of a *clipea* on a Roman sarcophagus, she surely represents a personification of the earth. That such an image has hegemonic implications is clear from its first Roman appearance, on the Ara Pacis,[4] which reminds us that profuse and literal figural imagery in the arts of al-Andalus is nearly always bound to abstract notions of power by virtue of its connection to the Roman and Sasanian pasts.

The combination of iconographical concerns treated on the Játiva basin suggests that the issue of authority implied by princely activities is here linked to the notion of the ownership of and dominion over the land. The cycle can be seen as growing ultimately from late Roman iconographical traditions that include images —among them offering bearers—that verify such ownership. In addition we see the strong intervention of more strictly royal themes of domination in combat shared by Sasanian and Parthian as well as Roman traditions.[5]

Such a meaning for the Játiva basin is surely reinforced by its function. This wide, low trough must have adorned the garden of a palace or villa: It is difficult to imagine the combination of a large, awkwardly shaped basin with such expensive, richly carved material in any other context. This setting would link the basin's iconography of sovereignty over the land with notions, which have emerged in recent studies by D. Fairchild Ruggles, that demonstrate that visual mastery over a garden and its fountains was evocative of political mastery over the land in al-Andalus.[6]

The early eleventh-century date commonly given to the Játiva basin accords well with this revised iconographical profile. In its strong connections with standard caliphal iconography yet lively divergence from traditional style, it can be seen as a work from the *Taifa* period, perhaps from the palace of a landowner associated with the court in Játiva. In fact, the basin's vast stockpiling of princely symbolism reminds us that many *Taifa* kingdoms used patronage and the arts to sustain an image of rulership far more ambitious than that which their military might could actually maintain.

JDD

1. Baer 1970–71, pp. 143–44.
2. Ibid., pp. 164, 148.
3. Ibid., p. 154, and "For the time being ... we can only suggest that the nursing woman has perhaps to be interpreted as part of the everyday rural atmosphere so preponderant in the other scenes, further stressing the popular character of the festivities shown in these reliefs" (p. 156).
4. Strong 1937, pp. 121–25.
5. Concerning a late antique "landowner's cycle" of iconography, see Grabar 1968, pp. 51–54; concerning Sasanian connections, see Kühnel 1960, p. 181.
6. Essay in this catalogue, pp. 163–71.

LITERATURE: Gómez-Moreno 1951, pp. 274–76, 278, figs. 328–30; Baer 1970–71, pp. 142–66; Sarthou Carreras 1947, pp. 8–10.

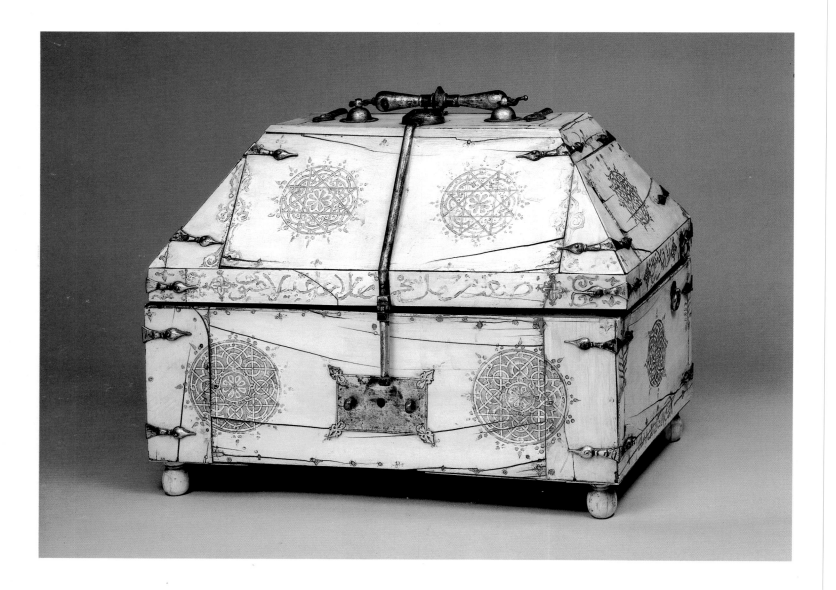

50

Casket

Almohad period, late 12th century
Ivory, wood, and gilt copper
16⅛ x 15 x 5½ in. (41 x 38 x 14 cm)
Instituto de Valencia de Don Juan, Madrid
4864

*T*his rectangular casket with coffin-shaped lid has a wooden frame overlaid with ivory plaques and rests on four spherical supports. Gilt copper trimmings, two at each angle except on the band with the inscription, anchor the plaques by means of rivets. A large lance with hinge articulation serves to hold the lid and connect it to the lock. The top of the lid has a fitted handle with a central knob for grasping.

Large circles with eight-pointed stars and engraved rosettes, with a variety of traceries, decorate the faces. Palm trees and other vegetal motifs embellish the edges where the ivory plaques meet. On the band that forms the lower portion of the lid, running along all four sides, a cursive inscription reads:

صنعت من جمل سحر بالاعاجيب لاحتوى وميز البيض
الرغائب وكنت توشحت من روض من زهري

With beauty I did wonders that are radiant all the while I was surrounded by gardens and embellished with plants and flowers.

The lower portion of the short sides bears the inscription اليمن والسعادة (*happiness and prosperity*).

This piece is significant for its thematic relationship to textiles from al-Andalus, some of them later in date. Examples of such textiles include the Las Navas de Tolosa banner (No. 92), currently located in the Monasterio de Santa María la Real de Huelgas in Burgos, and those of the cathedral in Toledo, the basis for the dating proposed here. J Z

LITERATURE: Cott 1939, no. 138, pl. 58; Ferrandis 1940, no. 97, pp. 216–17, pl. LXVI.

A rectangular base and a coffin-shaped lid characterize this richly decorated casket. All the exterior faces are inlaid with ivory, which creates a dramatic contrast with the black wood underneath. The marquetry decoration is distributed on the body and on the lid in a series of circular ornaments featuring deer, bulls, peacocks, lotus flowers, addorsed lions, and a tree of life motif in ivory against black backgrounds. Gilt paint generates relief in the figures and highlights the inscription. An inscription in Naskhī in a narrow register has been executed in the same system of ivory on a black ground.

The bottom of the casket has ornamental plasterwork decoration.

The inscription, in a cartouche derived from the Roman *tabula ansata*, reads بديع مسكني دار الخلافة . . . (. . . *and my house is the seat of the caliphate*).

JZ

LITERATURE: Ferrandis 1940, p. 262, pl. LXXXII, no. 163 (text refers erroneously to pl. LXXXIII); Zozaya 1986.

Tortosa Casket

Almohad period, late 12th–early 13th century
Ivory, wood, and gilt copper
9½ x 14⅛ x 9½ in. (24 x 36 x 24 cm)
Tesoro de la Catedral de Tortosa

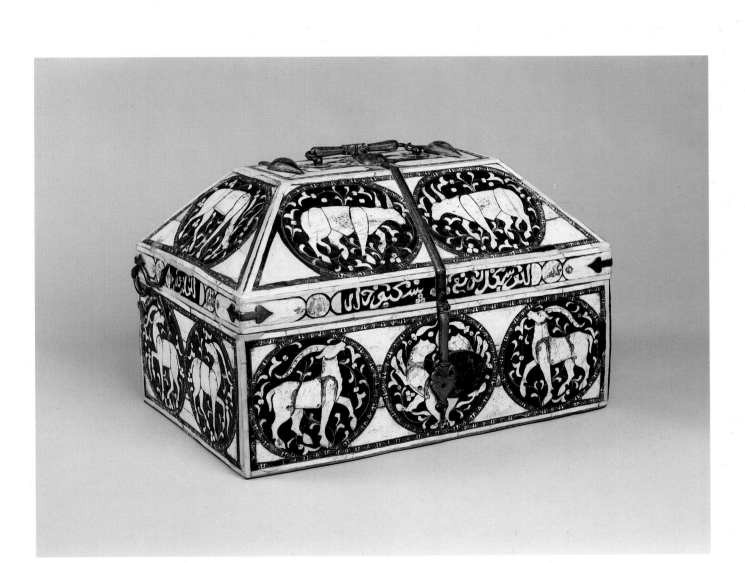

52

Pyxis

Naṣrid period, late 13th century
Ivory, silver, paint, and gold leaf
H. 3¾ in. (9.4 cm), diam. 4½ in.
(11.5 cm)
Cabildo Metropolitano de
Zaragoza

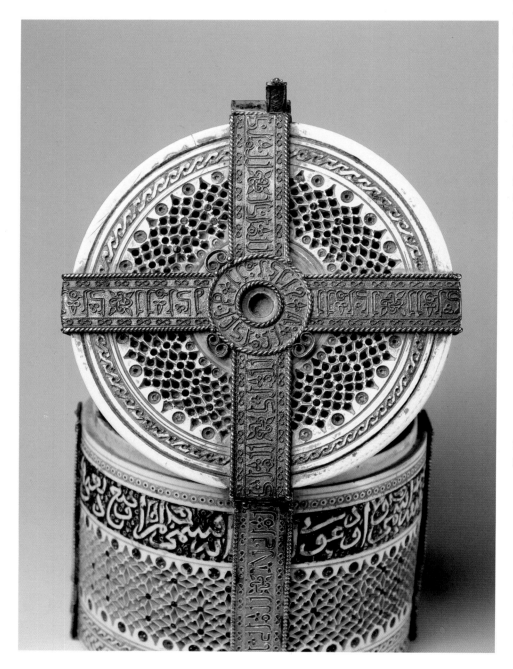

In this ivory pyxis with a flat lid, ornamentation is established in four major and two lesser registers. The upper register, consisting of the lid, and the lowest form a frame for the remaining zones. The widest band has an abstract sculpted decoration that features a *sebka* design, a typical late thirteenth-century Hispano-Islamic lacework motif that generates a repetitive pattern. The fourth major register, half the width of the lacework zone, is a bold epigraphic band with a Naskhī inscription that is an intriguing poem. These wide registers are separated and enframed by torus molding, bands of little circles, and bands of interlace called *cordon de la eternidad*, or eternal ribbon, an endlessly repeating interlace that may be composed of two to four strands. The painted background of the carved decoration is green, which carries allusions to vegetation and heavenly light and also suggests a kind of rich cloth with paradisiacal associations. Accents of gold leaf also evoke richness and paradise.

The piece has a silver fitting: two silver bands that crisscross the pyxis from top to bottom and strengthen it. One band holds a swivel, the other a lock, a system commonly used with this type of pyxis in al-Andalus. The fitting is ornamented with a filigree of bows and other designs, as well as with the inscription *al-mulk*, the title of the sixty-seventh chapter of the Qurʾan. *Al-mulk* can mean dominion, or kingship. Here it implies a fuller phrase that is part of the chapter's first line, "Blessings are in the hands of the One who has power."

A date of the late thirteenth century and a Spanish provenance for this pyxis seem assured by the inscription, the *sebka* design, and the typical fitting.

The poem on the body refers to the object itself, as often happens in al-Andalus, whether a small work of art or an architectural monument is involved:

باحق جن الحقيقة اسمي
واودعوني ان الأمانة قسمي
لم أضع وديعتي طول عمري
و بهذا العلو أعلا النابن إسمي
لمن صلح إلا المليح

*Truth is in me like something stored in
 a pyxis
and they say faithfulness is my share in life.
Never did I betray this confidence [in me].
Thus my name soared so I serve only the
 great.* J Z

LITERATURE: Migeon 1927, vol. 1, pp. 358, 360, fig. 163; Ferrandis 1940, no. 7, p. 125, pl. v.

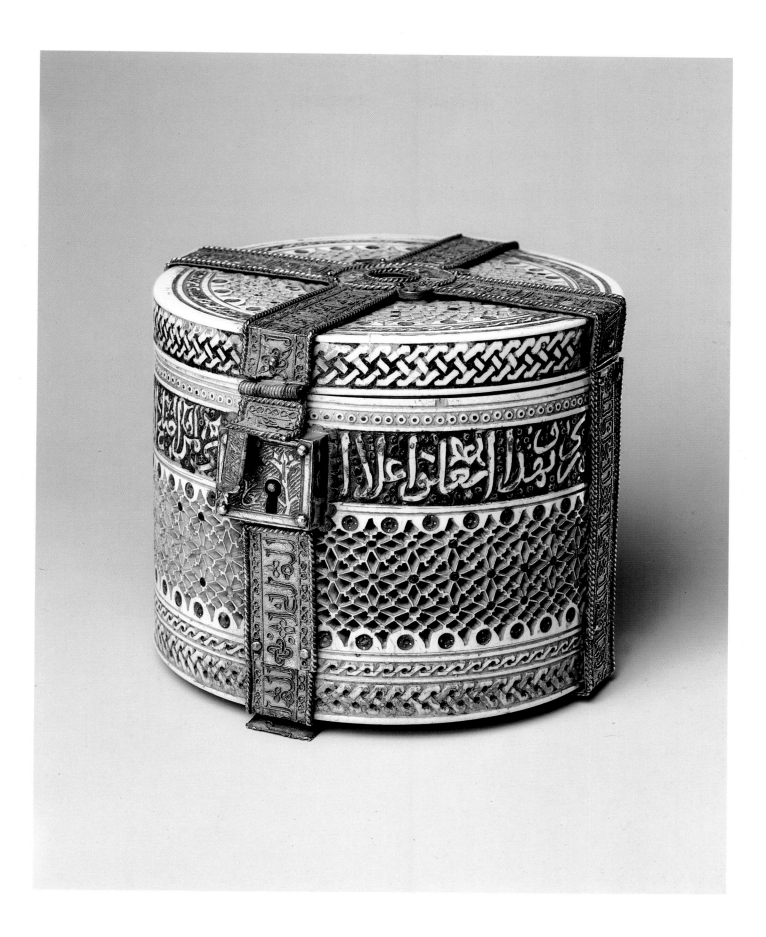

Writing Desk

Naṣrid period, 14th century
Wood, ivory, metal, and pigment
8 x 17⅜ x 11⅛ in. (20.2 x 44 x 28.3 cm)
Museo Arqueológico Nacional, Madrid
72/105 2

\mathcal{B}oards of pine, one for each side and the lid, form this rectangular box. The lid opens up to reveal a polygonal interior, which has compartments in the upper third, on the sides, and at the bottom, the first two topped with pivot lids whose fronts have rectangular bays. The one on the bottom seems to be a support, for although it has a gudgeon, which implies a lost lid, it never had a bottom. Because it is longer than the others, it has two bays instead of one. These spaces were intended to hold writing materials.

The exterior trimmings of simple folded bronze plates with incised decoration on the corners are riveted to the support. On the lid, two long hinges flank the handle, which is of a commonly used type, with a small decorative polygon where the fingers can be placed. Two handles are located on the sides, their profile forming volutes. Another trimming on the front of the

desk indicates the place for the lock. All the trimmings were made especially for the desk.

The box is decorated with marquetry, either incised or painted on the wood. The painted marquetry is located in the areas most hidden from view—that is, the bottom and interior —the incised in the most visible areas. The four outer sides carry a central decoration of rather complex eight-pointed stars in white, green, and dark and light brown. Four are grouped tangentially in a square on the sides, and ten on the front and back in rectangles. The intermediate spaces are filled with one or four four-pointed stars. On all sides the star panels are surrounded by a red fillet and by a number of consecutive enframing devices: diamonds, squares, dentate merlons, and *cordons de la eternidad*, or endless ribbons; on the short sides the *cordon de la eternidad* occurs twice. The

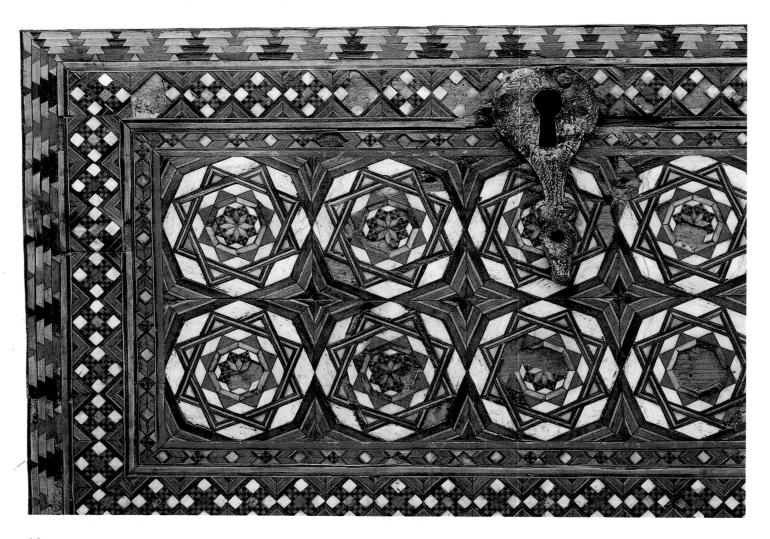

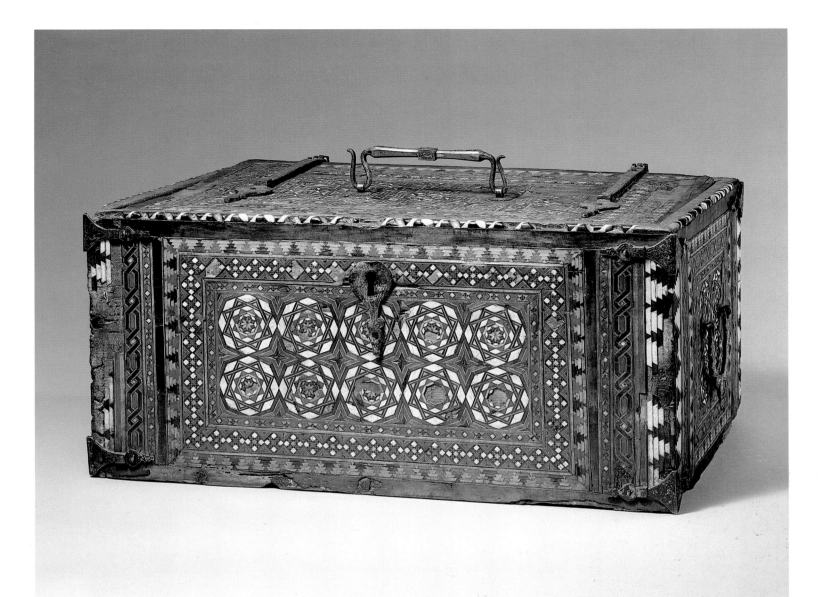

corners feature merlon motifs in white bone and deep chestnut inlay, creating a figure-ground relationship that can be read in two different ways. A similar program dominates the front and back, which also show a frieze of squares in intarsia of bone and alternating green and red centers. The edge has a molding of bone and ebony forming a deteriorated *cordon de la eternidad*.

The decoration of the lid uses slightly different elements in a slightly different configuration. A panel of six-pointed stars distributed in circles is framed in a geometric band, edged with six-pointed stars in bone with a frame, a band of *cordon de la eternidad*, merlons, and a border. The interior of the box has connected six-pointed stars. The various spaces are related by means

of a geometric *cordon de la eternidad*, and the interior trimmings have engraved decoration.

Although comparable in style, the present desk is larger than the one from the cathedral in Jaén.[1] It is possible that this desk is an immediate predecessor of what may be the last furnishing of this type to be used in the Arab style: the casket now in the Hispanic Society of America in New York.[2] J Z

1. Pavón Maldonado 1984, pp. 361–66, fig. 7a.
2. Hispanic Society of America 1954, pp. 118, 128, ill.

54

Monzón Lion

Almohad period, 12th–13th century
Bronze
H. 12⅛ in. (30.8 cm)
Musée du Louvre (Section islamique),
Paris
7883

Fortuny, the Spanish painter-collector, found the Monzón lion near Palencia. It was discovered in a ruined Islamic castle-fortress that had fallen into Christian hands at the beginning of the eleventh century.[1] The lion decorated a fountain in the castle. Fountains played an important part in the Hispano-Islamic environmental aesthetic, as is exemplified in the Patio de los Leones at the Alhambra. Here, twelve lions, which date to the eleventh century, are arranged, facing outward, around a fountain. Each animal's mouth contains a spout from which a stream of water cascades into a shallow pool at its feet.

The production site and patron of the Monzón lion, as well as the original building in which it was used, are unknown: The Kūfic inscription that adorns the sides of the sculpture in the manner of a ṭirāz textile merely expresses typical and generic good wishes for the owner. Such inscriptions commonly embellished secular luxury items like ivories, textiles, and marble fonts throughout the Islamic world during the caliphal, fitna, and Taifa periods.[2]

Trade in luxury arts of diverse mediums was one of the primary means by which stylistic innovations were diffused throughout the medieval Islamic and western world.[3] For example, bronze sculptures similar to the Monzón lion enjoyed a certain fashion in Fāṭimid and Ayyūbid Egypt, with which Spain had an active commercial relationship.[4] The various mechanisms through which the transfer of aesthetic ideas occurred have long been a favorite subject of speculation among scholars. Traveling artisans from important cultural centers may have been responsible for some of the interchanges that took place. More often, however, provincial patrons, eager to exhibit cosmopolitan taste, seem to have commissioned local artisans to make objects that followed available prototypes from major cities. These artisans created products in regional idioms that were similar enough to the original models to be recognized by contemporary viewers as related to them.

Lions were associated with courtly imagery and with kingship in the repertoires of all regional decorative styles, but they appear to have enjoyed a special popularity in Islamic Spain. Other animals, such as griffins, peacocks, and stags, had a similar significance for the informed contemporary audience. These meanings implicitly augmented the prestige of the possessors or patrons of objects in the form of such animals.

In light of the place in which it was found, the Monzón lion may have been owned or even commissioned by a Christian. If this is so, its possession would have had additional significance: the appropriation of power and prestige through the ownership of the courtly art of the Islamic rulers of al-Andalus.

The Monzón lion exhibits many stylistic characteristics common to other bronze animal sculpture currently assigned a Spanish provenance. The lion's face and body are entirely covered with incised ornament, and the elements that indicate the texture of the mane and coat are extremely stylized. Such decorative motifs, like those of the Córdoba stag and the Pisa griffin (Nos. 10, 15), for example, are related to textile design. The lion, the stag, and the griffin all appear to be draped with tapestry mantles. Finally, the lion, the stag, and the griffin, as well as two bronze peacock aquamaniles to which the latter object is probably related (see No. 15), share rigid stance and simple, volumetric body parts. These common features constitute broad stylistic criteria that perhaps serve to define a distinctly Hispano-Islamic school of metal sculpture with a production that appears to have substantially influenced Mediterranean taste. C R

1. Migeon 1927, vol. 1, p. 382, fig. 191. Although Migeon says it is Fāṭimid, most scholars who have written subsequently agree that the Monzón lion is Spanish.
2. For a good survey of the luxury arts of this period, see Gómez-Moreno 1951.
3. The role of textiles—the most easily portable of the luxury arts—and ceramics in this process cannot be overestimated. A comparison of a Spanish silk textile of the eleventh or twelfth century that depicts two confronted harpies (Migeon 1927, vol. 2, p. 322, fig. 421) to the Monzón lion illuminates the relationship between textile and metal styles. The vegetal decoration that articulates the body parts of the harpies and the lion is strikingly similar, and the tails of all the beasts are identical.
4. For Fāṭimid and Ayyūbid pieces that resemble the Monzón lion, see Sourdel-Thomine and Spuler 1973, fig. 195; Fehérvári 1976, pls. 9a, esp. 9b, nos. 27, 28. Both the examples in Fehérvári are attributed to Spain or Sicily. They are sufficiently different from the Monzón lion to have been produced in Sicily, and it is certain there was frequent commercial and cultural interchange between Spain and Sicily at the time these sculptures were made.

LITERATURE: Kühnel 1924, p. 73, pl. 121; Migeon 1927, vol. 1, p. 382, fig. 191; Gómez-Moreno 1951, p. 336, fig. 396a; Paris 1989, no. 127, p. 154.

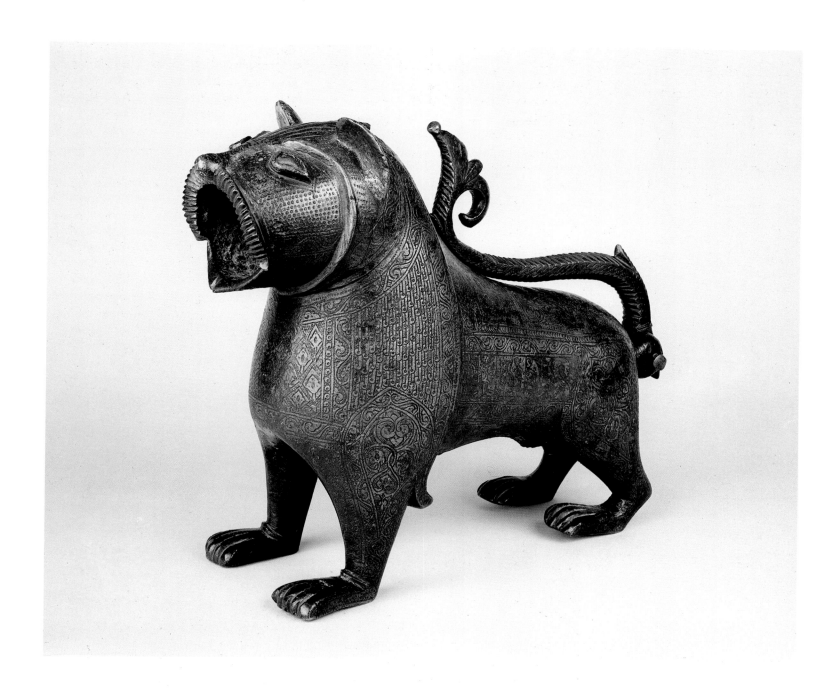

55

Lamp from the Qarawiyyīn Mosque, Fez

Almohad period, late 12th–early 13th
century
Copper alloy
Diam. 28⅜ in. (72 cm)
Qarawiyyīn Mosque, Fez

A modest oratory in its original form, from the third to the ninth century, the Qarawiyyīn mosque at Fez continually received additions and major acquisitions, such as its minbar, ⁽anza, or auxiliary mihrab, and lamps, and became one of the most celebrated mosques of the Moslem west. Among its enhancements were numerous lamps and bells converted into lamps; the bells had been taken from churches on the Iberian Peninsula during the propagation of Islam by Muslim dynasties —the Almoravids, the Almohads, and the Marīnids—as signs of victory over the Christians[1].

According to Abdalhadi al-Tazi, the number of lamps possessed by the Qarawiyyīn mosque once totaled one hundred thirty;[2] they were hung at the entrance doors, in the central nave, alongside the minaret, and in other naves and transepts of the oratory. Only ten remain inside the mosque, hung from the cupolas of the central nave; another may be found by the side of the Bāb al-Sammaʾyn, one of the mosque's

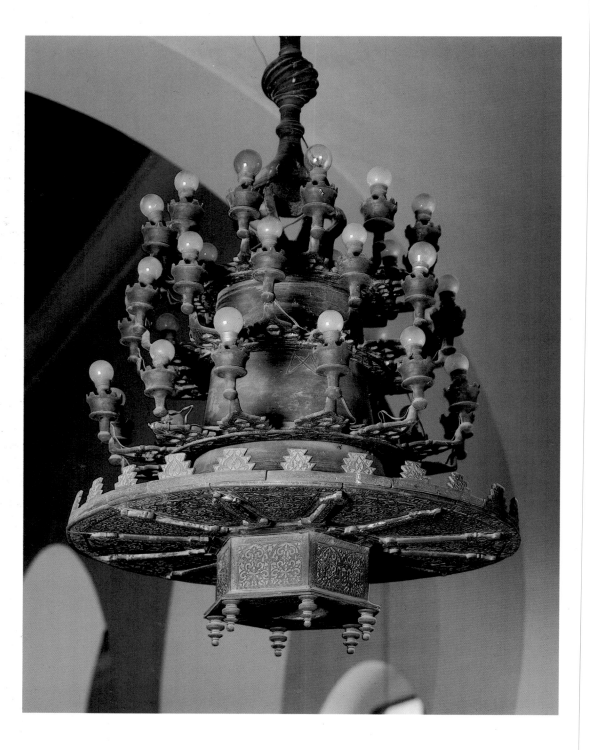

gates. The largest and richest of these lamps dates from the Almohad period and adorns the ribbed cupola of the axial nave (the sixth, counting from the ʿanza).

The lamp from the Qarawiyyīn mosque seen here is an example of those fixtures made from converted bells. The bell used in this lamp also dates from the Almohad period; the chronicler Ibn Ṣāḥib al-Ṣalāt reports in his work *Tarib al-Mann bi-l-Imama* that the Almohads, re-entering the Spanish town of Ubeda in 1180 (A.H. 576), took nine bells, which were distributed among the mosques of Morocco, in particular the Qarawiyyīn.[3]

Relatively small in size, this bell lamp is admirably executed, distinguished especially by the middle section made up of lamp holders arranged horizontally and by a hexagonal base richly ornamented with floral and epigraphic motifs. Although the bell dates from the Almohad period, the shackle, decorated at the top with a rosette with falling petals followed by two chiseled balls and a third corded ball, is similar to those of Marīnid lamps, as is the underside of the base.

The middle portion of the lamp is composed primarily of three graduated horizontal circular disks to which the holders originally supporting the glass cups for oil are fixed.[4] Below these three disks is a larger disk measuring seventy-two centimeters in diameter that is encircled by a series of crenellations in three steps, each four centimeters high; the faces of the crenellations are covered with chiseled symmetrical bilobate palms. The underside of the large disk is divided into twelve sections overlaid with floral decoration and divided by arrow-shaped strips nineteen centimeters in length. Along each arrow runs a wavy line set with bilobate palms; the arrowheads end in the shape of a trilobate flower topped by a circle that touches the outer edge of the disk.

The hexagonal base of the bell measures twenty-six centimeters in diameter; each face is adorned with two twin arches enclosing an inscription mingled with plant designs. The underside of the base is cambered in the middle with a shallow, smooth dome, around which are epigraphic bands punctuated with lamp holders.

A E-H & L M A

1. See the essay by Jerrilynn D. Dodds in this catalogue, p. 18.
2. Al-Tazi 1972, vol. 1, p. 80.
3. Ibid., vol. 2, p. 330.
4. These glass cups have been replaced with electric light bulbs.

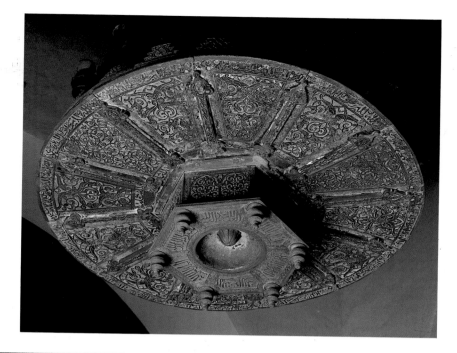

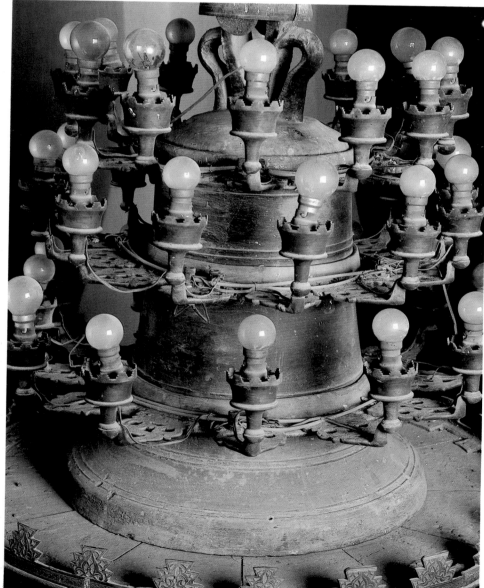

56

Brazier

Almohad period, early 13th century
Bronze
H. 10¼ in. (26 cm)
Museo Arqueológico Provincial
de Córdoba
D. 92/2

This six-sided bronze brazier from Córdoba stands on six legs. The lower portions of the legs, cylindrical and of solid bronze, have horizontal incisions on the outer sides. A boss accentuates the middle of each leg, and small spheres act as feet. The legs mark six beveled corners on which the brazier's bottom rests. The corners are secured with prominent rivets. A finial sprouts from each hollow corner as if it were a prolongation of the leg below. The finials alternate with diminutive crescent moons that crown each of the brazier's sides.

These lateral faces are formed of sheets, each eleven centimeters high and twelve centimeters long. Their decoration is structured in three bands: The lower, the widest, is filled with four epigraphic cartouches framed by garlands of acanthus flowers. The Kūfic inscription repeats the phrase بركة كاملة (*total blessing*). An interesting anomaly is that on one of the two sheets to which the half-circle handles are attached, the cartouche is replaced by a motif of two confronted hares. In the upper portion of this cartouche is the inscription عافية دائمة ونعمة (*perpetual health and [divine] grace*).

The second band contains a pierced Kūfic epigraphic decoration that says بركة الحميد لمالكه (*The blessing of the Exalted One upon the possessor*). The upper band is formed of a pierced decoration of pyramidal merlons that call to mind the crenellations of the Great Mosque of Córdoba, and the body is ornamented with an incised vegetal motif.

The lower sections of four of the corners feature incised vegetal ornament, and the remaining two display a vertical inscription that repeats those on the lower cartouches: بركة كاملة (*total blessing*). The interior of the brazier is formed by a sheet of bronze held in place by crossed ribs that originate in the seams of the lateral faces.

This brazier, along with others showing similar characteristics, is now in the Museo Arqueológico Provincial de Córdoba.[1] The existence of polygonal braziers and trays has been documented in a group of bronzes found in Denia.[2] Its precedents are clearly Persian,[3] and they relate specifically to twelfth-century Iranian silver trays[4] that can be identified in miniatures as palatine pieces.[5] RAR

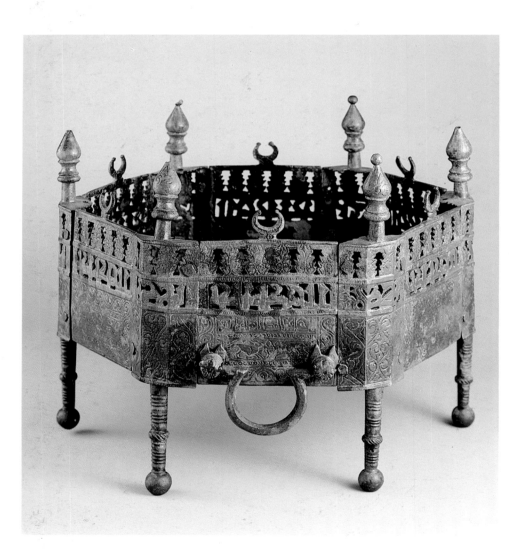

1. Santos Jener 1955–57, pp. 190–93, pls. xxxv-1, xxxvi.
2. Azuar Ruiz 1989.
3. Allan 1982.
4. Allan 1976–77, p. 20, figs. 66, 67.
5. Geneva 1985, pls. 57, 89.

LITERATURE: Santos Jener 1955–57, p. 191, pl. xxxv-2, p. 191; Torres Balbás 1957b, fig. 616, p. 761; Allan 1976–77; Allan 1982; Geneva 1985; Ocaña Jiménez 1985, figs. 4–11, pp. 410–12; Córdoba 1986a, no. 134, p. 88; Córdoba 1986b, no. 1, fig. 1, p. 138; Azuar Ruiz 1989.

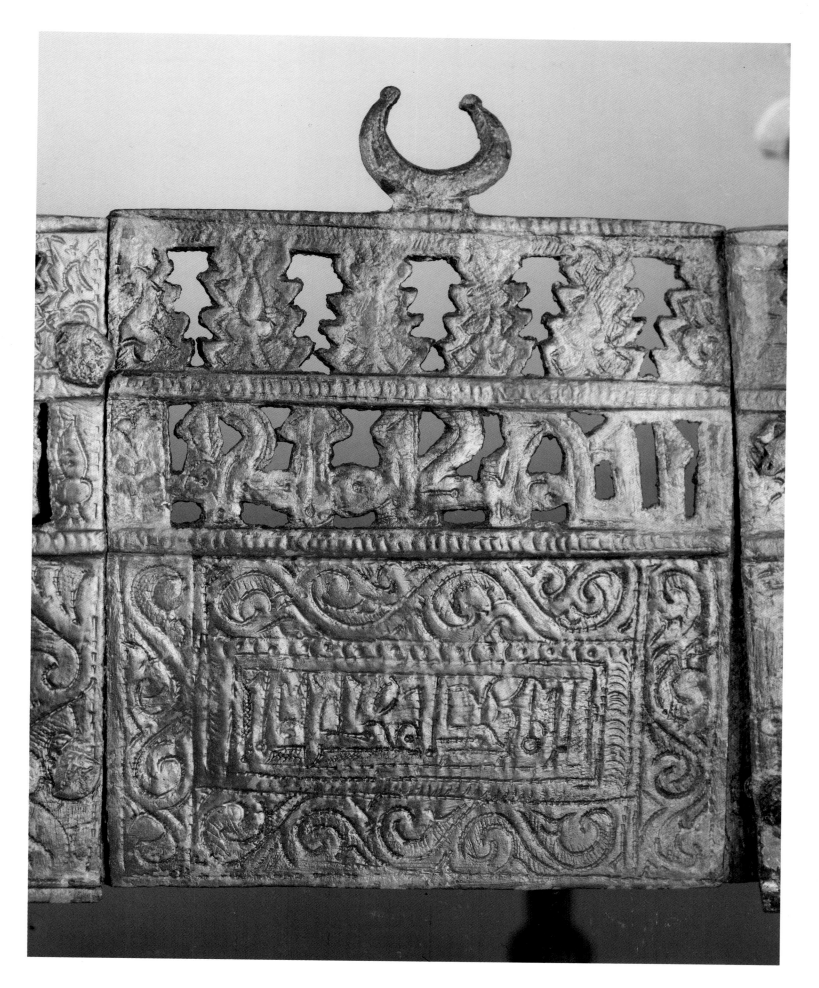

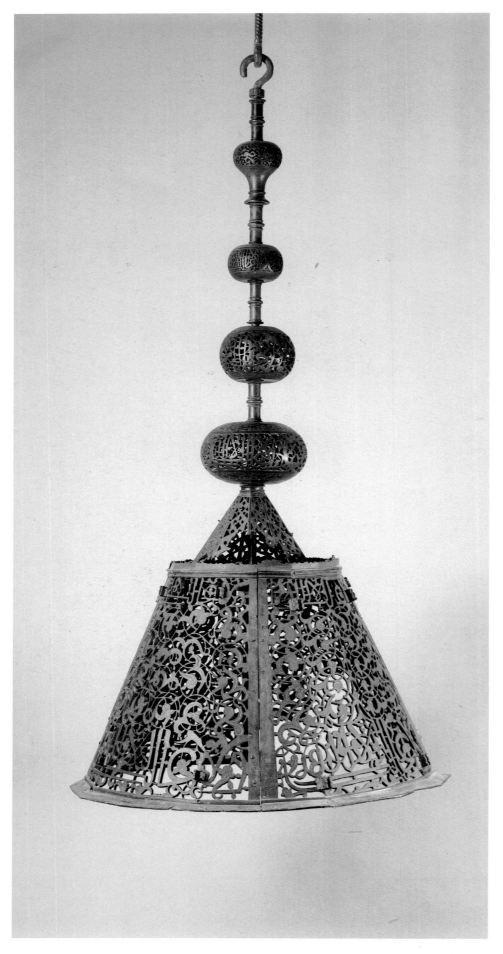

Lamp

Naṣrid period, 1305
Bronze
H. 90⅝ in. (230 cm)
Museo Arqueológico Nacional, Madrid
50.519

Royal workshops of the Naṣrid court
produced this lamp for the mosque of the
Alhambra. When Granada was conquered in
1492 (A.H. 898), it was confiscated and became
part of the treasury of Cardinal Cisneros, along
with a bucket dating from the late fourteenth
century (No. 59). When the cardinal died in
Alcalá de Henares, these objects, which are
mentioned in his will, were found in his palace.
At the end of the nineteenth century, they came
to enrich the holdings of the Museo Arqueológico
Nacional in Madrid.

The lamp is composed of six elements aligned
on a central shaft. The four superior elements
are graduated spheres, arranged from the small-
est to the largest. Each features a wide central
band pierced with an epigraphic, Naskhī-type
emblematic inscription surrounded by stylized
vegetal decoration. These spheres are followed
by a pyramidal piece with eight sides soldered
into a single unit, of which two faces are incom-
plete. The vegetal decoration runs vertically.

Attached to the pyramidal section is the most
important and most striking piece of the lamp:
a large, four-sided prism fifty-five centimeters
high, with a diameter at the base of eighty
centimeters. All four faces are intricately
pierced, with a vertical vegetal motif and two
epigraphic cartouches in the upper and lower
parts of the sides that bear the name of the
Naṣrid emir Muḥammad III and proclaim:
ولا غالب إلا الله تعالى (There is no Conqueror but
God. Glorify his name!).

On the lip of the lower rim, an inscription
incised in Naskhī dates the casting of this
extraordinary piece:

بسم الله الرحمن الرحيم صلى الله على سيدنا محمد وآله
وسلم تسليماً أمر مولانا السلطان الأعلى المؤيد المنصور
العادل السيد [متعد] البلاد وحد سيرة العدل بين العباد
الأمير أبو عبد الله إبن مولانا أمير المسلمين أبو عبد الله
إبن مولانا الغالب بالله المنصور بفضل الله أمير المسلمين
أبي عبد الله أعلى الله تعالى ... فضله سبحانه
بخالص نية وصادق يقين وكان ذلك في
شهر ربيع الأول المبارك في عام خمسة وسبعمائة

In the name of God the Merciful, the Compassionate. May the peace and blessing of God be upon our master Muḥammad and upon his progeny. Commanded by our lord, his majesty the Sultan, who is the favored, and the victorious, the just, and noble, the conqueror of cities, and the ultimate in just conduct among [God's] servants, Emir of the Muslims Abū ʿAbdallah, son of our lord, Emir of the Muslims Abū ʿAbdallah, son of our lord al-Ghālib-illāh, the victorious by the grace of God, Emir of the Muslims, Abū ʿAbdallah, may the Almighty favor [him] beneath it, to him whom my light illuminates with its splendor and care of its... with wholesome intent and absolute conviction. And this was in the blessed month of Rabīʿ, the first, in the year 705 [A.D. 1305]. Glorify his name![1]

In this opulent piece from the beginning of the fourteenth century, as in the Naṣrid bucket (No. 59), a strong Seljuk influence is already visible in the vegetal decoration; there is no question, however, that it originated in Granada.

<div align="right">R A R</div>

1. Amador de los Ríos 1873, pp. 465–91.

LITERATURE: Amador de los Ríos 1873; Kühnel 1924, p. 73, pl. 119; Torres Balbás 1949, p. 299, fig. 250; London 1976, no. 175, p. 168.

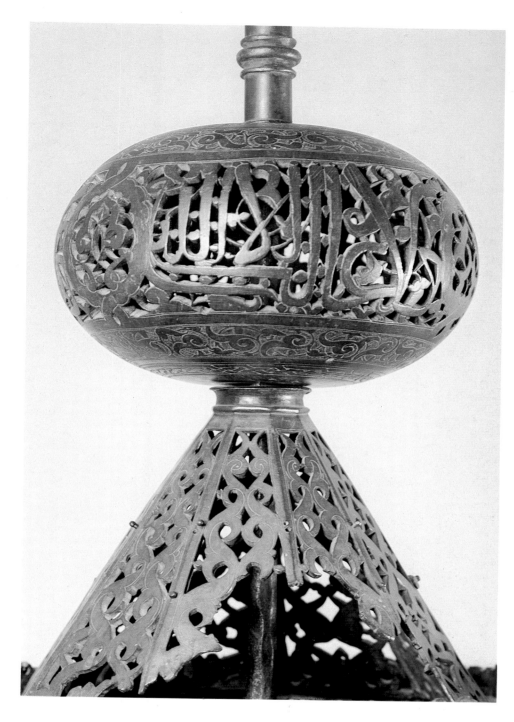

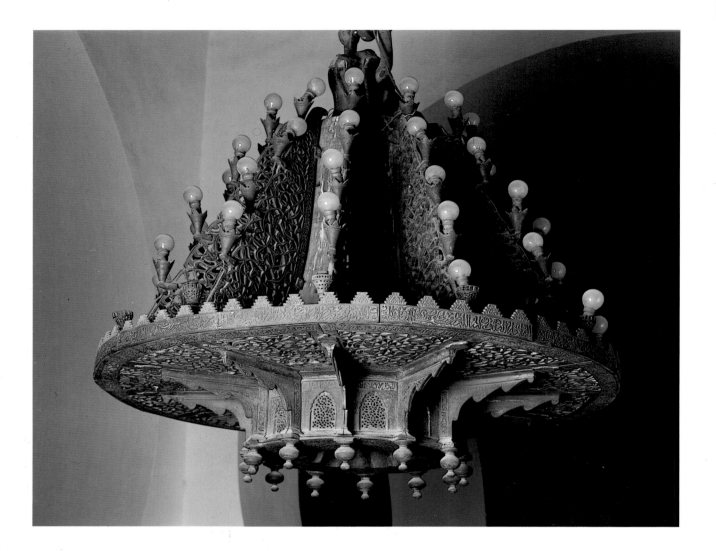

58

Lamp from the Qarawiyyīn Mosque, Fez

Marīnid period, 1333–37
Copper alloy
Diam. 44⅞ in. (114 cm)
Qarawiyyīn Mosque, Fez

*F*ortunately, the information we have concerning the history of this bell and its conversion into a lamp is more complete than that for the previous example. The bell itself weighed ten quintals[1] and came from Jabal al-Fath (Gibraltar), reconquered in 1333 (A.H. 737) by the Marīnid prince Abū Mālik, son of Abū al-Ḥasan ʿAlī, sultan of Morocco (r. 1331–51 [A.H. 732–52]).[2] Its conversion to a lamp was supervised by Aḥmad ibn Muḥammad ibn al-Ashqar al-Ṣanhāgī, and it was installed in the Qarawiyyīn mosque in Fez in 1337 (A.H. 737); the cost of the bell was financed out of funds from the Qarawiyyīn *hubus*, or pious foundations. The completed fixture still hangs under the third cupola from the ʿanza, where it was placed in the fourteenth century.

The shackle used to hang the lamp is ornamented with a hexagonal prism and balls of varying diameters. The body of the lamp is curious; the lamp holders are mounted on twelve vertical panels adorned with openwork arabesques that surround the actual bell and form a truncated pyramid. This structure rests on a large disk one hundred fourteen centimeters in diameter. Along the outer rim of the disk runs an inscription in cursive script, surmounted by a series of crenellations embellished with trilobate flowers.

The underside of the disk is divided into twelve sections joined by supports in the shape of flattened ovals; these rings are largely masked by brackets attaching the disk to the base of the bell. Labyrinthine pierced floral motifs adorn the twelve sections of the disk; stems intersect and intertwine continuously, terminating in incised trilobate motifs.

The dodecagonal base of the bell is forty-seven centimeters in diameter; the face comprises twelve brackets enclosing polylobate arcs filled in with openwork floral decoration. The bottom of the base is hollowed in the center to

form a shell, and pendant lamps are attached to each vertex.

With the exception of the unusual body, the bell was modified in the traditional manner of Marīnid lamp craftsmen. The dodecagonal base is reminiscent of the chandelier in the Jadīd mosque in Fez.[3] Other elements of the base, however, such as its arcs, brackets, and pendants, resemble those of a chandelier in the madrasa al-ʿAṭṭārīn at Fez[4] as well as those of a chandelier in the Great Mosque at Taza[5] and the great Almohad-period lamp of the Qarawiyyīn mosque.[6]

Al-Jaznāʾī, the author of *Zahrat al-ʾĀs*, a history of the city of Fez, mentions an epigraphic text that was to have been engraved on the bell. Close examination, however, reveals no trace of any such text. Mention of this inscription in *Zahrat al-ʾĀs* thus presents some problems: Has it vanished in the course of the centuries, or was it simply never executed? The available documents hold no answer to this question.[7] The existing inscriptions on the bell include verses from the Qurʾan and various religious formulas. A E-H & L M A

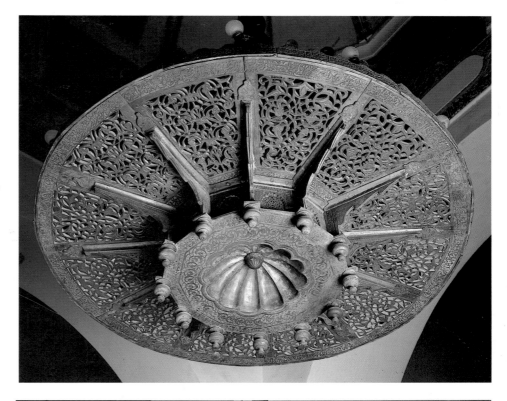

1. Al-Jaznāʾī 1923, p. 146.
2. On the retaking of Gibraltar, see ibid., p. 146, and Ibn Khaldūn 1982, vol. 4, p. 217.
3. Aouni 1991.
4. Ibid., p. 289. This madrasa, or school, was built as the perfumer's madrasa; the fixtures date from the time of Abū Saʿīd ʿUthmān, 1325 (A.H. 725).
5. Terrasse 1944, pl. 74.
6. Terrasse 1968, pl. 104.
7. The supposed epigraphic text as presented in Al-Jaznāʾī 1923, p. 147, is worth reproducing here:

> Praise to God Alone. This holy bell was ordered emplaced by the lord of the Muslims, defender of the faith Abū al-Ḥasan ʿAlī, son of the lord of the Muslims, combatant in the Way of the Lord of Worlds, Abū Yūsuf Yaʿqūb ibn ʿAbd al-Ḥaqq, may God assist their power, may He make joyous their reign and their time.

> This is the bell found at Jabal al-Fatḥ, God keep it, conquered by the help of God and with His aid by the lord of the Muslims Abū al-Ḥasan, may God assist and give him victory, in aid of his son the lord Abū Mālik al-Saʿīd, and this at the time when our master (Abū al-Ḥasan), whom God assist and give him victory, besieged the city of Sijilmasa.

The siege of Sijilmasa, the great medieval caravan city in southeastern Morocco, had lasted a year. In taking possession, Abū al-Ḥasan ended the rule of his brother and rival Abū ʿAlī, which had lasted for some years.

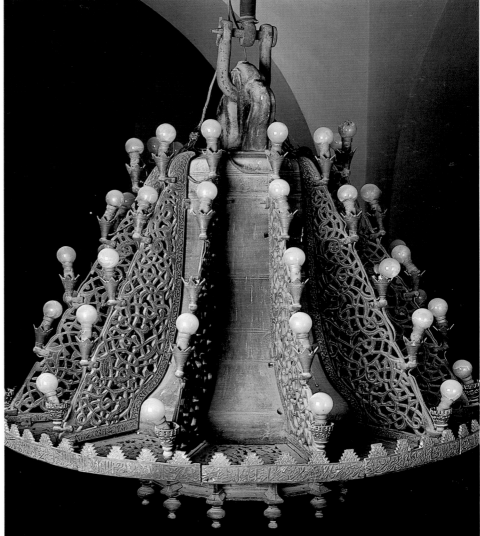

Bucket

Naṣrid period, 2nd half of 14th century
Gilt bronze and niello
H. 6¾ in. (17 cm)
Museo Arqueológico Nacional, Madrid
50.888

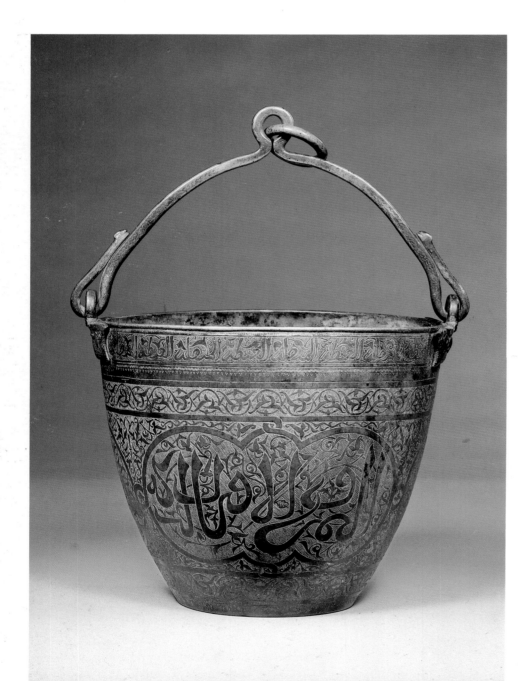

*D*ecorated with niello on a gilt background, this bronze bucket has a flat base, rather rounded open walls, and a slightly thickened rim. Two fittings in the rim are riveted where the handle begins. The handle has typical up-turned ends and in the center narrows to form a loop, which contains a metal ring. In its shape, it bears little relation to Hispano-Islamic precedents, which typically are more cylindrical and broad-based. Examples of the latter can be seen in the Instituto de Valencia de Don Juan in Madrid.

The principal decorative motif takes up the major portion of the body and is framed top and bottom by two narrow bands of stylized leaf garlands on the gilt background. On this central band, two circles containing six-pointed stars sit between two large cartouches containing epigraphic decoration.

The cartouches feature the same phrase, split in half, as follows: اليمن والاقبال (*good fortune and prosperity, [God's] blessing upon you*); و بلوغ لآمال [لصاحبه للمسلمين] (*and the fulfillment of all desires*).

The decoration of the bucket is finished with a narrow epigraphic band on the rim containing the inscription الغبطة المتصلة [لصاحبه] (*continued prosperity for the owner*). The upper face of the handle displays two serpents with intertwined heads.

Although the decorative treatment shows obvious Seljuk influence, evident in the vegetal stylization, the inscription reproducing the emblem of the Naṣrid monarchy, as well as the object's delicacy, opulence, and meticulous decoration, leads to the conclusion that it was crafted in the royal workshops. RAR

LITERATURE: Amador de los Ríos 1876, pp. 467–81; Kühnel 1924, pl. 188 (top); Torres Balbás 1949, p. 229, fig. 247; London 1976, no. 176, p. 169; Domínguez Perela 1987.

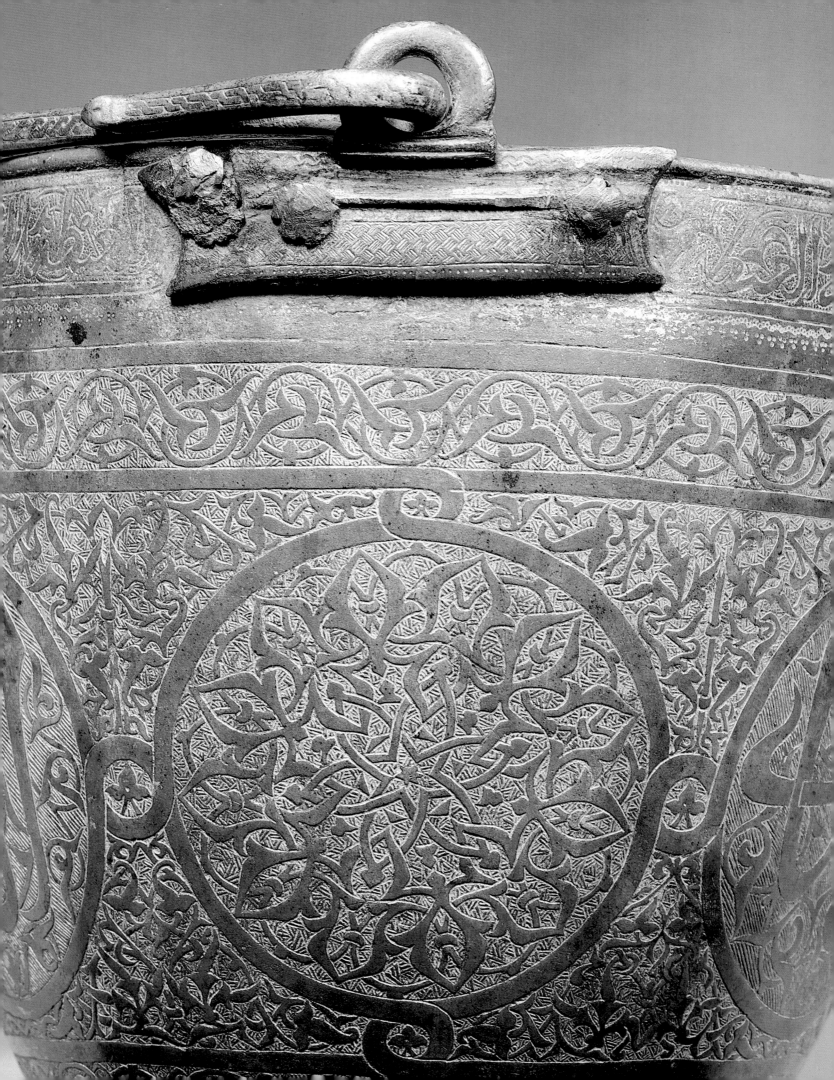

60

Sword

Naṣrid period, second half of
14th century
Ivory, bronze, silver, and wood
L. 39 in. (99 cm)
Museo del Ejército, Madrid
24.903

*T*his is one of the few swords from al-Andalus that does not belong to the *jineta* group. It is difficult to know with any exactitude the range of forged weapons used during the Naṣrid era because of the paucity of surviving examples and dearth of literary sources. *Jineta* swords are conspicuous by reason of number, originality of form, and opulence. However, we know from contemporary paintings that Spanish Muslims also used swords that were based on Christian models.[1]

The most striking feature of this sword is the Naṣrid ivory hilt and its lack of both quillons, or cross guard, and conventional pommel. The hilt is formed of two independent pieces, which are attached to the sides of the tang by supports composed of layers of silver, wood, and bronze. The only sword from the peninsula that is similar in both form and construction is one portrayed on a mid-fourteenth-century corbel in the chapel of Santa Catalina in the cathedral at Burgos. However, this is not the only surviving Naṣrid piece with a hilt made of two parts, for the construction is basically the same as that of the ear dagger preserved in the Real Armería in Madrid (No. 64).

Another similarity this sword shares with the ear dagger is the striking effect of the white of the carved ivory against a black background. The dominant decorative motif is a progression of dissimilar palmettes on both faces of the sword, although dynastic emblems on the obverse are also important design elements. The Naṣrid shield appears on the part of the hilt that corresponds to the pommel, and two criss-crossing bands on the shaft of the hilt divide the area into three sections; the central one frames the Naṣrid motto. This hilt, along with the ivory grips of *jineta* swords and daggers, demonstrates the vitality and power of Naṣrid ivory carving, which was dedicated, at least in part, to producing components for luxury arms.

The blade is probably an addition imported from the east. 　　　　　　　　　　　　　A S

1. An example is a sword with a spherical pommel and curved quillons from Pardo del Rey in Cádiz, now housed in the Museo Arqueológico Provincial in Seville (RE 13208). Although its pommel and quillons preserve many Christian characteristics, the curve of the quillons suggests developments in Christian swords.

LITERATURE: Fernández y González 1875a, pp. 389–400; Madrid 1893b, pls. LXVI, LXVII; Kühnel 1924, p. 124; Ferrandis Torres 1943, pp. 165–66, fig. 23; Mann 1961, p. 20.

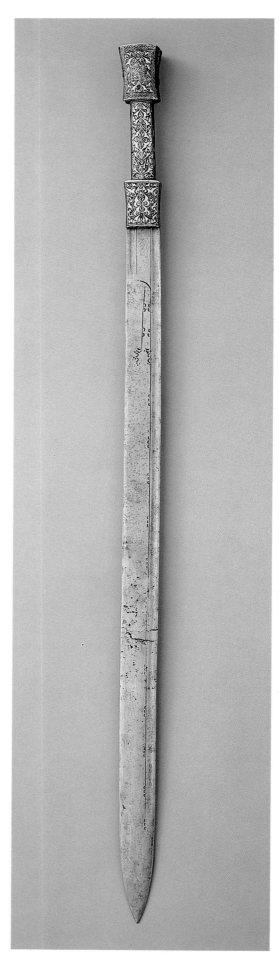

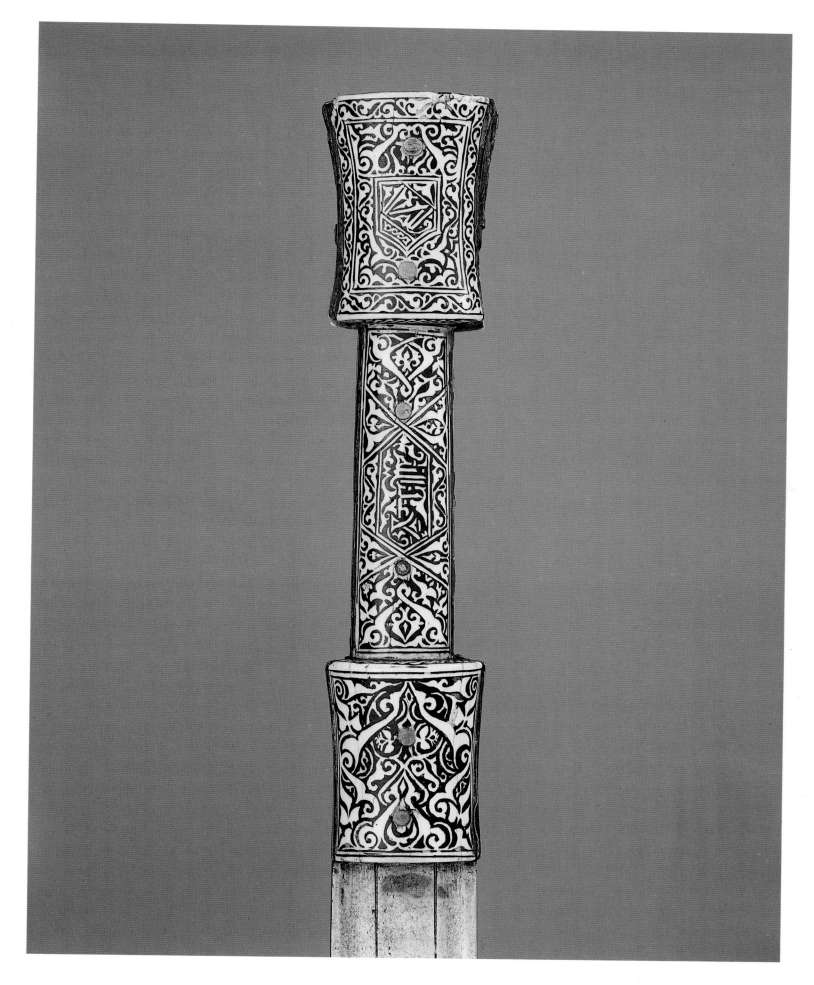

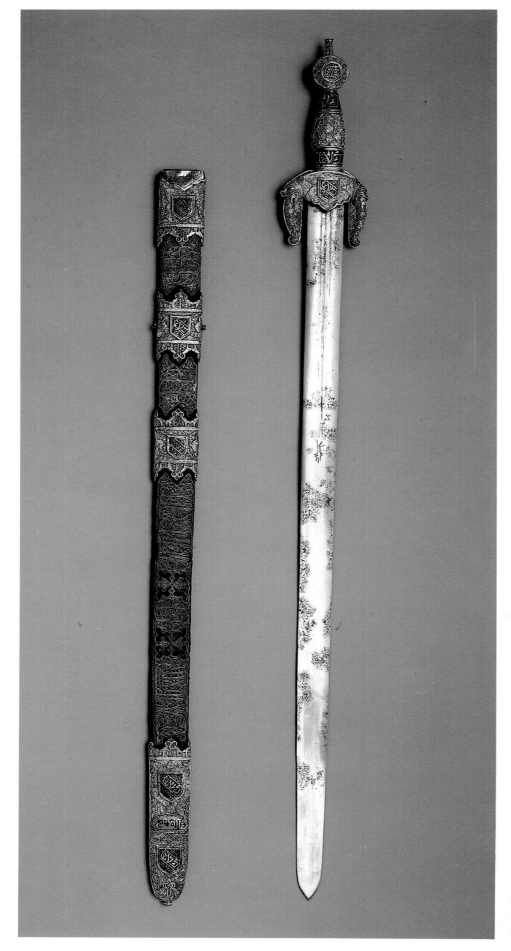

Jineta Sword and Scabbard

Naṣrid period, 15th century
Sword: steel, silver gilt, and cloisonné
enamel
L. 37¾ in. (95.7 cm)
Scabbard: wood, leather, silver gilt,
cloisonné enamel, and silver thread.
L. 37⅜ in. (95 cm)
Bibliothèque Nationale, Cabinet des
Medailles Luynes, Paris
959

*P*aintings in the Partal and the Sala de los Reyes of the Alhambra from the second half of the fourteenth century record a class of swords known as *jinetas*, a designation used in late medieval and modern documentation[1] whose original meaning has been lost. Extremely elaborate hilts decorated with enamel, filigree, and granulation are one of the outstanding features of these swords. Paintings in the Sala de los Reyes that date from approximately 1380 (A.H. 782) detail the characteristics of *jineta* swords. Their most distinctive peculiarity, absent in contemporaneous western arms, is highly arched quillons with internal faces that are parallel to the blade. The grip is divided into three parts, either by virtue of its construction or its decoration. The pommel, the knob on the end of the hilt, is in the form of a disk, following western models, or spherical, and is finished with an elongated button. Even though the paintings in the Partal seem to indicate a military purpose for these arms, their opulence is more appropriate to ceremonial swords, reflecting the lavishness of the Naṣrid court and earning the esteem these objects have been accorded in the Islamic world.

The hilt of this magnificent sword is silver gilt, with a disk-shaped pommel topped with a faceted button and a grip with an enamel washer at each end. The highly curved quillons incorporate two heads of fantastic animals, whose open maws, positioned at the extreme of the curvature at either side, mark the transition to the end of the horseshoe-curved bars, which terminate in volutes. The interior faces of the bars are embellished with five openwork rosettes containing six-petaled flowers. The disposition of the heads and the ornamentation on the bars distinguish a first subgroup of *jinetas*, which includes those now in the collection of

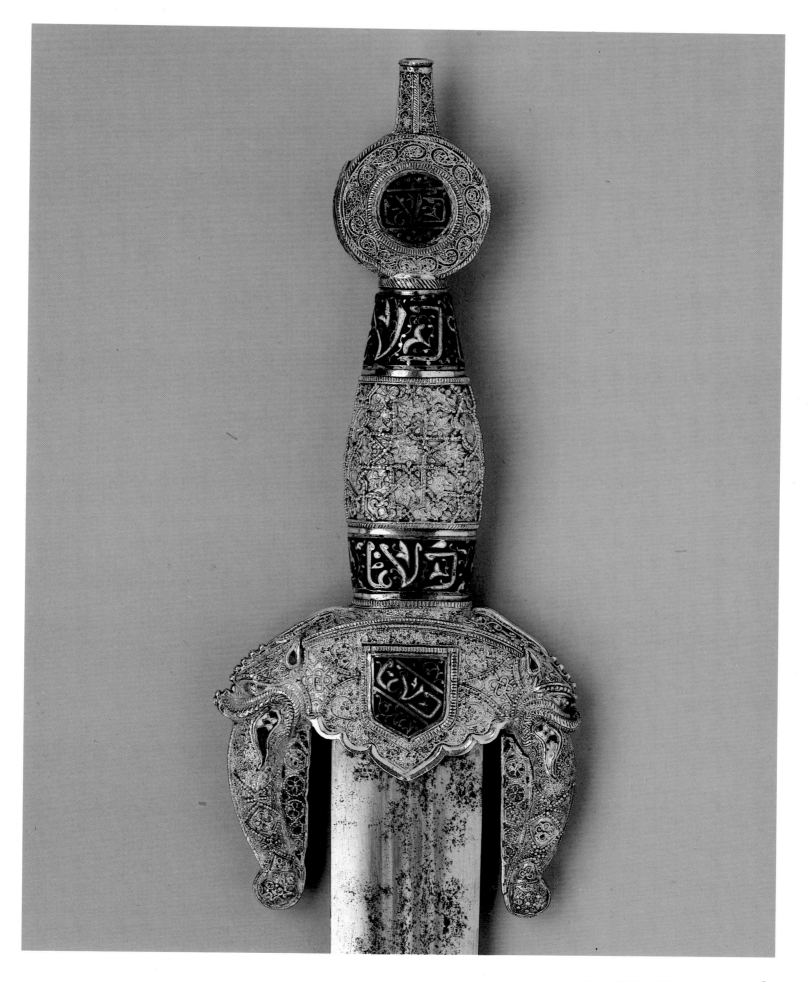

the Staatliche Kunstsammlungen in Kassel and the Museo Municipal de San Telmo in San Sebastián as well as the present example. The bars delimit a wide field—a field that on this *jineta* is outlined with a five-lobed lower border and on the others with a three-lobed lower border.

The presence of animal heads as a decorative element was common among post-twelfth-century Islamic swords.[2] The Aliatar *jineta* in the Museo del Ejército in Madrid and one in the Pidal collection,[3] for example, have quillons ending in elephant heads. Indeed, the elephant heads, combined with certain somewhat unrefined features, such as a less pronounced curve in the quillons, which themselves are less developed, distinguish them as a second subgroup of *jinetas* and may signal an earlier manufacture.

The blade is elliptical in section and has three grooves on each face that extend a third of its length. Farther down on each face is the maker's mark, a gilt running dog or wolf. The scabbard is characteristic of *jineta* swords. It is formed of two sections of leather-covered wood embellished with a top locket, two midlockets, and a chape (the metal mounting or trimming), all decorated to match the hilt. Raised leather trimming follows the outlines of the metal mounts. The presence of the two midlockets is owing to the custom of suspending the sword from the shoulder by means of a baldric, a tradition in al-Andalus recorded in the *Libro de juegos* of Alfonso X.[4] There is intricate embroidery of silver thread, forming inscriptions on the obverse and palmettes and interlace on both faces.

The Naṣrid dynastic emblem, executed in red, white, blue, black, and green enamel, set against a background of filigree and granulation, constitutes the principal ornamentation of the obverse of both sword and scabbard. The cloisonné enamel is laid in bands or hexagonal lozenges on the pommel and the grip and in shields on the quillons, lockets, and chape—on the latter, alternating with a hexagonal lozenge. On the reverse, the scheme is altered; the shields are replaced by lozenges, while on the chape a shield is inserted between lozenges.

Spiraled filigree and granulation appear on all the pieces. On the hilt or framing the shield of the quillons, where they form knots on the obverse and a fleuron on the reverse of the field, they take the form of interlace. The volutes on the quillons display six-petaled flowers; those on the obverse are made more elaborate by intersecting lines.

The variation and placement of the motifs lend a rhythm to the whole that distinguishes it from other swords that are embellished with geometric patterns. The most important decorative elements, however, are the Naṣrid shields. The Naṣrid emblem first appeared at the beginning of the fourteenth century[5] and is visible in the palace architecture of the Alhambra as well as on other pieces that may have originated in palatine circles. The use of the shields here, together with the dynastic motto (There is no conqueror but God) and the precious materials, suggests a royal provenance.

A S

1. Ferrandis Torres 1943, p. 7.
2. Alexander 1985, p. 88.
3. Ferrandis Torres 1943, figs. 13, 14.
4. Libro de los Juegos, ms. T.I.6, folio 67v.
5. Fernández-Puertas 1973, p. 84.

LITERATURE: Beaumont 1885, pl. 6; Maindron 1890, p. 232, fig. 169; Laking 1921, pp. 285–86, fig. 662; Ferrandis Torres 1943, pp. 160–61, fig. 17; García Fuentes 1969, pp. 16, 29; Paris 1971, no. 179; Fernández-Puertas 1973; Alexander 1985, pp. 81–118.

62

Jineta Sword and Scabbard

Naṣrid period, 15th century
Sword: gilded bronze, cloisonné enamel, and steel
L. 38¼ in. (97 cm)
Scabbard: wood, leather, gilded bronze, and cloisonné enamel
L. 31¾ in. (80.5 cm)
Staatliche Kunstsammlungen, Kassel
B II 608

*T*his *jineta* sword is significant for the predominance of its enamel decoration. It has a hilt of gilded bronze and a discoid pommel finished with a pronounced polygonal button. The three-segmented grip is widest in its center section. The curved quillons display two sculpted fantastic animal heads; the heads bracket the field, and the line of its three-lobed lower edge depends between them. The heads also initiate the descending curves of the bars, which begin at the animals' maws; the space between their interior faces and the hilt is filled with intertwined openwork stems.

The scabbard, now incomplete, is made of wood covered with leather. The ornamentation is nearly intact. It consists of the top locket, two midlockets with attached rings, a fitting for a baldric, and the chape, all of which are framed by the raised leather border of the scabbard. Except for the upper edge of the top locket and the lower end of the chape, all these elements are framed by festoons of intertwined openwork stems attached to a narrow pearl border.

While this sword belongs to the same group as the *jineta* in the Bibliothèque Nationale in Paris (No. 61), its decoration is plotted on a geometric grid of rhomboids formed of eight-pointed stars without emblems or inscriptions, an often-used pattern with a long tradition.[1] The most salient feature is the cloisonné enamel, arranged in rows alternating with gold filigree rhomboids centered with dots of white enamel. Each cell of cloisonné contains a quadrifoil fleurette with two additional enamel petals, one red and the other blue, the latter a hallmark of this classification of swords.

A S

1. Fernández-Puertas 1980, fig. 75, pls. XXVI, LXVa, LXXVI.

LITERATURE: Sarre and Martin 1912, vol. 3, no. 534, pl. 245; Kühnel 1924, p. 122; Ferrandis Torres 1943, p. 162, fig. 19; Seitz 1965, pp. 180–81, pl. VII; García Fuentes 1969, pp. 17, 31; Burckhardt 1972, pl. 32; London 1976, no. 231, p. 198; Fernández-Puertas 1980; González 1985, p. 69, fig. 4; Berlin 1989, no. 7/22, p. 694.

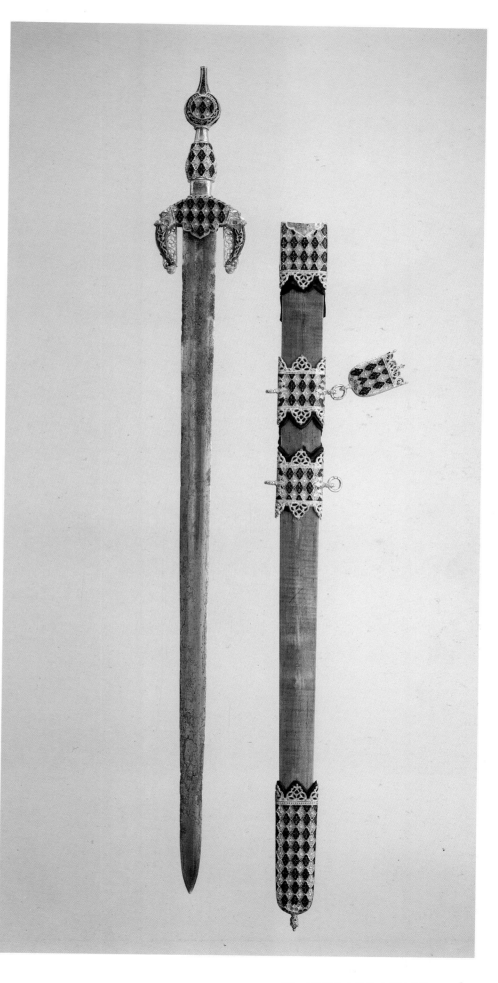

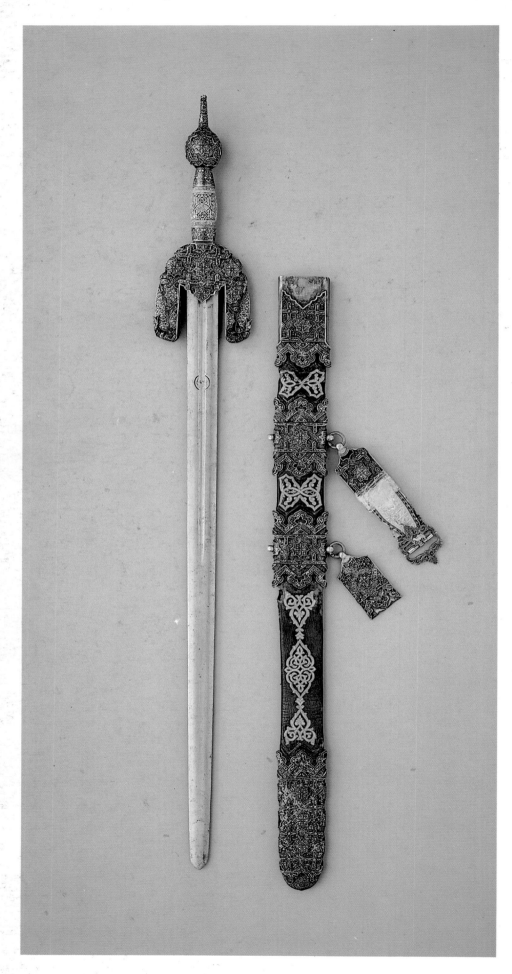

Jineta Sword, Scabbard, and Baldric Fragment

Naṣrid period, 15th century
Sword: steel, silver gilt, cloisonné
enamel, and ivory
L. 38¼ in. (97 cm)
Scabbard: wood, leather, silver gilt,
cloisonné enamel, and silver gilt thread
L. 30¼ in. (77 cm)
Baldric: silk and silver
Museo del Ejército, Madrid
24.902

*I*n the Battle of Lucena, which took place in
1483 (A.H. 888), Muḥammad XII, known as
Boabdil, was taken prisoner by the troops of
Diego Fernández de Córdoba, to whom the
Catholic sovereigns ceded the arms and gar-
ments believed to have belonged to the pris-
oner. These spoils were retained by Fernández's
descendants until the Marquesa Viuda de Viana
divided the legacy in her will in 1901. A portion
was bequeathed to the Museo del Ejército in
Madrid in 1906, and the rest remained in the
collection of her son, who in 1927 presented it
to King Alfonso XIII.[1] It was then consigned to
the Real Armería in Madrid. This sword is part
of the marquesa's bequest to the Museo del
Ejército and so retains the association with the
last Naṣrid monarch.

The hilt of this sword consists of a spherical
pommel topped by a prominent conical button
and a carved ivory grip framed by two bands.
The curved quillons are wavy on the upper
edge, there are no animal heads on the upper
edge, and the openwork is on the exterior of the
bars, not the interior, as in the *jineta* of the
Bibliothèque Nationale in Paris (No. 61). These
features distinguish a third grouping of *jinetas*
(see No. 61), which includes those in the Campo-
tejar collection[2] in the Museo Arqueológico
Nacional in Madrid and in the Real Armería.
The blade is of a later date.

The scabbard is formed by two leather-covered
sections of wood; the top locket, the two mid-
lockets, and the chape have three-lobed fes-
toons. Two fittings, one set in each of the rings
of the midlockets, conserve a portion of a silk
baldric, a shoulder belt for a sword. Their orna-
mentation is enriched with silver-gilt embroidery

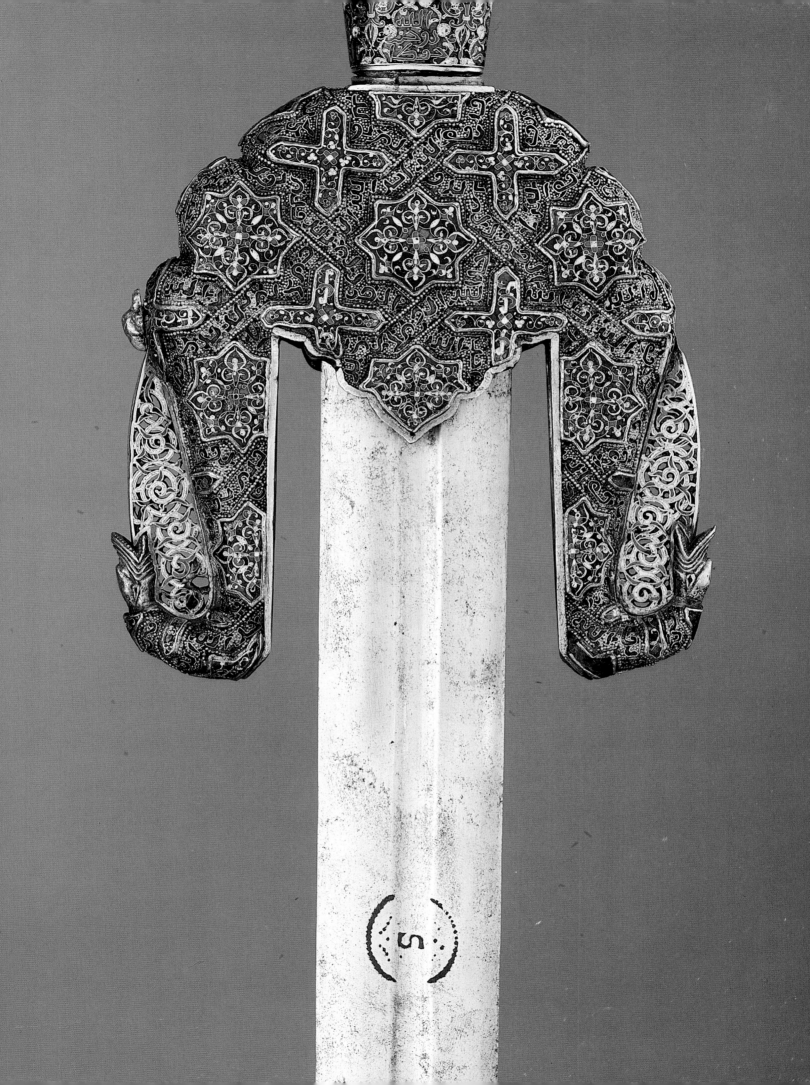

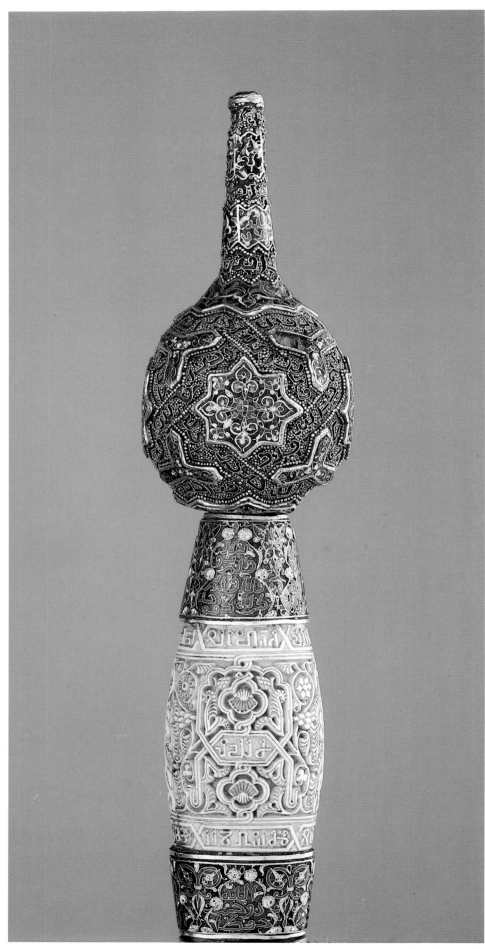

63, detail, handle

and panels with palmettes on the reverse of the fittings and on the lateral bands of the baldric.

The overall ornamentation follows a geometric design in which the hilt and scabbard are conceived as forming a single plane, on which eight-pointed stars and cruciforms are contained within bands of filigree. The bands, quillons, stars, and cruciforms are enameled, with white and red as the central colors, and black and green as background colors. This range furnishes a chromatic richness in which green is the dominant note. The absence of emblems and the presence of inscriptions in praise of God are distinctive. The meaning of the inscriptions is heightened by the prevalence of stars symbolizing the divinity.[3] A S

1. Palacio Real, box 321, file 19.
2. Ferrandis Torres 1943, fig. 16.
3. Burckhardt 1985, p. 241.

LITERATURE: Fernández y González 1875a, pp. 394–97; Riaño 1879, pp. 84–87; Madrid 1893b, pls. LXI–LXIII; Laking 1921, pp. 283–85, fig. 661; Kühnel 1924, p. 123; Hildburgh 1941, pp. 211, 215, 216, pl. XLIIa; Ferrandis Torres 1943, pp. 158–60, fig. 15; Zakī 1957, pp. 278–79; Mann 1961, p. 20, pl. XI; García Fuentes 1969, pp. 16, 18, 26; Rosenberg 1972, figs. 275–76; Burckhardt 1985; González 1985, pp. 64–69.

64

Ear Dagger, Scabbard, Knife, Belt, Pouch, and Case

Naṣrid period, last third of 15th century
Ear dagger: steel, ivory, wood,
and bronze
L. 13⅞ in. (35.1 cm)
Scabbard: leather, silver thread, and
wood with silk tassel
L. 9⅞ in. (25.1 cm)
Knife: gilded steel
L. 7½ in. (19.1 cm)
Belt: leather, silver thread, and gilded iron
L. 43½ in. (110.4 cm)
Pouch: leather, silver thread, and gilded iron
2½ x 3⅞ in. (6.5 x 9.7 cm)
Case: leather and silver thread
4⅞ x 4⅛ in. (12.5 x 11.1 cm)
Patrimonio Nacional,
Real Armería, Palacio Real de Madrid
Cat. G361

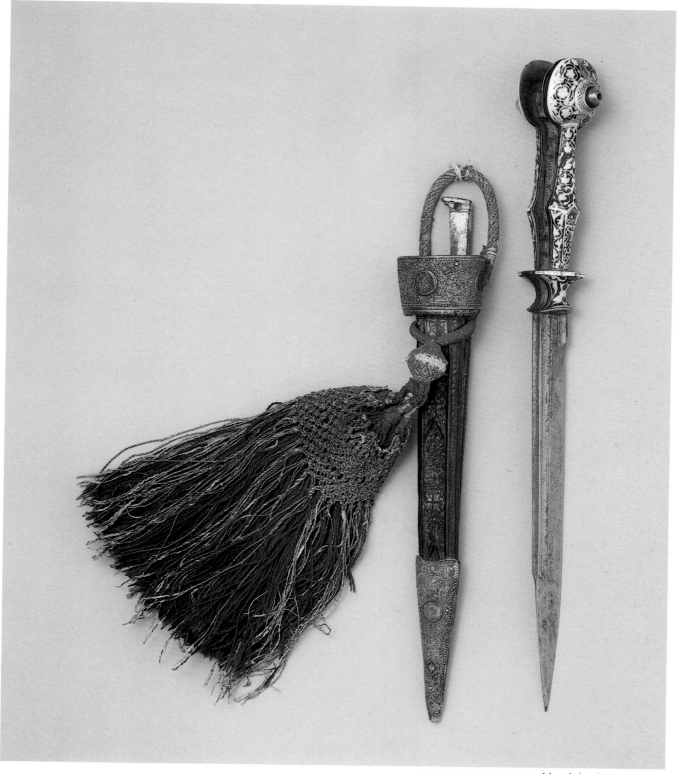

scabbard, knife, ear dagger

This set was part of the legacy of the Marqués de Viana[1] and is thereby associated with the capture of Muḥammad XII following the Battle of Lucena in 1483 (A.H. 888).

The dagger is one of a Naṣrid class called ear daggers after the ear-shaped rounded pommel. The hilt is formed of two pieces of ivory over fine layers of wood and bronze cut to its outline. These carved pieces constitute a conical pommel, a grip that widens at its center and is divided into two faceted sectors, and a biconcave guard. Bronze pins join the ivory to the tang, which is faceted below the three segments of the hilt. The carving of the hilt depicts five-petaled flowers, the *cordon de la eternidad*, or endless ribbon, pineapples, trifoliate motifs,

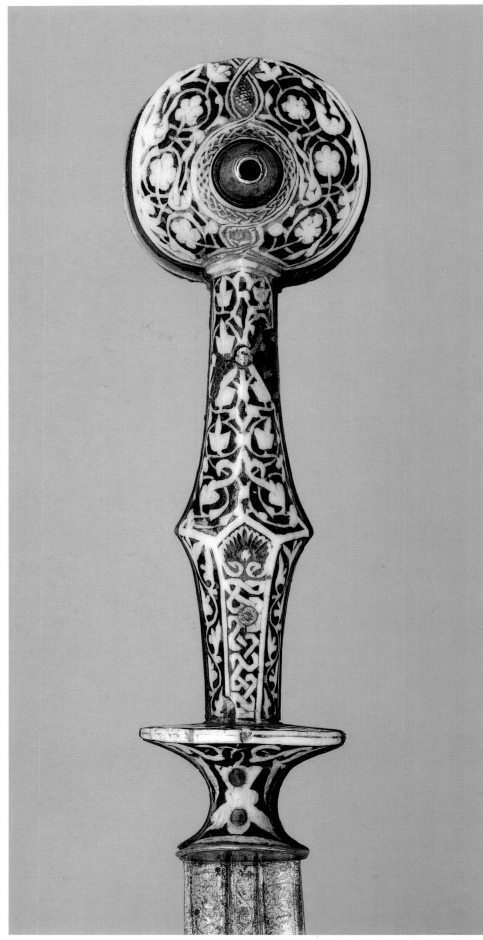

shells, palmettes, and knots. The blade is decorated with etched and gilt lotus flowers and inscriptions alluding to God. There is a scholarly tradition that interprets an inscription on one side of the blade as the signature of Reduan.[2] However, a more recent, unpublished reading by Juan Zozaya suggests that this attribution is incorrect.

The scabbard is embellished with a cord and tassel of crimson and yellow silk and silver thread. The silver locket and chape, decorated with filigree, feature medallions that have lost their green enamel, and the locket has a better preserved medallion with the Naṣrid shield.[3] Medallions enclosing representations of the Garden of Paradise reinforce the meaning of the inscriptions on the dagger. A compartment in the scabbard houses a second weapon, a small partially gilt knife.

The dagger is accompanied by a belt with belt pouch and a case, an exceedingly rare set in leather embroidered with silver thread. The pouch is rectangular with a pointed flap and a buckle gilt in the mode of the late fifteenth century.[4] The buckle fastens a flat strap that runs vertically around the pouch, with the Naṣrid motto on either side, a decoration completed by palmettes in the lower corners of the flap. The two-piece belt has a buckle, a center ring, and a tip of engraved and gilt iron. Three threads of intricate embroidery cross at regular intervals, tracing concentric circles and inscriptions.

The square case (not pictured), the embroidery of which differs from that of the other pieces, may have held a Qurʾan. It has a scalloped flap with the Naṣrid motto, and straps were attached to the sides. On the reverse is the hand of Fāṭima, symbol of the name of God and protection against evil. A S

1. Palacio Real, box 321, file 19.
2. Fernández y González 1875a, pp. 397–99; Fernández Vega 1935, pp. 366–67, pl. IIIa; Seitz 1965, pp. 180–81.
3. Fernández y González 1875a, pp. 397–99.
4. Bernis 1979, p. 79, figs. 35, 38.

LITERATURE: Fernández y González 1875a, pp. 397–99; Fernández Vega 1935, pp. 366–67, pl. IIIa; Rodríguez Lorente 1963, pp. 121, 123–24, pl. II, fig. 2; Rodríguez Lorente 1964, pp. 69–70, 79–82, fig. 1; Seitz 1965; Bernis 1979.

64, detail, ear dagger handle

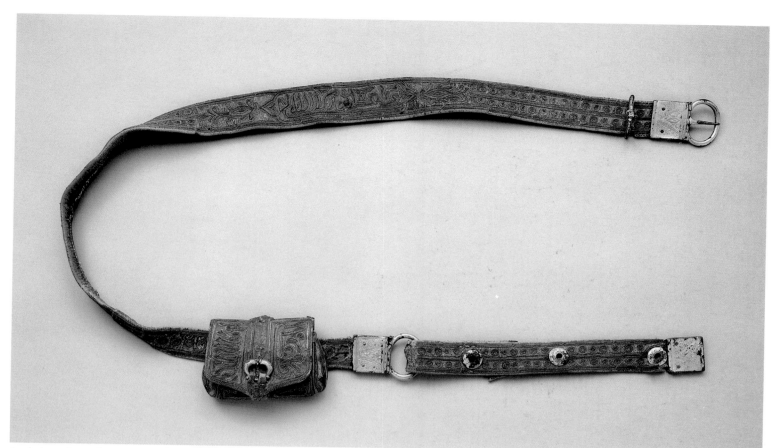

64, belt and pouch (top); pouch (bottom)

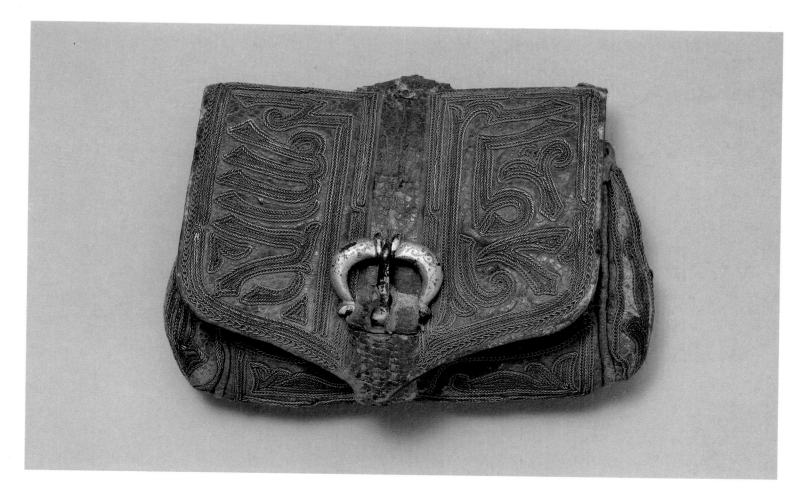

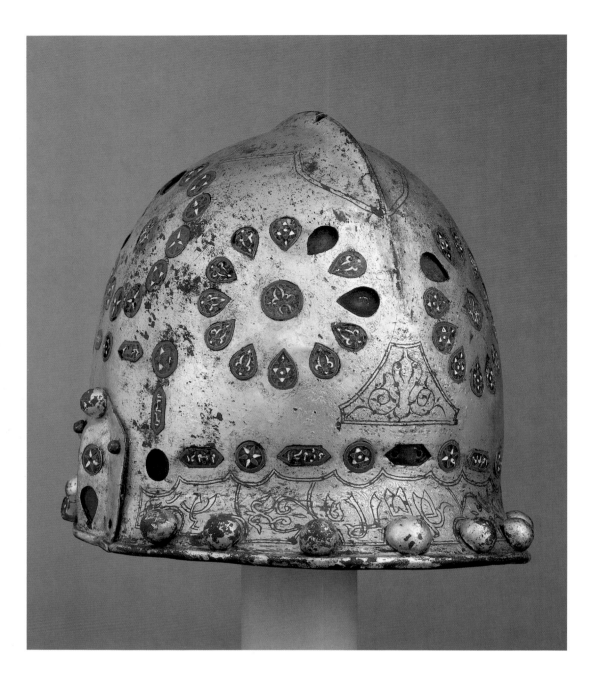

65

Parade Helmet

Naṣrid period, late 15th century
Steel, gold, silver, and cloisonné enamel
H. 7⅞ in. (20 cm)
The Metropolitan Museum of Art,
New York, from the Lord Astor of Hever
Collection, Purchase, The Vincent Astor
Foundation Gift, 1983
1983.413

*B*y the end of the fifteenth century, the helmet of Spain showed particular characteristics, such as semicircular cutouts above the eyebrows, a turned edge, a barely developed short projection over the nape, and apertures for the ears—peculiarities divided between two groups of Spanish helmets. This sallet, a helmet with a low, rounded crown, combines the principal characteristics of each group,[1] displaying, in addition to the ear coverings, which have been lost on other surviving pieces, large spherical rivet heads placed around the rim and a minimal comb with a circular opening for holding a plume or crest.

This piece is notable for its opulent ornamentation, which makes it an unparalleled example of parade armor. Set in the surface, all but the silver-plated border of which is gilt, is a total of 116 enamels (22 have been lost) with little punchwork borders. Teardrop-shaped, circular, or hexagonal, they contain knots, six-pointed stars, interwoven palmettes, and inscriptions in green, red, blue, black, and white. In the skull of the helmet are perforations to facilitate a firm seating and additional plates riveted to the interior, which was lined with fabric, as is indicated by remnants of cloth. The enamels are disposed more or less symmetrically in six large circles, three of which are on each side of the skull; each circle encloses a center enamel. A squared row of alternating hexagonal and circular enamels outlines each ear cover,

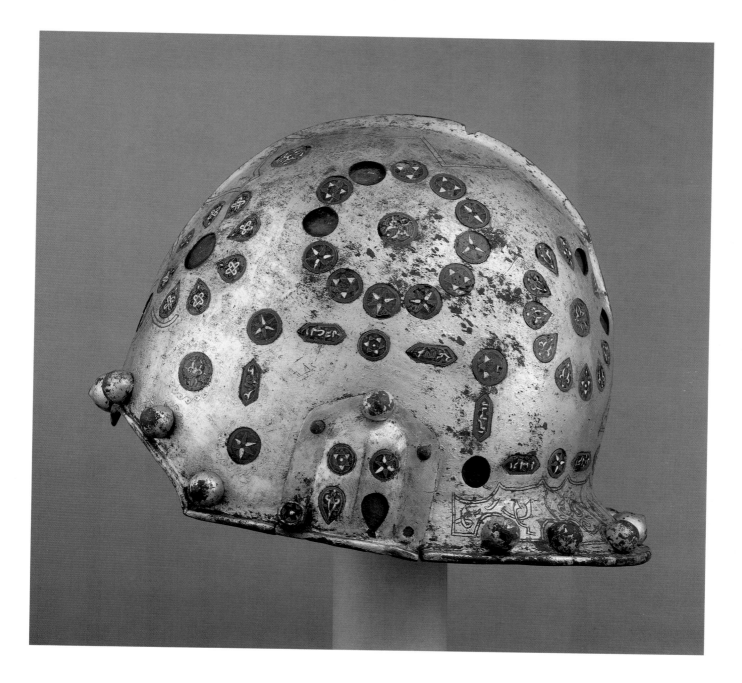

and a festooned lozenge at the nape encloses pseudoinscriptions. On the front of the helmet a discontinuous double line of engraving surrounds enamels and the comb. A triangular cartouche at the base of the comb at the back contains two stylized stems or shoots.

The absence of documentation or any known parallel, as well as our limited knowledge of Naṣrid arms, leaves a number of questions about this piece unanswered. However, it is worth noting that certain characteristics, such as the presence of inverted or pseudoinscriptions, the discontinuous lines of engraving, the spaces left unfilled, and the simplicity of the cutouts for the ears, are not common in the arts and crafts of the Naṣrid period, especially on such a

luxury piece. All of these factors give rise to the possibility that this helmet is a work of Christian artisanry influenced by Naṣrid metalwork, and that the use of polychrome enamel on gilt here represents a crystallization of the symbiosis between Christian type and Naṣrid taste. A S

1. Pyhrr and Alexander 1984, pp. 21–22.

LITERATURE: Percy sale 1825, pp. 9–10, no. 53; Percy sale 1829, pp. 15–16, no. 62; Laking 1921, pp. 15–18, fig. 356; Mann 1933, p. 301, pl. XC; *Hever Castle Collection* 1983, lot 34, p. 28; Pyhrr and Alexander 1984, pp. 21–22; Metropolitan Museum of Art 1987, pp. 66–67; González 1990, pp. 198–99.

Adarga

Naṣrid period, second half of
15th century
Leather, silk thread, and quill
H. 35⅜ in. (90 cm)
Kunsthistorisches Museum, Vienna
C195

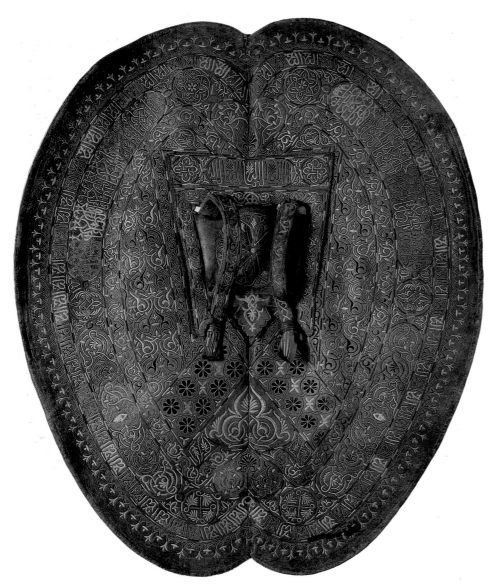

*F*rom the beginning of the thirteenth century, the term *adarga* was associated with a leather shield of distinctive bilobed shape documented in the *Cantigas de Santa María* of about 1281–84.[1] Although it was an extremely common type of shield in al-Andalus, this example is one of only two that remain. Its survival is no doubt due to its status as a luxury weapon of high quality. As a luxury weapon, this shield is smooth on the obverse and profusely decorated on the reverse with black, yellow, blue, green, red, and white silk thread. The shape of the *adarga* dictates the decoration; festooned border and parallel bands follow the perimeter of the shield in varicolored silk threads that also frame the field and cover the padded enarme (the handgrip). Palmettes are the principal motif, accompanied by inscriptions in the bands and on the enarme, eight-petaled flowers on the field, and, again on the enarme, a twelve-pointed star.

In the Real Armería in Madrid is a Naṣrid *adarga* (D-86) embroidered in silk thread in the same range of colors and with a similar disposition defining the bands.[2] It differs in the decorative concept, which is not concentrated, as on this *adarga*, in a field determined by the placement of the enarme. A S

1. Códice Rico, ms. T.I.1.
2. Valencia de Don Juan 1898, p. 161; Torres Balbás 1949, fig. 220.

LITERATURE: Valencia de Don Juan 1898; Torres Balbás 1949; Buttin 1960, p. 450, pl. XVIII; Thomas, Gamber, and Schedelmann 1974, no. 45; Thomas and Gamber 1976, pp. 128–29, pl. 63; Thomas 1977, pp. 188, 193.

67

Ornamentation for a Horse Harness

Naṣrid period, 15th century
Silver gilt and cloisonné enamel
6⅛ x 2⅜ in. (15.5 x 6 cm)
Kunsthistorisches Museum, Vienna
C33
†

Esteem for horses, translated into treatises on the equestrian arts, and appreciation for richly ornamented harnesses as a manifestation of court pageantry, as evidenced in this ornament of silver gilt, were present in the culture of al-Andalus from the High Middle Ages. The ornament is structured of small rectangular interlocking slides that attach to a strap without affecting its flexibility. On the obverse is a pattern of eight-pointed stars; on the reverse there are chased interwoven ribbons. The crescent-shaped slides display lion heads with open maws, symbolic of bravery and nobility, and the Naṣrid shield is enclosed in a *cordon de la eternidad*, or endless ribbon, possibly indicating a royal provenance. The decoration is heightened on the obverse with blue, green, white, black, and red enamel.

It is believed that this piece served as ornamentation on a throatlatch,[1] but similar models that appear in paintings in the Sala de los Reyes in the Alhambra[2] and in Venetian iconography[3] occur as trim for breast leathers.

AS

1. Thomas 1977, p. 188.
2. Bernis 1982, fig. 1.
3. Dalton 1907, p. 378.

LITERATURE: Dalton 1907, p. 378; Thomas, Gamber, and Schedelmann 1965, no. 5; Thomas, Gamber, and Schedelmann 1974, no. 7/8; Thomas and Gamber 1976, pp. 129–30, pl. 62; Thomas 1977, p. 188.

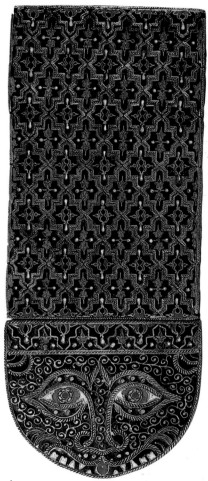

obverse *reverse*

68

Ornamentation for Horse-Bridle Parts

Nasrid period, 15th century
Gilt bronze and cloisonné enamel
Browband: L. 8¼ in. (21 cm)
Badges: each, w. 3½ in. (8.8 cm)
Headstall trim: w. 1½ in. (3.8 cm)
The British Museum, London
1890, 10-4, 1

*T*hese ornaments are among the only decorated bridle parts known to survive from al-Andalus. They are luxury pieces, fashioned in gilt bronze and cloisonné enamel and composed of cruciform badges with festooned extensions and twenty-four pieces with internal convex and external concave sides. The hollow rectangular sections permit the passage of a browband and cheekpieces; the inner faces fit together, and the outer faces create a festooned edge. A circular opening in the back of the badges facilitates adjustment of the headstall. The terminals are large and pointed, with discoid tips for the fastening.

The obverse of each piece is divided into two compartments. These compartments are decorated in alternating filigree and cells of blue, red, white, and translucent green cloisonné enamel; the color of the compartments also alternates, creating a zigzag effect, and the whole suggests a *cordon de la eternidad* pattern. The field of the badges is delimited by four circles; within the circles is enamel and filigree decoration set in four opposing diagonal compartments initiating the pattern of the *cordon de la eternidad*. A S

LITERATURE: Dalton 1907, pp. 375–80; Laking 1921, p. 33, fig. 359; Hildburgh 1941, pp. 211, 214, pl. XLIIb.

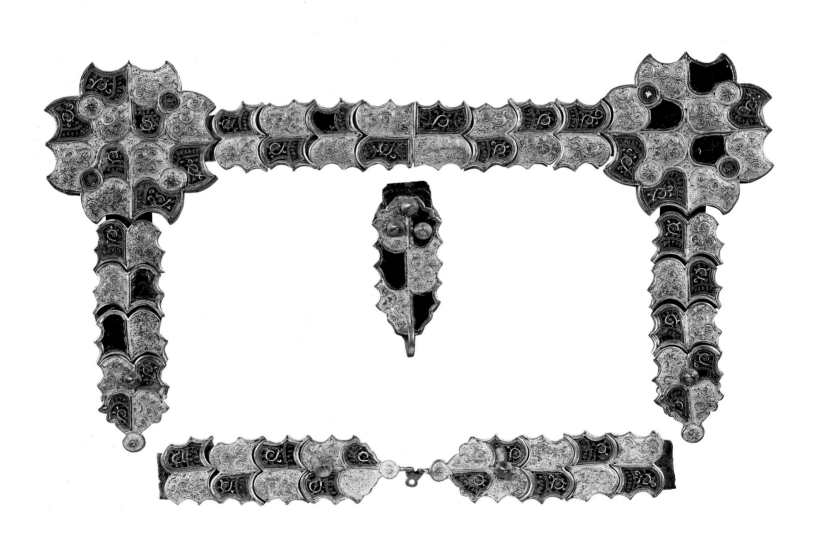

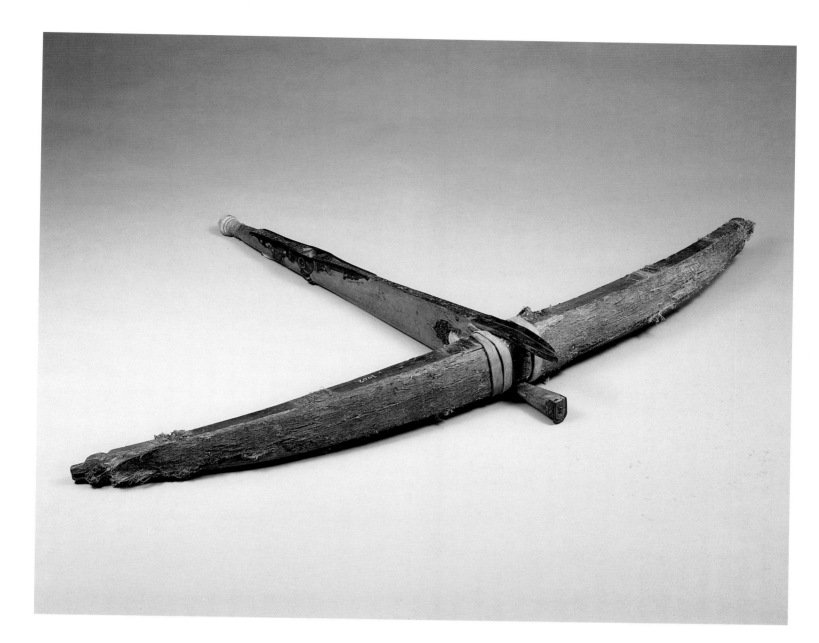

\mathscr{A} bow of a military weapon and a stock of a luxury arm were combined to form this crossbow from Granada. The bow, whose size and strength tell us that it originally must have been part of a military crossbow, is fitted with two nocks and constructed of two pieces of wood reinforced with sinew and five bands of thread, a system recorded by Ibn Hudhayl[1] and in paintings in the Alhambra.[2] The height of the stock diminishes progressively from the cheeks to the cylindrical bone tip of the handle, a feature documented in the *Cantigas de Santa María*.[3] An engraved metal fitting equipped with a lock reinforces the handle and the box for the nut. Decorated with laminae of openwork bronze, originally gilt, the stock features arabesques on the mortises, box, and obverse, contrasting with the geometric motifs on the reverse. The background colors of the openwork circles on the box are alternately red and blue. The trigger is overlaid with ivory plaques, and the lock that reinforces it is defined with inlay. The richness of the decoration of this stock indicates that it was a luxury arm used for hunting. A S

1. Ibn Hudhayl 1977, p. 201.
2. Bernis 1982, fig. 1.
3. Códice Rico, ms. T.I.1, fol. 76r.

LITERATURE: Torres Balbás 1949, fig. 225; Ibn Hudhayl 1977; Bernis 1982; Mendoza Eguáras, Sáez Pérez, and Santiago Simón 1982, pp. 179–82; Harmuth 1983, pp. 141–44.

69

Crossbow

Naṣrid period, 14th–15th century
Wood, bronze, ivory, iron, bone, and sinew
Bow: L. 48⅜ in. (123 cm)
Stock: L. 31½ in. (80.1 cm)
Museo Arqueológico de Granada
1002

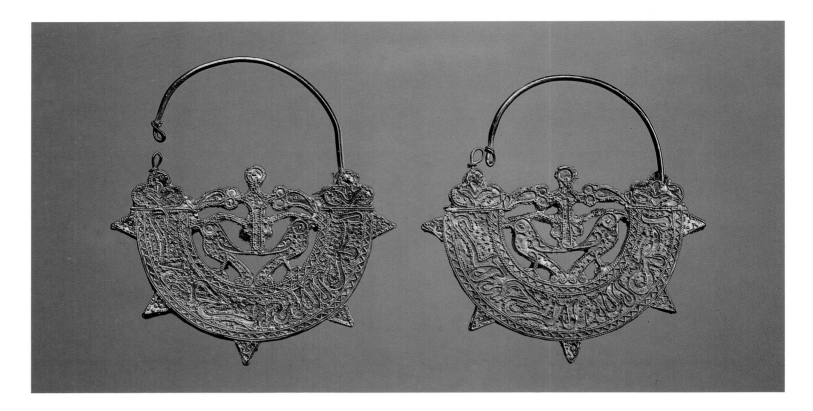

70

Pair of Earrings

Almoravid or Almohad period,
12th century
Gold
L. 2¼, 2⅛ in. (5.8, 5.3 cm)
Museo de Mallorca, Palma de Mallorca,
Donación de la
Societat Arqueològica Luliana
23812/23813

*T*hese earrings form part of a treasure that was discovered in a small jar, which is still preserved. The find was dated by means of coins among the contents of the jar. From each curved post and hooked closing of the earrings depend two counterpoised semicircular plates, folded and soldered at the edge. The perforated interior area of the plates constitutes the principal decoration.

A lotus flower at each upper edge of the earrings conceals the starting point of the drop element and the hinge. The solid portion has been decorated with filigree and granulation, the former being used for the edges, composing a *cordon de la eternidad*, or endless ribbon, and for the interior, which contains an incomplete granulated inscription in Naskhī script reading, بسم الله الرحمن الرحيم (*In the Name of God, the Merciful, the Compassionate*).

The interior semicircle shows two counterpoised falcons. From the tips of their wings emerges the axis of a tree of life, whose branches are in the form of palmettes that are attached to the lotus flowers at the upper edges of the semicircle. Two-strand filigree delineates the profiles of the birds and tree, and their interiors are decorated with granulation. The outside edge of the semicircle has five regularly spaced triangular points with their apexes pointing outward.

The form of the present earrings, like that of earrings from the National Museum of Damascus,[1] derives from Roman models of the second century A.D. This form passed from Rome to Byzantium, as can be seen, for example, in pieces from the British Museum in London[2] and the Archaeological Museum in Istanbul[3] and in those exhibited in Jerusalem.[4] Subsequently the model was used in the Fāṭimid world, as demonstrated by an example in the collection of the Metropolitan Museum.[5] In the eleventh century it appeared in Syria, as earrings in The David Collection in Copenhagen show.[6] Later it follows the formal scheme—more refined in the present pair—of the twelfth-century Iranian earrings in Jerusalem.[7] The pair in the Benaki Museum in Athens,[8] attributed to al-Andalus in the fourteenth century, are certainly from the same jeweler. Many correspondences can be seen between these earrings and later examples in the Kuwait National Museum in Kuwait City.[9] J Z

1. Mainz 1982, p. 219, pl., p. 167.
2. Dalton 1901, nos. 267, 269, pp. 43–45, pls. IV, V.
3. Rome 1987, nos. 264, 265, p. 102.
4. Hasson 1987, no. 3, p. 13.
5. Jenkins and Keene 1982, no. 48, p. 82.
6. Folsach 1990, no. 371, p. 218.
7. Hasson 1987, no. 31, p. 36.
8. Philon 1980, no. 225, p. 44, fig., p. 50.
9. Jenkins 1983, p. 91.

LITERATURE: Palma de Mallorca 1991, pp. 9, 17, 23, pls., pp. 6, 17, 22.

A plaque that combines a quadrangular and a triangular shape, the latter decorated with a lotus petal, and three hollow quadrangular elements that can be articulated are the remnants of a gold belt. All the quadrangular elements have semicircular notches on their long sides. The short sides are finished with edges that recall merlons. The triangular element ends, at its apex, in a hoop of turned and hammered metal. Three central elements stand out in relief on each of the rectangular plaques. In three of the plaques, these elements consist of two striated semispheres on either side of the remains of a central cabochon. The fourth plaque shows an inverse arrangement of these features, which suggests that the complete grouping had plaques with alternating decorative systems.

The decoration is of flattened filaments soldered to the gold plaques. *Cordon de la eternidad* motifs edge the two short ends, and concentric circles fill the interior. In the merlons are palmettes and *paraisos*, or embellished cross patterns symbolic of paradise. There appears, in addition, hammered, polished ornamentation in the triangular element. Finally, there are inscriptions, in somewhat corrupt Naskhī, of isolated words between the circular elements and the dentate edge of each rectangle. On one the word is غالب (*victorious*), presumably someone's name or an invocation to God the Conqueror.

The decorative technique used here is related to that employed in belt ornaments or horse-bridle parts in the collection of The Metropolitan Museum of Art in New York (No. 72) and derives from features known from the Charrilla hoard (see No. 17). J Z

LITERATURE: Berlin 1979, no. 337, p. 91.

Belt Elements

Naṣrid period, 14th century
Gold
Rectangular plaques: each, 2⅜ × 1⅛ in.
(6 x 2.8 cm); plaque with triangle,
2⅜ x 2 in. (6 x 5 cm)
Museum für Islamische Kunst,
Staatliche Museen
Preussischer Kulturbesitz,
Berlin
I. 4941–4944

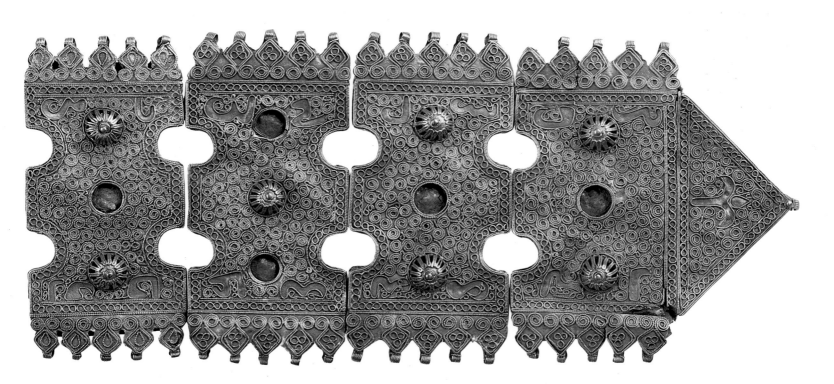

72

Horse Bridle or Belt Ornaments

Naṣrid period, 15th century
Gilt copper or bronze and cloisonné enamel
⅞ in. (2.1 cm)–2½ in. (6.2 cm)
The Metropolitan Museum of Art, New York, Gift of J. Pierpont Morgan, 1917
17.190.962

These ten hollow gilt copper or bronze ornaments brilliantly decorated with enamel are part of an ensemble that must once have been larger.[1] The present incomplete form and the absence of the leather(?) strap or belt that would have passed through the units make it impossible to know how the parts were originally arranged.

The pieces are of four different shapes. There are six small rectangular elements, each with a projecting point at top and bottom, through which the strap or belt passed horizontally. Two larger ornaments take the form of lobed rosettes; one has openings for the strap at the four cardinal points; the other opens at the top and both sides but not at the bottom. One piece, the smallest, is roughly chevron shaped, with a pointed indentation on the left and a pointed projection on the right. The tenth ornament resembles the rectangular units in size and shape, save for its right side, which is in the form of a lotus petal. This configuration is reminiscent of lotus petals seen on Hispano-Islamic jewelry in the National Museum of Kuwait in Kuwait City and of floral edgings of jewelry from Mondujar and Bentarique now in the Museo Arqueológico Nacional in Madrid. The last piece has an opening for a strap only on the left, so it must have functioned as a terminal. The decorated top surfaces of all the ornaments feature enamel plaques set into intricate patterns of filigree and granulation.

These pieces may have been part of a belt. However, the transverse openings in the large rosettes suggest that they may have accommodated crossed or joined straps, making it more likely that the ensemble was a horse bridle, a possibility suggested by the appearance of larger rosette-shaped elements in other bridle sets (see No. 68). J Z

1. For a discussion of other ornaments with enamel of this period, see Hildburgh 1941, pp. 212–19, pls. XLII–XLIV.

LITERATURE: González 1990, p. 198, fig., p. 201.

73

Necklace Elements

Naṣrid period, late 15th century
Gold sheet and wire and enamel
Circular element: Diam. 3 in. (7.6 cm)
Beads: L. 2, 1½, 1 in. (5.1, 3.8, 2.5 cm)
Pendant elements: L. 3¼ in. (8.3 cm)
The Metropolitan Museum of Art, New York, Gift of J. Pierpont Morgan, 1917
17.190.161

Four tubular internodes, or beads, a tute, four five-pointed pendants, and one circular pendant once formed part of a necklace. The tute, the tubes, and the pendants all have traces of enamel, which in some cases is very well preserved. The tubes and the tute are related in shape to those of a necklace from the early Umayyad period,[1] although they vary from them somewhat. The four splayed pendants are inspired by the lotus flower; they derive directly from pendants found in the treasures of Mondujar and Bentarique—although the latter are more curved and graceful—and not from the hands of Fāṭima, as W. L. Hildburgh supposed.[2] The present pendants show traces of enamel, as do some of the examples in Spanish museums. The circular pendant, with quasicircular protrusions running along its circumference, each having a hole for setting enamels (some of which remain), is extremely unusual. The interior is marked with cavities, many of them empty, also meant to hold enamels. All the pendants are of folded and counterpoised dobrel sheet approximately three millimeters thick.

The decorative techniques are perforated laminate for the tubes and the tute, with granulated relief and filigree. Near the ends of the tubes, there are bands of enamel with vermiculate work in green, white, and garnet. The ends are of hollow filigree, forming small spheres finished in their extremities with crystals. The pendants, of notched, perforated plates, with loops for stringing, show cavities for enamel, some of which is preserved, in white, garnet and white, and green and white. The circular pendant has granular and filament decoration, as well as repoussage. A circular band bears the inscription, fitted in a molding, + AVE MARIA GRACIA PLEN[A], so common in ceramics and weaponry from the early sixteenth century on.

The four splayed pendants, whose form is based on lotus flowers, have their clearest antecedent in central Asia, as can be seen in the philactery in the State Hermitage Museum in Saint Petersburg.[3] In addition, there are parallels in Ottoman textiles. A Turkish or Italian brocaded velvet in the Metropolitan Museum (Rogers Fund, 1912, 12.49.5) has a similar design, which is indicative of the possible origins of the form.[4] J Z

1. Gómez-Moreno 1951, p. 341, fig. 402a.
2. Hildburgh 1941, pp. 216–18, pl. XLIV.
3. Kramarovskii 1985, p. 170, pl. 11, 1–3.
4. Frankfurt 1985, vol. 1, p. 29, fig. 5.

LITERATURE: Hildburgh 1941, pp. 216–18; Jenkins and Keene 1982, no. 52, pp. 92–93.

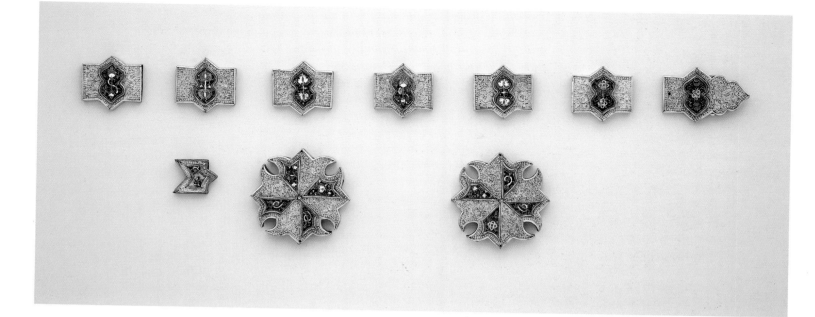

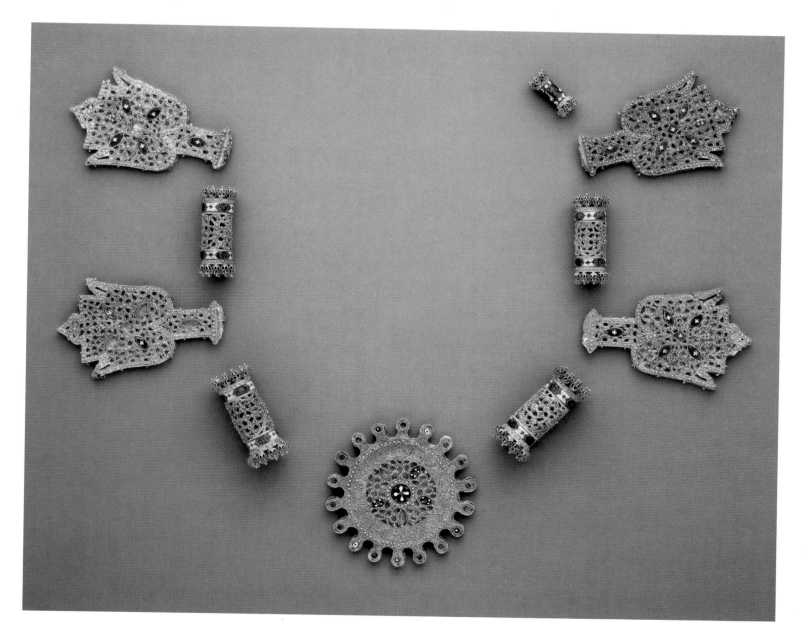

folio 2b

74

Qurʾan Manuscript

Taifa or Almoravid period, 1090
(dated A.H. 483)
Vellum
7⅜ x 6⅛ in. (18.8 x 15.5 cm)
Uppsala Universitetsbibliotek

75

Qurʾan Manuscript

Almoravid period, 1143
(dated A.H. 538)
Vellum
7⅛ x 7⅜ in. (18 x 18.8 cm)
Istanbul University Library
A6755

A provenance of either Spain or North Africa can be proposed for this Qurʾan manuscript. Written in Maghribī script with black ink, it is the earliest dated illuminated manuscript known to have survived from the western Islamic world. Its general character indicates a relatively early state of development, particularly in the illumination.

The sura illustrated here is *al-Ṭūr*, or "The Mount." The heading is written in ornamental Kūfic in gold and is positioned on a crosshatched background of red lines within an oblong panel that ends in a decorative medallion in the margin. Vowels are marked in red, diacritics in blue. The verses are separated by a simple three-dot pattern, the precursor of the more ornate trefoils usually rendered in gold. A rondel with a central disk in gold surrounded by alternating red and blue wedges marks the end of a verse.

S K

LITERATURE: Tornberg 1849, no. 371, pp. 245–46; Uppsala 1982, p. 11, no. 1.

*I*n this remarkable frontispiece illumination from a Cordobán manuscript, the central octagon is inscribed within an eight-pointed star, each apex of which is the departure point for a complex pattern of knotted interlace. The bands of interlace are edged with a thin gold band, itself outlined with an extremely fine line of black. At the center of the design a knotted motif in pale blue creates a sense of rotation, the gentle momentum of which takes us out through the octagon and the star to a ring of eight circles. Diametrically opposed arrowheads break through the ring of circles, resulting in an expanding dynamism. Paradoxically, there is also a balancing sense of inward movement—the star appears to be on a deeper plane than the circles, taking us in toward the central motif, whose pale blue color alludes to water and whose pattern suggests the spiral of a whirlpool leading to infinity. The overall palette of red, dark blue, black, and gold creates an effect reminiscent of that in the mihrab of the Great Mosque at Córdoba, while the motif of an octagon within an eight-pointed star recalls the design in the cupola in front of the mihrab in the same mosque.

The manuscript also contains a beautifully designed colophon in which the text is set within a decorative frame executed in the same style of interlace as that of the frontispiece illumination. The text, written in Western Kūfic style outlined in gold and filled with dark blue, reads as follows: "The whole of the Qurʾan was completed with the help and providence of God in the town of Córdoba, may God protect it, in the year 538. God bless Muḥammad His Prophet, his family, and companions and bring peace, exaltation, and honor upon them." S K

LITERATURE: Karatay 1951, p. 5., no. 13.

folio 3a (top); folio 146a (bottom)

Qur'an Manuscript

Almoravid or Almohad period, 1162
(dated A.H. 557)
Parchment
7⅛ x 7⅛ in. (18 x 18 cm)
General Egyptian Book Organization,
Cairo
Masahif n. 196

*C*omparatively small, square in format, and written in so-called Andalusī script with light brown ink, this manuscript belongs to a particular, recognizable type; several signed and dated in the twelfth century, giving Valencia as their place of completion, have survived. The way the horizontal strokes of the letters are drawn clearly demonstrates the relation of the Andalusī script to Kūfic.

Illustrated here are sura *al-Fātiḥa*, "The Opening," and part of sura *al-Baqara*, "The Cow." The sura headings are written in Western Kūfic against a hatched background set in rectangular frames ending in decorative medallions in the outer margin. The verse markers, rendered in gold, consist of small trefoils; every fifth verse is indicated by a small leaf, and every tenth designated by a rondel. The colophon informs us that the manuscript was commissioned by "the minister Abū Muḥammad ibn ʿAbdallah ibn ʿAbd al-Raḥmān ibn ʿAbdallah al-Mazhajī, also known as al-Lawsh, and was copied by ʿAbdallah ibn Muḥammad ibn ʿAlī."

S K

LITERATURE: Moritz 1905, no. 47.

folios 95r, 96v

The text of this manuscript, which was produced in Valencia, concerns Muslim tradition and was compiled by al-Quḍāʿī Abū ʿAbdallah Muḥammad ibn Salāmat ibn Jaʿfar ibn ʿAlī (died 1062 [A.H. 454]). This Almohad copy is written in elegant Maghribī script in brown ink; diacritical marks are rendered in red, blue, and brown ink with a finer pen. Chapter headings are written in gold. Medallions decorated in gold, blue, and red are used in keeping with the tradition of Qurʾanic verse

markers and serve as punctuation. Some margins contain comments written diagonally in finer script. A note has been added to the manuscript stating that it was read in its entirety in the Great Mosque at Córdoba in A.H. 584 (1188) by "al-faqīh al ustādh Abū Muḥammad ibn Aghlab, known as Ibn Abī al-Daqqāq." SK

LITERATURE: Sijelmassi 1987, pp. 44, 57, ill.

77

Shihāb al-Akhbār Manuscript

Almohad period, 1172/3
(dated A.H. 568)
Vellum
9⅛ x 7⅛ in. (23 x 18 cm)
Bibliothèque Royale, Rabat
1810

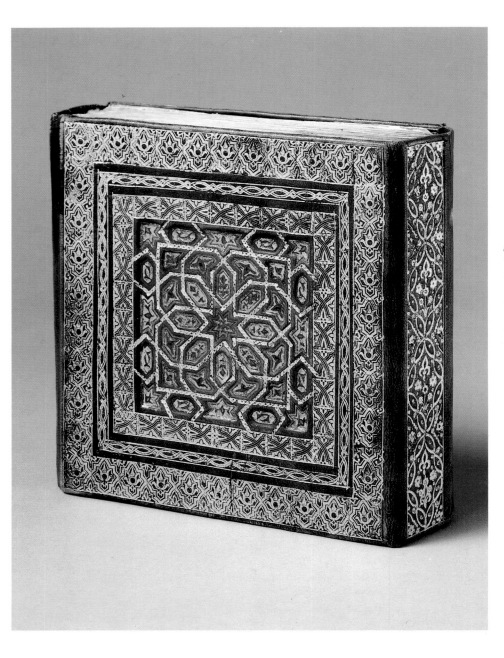

Qur'an Binding

Almohad period, 1178
(manuscript dated A.H. 573)
Leather and gold
6½ x 6½ in. (16.5 x 16.5 cm)
Bibliothèque Royale, Rabat
12609

*G*eometrical interlacing that originates from an eight-pointed star, a pattern type used profusely in the art of al-Andalus, is the basis for the elaborate design pattern of this binding. The binding was first engraved, then lavishly gilded and colored. Gold covers almost all the surface of the leather, with only the spine and a few other areas left in reserve; green and pinkish mauve bring out details of the design. The small scale of the decorative motifs and the meticulous rendering of the details evidence a high standard of workmanship. The flap (*lisān*) on this binding remains intact; such flaps are considered one of the greatest contributions made by Islamic binders to the craft of bookbinding.

The central design element of this binding bears a great similarity, especially in the use of polygonal interlace, to another Almohad Qur'an binding from Marrakesh (Fig. 10, p. 123), dated A.H. 654 (1256). In view of the resemblance between these bindings and the well-established tradition of bookbinding in Morocco, it is most likely that the binding shown here was also produced in Morocco. Because the binding was produced in the period of common rule, which was characterized by free cultural exchange, its Qur'an, written in a style of script from al-Andalus typical of Valencia, may have been copied in Spain but bound in Morocco. Morocco played an important role in the history of bookbinding and significantly influenced the development of bookbinding in Europe, where the first bindings with gilded decoration did not appear until the middle of the fifteenth century.

S K

LITERATURE: Ricard 1933; Ricard 1934; Sijelmassi 1987, pp. 46–47, ill.; Paris 1990, no. 496, pp. 250–51.

folio 68b

The portion of the sura *Maryam,* or "Mary," we see in this manuscript from Marrakesh is written in Andalusī script with a strong Kūfic influence; the horizontal lines are straight and elongated, and the loops of the letters above the line, such as *kāf* and *ṣād,* are not rounded. The sura heading is written in Western Kūfic script in gold against a vibrant red background decorated with fine gold floral scrollwork and framed by a knotted-motif border also rendered in gold. Verse divisions are marked by gold trefoils with red and blue dots between the leaves; every fifth verse is marked by a half-palmette motif with a red-shaded diagonal edge, and every tenth verse is marked both within the text by a simple gold circle and in the margin by a medallion decorated in gold and red. The style of the illumination brings to mind other manuscripts produced in Marrakesh. S K

LITERATURE: Karatay 1962, pp. 83–84, no. 299; Lings 1976, p. 205, pls. 102, 103.

Qur'an Manuscript

Almohad period, 1202/3
(dated A.H. 599)
Vellum
8¾ x 7⅛ in. (22.3 x 18 cm)
Topkapi Saray Museum Library, Istanbul
R.33

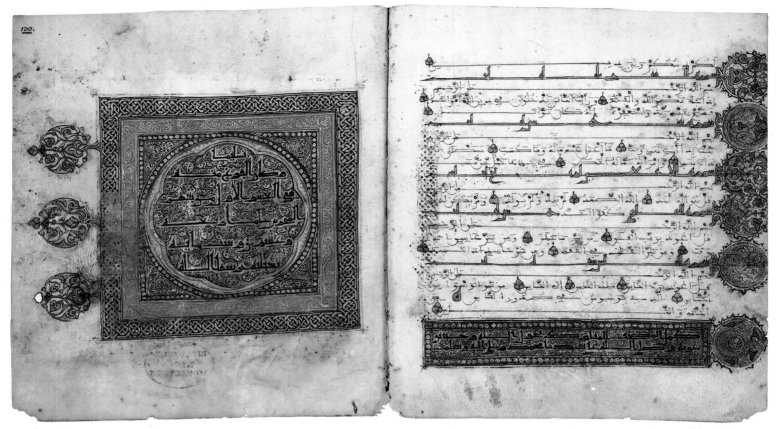

folios 119r, 120v

80

Qur'an Manuscript

Almohad period, 1227 (dated A.H. 624)
Vellum
8⅝ x 7¾ in. (22 x 19.5 cm)
Bayerische Staatsbibliothek, Munich
Cod. arab. 1

These folios from a manuscript produced in Seville contain the last five suras of the Qur'an and a colophon. The suras are written in Andalusī script in reddish brown ink, with the horizontal strokes of some letters particularly elongated; diacritics are marked in blue. The sura headings are written in Western Kūfic script in gold outlined with an extremely fine black line and shaded in red. Gold trefoils with red dots between the leaves indicate individual verses, and leaf-shaped ornaments mark the passage of each fifth verse. Below the text, a rectangular panel decorated in gold contains the initial two lines of the colophon, written in Western Kūfic in black ink against a background of fine scrollwork with the area surrounding the letters left in reserve. The remainder of the colophon is set in a rosette against a similar background of palmette motif drawn in a manner reminiscent of metalwork decoration; indeed, the rosette itself has been rendered in such a way as to create the illusion of an actual medallion. One outstanding feature of this illumination is its pink frame, which contrasts with the pale blue surrounding the central rosette; both colors appear in some of the margin medallions on the previous page.

S K

LITERATURE: Aumer 1866; Gratzl 1924, pl. III, no. 4; Munich 1982, p. 123, pl. 18, no. 56.

81

Qur'an Manuscript

Almohad period, 13th century
Paper
13⅜ x 10¼ in. (34 x 26 cm)
Bibliothèque Ben Youssouf, Marrakesh
431

The beautiful Maghribī script of this twenty-volume Qur'an that was made in Spain is written in brown ink on very good quality peach-colored paper. The letters are relatively large, and the writing is well spaced, accommodating about three or four words to the line and five lines to the page. The diacritical marks, finely outlined in brown, are filled in with gold or silver that has now tarnished; large yellow or green dots indicate the hamzas. The sura heading, written in Western Kūfic script rendered in gold with red shading, appears on a blue background with fine white scrollwork, all framed by a knotted-motif border also in gold. This oblong panel contrasts well with the comparatively free-flowing Maghribī script of the text. The medallion linked to the heading indicates that the sura following was revealed to the Prophet at Medina. A leaf-shaped decoration, often called the tree of life, is decorated with the same rosette motif as the medallion and contains the word *khams* (five), thus marking the passage of every fifth verse, in this case the last five verses of sura *al-Nisā*, "Women." The word *ḥubūs*, or pious foundations, is marked by needle holes at the top left of every page. The peach-colored paper, called *al-waraq al-shāṭibī*, is believed to have come from Játiva in Spain, which was celebrated for its papermaking.

S K

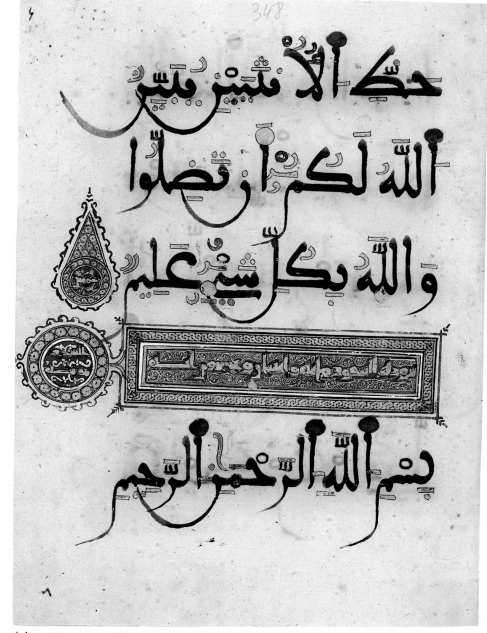

folio 348v

على شاكِيه، النهرِ وصورةِ العينِ فوقَ العورِ فرؤوفُ علَيهِ يَنْهِ ويَنهُ
وممّا جازاءِ حسنُارٍ مِنْ هنا ثِنَا بن خُورِ الترّ تارِ

فقالَ فيهِ إن ذكرَ لهُ جَنى مع عَينيهِ وقامَ علَى نفسِهِ وموعِنتم
بِي فبيستُ وجمعةٍ وقلت لا لا اسوعلبه نحملِ اللهِ ما بعلتِ فرفِعلهِ
عنبكَ فانتَ وأجبِرَ من الوفِ لا يَخصِ فمالِكَ عنبَرَما اسمع عندَ ذلكَ المَعزِرة

19

folio 19r

82

Ḥadīth Bayāḍ wa Riyāḍ Manuscript

Almohad period, 13th century
Paper
11⅛ x 7⅞ in. (28.2 x 20 cm)
Biblioteca Apostolica Vaticana, Rome
Vat. Ar. 368

ghinā (get-together) organized by the Lady of the Palace, the daughter of al-Ḥājib; the lovers sing and play the lute, declaring their passion (folio 10r). This upsets the Lady of the Palace, who is apprehensive that her father will find out about Bayāḍ and Riyāḍ; she orders that Riyāḍ be kept in a separate house, where she is left alone to cry and pine. Meanwhile, Bayāḍ is seen wandering, talking to himself, and fainting (folio 19r). Eventually letters are exchanged between the lovers (folio 17r), and the old woman arranges a reconciliation between Riyāḍ and the Lady of the Palace (folio 26v), who finally decides to bring Bayāḍ and Riyāḍ together, whatever the consequences; the old woman is told to "go home and wait for my messenger." For two long months nothing happens; then one day, when the coast is clear, the Lady of the Palace sends ten of her servants, wearing their veils. The old woman disguises Bayāḍ so that eleven veiled women return to the palace, where Riyāḍ is waiting. The story, similar to tales found in the famous *One Thousand and One Nights*, includes such elements essential to this well-known literary genre as the lovers who are both fluent poets and a wise and cunning old woman who plays their go-between.

The style of the miniatures displays clear similarities with manuscripts from Syria and eastern Mesopotamia of the late twelfth and early thirteenth centuries, especially in the compositional elements, the arrangement of the figures, and the rendering of the trees. The integral relationship between the text and the miniatures is revealed in the specific scenes chosen for the miniatures; the incidents depicted reflect a sensitivity to the nature of the narrative. Islamic Spain, with its flourishing gardens and running waters, was a particularly favorable context for love and the celebration of beauty. We notice that six of the miniatures in the manuscript are set outdoors, and in all of these greenery, and sometimes water, can be seen.

In this manuscript love is portrayed as a sickness, the symptoms of which are no sleep, no eating, sighing, wandering, and, especially, fainting. Occasional sleep would only be sought in the hope of seeing the beloved in one's dreams:

<div dir="rtl">إذ القلوب بيد الله عز وجل</div>

I did not sleep to rest but in the hope that my beloved would appear.[1]

It is significant that the Hispano-Muslim Ibn Ḥazm (994–1064 [A.H. 384–457]), a man of politics, law, and philosophy, compiled *Ṭawq*

Among the very few illustrated manuscripts from al-Andalus that have survived, *Ḥadīth Bayāḍ wa Riyāḍ* has no equal. The illustrations, with their graceful lines, elegant forms, refined details, and carefully studied compositions, testify to the presence in medieval al-Andalus of an advanced tradition of miniature painting about which we know almost nothing.

The manuscript is extensively illustrated; fourteen of its miniatures have survived. Though its beginning and end are missing, not much of the story seems to be lost. The narrative tells of a young merchant called Bayāḍ who falls in love with a handmaiden named Riyāḍ. She is under the control of al-Ḥājib, a chamberlain who has his own amorous interest in her. This presents complications for Bayāḍ, but he finds a good listener in an old woman who soon becomes his go-between and adviser. She arranges for the two lovers to meet at a *majlis*

al-Ḥamāma at the request of a friend who had written to him from Almería, asking that he compose a book on the actual characteristics of love, its meaning, and its reasons. In Ḥadīth Bayāḍ wa Riyāḍ we are presented with precisely the same conception of love as described by Ibn Ḥazm: a belief that love is not man's creation since إذ القلوب بيد الله عز وجل (the hearts are in the hands of the Almighty God).[2]

It has already been pointed out that Ḥadīth Bayāḍ wa Riyāḍ should be attributed to a center where weaving was important, such as Granada or Seville, because of its close resemblance to a group of textiles.[3] Several other details connect this manuscript to Seville. The motif that decorates the headgear of al-Ḥājib's daughter (folio 10r), for example, can be found in the illumination of a Qurʾan (No. 80) produced in Seville in 1227 (A.H. 624).

Moreover, the architecture depicted, which plays an important role in the miniatures, can easily be identified as that of al-Andalus. Elements such as the double windows, the horseshoe arches, and the peaked roofs are clearly Islamic features. Closer inspection reveals specific elements that can be found in Almohad architecture. A rather unusual three-lobed arch in the palace (folio 19r) has its equivalent not only in the Cistercian monastery of Santa María la Real de Huelgas in Burgos (the building was probably originally erected by the Almohads in 1189 [A.H. 585]) but also in the Kutubiyya mosque in Marrakesh (begun 1146 [A.H. 541]). The decoration of the window grilles within the miniatures is obviously a simplification of the decorative diaper of indented lozenges frequently found in Almohad buildings. Other features in the miniatures, such as the three-quarter corbels supporting the projecting balconies and the pattern of construction based on alternating pairs of vertical and horizontal blocks (folio 10r), can also be found in Almohad architecture.

The manuscript is written in a type of Maghribī script that in its style of handwriting, general layout, and colors used in the text bears a great similarity to the calligraphy in two manuscripts from al-Andalus, one of which is dated 1240 (A.H. 638).[4] Given this relationship in addition to those mentioned above, Ḥadīth Bayāḍ wa Riyāḍ must have been produced in one of the leading Almohad cities, most likely Seville, in the early thirteenth century. S K

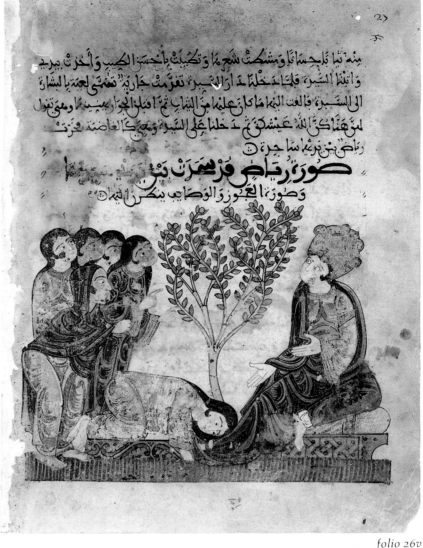

folio 26v

4. One of these is a copy of the anthology of Abū'l-ʿAlāʾ al-Maʿarri (1240 [A.H. 638]), now in the Bibliothèque Royale in Morocco (N. 802); the other manuscript from al-Andalus, now in the Bibliothèque Nationale in Tunis (ʿAbd al-Wahāb 18656,3; Chabbouh 1989, p. 43, pl. 71), is also an anthology. Although not dated, it is attributed to the thirteenth century and contains an appendix in which the name Seville can be deciphered. It is not clear whether Seville indicates the place where a reading of the anthology took place or where the manuscript was compiled; nevertheless, a connection with Seville, the Almohad capital, is definitely established.

LITERATURE: Levi della Vida 1935, p. 39; Monneret de Villard 1941; Nykl 1941; Ettinghausen 1962, pp. 128, 162, pls. pp. 126–27, 129; Sourdel-Thomine and Spuler 1973, p. 266, pl. 202, pl. XXXVII; Ettinghausen and Grabar 1987, p. 163, pls. 143–45.

1. Ḥadīth Bayāḍ wa Riyāḍ, folio 20.
2. Ibn Ḥazm 1982, p. 60, Arabic text.
3. Ettinghausen and Grabar 1987, p. 163, pl. 142. For the textiles, see also May 1957, figs. 40, 91, 92.

83

Qur'an Manuscript

Naṣrid period, late 13th–
early 14th century
Vellum
21 x 23⅞ in. (53.5 x 60.5 cm)
Museum of Turkish and Islamic Art,
Istanbul
T. 360

*T*his folio, from the second of two volumes written in Maghribī script in brown ink with only seven lines to the page, shows the final line of sura *al-Fatḥ*, "Victory," and the beginning of sura *al-Ḥujurāt*, "Apartments." Vowels are marked in red and diacritics in blue; other orthographical marks are indicated with green and orange dots. Verses are sometimes separated by a trilobate leaf rendered in gold with blue and red dots. Circular medallions with a serrated edge outlined in dark blue are decorated with a geometrical motif surrounding an eight-pointed star filled in gold and containing the word *āya* (verse). The sura heading, written in ornamental Western Kūfic script in gold with edges shaded in red, creates a sense of weight that contrasts with the lightness of the Maghribī script. The heading is further emphasized by a large medallion in the margin filled with remarkably delicate yet compact filigree scrollwork in gold and blue. The free and flowing handwriting is beautifully balanced, achieving an outstanding effect of elegance. The combination of the fine line of the script within the monumental format creates a sense of lightness that gives this manuscript a majestic character. The manuscript was produced in Spain, probably in Granada. s k

Literature: Lings 1976, p. 205, pls. 97, 98.

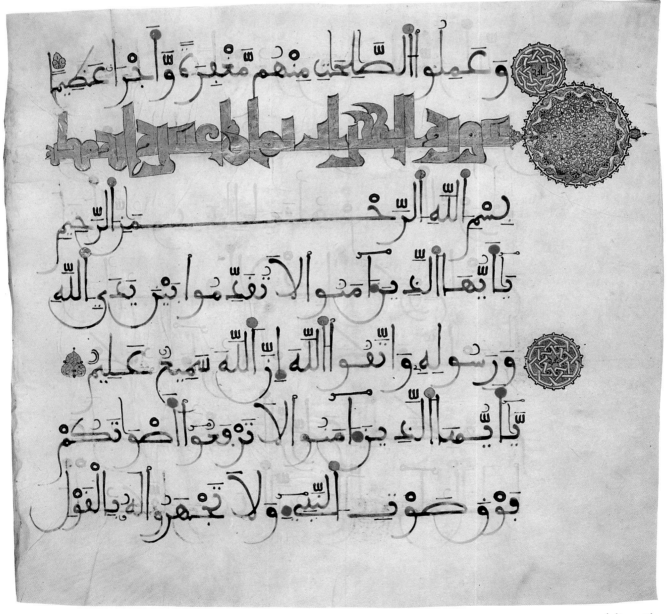

folio 338b

folios 1v, 2r

\mathcal{L}ike the example in the preceding entry, this manuscript is attributed to Spain and was probably made in Granada. Its elegant Maghribī script is achieved by employing a costly and time-consuming technique that consists of tracing the contours of each letter with a very fine pen and an ink based on resin and burned oak gall, then filling in the contours with gold; in time the fine line turns black. Here, diacritical marks are added in red and blue, with orange dots indicating the hamza. To distinguish them from the rest of the text, sura headings, written in ornamental Western Kūfic, are rendered in dark letters outlined in gold; the headings end in the margin with finely decorated medallions. Small rondels, decorated in gold and containing the word *āya* (verse) reserved in white on a dark background, separate the verses. The leaf-shaped ornament colored predominantly with gold bears the word *khams* (five) to mark the passage of five verses.

This style of Maghribī script shows a remarkable dexterity and balance. The interrelation between the letters is unique; often the end of one letter is so prolonged that it becomes the beginning of another, the whole creating an original sense of integration and elegant movement. Some letters end with buttonlike rondels, while curves below the line often form full semicircles encroaching on other letters, a rhythm echoed in the final letter of almost every line, which goes with a swing toward the left.　s k

Literature: Lings 1976, p. 205, pl. 95; Déroche 1985, no. 304, p. 35, pl. IIIA; Paris 1987, p. 37, no. 11.

84

Qur'an Manuscript

Almohad or Naṣrid period, 13th
or 14th century
Vellum
10⅜ x 8⅝ in. (26.2 x 22 cm)
Bibliothèque Nationale, Paris
Smith-Lesoeuf 217

folio 130r

Qur'an Manuscript

Naṣrid period, 1304 (dated A.H. 703)
Vellum
6⅞ x 6⅝ in. (17.6 x 16.7 cm)
Bibliothèque Nationale, Paris
Arabe 385

One of the final illumination pages from a Qur'an, this folio displays a complex design in which the strapwork is intricately interwoven to create a sense of several planes. Large stars are placed on the diagonals; the central star, the only one shown in full, is defined by a braided gold band. Around it small sections of luminous blue create an impression of concentric circles that contrast with the straight lines and sharp angles of the strapwork. The whole of the design, down to its smallest detail, is outlined in extremely fine dark lines. Given its diminutive scale, this illumination reveals the singular level of craftsmanship and the resolute devotion of its creator. This Qur'an is Spanish and was most likely made in Granada. S K

LITERATURE: Blochet 1926, pp. 62–64; Paris 1973, p. 64, no. 172; Lings 1976, p. 205, pls. 104, 105; Lings and Safadi 1976, p. 40, pl. VI, no. 48; Paris 1977, no. 212, p. 118; Déroche 1985, no. 296, p. 31, pl. XIVB.

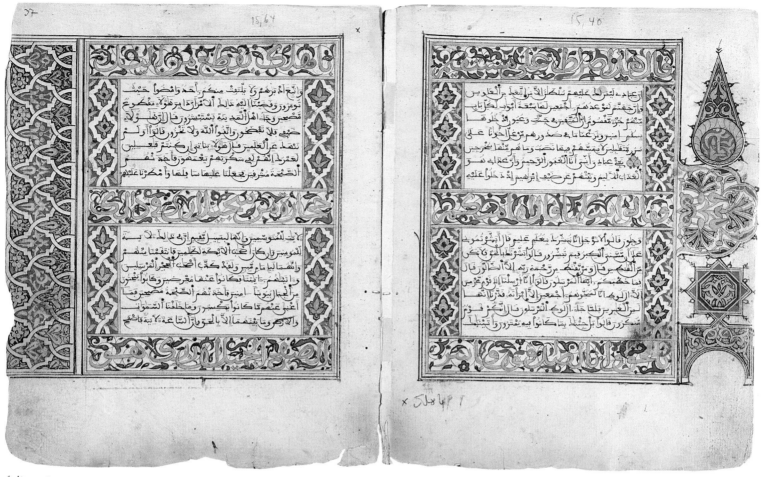

folios 36v, 37r

The main body of text on these Qurʾan folios from a manuscript produced in Spain or North Africa is written in fine Maghribī script in black ink; orthographical marks appear in red, while yellow dots indicate the hamzas. Each page is divided into two sections, each framed with a decorative border. The top, middle, and bottom lines of the text are written in Naskhī script in gold over fine, freely drawn scrollwork of leaves and flowers; these lines form the horizontal part of the decorative border. The narrow vertical bands of the decorative border are composed primarily of a pattern of indented lozenges, a design that first appeared on Almoravid architecture and became a ubiquitous architectural feature in North Africa. We find it in the same form not only in the minaret of the thirteenth-century Great Mosque at Fez but also in the Alhambra at Granada. The margin of the left folio contains a more elaborate rendition of this motif, an identical version of which can be found in the minaret of the fourteenth-century

Ibn Ṣāliḥ mosque in Marrakesh, although in a semicircular form marking a decorative arch. Even more striking is its appearance in an identical form, down to the details of the floral motif filling the enclosed areas of the design, in the Alhambra, where it can be seen as a horizontal band above the arches of some of the miradors. The use of the Naskhī script on a floral background, as seen in these folios, is also a common feature in the Alhambra. Although decoration in these folios is comparable to motifs in architecture, suggesting the late fourteenth century as a plausible date for their production, they display a rare originality among manuscripts. It should be noted, however, that several later manuscripts from Morocco use a similar palette and include related elements of design.

S K

LITERATURE: Kühnel 1924, p. 49, pl. 139; Kühnel 1963, pp. 25–26, pl. 4; Kühnel 1972, pp. 57–58, pl. 61.

86

Six Folios from a Qurʾan Manuscript

Naṣrid period, probably late 14th century
Paper
9 x 6 in. (22.9 x 15.2 cm)
Museum für Islamische Kunst, Staatliche Museen Preussischer Kulturbesitz, Berlin
17163

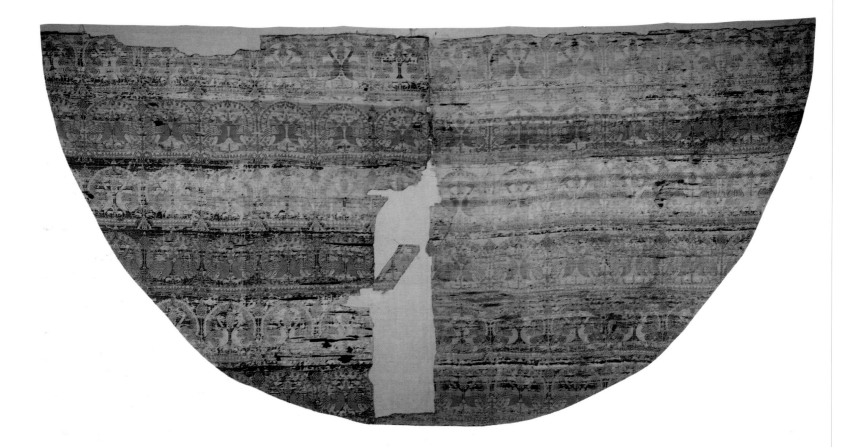

87

Chasuble

Almoravid period,
1st half of 12th century
Silk twill
59½ × 113⅛ in. (151 × 287 cm)
Basilique Saint-Sernin, Toulouse

*A*nimals and birds disposed in horizontal rows make up the decoration of this piece. Rondels are formed by the tails of paired, facing peacocks; between each pair of birds is the *hom*, or tree of life, in the form of a stylized palmette. Beneath the peacocks are two small gazelles, with heads turned backward; on the same plane as the gazelles are two small leaping dogs. All these figures stand on socles outlined with a pearl ribbon containing an Arabic inscription in which the phrase *perfect blessing* is repeated in Kūfic characters.[1] Beneath the socle are two small addorsed birds, and between them is the base of the palmette, which supports a slim, vertical stalk.

The unity of the design is apparent in the arched spaces created by the fan of the peacocks' tails, which are separated by large palmettes. At the base of the stem is a triangular vegetal element decorated on the outer edges with virgules; the stem is topped by a pineapple-shaped ornament with imbrications, a pearl border, and virgules on the outer edges. The background is blackish blue; the animals appear in their respective rows in tones of red and yellow, yellow and beige, and green and beige—with touches of pale blue.

In the archive of the basilica of Saint Sernin it is stated that in 1258 relics of Saint Exupéry, who was the bishop of Toulouse in the fifth century, were wrapped in this chasuble. For many years this piece was exhibited in the treasury of the basilica as the cope of King Robert of Naples (r. 1309–43), and it is surely for this reason that some authors have classified the piece as Sicilian. In fact, the cloth is closer in style to Hispano-Islamic textiles and arts. There is, furthermore, no comparable weaving that has been definitively attributed to Sicily.[2] On the other hand, the piece can be likened stylistically to numerous weavings manufactured in al-Andalus during the Almoravid period, even though the techniques differ.

One of the most obvious clues is the epigraphy. In addition, the peacocks are treated exactly like those on many caliphal ivories designed with the same disproportionate scale between the primary and secondary animals. And, finally, there are the palmettes and the *hom*. All these ornamental details are typical of weavings from the various textile workshops in the cities of twelfth-century al-Andalus, which produced widely divergent models. C P

1. Translation of Muhammad Yusuf.
2. Volbach 1969, pp. 23–24.

LITERATURE: Shepherd and Vial 1965, pp. 20–32; Volbach 1969, pp. 23–24; Costa 1989.

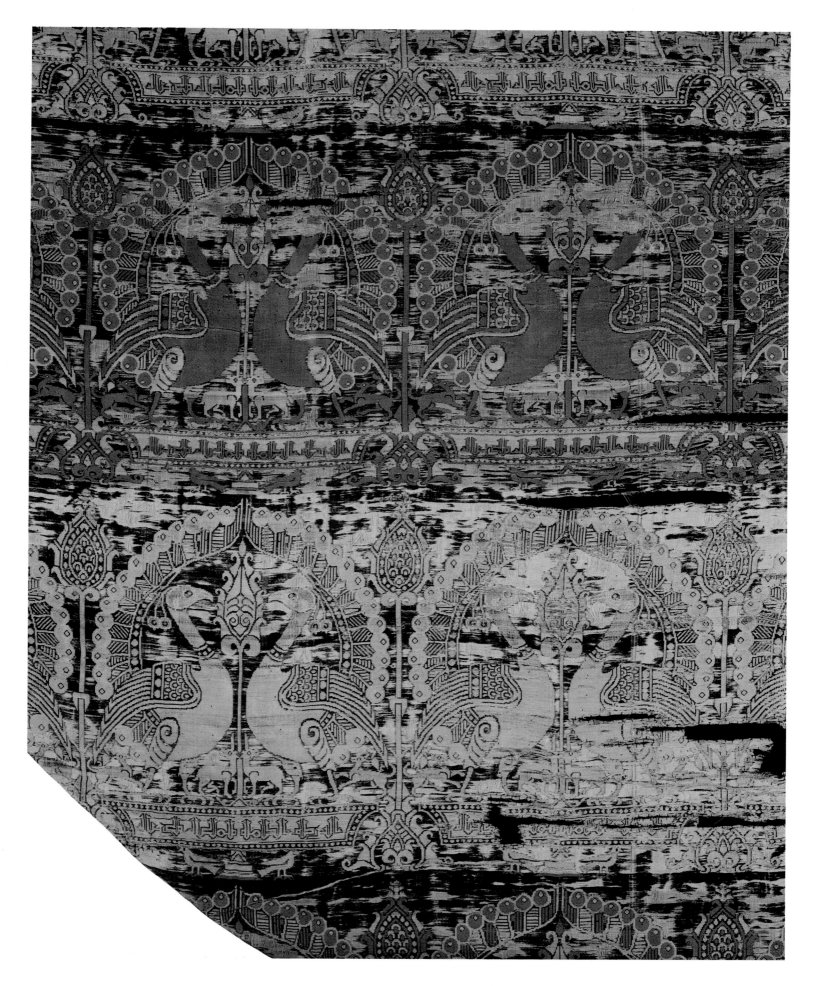

88

Textile Fragment: The Lion Strangler

Almoravid period,
1st half of 12th century
Silk and gold thread
20⅝ x 19½ in. (52.5 x 49.5 cm)
Cooper-Hewitt Museum,
The Smithsonian Institution's National
Museum of Design, New York, Gift of
J.P. Morgan, Miguel y Badia Collection
1901-1-220

Found in his tomb in Vich cathedral in Barcelona, this fragment is part of the dalmatic of San Bernardo Calvó, bishop of Vich from 1233 to 1243 (A.H. 631–41). The piece is decorated with rows of tangent rondels, each containing the figure of a bearded man wearing a turban and a richly embroidered tunic standing between two confronted lions that he is strangling in the crook of each arm. The frame of each rondel is formed of two concentric circles of pearl bands between which is a band of confronted griffins. Beneath the rondels is a horizontal border of Arabic characters repeating the word *al-yumn*, "prosperity,"[1] in ornamental Kūfic. The interstices are filled with extremely fine stars and palmettes. The decorative motifs are woven in red and blue green on an ivory ground. The head, hands, feet, and belt of the "lion strangler" and the heads of the lions are brocaded in gold thread in a honeycomb effect.

This fragment is the best example from a Hispano-Islamic workshop of a textile influenced by Persian weaving,[2] both in the pose of the figure and in its attire. In style and especially in its peculiar technique, it can be linked to the same school of textiles as that responsible for the textile from the church in Quintanaortuño (Burgos) from which the chasuble of San Juan de Ortega was made. Appearing on the latter is the name of ʿAlī Yūsuf, the Almoravid sovereign who governed Spain and North Africa between 1106 and 1142 (A.H. 500–537). The date of our example, therefore, is approximately the first half of the twelfth century, and we may tentatively attribute it to the city of Almería, where, according to al-Idrīsī, figured textiles with rondels were manufactured during the Almoravid period.[3]

C P

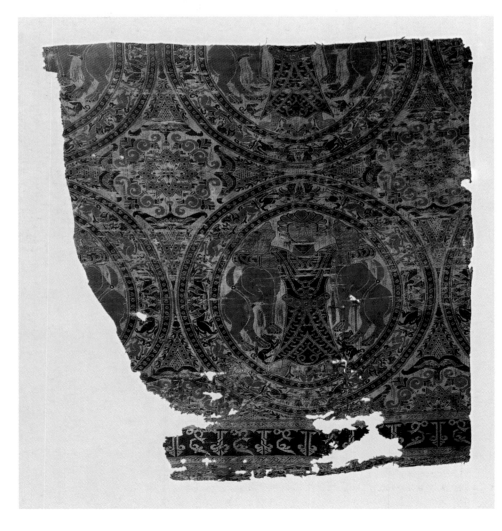

1. Translation by Muḥammad Yusuf. Yusuf interpreted the phrase as meaning good augury. In 1915 Rodrigo Amador de los Ríos translated the word *yumn* without the article as "prosperity."
2. As suggested by Otto von Falke, the textile design may have been a symmetrical duplication of a Persian motif appearing on an Achaemenid relief in Persepolis in which a man in a similar costume is strangling a lion with his right arm (1922, fig. 146). Rosa M. Martin i Ros, along with other authors, believes that this "lion strangler" is the hero Gilgamesh.
3. According to Josep Gudiol i Cunill (1913), this fabric might have been part of the booty won in 1238 (A.H. 636) when James I took Valencia from the Muslims; San Bernardo Calvó was among the men accompanying the king in that battle. Many fine silks were taken as spoils, one of which may have been the "lion strangler" from which the dalmatic was subsequently fashioned. Marielle Martiniani-Reber claims that these textiles were used for religious purposes (1986); there is evidence that scenes of combat against beasts were believed to have protective powers and to furnish the wearer with good fortune and strength, which probably explains the high esteem accorded these textiles in the west.

LITERATURE: Gudiol i Cunill 1913; Amador de los Ríos y Villalta 1915, pp. 173–212; Falke 1922, p. 18, figs. 144, 146; Shepherd 1943, fig. 5; Shepherd 1951, pp. 59–62; Weibel 1952, p. 99, fig. 72; Partearroyo 1982, p. 357; Martiniani-Reber 1986, pp. 99–100; Martin i Ros 1986, pp. 728–31.

89

Pillow Cover of Berengaria

Almohad period, ca. 1180–1246
Silk and gold thread
33⅞ x 19⅝ in. (86 x 50 cm)
Patrimonio Nacional,
Museo de Telas Medievales,
Monasterio de Santa María la Real
de Huelgas, Burgos
00650512

†

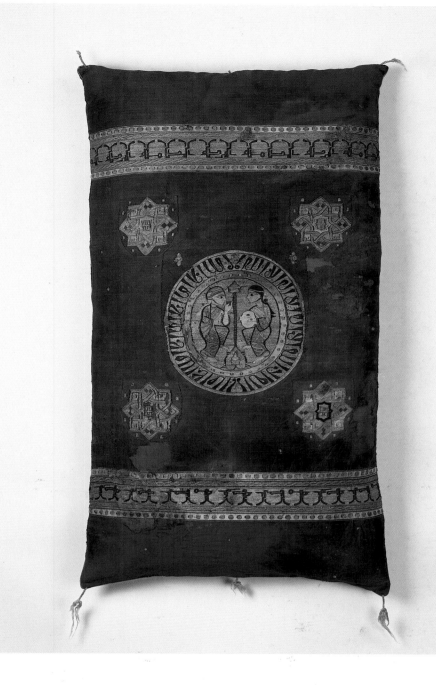

The pillow cover, which is of Hispano-Arabic manufacture, is woven in crimson silk using the tabby, or taffeta weave, technique and has twenty-five warp threads per centimeter. The upper face features tapestry-woven coinlike ornamentation in pure gold thread and a large central medallion of polychrome silks. The slightly elongated rondel is defined by a band of Arabic cursive script that repeats the words *There is no deity but God.* This band frames two female dancing figures facing each other, one holding a stringed instrument; between them is a stylized tree of life. Rondels with figures in dance positions such as the Nereid that today is part of an important textile collection in the Kunstgewerbemuseum in Berlin,[1] are typical of Coptic art.

Four stars woven with the same technique and materials are symmetrically placed about the center medallion, and an upper and lower band bear Arabic inscriptions reading *The Perfect Blessing.* The unadorned pillow back is woven in crimson silk taffeta that is finer than the front side. The pillow is edged on the shorter sides with a yellow cording that ends in small tassels.

Berengaria was the daughter of Alfonso VIII of Castile and Eleanor of England, the king and queen who had founded the Monasterio de Santa María la Real de Huelgas in Burgos. Until the birth of her brother Henry, she was the presumed heir to the throne. In 1197 a marriage was arranged between Alfonso IX of León and the Infanta of Castile, and the wedding was celebrated in Valladolid in December. However, the Church hierarchy was not unanimous in its approval of the marriage, which later was canonically annulled because of the degree of kinship between husband and wife. To effect their separation, Innocent III placed the kingdom of León under interdiction and excommunicated the king. Nonetheless, the separation did not

take place until 1204, at which time Berengaria returned to Castile.

On June 6, 1217, upon the death of Henry I, the crown fell to Berengaria, who surreptitiously arranged for her son, the infante Ferdinand, to leave the kingdom of León and go to Valladolid. There Berengaria renounced her right of succession in Ferdinand's favor, and he was proclaimed king of Castile. When Alfonso IX died on September 24, 1230, Berengaria saw the advantage of summoning Ferdinand to travel posthaste to León, where he was recognized as king.

At the end of her life, Queen Berengaria retired to the Monasterio de las Huelgas; she is believed to have died on November 8, 1246, and was buried in the monastery. Rodrigo Jiménez de Rada, archbishop of Toledo, and the *Crónica general*, a national history of Spain, hold Berengaria in high esteem.[2]

In her sepulcher, in addition to this cover, were found remains of her clothing: a splendid silk brocade with gold thread decorated with horizontal bands featuring a particularly vibrant green obtained from the coloring agent indigo —*Istatis tinctoria L.*—(PN Inv. 014/001 MH).

C H C

1. Lewis 1937, pp. 95, 99.
2. *Diccionario* 1968–69, vol. 1, pp. 507–8.

LITERATURE: Gómez-Moreno 1946, pp. 30–31, no. 62, pp. 82–83, pls. XLIII, LXIV, CXV; Bernis 1956, pp. 98–99; May 1957, p. 67, fig. 40; May 1959, pp. 94–95, 97–98; Herrero Carretero 1988, pp. 102–3; *Catálogo 1982–1986*, p. 171.

90

Pillow Cover of María de Almenar

Almoravid period, ca. 1200
Silk and gold thread
14⅝ x 26 in. (37 x 66 cm)
Patrimonio Nacional,
Museo de Telas Medievales,
Monasterio de Santa María la Real
de Huelgas, Burgos
00650516

*W*oven in the tabby, or taffeta weave, technique of silk with twisted gold thread, this Arabic brocade was believed to have been a pillow cover formed of three pieces sewn lengthwise. The compositional motifs of stylized plants in gold, blue, red, and white dominate the central band of the weaving. The upper and lower bands feature gold disks alternating with smaller disks surrounded by blue interlaced quatrefoils forming eight lobes. The central band, of greater complexity of design, presents symmetrical phytomorphic patterns woven in gold on a blue ground and bordered by selvages woven in red silk. The piece has been subjected to cleaning and strengthening and is reinforced with a backing of Swiss cotton batiste using natural silk thread.

Manuel Gómez-Moreno classifies the pillow cover as belonging to a group of handsome textiles of a classic Arabic series attributed to Baghdad manufactory. The technique is mixed tabby weave, that is, long tabby used for the tram of the motifs, and short tabby for the tram composing the field of the design.

C H C

LITERATURE: Gómez-Moreno 1946, p. 29, nos. 4, 5, pp. 46–47, pls. XLI, LII; May 1957, p. 83, fig. 52; Herrero Carretero 1988, pp. 92–93.

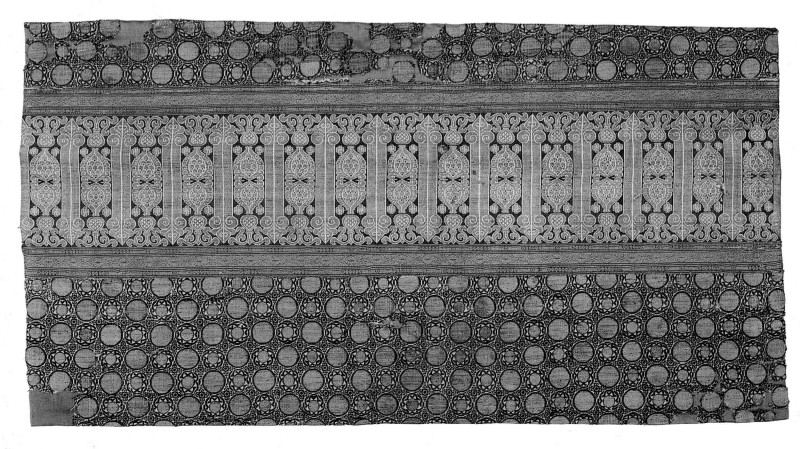

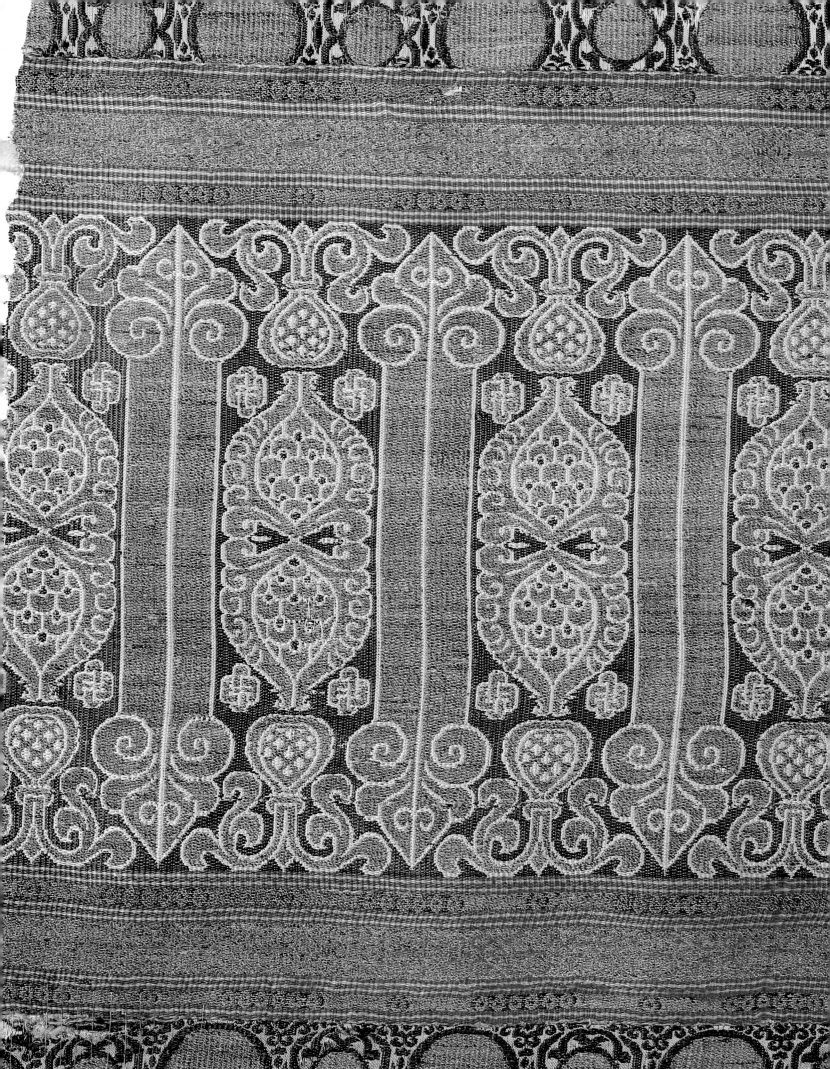

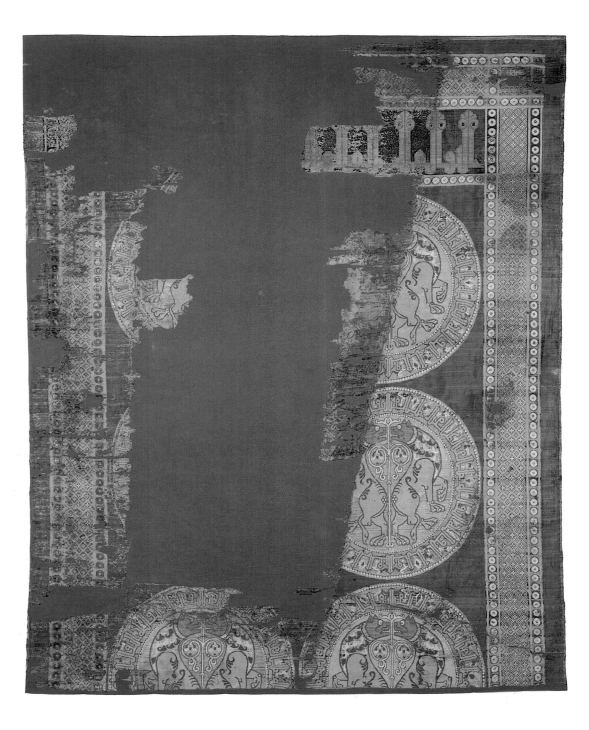

91

Coffin Cover of María de Almenar

Almohad period, ca. 1200
Silk and gold thread
88⅝ × 68⅞ in. (225 × 175 cm)
Patrimonio Nacional,
Museo de Telas Medievales,
Monasterio de Santa María la Real
de Huelgas, Burgos
00650542

*L*arge rondels containing paired lions embellish this magnificent Arab weaving of twill cloth. According to Manuel Gómez-Moreno, this weaving matched a piece that covered the plinth for the casket.

The circle, symbolizing eternity, was the principal Sasanian decorative motif. It had clear religious significance, and its repetition was the reiterated affirmation of the belief in eternal life. The rondels of this brocade are defined by circular bands of Kūfic inscriptions with the exhortation *Faithfulness to God*; the bands encircle addorsed lions whose heads meet on either side of a stylized *hom*, or tree of life, the most famous Assyrian motif.[1] The origin of the emblem was the date palm that to the Sasanians represented the eternal cycle of life. The borders create a frame for the rondels formed by a vertical series of small circles and lozenges with eight-pointed stars.

The piece belongs to a group of twill weavings in which great technical simplicity stands in contrast to a magnificent artistic composition. This is a characteristic example of the *pallia rotata* silks recorded in medieval documents. Chromatographic analyses have demon-

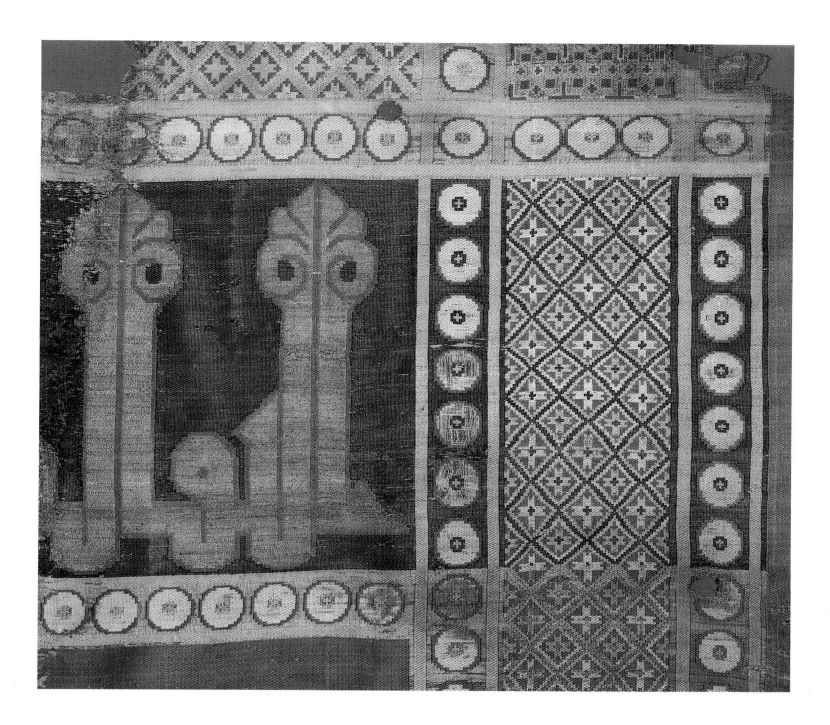

strated the presence of kermes used as a coloring
agent to obtain the brilliant crimson of the
field. Metallographic analyses indicate a high
content of silver (93.24 percent) in the gold
threads.

In the same sepulcher—in the nave of San
Juan Evangelista in the Monasterio de Santa
María la Real de Huelgas and bearing the epitaph
TERCIO X KL IANVARII OVIIT FAMVLA / DEI MARIA DE
ALMENARA E MCCXXXIIII (On the thirteenth,
before the calends of January 1234 [A.D. 1196],
María Almenara, handmaiden of God, died)—the
pillow cover assumed to have belonged to María

de Almenar (No. 90) was also found. María's
identity has been a matter of no little debate; it
has recently been proposed that she was the
daughter of the count of Urgel, Armengol el
Castellano.[2] CHC

1. Lewis 1957, p. 17.
2. Menéndez Pidal de Navascués 1983, p. 129.

LITERATURE: Gómez-Moreno 1946, pp. 28–29, no. 34,
pp. 59–60, pls. XV, LXXV–LXXVII; May 1957, p. 83, figs.
53–55; Herrero Carretero 1988, pp. 90–91; *Catálogo
1982–1986*, p. 175.

92

Las Navas de Tolosa Banner

Almohad period, 1212–50
Silk and gilt parchment
129⅞ × 86⅝ in. (330 × 220 cm)
Patrimonio Nacional,
Museo de Telas Medievales,
Monasterio de Santa María la Real
de Huelgas, Burgos
00652193

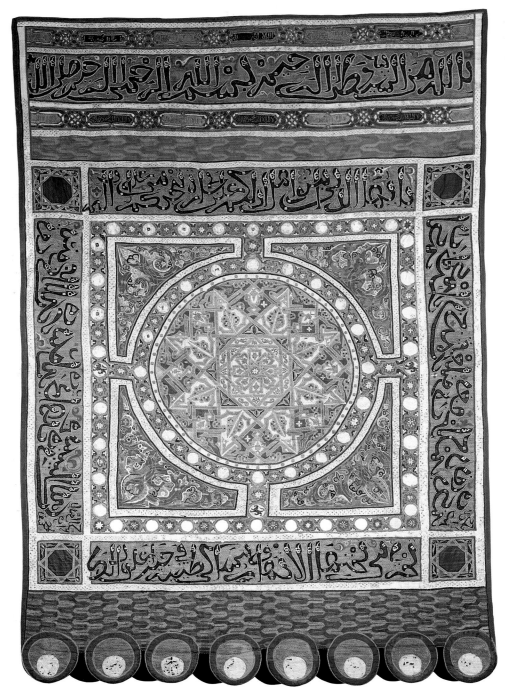

It was once thought that this tapestry was a part of the campaign tent of the Almohad sultan al-Nāṣir, who in 1212 (A.H. 609) was defeated by Alfonso VIII in the Battle of Las Navas de Tolosa. However, recent studies have posited that the piece is a trophy won by Ferdinand III, the Saint, the son of Alfonso IX, in his campaigns and donated to the Monasterio de Santa María la Real de Huelgas when the cloister was undergoing reconstruction.

There are twenty-two warp threads per centimeter. The central motif is an eight-pointed star contained in a ring of alternating stars and circles that is in turn enclosed in a broad frame formed by bands of Kūfic inscriptions with interlacery stars at the four corners. The upper part of the tapestry is formed of three joined bands, the widest of which contains a quote from the Qurʾan. The banner is finished at the bottom with eight circular lobes, or scallops, containing white medallions nearly encircled by gold crescents; a substantial portion of the inscriptions on the medallions has been lost.

The transcription and translation of the inscription—in Naskhī or Maghribī characters—that form an integral part of the banner were effected in the nineteenth century.[1]

The most important inscription, judging by the space allotted to it, is found in a band in the upper border bracketed by two narrower bands of oblong medallions joined by interlacery with eight-pointed stars:

[أعوذ] بالله من الشيطان الرجيم بسم الله الرحمن الرحيم
صلى الله [على سيدنا محمد وعلى آله وصحبه وسلم]

In God I find refuge from Satan, punished by stoning. In the name of a compassionate and merciful God. The blessing of God be upon our Lord and Master Muḥammad, the honored prophet, and upon his family and friends. Health and Peace.

The most representative Qurʾanic quotes are dispersed over the four wide bands that form the large square, which is woven in blue on a gold field. They read:

يا أيها الذين آمنوا هل أدلكم على تجارة تنجيكم
من عذاب أليم | تؤمنون بالله ورسوله وتجاهدون
في سبيل الله بأموالكم وأنفسكم ذلكم خير لكم
إن كنتم تعلمون | يغفر لكم ذنوبكم و يدخلكم
جنات تجري من تحتها الأنهار ومساكن
طيبة في جنات عدن ذلك الفوز العظيم |

O believers, shall I direct you to a commerce that shall deliver you from a painful chastisement?
You shall believe in God and His Messenger, and struggle in the way of God with your possessions and your selves. That is better for you, did you but know.
He will forgive you your sins and admit you into gardens underneath which rivers flow, and to dwelling-places goodly in Gardens of Eden; that is the mighty triumph.

(Qurʾan, 61:10–12)

The banner has clear similarities to the ensigns of Abū-Saʿīd Otsmín and Abūʾl Ḥasan, made, respectively, in 1312 (A.H. 712) and about 1340 (A.H. 741), two banners from the Battle of Salado, now conserved in the cathedral in Toledo.

The tapestry underwent meticulous restoration directed by Francisco Iñiguez Almech, fine arts consultant to the Patrimonio Nacional, and researched by Professor María Díez de Fernández Cuervo of the Escuela de Artes y Oficios Artísticos in Madrid. Her work, begun in March 1953, was completed two years later, in February 1955:

> A preliminary assessment was necessary to establish what portion of the Las Navas tapestry conserved in the Monasterio de las Huelgas was authentic. The investigation has been completed. The tapestry is in lamentable condition but nearly intact, and of such outstanding artistic and historical importance that it demands restoration. This is a unique piece from the oldest period of Arab tapestry and is of great interest and value both for its size and richness and for the degree to which color and design have been preserved.[2]

The latest restoration of the banner was carried out by the textile restoration team of the Patrimonio Nacional as part of the nine hundredth anniversary of the founding of the Monasterio de Santa María la Real de Huelgas.[3] Of utmost importance was the consolidation of the weaving: The nonoriginal pieces that had been inserted during repair in the 1950s were removed, a lining was affixed, and an adequate arrangement was devised for distributing the weight of the weaving uniformly to prevent distortion of the tapestry when hung on exhibition. CHC

1. Fernández y González 1875, pp. 463–75; Amador de los Ríos 1893, pp. 27–87.
2. File on the restoration of the Las Navas de Tolosa Banner. Servicio de Tesoro Artístico de Patrimonio Nacional, 1952–1956. Archivo de Palacio, file 2733/35.
3. The team was composed of textile restorers Purificación Cereijo and María Lourdes de Luis, archaeological restorer Carlos Torreiro Luengo, and chemist Pilar Baglietto.

LITERATURE: Fernández y González 1875, pp. 463–75; Amador de los Ríos 1892, pp. 505–9; Amador de los Ríos 1893, pp. 18, 22, 27–87; Madrid 1893a, Sala V, no. 96; Williams 1908, vol. 3, pp. 17, 23, pl. 1; Abad 1912; Kühnel 1924, p. 75, pl. 148; Niño y Más 1942, vol. 2, p. 21; Torres Balbás 1949, p. 61, fig. 47; Bernis 1956, pp. 110–12, pl. XI; May 1957, pp. 56–59, fig. 39; Pita Andrade 1967, pp. 118–19; Shepherd 1978, p. 128; Toledo 1984, pp. 123–24; Herrero Carretero 1988, pp. 121–24; Gaya Nuño n.d., p. 17.

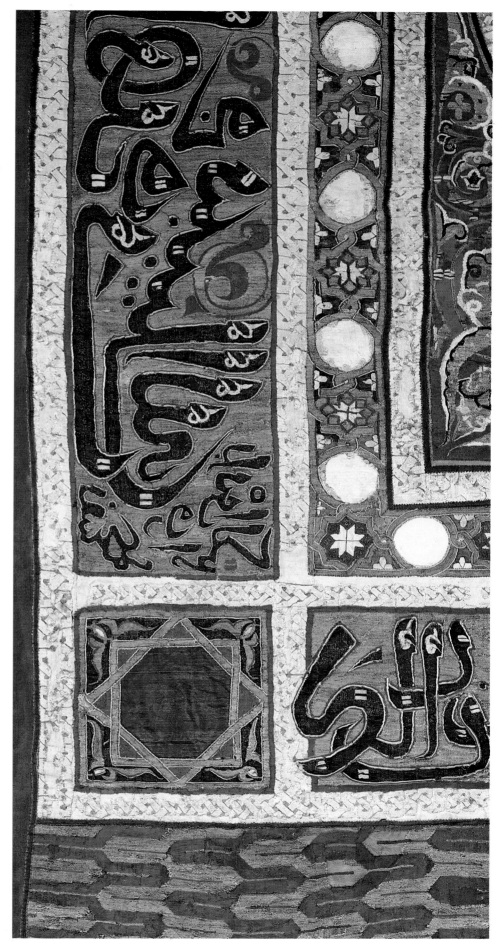

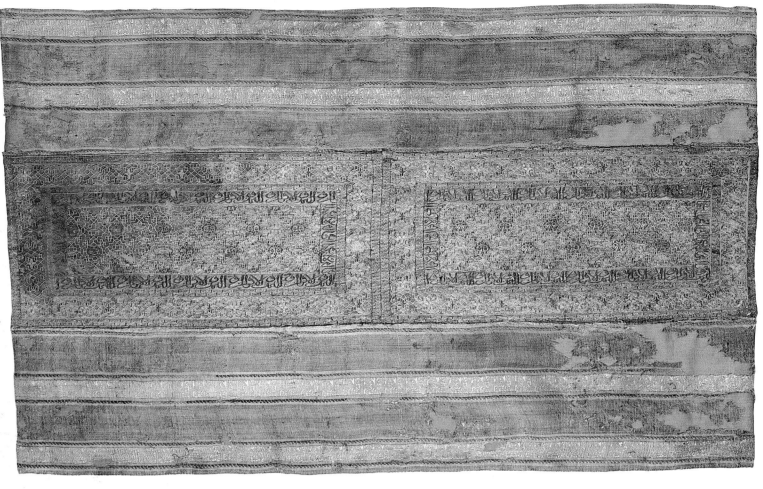

93

Pillow Cover of Leonor of Castile

Almohad period, before 1244
Silk and gold thread
19¼ x 28 in. (49 x 71 cm)
Museo de Telas Medievales, Monasterio
de Santa María la Real de Huelgas,
Burgos, Patrimonio Nacional
00650511

†

This pillow cover with gold and blue bands and a wide center strip of Almohad-type tapestry in silk and gold thread was probably woven by Arabs in the kingdom of Granada. The central rectangle of tapestry has twenty-five warp threads per centimeter. According to Manuel Gómez-Moreno's translation, the inscriptions on the cloth and the tapestry read *happiness and prosperity*.

It is similar to those believed to be from thirteenth- and fourteenth-century Granada, and in technique it recalls a piece found in the tomb of San Valero in the collegiate church of Roda de Isábena in Lérida, now in the Museu Tèxtil i d'Indumentària in Barcelona (No. 95). It also reveals strong technical similarities to the humeral veil of Saint Eudald, now in the Museo de Ripoll in the diocese of Vic.[1]

The pillow served as a headrest for the corpse of Leonor of Castile, a daughter of the founders of the Monasterio de Santa María la Real de Huelgas, Alfonso VIII of Castile and Eleanor of England. On February 6, 1221, Leonor was wed in Agreda to the monarch James I of Aragon, thus becoming the queen of Aragon.

The Aragonese monarch, however, sought a divorce in 1229, stating reasons of consanguinity. Because both were great-grandchildren of Alfonso VII of Castile, the marriage was annulled. Infante don Alfonso, born of this union, was legitimized on April 29, 1229. Leonor took her son to Castile and lived at the court with her sister, Queen Berengaria, until she retired to the Monasterio de Santa María la Real de Huelgas, where she died in 1244.[2]

The zigzag pillow (PN Inv. 002/002 MH) belongs to this same queen, as do articles of clothing—the corded tunic (PN Inv. 002/005 MH) and pelisse (PN Inv. 002/006 MH)—which were found in her tomb and removed in 1943; these pieces are exhibited in the Museo de Telas Medievales at the Monasterio de Santa María la Real de Huelgas. CHC

1. Martín i Ros and Calabuig i Alsina 1988, no. 66.
2. *Diccionario* 1968–69, vol. 2, p. 694.

LITERATURE: Gómez-Moreno 1946, pp. 23, 82, pls. LXII, CXIV; Bernis 1956, pp. 102–5, pls. IV–VI; Herrero Carretero 1988, pp. 48–49; Martín i Ros and Calabuig i Alsina 1988, no. 66, p. 50.

94

Tunic of Don Rodrigo Ximénez de Rada

Almohad or Naṣrid period, before 1247
Silk, gold thread, silver thread, and
gold-wrapped thread
L. 55½ in. (141 cm)
Monasterio de Santa María,
Santa María la Real de Huerta, Soria

*P*art of a set of pontificals, this tunic of Don Rodrigo Ximénez de Rada was found in the archbishop's tomb in the Cistercian monastery of Santa María la Real de Huerta in Soria. The textile is woven of natural silk and decorated with vegetal volutes symmetrically aligned and terminating in small buds. This ornamentation may have its antecedent in similarly decorated bronze caliphal stags. The intermediate spaces are filled with small four-pointed stars and minute *ataurique* motifs. There are three tex-

tiles in other collections, one of them in the Monasterio de Santa María la Real de Huelgas in Burgos, that display the same themes.

On the back of the tunic is a rectangular piece, an exquisite weft-faced compound tabby, worked with gold; the decoration is arranged in bands of rondels bordered by three lines on a gold ground, with palmettes in the intermediate spaces, lobed polygons and stars, and two bands with Kūfic characters repeating, symmetrically, the Arabic word *al-yumn,* "prosperity." Two

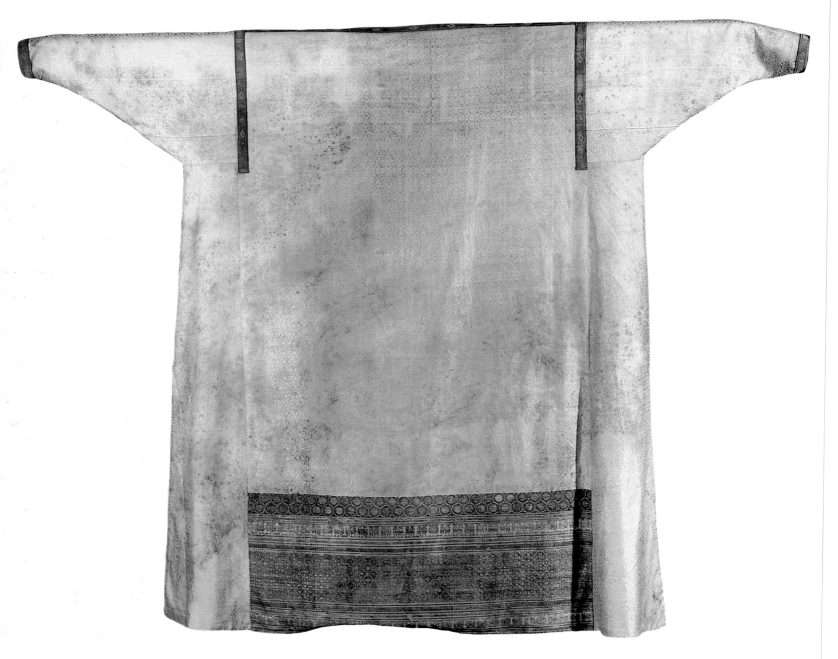

types of galloons with rhomboidal designs of silver and gold thread border the neck, shoulders, cuffs, and back. The tunic is lined with plain red silk and is woven of white, black, and red silk and gold-wrapped thread.

The archbishop's pontificals also included a dalmatic (in the process of restoration), which is made of the same textile, and a Gothic chasuble. These Hispano-Islamic garments are stylistically similar and date from the thirteenth century. There is a generally held belief that these vestments, of totally Muslim manufacture, were a gift from the sultan of the Naṣrid kingdom of Granada, Ibn al-Aḥmar—the sultan being a tributary of the king of Castile—to King Ferdinand III, the Saint, and that the king, posthumously honoring the archbishop, in turn bestowed the tunic on him.[1]

CP

1. Mantilla de los Ríos and Yravedra 1972, p. 54, n. 6 [Aguilera y Gamboa 1908].

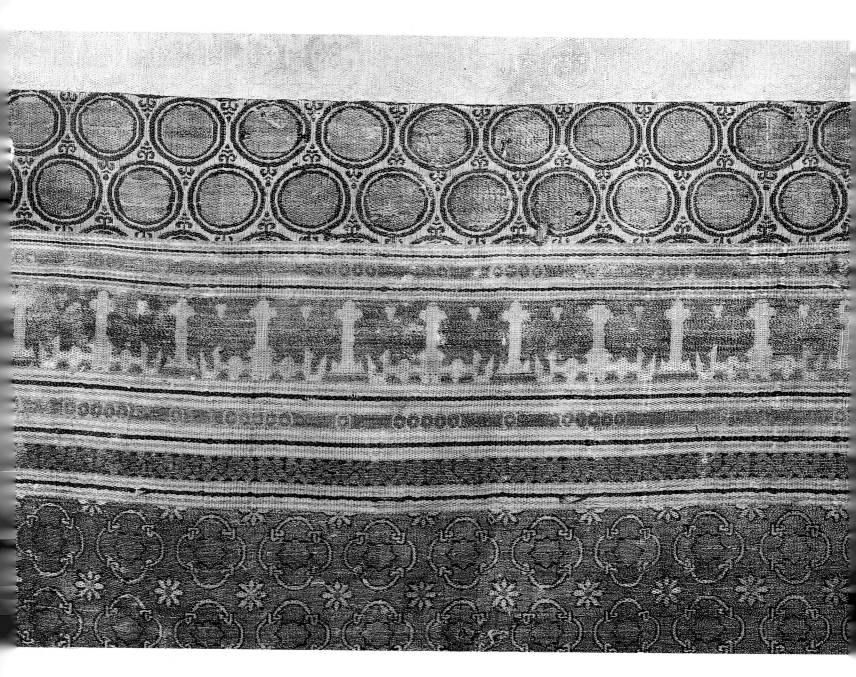

95

Vestments of San Valero

Almohad period, 13th century
Pluvial: silk and gold thread
49⅝ x 114¼ in. (126 x 290 cm)
Dalmatics: silk
57⅛ × 57⅛ in. (145 × 145 cm),
50 × 48½ in. (127 × 122 cm)
Chasuble: silk and gold thread
48½ x 71¾ in. (123 x 182 cm)
Museu Tèxtil i d'Indumentària,
Barcelona
5201, 5202, 5203, 5572
†

A document discovered and transcribed by Pere Pach in 1925[1] states that "in the year 1275 a Provincial Council was called in Tarragona, which was attended by Vernardus, Prior of Rhodes, accompanied by the Bishop of Lleida [Lérida], Guillem de Montcada. Once the said Council had ended, the two traveled to Rhodes and brought for our Church different ornaments, among them a complete set of vestments, of Muslim manufacture, which ornaments they dedicated to San Valero." This document errs in regard to the name of the prior of Rhodes:[2]

Bernat de Galliner died on January 4, 1275, and was succeeded by Berenguer de Chiriveta.

The precise date that the Rhodes vestments came into the possession of the cathedral at Lérida is not known, but we do know that the cathedral chapter determined to repair them, as recorded in the chapter minutes of February 4, 1498;[3] we must assume that it was on this occasion that the sleeves of the two dalmatics were replaced. Despite the chapter's good intentions, Father Villanueva[4] recorded in 1851 that one chasuble was taken apart and remade for "everyday use," so by the nineteenth century the transformations individual garments had suffered were already evident.

In 1922 the chapter of Lérida sold the vestments of San Valero to a collector from Barcelona, Lluís Plandiura,[5] but as a result of the great concern of Joaquim Folch i Torres, director of the Museos de Barcelona—whose interest predated the purchase—the vestments were acquired on August 18, 1922, and consigned to the municipal museums of that city.[6] Today the vestments are in the Museu Tèxtil i d'Indumentària in Barcelona.

The pluvial (5201) comprises more than one weave. The widest is the so-called *Tejido de las estrellas* (Cloth of Stars), consisting of two rows of squares framed by white lines. In one row the squares contain rosettes with a central star; in the other, the squares enclose stars formed of interlaced lines. The piece is of green, blue, and red silk with gold thread on a white ground. According to Félix Guicherd's 1956 analysis of a fragment of it in the Musée Historique des Tissus in Lyons,[7] the piece is a lampas weave of double cloth with four thrown threads and one background weft thread that join in tabby. This weave is twice interrupted to form the adornment of the cape, which is woven not in lampas but in tapestry on the same loom. The decorations consist of interlacery in white, red, and blue silk with gold thread. Inside the smallest rectangle in the tapestry adornment of the cape is a cursive inscription in blue silk on a gold ground. Both weaves are made on a draw loom, activated only when weaving the lampas. The center scapular of the cape is a design of addorsed, regardant hawks, with a tree of life between. They are woven in white, beige, and blue silks with gold threads of Chipre. Technically, the piece is a samite of three weft and two warp threads, one of silk and the other flax, that join the wefts on a twill foundation of three.

The two dalmatics (5202, 5203) are made of

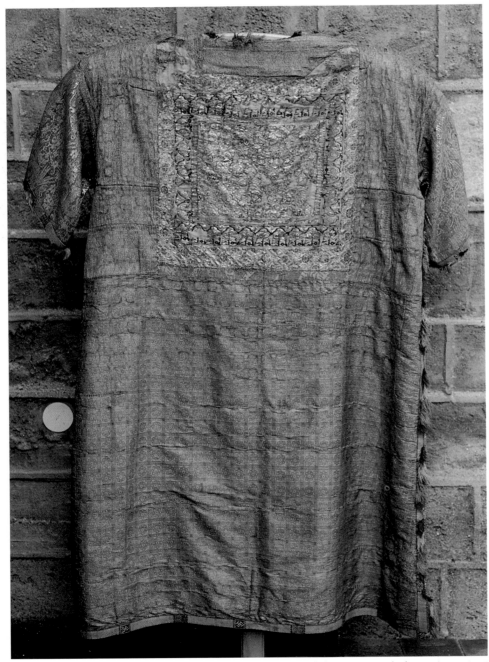

dalmatic 5202 (before restoration)

the same textile. Their widest section is the *Tejido de los rosetones* (Cloth of Rosettes), comprising small squares containing rosettes made by interlacing several geometric lines originating from an eight-pointed star. It is made of red, white, green, and blue silk—the background—and gold thread. Technically, it is lampas with four thrown wefts and one forming the ground in tabby.

The dalmatics are decorated on chest and back, each with a different design. On the chest is a rectangle with an interlace decoration similar but not identical to that of the cape; the silks are blue, white, green, and red, and the thread is gold. On the chest there are also two horizontal bands with red cursive on a gold ground. The ornament on the back is a large square decorated with interlacery of red, blue, green, and white silk, and gold thread. The design is framed by a Kūfic inscription in blue silk on gold, closed on the outer edge by small arches; this band is in turn framed by another of small medallions. The technique of both ornaments is tapestry weave:[8] a tabby worked in tapestry[9] on a low-warp loom.

As mentioned above, the present sleeves of the dalmatics were set in at a later time; some authors believe they are a Chinese textile, and others that this is a fourteenth-century Luccan weaving.

The chasuble (5572) was destroyed and exists now as a restoration. It was composed of two weavings. One was the *Tejido de los leones* (Cloth of Lions) formed of eight-pointed stars within which were two lions rampant regardant. The lions' tails join in a rosette that recalls a tree of life. Two rows of these figures alternate with one in which the stars contained confronted panthers; these three rows in turn combined with a band of Kūfic inscription. The piece was in pale rose, green, and blue, with gold thread. According to Guicherd's 1956 analysis, it is technically a weft-faced compound tabby woven with three wefts.[10] It was woven on a draw loom. The other weaving consists of a decoration formed of a strip with sprigged decoration of yellow, white, red, and green silk. It was made on a cartoon loom.

The greater part of the textiles composing these vestments are Hispano-Arab, dating from the second half of the thirteenth century and woven in the kingdom of Granada, probably in the region of Almería. The scapular of the cape is a *filoseda*, a type of silk-and-linen weave fabricated in a Christian area of the peninsula

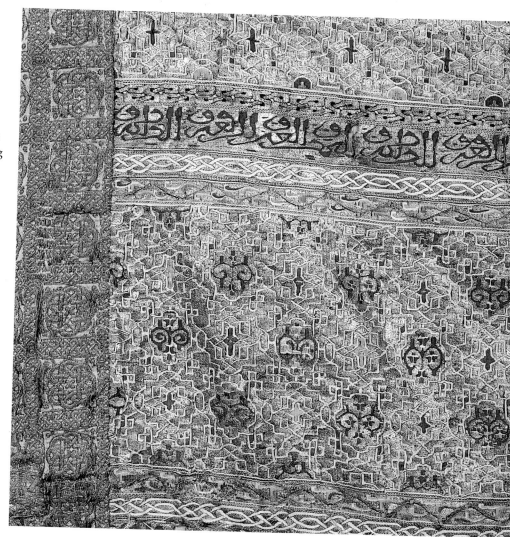

detail, dalmatic 5202 (restored)

by Muslim artisans, or by workmen schooled in Muslim ateliers. As explained above, the sleeves of the dalmatics are not Hispano-Arab. The fragments of the *Tejido de los leones* of the chasuble were used as patches for the dalmatics, which has caused some authors to believe that the weave was original to them.[11]

Fragments of the different weaves constituting the vestments of San Valero are found in various museums and textile collections throughout Europe and the United States.[12] R M M R

1. Pach 1925, p. 198.
2. Iglesias Costa 1980, p. 199.
3. Lladonosa i Pujol 1979, p. 227.
4. Villanueva 1851, p. 75.
5. Folch i Torres 1922, p. 11.
6. Ibid., pp. 13, 14.
7. Guicherd 1956, p. 1.
8. Bernis 1956, pp. 102–5.
9. Vial 1983, p. 1.
10. Guicherd 1958, p. 1.
11. Martín i Ros, forthcoming.
12. Ibid.

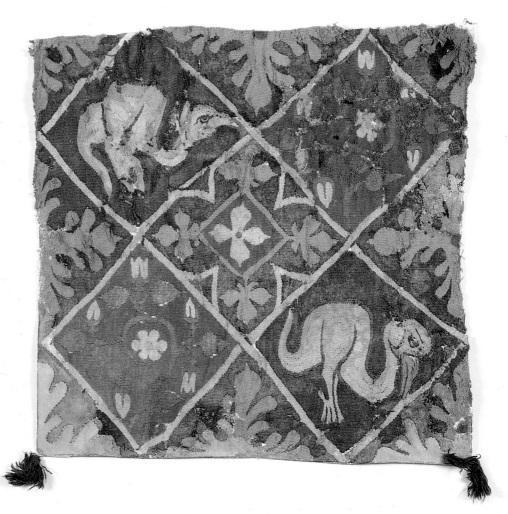

Pillow Cover of Alfonso
de la Cerda

Naṣrid period, ca. 1271–1333
Wool
22⅞ × 22 in. (58 × 56 cm)
Patrimonio Nacional,
Museo de Telas Medievales,
Monasterio de Santa María la Real
de Huelgas, Burgos
00651904

*W*oven in wool on wool warp, this cover for a pillow intended as a headrest is of Hispano-Arabic manufacture. There are eight warp threads per centimeter. The design consists of large squares containing animals and plants in naturalistic Gothic style and intersecting on the diagonal. The background of the floral themes is red or blue wool, while that of the fantastic animals is green.

This piece and a case for a cross were found in the coffin of Alfonso de la Cerda, who probably died in 1333. The case is of leather decorated with fleurs-de-lis and medallions gilded and stamped with the image of Saint Michael victorious over Satan. Alfonso de la Cerda was the son of Infante Fernando de la Cerda and Blanche of Castile and thus the grandson of Alfonso X the Learned and Louis IX of France. The sculptural ornamentation of the stone sar-

cophagus also features fleurs-de-lis enclosed in octagons formed by Mudejar interlacery with alternating castles and lions.

This tapestry belongs to the group erroneously classified by Manuel Gómez-Moreno as medieval needlepoint. The weavings thus classified—the cap of Infante Fernando (Fig. 4, p. 110), the pillow cover of Queen Berengaria, the pillow cover of Leonor of Castile (Nos. 89, 93), and the pillow cover of Alfonso de la Cerda—are not pieces embroidered with a needle but are loom-woven tapestries. The group described by Gómez-Moreno consists of three categories: tapestries, Mudejar plain knitting, and Moresque chain stitch. CHC

LITERATURE: Gómez-Moreno 1946, p. 34, no. 66, p. 84, pls. CXVII–CXVIII; Monteverde 1949, no. 109, p. 244.

97

Textile Fragment

Naṣrid period, 14th century
Silk
40⅜ x 14¾ in. (102.6 x 37.5 cm)
The Metropolitan Museum of Art,
New York, Fletcher Fund, 1929
29.22

*W*e can assume that this silk pattern was one of the most frequently employed and subsequently most widely distributed, for examples of it are found in most Hispano-Islamic textile collections. One of the lateral borders, or selvedges, of this fragment is intact, which enables us to determine the length of the piece on the loom.

On a predominantly red background, the ornamental themes are disposed in horizontal bands of different widths. The two larger bands are filled with elegant interlacery formed by ribbons of yellow, white, green, and black, employing the basic motif of the eight-pointed star. The designs on the two bands are different: The lower one more closely resembles tile wainscoting, while the upper pattern is reminiscent of Naṣrid stuccowork. The two are separated by narrow bands with merlons, bows, connected Kūfic inscriptions reading *beatitude*, and cartouches with cursive inscriptions that repeat the words *happiness and prosperity*.

The weaving technique is typical of textiles dating from the end of the fourteenth century. Characteristic of these textiles is the substitution of yellow thread for gold. According to Antonio Fernández-Puertas, the Kūfic inscriptions date from the time of Muḥammad V (r. 1354–59 [A.H. 755–61] and 1362–91 [A.H. 764–94]).

In both the plaster and the tile work in the buildings constructed by Muḥammad V, such as the Palacio de los Leones in the Alhambra, the interlacery is closely related to this weaving; even the coloring of some original plaster polychromy is the same, evidence of the textile character of that work. Similar weavings continued to be made during the fifteenth century.

CP

LITERATURE: Artiñano [1917], pl. XIV, no. 15; Niño y Más 1942, p. 24, fig. 5; Torrella Niubó 1949; Mackie 1972, no. 11; Sánchez Trujillano 1986, pp. 94–100, figs. 22, 23; Metropolitan Museum of Art 1987, p. 65, no. 47.

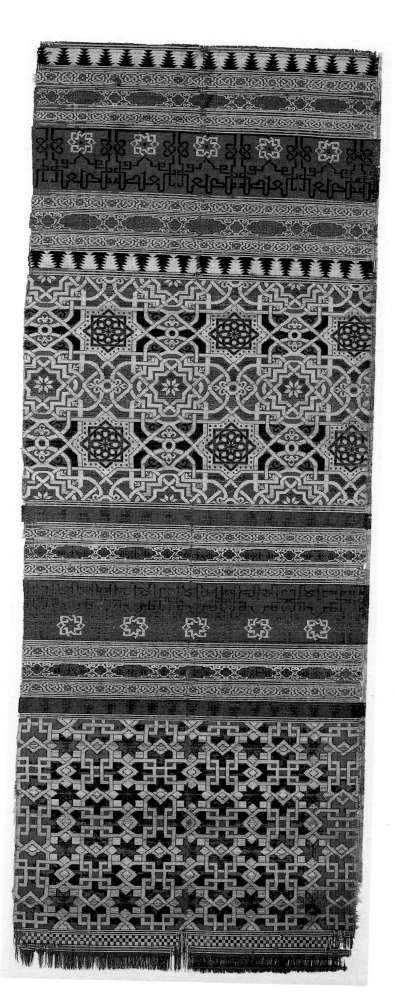

98

Pluvial

Nasrid period, late 14th century
Silk and gold thread
55⅛ x 34¼ in. (140 x 87 cm)
Museo Diocesano-Catedralicio, Burgos

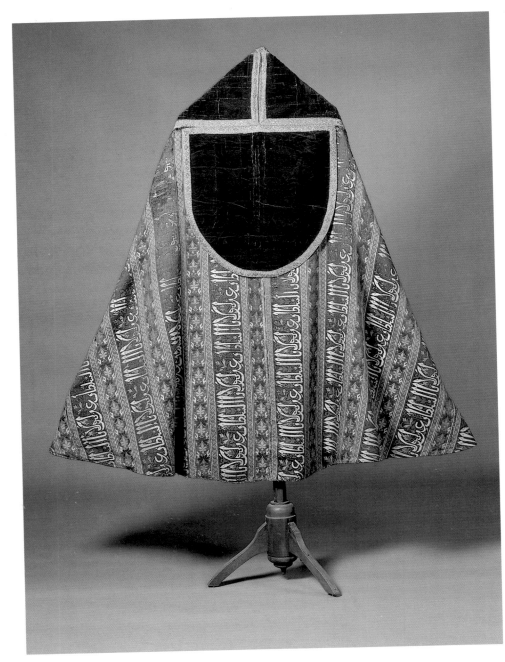

*W*oven horizontally on the loom, this pluvial is decorated with parallel, vertical bands of differing widths. The widest bands contain a repeated Arabic inscription of the thuluth Andalusī form, reading *Glory to our Lord the Sultan*.[1] Between the letters are vegetal elements naturalistically rendered and reminiscent of Gothic flora, such as pinks. On either side of the bands with inscriptions are two narrow borders of interlacery, and between them, forming alternating rows, is a second medium-width band with *ataurique* decoration of stylized vegetal motifs. The cowl and border are velvet, embroidered and finished with gold galloon.

The pluvial is white, red, yellow, green, and blue on a dark blue background. The garment bears the embroidered fifteenth-century coats of arms of the Condestables.

Rodrigo Amador de los Ríos believed that silks in which only the motto *Glory to our Lord the Sultan* appeared, without a specific sultan's name, were woven in Naṣrid workshops for commercial sale.[2] By the type of epigraphy on this pluvial, we can identify the period of its manufacture as the end of the fourteenth century. Other known pieces fall between the date of a chasuble in the Museo de Antequera fashioned, according to tradition, from a banner won from Muslims at the Battle of Chaparral of 1424 (A.H. 828), and of this pluvial from Burgos, appropriated by the Condestables and placed in their chapel in the cathedral at Burgos in the late fifteenth century.

Arabic inscriptions appear as a principal element of decoration in several Hispano-Islamic textiles. According to Dorothy Shepherd, one in the Cooper-Hewitt Museum in New York is among the finest.[3] This Burgos cape is certainly one of the most spectacular. The silk was wider than the so-called Alhambra silks.

The ornamental precedent could have been weavings like the *panni tartarici* that came from central Asia in the early fourteenth century through commercial trade routes. The *panni tartarici* have the same ornamental disposition of parallel bands of cursive inscriptions, palmettes, and lotuses as seen in the Burgos pluvial and the coffin lining of Infante Alfonso de la Cerda (d. 1333 [A.H. 734]) in the Museo de Telas Medievales, Monasterio de Santa María la Real de Huelgas in Burgos. Both the *panni tartarici* and the latter textile are woven with gold, however, whereas the Burgos pluvial is not. C P

1. Translation of Muḥammad Yūsuf.
2. Amador de los Ríos 1888, p. 566.
3. Shepherd 1943.

LITERATURE: Villanueva 1935, pl. XIII; Shepherd 1943, p. 392, fig. 23; May 1957, pp. 193–94, fig. 125; Partearroyo 1982, p. 364; Wardwell 1988–89, p. 98, fig. 13.

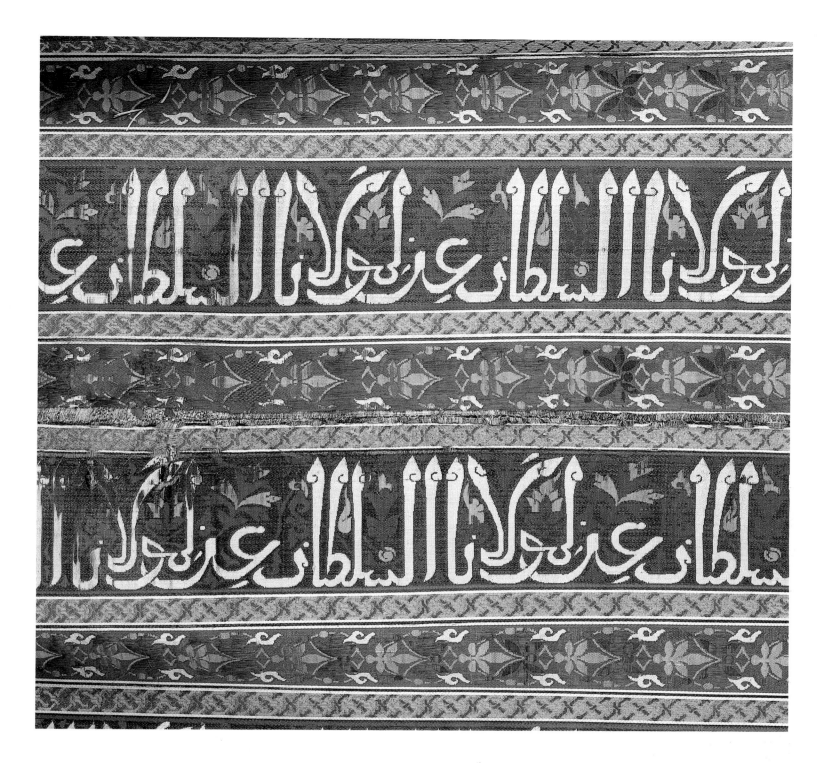

99

Curtain

Naṣrid period, 15th century
Silk
14 ft. 4½ in. x 8 ft. 11 in. (438 x 272 m)
The Cleveland Museum of Art, Leonard
C. Hanna, Jr., Fund
82.16

The curtain is composed of two lateral panels of the same weave joined to a different center panel. This center panel, on a navy blue ground, consists of nine bands of differing widths disposed four on either side of a wider band. This wider band is decorated with a design of ogival lozenges created by asymmetrical annulated leaves and a reticulation of yellow ribbons forming interlacery and billets with a white Naskhī inscription *There is no conqueror but God*—the Naṣrid motto, used by the sultans of that dynasty from 1231 to 1492 (A.H. 629–898). Above this motto is a second symmetrical inscription reading *blessing*. The interstices of the background are filled with a red floral network. A narrow band on either side of the center band is decorated with interlacery in red and yellow, followed by wider green bands bearing the Naskhī inscription *God is the glory*[1] in white with floral motifs. The outermost bands repeat the red and yellow interlacery, and, finally, there are bands of yellow and red merlons with blue trefoils.

The two lateral panels joined to the center strip are very similar in overall decoration to silk curtains in the Metropolitan (No. 97) and Cooper-Hewitt museums in New York. The red

of the background weave is satin with three rectangular decorations. Anne Wardwell believes the design may have been based on thirteenth-century tapestries of medallions on a red background, like the tapestry panel of Bishop Gurb (see No. 20).[2]

The ornamentation of the present example is more elaborate than that on the silk curtains in New York. On the upper edge of the panels is a wide border subdivided into bands containing merlons, interlacery, and an inscription in a knotted Kūfic script repeating the word *prosperity*, along with *ataurique*-embellished arches resting on short pillars. Between the arches are stars and a reticulated interlacery created by ribbons of Kūfic inscription below each arch reading *good fortune*; above is a cartouche containing the Naṣrid motto in Naskhī.

Within the principal field of each lateral panel are three large rectangles, each bordered by cartouches with the Naskhī passage *Dominion belongs to God alone* and enclosing in its center an ornamentation resembling a tile, decorated with an orle of geometric ribbons with an *ataurique* quatrefoil and an eight-pointed star. The upper and lower panels are woven in navy blue[3] and the center in green, with touches of yellow and white. Parallel to the sides of these ornamental panels, and in the corners, are rectangles and squares filled with small *ataurique* decoration bordered with yellow interlacery; this adornment, in the manner of a frame, must have been the mark of the workshop, for we see it on the curtains in the Metropolitan and the Cooper-Hewitt museums as well. In the lower edge of the two panels is a border with narrow bands of interlacery flanking a wide band of running Kūfic inscription, identical to that in the upper border.

Several of the decorative motifs in the curtain are identical to those used in the stucco decoration of the Alhambra, and we know that silk curtains of similar fabric hung on the walls of the palace. In 1362 Ibn al-Khaṭīb described the dependencies of the Mexuar of Muḥammad V as fine silk textiles that might very well be the type of this curtain.[4]

C P

1. Translation by Muḥammad Yusuf.
2. We particularly recommend Anne Wardwell's article (Wardwell 1983).
3. A small fragment of the panel is found in the Museu Episcopal in Vic (M.E.V. 9781).
4. García Gomez 1988, p. 148.

LITERATURE: Partearroyo 1977, pp. 78–81; Wardwell 1983, pp. 58–72.

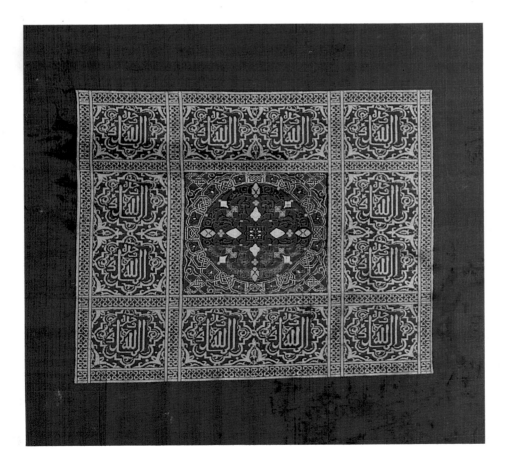

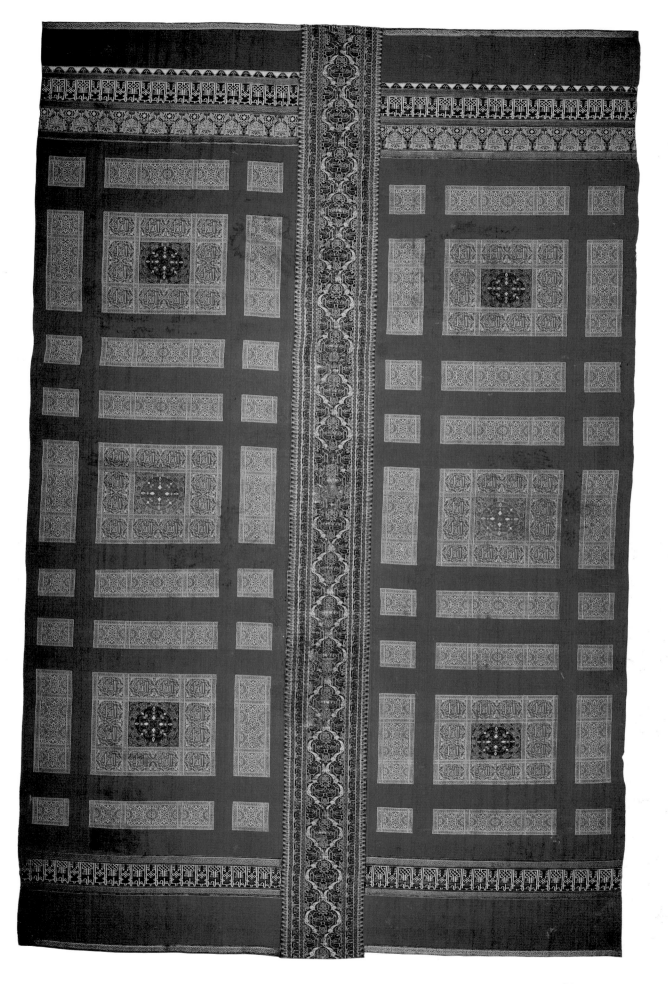

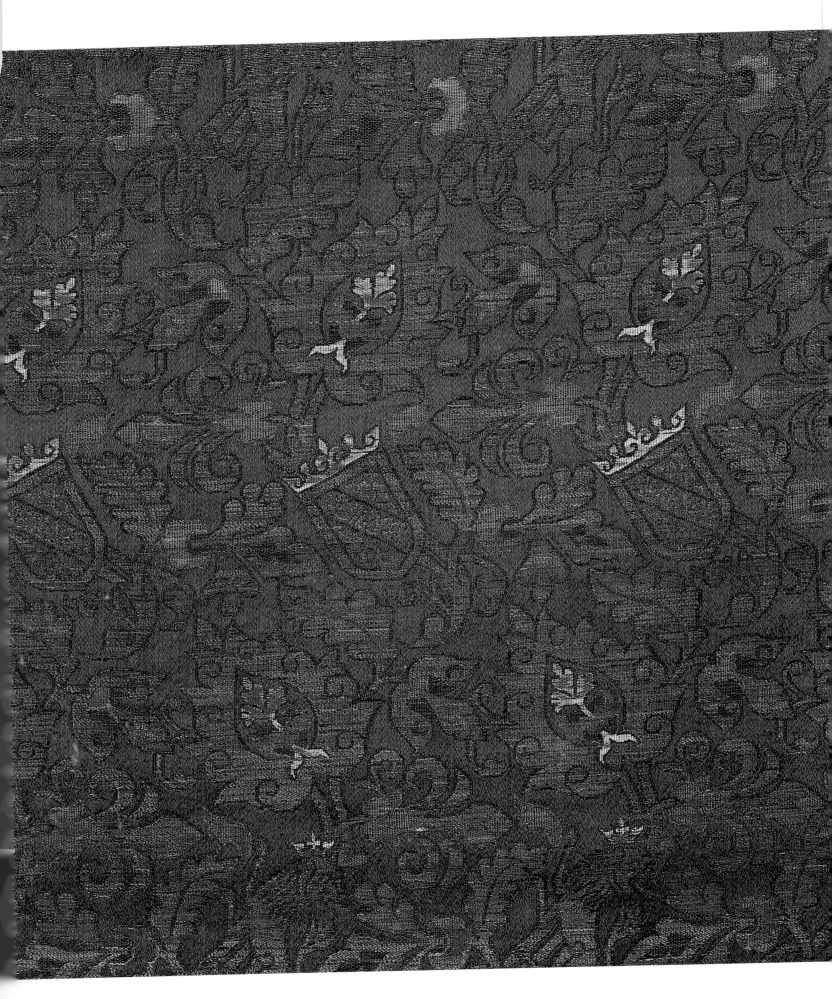

Horizontal bands of pomegranates comprising two distinct designs on a red ground decorate this textile. In one row the fruit, with curved stems and leaves, is inclined to the right; imposed upon the middle of each stem is a coroneted shield containing an Islamic cursive inscription. The pomegranate is gold outlined in dark blue silk; its interior is red and its heart is gold with a white rosette and blue embellishments. The stems and the leaves that spring from it are also gold outlined in blue. Of these leaves, the larger ones pointing left are green and gold; those pointing right are green, blue, and gold. The leaves that spring from the pomegranate itself are gold with areas of blue. The interiors of the shields are gold; the crowns are white.

The succeeding row contains identical pomegranates, but tilting to the left. On their stems, a crowned rampant lion with protruding tongue replaces the shield. The pomegranate, stem, and leaves are of the same colors as those of the preceding row. The lion is gold outlined with blue; its crown is white.

Technically, the piece is lampas, with a satin ground of five weft threads. It has two warps of red silk, both the same: a, the warp of four threads forms the ground; b, the warp of one thread, forming the decoration, is the compound warp. The wefts are a, red silk, the color of the ground; b, blue silk; c, white silk; d, green silk; e, gold of Chipre. Weft a joins the warp of the ground in satin. Wefts b, c, d, and e join the warp of compound tabby, forming the decorations. The left selvage is intact, with a warp of three cordonnets.

The textile, which was woven on a draw loom, was manufactured in the Naṣrid kingdom of Granada during the fifteenth century.[1] Stylistically—in its movement of laterally inclined pomegranates and curling stems[2]—it reveals the influence of contemporary Italian velvets. May and Hennezel[3] attribute this piece to Muslim manufacture. A like fragment is found in the Musée Historique des Tissus in Lyons.[4]

RMMR

1. May 1957, p. 182.
2. Ibid., fig. 115.
3. Hennezel 1930, p. 122.
4. Ibid., p. 123, fig. 177.

100

Textile Fragment

Naṣrid period, 15th century
Silk and gold
29⅛ x 29⅞ in. (74 x 76 cm)
Museu Tèxtil i d'Indumentària,
Barcelona
28291

101

Carpet

1st half of 15th century
Wool
10 ft. 2 in. x 5 ft. 6½ in.
(3.10 x 1.69 m)
The Metropolitan Museum of Art, New
York, The Cloisters Collection, 1953
53.79

*O*nly a sketchy picture of carpet weaving in Spain prior to the fifteenth century has emerged. Textual references[1] offer little concrete information except the following: The industry existed by the twelfth century, if not before, the towns of Chinchilla and Cuenca were noted for their woolen carpets, and some Spanish carpets were exported. That there was a foreign demand for Spanish rugs as early as the twelfth century speaks for the achievement of a certain level of quality and suggests that the industry was already well established by that time. Carpets predating 1400 exist only in fragmentary form. Several small bits found at Al-Fustāt (Old Cairo) have bands of Kūfic script; one of these fragments and another, without script, have geometric elements in their fields.[2] There is only one relatively well preserved early carpet, and because it stands alone few conclusions can be drawn from it.[3]

By the fifteenth century, when carpets themselves, as well as references to them, were bountiful (more fifteenth-century rugs survive from Spain than from anywhere else), the carpet-weaving industry was entirely in Mudejar hands. The province of Murcia, long since recovered from Muslim rule by Christians, was evidently the center of the industry; the sources draw special attention to Alcaraz, Letur, Liétor, and Hellín as important manufacturing sites. It is to the brilliant carpets of fifteenth-century Spain, produced for Christian patrons, that we must turn for insight into earlier production.

Spanish carpets of the fifteenth century generally fall into three groups. The first draws heavily from local traditions (including Islamic) and features coats of arms of royal or noble families of Castile. The second has field designs based on textile patterns in various Gothic or Renaissance styles. The third consists of Spanish versions of various patterns seen in Turkish carpets of the fifteenth century. The most popular patterns from the third group are the large- and small-patterned Holbeins, so called because they are depicted in paintings by Hans Holbein the Younger, among other artists. In the large-pattern Holbeins, square compartments contain octagons in which may be found different configurations of elements.

The present carpet is a typical large-pattern Holbein made with wool pile on a wool foundation with a single-warp knot. Many examples of this group survive;[4] they range in size from a runner with a column of three squares to a carpet with six rows of three compartments. Within each octagon in the example here a central star is linked to the frame by eight spokelike volutes. This particular pattern is found in extant Turkish rugs;[5] the two variant patterns probably preserve Turkish patterns now otherwise lost. While the field patterns of these rugs are based on Turkish models, the borders follow local styles. Knot types and colors also serve to distinguish Spanish pieces from their Turkish counterparts.

The colors of the Holbein rugs are vivid and gay, in contrast to the relatively subdued palettes of the armorial carpets. Spanish Holbeins are generally attributed to Alcaraz, based on sixteenth-century inventory descriptions of wheel designs in carpets from this center,[6] but it is possible that they were made in more than one place. In the sixteenth century the octagons of the Holbein patterns evolved into Renaissance-style wreaths in some carpets; it may be to these carpets, which were probably woven in the same place or places as the Spanish Holbeins, that these inventories refer. They may be dated to the second half of the fifteenth century because this pattern appears in paintings of that date from Spain, Italy, and northern Europe. The present carpet and several others of the same type are said to have come from the Convent of Santa Ursula in Guadalajara. DW

1. References cited succinctly by Ferrandis Torres (1933) and copiously by Sánchez Ferrer (1986).
2. Textile Museum, Washington, D.C., nos. 73.133, 73.55, 73.471, see Kühnel and Bellinger 1953, pp. 5–7, pls. I–III; The Metropolitan Museum of Art, no. 27.170.8, see Dimand and Mailey 1973, p. 253, fig. 217; Benaki Museum, Athens, nos. 16172, 16180; Keir Collection, no. 1, see Spuhler 1978, no. 1, p. 29.
3. Staatliche Museen zu Berlin, Islamisches Museum, no. I.27, see London 1983, no. 3, pp. 50–51, pl., p. 33.
4. For further discussion and other examples, see, in addition to works cited in Literature below, Ferrandis Torres 1933, esp. pp. 39–42; Kühnel and Bellinger 1953, pls. XII–XVII.
5. A particularly close version is in the Philadelphia Museum of Art, no. 43-40-67, see Ellis 1988, no. 2, pp. 8–9.
6. Ferrandis Torres 1933, esp. pp. 63 (1527 inventory), 64–65 (1555 inventory).

LITERATURE: Dimand 1963–64, pp. 341–52, fig. 9; Dimand and Mailey 1973, pp. 257, 262, no. 152; Sánchez Ferrer 1986, pp. 344–45, pl. 32.

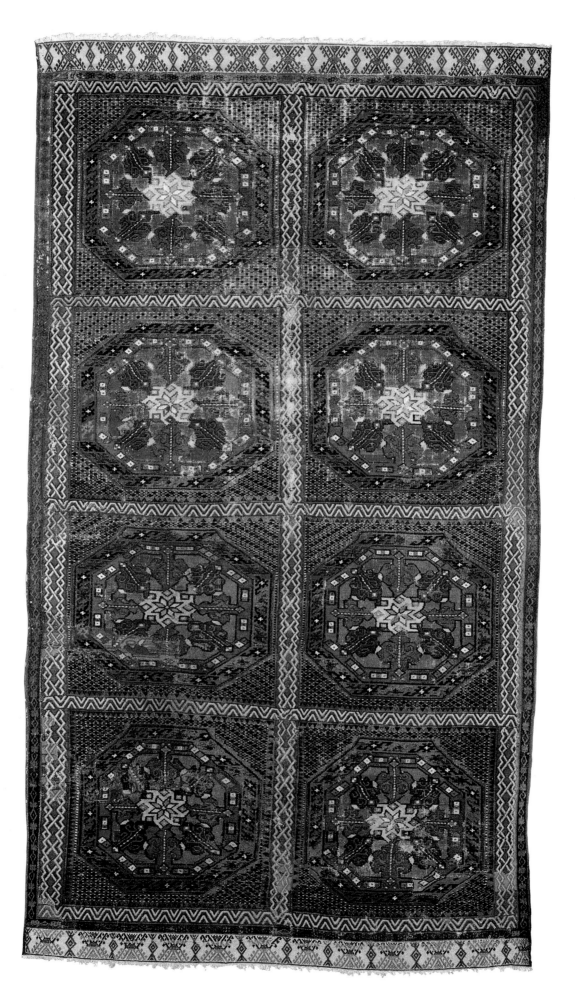

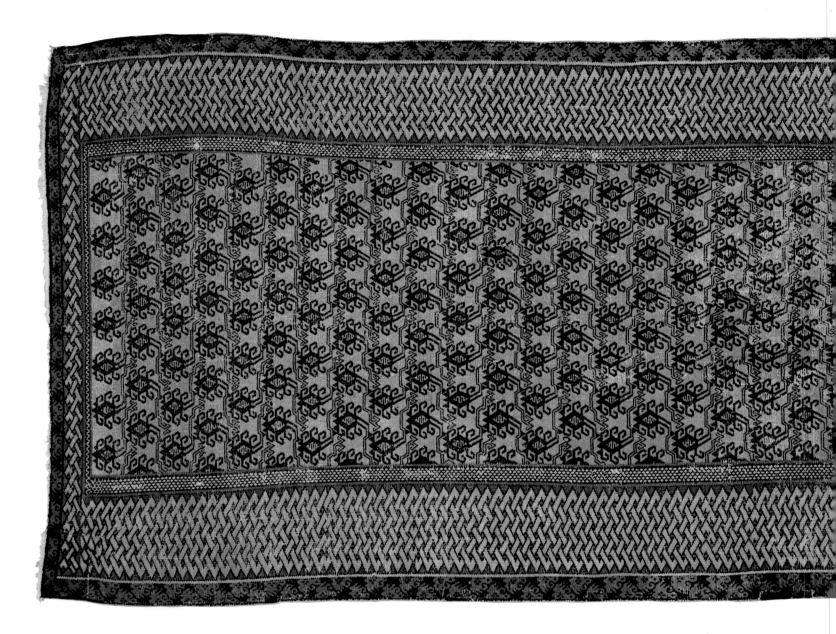

102

Carpet

2nd half of 15th century
Wool
12 ft. 2⅞ in. x 4 ft. 11⅞ in.
(3.73 x 1.52 m)
The Textile Museum, Washington, D.C.,
Purchase, Arthur D. Jenkins Gift Fund
and Proceeds from the Sale of Art
1976.10.3

*T*his Mudejar carpet is made of wool pile on a wool foundation with a single-warp knot. Its allover repeating field pattern of hooked, angular motifs arranged in staggered rows is not known in other Spanish examples but also appears in a single Turkish carpet, a fragment probably dating from the fourteenth century.[1] The similarities are remarkable, from the configuration and number of the hooks, to the attachment of a tail to each motif, to the orientation in opposite directions of motifs in alternate rows. This is, in fact, a pattern derived from textiles, specifically the cloud pattern of Chinese silk damasks of the early fourteenth century, some of which were excavated in Egypt.[2] The textile version of the pattern is rendered in much more curvilinear fashion and its subject is much more easily identifiable, but the relation-

ship to the carpet motif is unmistakable. The border patterns of this carpet, chief among them a nine-strand braid, are not based on foreign prototypes but rather are typically Spanish and are familiar from other fifteenth-century examples.

The mustard yellow ground color is so unusual that we might wonder if this is the original color or if it has changed over time, as is the case with one other fifteenth-century carpet.[3] It was not likely to have been red because the field is edged by a stripe that remains red. If the yellow is original, a Chinese textile may have served as the direct model for this carpet rather than transmitting its inspiration through a Turkish medium; a yellow ground was popular in Chinese textiles but is characteristic of neither Spanish nor Turkish material.

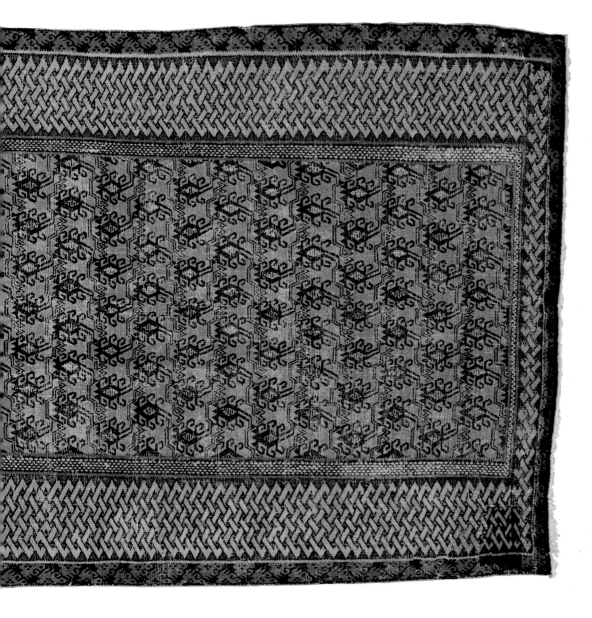

In either case, this carpet and the Holbein pattern example of the preceding entry provide evidence of the taste for foreign exotics that prevailed in the fourteenth and fifteenth centuries. The possession of objects with exotic designs and of imported furnishings was undoubtedly a mark of status. Several other Turkish patterns were duplicated in carpets, and one known carpet was made in the Mamluk style.[4] Some luster-painted ceramics from Málaga bear a distinct resemblance to Syrian ware.[5] It is perhaps ironic that Mudejar artists were looking to the Islamic world outside Spain for fresh inspiration, while Naṣrid artists were striving to perpetuate the glories of an Islamic Spain now largely gone. D W

1. Mackie 1977, fig. 18.
2. Ibid., fig. 19. The connection was first recognized by Agnes Geijer (1963, p. 84, figs. 1, 2).
3. Philadelphia Museum of Art, no. 55-65-21, see Ellis 1988, p. 242. This example has two yellows in the braid of the outer guard band.
4. Museo Arqueológico de Granada, unpublished.
5. For example, see Frothingham 1951, frontispiece, fig. 50.

LITERATURE: Mackie 1977, pp. 29–31, fig. 17; Mackie 1979, p. 94, fig. 29 (erroneously referred to in the text as fig. 28).

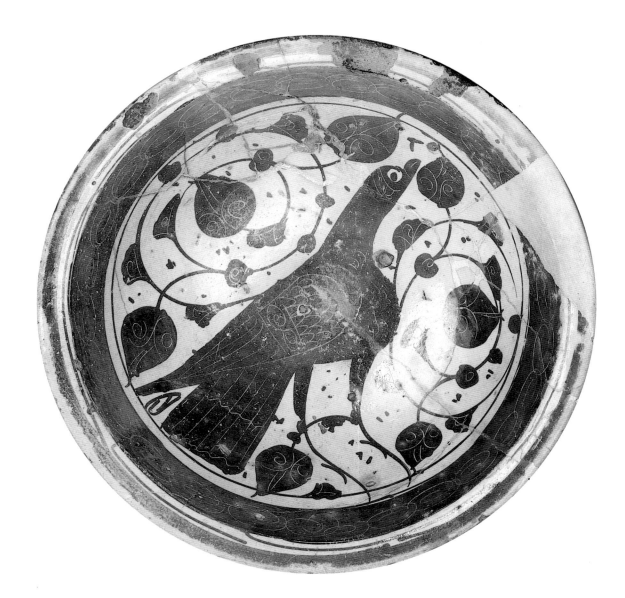

103

Bowl

Almohad period, 1st quarter of
12th century
Glazed and painted earthenware
with luster
Diam. 10⅜ in. (26.2 cm)
Museo Nazionale di
San Matteo, Pisa
232

\mathcal{A} flattened rim and small, high base distinguish this bowl of brick red clay with traces of yellow. It is decorated with an intense metallic luster with hints of olive green over a thin white tin glaze, which does not conceal the color of the clay beneath. The subject is a long-tailed bird with its head raised in the act of pecking at one of the leaves in the decorated field. Delicate sgraffito under the glaze delineates the details of the wings, neck, and tail with parallel lines, overlapping scales, and intersecting curves. The white background is sprinkled with volutes, dots, leaves, and oval motifs that enclose lotus-shaped flowers, also executed in sgraffito.

The architectural basis for our dating of the bowl, the church in Pisa whose wall it adorned, Sant' Andrea, was built in the first quarter of the twelfth century. We can suppose for this example a direct descent from Murcian unglazed sgraffito ware, in which motifs of similarly embellished birds have been fully documented. Its affinities with the bowl from the *dels amagatalls* cave (see No. 106) are evident in the handling of the sgraffito. If this is Murcian work, it is probably one of the oldest known examples. G R B

LITERATURE: Berti and Tongiorgi 1981, pp. 79, 262–66, pl. CLXXXIC; Berti and Torre 1983, p. 50; Berti 1987, table III C; Berti and Mannoni 1990, pp. 98–100, 116–17.

104

Bottle

Almoravid or Almohad period,
12th century
Glazed earthenware
H. 5⅛ in. (13 cm)
Museu Arqueològic de la
Ciutat de Denia

*W*hile the decoration of this piece is characteristic of a bottle, its shape, which is typical of gold and glass objects, suggests a jar. It has a trilobate spout, a short neck marked by two ribbed moldings, an ovoid, somewhat pear-shaped body, and a high mushroom foot. The handle, which is oval in cross section, joins the neck to the center of the belly. Both foot and body are decorated with scales that, although reminiscent of the pearl decoration of some bronze bottles, simulate the characteristics of a pinecone. That this decoration was formed in a mold is evident in the vertical marks left by the mold's joining. The piece was discovered in Deniya, in the urban outskirts of Denia, below water level in the bottom of a well of a twelfth-century house. This explains why the yellowish paste, with micaceous intrusions, has undergone a radical change of color, as has the glaze, which was originally a light green but now appears nearly black.

This unique piece reiterates the typology and decoration of twelfth-century bronze bottles and jars and glass pieces from the Middle East; indeed, it was found in a city known—through Arab sources as well as through archaeological evidence—to have imported metal and glass objects from Middle Eastern sources.

JAG

LITERATURE: Melikian-Chirvani 1982, no. 2, p. 41; Allan 1986, pp. 120–21, fig. 54; Gisbert Santonja 1986; Jenkins 1986, no. 14, p. 17; Metropolitan Museum of Art 1987, pp. 14–15.

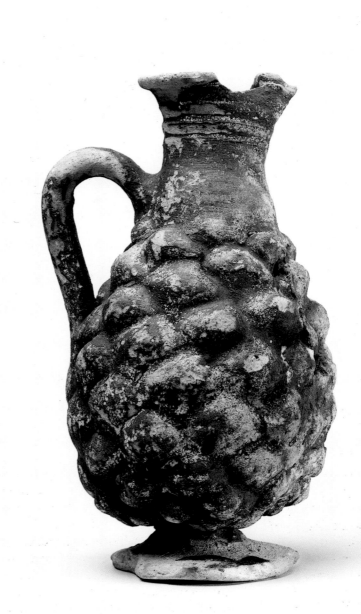

105

Two Jars

Almoravid period, 1st half
of 12th century
Glazed and painted earthenware
a. H. 7½ in. (19.2 cm)
Ayuntamiento de Valencia
1040
b. H. 5¾ in. (14.5 cm)
Ayuntamiento de Valencia
1054

These small two-handled ceramic jars with foot rings, spherical bodies, and inverted conical necks come from Valencia. The handles of each connect the neck to the midpoint of the body. Both are made of pale ocher paste and were formed on the wheel sometime in the first half of the twelfth century.

The outer surface of the first jar is decorated in the *cuerda seca* technique with light green enamel. Short strokes or dots of black and red paint have been applied in the spaces of the areas in reserve. The upper band on the neck features a pseudoepigraphic decoration in Kūfic lettering, based on a single word— بركة (blessing)—enclosed in triangles to form a design suggesting a garland. The upper body is encircled by a typical vegetal motif, a band of trifoliate flowers with their tips pointing downward.

The second jar is not as tall as the first and the neck is shorter in proportion to the body. Its decoration, which covers the entire neck and the upper portion of the body, is executed in light green enamel. Small strokes or dots of black and red paint have been applied in the spaces that are in reserve. The band around the neck, like that on the other jar, offers a pseudoepigraph in Kūfic lettering, based on the word blessing. Here the letters are also enclosed in triangles that weave around the neck like a garland.

The decoration of the body consists of elongated ovoid shapes open at the lower edge alternating with small triangular motifs—black brushstrokes on reserve areas—placed at the lower margin of the band. R A R

LITERATURE: Bazzana et al. 1983, nos. 353, 354, pp. 129, pls. XII, XIII, fig. 42; Lerma 1986, p. 240; Lema, Miralles, and Soler 1986; Soler 1988, p. 81.

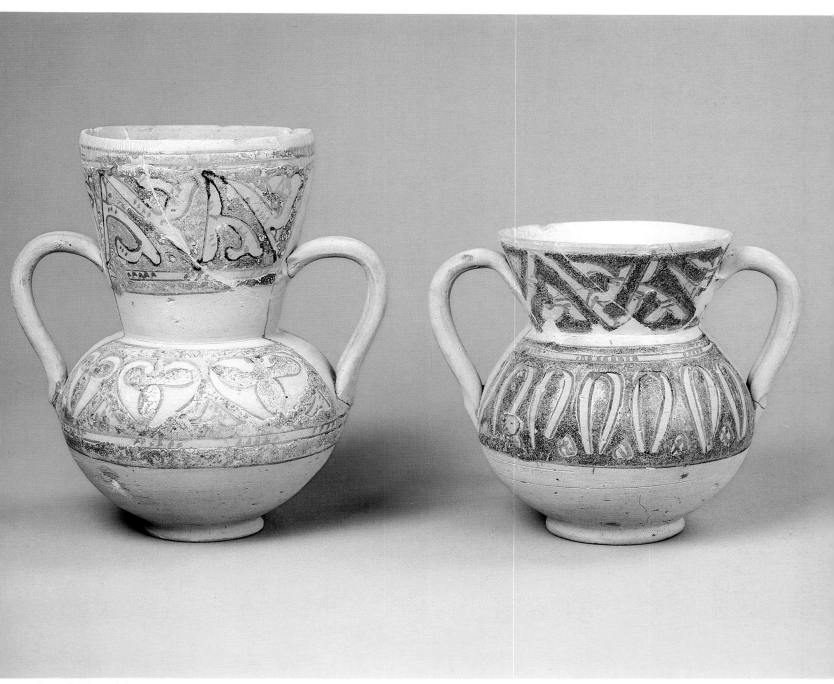

jar a (left); jar b (right)

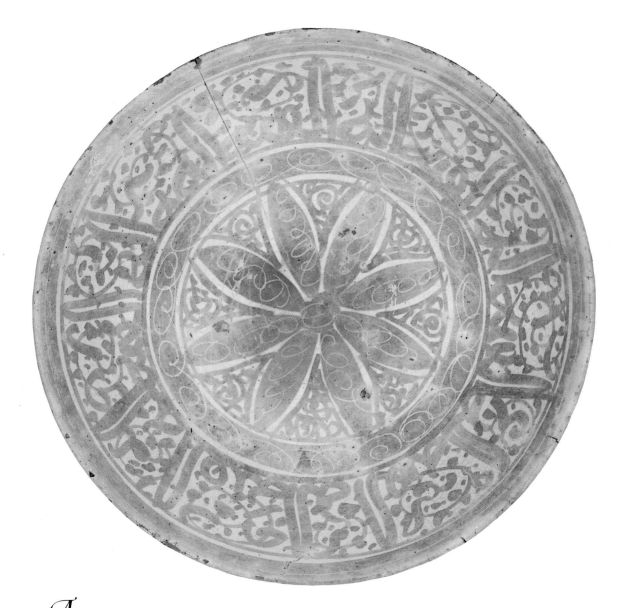

106

Bowl

Almohad period, late 12th–1st third of
13th century
Glazed and painted earthenware with
luster
Diam. 9⅛ in. (23.2 cm)
Museo de Mallorca,
Palma de Mallorca
13505

A central disk containing a flower with eight petals that is enclosed by concentric bands decorates this shallow bowl, or *ataifor*, with flat rim and base. The interior band hugs the central disk, and the exterior one borders the rim of the bowl. The latter band bears a stylized epigraphic decoration confused by an elegant rinceau pattern. The design is carried out in a mixed technique of painting and sgraffito under glaze. Its shape is a well-documented one from the Almohad period. The motifs that appear are common in the ceramics of the time, when sgraffito was widely used. The decorative scheme utilizes broad brushstrokes with sgraffito embellishments within the inner concentric band and on the petals of the central flower. The rest of the design, including the ornament that complements the epigraphic text, is based on a series of thin, graceful calligraphic strokes. The inscription is in the cursive form called Naskhī, introduced into al-Andalus at the end of the twelfth century.

The traditional motto عزة لله (Glory is God's) is repeated eight times. A design of leaves and flowers fills the empty space around the letters, so that the whole is a pattern of swirls, dots, and tendrils that echoes the curving sgraffito decoration. Sgraffito beneath glaze has roots in Fāṭimid pottery.

This bowl is in good condition, save for a slight radial fracture. It was discovered in a natural cave used as a refuge when an Islamic community was threatened by the Catalan invasion of September to December of 1229 (A.H. 627) and therefore must have been made before this event. The cave was named *dels amagatalls* (the hiding places) when ceramics were found hidden in natural hollows in the rock. GRB

LITERATURE: Trías 1982; Rosselló Bordoy 1986, pp. 225–38; Navarro Palazón 1987, pp. 225–38.

Drinking Vessel

Almohad period, 2nd quarter of 13th
century
Painted earthenware
H. 5¼ in. (13.4 cm)
Ayuntamiento de Murcia,
Centro de Estudios Arabes y
Arqueológicos "Ibn Arabi"
M-18-1-84-A-16

*A*bsence of glaze and the peculiar clay used in its manufacture indicate that this container from Murcia is a receptacle for water. Specifically, it seems to have been intended as a drinking vessel.

The ornamental technique used was sgraffito, whereby the decoration was incised on still fresh manganese oxide. After that procedure, the jar underwent its first and only firing. The four zones in which the decoration is distributed are determined by the shape of the vessel and the position of the arms. The ornamental theme is the same in each of the zones: A profusion of *ataurique* motifs covers the entire surface, producing a broad range of spirals and counterspirals. Despite the freedom of the decoration, there was an attempt to establish in each of the zones an axis from which two stems spring to form a heart-shaped design. Because of the profusion of ornament, it was necessary to distinguish the design from the background; to do so, the latter was deeply scored to obtain a lighter tone.

A reason that this jar and many other sgraffito pieces are interesting is that they provide information about the metalwork of the time, of which very little is known. It seems apparent that some of these vessels are creditable imitations of examples of that art. In the present case, the decoration and especially the manner of execution are highly evocative of the niello technique. Moreover, imitation of metalwork was not confined solely to decoration, but in some cases extended to the form of the vessel as well. It is possible that the extreme thinness of the walls of this jug, for example, results from the attempt to imitate a work in metal.

On the interior of the neck, running around the rim, is a band of script painted in manganese oxide. Although it has not been deciphered, nor have any of the signs even been identified, I am of the opinion that it is an inscription, specifically an apotropaic religious formula, since it was common in both the eastern and western Islamic worlds to protect the contents of such receptacles with legends of this kind. It is also possible that it is an epigraph of a more profane nature that refers to health and well-being.

JNP

LITERATURE: Navarro Palazón 1986a; Navarro Palazón 1986b; Navarro Palazón 1991.

108

Jug

Post-Almohad period, 2nd quarter of
13th century
Painted earthenware
H. with stand, 18½ in. (46.9 cm)
Ayuntamiento de Murcia,
Centro de Estudios Arabes y
Arqueológicos "Ibn Arabi"
M-18-1-84-P-1-3

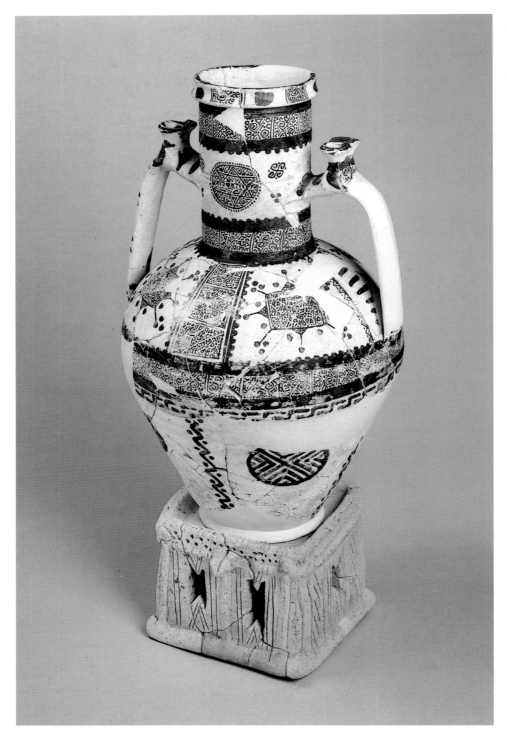

This jug from Murcia belongs to a class of water vessels I have defined as domestic, to distinguish them from others intended for transporting water, the group I have called carriers. Domestic jars are smaller than carrier pieces; their specific function was to hold water in the main room of the home, making it unnecessary to go to the courtyard repeatedly to fill drinkings vessels from the large earthen storage jars outside. The rich ornamentation of the example before us can be understood only in relation to its location in the most revered room of the home, for which both the furnishings and the architectural decoration were accorded the greatest attention.

It was common for these domestic jars to stand on beautiful and often strikingly embellished ceramic bases that collected the water that seeped through the jars. The function of such stands was confirmed with the discovery of an intact example near the jar we are considering here. This example is square, with a spout in the rim for pouring, and has a platform on which the jar was set. In addition to collecting water, such stands added height to the receptacle and thus facilitated its use, for the absence of tables as we understand them in the west made it necessary for vessels to be used when the householder was seated on the floor. (As support for this hypothesis, we can consider a Mudejar example dating from the thirteenth century and discovered in Paterna; in this piece both stand and jar have been incorporated into a single object.)

The complex decoration of the present jar is perhaps its most interesting feature. A detailed analysis leads us to hypothesize that the pattern based on circles and six- and eight-pointed stars is probably a symbolic apotropaic program. We might also remember the jars and jugs on which appear similar themes, such as the *hamsa*, or the hand of Fāṭima, and the inverted tree flanked by a bird on either side. The frequent appearance of such themes on jars, jugs, and storage vessels indicates great interest in protecting water from evil spirits. JNP

LITERATURE: Navarro Palazón 1986a; Navarro Palazón 1986b; Mesquida 1989; Navarro Palazón 1991.

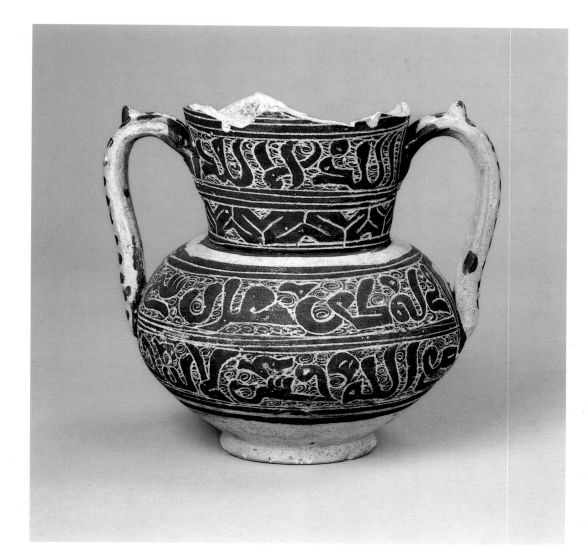

Formed from fine yellow clay on the wheel, this small ceramic jar has a foot ring, spherical body, and tall, inverted conical neck. Each of its two ribbon handles, which join the neck to the midpoint of the body has a conical form on the shoulder. The decoration covers the entire neck and two-thirds of the body, stopping short of the base.

The sgraffito technique is used to present a series of epigraphic motifs. The predominantly Naskhī-type epigraphic decoration is distributed in three bands, one on the upper part of the jar's neck and the remaining two on the body. The bands of the neck and body are separated by a fourth band on the lower part of the neck containing a geometric design.

In the inscription several narrative or poetic-descriptive lines personify the jar, which speaks, in the first person, of the qualities that make it worthy of bearing the holy name of God.

أنبذ الأ بعد أكبر [...] د

في له طعب عار سمي عال وحلولي المد

وضع حن لأنه حن في لله فن إنه عن في

Band I: *Glorify God for [...]! Reject that most alien to you!*

Band II: *Behold excellence, for you see the results before your eyes. My mouth has an agreeable savor; it is devoid of defect; it is sublime.*

Band III: *In me, by God's grace!, is art made beauty. To set forth [the name of] God is good, for He is supreme.*

<div align="right">RAR</div>

LITERATURE: Lerma and Barceló 1985; Lerma 1986, p. 242.

<div align="right">

109

Jar

Almohad period, 1st half of 13th century
Painted earthenware
H. 5½ in. (14 cm)
Ayuntamiento de Valencia
1000

</div>

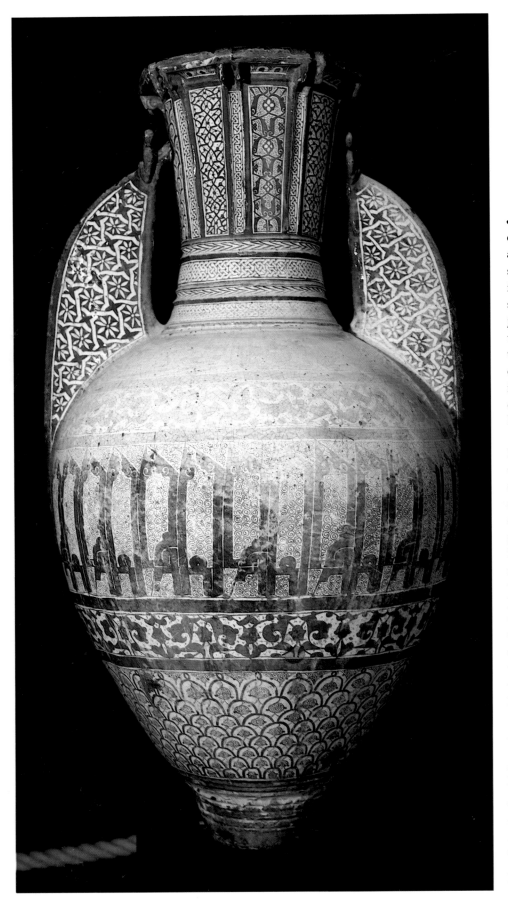

Alhambra Vase

Naṣrid period, late 13th century
Glazed and painted earthenware with
luster
H. 50⅜ in. (128 cm)
Galleria Regionale della Sicilia, Palermo
5229

*A*mong the highest manifestations of the art of Naṣrid ceramics are the large vessels known as Alhambra vases. They may be dated, with some uncertainty, from the thirteenth to the fifteenth century. Although they adopt the shape traditional for storage jars (in Arabic, *jābīya*, pl. *jawābī*), because of their size and unwieldy contours we must assume that these vessels were more decorative than practical. The ovoid body, with its narrow base and tall neck, is provided with flat, triangular handles that could only be ornamental, since they offer no handhold.

This vessel was found in excavations at Mazzara del Vallo in Sicily. It displays the neck with vertical bands separated by ribs, the graduated rings at the juncture of the neck and body, as well as the ovoid body and handles that are characteristic of the Alhambra vases. Like the great vase from the State Hermitage Museum in Saint Petersburg (No. 111), it has been preserved intact. The decorative scheme relates the present vessel to vases at the Instituto de Valencia de Don Juan, the Nationalmuseum in Stockholm, the Carthusian monastery at Jérez, and the Hermitage. It is ornamented with horizontal registers of various widths, one of which is enframed by thick bands that shelter a large inscription in the graceful characters of the Granadine Kūfic, repeating endlessly the watchword الملك (*al-mulk*, kingship or dominion). The colors are an intense olive gold on white.

The inscription would be useful in dating the piece if we knew more about the evolution of this type of writing, which has not been thoroughly studied. The characters are austere—especially in the terminals of the *alif*, *lām*, and *kāf*—and call to mind a time in which the Granadine Kūfic had not attained its most exaggerated baroque, when the letters had not yet become entangled and confused with the surrounding interlace. This vase may belong to a moment marked by a return to an archaic Kūfic, like that on the gold coins minted by the first

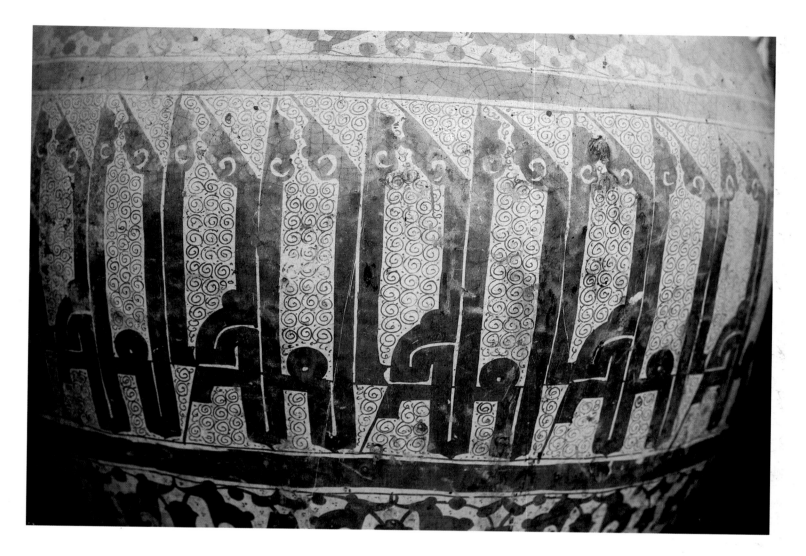

Ḥafṣī rulers in Tunis, who maintained close relations with the sultans of Granada in the second half of the thirteenth century. The acceptance of archaizing Kūfic can be explained as a reaction to the Almohad influence, which introduced the highly embellished Naskhī calligraphy into al-Andalus at the end of the twelfth century. (We think that the Naṣrid sultanate was created as a consequence of this same opposition to the Almohad hegemony.) The inscriptions on the vases from the Hermitage and the Instituto de Valencia de Don Juan show a more evolved Kūfic, which presumably corresponds to a later phase of this type of writing, than that on the Palermo vessel. On the vase at the monastery in Jérez, we find a more schematic writing, similar to that on the Palermo jar; however, the arabesques of the background are more profuse and complicated in the Jérez example.

The inscription is a fundamental element in the decorative scheme of the present vase. It stands out clearly against the white ground of the band, because there is no intricate embellishment to distract the reader. Here the repeated *al-mulk*, unadorned, perfectly legible, may have been an expression of a force that was more imaginary than real. The presence of *al-mulk* recalls the caliphal ceramics of al-Zahrāʾ in its moment of greatest splendor, when the simple articulation of this word was enough to define a political reality. The bands above and below the central subject bear symmetrical plant motifs set off by broad lines in gold. The band that links the neck to the body is similarly decorated. A large area near the base is filled with a design of overlapping scales. The rectangular vertical panels encircling the neck are adorned with geometric themes and interlace, and the handles are covered with arabesques.

<div align="right">GRB</div>

LITERATURE: Ferrandis Torres 1925, pp. 66–67, pl. II; Camps Cazorla 1943, p. 20; Torres Balbás 1949, p. 217; Frothingham 1951, pp. 22, 25, figs. 11, 12, 36–39; Ettinghausen 1954, pp. 145–48; Caiger-Smith 1973, pp. 61–63; Llubiá 1973, pp. 82–110; Serrano García 1988, pp. 127–62.

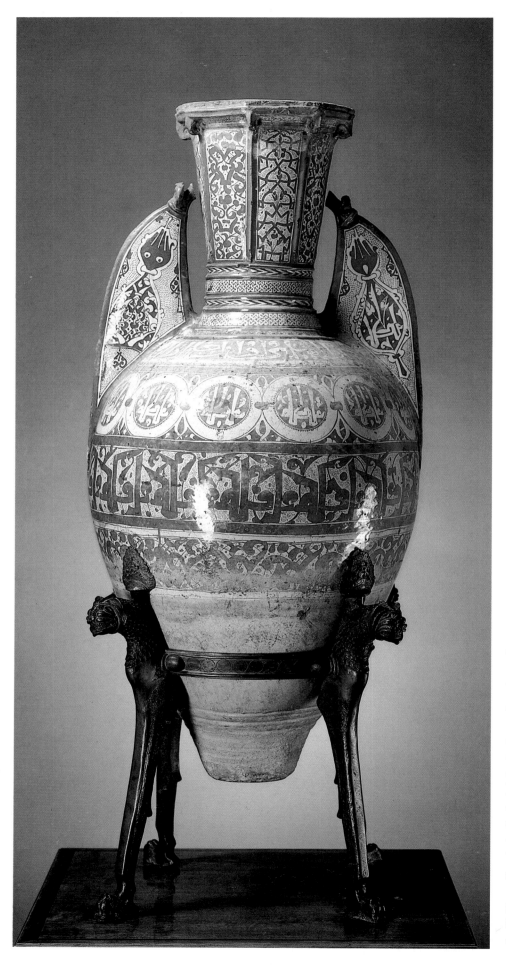

Alhambra Vase

Naṣrid period, early 14th century
Glazed and painted earthenware with
luster
H. 46⅛ in. (117 cm)
State Hermitage Museum,
Saint Petersburg
F317

*T*his piece can be placed within a series of
vases decorated with a system of horizontal
bands; its most direct parallels are at the Instituto
de Valencia de Don Juan, the Carthusian mon-
astery in Jérez, and the Galleria Regionale della
Sicilia in Palermo (No. 110). A chronology for
the present example can be established on the
basis of epigraphical evidence, for it displays an
unevolved Granadine Kūfic-style inscription clos-
est to the writing on the Palermo vase; this may
predate the inscriptions on the vessels at the
Valencia de Don Juan and at the Jérez monastery.

The decorative scheme, like that of the Palermo
example, presents a double central band with
inscriptions, bordered above and below by areas
ornamented with arabesques. The double band
does not appear on any other vases of this type.
The upper cincture presents a composition of
tangent concentric circles, each bearing the
word غبطة (pleasure). Interlaced elements
in reserve appear in the spandrels between the
circles. The circles, inscriptions, and surround-
ing floral patterns are also reserved. On the
lower band the word عافية (health) appears
repeatedly in Granadine Kūfic, without the
usual article, painted in gold on a white ground.
This offers a chromatic contrast to the band
above, which is executed in white on gold.
Vegetal motifs fill the free spaces. The bands
are separated by broad horizontal lines in gold.

The handles, with their festooned edges,
display the symbol of the hand of Fāṭima above
a schematic tree of life that can also be interpreted
as a cuff from which the hand is emerging. One
handle is embellished with arabesque decoration,
and the other bears an epigraphic motif that
could be read as بركة (benediction)—although
this interpretation calls for further study.
Vertical panels on the neck show alternating
designs of interlace and arabesque.

The vessel is in a state of perfect conserva-
tion, with its handles and their appendages
intact. That this example and the other large
vases of the same type have been so well-

preserved can be explained by circumstances unrelated to the world of art. We know the vicissitudes of the example in Granada (No. 112) from Washington Irving's account in his *Tales of the Alhambra*, one of the first written references to an Alhambra vase. Captured by the Turks as booty in the sixteenth century, the Stockholm vase survived veneration as a supposed amphora from the Wedding at Cana, passage to the collections of the courts of Vienna and Prague, and a final voyage via the sack of Prague to the court of Sweden. It was not religious fervor that saved other vases, but less noble motives, such as the need to fill the vaults of the monastery in Jérez. The present example was bought by the painter Fortuny in 1871, when it was serving as the base for the holy-water font in the del Salar church in the province of Granada. It was purchased from the sale of Fortuny's collection in Paris in 1875 by the Russian A. P. Basilevsky. In 1885 the vase entered the collection of the Hermitage as part of Basilevsky's collection, which was bought by the Russian government.

The use of gold against a white ground is common to most of the known vases of the Alhambra type. An exception among complete examples is the vase in Granada, where the two-color scheme is heightened by the addition of cobalt blue. However, in terms of the full range of ceramics that was produced, this is not an exception, if we are to judge from the fragments conserved in the Alhambra museum, in which the combination of three colors seems to have been usual.

The cracked and repaired body of a vase from Antequera, the handles and neck of which are missing, is in the Museo Arquelógico de Granada. Decorated in monochrome green with very faint traces of gold, it suggests the existence of another series of Nasrid vases, which has never been documented and should be investigated.

<div align="right">GRB</div>

LITERATURE: Ferrandis Torres 1925, pp. 66–67, pl. II; Camps Cazorla 1943, p. 20; Torres Balbás 1949, p. 217; Frothingham 1951, pp. 16, 19, 36–39, figs. 8, 9; Ettinghausen 1954, pp. 145–48; Caiger-Smith 1973, pp. 61–63; Llubiá 1973, pp. 82–110; Kurz 1975, pp. 205–12, pls. 8–10; Serrano García 1988, pp. 127–62.

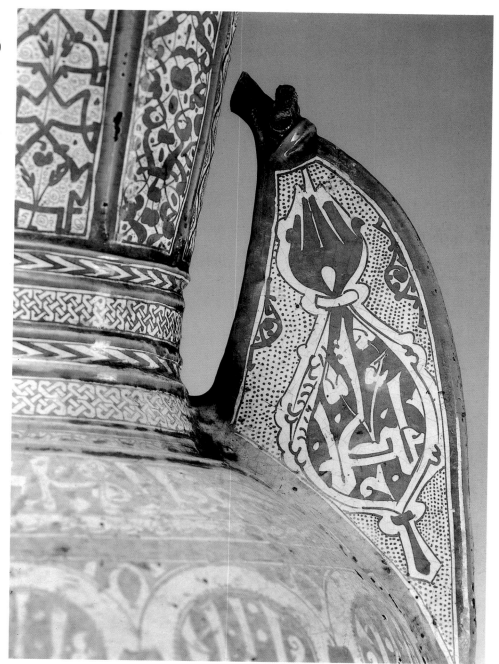

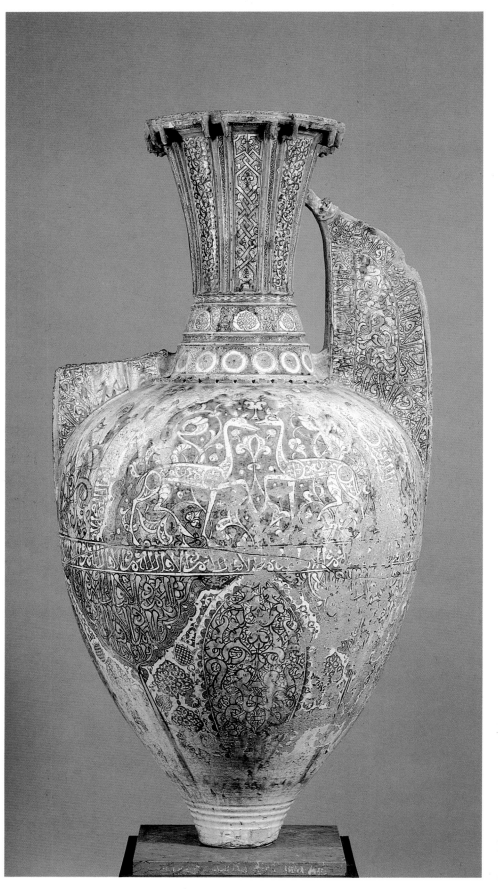

Alhambra Vase

Naṣrid period, 14th or 15th century
Glazed and painted earthenware with
cobalt and luster
H. 53⅛ in. (135 cm)
Museo Nacional de Arte
Hispanomusulmán, Granada
290

*I*n the series of Alhambra vases, this may be one of the most recent examples. Like all the Alhambra-type vessels, its shape derives from traditional storage jars. The decoration covers the three fundamental elements of the vase —the neck, the handles, and the body. The design on the body is laid out in accordance with a system of horizontal bands relieved by diagonal elements described and classified by Carmen Serrano García.[1] The central band, in gold, with its reserved cursive inscription, is complemented by diagonal elements that frame a pattern of curvilinear and rectilinear forms.

This example presents us with a rich decorative complexity: The upper zone of the best-preserved side of the vase displays two confronted striding gazelles; they are set against a blue background embellished with gold arabesques. The slender grace of the animals, with their delicate line and expressive fluidity, speaks of the highest achievement of Naṣrid decoration. The central motif is enclosed by a semicircular band in gold bearing the same reserved inscription that appears in the central band. Between this epigraph and the handles lie rectangular areas decorated with blue floral patterns and gold tendrils. The inscription, which is perfectly legible, is a eulogy in Granadine cursive: اليمن والاقبال (*good fortune and prosperity*). The lower half of the design is a combination of ovals and triangles in blue, set off by gold bands with vegetal motifs. The same inscription appears again in gold, arranged in parallel lines and outlined in blue.

On the other side of the vase there are chromatic reversals, particularly in the epigraph, which repeat the inscriptions of the first side. The upper zone displays a large semicircle of plant motifs in gold on a blue ground, flanked by unembellished blue gazelles standing against finely stylized arabesques in blue and gold. The lower part maintains the same composition of central ovals and lateral triangles as well as the blue arabesques over gold tendrils seen on the first side.

Two bands mark the juncture of the body and the neck. The lower one is blue with large circles in gold and white, and the upper consists of gold foliage interrupted by oval medallions in gold and white. Alternating vertical panels of floral patterns and blue and gold fretwork ascend the neck to the festooned lip of the jar. The same inscription shown on the body of the vase appears around the edge of each side of the remaining handle, framing a central triangular space filled with foliage in blue, accented by gold tendrils.

If we are to judge from the pottery fragments in the Alhambra museum, the combination of gold, white, and cobalt blue seen on this vase is the usual color scheme of the Alhambra vases, although most of the other vessels discussed here show only gold against a white ground.

GRB

1. Serrano García 1988, p. 137.

LITERATURE: Ferrandis Torres 1925, pp. 66–67, pl. II; Camps Cazorla 1943, p. 20; Torres Balbás 1949, p. 217; Frothingham 1951, pp. 36–45, figs. 22–25; Ettinghausen 1954, pp. 145–48; Casamar 1961, pp. 185–90; Caiger-Smith 1973, pp. 61–63; Llubiá 1973, pp. 82–110; Serrano García 1988, pp. 127–62.

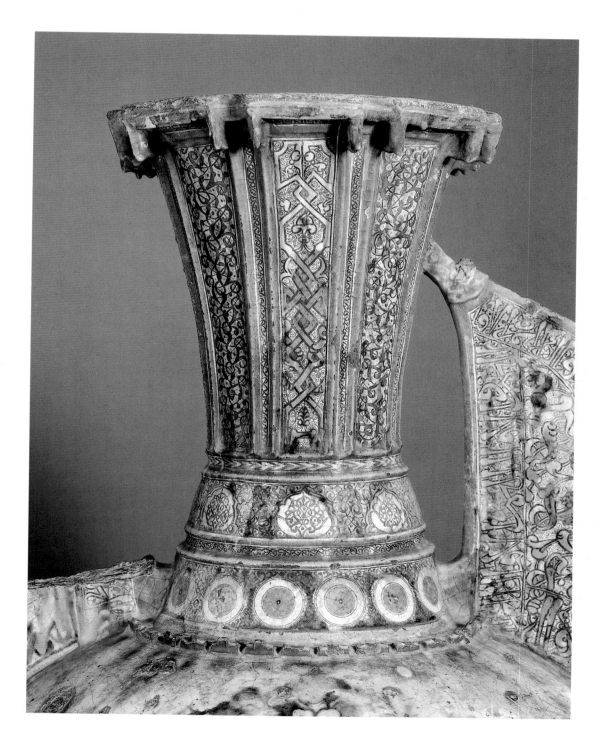

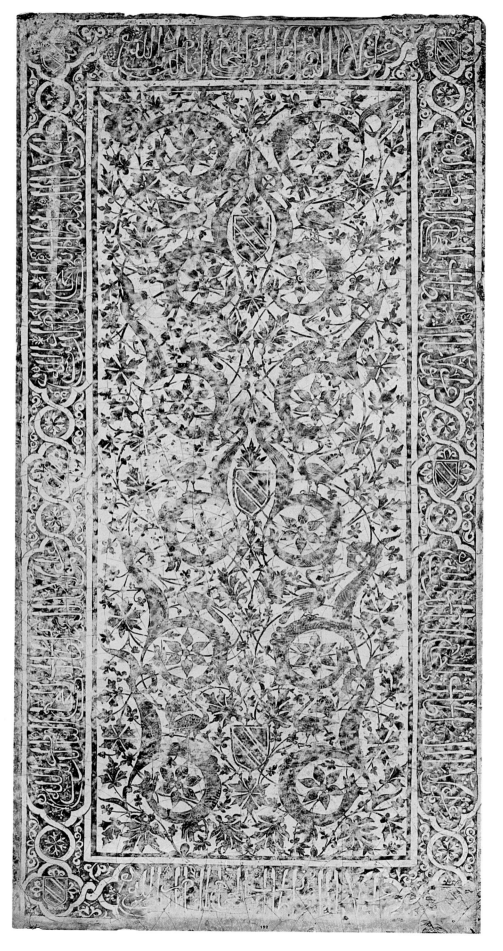

Fortuny Tile

Naṣrid period, early 15th century
Glazed and painted terracotta with luster
With frame, 42½ x 24¼ in. (108 x 63 cm)
Instituto de Valencia de Don Juan,
Madrid

†

*F*ortuny, the Spanish painter, purchased this tile, which was found in a house in Albaicín in 1871. The rectangular plaque is made to resemble a tapestry and has a rectangular border bearing an inscription. The inscription is perfectly legible and cursive; it is framed by cartouches and knots that encircle vegetal motifs and quatrefoils enclosing banded shields and is repeated six times. The text, some of whose letters are written above the line, is a paean to Yūsuf III (r. 1408–17) and thus dates the piece. It reads: عز لمولنا السلطان أبي الحجاج الناصر لدين الله (*Glory to our lord Sultan Abū'l-Ḥajjāj al-Nāṣir li-dīn-illāh*). The letters in superior position are the *nūn* in Sultan, the final *jīm* in Ḥajjāj, and the ṣād and the rāʾ in al-Nāṣir: These details are important for a close study of Naṣrid cursive writing. The epigraph, in reserve against a gold ground, is complemented by flowers and linking designs in white. The luster shields are outlined in sgraffito.

Large palmettes arranged symmetrically about an axis of three banded shields make up the central composition. The palmettes contrast with details that are asymmetrically disposed. The upper and central shields are flanked by palmettes that extend upward to form a frame around them. The lower part of the design centers about a shield surrounded by four palmettes terminating in fantastic heads of wolves or dragons. Facing and addorsed peacocks alternate to complete the decoration. The background is filled with a profusion of stems that end in flowers, each with six petals that radiate from its pistil, and delicate leaves that resemble parsley. This is a common motif in the fifteenth-century lusterware of Manises. Details of the sgraffito of the flowers seem to be inspired by the patterns of pinecones.

Leopoldo Torres Balbás believes that this tile was originally gold and blue and that the blue is lost.[1] This is arguable, since no traces of blue are visible. A tile in the Museo Arqueológico Nacional in Madrid (Fig. 1, p. 102), the piece that most closely resembles the Fortuny example,

does display vestiges of manganese and blue; the composition, however, is more careless and the appearance more garish. Its symmetrical structure is masked by profuse ornamentation, although it displays the same decorative motifs: shields and birds facing each other and addorsed, palmettes, and leaves; the latter two elements, however, are depicted differently. GRB

1. Torres Balbás 1949, p. 179.

LITERATURE: Torres Balbás 1949, pp. 179, 185; Frothingham 1951, pp. 72–73, 75, fig. 47; Llubiá 1973, pp. 100–103; Martínez Caviro 1983, pp. 94–98; Caiger-Smith 1985, pp. 96–99.

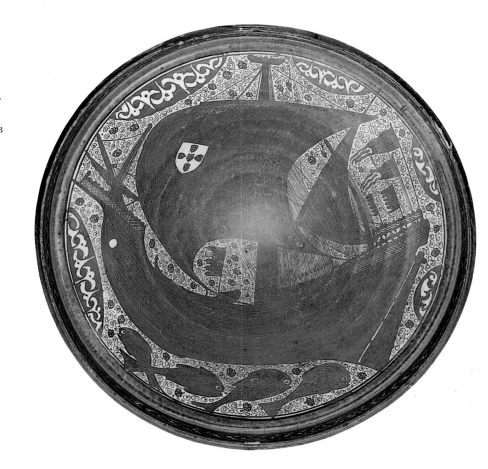

114

Bowl

Naṣrid period, 15th century
Glazed earthenware with luster
Diam. 20 in. (50.8 cm)
Trustees of the Victoria and Albert
Museum, London
486-1864

The shape of this footed bowl of unknown provenance, with its conical profile and raised rim, is characteristic of fifteenth-century Naṣrid production. Similar pieces can be seen in museums at Málaga, Almería, and the Alhambra, areas in which the Naṣrids dominated. However, this particular type has not been found among Naṣrid commercial exports on the island of Majorca. An analysis of the clay used in this bowl shows the presence of schistose material found in the earth near Málaga but not in the Valencia area, where it was once believed to have been made.

The decoration shows a ship typical of the Christian vessels of the *coca* or *nao* class. Its hull is very much like that of the Coca de Mataró, which is clearly Christian. A hull of this type is preserved in the Maritiem Museum Prins Hendrik in Rotterdam and represented in Codex H3, from the year 1343, in the Archivo Historico in Majorca. The mainmast carries a large square sail; there is a lateen sail on the mizzenmast and a furled sail on the foremast. The mainsail displays a shield bearing five elements in the shape of a cross, which could be interpreted as the arms of Portugal. However, the cross is not unknown in Naṣrid decoration.

From the poop fly four pennants with unidentifiable markings. On the foredeck is stowed a small boat with its pennant flying. The ship is equipped with a stern rudder. The finest details of the ship and its rigging are quite clear, thanks to the delicate sgraffito. The space surrounding the ship is decorated with gold lunettes bearing vegetal motifs and embellished with volutes and flowers. Four fish—possibly groupers— three facing right, one facing left, swim beneath the keel. The inside of the rim carries a chevron design in gold. On the outside of the bowl the *hom*, or tree of life, alternates with foliage groupings on a white ground.

The ship theme was popular in Islamic ceramics. It was used as early as the eleventh century on bowls found in Pisa and made in Majorca (see No. 31). In the Naṣrid period it appeared on bowls executed in green monochrome with traces of manganese—examples of which are now in the Málaga museum—as well as in blue and gold. GRB

LITERATURE: Frothingham 1951, pp. 91–93, figs. 56, 57; Llubiá 1973, pp. 98–99; Martínez Caviro 1983, p. 88, fig. 57; Caiger-Smith 1985, pp. 94–96; Pastor and Rosselló Bordoy forthcoming.

115

Minbar from the Kutubiyya Mosque, Marrakesh

Almoravid period, 1125–30
Wood and ivory
11 ft. 9 in. x 10 ft. 7 in. x 2 ft. 8 in.
(3.86 x 3.46 x .89 m)
Badiʿ Palace Museum, Marrakesh

†

This is the finest Almoravid minbar to survive and one of the most important examples of woodwork from the medieval Islamic world. An inscription on the backrest states that the minbar was made in Córdoba for *this venerated mosque*, and the phrase was interpreted as a reference to the Kutubiyya (Booksellers') mosque in Marrakesh, built by the Almohads between 1146 and 1162 (A.H. 541–58), in which the minbar formerly stood.[1] Another fragmentary inscription on the backrest, however, indicates that the minbar must have been ordered by an Almoravid ruler well before the Almohads came to power and constructed the Kutubiyya mosque. This minbar, therefore, was probably ordered by the Almoravid sultan ʿAlī ibn Yūsuf ibn Tāshufīn (r. 1106–42 [A.H. 500–537]) for the mosque he built in Marrakesh about 1120 (A.H. 514) and was transferred to the Kutubiyya mosque after it became the principal mosque of the city.[2]

The Kutubiyya minbar, like others from western Islamic lands, consists of a triangular wooden structure containing a staircase leading to a raised seat for the *khaṭīb*, or preacher, who addresses the congregation at Friday noon prayers. The lowest of the nine steps is flanked by two tall panels pierced with arches; two shorter pierced panels flank the seat at the top. The panels (and originally the sides of the staircase) were surmounted by carved wooden finials. Each of the triangular sides of the minbar is decorated with a geometric pattern exactly coordinated to the minbar's stepped profile, in which strapwork bands separate several hundred small panels. The strapwork bands are executed in marquetry of precious woods and ivory, prepared by first cutting the materials into thin strips, gluing them together so that they form rods, slicing the rods, and fitting the slices together in patterns. This technique is found on several panels attributed to late ninth-or early tenth-century Egypt, including one in the Metropolitan Museum (37.103), and it became popular in many parts of the Islamic world.[3] Unlike later Moroccan minbars with marquetry, where the individual pieces are glued to a base of cloth, leather, or cardboard, the marquetry plaques on the Kutubiyya minbar were glued directly to the wood.

Despite the apparent complexity of the design on the sides of the minbar, the carved panels between the marquetry strapwork bands were made in only three distinct shapes: eight-pointed stars, Ys with forked ends, and elongated hexagons with triangular projections on either side, although these shapes are modified at the edges of the composition where the strapwork meets the border. The panels, with dimensions ranging from eight to seventeen centimeters, are deeply carved and pierced with designs worked on several levels, a technique very close to that found on an ivory panel in the Metropolitan Museum (No. 6) carved with figured arabesques and attributed to eleventh-century Spain.[4] Most of the panels on the sides of the minbar have exquisitely fine arabesques of scrolling vines supporting split palmettes and blossoms, but there are others with lobed arches resting on columns. No two of the one thousand individual panels are exactly the same, and the contrast between the individuality of the panels and the regularity of the strapwork patterns invites contemplation from near as well as from afar. The stepped edges of the triangular sides preserve fragments of Qurʾanic inscriptions inlaid in a broad angular script on a marquetry ground, while the interior faces of the tall lower panels are carved with Qurʾanic texts in an elongated angular script.[5] The risers of the steps are decorated with marquetry designs depicting short columns supporting ivory capitals and a continuous horseshoe arcade outlined in a pearl band. The areas beneath the arcade are filled with arabesque motifs in marquetry, while the spandrels have similar motifs worked in relief. The backrest of the seat is worked with a design of intersecting cusped arches against a ground once decorated with marquetry. The edges and inner sides of the stair are covered with plaques exquisitely carved with arabesques.

This splendid minbar did not escape contemporary notice. In an often-quoted passage, Shams al-Dīn Muḥammad ibn Marzūq (1311–79 [A.H. 711–81]), a famous traditionalist who prided himself on having preached from forty-eight different pulpits, wrote that the minbars of the mosques of Córdoba and Marrakesh were far superior to eastern examples, which were made by people who did not know the art of carving wood.[6] The minbar from the Great Mosque of Córdoba, which was destroyed in the sixteenth century, is known only from literary sources.[7] It was made between 966 and 976 (A.H. 356–66) at a cost of 35,705 dinars and was inlaid with red and yellow sandalwood, ebony, ivory, and Indian aloewood. Its elaborate marquetry must have been the model for that of the Kutubiyya minbar. To judge from the minbar made in 980 (A.H. 370) for the Mosque of the Andalusians at Fez (No. 41), the triangular sides of the Córdoba

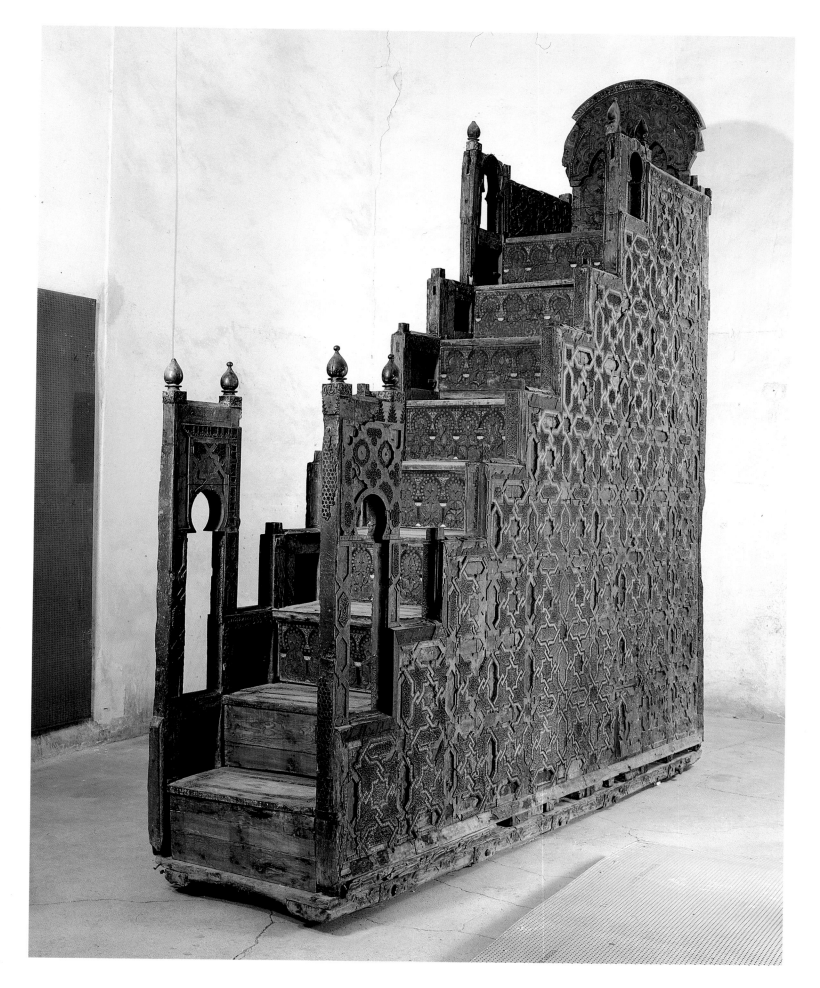

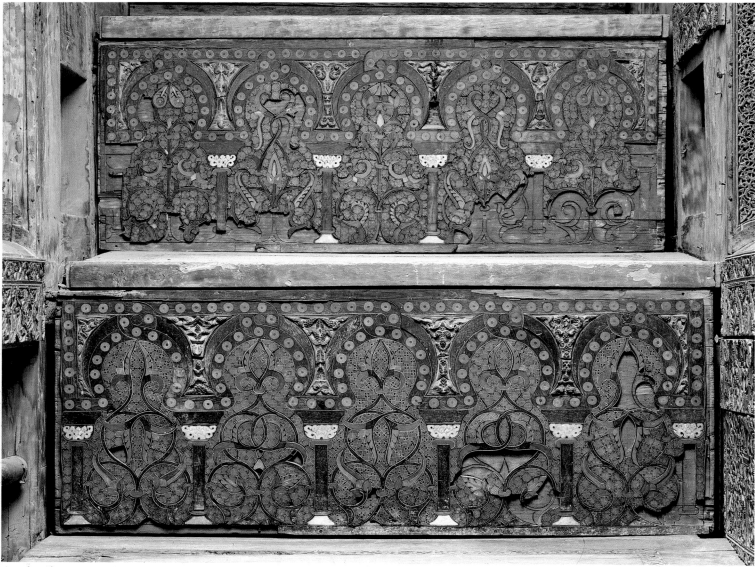

115, detail, staircase

minbar would have been decorated with a framework enclosing square panels corresponding in height to the risers of the steps. The use of square panels contrasts with the rectangular panels of varying height used on the minbar in the congregational mosque at Kairouan, Tunisia, made in 862–63 (A.H. 248), and persisted for two centuries. It appears in the earliest surviving Almoravid minbar, that from the Great Mosque of Nedroma, Algeria, made before 1086 (A.H. 479) and now in the Musée Nationale des Antiquités Classiques et Musulmanes in Algiers, as well as in that from the Great Mosque of Algiers, which was made in 1097 (A.H. 490).[8] The framework of the latter encloses square panels decorated with arabesques carved in relief. The only Almoravid minbar closely comparable in the sophistication of its design and

quality of its execution to that of the Kutubiyya mosque is the one made in 1144 (A.H. 538) for the Qarawiyyīn mosque of Fez.[9] Its triangular sides, which differ slightly in size and detail, are also decorated with deeply carved small panels and marquetry strapwork in a pattern generated from eight-pointed stars. Although the geometry is simpler, the carving a bit less varied, and the overall effect somewhat more monotonous than that of the Kutubiyya minbar, it is likely that this minbar, too, was made in Córdoba, perhaps in a related workshop. The same techniques of joinery, carving, marquetry, and inlay were also used for contemporary wooden minbars in the central and eastern parts of the Islamic world, but the geometric patterns on the triangular sides were not coordinated to the height of the risers as in western examples.[10]

115, detail, side

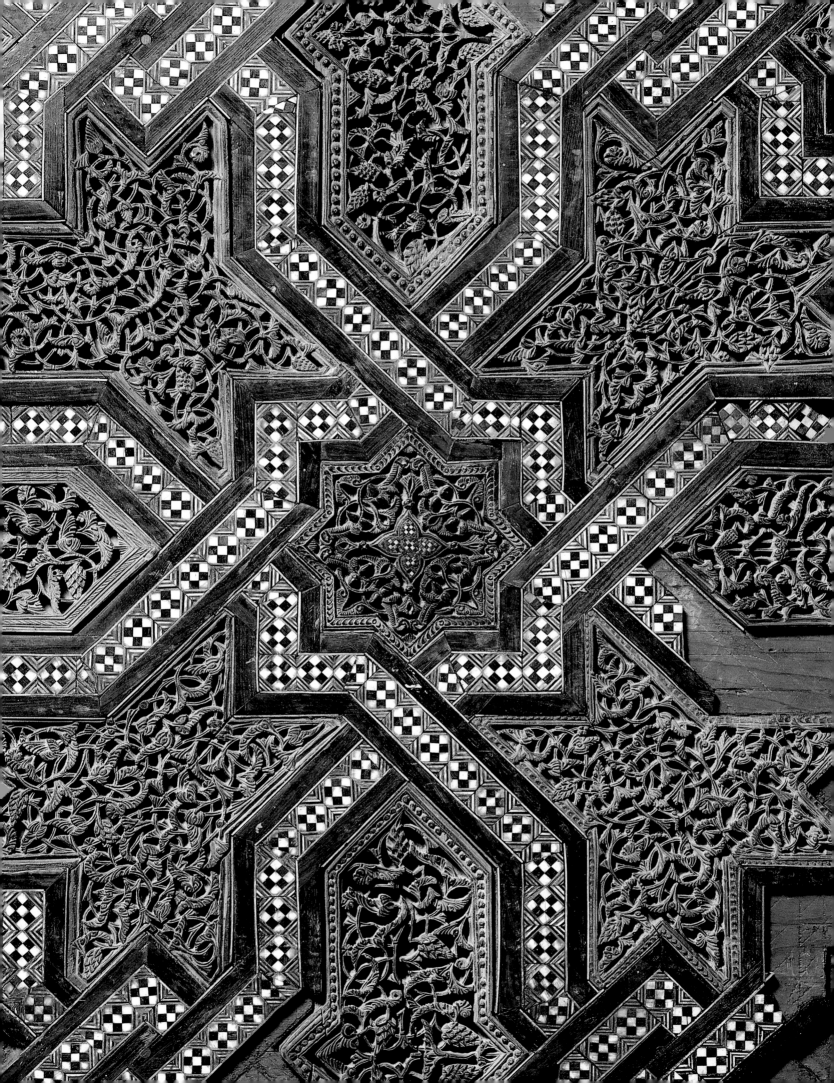

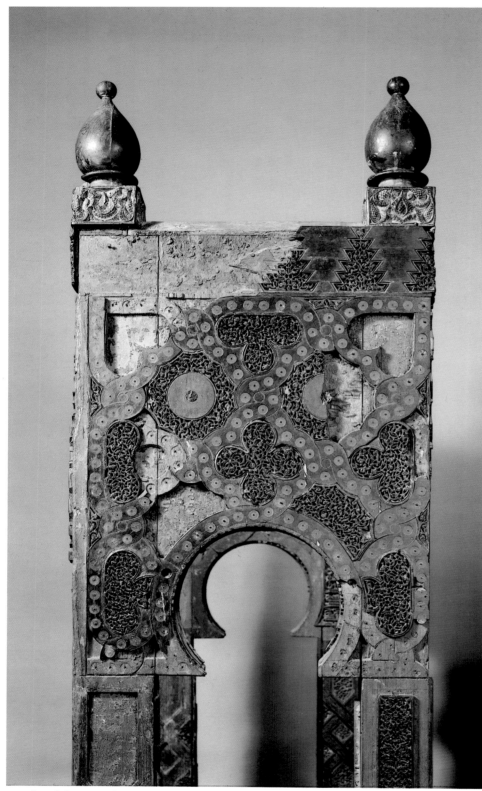

115, detail, lower right pierced panel

The minbar, which derived from the seat of a ruler or judge in pre-Islamic Arabia, is the only type of liturgical furniture sanctioned by the Prophet Muḥammad, and he used it when he addressed the assembled believers. After his death his successors and their representatives continued to use it during Friday prayers, a ceremony that retained a strikingly secular character throughout the first century of Islam. By the middle of the eighth century, this secular character had largely disappeared, and the minbar was transformed from a ruler's seat into a preacher's pulpit. The minbar, which became an essential feature of every congregational mosque, soon came to signify the existence of a congregational mosque, and as the sermon (khutba) included an invocation in the name of the sovereign, the minbar became a symbol of sovereignty, much like coinage or official textiles.[11] Indeed, the fragmentary inscription on the backrest of the Kutubiyya minbar, as well as those on many others, has an official character, the phrasing of which is reminiscent of the khutba, with good wishes for the sovereign, who is designated by the caliphal title Commander of the Faithful (*amīr al-muʾminīn*), and his heir apparent.[12] The Prophet's minbar, which had two steps, was only high enough to raise him above the congregation; it was elevated by the Umayyad caliphs on a socle with six steps, and high minbars became the norm for most of the Muslim community.[13] The Prophet's minbar came to have eight steps, but no particular number of steps was standard, and examples with four, five, six, eight, nine, and eleven are known.[14]

Opinions also differed about what to do with the minbar when it was not in use. According to literary and historical sources, the Prophet's minbar was moved to a suitable spot in the mosque of Medina when he preached, but after his death it was given a permanent place there. Once every congregational mosque had a minbar, the minbar could either be placed in a fixed location in the mosque, or, following the example of the Prophet's mosque, it could be kept out of the mosque, which would preserve its initially nonreligious character. The first solution, widely accepted in the central and eastern Islamic lands, resulted in fixed minbars that protruded into the prayer hall to the right of the mihrab. The second, followed particularly in East and North Africa, resulted in either a minbar carved out of or behind the qibla wall or a movable minbar, which could be stored in a closet and brought out when needed. Although movable minbars were used in some ninth-century mosques in Iraq,

including the enormous congregational mosques at Samarra, the ʿAbbāsid capital, they are a distinctive feature throughout North Africa, and the Kutubiyya minbar was undoubtedly stored when not in use.[15] Portability is another characteristic that differentiated western Islamic minbars from their eastern counterparts, for most had wheels to allow them to be moved to storage; the stone and brick minbars that developed in the Islamic east were hardly known in the west.

It is no accident that a large number of minbars of high quality survive from the Almoravid period in Morocco, for the region had a long tradition of minbars imbued with political and artistic significance. For the mosque at Tlemcen the Rustamid ruler Idrīs I ordered an inscribed wooden minbar in 790 (A.H. 174), to which his son Idrīs II added another inscription, but the oldest extant example, made in 862–63 (A.H. 248), is that in the congregational mosque at Kairouan. The minbar made in 980 (A.H. 370) for the Mosque of the Andalusians at Fez (No. 41) records the shifts of power between the rival Fāṭimids of Tunisia and Umayyads of Spain. The original minbar, erected by clients of the Fāṭimids, was severely damaged in a revolt six years after its construction, so the Umayyads repaired its panels and provided a replacement for the backrest, which had been taken to Córdoba as a trophy.[16] In response to the construction of magnificent minarets by the Umayyads of Spain, the Fāṭimids, who eschewed minarets, attempted to recharge the minbar as a symbol of their dominion.[17] The Almoravids, patrons of the Kutubiyya minbar, were strict and conservative followers of the Malikī sect and known as great builders of fortresses and mosques. The founder of the dynasty, Yūsuf ibn Tāshufīn, is said to have reproached the inhabitants of a street without a mosque.[18] Of the three extant Almoravid mosques, at Nedroma, Algiers, and Tlemcen, all preserve their wooden minbars, and two others were commissioned for the mosques of Marrakesh and Fez, although it is significant that none of these mosques had a contemporary minaret.[19] The construction of spectacular wooden minbars with elaborate carving and marquetry decoration by the Almoravids represents a marriage of the North African tradition of the minbar as the standard Islamic sign of sovereignty to the Cordobán tradition of exquisite craftsmanship. JMB

1. Basset and Terrasse 1926, pp. 168–207, pls. XXXI–XXXVI, figs. 90–97; idem 1932, pp. 234ff.
2. Sauvaget 1949, pp. 313–19.
3. For the panels, see Anglade 1988, pp. 34–38. For the development of the marquetry technique in the Islamic world, see Monneret de Villard 1938. In Iran, where the technique is commonly used to decorate small wooden boxes, it is known as khātam-kārī. For a technical description, see Wulff 1966, pp. 92–97.
4. Kühnel 1971, no. 39.
5. The inscription on the left flank of the minbar contains Qurʾan 2:255–57, while that on the right flank contains 7:54–61. The inscription on the left arcade begins with the basmala (invocation), followed by the taslīm (blessings on the Prophet and his family), and Qurʾan 112. That on the right arcade contains Qurʾan 113.
6. Lévi-Provençal 1925, p. 65; Hadj-Sadok 1971, pp. 865–68.
7. Ibn ʿIdhari al-Marrakushi 1948, 2, pp. 238, 250; Hernández Jiménez 1959, pp. 381–99.
8. For Kairouan, see Creswell 1940, pp. 317–19; for Nedroma, see Marçais 1932, pp. 321–31.
9. Terrasse 1968, pp. 49–53.
10. The earliest extant example is the minbar ordered in 1091–92 (A.H. 484) for the shrine of Ḥusayn at Ashqelon, which was later transferred to the Ḥaram al-Khalīl mosque at Hebron. The triangular fields on the sides of the minbar are decorated with a geometric interlace of scrolled bands forming hexagons and hexagrams, and the interstices are filled with richly carved but delicate arabesques. The most famous example is the minbar ordered by Nūr al-Dīn for the al-Aqṣā mosque in Jerusalem, made between 1168 and 1175 (A.H. 564–71) and now largely destroyed.
11. For the history of the minbar, see Pedersen et al. 1990, pp. 73–80.
12. Sauvaget 1949, p. 316.
13. This innovation was challenged briefly by the early ʿAbbāsid caliphs, but the Ibāḍī khārijites of North Africa, a group that splintered off from the community in the early years of Islam, have preserved the use of low minbars. See Schacht 1954, pp. 11–27; Bloom 1989, p. 49.
14. Terrasse 1957, pp. 159–67. The ninth-century minbar at Kairouan, for example, has eleven steps.
15. Schacht 1957, pp. 151 (quoting Basset and Terrasse 1932, p. 235), 154–55.
16. Terrasse [1942], pp. 34–40.
17. Bloom 1989, pp. 99–124.
18. Marçais 1954, p. 186.
19. Bloom 1989, pp. 99–124.

LITERATURE: Lévi-Provençal 1925, p. 65; Basset and Terrasse 1926, pp. 168–207, pls. XXXI–XXXVI, figs. 90–97; Terrasse 1932, pp. 383–424; Sauvaget 1949; Torres Balbás 1949, pp. 65–69, figs. 56–59; Gómez-Moreno 1951, pp. 294–96; Terrasse 1957, pp. 159–67; Sourdel-Thomine and Spuler 1973, pp. 285–86, figs. 230–31.

116

Cupola Ceiling from the Torre de las Damas, the Palacio del Partal, Granada

Naṣrid period, 13th or 14th century
Wood
11 ft. 7¾ in. x 11 ft. 7¾ in. x 6 ft. 2⅜ in.
(3.55 x 3.55 x 1.89 m)
Museum für Islamische Kunst,
Staatliche Museen Preussischer
Kulturbesitz, Berlin
I. 5/78

Once this square ceiling covered the Torre de las Damas of the Palacio del Partal. During the nineteenth century, the tower was owned by Arturo Gwinner Dreiss, who partly donated and partly sold the structure to the Alhambra when he left Spain. He retained the magnificent ceiling, which he dismantled and removed. It was recently purchased by the Museum für Islamische Kunst in Berlin. A good reproduction now occupies the original space.

Wooden ceilings have a long tradition in the Hispano-Islamic area, and from the time the magnificent carved ceiling was made for the Great Mosque at Córdoba, they were to be a constant decorative system, attaining their greatest splendor under the Naṣrid sultans. One of the most exquisite examples, both in workmanship and in the use of symbolic geometric design, can be seen today in the Salón de Comares in the Alhambra.

The ceiling shown here dates from the first Naṣrid period—late thirteenth and early fourteenth centuries—and is remarkable for its structural originality. The usual scheme for covering the area between the slope of the roof and the square or rectangular space that frames it is a series of closely set parallel beams that interlace decoration and structure. This ceiling, however, transforms the square to an octagon, and the octagon to a figure with sixteen sides, which culminates at the crown of the roof. Here the surface decoration hides the structure.

Each corner of the square is occupied by a pendentive bearing an eight-part decoration. Narrow incised bands, which were later polychromed, enclose geometric areas filled with carved vegetal motifs. The effect is one of great richness and must have been enhanced by the height of the ceiling. At the center, aligned with the axes of the square, is a large eight-pointed star formed by the intersection of two squares. The contained octagon surrounds a small cupola of *muqarnaṣ* (stalactites) whose points of contact generate a design of eight-pointed stars in three dimensions. *Muqarnaṣ* decoration was frequently used on friezes and capitals, as well as on small cupolas, but it was during the reign of Sultan Muḥammad V that the device attained the splendor to be seen in the Palacio de los Leones.

Above the pendentives runs a carved octagonal frieze of palm arches, enclosing areas filled with Kūfic inscriptions. Each spandrel displays a festooned palmette encircled by deeply carved simple palm leaves. A series of eight pendentives transforms the octagonal area into one having sixteen sides. The cupola does not spring directly from this divided space but rests upon a *muqarnaṣ* frieze that seems to be supported by small columns. The described arc frames the Naṣrid dynastic motto in cursive characters.

The ceiling is composed of planes that narrow as they approach the center. Here a wheel with sixteen lobes opens out to form three rows of octagonal levels; all but the lowest one seem to be pierced by the angles of each panel. The geometric areas between the bands are filled with small plaques carved with plant motifs.

P M S

LITERATURE: Bermúdez Pareja 1966, pp. 129–30, pls. XLV, XLVI; Fernández-Puertas 1977; Brisch 1979; Brisch 1983.

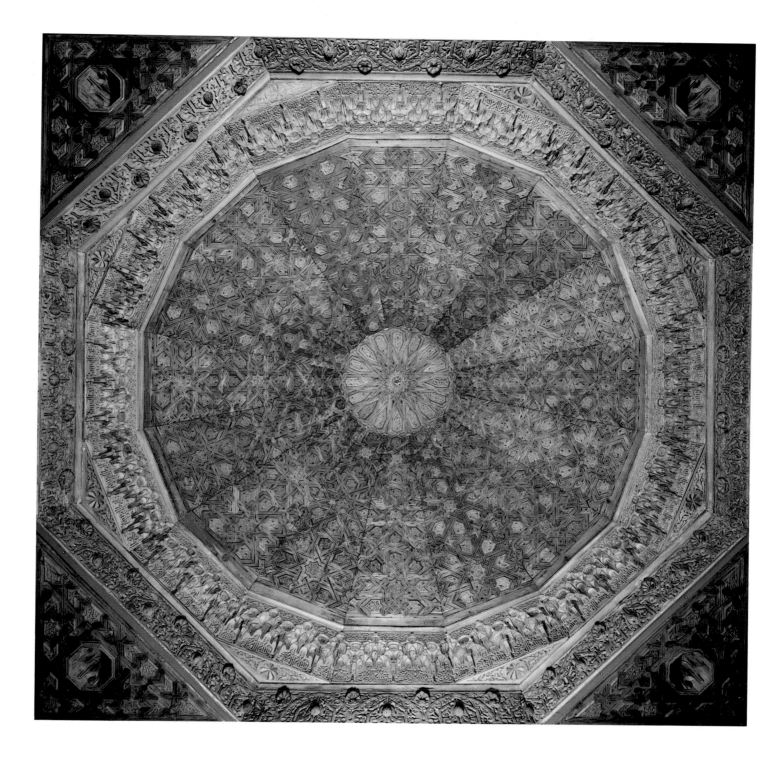

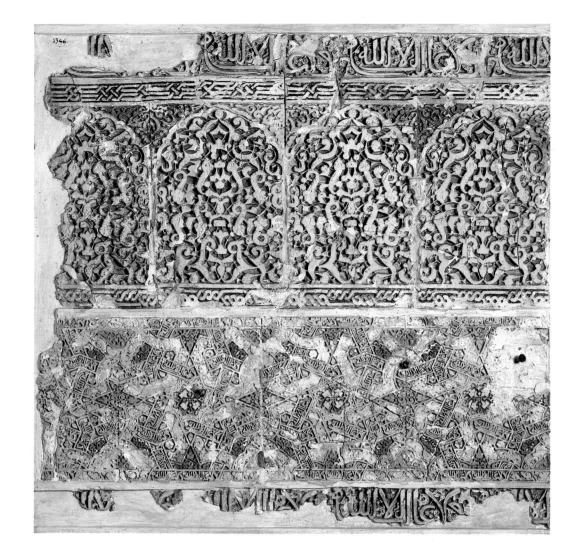

117

Panel from the Patio de la Acequia, the Generalife, Granada

Naṣrid period, 1273–1309
Polychromed plaster
41 x 40⅛ in. (104 x 102 cm)
Museo Nacional de Arte Hispanomusulmán, Granada
1.346

After his victory over Castile in 1319 (A.H. 719), Sultan Ismāʿīl I redecorated the mirador in the Patio de la Acequia. He covered the existing wall panels, dating from the reigns of Muḥammad II or Muḥammad III, with new stuccowork. This section of the original interior south wall has retained much of its color and detail because it was thus hidden and protected. In artistry, technique, and composition it is reminiscent of the decoration found in the Palacio del Partal, on the Puerta del Vino, and in other parts of the Generalife.

The carved and polychromed plaster panel is made up of independent bands of decoration of comparable size. The Naṣrid dynastic motto, repeated in cursive characters in red ocher, frames the composition. The background of the calligraphy is occupied by winding tendrils from which palms and fruits with digitate decoration grow. On the lower band is a motif of eight-part knots. The ribbon that forms these knots signals two different decorative themes: one is the dynastic motto of the Naṣrids, in blue; the other is of palms, in light green with interior decoration. This band is divided into rectangular panels with a central star. At the upper and lower edges the ribbons form a frame for the design.

The upper band is framed by two knotted borders, both painted black, and each with distinct geometric solutions. The space that is left between these borders is occupied by arches of palms with little columns, complete with bases serving as support, and cubic palm capitals. The interior of each arch is filled with a vegetal theme of digitate palms arranged symmetrically about a central axis. The rectangular areas are painted alternately red and green, and the spandrels are decorated with another design of digitate palm leaves. These rectangles are separate panels, with their lines of junction concealed by the slender columns that seem to be supporting the arches.

PMS

LITERATURE: Gallego y Burín 1961; Cabanelas Rodríguez and Fernández-Puertas 1978.

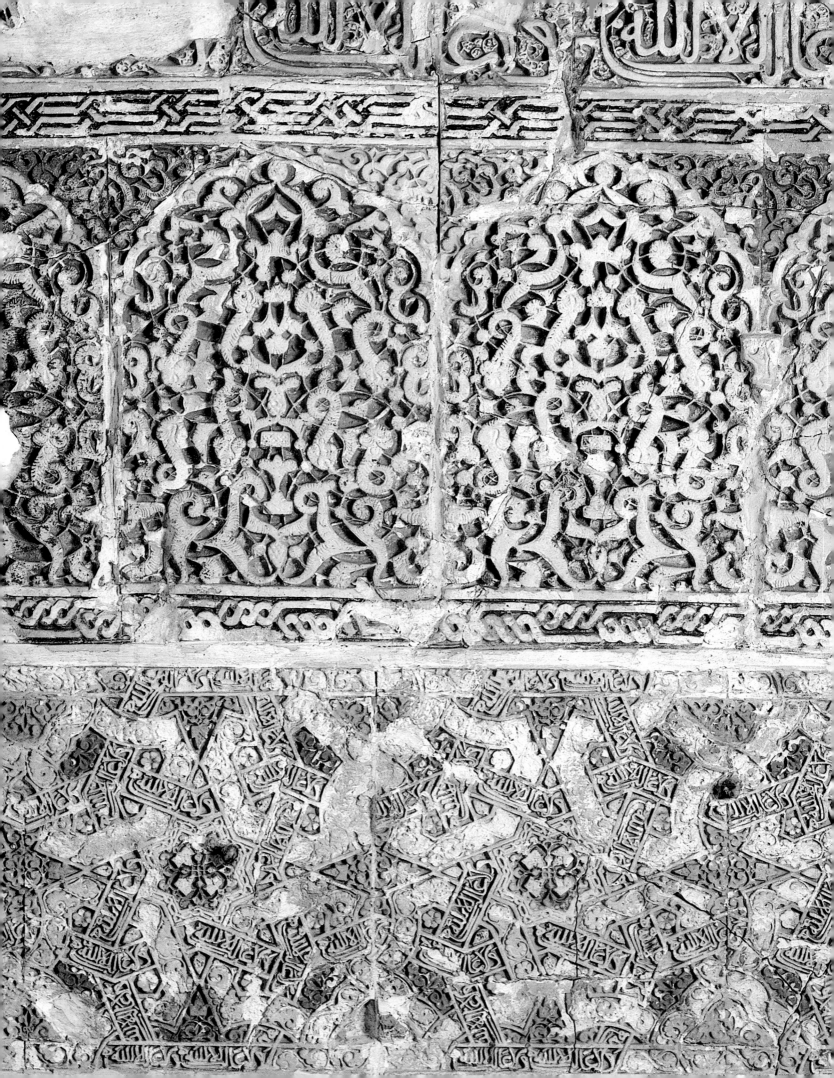

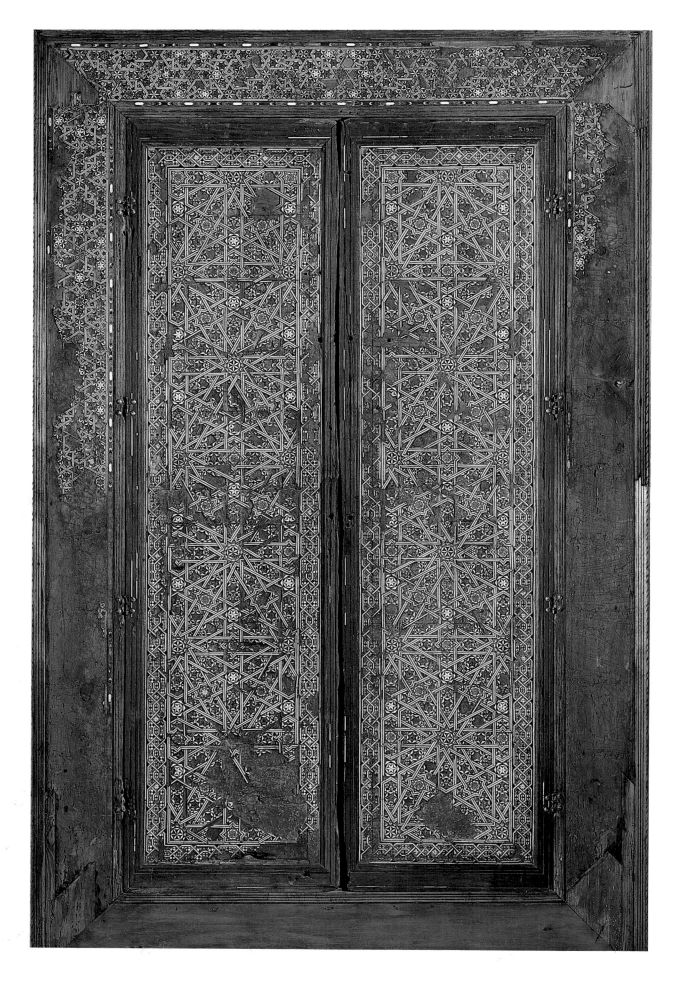

Marquetry faces these doors inside and out. The sumptuous inlay covers the entire surface of the doors and the external side of the frame. Like other architectural remains from the residential Palacio de los Infantes, they are evidence of the delicacy and splendor of its decoration.

Taracea, or inlay work, was used for decoration continuously throughout the Hispano-Islamic area. It appeared on the much-admired minbar in the Great Mosque at Córdoba at the time of its enlargement under al-Ḥakam II in the tenth century and is still being employed today. According to historians, the caliphal marquetry workshops continued to execute court commissions under the Almoravids and the Almohads. They contributed to the splendor of the minbar in the Qarawiyyīn mosque at Fez and those in the Kutubiyya (No. 115) and the Qaṣba mosques at Marrakesh.

Techniques varied according to the requirements of the individual piece. The inlay was cut very thin and either glued directly to the background—as is the case with the doors we see here—or cemented to a sheet of paper or leather, which was then laid over the object to be decorated, as can be seen on some small Morisco chests.

On the interior surface of the doors, the panels were cut out to receive the inlay pattern, which is made up of three rows of eight-pointed stars enframed by knots. On the outside of the panels is a design of three rectangular double guilloches enclosing twelve-lobed wheels framed by hexagons with six- and eight-pointed stars. The decoration has been further enriched and complicated by filling each geometric space with small wheels of marquetry made with tiny pieces of multicolored wood and bone, left natural or stained green, silver, or black. These wheels divide and subdivide each space. P M S

LITERATURE: Basset and Terrasse 1932; Prieto y Vives 1935, pp. 206–7; Torres Balbás 1935; Ferrandis Torres 1940; Gómez-Moreno 1940; Torres Balbás 1949; Terrasse 1968.

Cabinet Doors from the Palacio de los Infantes, Granada

Naṣrid period, 14th century
Wood, bone, and silver
Total with frame, 66⅞ × 43¼ in.
(170 × 110 cm);
each door, 55⅛ × 15 in.
(140 × 38 cm)
Museo Nacional de Arte
Hispanomusulmán, Granada
190

†

detail, inside of door

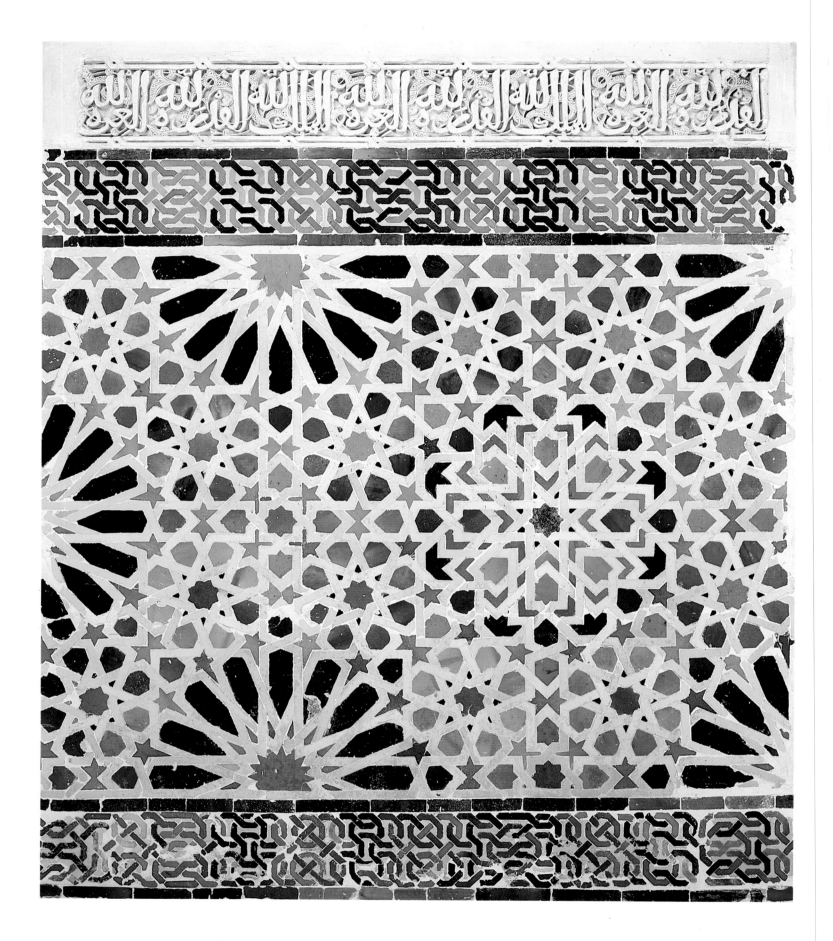

119

Panel from the Mexuar, the Alhambra, Granada

Naṣrid period, 14th century
Glazed mosaic tile
60 x 50⅝ in. (152.5 x 128.5 cm)
Museo Nacional de Arte
Hispanomusulmán, Granada
1612

This fragment of mosaic tile dado, which once closed off the opening leading from the courtyard of the Mexuar to that of the Cuarto Dorado, dates from the Naṣrid period. The panel was moved from the vanished Sala de las Aleyas (south chamber of the Patio de los Arrayanes) to the Mexuar when it was adapted as a Christian chapel. These modifications may have been carried out in 1537 and 1544 by Morisco artisans who were still proficient in the techniques of tile mosaic. Their work incorporated sixteen-pointed stars with heraldic emblems from the reign of Emperor Charles I, among which was the Naṣrid coat of arms of the kingdom of Granada.

Along the top of this tile panel runs an epigraphic frieze in cursive script repeating the mottoes القدرة لله العزة لله الملك لله (*Power is God's, Glory is God's, Dominion is God's*). The background is filled with spiraling tendrils bearing digitate palm leaves. According to Jesús Bermúdez Pareja, this was originally part of the frieze running above the arches of the vanished Patio de Machuca.

The panel bears an interlaced design forming alternating stars of eight and sixteen points in the central area and half wheels along the upper and lower edges. The whole is a network of intersecting bands set obliquely and at right angles. Each of the half-wheels with sixteen lobes is surrounded by eight smaller ones with eight lobes, and the central area displays an octagon surrounded by stars. The design is created by interweaving white bands that generate various rhythmic geometric motifs polychromed in black, buff, green, and blue. PMS

LITERATURE: Gómez-Moreno González 1892; Torres Balbás 1967, pp. 129–30; Bermúdez Pareja 1977b; Fernández-Puertas 1982.

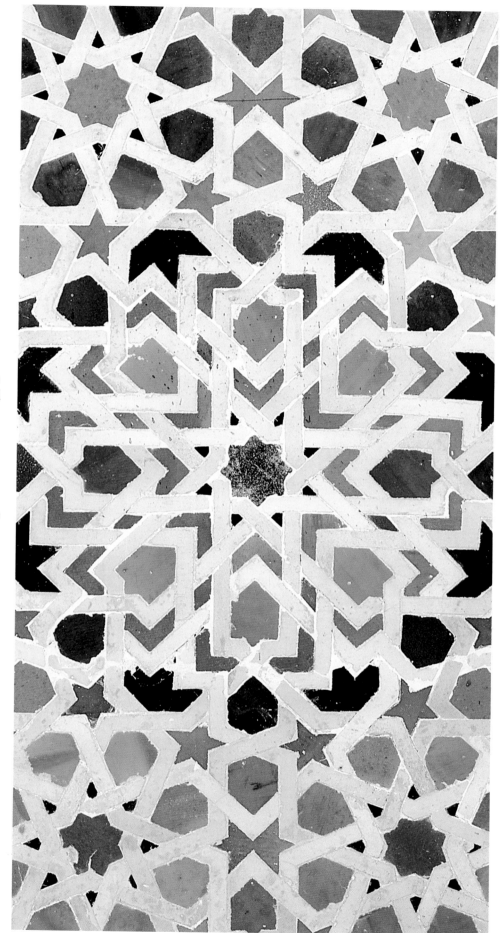

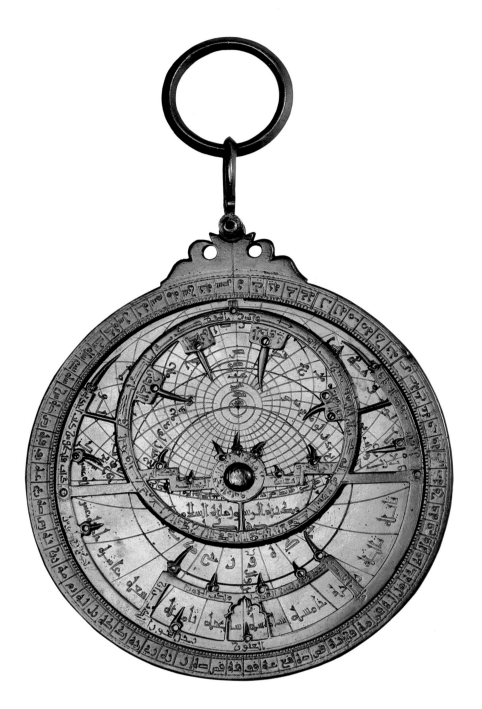

120

Standard Astrolabe of Aḥmad ibn Muḥammad al-Naqqāsh

Taifa period, 1079/80 (dated A.H. 472)
Brass
Diam. 4½ in. (11.5 cm)
Germanisches Nationalmuseum,
Nuremberg
WI 353

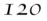hen fitted with a sighting device for measuring celestial altitudes, an astrolabe enables the user to feed in the altitude just measured and set the instrument to represent the instantaneous configuration of the sky for his own latitude.[1] The Muslims inherited such an analogue computer—the planispheric astrolabe—from their Hellenistic predecessors, and they developed it in virtually every conceivable way. The astrolabe results from a stereographic projection, first developed by Hipparchus of Rhodes about 150 B.C. The northern part of the celestial sphere, that is, the part that is visible in the Northern Hemisphere, is projected onto the

plane of the celestial equator from the south celestial pole.

The standard astrolabe consists of two main parts, one celestial and the other terrestrial. First, there is a grid called a rete, bearing pointers representing the positions of certain prominent fixed stars and a ring representing the ecliptic, the annual path of the sun around the stars. Second, there is a plate for a specific latitude bearing markings representing the meridian and the local horizon. Curves showing the altitude and an orthogonal set showing the azimuth (bearing) are also included on the plate. When the rete (the celestial part) rotates over the plate (the terrestrial part) the apparent rotation of the sun and stars across the sky with respect to the horizon of the observer is simulated.

Literally dozens of Arabic treatises on the use of the astrolabe were compiled between the ninth and the sixteenth century, and hundreds of Islamic astrolabes survive. The astrolabe was transmitted to Europe mainly by way of al-Andalus and became the most popular European instrument during the Middle Ages and the Renaissance.

The principal use of the astrolabe—apart from being a model of the universe that can be held in one's hand—was in timekeeping. Since in Islam the times of prayer are astronomically defined, astrolabic plates were often fitted with special curves for prayer times. Because the configuration of the heavens with respect to the local horizon was widely believed to be influential in human affairs, the astrolabe is also ideally suited for astrological purposes.

This astrolabe was made in Saragossa by Aḥmad ibn Muḥammad al-Naqqāsh. It is an elegant piece, although from a scientific point of view it is distinguished as the only early astrolabe that displays errors in construction. Indeed, there are places where al-Naqqāsh made major mistakes in the engraving.

The throne (*kursī*) at the top of the astrolabe is typical of early Andalusian instruments and supports a pair of large rings to suspend the instrument when in use. The rete (*shabaka*), also of typical Andalusian form, has the horizontal bar counterchanged twice on each side. There are no knobs with which to rotate the rete, but there must once have been three because there are two holes at the ends of the horizontal bar and another at the top of the rete. The lower circular bar is unusually short and bears a mihrab-shaped design below its middle. The star pointers are simple, with one

or two holes in their bases; these once bore silver studs. Altogether there are twenty-three pointers, serving twenty-four stars.

The mater (*umm*), or backing, and five plates (*ṣafāʾiḥ*) are engraved with altitude circles for each six degrees and with azimuth circles for each nine degrees. The following latitudes and localities are served:

21°	30′	Mecca. Taif. Yamāma. Beja [East Sudan]
25°		Medina
31°		Alexandria. Damietta. Shāpūr
33°		Baghdad. Damascus. Fez. Ashqelon
34°		Menorca. Aleppo. Antioch. Basra
35°		Ceuta. Sicily. Mosul. Ruṣāfa
36°	30′	Almería. Samarkand. Harran. Raʾs al-ʿAyn
37°	30′	Seville. Granada. Al-Anbār
38°	30′	Córdoba. Jaén. Jurjān. Balkh
39°	30′	Valencia. Badajoz. Majorca
41°	30′	Saragossa. Huesca. Calatayud

The alidade (*al-ʿiḍāda*), or diametral rule with sights, is plain and counterchanged at the middle. There are altitude scales on the back, as well as a pair of scales for finding the position of the sun from the date in the Julian calendar, which was used by astronomers in al-Andalus. The calendrical scale is excentric, and the equinox is shown at March 16 (which corresponds to about 800, rather than the late eleventh century). There is a square shadow scale in the lower left that serves to measure shadow lengths for a given solar altitude. The inscription in the top of the central space is as follows:

صنعه أحمد بن محمد النقاش بمدينة سرقسطة سنة تعب

Made by Aḥmad ibn Muḥammad al-Naqqāsh in the city of Saragossa in the year 472 [Hijra].

D A K

1. For general works on the astrolabe, see Hartner 1939 and Hartner 1960, which focus on Islamic instruments, both reprinted in Hartner 1968; North 1989 and Poulle 1986, which focus on European instruments; García Franco 1945, an account of all astrolabes preserved in Spain; King 1987, general; Mayer 1956, on Islamic astrolabes arranged by maker; Maddison and Brieux forthcoming, an update of Mayer 1956; Gunther 1932, vol. 1, with information on over one hundred Islamic astrolabes; and King forthcoming, which has descriptions of Islamic and European astrolabes. On timekeeping in the Islamic world see King 1990a, reprinted in King 1992.

LITERATURE: Mayer 1956, p. 37, pl. III (back); Gibbs, Henderson, and de Solla Price 1973, no. 1099; Nuremberg 1983, p. 30 (front); King forthcoming, section 1.2.9.

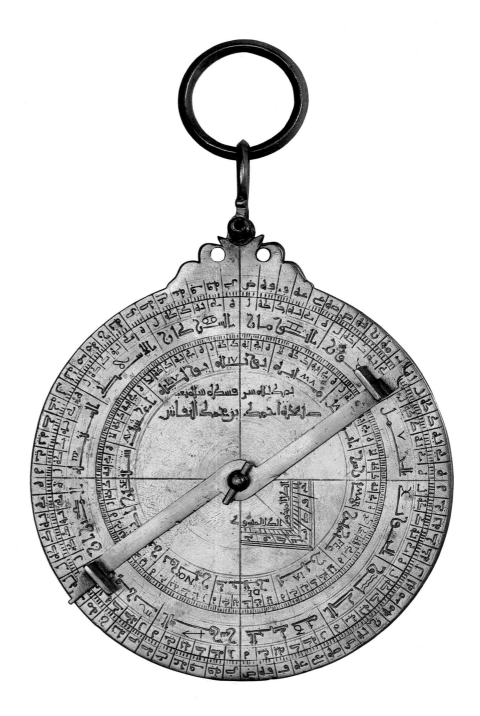

121

*Celestial Globe attributable to
Ibrāhīm ibn Saʿīd al-Sahlī*

Taifa period, ca. 1085
Brass
Diam. 7½ in. (19 cm)
Bibliothèque Nationale, Département
des Cartes et Plans, Paris
N. Res. Ge. A 325

A celestial globe is an instrument serving general didactic purposes rather than specific practical needs.[1] At a glance one can see the positions of the stars relative to the ecliptic —the apparent annual path of the sun against the background of stars—or relative to the celestial equator. One can also see the configuration of the ecliptic relative to the local horizon. The stars and the ecliptic are represented on the outside of a sphere of arbitrary radius that is set inside a horizontal ring that represents the horizon. The axis of the sphere is fixed in the plane of the meridian, or vertical north-south plane, but its inclination to the horizon can be adjusted so that the ensemble represents the heavens with respect to the horizon of any locality. One rotation of the sphere about its axis corresponds to one twenty-four-hour time period.

The Muslims inherited the celestial globe from the Greeks, and a description of such an instrument was available to them in Ptolemy's *Almagest*. Several Arabic treatises on the celestial globe were written over the centuries. The instrument was called in Arabic *al-kura*, *al-bayḍa*, or *dhāt al-kursī*, terms meaning "the sphere," "the egg," or "the instrument resting in horizontal frame." There are three main types of Islamic celestial globes: those with outlines of constellation figures and numerous stars, those showing no constellation figures and only the brightest stars, and those marked only with a spherical coordinate system. The instrument illustrated here belongs to the first type.

This is one of the two oldest Islamic celestial globes. Although it is not signed, it is clearly the work of Ibrāhīm ibn Saʿīd al-Sahlī, who, together with his son, made a very similar globe dated A.H. 478 and now preserved in the Museo di Storia della Scienza in Florence. Already in 1958, Marcel Destombes compared the two globes and established that they are without a doubt by the same maker. Ibrāhīm al-Sahlī is also known to us by several astrolabes bearing his signature, and another astrolabe survives bearing the signature of his son Muḥammad.

The sphere is in two hemispheres joined along the celestial equator. Both the ecliptic and the celestial equator are shown, inclined to each other at an angle of about twenty-three and one-half degrees. Their scales are divided into degrees and labeled for each five degrees. The zodiacal signs are separated by circles that intersect at the pole of the ecliptic. Some 47 constellation figures and 1,004 individual stars are displayed on the sphere. The ring that represents the horizon is original and bears a scale divided into increments of five degrees and further subdivided into single degrees. The remainder of the stand is a replacement. D A K

1. For a general survey of astronomy in al-Andalus, see Samsó 1992. For general surveys of Islamic astronomical instrumentation, see Samsó 1981; King 1987; King 1990b. For a catalogue of all known Islamic celestial globes, see Savage-Smith 1985.

LITERATURE: Sédillot 1841, pp. 115–41 (detailed description); Jomard 1852, pls. 1, 2 (lithographs); Destombes 1958, pp. 305–6; Savage-Smith 1985, p. 236, no. 34 (with additional bibliography). On the Florence globe, see Meucci 1878; Millás Vallicrosa 1944, pp. 32–33, pl. 1 (reproduced from Meucci 1878); Mayer 1956, pp. 51–52; and Savage-Smith 1985, p. 217, no. 1 (both with additional bibliography). See also King forthcoming, section 1.3 on astrolabes by al-Sahlī father and son, Section 5.1 on these two globes.

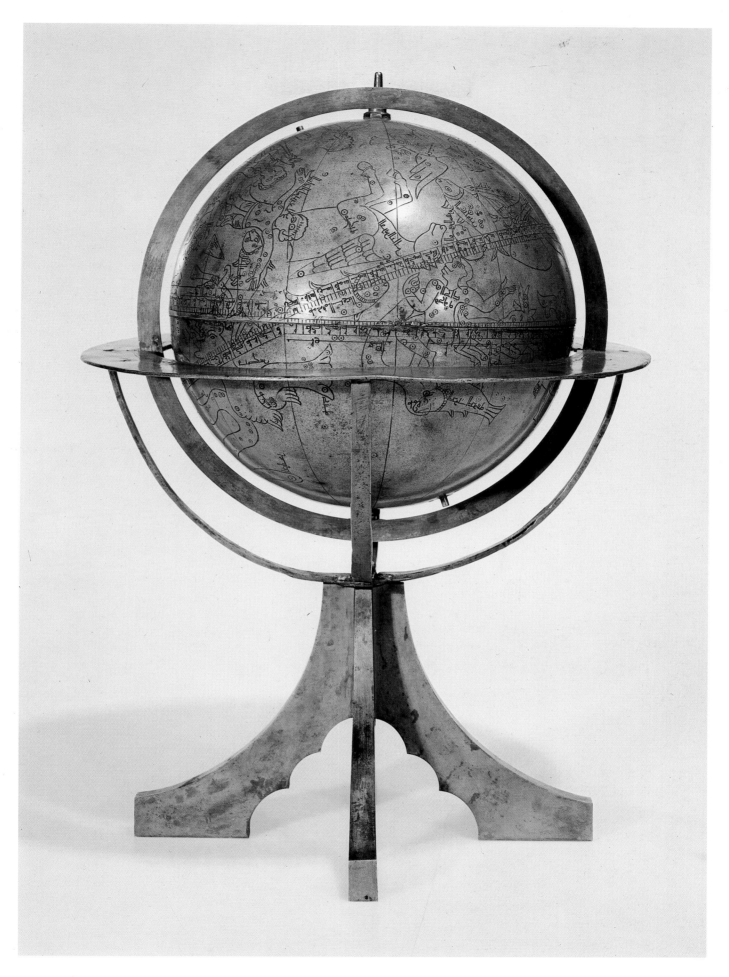

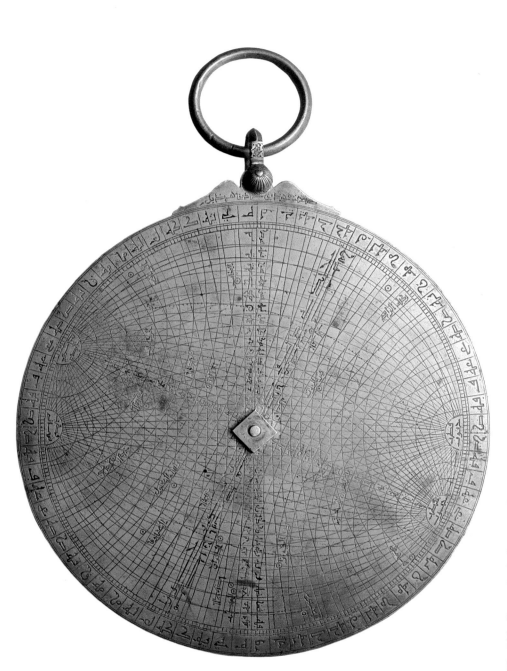

Universal Plate of Muḥammad ibn Muḥammad ibn Hudhayl

Almohad period, 1252/3
(dated A.H. 650)
Brass
Diam. 6¾ in. (17 cm)
Real Academia de Ciencias y Artes,
Barcelona

*I*n the eleventh century, Muslim astronomers in Toledo developed a universal plate bearing markings related to those on an astrolabic plate for latitude zero and thence an astrolabe that would function for all latitudes with a single plate.[1] The astronomer al-Zarqāllu (Azarquiel) appears to have developed the universal plate called *al-shakkāziyya* with a regular alidade (sighting rule) with which some of the problems of spherical astronomy can be solved. He also devised a plate called *al-zarqālliyya*, which consisted of two *shakkāziyya* grids inclined at an angle equal to the obliquity of the ecliptic (the path of the sun around the stars). The alidade is now equipped with a movable cursor and the combination serves to convert between ecliptic and equatorial coordinates. On the back of a typical instrument is a pair of grids for solving problems involving trigonometry and a small circle that constitutes a highly ingenious device for finding the distance of the moon from the earth and hence the lunar parallax, important in eclipse determinations.

The throne of this universal plate is low, with a prominent lobe on each side of the central part, to which are attached a shackle and ring. The inscription on the front continues on the back and reads: صنعه محمد بن محمد بن هذيل بمرسية سنة خن للهجرة (*Constructed by Muḥammad ibn Muḥammad ibn Hudhayl in Murcia in 650 Hijra*). The front of the plate (*ṣafīḥa*) bears a typical *zarqālliyya* grid with circles for each five degrees of both arguments for each of the ecliptic and equatorial coordinate systems. Twenty-one stars are indicated.

On the back of the instrument there are altitude scales around the upper half and shadow scales around the lower one. The calendrical scale is concentric with the solar scale, and the equinox is shown at March 14.5 (which corresponds to about 1000, rather than the mid-thirteenth century). Inside these scales is a pair

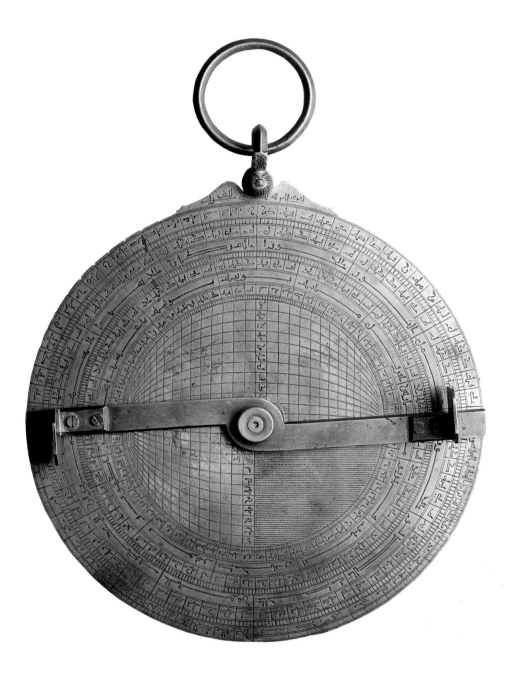

of trigonometric grids as proposed by al-Zarqāllu, one covering three-quarters of the available space and the other, one-quarter. On the vertical axis below the center is a "circle of the moon." The screws attaching the sights to the alidade are not original. DAK

LITERATURE: Millás Vallicrosa 1943–50, p. 449, pls VII, VIII (front and back); Millás Vallicrosa 1944, passim, with ills. (front and back); Millás Vallicrosa 1949, pls. III, IV (front and back); Mayer 1956, p. 73; Gibbs, Henderson, and de Solla Price 1973, no. 1071; Santa Cruz 1985, no. 16, pp. 94–95, pls. (front and back), King forthcoming, section 1.6.4.

1. To the basic studies of the universal astrolabe and plate of Millás Vallicrosa (1932, 1943–50, 1944, 1949) add King 1979, reprinted in King 1987, VII, and Puig 1985, 1986, and 1989. The use of the ingenious circle of the moon is explained for the first time in Puig 1989.

Astrolabe with Universal Plate and Astrological Plates of Aḥmad ibn Ḥusayn ibn Bāṣo

Naṣrid period, 1304/5 (dated A.H. 704)
Brass
Diam. 6½ in. (16.5 cm)
Linton Collection, Point
Lookout, New York

*T*he astronomer ʿAlī ibn Khalaf al-Shajjār invented the universal astrolabe, an instrument known only from the thirteenth century Andalusian compilation entitled *Libros del saber.* The universal astrolabe of ʿAlī ibn Khalaf and his treatise on its use do not seem to have been known in the Muslim world outside al-Andalus and the Maghrib. The instrument consists essentially of one set of *shakkāziyya* markings (see No. 122), which can rotate over another one and can be used to convert from any celestial coordinate system to any other and is therefore particularly useful for solving problems of timekeeping for any latitude. The same instrument was "reinvented" in Aleppo by Ibn al-Sarrāj in the early fourteenth century, and a unique example designed and constructed by him survives in the Benaki Museum in Athens.

In the fourteenth century the astrolabist Aḥmad ibn Ḥusayn ibn Bāṣo, a member of an important family of timekeepers of the Jāmiʿ mosque in Granada, devised a modification of the *shakkāziyya* plate for use with a standard astrolabe rete.[1] Three such astrolabes signed by Ibn Bāṣo are known. This is one example. They represent the culmination of astronomical instrumentation in al-Andalus.

The throne is decorated *à jour* (that is, in holes). The rete has a horizontal bar that is counterchanged twice on both sides. It also has an upper equatorial bar inside the ecliptic. The lower equatorial bar is attached by two symmetrical bars, of which only the right-hand one serves as a star pointer. There are barbed hook-shaped pointers for twenty-nine stars, of which only twenty-seven are named.

The mater (backing) is marked with two base diameters and inside the equatorial circle with altitude circles for each six degrees and with azimuth circles (bearings) for each ten degrees for an unspecified latitude. There are eight plates that are original and two more that do not fit. The latitudes and localities served are:

21°	40′	Mecca
30°		Marrakesh
31°		Alexandria
33°		Fez
35°	20′	Ceuta
36°	30′	Almería
37°		Málaga
37°	30′	Granada
39°	30′	Algeciras

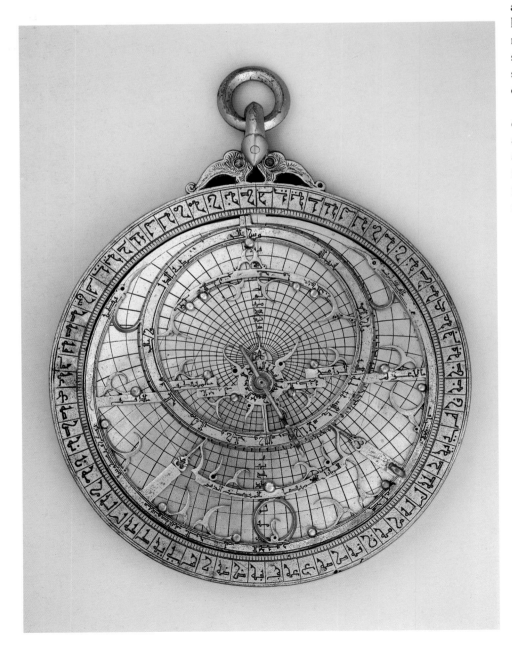

One side bears an Ibn Bāṣo-type projection for all latitudes (*li-jamīᶜ al-ᶜurūḍ*), with both horizons and meridians for each six degrees. There are also five sides of plates for the astrological doctrine known as casting of the rays. These are marked between the solstitial circles for each third of each astrological house, the latter being indicated by fish-bone curves and named in words. They serve the following latitudes: 33°, 36°30', and 37°30' (by three different methods, namely, those of al-Ghāfiqī, Ptolemy, and Hermes).

The back bears two altitude scales, an ecliptic scale, an excentric calendrical scale, a universal horary quadrant in the upper left, and a double shadow square with additional shadow scales in both lower quadrants. The equinox is at March 13.5 (which corresponds to about 1100, rather than about 1300). The inscription reads: صنعه أحمد بن حسين بن باصة سنة ذد (*Constructed by Aḥmad ibn Ḥusayn ibn Bāṣo in the year 704*). The alidade (sighting device) is rectilinear and bears markings but no inscriptions. There are twelve equal divisions on the fiducial side of one arm and shadows at the hours along the other side. The markings are incompetently engraved and incomplete. The pin can be inserted only from the back, and the wedge is an elegant bird's head with ear feathers and a long beak.

DAK

1. The theory and use of the universal plate of Ibn Bāṣo are investigated for the first time in Calvo Labarta 1991.

LITERATURE: Gunther 1932, p. 89, no. 144 (maker misidentified); Mayer 1956, pp. 35–36 (*sub* Ahmad b. Hasanain and Ahmad b. Husain b. Baso), corrected p. 86, no. IV; Gibbs, Henderson, and de Solla Price 1973, no. 144; Linton Collection 1980, p. 87, no. 162, pls. (front and back); Gibbs and Saliba 1984, pp. 137–39 (no. 144), figs. 25, 90 (back and rete with alidade); Washington, D.C. 1989, p. 6, pl. (front). Astrological plates: Viladrich and Martí 1983; North 1986, pp. 60–65.

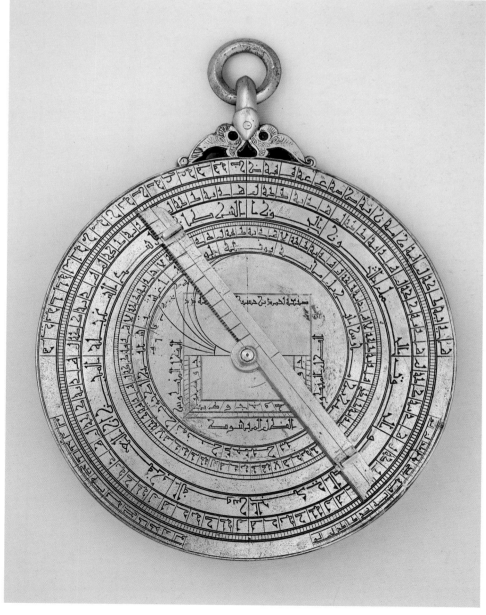

The first Arab coins produced in Spain, unlike the coins in all the other lands of the early Arab conquests, did not continue in any respect the coinage of the previous regime. Instead, Spanish issues, beginning in 711 (A.H. 92), resemble the coins of North Africa, from which the conquering army came; they were probably made by die engravers and technicians brought from Africa. Their inscriptions are in Latin and, like those of the African coins, they translate Muslim religious formulas and give the name of the mint and the date. The most notable feature differentiating the Spanish coins is the addition of a large central eight-rayed star. Gold dinars, of about 4.3 grams in weight, were the only type of coin produced in this early series, called Arab-Latin by modern numismatists. Unlike their African counterparts, these dinars are very irregular in alloy; most likely they were made primarily as a convenient way to divide the booty of the conquest, with the fineness of any batch of coins dependent on the quality of the metal used to make them (No. 124).

In the eastern regions of the caliphate, a fully arabicized coinage had been in use since 697 (A.H. 78). North Africa and Spain took the first step toward conformity with the rest of the caliphate in 716 (A.H. 97–98) with bilingual gold coins inscribed both in Arabic and in Latin (No. 125); from this date Spain had its own mint separate from that of North Africa. The bilingual coins were issued in three denominations: full dinars, half-dinars, and third-dinars. In 720/1 (A.H. 102) Spain, following Africa's example, moved yet closer to conformity with the rest of the caliphate by issuing purely Arabic dinars, which differed from those of the east only in their shorter inscriptions (No. 126). Silver dirhams like those of the east were first struck two years later. By 732/3 (A.H. 114) the dinars of Spain were identical to those of the east, with the exception of the mint name. During this period (from about 720 to about 750 [A.H. 102–32]) the mint also produced an abundance of copper coins for small, everyday transactions.

All these were produced at a single mint in Spain, called al-Andalus on the coins (at that time Arab coins often named the province, rather than the city, where the coin was struck). The mint is believed to have been located in the capital of the province (Seville until about 718 [A.H. 100], then Córdoba), although the equipment for a mint was portable enough for the governor to have it moved from place to place whenever he changed headquarters.

All dinars and dirhams were dated with the year of the Muslim *Hijra* calendar, as were many coppers. The denomination and place of minting were included in the same formula with the date. The remaining inscriptions were religious statements. In general, all these elements appeared on the coins of Spain—and other areas of the Muslim world—until the eleventh century.

When the Umayyad caliphate of Damascus was overthrown by the ʿAbbāsids, Spain came under separate rule by emirs from the Umayyad family. During their reign the Córdoba mint continued the old silver dirham coinage of the Umayyad caliphate, ignoring new developments in the east, until the end of the ninth century (No. 127); only the date on the coins changed. In the east caliphs and other officials began to put their names on coins, but the Umayyad emirs never followed their example. By the close of the ninth century, when this type of Umayyad coinage ended, it was quite archaic in comparison with that of the rest of the Muslim world. No gold dinars were struck during this period, and only a few coppers appeared toward the end.

The Umayyad ʿAbd al-Raḥmān III revived his family's claim to the caliphate in 928 (A.H. 316); he also renewed minting in Córdoba with gold dinars and silver dirhams bearing his name and caliphal titles along with the names of officials, such as his hajib, or chamberlain, and the masters of the mint (see No. 128, struck by his successor). These coins continued to be produced until the dynasty ended in the eleventh century.

Most of the coins of the *Taifa* period maintained the same tradition, usually naming a putative Umayyad overlord and only gradually, in the course of the eleventh century, adding the name of the actual local ruler and the real name of the mint city instead of the name of the country, al-Andalus (No. 129). Among the places named as mints on coins of the eleventh and twelfth centuries are Ishbīliyya (Seville), Balansiyya (Valencia), Saraqusta (Saragossa), Ṭulayṭula (Toledo), Gharnāṭa (Granada), Qurṭuba (Córdoba), Qalāʿat Ayyūb (Calatayud), and Mayūrqa (Majorca). Issues included gold dinars, silver dirhams, and copper *fulūs*. Coinage in eleventh-century Spain was also influenced by the practices of the Fāṭimid caliphs of the eastern Mediterranean, especially in the introduction of a new gold coin, the small *rubʿ*, or

quarter-dinar, a convenient denomination minted by Muslims and Christians throughout the Mediterranean world (No. 130).

Spain's coinage was again revised when the country was conquered by the Almoravids starting in 1086 (A.H. 479). Following their North African custom, they introduced handsome large gold dinars and small silver dirhams at several mints in Spain. The Almoravids preached a revival of the original spirit of Islam and put on their coins a new Qurʾanic quotation admonishing those who deviated from the faith (No. 131).

The Almohad conquest of Muslim Spain in 1145 (A.H. 540) produced another change, more radical and with lasting effects. The founder of the dynasty, ʿAbd al-Muʾmin, brought to Spain, as he had previously introduced in North Africa, uniform gold dinars with a new design (inscriptions appearing inside a square within a circle) and a new higher weight standard (about 4.6 grams), which was believed to have been used in Mecca at the time of the Prophet Muḥammad. The gold coinage also included coins of similar design with the weight of half a dinar. The Christians of Spain regarded this as the unit and called the full dinars doblas (No. 132).

By the early eleventh century the Christians of Spain (those in Barcelona, for example) had begun minting Arabic-style coins in addition to their small, debased silver pennies (*dinaros*) of European type. Some of the Christian Arabic coins were close or crude imitations of Muslim issues, whereas others utilized the design and Arabic script of the Muslim coins for inscriptions naming Christian rulers and proclaiming Christian beliefs. The most spectacular of these was a series minted at Toledo from 1174 to 1221 (A.H. 570–618). Coins from this series state their Christian origin with a cross and the letters *ALF* (for Alfonso VIII, king of Castile), but they name in Arabic the emir of the Catholics الفنش بن سنجة (*Alfunsh ibn Sanjuh*) and call the pope the imam of the Christian faith; they were issued in the name of الآب والابن والروح القدوس (*al-Āb waʾl-Ibn waʾl-Rūḥ al-Quddūs*), the Father and the Son and the Holy Ghost (No. 133). Such coins were called maravedis, the name in Spanish of the gold dinars of the Almoravids, which had been abolished by the Almohads just a few years before the Christian gold coinage at Toledo began.

Although the Toledo coins were an attempt to continue a popular old coinage that the Muslims had ceased to issue, other Christians imitated the Almohad's new square-in-circle gold dinars, as well as their small square silver dirhams (No. 134). Even after the fall of the Almohad dynasty in 1269 (A.H. 667), Almohad-type gold and silver coins remained a standard currency for both Muslims and Christians in the western Mediterranean until the sixteenth century.

Among those who issued Almohad-type coins were the Naṣrids of Granada, the last Muslim dynasty of Spain. They minted gold and silver coins from the thirteenth century (No. 135) until at least 1487 (A.H. 892), and probably until the end of Muslim rule in Spain. Some of the inscriptions on these examples (see No. 136) seem poignant anticipations of Ferdinand and Isabella's ultimate elimination of the last Muslim kingdom in Spain in 1492 (A.H. 898). M L B

124

Solidus

Period of the Umayyad governors, 712
(dated A.H. 93; Byzantine indiction 11)
Minted in Spain
Gold
3.38 g., diam. ½ in. (1.2 cm)
Museo Arqueológico Nacional, Madrid
60.003

Obverse
Center: Eight-rayed star
Margin: NINDNNINDSSINSLSSDSNSD (for
*In Nomine DomiNI Non DeuS NISi
SoLuS Sed DeuS Non Socius Deo*)
In the name of God there is no other

*god but God alone, none can be asso-
ciated with Him.*

Reverse
Center: INDC XI (for *INDiCtione XI*)
Margin: HSLDFRTINSPNANNXCIII (for *Hic
SoLiDus FeRiTus IN SPaNia ANNo
XCIII*)
*This solidus was struck in Spain
year 93.*

The first two letters and the letters *NIS* of the
obverse inscription are reversed in order by
engraver's error; the word *SoLuS* is also out of
order.

LITERATURE: Codera y Zaidín 1879, pl. I, no. 19; Vives
y Escudero 1892, no. 3; Vives y Escudero 1893, no. 2;
Navascués 1959, no. 3; Balaguer Prunes 1976, no. 21;
Rodríguez Lorente and Ibn Ḥāfiẓ Ibrāhīm 1985, pl. 1, no. 2.

125

Solidus / Dinar

Period of the Umayyad governors,
716/7 (dated A.H. 98)
Minted in Spain
Gold
4.29 g., diam. ⅝ in. (1.5 cm)
Museo Arqueológico Nacional, Madrid
60.016

Obverse
Center: Eight-rayed star
Margin: FERITOSSOLIINSPANANXCI (for

*FERITOS SOLIdus IN SPANia ANno
XCI*)
Solidus struck in Spain year 91 [sic].

Reverse
Center: محمد ر
سول الله
Muḥammad is the messenger of God.
Margin: ضرب هذا الدينر بالأندلس سنة
ثمان وتسعين
*This dinar was struck in al-Andalus
year eight and ninety.*

LITERATURE: Rivero and Mateu y Llopis 1935, p. 22,
no. 222; Navascués 1959, no. 23; Balaguer Prunes 1976,
no. 49.

126

Dinar

Period of the Umayyad governors,
724/5 (dated A.H. 106)
Minted in Spain
Gold
4.24 g., diam. ¾ in. (1.9 cm)
Museo Arqueológico Nacional, Madrid
60.033

Obverse
Center: لا اله ا
لا الله
وحده
There is no god but God alone.

Margin: محمد رسول الله أرسله بالهدى ودين الحق
*Muḥammad is the messenger of God
who sent him with guidance and the
religion of truth.*

Reverse
Center: بسم الله
الرحمن
الرحيم
*In the name of God the Merciful the
Compassionate.*

Margin: ضرب هذا الدينر بالأندلس سنة ست ومئة
*This dinar was struck in al-Andalus
year six and one hundred.*

LITERATURE: Calvo and Rivero 1925, pl. X, no. 10;
Miles 1950, no. 6a; Walker 1956, p. 102, no. Mad. 4.

127

Dirham

Emirate, 772/3 (dated A.H. 156)
Minted in Spain
Silver
2.59 g., diam. 1⅛ in. (2.9 cm)
Museo Arqueológico Nacional, Madrid
CS16523

Obverse
Center:

لا إله إلا
الله وحده
لا شريك له

*There is no god but God alone, none
can be associated with Him.*

Margin:

بسم الله ضرب هذا الدرهم بالأندلس سنة ست
وخمسين ومئة

In the name of God this dirham was

*struck in al-Andalus year six and fifty
and one hundred.*

Reverse
Center:

الله أحد الله
الصمد لم يلد و
لم يولد ولم يكن
له كفواً أحد

*God is one, God is the Eternal; he did
not beget nor was he begotten, and
none is comparable to Him.*

Margin:

محمد رسول الله أرسله بالهدى ودين الحق ليظهره
على الدين كله ولو كره المشركون

*Muḥammad is the messenger of God
who sent him with guidance and the
religion of truth to make it supreme
over all other religions even though
the associators may object.*

LITERATURE: This coin is probably among those listed
by Miles 1950, no. 47.

128

Dinar

Caliphal period, 971/2 (dated
A.H. 361)
Minted in Madīnat al-Zahrā᾽
Gold
4.37 g., diam. ⅞ in. (2.3 cm)
Museo Arqueológico Nacional, Madrid
104.309

Obverse
Center: Six-rayed star above and below

لا إله إلا
الله وحده
لا شريك له

*There is no God but God alone, none
can be associated with Him.*

Margin:

محمد رسول الله أرسله بالهدى ودين الحق
ليظهره على الدين كله

*Muḥammad is the messenger of God
who sent him with guidance and the
religion of truth to make it supreme
over all other religions.*

Reverse
Center

الامام الحكم
أمير المؤمنين
المستنصر بالله

*The imam al-Ḥakam, Commander of
the Faithful, al-Mustanṣir bi-llāh.*

Margin:

بسم الله ضرب هذا الدينار بمدينة الزهرا سنة
إحدى وستين وثلثمئة

*In the name of God this dinar was
struck in Madīnat al Zahrā᾽ year
one and sixty and three hundred.*

The center inscription on the reverse names the
Umayyad caliph of Spain al-Ḥakam II.

LITERATURE: Calvo and Rivero 1925, pl. XI, no. 1; Miles
1950, no. 254d.

129

Dinar

Taifa period, 1070/71 (dated A.H. 463)
Minted in Córdoba
Gold
4.451 g., diam. ¹⁵⁄₁₆ in. (2.4 cm)
The American Numismatic Society,
New York
1917.215.1602

Obverse

Center: لا إله إلا الله محمد رسول الله الحاجب
سراج الدولة إبن فرجون

*The Chamberlain—there is no god
but God, Muḥammad is the messen-
ger of God—Sirāj al-Dawla; Ibn
Farjūn.*

Margin: بسم الله ضرب هذا الدينر بمدينة قرطبة
سنة ثلث وستين وأر[بعمئة]

*In the name of God this dinar was
struck in the city of Córdoba year
three and sixty and f[our hundred].*

Reverse

Center: المعتمد على الله الامام عبد الله أمير المؤمنين
المؤيد بنصر الله

*Al-Muʿtamid ʿala' Allāh the imam
ʿAbdallah, the Commander of the
Faithful, He Who Is Supported by
God's Victory.*

Margin: محمد رسول الله أرسله بالهدى ودين الحق
ليظهره على الدين كله

*Muḥammad is the messenger of God
who sent him with guidance and the
religion of truth to make it supreme
over all other religions.*

The center inscription on the obverse gives the
titles (the Chamberlain, Lamp of the State) of
the heir apparent to the throne, ʿAbbād; Ibn
Farjūn has not been identified. The center
inscription on the reverse gives the titles of
Muḥammad ibn ʿAbbād of Seville, who also
ruled Córdoba.

LITERATURE: Miles 1954, no. 573.

130

Twenty Quarter-Dinars from a Hoard

Taifa period, ca. 1037–44 (A.H. 429–35)
Minted in Almería
Group, .34–1.06 g., diam. ⁵⁄₁₆–⁹⁄₁₆ in.
(.9–1.5 cm); gold coin illustrated, .941 g.,
diam. ⁹⁄₁₆ in. (1.5 cm)
The American Numismatic Society,
New York
1917.215.1624–44

Obverse

Center: لا إله إلا الله محمد رسول الله إبن عبد
الرحيم

*Ibn ʿAbd—there is no god but God,
Muḥammad is the messenger of
God—al-Raḥīm.*

Reverse

Center: المنصور الامام هشام المؤيد بالله أمير المؤمنين
*Al-Manṣūr, the imam Hishām, He
Who Is Supported by God, Commander
of the Faithful.*

Margin: Illegible

These coins come from a hoard of at least 153
quarter dinars of Spain, Sicily, and North Af-
rica. The center inscription on the reverse names
al-Manṣūr, ruler of Almería, and Hishām,
Umayyad caliph of Spain.

LITERATURE: Miles 1954, nos. 202–21.

131

Dinar

Almoravid period, 1097/8
(dated A.H. 491)
Minted in Almería
Gold
4.087 g., diam. 1¹/₁₆ in. (2.7 cm)
The American Numismatic Society,
New York
1951.146.6

Obverse
Center: لا إله إلا الله
محمد رسول الله
الأمير يوسف بن تاشفين

*There is no god but God, Muḥammad
is the messenger of God, the Emir
Yūsuf, son of Tāshufīn.*

Margin: ومن يبتغي غير الاسلام ديناً فلن يقبل منه وهو
في الآخرة من الخاسرين

*And whoever desires a religion other
than Islam, it will not be accepted
from him and he will be among the
lost at the end (Qurʾan 3:85).*

Reverse
Center: الامام
عبد الله
أمير المؤمنين

*The imam ʿAbdallah, Commander of
the Faithful.*

Margin: بسم الله ضرب هذا الدينار بالمرية سنة إحدى
وتسعين وأربعمائة

*In the name of God this dinar was
struck in Almería year one and ninety
and four hundred.*

The emir Yūsuf ibn Tāshufīn mentioned in
the center inscription on the obverse, was the
Almoravid ruler from 1061 to 1106 (A.H. 453–
500). The center inscription on the reverse
refers to the ʿAbbāsid caliph by his titles with-
out naming him.

LITERATURE: This coin is unpublished and unique;
see Hazard 1952, no. 117, for a similar dinar of the
next year.

132

Dinar

Almohad period, 1184–99 (A.H. 580–95)
Minted in Spain or North Africa
Gold
4.6 g., diam. 1¹/₈ in. (2.8 cm)
Museo Arqueológico Nacional, Madrid
104132

Obverse
Center: بسم الله الرحمن الرحيم
والحمد لله وحده
لا إله إلا الله
محمد رسول الله
المهدي إمام الأمة

*In the name of God the Merciful the
Compassionate, and praise to God
alone, there is no god but God,*

*Muḥammad is the messenger of
God: al-Mahdī imām al-umma.*

Margin: وإلهكم إله واحد | لا إله إلا هو الرحمن الرحيم |
وما بكم من نعمة فمن الله | وما توفيقي إلا بالله

*And your God is one god there is no
god but He, the Merciful the Com-
passionate (Qurʾan 2:163), and what-
ever benefit you have is from Him
(Qurʾan 16:53), and my success is
only with God (Qurʾan 11:88).*

Reverse
Center: القائم بأمر الله الخليفة
أبو محمد عبد المؤمن بن
علي أمير المؤمنين
أمير المؤمنين أبو يعقوب
يوسف بن أمير المؤمنين

Al-Qāʾim bi-amrʾ Allāh, the caliph Abū Muḥammad ʿAbd al-Muʾmin, son of ʿAlī the Commander of the Faithful, the Commander of the Faithful Abū Yaʿqūb Yūsuf son of the Commander of the Faithful.

Margin: أمير المؤمنين | أبو يوسف يعقوب | بن أمير

المؤمنين | بن أمير المؤمنين

The Commander of the Faithful Abū Yūsuf Yaʿqūb son of the Commander of the Faithful son of the Commander of the Faithful.

The Almohad caliph who issued this coin, Abū Yūsuf Yaʿqūb (r. 1184–99 [A.H. 580–94]), is named on the marginal inscriptions of the reverse. The central reverse inscriptions name his grandfather ʿAbd al-Muʾmin, founder of the dynasty (d. 1163 [A.H. 558]), and his father, Yūsuf, caliph from 1163 to 1184 (A.H. 558–80).

LITERATURE: Rivero 1933, no. 134.

133

Dinar or Maravedi

Almohad period, 1184 (A.H. 579/80)
(dated 1222 Ṣafar era)
Minted in Toledo
Gold
3.69 g., diam. 1⅛ in. (2.8 cm)
Museo Arqueológico Nacional, Madrid
106621

Obverse
Center: Cross above
الامام البيعة
المسيحية بابه

The imam of the Christian Faith, Pope ALF

Margin: بسم الآب والابن والروح القدوس الاله الواحد

In the name of the Father and the Son and the Holy Ghost, the One God: whosoever believes and has faith will be saved.

Reverse
Center: أمير
القتولقين
الفنش بن سنحه
أيده الله
ونصره

The emir of the Catholics Alfonso son of Sancho, may God support him and make him victorious.

Margin: ضرب هذا الدينار بمدينة طليطلة سنة إثنتين
وعشرين ومائتين وألف للصفر

This dinar was struck in the city of Toledo year two and twenty and two hundred and a thousand of Ṣafar.

ALF (seemingly written AIF) and Alfonso refer to Alfonso VIII, king of Castile 1158–1214, son of Sancho III (r. 1157–58).

LITERATURE: This coin is unpublished; see Vives y Escudero 1893, no. 2022, for another example of the same year.

134

Dirham

Almohad period or later, ca. 1145–1236
(A.H. 540–634)
Minted in Córdoba
Silver
1.549 g., ¾ x ¾ in. (1.9 x 1.9 cm)
The American Numismatic Society,
New York
1917.215.2808

Obverse
Center: لا إله إلا الله
الأمر كله لله
لا قوة إلا بالله
قرطبة

There is no god but God, the entire matter is God's, there is no power except with God—Córdoba.

Reverse
Center: الله ربنا
محمد رسولنا
المهدي إمامنا

God is our Lord, Muḥammad is our messenger, the Mahdi is our imam.

LITERATURE: Hazard 1952, no. 1112.

135

Dinar

Naṣrid period, 1238–72 (A.H. 636–71)
Minted in Málaga
Gold
4.7 g., diam. 1⅛ in. (2.8 cm)
Musée du Batha, Fez
52-2-1

Obverse
Center:

لا إله إلا الله
محمد رسول الله
المهدي إمام الأمة
مالقة

*There is no god but God, Muḥammad
is the messenger of God: the Mahdi
imam of the Community—Málaga.*

Margin: أمير المسلمين | الغالب بالله | محمد بن يوسف
| بن نصر أيده الله

*Commander of the Muslims, the Con-
queror with God Muḥammad son of*

*Yūsuf son of Naṣr, may God support
him.*

Reverse بسم الله الرحمن الرحيم
Center: صلى الله على محمد
لا غالب إلا الله

*In the name of God the Merciful the
Compassionate, may God bless
Muḥammad, there is no conqueror
but God.*

Margin: وإلهكم | إله واحد | لا إله إلا هو | الرحمن الرحيم

*And your God is one god, there is no
god but He, the Merciful the
Compassionate (Qurʾan 2:163).*

The marginal inscription on the obverse names
Muḥammad son of Yūsuf son of Naṣr, that is,
al-Ghālib Muḥammad I, founder of the Naṣrid
dynasty.

LITERATURE: This specimen is unpublished; it is identi-
cal to Brethes 1939, no. 430, which is wrongly attrib-
uted and described.

136

Dinar

Naṣrid period, 1333–54 (A.H. 733–55)
Minted in Granada
Gold
4.665 g., diam. 1¼ in. (3.2 cm)
The American Numismatic Society,
New York
1982.89.1

Obverse
Center:

قل اللهم مالك الملك
تؤتي الملك من تشآء
وتنزع الملك ممن تشآء
وتعز من تشآء وتذل
من تشآء بيدك الخير

*Say: O God, Master of Dominion, you
give dominion to whom you wish and
strip dominion from whom you wish,
and you exalt whom you wish and
humble whom you wish—in your
hand is all good (Qurʾan 3:26)*

Margin: بسم الله الرحمن الرحيم | صلى الله على سيدنا
محمد | وإلهكم إله واحد | لا إله إلا الله هو
الرحمن الرحيم

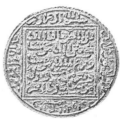

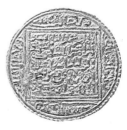

*In the name of God the Merciful the
Compassionate, may God bless Our
Master Muḥammad: and your God
is one god, there is no god but Him,
the Merciful the Compassionate.*

Reverse الأمير عبد الله يوسف
Center: بن أمير المسلمين أبي
الوليد اسماعيل
بن فرج بن نصر أيده
الله وأسعده

*The emir ʿAbdallah Yūsuf son of the
Commander of the Muslims Abūʾl-
Walīd son of Faraj son of Naṣr,
may God support him and give him
happiness.*

Margin: In each of four segments
لا غالب إلا الله

There is no conqueror but God.

The reverse center names the Naṣrid Yūsuf ibn
Ismāʿīl, known as Yūsuf I, ruler of Granada
1333–54 (A.H. 733–55).

LITERATURE: This example is of an unpublished vari-
ety but generally follows Vives y Escudero 1893, no. 2167.

Mosque Plan

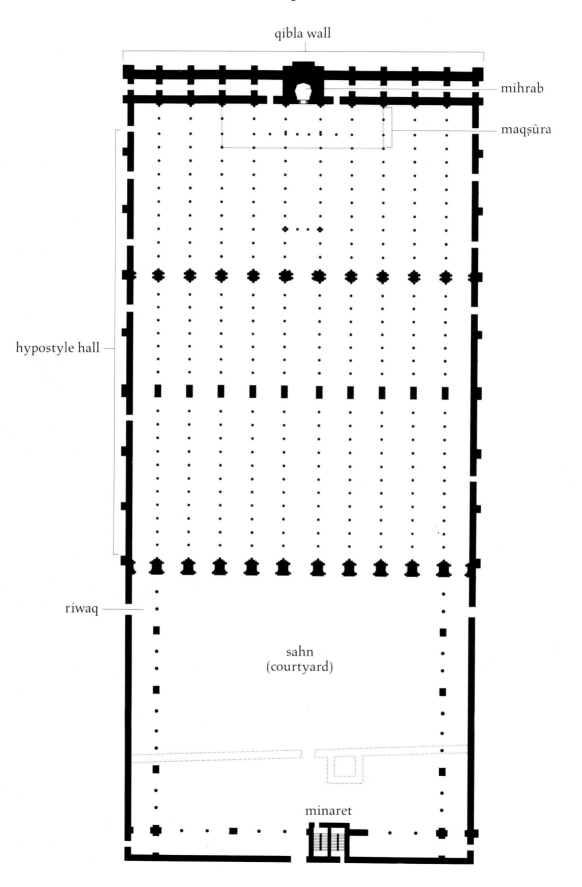

qibla wall

mihrab

maqṣūra

hypostyle hall

riwaq

sahn
(courtyard)

minaret

Glossary

adarve
in military architecture, a protected path on top of a wall; in city planning, a road without exit that might be closed off by means of a door

alcazaba
central part of a town or palace complex

alcazar
Islamic royal palace; Arabic term adopted by Christians

alfiz
molding that enframes an arch

aljama
(*al-masjid al-jami*ᶜ) principal congregational mosque

almunia
estate

al-Andalus
term that appeared as early as 716 (A.H. 98) on bilingual coins as the translation of Spania, the Latin name for Spain; possibly derived from the Berber name for the Vandals, who once lived on the Iberian Peninsula, or from an identification of the peninsula with the mythical Atlantis; used to designate the areas of the peninsula under Islamic control

arabesque
ornamentation based on intertwining leaf and flower motifs; in English interchangeable with *ataurique*; in Spanish (*arabesco*) considered a romantic term that refers to the ornamental effect of Islamic art

ataifor
shallow bowl

atalaya
watchtower

ataurique
stylized intertwining vegetal ornamentation; see arabesque

baraka
blessing, benediction, grace

basmala
the blessing at the beginning of each chapter of the Qurʾan: In the Name of God, the Merciful, the Compassionate

caliph
supreme ruler in Islamic society, combining religious and political attributes of leadership; the term originally described the first successors to the Prophet Muḥammad in the leadership of the community

cordon de la eternidad
motif of interlacing ribbons in a never-ending pattern

cuerda seca
ceramic technique in which areas of different colors are separated by a painted line of oily material

emir
political rank equivalent to prince or commander; in al-Andalus the title of the first Umayyad as well as various later *Taifa* rulers

faqih (pl. *fuqahāʾ*)
Muslim theologian who specialized in jurisprudence

fitna
literally, trial or sedition; a term with both religious and political connotations used to characterize a period of civil war; in al-Andalus the period of civil war and confusion of 1010 to 1013 (A.H. 401–4)

Hadith
sayings of the Prophet recounted by his companions and transmitted orally during the early Islamic period

hajib
chamberlain or chief associate of the emir or caliph

hom
tree of life motif

imam
the leader of the Muslim congregational prayers; the term is sometimes applied to religiously guided political leaders

iwan
vault closed on one end and open on the other

jihad
literally, effort, struggle; connotes a general sense of the individual Muslim's attempt to maintain a righteous life; in more popular usage, the military engagement between Muslims and non-Muslims

khaṭīb
pronouncer of the sermon at Friday prayers

khutba
sermon delivered by the *khaṭīb* at Friday prayers

madina
city

madrasa
Islamic educational institution specializing in religious learning

the Maghrib
northwest Africa and the Iberian Peninsula under Islamic rule; now applied to Morocco, Algeria, Tunisia, and sometimes Libya

maqsūra
reserved space in the mosque in which the emir or caliph prayed

Marranos
term used in Spanish kingdoms for Jewish converts to Christianity after the reconquest

mihrab
recess, niche, or arch in the mosque indicating the qibla

minbar
pulpit

Moriscos
term used in Spanish kingdoms for Muslim converts to Christianity after the reconquest

Mozarabs
Christians living under Muslim rule in al-Andalus

Mudejars
Muslims living under Christian rule on the Iberian Peninsula; Mudejar also designates the arts that represent craft traditions begun under Islamic rule and continued under Christian patrons after the Christian conquest of an area

mujāhidūn (sing. *mujāhid*)
participants in the enterprise of jihad

muladies
Spanish for *muwalladūn*

al-mulk
the power, the dominion, kingship

muqarnaṣ
three-dimensional architectural ornament formed by juxtaposing sections of cones, sometimes creating the effect of stalactites

muwalladūn (sing. *muwallad*)
individuals born into the faith as descendants of converts to Islam or of mixed marriages between Muslims and Christians

qibla
the direction of prayer, intended to be toward Mecca

qubba
dome

ribat
frontier fortress and center for devout warriors

riwaq
portico

sabat
covered passageway

sahn
mosque courtyard

ṣawmaᶜa
staircase minaret

Taifa
(*mulūk al-Ṭawāʾif*) term applied to local princes who ruled as kings of provincial states that arose in the period following the Umayyad caliphate

taracea
inlay with precious wood and ivory

ṭirāz
royal textile manufactory; also the textiles produced there

ulama
Muslim theologians, including specialists in Hadith, *fiqh* (jurisprudence), and other categories of study

umma
community of the faithful

wazīr
(vizier) chancellor or chief minister to the emir or caliph

yamur
minaret finial topped with balls of diminishing size

Bibliography

Edited by Rodolfo Aiello and Heidi Colsman-Freyberger

Abad 1912
Camilo María Abad, "Una exposición provincial de arte retrospectivo: el pendón de Huelgas y otros recuerdos de la batalla de las Navas." *Razón y Fé* 34 (Sept.–Dec. 1912), pp. 169–83.

Acién Almansa 1987
Manuel Acién Almansa, "Madīnat al-Zahrāʾ en el urbanismo musulmán." *Cuadernos de Madīnat al-Zahrāʾ* 1 (1987), pp. 11–26.

Acién Almansa and Martínez Madrid 1989
Manuel Acién Almansa and Rafael Martínez Madrid, "Cerámica islámica arcaica del sureste de al-Andalus." *Boletín de Arqueología Medieval* 3 (1989), pp. 123–35.

Aguado Villalba 1983
José Aguado Villalba, *La cerámica hispanomusulmana de Toledo.* Madrid, 1983.

Aguilera y Gamboa 1908
Enrique de Aguilera y Gamboa, marqués de Cerralbo, *Discursos leídos ante la Real Academia de la Historia en la recepción pública [El arzobispo d. Rodrígo Ximénez de Rada y el monasterio de Santa María de Huerta].* Madrid, 1908.

Ainaud de Lasarte 1943
Juan Ainaud de Lasarte, "Una versión catalana desconocida de los *Dialogi* de Pedro Alfonso." *Sefarad* 3 (1943), pp. 359–76.

Albarn et al. 1974
Keith Albarn et al., *The Language of Pattern: An Enquiry Inspired by Islamic Decoration.* New York, 1974.

Alexander 1985
David G. Alexander, "European Swords in the Collections of Istanbul: Part 1, Swords from the Arsenal of Alexandria." *Waffen- und Kostümkunde* 27, no. 2 (1985), pp. 81–118.

Allan 1976–77
James W. Allan, "Silver: The Key to Bronze in Early Islamic Iran." *Kunst des Orients* 11 (1976–77), pp. 5–21.

Allan 1982
James W. Allan, *Nishapur: Metalwork of the Early Islamic Period.* New York, 1982.

Allan 1986
James W. Allan, *Metalwork of the Islamic World: The Aaron Collection.* London, 1986.

Allen 1988
Terry Allen, "The Concept of Regional Style." In *Five Essays on Islamic Art,* pp. 91–110. Sebastopol, Cal., 1988.

Almagro 1967
Martín Almagro, "Una joya singular en el reino moro de Albarracín." *Teruel* 37–38 (1967), pp. 5–14.

Almagro et al. 1975
Martín Almagro et al., *Quṣayr ʿAmrā: Residencia baños omeyas en el desierto de Jordania.* Madrid, 1975.

Almagro Gorbea 1976
Antonio Almagro Gorbea, "Las torres beréberes de la Marca Media: aportaciones a su estudio." *Cuadernos de la Alhambra* 12 (1976), pp. 279–307.

Almagro Gorbea 1979–81
Antonio Almagro Gorbea, "Restos musulmanes en las murallas de Cuenca." *Cuadernos de la Alhambra* 15–17 (1979–81), pp. 233–47.

Almagro Gorbea 1987
Antonio Almagro Gorbea, "El sistema defensivo de Albarracín." In *Actas del II Congreso de Arqueología Medieval Española, Madrid, 1987,* vol. 2, pp. 71–84. Madrid, 1987.

Amador de los Ríos 1873
Rodrigo Amador de los Ríos, "Lámpara de Abū-ʿAbdil-lah Moḥammad III de Granada, apellidada vulgarmente lámpara de Orán, y custodiada hoy en el Museo Arqueológico Nacional." In *Museo Español de Antigüedades,* vol. 2, pp. 465–91. Madrid, 1873.

Amador de los Ríos 1876
Rodrigo Amador de los Ríos, "Acetre arábigo que se conserva en el Museo Arqueológico Nacional." In *Museo Español de Antigüedades,* vol. 7, pp. 467–81. Madrid, 1876.

Amador de los Ríos 1888
Rodrigo Amador de los Ríos, *España: sus monumentos y artes, su naturaleza e historia.* Vol. 21, *Burgos.* Barcelona, 1888.

Amador de los Ríos 1892
Rodrigo Amador de los Ríos, "Monumentos de arte mahometano, con inscripciones arábigas, en la Exposición Histórico-Europea." *Boletín de la Real Academia de la Historia* 21 (1892), pp. 503–26.

Amador de los Ríos 1893
Rodrigo Amador de los Ríos, *Trofeos militares de la Reconquista: estudio acerca de las enseñas musulmanas del Real Monasterio de las Huelgas (Burgos) y de la Catedral de Toledo.* Madrid, 1893.

Amador de los Ríos y Villalta 1915
R. Amador de los Ríos y Villalta, "Notas acerca de algunas reliquias de los musulmanes en Cataluña." *Revista de Archivos, Bibliotecas y Museos.* 3d ser., 33 (July–Dec. 1915), pp. 173–212.

Anglade 1988
Elise Anglade, *Musée du Louvre: catalogue des boiseries de la section islamique.* Paris, 1988.

Aouni 1991
Lhaj Moussa Aouni, "Etude des inscriptions mérinides de Fès." Doctoral diss. Université d'Aix-Marseille, 1991.

Archivo R. A. H.
"Ensayo histórico sobre la bandera árabe de San Esteban de Gormaz." Translated by Pascual de Gayangos. Archivo de la Real Academia de la Historia, Madrid, Antigüedades por Provincias: Soria, file 109.

Argote de Molina 1807
Simón de Argote de Molina, *Nuevos paseos históricos, artísticos, económico-políticos por Granada y sus contornos.* 3 vols. Granada 1807.

Arié 1965–66
Rachel Arié, "Acerca del traje musulmán en España desde la caída de Granada hasta la expulsión de los Moriscos." *Revista del Instituto de Estudios Islámicos en Madrid* 13 (1965–66), pp. 103–17. Reprinted in Arié 1990, pp. 121–41.

Arié 1973
Rachel Arié, *L'Espagne musulmane au temps des Naṣrides (1232–1492).* Paris, 1973.

Arié 1982
Rachel Arié, *España musulmana (siglos VIII–XV).* Vol. 3 of *Historia de España,* edited by Manuel Tuñon de Lara. Madrid, 1982.

Arié 1990
Rachel Arié, *Etudes sur la civilisation de l'Espagne musulmane.* Medieval Iberian Peninsula Texts and Studies, 6. Leiden, 1990.

Artiñano [1917]
Pedro M. de Artiñano, *Catálogo de la exposición de tejidos antiguos españoles anteriores a la introducción del Jacquard,* exh. cat. Madrid [1917].

Artiñano 1925
Pedro M. de Artiñano, *Catálogo de la exposición de orfebrería civil española*, exh. cat. Madrid, 1925.

Asín Palacios 1944
Miguel Asín Palacios, *Contribución a la toponimia árabe de España*. Madrid, 1944.

Atil 1990
Esin Atil, ed., *Islamic Art and Patronage: Treasures from Kuwait*, exh. cat. The Walters Art Gallery, Baltimore. New York, 1990.

Atil, Chase, and Jett 1985
Esin Atil, W. T. Chase, and Paul Jett, *Islamic Metalwork in the Freer Gallery of Art*, exh. cat. Freer Gallery of Art, Smithsonian Institution. Washington, D.C., 1985.

Aumer 1866
J. Aumer, *Die arabischen Handschriften der K. Hof- und Staatsbibliothek in München*. Catalogus codicum manu scriptum Bibliothecae Regiae Monacensis, I, 2. Munich, 1866.

Azuar Ruíz 1981
Rafael Azuar Ruíz, *Castellología medieval alicantina: area meridional*. Publicaciones del Instituto de Estudios Alicantinos, ser. 1, 60. Alicante, 1981.

Azuar Ruíz 1989
Rafael Azuar Ruíz, *Denia islámica: arqueología y poblamiento*. Alicante, 1989.

Baer 1965
Eva Baer, *Sphinxes and Harpies in Medieval Islamic Art: An Iconographical Study*. The Israel Oriental Society, Oriental Notes and Studies, 9. Jerusalem, 1965.

Baer 1970–71
Eva Baer, "The 'Pila' of Játiva: A Document of Secular Urban Art in Western Islam." *Kunst des Orients* 7 (1970–71), pp. 142–66.

Baer 1983
Eva Baer, *Metalwork in Medieval Islamic Art*. Albany, N.Y., 1983.

Baeza 1868
Hernando de Baeza, "Las cosas que pasaron entre los reyes de Granada desde el tiempo del rey don Juan de Castilla, segundo de este nombre, hasta que los Católicos Reyes ganaron el reyno de Granada." In *Relación de algunos sucesos de los últimos tiempos del reino de Granada*. Sociedad de Bibliófilos Españoles, 3. Madrid, 1868.

Balaguer Prunes 1976
Anna M. Balaguer Prunes, *Las emisiones transicionales árabe-musulmanas de Hispania*. Barcelona, 1976.

Banks and Zozaya 1984
P. Banks and Juan Zozaya, "Excavations in the Caliphal Fortress of Gormaz (Soria), 1979–1981: A Summary." *British Archaeological Reports* (IS) 193 (1984), pp. 674–704.

Barceló Perello forthcoming a
Miquel Barceló Perello, "Al-mulk, el verde y el blanco: la vajilla califal omeya de Madīnat al-Zahrāʾ." *Arqueología y Patrimonio: Coloquio de Salobreña, 1991*. Forthcoming.

Barceló Perello forthcoming b
Miquel Barceló Perello, *Al-Mulk en la epigrafía califal cordobesa*. Forthcoming.

Barceló Perello forthcoming c
Miquel Barceló Perello, *El califa patente: el ceremonial omeya de Córdoba o la escenificación del poder*. Universidad de Salamanca. Forthcoming.

Bargebuhr 1956
Frederick P. Bargebuhr, "The Alhambra Palace of the Eleventh Century." *Journal of the Warburg and Courtauld Institutes* 19 (1956), pp. 192–258.

Bargebuhr 1968
Frederick P. Bargebuhr, *The Alhambra: A Cycle of Studies on the Eleventh Century in Moorish Spain*. Berlin, 1968.

Basset and Terrasse 1926
Henri Basset and Henri Terrasse, "Sanctuaires et forteresses almohades: V, La chaire de la Kotobîya." *Hespéris* 6 (1926), pp. 168–207.

Basset and Terrasse 1932
Henri Basset and Henri Terrasse, *Sanctuaires et forteresses almohades*. Collection Hespéris, 5. Paris, 1932.

Bazzana et al. 1983
Andrés Bazzana et al., *La cerámica islámica en la ciudad de Valencia*. Vol. 1, *Catálogo*. Valencia, 1983.

Bazzana et al. 1988
Andrés Bazzana et al., *Les châteaux ruraux d'al-Andalus: histoire et archéologie des Husun du Sud-Est de l'Espagne*. Publications de la Casa de Velázquez, Archéologie, 11. Madrid, 1988.

Bazzana, Lemoine, and Picon 1986
Andrés Bazzana, C. Lemoine, and M. Picon, "Le problème de l'origine et de la difusion des céramiques dites califales: recherche préliminaire." In proceedings of *II Coloquio Internacional de Cerámica Medieval en el Mediterraneo Occidental, Toledo, 1981*, pp. 33–38. Madrid, 1986.

Beaumont 1885
Edouard de Beaumont, *Fleur des belles épées*. Paris, 1885.

Beaumont 1975
J. H. L. Beaumont, "Petrus Alfonsus: An Examination of His Works, Their Scientific Content, and Their Background." Doctoral diss., Oxford University, 1975.

Beckwith 1960
John Beckwith, *Caskets from Cordoba*. Victoria and Albert Museum. London, 1960. Reprinted in Beckwith 1989, pp. 194–265.

Beckwith 1989
John Beckwith, *Studies in Byzantine and Medieval Western Art*. London, 1989.

Bell 1969
R. C. Bell, *Board and Table Games from Many Civilizations*. Vol. 2. London, 1969.

Berlin 1979
Staatliche Museen Preussischer Kulturbesitz. *Museum für Islamische Kunst: Katalog 1979*. 2d ed. Berlin-Dahlem, 1979.

Berlin 1989
Martin-Gropius-Bau. *Europa und der Orient, 800–1900*, exh. cat. Berlin, 1989.

Bermúdez López 1987a
Jesús Bermúdez López, *La Alhambra y el Generalife*. Madrid, 1987.

Bermúdez López 1987b
Jesús Bermúdez López, "Notas sobre la traza urbana de la Alhambra: sus calles principales." In *Actas del II Congreso de Arqueología Medieval Española, Madrid, 1987*, vol. 2, pp. 443–50. Madrid, 1987.

Bermúdez López 1989
Jesús Bermúdez López, "Crónica arqueológica." *Cuadernos de la Alhambra* 25 (1989), pp. 163–67.

Bermúdez Pareja 1955
Jesús Bermúdez Pareja, "Excavaciones en la Plaza de los Aljibes de la Alhambra." *Al-Andalus* 20 (1955), pp. 436–52.

Bermúdez Pareja 1965
Jesús Bermúdez Pareja, "El Generalife después del incendio de 1958." *Cuadernos de la Alhambra* 1 (1965), pp. 9–40.

Bermúdez Pareja 1966
Jesús Bermúdez Pareja, "Techo cupular del mirador de la Torre de las Damas." *Cuadernos de la Alhambra* 2 (1966), pp. 129–30, pls. XLV, XLVI.

Bermúdez Pareja 1972
Jesús Bermúdez Pareja, "Los postigos de la cerca de la Alhambra de Granada." In *Homenaje al Profesor Carriazo*, vol. 2, pp. 57–66. Sevilla, 1972.

Bermúdez Pareja 1977a
Jesús Bermúdez Pareja, *El Partal y la Alhambra Alta*. Granada, 1977.

Bermúdez Pareja 1977b
Jesús Bermúdez Pareja, "El gran zócalo del Mexuar de la Alhambra." In *España entre el Mediterraneo y el Atlántico: Actas del XXIII Congreso Internacional de Historia del Arte, Granada 1973*, vol. 2, pp. 57–61. Granada, 1977.

Bernis 1954
Carmen Bernis, "Tapicería hispano-musulmana (siglos IX–XI)." *Archivo Español de Arte* 27, no. 107 (1954), pp. 189–211.

Bernis 1956a
Carmen Bernis, "Tapicería hispano-musulmana (siglos XIII–XIV)." *Archivo Español de Arte* 29, no. 114 (1956), pp. 95–115.

Bernis 1956b
Carmen Bernis, *Tapicería hispano-musulmana (siglos XIII–XIV)*. Madrid, 1956.

Bernis 1979
Carmen Bernis, *Trajes y modas en la España de los Reyes Católicos*. Vol. 2, *Los hombres*. Artes y artistas. Madrid, 1979.

Bernis 1982
 Carmen Bernis, "Las pinturas de la Sala
 de los Reyes de la Alhambra: los asuntos,
 los trajes, la fecha." *Cuadernos de la
 Alhambra* 18 (1982), pp. 21–50.
Berti 1987
 Graziella Berti, "Notizie su bacini ceramici
 di chiese di Pisa." *Faenza* 73 (1987),
 pp. 5–13, pls. I–III.
Berti and Mannoni 1990
 Graziella Berti and T. Mannoni, "Rivesti-
 menti vetrosi e argillosi su ceramiche
 medievali e risulato emersi da ricerche
 archeologiche e analisi chimiche e minera-
 logiche." In *Scienza in Archeologia*,
 pp. 98–118. Florence, 1990.
Berti and Tongiorgi 1981
 Graziella Berti and Liana Tongiorgi, *I
 bacini ceramici medievali delle chiese di
 Pisa.* Quaderni di cultura materiale, 3.
 Rome, 1981.
Berti and Torre 1983
 Graziella Berti and Paola Torre, *Arte
 islamica in Italia: i bacini delle chiese
 pisane.* Pisa, 1983.
Berti, Rosselló Bordoy, and Tongiorgi 1986
 Graziella Berti, G. Rosselló Bordoy, and
 Ezio Tongiorgi, "Alcuni bacini ceramici di
 Pisa e la corrispondente produzione di
 Maiorca nel secolo XI." *Archeologia
 Medievale* 13 (1986), pp. 97–115.
Berti, Tongiorgi, and Tongiorgi 1983
 Graziella Berti, Liana Tongiorgi, and Ezio
 Tongiorgi, "I bacini delle chiese di Pisa."
 In *Arte islamica in Italia: i bacini delle
 chiese pisane*, pp. 33–64, exh. cat. Rome,
 Museo Nazionale d'Arte Orientale. Pisa,
 1983.
Bienes Calvo 1987
 Juan Bienes Calvo, "Introducción al estudio
 de la cerámica musulmana en la ciudad de
 Tudela." *Turiaso* 7 (1987), pp. 115–58.
Blake 1986
 Hugo Blake, "The Ceramic Hoard from
 Pula (Prov. Cagliari) and the Pula Type of
 Spanish Lustreware." In proceedings of
 *II Coloquio Internacional de Cerámica
 Medieval en el Mediterraneo Occidental,
 Toledo, 1981*, pp. 365–405. Madrid, 1986.
Blochet 1926
 Edgard Blochet, *Les enluminures des
 manuscrits orientaux—turcs, arabes,
 persans—de la Bibliothèque Nationale.*
 Paris, 1926.
Bloom 1989
 Jonathan Bloom, *Minaret: Symbol of
 Islam.* Oxford Studies in Islamic Art, 7.
 Oxford, 1989.
Bolens 1990
 Lucie Bolens, *La cuisine andalouse, un art
 de vivre: XIe–XIIIe siècle.* Paris, 1990.
Bosch Vilá 1959
 Jacinto Bosch Vilá, *Albarracín musulmán:
 el reino de Taifas de los Beni Razín, hasta
 la constitución del señorío cristiano.*
 Vol. 2, part 1 of *Historia de Albarracín y

su Sierra*, edited by Martín Almagro.
 Teruel, 1959.
Bosch Vilá 1984
 Jacinto Bosch Vilá, *Historia de Sevilla: la
 Sevilla islámica, 712–1248.* Seville, 1984.
Bourouiba 1973
 Rachid Bourouiba, *L'art religieux
 musulman en Algérie.* Algiers, 1973.
Brentjes 1981
 Burchard Brentjes, *Die Stadt des Yima.
 Weltbilder in der Architektur.* Leipzig, 1981.
Brethes [1939]
 J. D. Brethes, *Contributions à l'histoire
 du Maroc par les recherches numis-
 matiques: monnaies inédites ou très rares
 de notre collection.* Casablanca [1939].
Brieux and Maddison, forthcoming
 Alain Brieux and Francis Maddison,
 *Repertoire des facteurs d'astrolabes et
 de leurs oeuvres.* C.N.R.S. Paris,
 forthcoming.
Brisch 1961
 Klaus Brisch, "Zu einer Gruppe von
 islamischen Kapitellen und Basen des 11.
 Jahrhunderts in Toledo." *Madrider
 Mitteilungen* 2 (1961), pp. 205–15.
Brisch 1965
 Klaus Brisch, "Zum Bāb al-Wuzarāʾ
 (Puerta de San Esteban) der Hauptmoschee
 von Córdoba." In *Studies in Islamic Art
 and Architecture in Honour of Professor
 K. A. C. Creswell*, compiled by Charles
 Geddes et al., pp. 30–48. Cairo, 1965.
Brisch 1966
 Klaus Brisch, *Die Fenstergitter und ver-
 wandte Ornamente der Hauptmoschee
 von Córdoba: Eine Untersuchung zur
 spanisch-islamischen Ornamentik.*
 Madrider Forschungen, 4. Berlin, 1966.
Brisch 1979
 Klaus Brisch, "Kuppeldach." In *Museum
 für Islamische Kunst: Katalog 1979*,
 no. 654. 2d ed. Staatliche Museen
 Preussischer Kulturbesitz. Berlin-Dahlem,
 1979.
Brisch 1979–81
 Klaus Brisch, "Sobre un grupo de capiteles
 y basas islámicas del siglo XI de Toledo."
 Cuadernos de la Alhambra 15–17 (1979–
 81), pp. 156–64.
Brisch 1983
 Klaus Brisch, "Kuppeldach aus dem Aus-
 sichtsturm des Torre de las Damas (Damen-
 turm)." In pamphlets 808a and 808b,
 Museum für Islamische Kunst, Staatliche
 Museen Preussischer Kulturbesitz.
 Berlin–Dahlem, 1983.
Bulliet 1979
 Richard W. Bulliet, *Conversion to Islam
 in the Medieval Period: An Essay in Quan-
 titative History.* Cambridge, Mass., and
 London, 1979.
Burckhardt 1972
 Titus Burckhardt, *Moorish Culture in
 Spain.* Translated by Alisa Jaffa. New
 York and Toronto, 1972.

Burckhardt 1985
 Titus Burckhardt, *La civilización hispano-
 árabe.* Madrid, 1985.
Burgos 1990
 Catedral de Burgos. *Las edades del
 hombre*, exh. cat. Burgos, 1990.
Buttin 1960
 François Buttin, "Les adargues de Fès."
 Hespéris-Tamuda 1 (1960), pp. 409–55.
Caballero Zoreda 1977–78
 Luis Caballero Zoreda, "La 'forma en
 herradura' hasta el siglo VIII, y los arcos
 de herradura de la iglesia visigoda de
 Santa María de Melque." *Archivo Español
 de Arqueología* 50–51 (1977–78),
 pp. 323–74.
Caballero Zoreda and Mateo Sagasta 1988
 Luis Caballero Zoreda and A. Mateo Sagasta,
 "Atalayas musulmanas en la provincia de
 Soria." *Arevacón* 14 (1988), pp. 9–15.
Caballero Zoreda and Mateo Sagasta 1990
 Luis Caballero Zoreda and A. Mateo
 Sagasta, "El grupo de atalayas de la Sierra
 de Madrid." In *Madrid del siglo IX al XI*,
 pp. 65–77. Madrid, 1990.
Cabanelas Rodríguez 1965
 Darío Cabanelas Rodríguez, *El morisco
 granadino Alonso del Castillo.* Granada,
 1965.
Cabanelas Rodríguez 1988a
 Darío Cabanelas Rodríguez, "La Madraza
 árabe de Granada y su suerte en época
 cristiana." *Cuadernos de la Alhambra* 24
 (1988), pp. 29–54.
Cabanelas Rodríguez 1988b
 Darío Cabanelas Rodríguez, *El techo
 del Salón de Comares en la Alhambra:
 decoración, policromía, simbolismo y
 etimología.* Granada, 1988.
Cabanelas Rodríguez and Fernández-Puertas
1974–75
 Darío Cabanelas Rodríguez and Antonio
 Fernández-Puertas, "Inscripciones poéticas
 del Partal y de la fachada de Comares."
 Cuadernos de la Alhambra 10–11 (1974–
 75), pp. 117–200.
Cabanelas Rodríguez and Fernández-Puertas
1978
 Darío Cabanelas Rodríguez and Antonio
 Fernández-Puertas, "Las inscripciones
 poéticas del Generalife." *Cuadernos de
 la Alhambra* 14 (1978), pp. 3–86.
Cabañero Subiza 1985
 Bernabé Cabañero Subiza, "De las cuevas
 a los primeros castillos de piedra: algunos
 problemas del orígen de la castellología
 altomedieval en el norte peninsular."
 Turiaso 6 (1985), pp. 167–88.
Cabañero Subiza 1991
 Bernabé Cabañero Subiza, "La defensa del
 Reino de Pamplona-Nájera en el siglo X:
 materiales para el estudio de la evolución
 de sus castillos." *La marche supérieure
 d'al-Andalus et l'occident chrétien*,
 pp. 99–114. Publications de la Casa de
 Velázquez, Archéologie, 15. Madrid, 1991.

Caiger-Smith 1973
 Alan Caiger-Smith, *Tin-Glaze Pottery in Europe and the Islamic World: The Tradition of 1000 Years in Maiolica, Faience, and Delftware*. London, 1973.
Caiger-Smith 1985
 Alan Caiger-Smith, *Lustre Pottery: Technique, Tradition, and Innovation in Islam and the Western World*. London and Boston, 1985.
Caillé 1954
 Jacques Caillé, *La mosquée de Ḥassān à Rabat*. Paris, 1954.
Calvo and Rivero 1925
 I. Calvo and C. M. del Rivero, *Catálogo-guía de las colecciones de monedas y medallas expuestas al público en el Museo Arqueológico Nacional*. Madrid, 1925.
Calvo Labarta 1991
 Emilia Calvo Labarta, "Instrumentos astronómicos universales en al-Andalus—la *Risālat al-ṣafīḥa al-ŷāmiʿa li-ŷamīʾ al-urūḍ*: Tratado sobre la lámina general para todas las latitudes de Ibn Bāṣo m. 716 H/1316 J.C." Doctoral diss., Universitat de Barcelona, 1991.
Camps Cazorla 1943
 Emilio Camps Cazorla. *La cerámica medieval española*. Madrid, 1943.
Camps Cazorla 1947
 Emilio Camps Cazorla, "Cerámica y vidrios califales de Medina Az-Zahrāʾ (Córdoba)." In *Adquisiciones del Museo Arqueológico Nacional (1940–1945)*, pp. 148–54. Madrid, 1947.
Camps Cazorla 1953
 Emilio Camps Cazorla, *Módulo, proporciones y composición en la arquitectura califal cordobesa*. Madrid, 1953.
Casamar 1961
 Manuel Casamar, "Fragmentos de jarrones malagueños en los museos de El Cairo." *Al-Andalus* 26 (1961), pp. 185–90.
Casamar 1980–81
 Manuel Casamar, "Lozas de cuerda seca con figuras de pavones en los museos de Málaga y de El Cairo." *Mainake* 2–3 (1980–81), pp. 203–9.
Casamar 1981
 Manuel Casamar, *Cerámica medieval española*. Madrid, 1981.
Casamar and Valdés Fernández 1984
 Manuel Casamar and Fernando Valdés Fernández, "Origen y desarrollo de la técnica de cuerda seca en la Península Ibérica y en el Norte de Africa durante el siglo XI." *Al-Qantara* 5 (1984), pp. 383–404.
Catálogo 1982–1986
 Catálogo de las obras restauradas, 1982–1986. Instituto de Conservación y Restauración de Bienes Culturales, Dirección General de Bellas Artes, Ministerio de Cultura. Madrid, 1989.
Cerulli 1949
 Enrico Cerulli, *Il 'Libro della Scala' e la questione della fonti arabo-spagnole della 'Divina Commedia.'* Studi e Testi, 150. Vatican City, 1949.
Chabbouh 1989
 I. Chabbouh, *Al-Makhṭūt*. Tunis, 1989.
Chalmeta Gendrón 1967
 Pedro Chalmeta Gendrón, "El *Kitāb fī Ādāb al-Ḥisba* (Libro del Buen Gobierno del Zoco) de al-Saqaṭī." *Al-Andalus* 32 (1967), pp. 151–53.
Codera y Zaidín 1879
 Francisco Codera y Zaidín, *Tratado de numismática arábigo-española*. Madrid, 1879.
Códice Rico
 "Códice Rico de las Cantigas de Santa María." Biblioteca del Monasterio de San Lorenzo de El Escorial. Ms. T.I.1.
Cohen 1970
 Hayyim J. Cohen, "The Economic Background and the Secular Occupations of Muslim Jurisprudents and Traditionists in the Classical Period of Islam (Until the Middle of the Eleventh Century)." *Journal of the Economic and Social History of the Orient* 13 (1970), pp. 26–28, 40.
Colbert 1962
 Edward P. Colbert, *The Martyrs of Córdoba (850–859): A Study of the Sources*. Studies in Mediaeval History, n.s. 17. Washington, D.C., 1962.
Collantes de Terán and Zozaya 1972
 F. Y. Collantes de Terán and Juan Zozaya, "Excavaciones en el palacio almohade de la Buhayra." *Noticiario Arqueológico Hispánico* 1 (1972), pp. 223–59.
Conde 1844
 José Antonio Conde, *Historia de la dominación de los árabes en España sacada de varios manuscritos y memorias arábigas*. 3 vols. Barcelona, 1844.
Conde 1874
 José Antonio Conde, *Historia de la dominación de los árabes en España*. 3 vols. Madrid, 1874.
Continente 1969
 J. M. Continente, "Abū Marwān al-Ŷazīrī, poeta ʿamiri." *Al-Andalus* 34 (1969), pp. 123–41.
Contreras 1878
 Rafael Contreras, *Estudio descriptivo de los monumentos árabes de Granada, Sevilla y Córdoba o sea la Alhambra, el Alcázar y la Gran Mezquita de Occidente*. 2d ed. Madrid, 1878.
Coomaraswamy 1964
 Ananda K. Coomaraswamy, *The Arts and Crafts of India and Ceylon*. Reprint. New York, 1964.
Córdoba 1986a
 La mezquita de Córdoba: siglos XI al XIII, exh. cat. Consejería de Cultura de la Junta de Andalucía. Córdoba, 1986.
Córdoba 1986b
 Palacio de la Merced, *Maimónides y su época*, exh. cat. Ministerio de Cultura de la Junta de Andalucía. Córdoba, 1986.
Costa 1989
 G. Costa, *Saint Sernin de Toulouse: trésors et métamorphoses*, exh. cat. Musée Saint-Raymond. Toulouse, 1989.
Cott 1939
 Perry B. Cott, *Siculo-Arabic Ivories*. Princeton Monographs in Art and Archaeology, Folio Series, 3. Princeton, N.J., 1939.
Cressier, Riera Frau, and Rosselló Bordoy
 Patrice Cressier, María Magdalena Riera Frau, and G. Rosselló Bordoy, "La cerámica tarde-almohade y los orígenes de la cerámica nasrí." In proceedings of *IV Congreso Internacional de Cerámica Medieval del Mediterraneo Occidental, Lisboa, 1987*. Forthcoming.
Creswell 1940a
 K. A. C. Creswell, "The Great Mosque of Cordova." In *Early Muslim Architecture: Umayyads, Early ʿAbbāsids and Ṭūlūnids*. Part 2, *Early ʿAbbāsids, Umayyads of Cordova, Aghlabids, Ṭūlūnids, and Samānids*, A.D. 751–905, pp. 138–61. Edited by K. A. C. Creswell. Oxford, 1940.
Creswell 1940b
 K. A. C. Creswell, "The Great Mosque of Qairawan—II." In *Early Muslim Architecture: Umayyads, Early ʿAbbāsids and Ṭūlūnids*. Part 2, *Early ʿAbbāsids, Umayyads of Cordova, Aghlabids, Ṭūlūnids, and Samānids*, A.D. 751–905, pp. 309–20. Edited by K. A. C. Creswell. Oxford, 1940.
Creswell 1969
 K. A. C. Creswell, "The Works of al-Walīd." In *Early Muslim Architecture: Umayyads*, A.D. 622–750. 2d ed. Vol. 1, part 1, pp. 142–96. Oxford, 1969.
Critchlow 1974
 Keith Critchlow, *Islamic Patterns: An Analytical and Cosmological Approach*. London, 1974. Reprint. New York, 1976 and 1983.
Cutler 1985
 Anthony Cutler, *The Craft of Ivory: Sources, Techniques, and Uses in the Mediterranean World*, A.D. 200–1400. Dumbarton Oaks Byzantine Collection Publications, 8. Washington, D.C., 1985.
Cutler 1987
 Anthony Cutler, "Prolegomena to the Craft of Ivory Carving in Late Antiquity and the Early Middle Ages." In *Artistes, artisans et production artistique au Moyen Age*. Vol. 2, *Commande et travail*, edited by Xavier Barral i Altet, pp. 431–77. Paris, 1987.
Dallière-Benelhadj 1983
 V. Dallière-Benelhadj, "Le château en al-Andalus: un problème de terminologie." In *Habitats fortifiés et organisations de l'espace en Méditerranée médiévale*, pp. 63–68. Proceedings of the round-table discussion, Lyons, May 4–5, 1982. Edited by A. Bazzana et al. Lyons, 1983.

Dalton 1901
O. M. Dalton, *Catalogue of Early Christian Antiquities and Objects from the Christian East in the Department of British and Mediaeval Antiquities of the British Museum*. London, 1901.

Dalton 1907
O. M. Dalton, "Notes." *Proceedings of the Society of Antiquaries* 21 (1907), pp. 375–80.

Davillier 1879
Jean Ch. Davillier, *Recherches sur l'orfévrerie en Espagne au Moyen Age et à la Renaissance*. Paris, 1879.

Day 1954
Florence E. Day, "The Inscription of the Boston 'Baghdad' Silk: A Note on Method in Epigraphy." *Ars Orientalis* 1 (1954), pp. 191–94.

Delgado Valero 1987
Clara Delgado Valero, *Toledo islámico: ciudad, arte e historia*. Toledo, 1987.

Déroche 1985
François Déroche, *Catalogue des manuscrits arabes*. Part 2, *Manuscrits musulmans*. Vol. 1, sect. 2, *Les manuscrits du Coran du Maghreb à l'Insulinde*. Bibliothèque Nationale. Paris, 1985.

Destombes 1958
Marcel Destombes, "Un globe céleste arabe du XIIᵉ siècle." *Comptes rendus de l'Académie des Inscriptions et Belles Lettres*, pp. 300–313. Paris, 1958. Reprinted in Destombes 1987, pp. 91–104.

Destombes 1960
Marcel Destombes, "Les chiffres coufiques des instruments astronomiques arabes." *Physis* 2 (1960), pp. 197–210. Reprinted in Destombes 1987, pp. 127–40.

Destombes 1987
Marcel Destombes, *Marcel Destombes (1905–1983): Selected Contributions to the History of Cartography and Scientific Instruments*. Edited by Günter Schilder, Peter van der Krogt, and Steven de Clercq. Utrecht and Paris, 1987.

Diccionario 1968–69
Germán Bleiberg, ed., *Diccionario de Historia de España*. 2d ed. 3 vols. Madrid, 1968–69.

Dickie 1968
James Dickie, "The Hispano-Arab Garden: Its Philosophy and Function." *Bulletin of the School of Oriental and African Studies* 31 (1968), pp. 237–48.

Dickie 1976
James Dickie, "The Islamic Garden in Spain." In *The Islamic Garden*, edited by Elisabeth B. Macdougall and Richard Ettinghausen, pp. 89–105. Dumbarton Oaks Colloquium on the History of Landscape Architecture, 4. Washington, D.C., 1976.

Dickie 1981
James Dickie, "The Alhambra: Some Reflections Prompted by a Recent Study by Oleg Grabar." In *Studia Arabica et Islamica: Festschrift for Iḥsān ʿAbbās on His Sixtieth Birthday*, edited by Wadād al-Qāḍī, pp. 127–49. Beirut, 1981.

Díez-Coronel i Montull 1963–65
Luis Díez-Coronel i Montull, "Una antigua torre-atalaya en el castillo de la Rápita." *Ilerda* 27–28 (1963–65), pp. 81–97.

Dimand 1963–64
Maurice S. Dimand, "Two Fifteenth Century Hispano-Moresque Rugs." *Metropolitan Museum of Art Bulletin*, n.s. 22 (1963–64), pp. 341–52.

Dimand and Mailey 1973
Maurice S. Dimand and Jean Mailey, *Oriental Rugs in The Metropolitan Museum of Art*. New York, 1973.

Dodds 1982
Jerrilynn D. Dodds, "Aḥmad Ibn Bāso." In *Macmillan Encyclopedia of Architects*, edited by Adolf K. Placzek, vol. 1, p. 38. New York, 1982.

Dodds 1990
Jerrilynn D. Dodds, *Architecture and Ideology in Early Medieval Spain*. University Park, Pa., and London, 1990.

Domínguez Perela 1981
Enríque Domínguez Perela, "Los capiteles hispanomusulmanes del Museo Lázaro Galdiano." *Goya* 163 (1981), pp. 2–11.

Domínguez Perela 1987
Enríque Domínguez Perela, "Acetres hispanomusulmanes." *Iconica* 8 (1987), pp. 3–13.

Dozy 1845
R. P. A. Dozy, *Dictionnaire détaillé des noms des vêtements chez les Arabes*. 1845. Reprint. Beirut [1969].

Dozy 1932
R. Dozy, *Histoire des musulmans d'Espagne jusqu'à la conquête de l'Andalousie par les Almoravides (710–1110)*. New edition, revised and updated by E. Lévi-Provençal. 3 vols. Leiden, 1932.

Dozy 1961
R. Dozy, ed., *Le Calendrier de Cordoue*. Edited and translated by Charles Pellat. Medieval Iberian Peninsula Texts and Studies, 1. Leiden, 1961.

Düsseldorf 1973
Düsseldorf, Hetjens-Museum. *Islamische Keramik*, exh. cat. Düsseldorf, 1973.

Dyer 1979
Mark Dyer, "Central Saharan Trade in the Early Islamic Centuries (7th–9th Centuries)." Typescript, 1979.

Ellis 1988
Charles Grant Ellis, *Oriental Carpets in the Philadelphia Museum of Art*. Philadelphia, 1988.

Elsberg and Guest 1934
Herman A. Elsberg and Rhuvon Guest, "Another Silk Fabric Woven at Bagdad." *The Burlington Magazine* 64 (1934), pp. 270–72.

Esco and Sénac 1987
Carlos Esco and Philippe Sénac, "La muralla árabe de Huesca." In *Actas del II Congreso de Arqueología Medieval Española, Madrid, 1987*, vol. 2, pp. 590–601. Madrid, 1987.

Esco, Giralt, and Sénac 1988
Carlos Esco, Josep Giralt, and Philippe Sénac, *Arqueología islámica en la Marca Superior de Al-Andalus*. Huesca, 1988.

Ettinghausen 1950
Richard Ettinghausen, *Studies in Muslim Iconography: I, The Unicorn*. Freer Gallery of Art Occasional Papers, 1, 3. Washington, D.C., 1950.

Ettinghausen 1954
Richard Ettinghausen, "Notes on the Lusterware of Spain." *Ars Orientalis* 1 (1954), pp. 133–56. Reprinted in Ettinghausen 1984, pp. 545–78.

Ettinghausen 1959
Richard Ettinghausen, "Near Eastern Book Covers and Their Influence on European Bindings: A Report on the Exhibition 'History of Bookbinding' at the Baltimore Museum of Art, 1957–58." *Ars Orientalis* 3 (1959), pp. 113–31. Reprinted in Ettinghausen 1984, pp. 1121–60.

Ettinghausen 1962
Richard Ettinghausen, *Arab Painting*. Geneva, 1962.

Ettinghausen 1984
Richard Ettinghausen, *Islamic Art and Archaeology: Collected Papers*. Compiled and edited by Myriam Rosen-Ayalon. Berlin, 1984.

Ettinghausen and Grabar 1987
Richard Ettinghausen and Oleg Grabar, *The Art and Architecture of Islam: 650–1250*. Harmondsworth, G.B., 1987.

Eulogius of Córdoba
S. Eulogius, *Sancti Eulogii, archiepiscopi toletani et martyris, memorialis sanctorum, libri III*. In *Patrologia Latina* [q.v.], vol. 115, cols. 731–818.

Ewert 1966
Christian Ewert, "Spanisch-islamische Systeme sich kreuzender Bögen: II, Die Arkaturen eines offenen Pavillons auf der Alcazaba von Málaga." *Madrider Mitteilungen* 7 (1966), pp. 232–53.

Ewert 1968
Christian Ewert, *Spanisch-islamische Systeme sich kreuzender Bögen*. Vol. 1, *Die senkrechten ebenen Systeme sich kreuzender Bögen als Stützkonstruktionen der vier Rippenkuppeln in der ehemaligen Hauptmoschee von Córdoba*. Madrider Forschungen, 2. Berlin, 1968.

Ewert 1971
Christian Ewert, *Islamische Funde in Balaguer und die Aljafería in Zaragoza*. With contributions by Dorothea Duda and Gisela Kircher. Madrider Forschungen, 7. Berlin, 1971.

Ewert 1977a

Christian Ewert, "Die Moschee am Bāb al-Mardūm in Toledo: Eine 'Kopie' der Moschee von Córdoba." *Madrider Mitteilungen* 18 (1977), pp. 287–354.

Ewert 1977b
Christian Ewert, "Tradiciones omeyas en la arquitectura palatina de la época de los Taifas: la Aljafería de Zaragoza." In *España entre el Mediterraneo y el Atlántico: Actas del XXIII Congreso Internacional de Historia del Arte*, vol. 2, pp. 62–75. Granada, 1977.

Ewert 1978–80
Christian Ewert, *Spanisch-islamische Systeme sich kreuzender Bögen: III, Die Aljafería in Zaragoza*. Parts 1 and 2. Madrider Forschungen, 12. Berlin, 1978 and 1980.

Ewert 1979–80
Christian Ewert, *Hallazgos islámicos en Balaguer y la Aljafería de Zaragoza*. With contributions by Dorothea Duda and Gisela Kircher. Excavaciones Arqueológicas en España, 97. Madrid, 1979–80.

Ewert 1986
Christian Ewert, "The Mosque of Tinmal (Morocco) and Some New Aspects of Islamic Architectural Typology." *Proceedings of the British Academy* 72 (1986), pp. 116–48.

Ewert 1987
Christian Ewert, "Elementos decorativos en los tableros parietales del Salón Rico." *Cuadernos de Madīnat al-Zahrā'* 1 (1987), pp. 27–60.

Ewert and Wisshak 1981
Christian Ewert and Jens-Peter Wisshak, *Forschungen zur almohadischen Moschee*. Vol. 1, *Vorstufen: Hierarchische Gliederungen westislamischer Betsäle des 8. bis 11. Jahrhunderts: Die Hauptmoscheen von Qairawān und Córdoba und ihr Bannkreis*. Madrider Beiträge, 9. Mainz, 1981.

Ewert and Wisshak 1984
Christian Ewert and Jens-Peter Wisshak, *Forschungen zur almohadischen Moschee*. Vol. 2, *Die Moschee von Tinmal (Marokko)*. Madrider Beiträge, 10. Mainz, 1984.

Ewert and Wisshak 1987
Christian Ewert and Jens-Peter Wisshak, "Forschungen zur almohadischen Moschee: III, Die Qaṣba-Moschee in Marrakesch." *Madrider Mitteilungen* 28 (1987), pp. 179–210.

Falke 1922
Otto van Falke, *Decorative Silks*. New York, 1922.

Farmer 1938
H. G. Farmer, "Ziryab." In *Encyclopaedia of Islam: A Dictionary of the Geography, Ethnography, and Biography of the Muhammadan Peoples*, supplement, pp. 266–67. Leiden, 1938.

Fehérvári 1976
Géza Fehérvári, *Islamic Metalwork of the Eighth to the Fifteenth Century in the Keir Collection*. London, 1976.

Fernández-Ladreda Aguade 1983
Clara Fernández-Ladreda Aguade, "La arqueta de Leyre." In *La arqueta de Leyre y otras esculturas medievales de Navarra*, exh. cat., pp. 4–17. Diputación Foral de Navarra. Madrid, 1983.

Fernández-Puertas 1975
Antonio Fernández-Puertas, "El lazo de ocho occidental o Andaluz: su trazado, canon proporcional, series y patrones." *Al-Andalus* 40 (1975), pp. 199–203.

Fernández-Puertas 1977
Antonio Fernández-Puertas, "En torno a la cronología de la Torre de Abūl-l-Ḥayŷŷâŷ." In *España entre el Mediterraneo y el Atlántico: actas del XXIII Congreso Internacional de Historia del Arte*, vol. 2, pp. 76–88. Granada, 1977.

Fernández-Puertas 1980
Antonio Fernández-Puertas, *La fachada del Palacio de Comares: situación, función y génesis*. Granada, 1980.

Fernández-Puertas 1982
Antonio Fernández-Puertas, "Memoria de la excavación realizada en el sector N. del Mexuar del Palacio de Comares." *Cuadernos de la Alhambra* 18 (1982), pp. 231–38.

Fernández Vega 1935
Pilar Fernández Vega, "Dagas granadinas." *Anuario del Cuerpo Facultativo de Archiveros, Bibliotecarios y Arqueólogos* 3 (1935), pp. 359–71.

Fernández y González 1875a
Francisco Fernández y González, "Espadas hispano-árabes." In *Museo Español de Antigüedades*, vol. 5, pp. 389–400. Madrid, 1875.

Fernández y González 1875b
Francisco Fernández y González, "Pinturas sobre materiales textiles con aplicación a insignias cortesanas y militares. Tiraz de Hixem II. Enseña del Miramamolin Muḥammad An-Nāṣir en la batalla de las Navas." In *Museo Español de Antigüedades*, vol. 6, pp. 463–75. Madrid, 1875.

Ferrandis 1928
José Ferrandis, *Marfiles y azabaches españoles*. Barcelona and Buenos Aires, 1928.

Ferrandis 1935
José Ferrandis, *Marfiles árabes de Occidente*. Vol. 1. Madrid, 1935.

Ferrandis 1940
José Ferrandis, *Marfiles árabes de Occidente*. Vol. 2. Madrid, 1940.

Ferrandis Torres 1925
José Ferrandis Torres, "Los vasos de la Alhambra." *Boletín de la Sociedad Española de Excursiones* 33 (1925), pp. 47–77.

Ferrandis Torres 1933
José Ferrandis Torres, *Exposición de alfombras antiguas españolas*. Madrid, 1933.

Ferrandis Torres 1940
José Ferrandis Torres, "Muebles hispano-árabes de taracea." *Al-Andalus* 5 (1940), pp. 459–65.

Ferrandis Torres 1942
José Ferrandis Torres, "Alfombras hispano-moriscas 'tipo Holbein'." *Archivo Español de Arte* 15 (1942), pp. 103–11.

Ferrandis Torres 1943
José Ferrandis Torres, "Espadas granadinas de la jineta." *Archivo Español de Arte* 16 (1943), pp. 142–66.

Finster 1970–71
Barbara Finster, "Die Mosaiken der Umayyadenmoschee von Damaskus." *Kunst des Orients* 7 (1970–71), pp. 82–141.

Fité i Llevot 1984–85
Francesc Fité i Llevot, "El lot de peces d'escacs de cristall de roca del Museu Diocesà de Lleida, procedents del tresor de la col.legiata d'Ager (segle XI)." *Acta Historica et Archaeologica Mediaevalia* 5–6 (1984–85), pp. 281–312.

Florence 1954
Museo di Storia della Scienza, *Catalogo degli strumenti del Museo di Storia della Scienza*. Florence, 1954.

Florence 1987
Istituto e Museo di Storia della Scienza, *L'età di Galileo: il secolo d'oro della scienza in Toscana*, exh. cat. Edited by M. Miniati. Florence, 1987.

Flores Escobosa 1988
Isabel Flores Escobosa, *Estudio preliminar sobre loza azul y dorada nazarí de la Alhambra*. Madrid, 1988.

Folch i Torres 1922
Joaquim Folch i Torres, *La venda dels Terns de Sant Valeri i Sant Vicenç i la Mancomunitat*. Barcelona, 1922.

Folsach 1990
Kjeld von Folsach, *Islamic Art: The David Collection*. Copenhagen, 1990.

Frankfurt 1985
Museum für Kunsthandwerk, *Türkische Kunst und Kultur aus osmanischer Zeit*, exh. cat. 2d ed. 2 vols. Recklinghausen, 1985.

Franz 1958
Heinrich G. Franz, "Die ehemalige Moschee in Córdoba und die zweigeschossige Bogenordnung in der maurischen Architektur." *Spanische Forschungen der Görresgesellschaft*. 1st series, *Gesammelte Aufsätze zur Kulturgeschichte Spaniens* 13 (1958), pp. 171–87.

Frothingham 1951
Alice Wilson Frothingham, *Lustreware of Spain*. New York, 1951.

Gaborit-Chopin 1978
Danielle Gaborit-Chopin, *Ivoires du Moyen Age*. Fribourg, 1978.

Gaborit-Chopin 1984
Danielle Gaborit-Chopin, "Lamp or Perfume-Burner in Shape of Domed Building." In *The Treasury of San Marco*,

Venice, exh. cat., pp. 237–43. The Metropolitan Museum of Art, New York. Milan, 1984.

Gallego y Burín 1961
Antonio Gallego y Burín, *Granada: guía artística e histórica de la ciudad.* Madrid, 1961.

Gallego y Burín 1963
Antonio Gallego y Burín, *La Alhambra.* Granada, 1963.

García Franco 1945
Salvador García Franco, *Catálogo crítico de astrolabios existentes en España.* Madrid, 1945.

García Fuentes 1969
José Mª. García Fuentes, "Las armas hispanomusulmanas al final de la reconquista." *Chronica Nova* 3 (1969), pp. 7–38.

García Gómez 1967a
Emilio García Gómez, "Armas, banderas, tiendas de campaña, monturas de correos en los *Anales de al-Ḥakam II, por ʿĪsà [b. Ahmad al-]Rāzī." *Al-Andalus* 32 (1967), pp. 163–79.

García Gómez 1967b
Emilio García Gómez, ed. and trans., *El Califato de Córdoba en el 'Muqtabis' de Ibn Hayyān: anales palatinos del califa de Córdoba al-Hakam II, por ʿĪsā Ibn Ahmad al-Rāzī (360–364 H.= 971–975 J.C.).* Madrid, 1967.

García Gómez 1970
Emilio García Gómez, "Tejidos, ropas y tapicería en los *Anales de al-Hakam II por ʿĪsà Rāzī." *Boletín de la Real Academia de la Historia* 156 (1970), pp. 43–53.

García Gómez 1985
Emilio García Gómez, ed. and trans., *Poemas árabes en los muros y fuentes de la Alhambra.* Madrid, 1985.

García Gómez 1988
Emilio García Gómez, *Foco de antigua luz sobre la Alhambra desde un texto de Ibn al-Jaṭīb en 1362.* Madrid, 1988.

García Gómez and Bermúdez Pareja 1967
Emilio García Gómez and Jesús Bermúdez Pareja, *The Alhambra: The Royal Palace.* Granada and Florence, 1967.

García Guatas and Esteban 1986
M. García Guatas and J. F. Esteban, "Noticia sobre el hallazgo de un tejido musulmán." *Antigrama* 3 (1986), pp. 29–34.

Gaya Nuño 1932
Juan Antonio Gaya Nuño, "La torre árabe de Noviercas (Soria)." *Archivo Español de Arte y Arqueología* 8 (1932), pp. 219–23.

Gaya Nuño 1935
Juan Antonio Gaya Nuño, "Restos de construcciones musulmanas en Mezquetillas y Fuentearmegil (Soria)." *Al-Andalus* 3 (1935), pp. 151–55.

Gaya Nuño 1943
Juan Antonio Gaya Nuño, "Gormaz, castillo califal." *Al-Andalus* 8 (1943), pp. 431–50.

Gaya Nuño 1952
Juan Antonio Gaya Nuño, "Toponimia y arqueología sorianas: el estrato árabe." *Celtiberia* 4 (1952), pp. 239–54.

Gaya Nuño n.d.
Juan Antonio Gaya Nuño, *Guías artísticas de España: Burgos.* Barcelona, n.d.

Geijer 1963
Agnes Geijer, "Some Thoughts on the Problems of Early Oriental Carpets." *Ars Orientalis* 5 (1963), pp. 79–87.

Gelfer-Jørgensen 1986
Mirjam Gelfer-Jørgensen, *Medieval Islamic Symbolism and the Paintings in the Cefalù Cathedral.* Leiden, 1986.

Geneva 1985
Musée Rath. *Trésors de l'Islam*, exh. cat. Geneva, 1985.

Gibbs and Saliba 1984
Sharon Gibbs and George Saliba, *Planispheric Astrolabes from the National Museum of American History.* Smithsonian Studies in History and Technology, 45. Washington, D.C., 1984.

Gibbs, Henderson, and de Solla Price 1973
Sharon Gibbs, Janice A. Henderson, and Derek de Solla Price, *A Computerized Checklist of Astrolabes.* New Haven, Conn., 1973.

Giralt 1991
Josep Giralt, "Fortificacions andalusines a la Marca Superior d'al-Andalus: aproximación a l'estudio de la zona nord del Districte de Lleida." In *La marche supérieure d'al-Andalus et l'occident chrétien*, pp. 67–76. Publications de la Casa de Velázquez, Archéologie, 15. Madrid, 1991.

Gisbert Santonja 1986
Josep Antoni Gisbert Santonja, "Arqueología árabe en la ciudad de Denia: estado de la cuestión y perspectivas de la investigación." In *Actas del I Congreso de Arqueología Medieval Española (Huesca, 1985)*, vol. 3, pp. 181–200. Huesca, 1986.

Glick 1979
Thomas F. Glick, *Islamic and Christian Spain in the Early Middle Ages.* Princeton, N.J., 1979.

Glick and Pi-Sunyer 1969
Thomas F. Glick and Oriol Pi-Sunyer, "Acculturation as an Explanatory Concept in Spanish History." *Comparative Studies in Society and History* 11 (1969), pp. 136–54.

Glück and Diez 1932
Heinrich Glück and Ernst Diez, *Arte de Islam.* Translated by Manuel Sánchez Sarto. Barcelona, 1932.

Goitein 1966
S. D. Goitein, *Studies in Islamic History and Institutions.* Leiden, 1966.

Goitein 1967
S. D. Goitein, *A Mediterranean Society: The Jewish Communities of the Arab World as Portrayed in the Documents of the Cairo Geniza.* Vol. 1, *Economic Foundations.* Berkeley and Los Angeles, 1967.

Goitein 1971
S. D. Goitein, *A Mediterranean Society: The Jewish Communities of the Arab World as Portrayed in the Documents of the Cairo Geniza.* Vol. 2, *The Community.* Berkeley, Los Angeles, and London, 1971.

Goitein 1978
S. D. Goitein, *A Mediterranean Society: The Jewish Communities of the Arab World as Portrayed in the Documents of the Cairo Geniza.* Vol. 3, *The Family.* Berkeley, Los Angeles, and London, 1978.

Goitein 1983
S. D. Goitein, *A Mediterranean Society: The Jewish Communities of the Arab World as Portrayed in the Documents of the Cairo Geniza.* Vol. 4, *Daily Life.* Berkeley, Los Angeles, and London, 1983.

Goitein 1988
S. D. Goitein, *A Mediterranean Society: The Jewish Communities of the Arab World as Portrayed in the Documents of the Cairo Geniza.* Vol. 5, *The Individual: Portrait of a Mediterranean Personality of the High Middle Ages as Reflected in the Cairo Geniza.* Berkeley, Los Angeles, and London, 1988.

Golombek 1988
Lisa Golombek, "The Draped Universe of Islam." In *Content and Context of Visual Arts in the Islamic World: Papers from a Colloquium in Memory of Richard Ettinghausen*, edited by Priscilla P. Soucek, pp. 25–39. University Park, Pa., and London, 1988.

Golvin 1966
L. Golvin, "Le Palais de Zīrī à Achîr (dixième siècle J.C.)." *Ars Orientalis* 6 (1966), pp. 47–76.

Gómez-Moreno 1906
Manuel Gómez-Moreno, "Excursión á través del arco de herradura." *Cultura Española*, no. 3 (1906), pp. 785–811.

Gómez-Moreno 1919
Manuel Gómez-Moreno, *Iglesias mozárabes: arte español de los siglos IX a XI.* Madrid, 1919.

Gómez-Moreno 1924
Manuel Gómez-Moreno, *Cerámica medieval española.* Barcelona, 1924.

Gómez-Moreno 1929
Manuel Gómez-Moreno, ed., *Exposición Internacional de Barcelona, 1929—el arte en España: guía del Museo del Palacio Nacional.* 3d ed. Barcelona, 1929.

Gómez-Moreno 1940
Manuel Gómez-Moreno, "El bastón del cardenal Cisneros." *Al-Andalus* 5 (1940), pp. 192–95.

Gómez-Moreno 1941
Manuel Gómez-Moreno, "Capiteles árabes documentados." *Al-Andalus* 6 (1941), pp. 422–27.

Gómez-Moreno 1946
Manuel Gómez-Moreno, *El Panteón Real de las Huelgas de Burgos.* Madrid, 1946.

Gómez-Moreno 1948
Manuel Gómez-Moreno, "Preseas Reales Sevillanas (San Fernando, Doña Beatriz y Alfonso el Sabio en sus tumbas)." *Archivo Hispalense* 2d ser., 9, nos. 27–32 (1948), pp. 191–204.

Gómez-Moreno 1951
Manuel Gómez-Moreno, *El arte árabe español hasta los Almohades, arte mozárabe*. Ars Hispaniae, 3. Madrid, 1951.

Gómez-Moreno 1966
Manuel Gómez-Moreno, "Granada en el siglo XIII." *Cuadernos de la Alhambra* 2 (1966), pp. 3–41.

Gómez-Moreno González 1888
Manuel Gómez-Moreno González, *Medina Elvira*. Granada, 1888.

Gómez-Moreno González 1892
Manuel Gómez-Moreno González, *Guía de Granada*. 2 vols. 1892. Reprint. Granada, 1982.

Gonzalez 1985
Valérie Gonzalez, "L'émallerie cloisonée dans al-Andalus." *Revue de l'Occident Musulman et de la Méditerranée* 40 (1985), pp. 55–74.

Gonzalez 1990
Valérie Gonzalez, "Les collections d'oeuvres d'art du métal émaillé hispano-musulman dans les musées mondiaux hors d'Espagne." *Sharq al-Andalus* 7 (1990), pp. 195–202.

Grabar 1959
Oleg Grabar, "The Ummayad Dome of the Rock in Jerusalem." *Ars Orientalis* 3 (1959), pp. 33–62.

Grabar 1968
André Grabar, *Christian Iconography: A Study of Its Origins*. Princeton, N.J., 1968.

Grabar 1976
Oleg Grabar, *Studies in Medieval Islamic Art*. London, 1976.

Grabar 1978
Oleg Grabar, *The Alhambra*. London, 1978. Spanish ed., *La Alhambra: iconografía, formas y valores*. Madrid 1980.

Grabar 1987
Oleg Grabar, *The Formation of Islamic Art*. Rev. and enl. ed. New Haven and London, 1987.

Grabar 1988
Oleg Grabar, "Notes sur le *mihrab* de la Grande Mosquée de Cordoue." In *Le mihrab dans l'architecture et la religion musulmanes: Actes du colloque international: Formes symboliques et formes esthétiques dans l'architecture religieuse musulmane: le mihrab, Paris, 1980*, edited by Alexandre Papadopoulo, pp. 115–22. Leiden and New York, 1988.

Gratz 1924
Emil Gratz, *Islamische Bucheinbände des 14. bis 19. Jahrhunderts aus den Handschriften der Bayerischen Staatsbibliothek*. Leipzig, 1924.

Grohmann 1938
Adolph Grohmann, "Ṭirāz." In *Encyclopaedia of Islam: A Dictionary of the Geography, Ethnography, and Biography of the Muhammadan Peoples*, supplement, pp. 248–50. Leiden, 1938.

Grube 1976
Ernst J. Grube, *Islamic Pottery of the Eighth to the Fifteenth Century in the Keir Collection*. London, 1976.

Gudiol i Cunill 1913
José Segun Gudiol i Cunill, "Lo sepulchre de Sant Bernat Calvó, bisbe de Vich." In proceedings of *Congrés d'Historia de la Corona d'Aragón*, vol. 2, pp. 964–77. Barcelona, 1913.

Guichard 1977
Pierre Guichard, *Structures sociales "orientales" et "occidentales" dans l'Espagne musulmane*. The Hague and Paris, 1977.

Guicherd 1956
Félix Guicherd, "Lampas hispano-mauresque núm. 31.167." Archives du Centre International d'Etude des Textiles Anciens, Lyons, 1956. Typescript.

Guicherd 1958
Félix Guicherd, "Taqueté de soierie façonnée núm. 30.411-1." Archives du Centre International d'Etude des Textiles Anciens, Lyons, 1958. Typescript.

Gunther 1932
R. T. Gunther, *The Astrolabes of the World*. 2 vols. 1932. Reprint. London, 1976.

Gutiérrez Lloret 1988
Sonia Gutiérrez Lloret, *Cerámica común paleoandalusí del sur de Alicante (siglos VII–X)*. Alicante, 1988.

Hadj-Sadok 1971
M. Hadj-Sadok, "Ibn-Marzūḳ." In *Encyclopaedia of Islam*, 2d ed., vol. 3, pp. 865–68. Leiden, 1971.

Hamarneh 1962
Sami Hamarneh, "The Rise of Professional Pharmacy in Islam." *Medical History* 6 (1962), pp. 59–66.

Hamarneh 1965
Sami Hamarneh, "The First Known Independent Treatise on Cosmetology in Spain." *Bulletin of the History of Medicine* 39 (1965), pp. 309–25.

Harmuth 1983
Egon Harmuth, "Eine arabische Armbrust." *Waffen- und Kostümkunde* 25 (1983), pp. 141–44.

Hartner 1939
Willy Hartner, "The Principle and Use of the Astrolabe." In *A Survey of Persian Art*, edited by Arthur Upham Pope, vol. 3, pp. 2530–54. London and New York, 1939. Reprinted in Hartner 1968, pp. 287–311.

Hartner 1960
Willy Hartner, "Asturlab." In *Encyclopaedia of Islam*. 2d ed. Vol. 1, pp. 722–28. Leiden, 1960. Reprinted in Hartner 1968, pp. 312–18.

Hartner 1968
Willy Hartner, *Oriens-Occidens*. Hildesheim, 1968.

Hassar-Benslimane et al. 1982
Joudia Hassar-Benslimane, Christian Ewert, Abdelaziz Touri, and Jens-Peter Wisshak, "Tinmal 1981: Grabungen in der almohadischen Moschee." *Madrider Mitteilungen* 23 (1982), pp. 440–66.

Hasson 1987
Rachel Hasson, *Early Islamic Jewellery*, exh. cat., translated by R. Grafman. L. A. Mayer Memorial Institute for Islamic Art. Jerusalem, 1987.

Hazard 1952
Harry W. Hazard, *The Numismatic History of Late Medieval North Africa*. The American Numismatic Society, Numismatic Studies, 8. New York, 1952.

Hennezel 1930
Henri d'Hennezel, *Les tissus d'art*. Paris, 1930.

Hermosilla 1983
V. Hermosilla, *Monasterio de S. Millán de la Cogolla: un siglo de historia agustiniana, 1878–1978*. Rome, 1983.

Hernández 1930
Félix Hernández, "Un aspecto de la influencia del arte califal en Cataluña (basas y capiteles del siglo XI)." *Archivo Español de Arte y Arqueología* 6 (1930), pp. 21–49.

Hernández 1940
Félix Hernández, "The Alcazaba of Mérida: 220 H. (835)." In *Early Muslim Architecture: Umayyads, Early ʿAbbāsids and Ṭūlūnids*. Part 2, *Early ʿAbbāsids, Umayyads of Cordova, Aghlabids, Ṭūlūnids and Samānids, A.D. 751–905*, pp. 197–207. Edited by K. A. C. Creswell. Oxford, 1940.

Hernández Jiménez 1959
Félix Hernández Jiménez, "El almimbar móvil del siglo X de la mezquita de Córdoba." *Al-Andalus* 24 (1959), pp. 381–99.

Hernández Jiménez 1965
Felix Hernández Jiménez, "El convencional espinazo montañoso, de orientación Este-Oeste, que los geógrafos árabes atribuyen a la Península Ibérica." *Al-Andalus* 30 (1965), pp. 201–75.

Hernández Jiménez 1985
Félix Hernández Jiménez, *Madīnat al-Zahrāʾ: arquitectura y decoración*. Granada, 1985.

Herrero Carretero 1988
Concha Herrero Carretero, *Museo de telas medievales: Monasterio de Santa María la Real de Huelgas*. Madrid, 1988.

Hever Castle Collection 1983
Sotheby Parke Bernet, *The Hever Castle Collection, the Property of the Lord Astor of Hever*, sale cat. Part 1, *Arms and Armour*. London, 1983.

Hildburgh 1941
W. L. Hildburgh, "A Hispano-Arabic

Silver-Gilt and Crystal Casket." *The Antiquaries Journal* 21 (1941), pp. 211–31.

Hispanic Society of America 1954
Hispanic Society of America, *A History of the Hispanic Society of America, Museum and Library, 1904–1954, with a Survey of the Collections*. New York, 1954.

Historia Silense
Justo Pérez de Urbel and Atilano Gonzáles Ruiz-Zorrilla, eds., *Historia Silense*. Madrid, 1959.

Hodges and Whitehouse 1983
Richard Hodges and David Whitehouse, *Mohammed, Charlemagne and the Origins of Europe: Archaeology and the Pirenne Thesis*. London, 1983.

Huart 1908
Cl. Huart, *Les calligraphes et les miniaturistes de l'orient musulman*. Paris, 1908.

Huici Miranda 1917
Ambrosio Huici Miranda, ed. and trans., *El Anónimo de Madrid y Copenhague*. Valencia, 1917. *See also* Huici Miranda 1953, and Ibn ʿIdhari.

Huici Miranda 1953
Ambrosio Huici Miranda, ed. and trans., *Colección de crónicas árabes de la Reconquista*. Vol. 2, *Al-Bayān al-Mugrib fī Ijtiṣār Ajbār Muluk al-Andalus wa al Magrib por Ibn ʿIdārī al-Marrākušī: I. Los Almohades*. Tétouan, 1953.

Hurtado de Mendoza 1979
Diego Hurtado de Mendoza, *Guerra de Granada* [1627]. Edited by Bernardo Blanco-González. Madrid, 1979.

Ibn al-Zubayr 1959
Al-Qāḍī al-Rashīd ibn al-Zubayr, *Kitāb al-Dhakhāʾir waʾl-Tuḥaf*, edited by Muḥammad Hamidullah. Kuwait, 1959.

Ibn Gabirol 1978
Selomo Ibn Gabirol, *Poesía secular*. Edited and translated by Elena Romero. Madrid, 1978.

Ibn Ḥawqāl 1971
Abu al-Qasim Muhammad Ibn Ḥawqāl, *Configuración del mundo [Kitab Surat al-ard]*. Translated by María José Romani Suay. Textos Medievales, 26. Valencia, 1971.

Ibn Ḥayyān 1974
Ibn Ḥayyān de Córdoba [Abū Marwān Ḥayyān ibn Khalaf ibn Ḥayyān], *Al-Muqtabas min ʾanbʿa-ahli al-Andalus*. Edited by ʿAli Maki. Beirut, 1974.

Ibn Ḥayyān 1981
Ibn Ḥayyān de Córdoba [Abū Marwān Ḥayyān ibn Khalaf ibn Ḥayyān], *Crónica del califa Abdarrahman III an-Nāṣir entre los años 912 y 942 (al-Muqtabas V) [Muqtabis fī akhbār balad al-Andalus]*. Translated, with notes and indices, by María Jesús Viguera and Federico Corriente. Textos Medievales, 64. Saragossa, 1981.

Ibn Ḥazm 1982
Abū Muḥammad ʿAli ibn Ḥazm, *Ṭawq al-Ḥamāmah*. Edited by Faruq Saad. Beirut, 1982.

Ibn Hudhayl 1977
ʿAli ibn-ʿAbd-al Raḥmān Ibn Hudhayl, *Gala de caballeros, blasón de paladines*. Translated and edited by María Jesús Viguera. Madrid, 1977.

Ibn ʿIdhārī 1901–4
Ibn ʿIdhārī al-Marrākushī, *Histoire de l'Afrique et de l'Espagne intitulée Al-Bayano'l-mogrib*. Translated and annotated by E. Fagnan. Algiers, 1901–4.

Ibn ʿIdhārī 1948
Ibn ʿIdhārī al-Marrākushī, *Al-Bayān al-Mughrib*, edited by G. S. Colin and E. Lévi-Provençal. 2 vols. Leiden, 1948.

Ibn Khaldūn 1967
Ibn Khaldūn, *The Muqqadimah: An Introduction to History*. 2d ed. 3 vols. Translated by Franz Rosenthal. Bollingen series, 43. Princeton, N.J., 1967.

Ibn Khaldūn 1982
Ibn Khaldūn, *Histoire des Berbères et des dynasties musulmanes de l'Afrique septentrionale*. Translation of *Kitāb al-ʿibar* by M. de Slane. New edition under the direction of P. Casanour. 4 vols. Paris, 1982.

Ibn Ṣāḥib al-Ṣalāh 1965
ʿAbd al-Malik ibn Muḥammad ibn Ṣāḥib al-Ṣalāh, *Tāʾrij al-Mann bi-l-imāma ʿalā al mustaḍʿafīn*. Edited by ʿAbd al-Hadi Al-Tazi. Beirut, 1965. Spanish translation by Ambrosio Huici Miranda. Textos Medievales, 24. Valencia, 1969.

Iglesias Costa 1980
Manuel Iglesias Costa, *Roda de Isábena*. SCIC Monografías de Estudios Pirenaicos, 108. Jaca, 1980.

Imamuddin 1981
S. M. Imamuddin, *Muslim Spain, 711–1492 A.D.: A Sociological Study*. Medieval Iberian Peninsula Texts and Studies, 2. Leiden, 1981.

Iñiguez Almech 1934
Francisco Iñiguez Almech, "La Torre de Doña Urraca en Covarrubias (Burgos)." *Anuario del Cuerpo Facultativo de Archiveros, Bibliotecarios y Arqueólogos* 1 (1934), pp. 403–7.

Irving 1991
Washington Irving, *Bracebridge Hall, Tales of a Traveller, The Alhambra*. Edited by Herbert F. Smith et al. The Library of America, 52. New York, 1991.

Al-Jaznāʾī 1923
Abū-l-Ḥasan ʿAlī al-Jaznāʾī. *Jany zahrat al-ʿās fī bināʾ madīnat Fās (la fleure de myrte), traitant de la fondation de la ville de Fès*. Translated and annotated by A. Bel. Algiers, 1923.

Jenkins 1975
Marilyn Jenkins [Ivory plaque, acc. no. 13.141]. *Metropolitan Museum of Art Bulletin* n.s., 33 (1975), p. 9.

Jenkins 1978
Marilyn Jenkins, "New Evidence for the Possible Provenance and Fate of the So-Called Pisa Griffin." *Islamic Archaeological Studies* 1 (1978), pp. 79–85. Cairo, 1982.

Jenkins 1983
Marilyn Jenkins, ed., *Islamic Art in the Kuwait National Museum: The al-Sabah Collection*. London, 1983.

Jenkins 1988
Marilyn Jenkins, "Fatimid Jewelry, Its Subtypes and Influences." *Ars Orientalis* 18 (1988), pp. 39–57.

Jenkins and Keene 1982
Marilyn Jenkins and Manuel Keene, *Islamic Jewelry in The Metropolitan Museum of Art*. New York, 1982.

Jomard 1862
Edme F. Jomard, *Les monuments de la géographie*. Paris, 1862.

Jorge Aragoneses 1966
Manuel Jorge Aragoneses, *Museo de la muralla árabe de Murcia*. Madrid, 1966.

Karatay 1951
Fehmi Edhem Karatay, *Istanbul Üniversitesi Kütüphanesi Arapça Yazmalar Katalogu*. Vol. 1, fasc. 1, *Kuranlar ve Kurani Ilimler*. Istanbul, 1951.

Karatay 1962
Fehmi Edhem Karatay, *Topkapi Sarayi Müzesi Kütüphanesi Arapça Yazmalar Katalogu*. Vol. 1, *Kurʾan, Kurʾan ilimleri, Tefsirler, No. 1-2171*. Istanbul, 1962.

Kazhdan et al. 1991
Alexander P. Kazhdan et al., eds., *The Oxford Dictionary of Byzantium*. 3 vols. New York and Oxford, 1991.

King 1979
David A. King, "On the Early History of the Universal Astrolabe in Islamic Astronomy, and the Origin of the Term 'Shakkāziya' in Medieval Scientific Arabic." *Journal for the History of Arabic Science* 3 (1979), pp. 244–57. Reprinted in King 1987.

King 1987
David A. King, *Islamic Astronomical Instruments*. London 1987.

King 1990a
David A. King, "Science in the Service of Religion: The Case of Islam." *Impact of Science on Society* (UNESCO) 40 (1990), pp. 245–62. Reprinted in King 1992.

King 1990b
David A. King, "Strumentazione astronomica nel mondo medievale islamico." In *Gli strumenti*, edited by Gerard L'Estrange Turner, pp. 154–89, 581–85. Milan, 1990.

King 1992
David A. King, *Astronomy in the Service of Islam*. Aldershot, G.B., 1992.

King forthcoming
David A. King, *A Catalogue of Medieval Instruments: Astrolabes, Quadrants, and Sundials*. Forthcoming.

Kirchner 1988
Helena Kirchner, "Las técnicas y los conjuntos documentales: 1, La cerámica." In Miquel Barceló et al., *Arqueología medieval: en las afueras del medievalismo*, pp. 88–133. Barcelona, 1988.

Kirchner 1990
Helena Kirchner, *Etude des céramiques islamiques de Shadhfilah*. Lyons, 1990.

Krafft and Scriba 1989
F. Krafft and C. J. Scriba, eds., *Science and Political Order / Wissenschaft und Staat: Proceedings of the Symposium of the XVIII International Congress of History of Science at Hamburg-Munich, 1.–9. August 1989*. Bochum, 1989.

Kramarovskii 1985
M. G. Kramarovskii, "Serebro Levanta i khudozhestvennyi metall Severnogo Prichernomorya XIII-XV vekov (po materialam Kryma i Kavkaza [Levantine silver and metalworking of the northern Black Sea region, XIII-XV (based on material from the Crimea and Caucasus)]." In *Khudozhestvennye pamyatniki i problemy kultury Vostoka: sbornik statei*, pp. 152–80. Leningrad, 1985.

Kramrisch 1946
Stella Kramrisch, *The Hindu Temple*. 2 vols. Calcutta, 1946.

Krautheimer 1969
Richard Krautheimer, "Introduction to an 'Iconography of Medieval Architecture'." In *Studies in Early Christian, Medieval, and Renaissance Art*, pp. 115–50. New York and London, 1969.

Kroeber 1940
A. L. Kroeber, "Stimulus Diffusion." *American Anthropologist* n.s. 42 (1940), pp. 1–20.

Kühnel 1924
Ernst Kühnel, *Maurische Kunst*. Die Kunst des Ostens, 9. Berlin, 1924.

Kühnel 1928
Ernst Kühnel, "Omayadische Kapitelle aus Cordova." *Berliner Museen: Berichte aus den Preussischen Kunstsammlungen* 49 (1928), pp. 82–86.

Kühnel 1957
Ernst Kühnel, "Abbasid Silks of the Ninth Century." *Ars Orientalis* 2 (1957), pp. 367–71.

Kühnel 1960
Ernst Kühnel, "Antike und Orient als Quellen der spanisch-islamischen Kunst." *Madrider Mitteilungen* 1 (1960), pp. 174–81, pls. 52–57.

Kühnel 1963
Ernst Kühnel, *Islamische Kleinkunst*. 2d ed. Brunswick, 1963.

Kühnel 1971
Ernst Kühnel, *Die islamischen Elfenbeinskulpturen, VIII.–XIII. Jahrhundert*. Berlin, 1971.

Kühnel 1972
Ernst Kühnel, *Islamische Schriftkunst*. 2d ed. Graz, 1972.

Kühnel and Bellinger 1953
Ernst Kühnel and Louisa Bellinger, *Catalogue of Spanish Rugs: 12th Century to 19th Century*. The Textile Museum. Washington, D.C., 1953.

Kurz 1975
Otto Kurz, "The Strange History of an Alhambra Vase." *Al-Andalus* 45 (1975), pp. 205–12.

Labarta and Barceló 1987
A. Labarta and C. Barceló, "Las fuentes árabes sobre al-Zahrāʾ: estado de la cuestión." *Cuadernos de Madīnat al-Zahrāʾ* 1 (1987), pp. 93–106.

Lafuente and Zozaya 1977
Jaime Lafuente and Juan Zozaya, "Algunas observaciones sobre el castillo de Trujillo." In *España entre el Mediterraneo y el Atlántico: actas del XXIII Congreso Internacional de Historia del Arte*, vol. 2, pp. 119–27. Granada, 1977.

Lafuente y Alcántara 1859
Emilio Lafuente y Alcántara, *Inscripciones árabes de Granada, precedidas de una reseña histórica y de la genealogía detallada de los reyes Alahmares*. Madrid, 1859.

Laking 1921
Guy Francis Laking, *A Record of European Armour and Arms Through Seven Centuries*. Vol. 2. London, 1921.

Lamm 1937
Carl Johan Lamm, *Cotton in Mediaeval Textiles of the Near East*. Paris, 1937.

Lane 1947
Arthur Lane, *Early Islamic Pottery: Mesopotamia, Egypt, and Persia*. London, 1947.

Larrén 1989
Hortensia Larrén, "Apuntes para el estudio del sistema defensivo del Tajo: Oreja, Alarilla y Alboer." *Boletín de Arqueología Medieval* 2 (1989), pp. 87–93.

Lázaro López 1970
Agustín Lázaro López, "Découverte de deux riches étoffes dans l'eglise paroissiale d'Oña [Burgos]." *Bulletin de Liaison du Centre International d'Etude des Textiles Anciens* 31 (1970), pp. 21–25.

Lekvinadze 1959
V. A. Lekvinadze, "O drevneishikh oboronitel'nykh sooruzheniakh Arkheopolisa-Nokalakevi [About Ancient Fortificacions at Archaeopolis-Nokalakevi]." *Sovetskaya Arkheologiya* 3 (1959), pp. 144–58.

Lerma 1986
J. V. Lerma, "El Islamismo: cerámica y artes industriales." In *Historia del arte valenciano*, vol. 1, pp. 225–45. Valencia, 1986.

Lerma and Barceló 1985
J. V. Lerma and C. Barceló, "Arqueología urbana en Valencia: una jarrita con texto poético." *Sharq al-Andalus* 2 (1985), pp. 175–81.

Lerma, Miralles, and Soler 1986
J. V. Lerma, I. Miralles, and María Paz Soler, "Cerámicas musulmanas de 'El Tossalet de Sant Esteve' Valencia." In proceedings of *II Coloquio Internacional de Cerámica Medieval en el Mediterraneo Occidental, Toledo, 1981*, pp. 155–63. Madrid, 1986.

Levi della Vida 1935
Giorgio Levi della Vida, *Elenco dei manoscritti arabi islamici della Biblioteca Vaticana: Vaticani, Barberiniani, Borgiani, Rossiani*. Studi e Testi, 67. Vatican City, 1935.

Lévi-Provençal 1925
E. Lévi-Provençal, "Un nouveau texte d'histoire mérinide: Le *Musnad* d'Ibn Marzūḳ." *Hespéris* 5 (1925), pp. 1–82.

Lévi-Provençal 1931
E. Lévi-Provençal, *Inscriptions arabes d'Espagne*. Leiden and Paris, 1931.

Lévi-Provençal 1932
E. Lévi-Provençal, *L'Espagne musulmane au Xème siècle: institutions et vie sociale*. Paris, 1932.

Lévi-Provençal 1950
E. Lévi-Provençal, *Histoire de l'Espagne musulmane*. Vol. 1, *La Conquête et l'émirat hispano-umaiyade (710–912)*. Paris, 1950.

Lévi-Provençal 1951
E. Lévi-Provençal, *Conférences sur l'Espagne musulmane prononcées à la Faculté des Lettres en 1947 et 1948*. Publications de la Faculté des Lettres de l'Université Farouk Ier d'Alexandrie. Cairo, 1951.

Lévi-Provençal 1953
E. Lévi-Provençal, *Histoire de l'Espagne musulmane*. Vol. 3, *Le siècle du califat de Cordoue*. Paris, 1953.

Lévi-Provençal and García Gómez 1980
E. Lévi-Provençal (Ob. 1956) and Emilio García Gómez, eds. and trans., *El siglo XI en la persona: las "Memorias" de ʿAbd Allāh, último Rey Zīrí de Granada, destronado por los Almorávides (1090)*. Madrid, 1980.

Lewis 1937
Ethel Lewis, *The Romance of Textiles: The Story of Design in Weaving*. New York, 1937. Spanish ed., *La novelesca historia de los tejidos*. Madrid, 1958.

Libro de los Juegos
"Libro de los Juegos." Bibliotéca del Monasterio de San Lorenzo de El Escorial. Ms. T.1.6.

Lings 1976
Martin Lings, *The Quranic Art of Calligraphy and Illumination*. London, 1976.

Lings and Safadi 1976
Martin Lings and Yasin Hamid Safadi, *The Qurʾan*, exh. cat. The British Library. London, 1976.

Linton Collection 1980
Etienne Libert & Alain Castor and Alain Brieux, *Leonard Linton Collection: Scientific Instruments / Rare Books*, sale cat. Paris, 1980.

Lister and Lister 1987
 Florence C. Lister and Robert H. Lister, *Andalusian Ceramics in Spain and New Spain: A Cultural Register from the Third Century B.C. to 1700.* Tucson, Ariz., 1987.
Lladonosa i Pujol 1979
 Josep Lladonosa i Pujol, "Documents i notes del registre d'Actes Capitulars de la Catedral de Lleida (1498–1512) sobre ornaments, draps imperials i orfebreria de la Seu Antiga." In *VIIè Centenari de la Consacració de la Séu Vella*, special issue of *Ilerda*, no. 40 (1979).
Lledó Carrascosa 1986
 Rocío Lledó Carrascosa, "*Risala* sobre los palacios abbadíes de Sevilla, de Abu Ŷaʿfar Ibn Aḥmad de Denia: traducción y estudio." *Sharq al-Andalus* 3 (1986), pp. 191–200.
Llubiá 1973
 Luís M. Llubiá, *Cerámica medieval española.* 2d ed. [reprint of 1968 ed.] Barcelona, 1973.
Llull Martínez de Bedoya et al. 1987
 Pilar Llull Martínez de Bedoya et al., "Un itinerario musulmán de ataque a la frontera castellana en el siglo X: fortalezas, castillos y atalayas entre Medinaceli y San Esteban de Gormaz." *Castillos de España* 93 (1987), pp. 3–14.
Lombard 1978
 Maurice Lombard, *Études d'économie médiévale III: les textiles dans le monde musulman de VIIᵉ au XIIᵉ siècle.* Civilizations et sociétés, 61. Paris, The Hague, and New York, 1978.
London 1976
 Hayward Gallery. *The Arts of Islam*, exh. cat. London, 1976.
London 1983
 Hayward Gallery. *The Eastern Carpet in the Western World from the 15th to the 17th Century*, exh. cat. London, 1983.
López-Cuervo 1985
 Serafín López-Cuervo, *Medina az-Zahrāʾ: ingeniería y formas.* Madrid 1985.
López Ibor and Pan de Soraluce [1984]
 M. López Ibor and L. Pan de Soraluce, "Restos del Manto de Fernando III." In *Alfonso X*, exh. cat. Museo de Santa Cruz, Toledo. [Madrid, 1984].
Mackie 1972
 Louise W. Mackie, *Weaving Through Spanish History, 13th Through 17th centuries*, exh. cat. Washington Textile Museum. Washington, D.C., 1972.
Mackie 1977
 Louise W. Mackie, "Two Remarkable Fifteenth Century Carpets from Spain." *Textile Museum Journal* 4, no. 4 (1977), pp. 15–32.
Mackie 1979
 Louise W. Mackie, "Native and Foreign Influences in Carpets Woven in Spain During the 15th Century." *Hali* 2 (1979), pp. 88–95.

Maddison and Brieux forthcoming
 Francis Maddison and Alain Brieux, *Repertoire des facteurs d'astrolabes et de leurs œuvres.* C.N.R.S. Paris. Forthcoming.
Madrid 1893a
 Exposición Histórico-Europea, 1892 a 1893: catálogo general, exh. cat. Madrid, 1893.
Madrid 1893b
 La joyas de la Exposición Histórico-Europea de Madrid, 1892, exh. cat. 2 vols. Madrid, 1893.
Madrid 1966
 Casón del Buen Retiro. *Cerámica española de la prehistoria a nuestros días*, exh. cat. Madrid, 1966.
Madrid 1987
 Real Academia de Bellas Artes de San Fernando. *130 años de arqueología madrileña*, exh. cat. Madrid, 1987.
Madrid 1989
 La ciudad hispanoamericana: el sueño de un órden, exh. cat. Madrid, 1989.
Maindron 1890
 G. R. Maindron, *Les armes.* Paris, 1890.
Mann 1933
 James G. Mann, "Notes on the Armour Worn in Spain from the Tenth to the Fifteenth Century." *Archaeologia* 83 (1933), pp. 285–305.
Mann 1961
 J. Mann, *Exhibition of Spanish Royal Armour in the Tower of London*, exh. cat. London, 1961.
Mantilla de los Ríos and Yravedra 1972
 S. Mantilla de los Ríos and M. Yravedra, "Conservación y restauración de las vestiduras pontificales del arzobispo español Rodrigo Ximénez de Rada, siglo XIII." *Informes y trabajos del Instituto de Conservación y Restauración de Obras de Arte* [Madrid] 12 (1972), pp. 51–84.
Al-Maqqarī 1840–43
 Aḥmad ibn Moḥammed al-Maqqarī, *The History of the Mohammedan Dynasties in Spain Extracted from the Nafḥu-t-ṭīb min Ghoṣni-l-andalusi-r-raṭṭīb wa tarikh lisānu-d-din ibni-l-khaṭṭīb.* 2 vols. Translated and with critical notes by Pascual de Gayangos. London, 1840–43.
Al-Maqqarī 1855–61
 Aḥmad ibn Moḥammed al-Maqqarī, *Analectes sur la histoire et la littérature des arabes d'Espagne*, ed. R. Dozy et al. 2 vols. 1855–61. Reprint. Amsterdam, 1967.
Marçais 1926
 Georges Marçais, *Manuel d'art musulman—l'architecture: Tunisie, Algérie, Maroc, Espagne, Sicile.* Vol. 1, *Du IXᵉ au XIIᵉ siècle.* Paris, 1926.
Marçais 1932
 Georges Marçais, "La chaire de la Grande Mosquée de Nédroma." *Revue africaine* (1932), special issue Cinquantenaire de la Faculté des Lettres d'Alger (1881–1931), pp. 321–31.

Marçais 1938
 Georges Marçais, "Remarques sur l'esthétique musulmane." *Annales de l'Institut d'Etudes Orientales* (Algiers) 4 (1938), pp. 55–71.
Marçais 1954
 Georges Marçais, *L'architecture musulmane d'Occident.* Paris, 1954.
Marçais 1957
 Georges Marçais, *Mélanges d'histoire et d'archéologie de l'occident musulman.* Vol. 1, *Articles et conférences de Georges Marçais.* Algiers, 1957.
Marçais and Poinssot 1948
 Georges Marçais and Louis Poinssot, *Objets Kairouanais, IXᵉ au XIIIᵉ siècle: reliures, verreries, cuivres et bronzes, bijoux.* Notes et Documents, 11, fasc. 2. Tunis, 1948.
Marcel 1839
 J. J. Marcel, "Notice sur un monument arabe conservé à Pise." *Journal Asiatique*, 3d ser., 7 (1839), pp. 81–88.
Mármol Carvajal 1600
 Luís del Mármol Carvajal, *Historia del rebelión y castigo de los moriscos del Reyno de Granada.* Ms. B Escor, L.I.13. Málaga 1600. Also in *Biblioteca de Autores Españoles* 21, pp. 125–365. Madrid, 1946.
Marschak 1986
 Boris Marschak, *Silberschätze des Orients: Metallkunst des 3.–13. Jahrhunderts und ihre Kontinuität.* Leipzig, 1986.
Martín et al. 1990
 M. D. Martín et al., *Las murallas de Sepúlveda (Segovia): un ensayo de aproximación con métodos arqueológicos a un ejemplo de pervivencia arquitectónica.* Segovia, 1990.
Martín i Ros 1986
 Rosa M. Martín i Ros, "Tomba de Sant Bernat Calbó: Teixit dit de Gilgamés." In *Catalunya Romanica*, vol. 3, *Osona II*, pp. 728–31. Barcelona, 1986.
Martín i Ros 1987
 Rosa M. Martín i Ros, "San Joan de las Abadesses: Teixit anomenat *Palli de les Bruixes*." In *Catalunya Romanica*, vol. 10, *El Ripollès*, pp. 399–402. Barcelona, 1987.
Martín i Ros forthcoming
 Rosa M. Martín i Ros, "El Tern de Sant Valeri." In *Actes del Congrès de la Séu Vella de Lleida, Secció d'Història de l'Art.* Estudi General de Lleida, Universitat de Barcelona. Forthcoming.
Martín i Ros and Calabuig i Alsina 1988
 Rosa M. Martín i Ros and Ferran Calabuig i Alsina, "Le voile huméral de Saint Eudald." *Bulletin du Centre International d'Etude des Textiles Anciens* no. 66 (1988), pp. 45–52.
Martínez Caviró 1983
 Balbina Martínez Caviró, *La loza dorada.* Madrid, 1983.
Martínez Lillo 1987
 Sergio Martínez Lillo, "Algunos aspectos

inéditos en la fortificación musulmana de Talavera de la Reina." In *Actas del II Congreso de Arqueología Medieval Española, Madrid, 1987*, vol. 2, pp. 199–205. Madrid, 1987.

Martiniani-Reber 1986
Marielle Martiniani-Reber, *Lyon, Musée Historique des Tissus: soireries sassanides, coptes et byzantines, Vc–XIc siècles*. Paris, 1986.

May 1941
Florence Lewis May, "The Single-Warp Knot in Spanish Rugs." *Notes Hispanic* 1 (1941), pp. 92–99.

May 1945
Florence Luis May, "Hispano-Moresque Rugs." *Notes Hispanic* 5 (1945), pp. 30–69.

May 1957
Florence Lewis May, *Silk Textiles of Spain: Eighth to Fifteenth Century*. New York, 1957.

Mayer 1956
Leo A. Mayer, *Islamic Astrolabists and Their Works*. Geneva, 1956.

Mehrez 1955
Gamal Mehrez, "Muṣḥaf mudhahhab min al-ʿaṣr al-Garnāṭī, bi-khizanat kutub al-faqīh al-sayyid Muḥammad bin Dawūd bi-Taṭwān." *Revista del Instituto Egipcio de Estudios Islámicos en Madrid* 3 (1955), pp. 141–47. Spanish synopsis, "Un Códice del Corán iluminado de la época nazarí, en la Biblioteca de Falsil Ahmen Ibn Daud, en Tetúan," pp. 114–15.

Melikian-Chirvani 1968
Assadullah Souren Melikian-Chirvani, "Le Griffon iranien de Pise: matériaux pour un corpus de l'argenterie et du bronze iraniens, III." *Kunst des Orients* 5 (1968), pp. 68–86.

Melikian-Chirvani 1982
Assadullah Souren Melikian-Chirvani, *Islamic Metalwork from the Iranian World, 8th–18th Centuries*. Victoria and Albert Museum catalogue. London, 1982.

Mendoza Eguaras, Sáez Pérez, and Santiago Simón 1982
Angela Mendoza Eguaras, Leovigildo Sáez Pérez, and Emilio de Santiago Simón, "La ballesta nazarí del Museo Arqueológico de Granada." *Cuadernos de la Alhambra* 18 (1982), pp. 179–82.

Menéndez-Pidal 1986
Gonzalo Menéndez Pidal, *La España del siglo XIII leída en imágenes*. Madrid, 1986.

Menéndez Pidal de Navascués 1983
Faustino Menéndez Pidal de Navascués, "Un notable monumento heráldico de principios del siglo XIII." In proceedings of *XV Congreso Internacional de las Ciencias Genealógica y Heráldica*. Instituto Salazar y Castro. Madrid, 1983.

Mergelina 1927
Cayetano de Mergelina, *Bobastro: memoria de las excavaciones realizadas en las Mesas de Villaverde-El Chorro (Málaga)*. Memorias de la Junta de Excavaciones y Antigüedades, 89. Madrid, 1927.

Mesquida 1989
M. Mesquida, *La cerámica de Paterna al segle XIII*. Paterna, Valencia, 1989.

Metropolitan Museum of Art 1987
The Metropolitan Museum of Art, *The Islamic World*. Introduction by Stuart Cary Welch. New York, 1987.

Meucci 1878
F. Meucci, *Il globo celeste arabico del secolo XI esistente nel Gabinetto degli Strumenti Antichi di Astronomia, di Fisica e di Matematica del R. Istituto di Studi Superiori*. Florence, 1878. Reprinted in Sezgin 1991, vol. 2, pp. 126–44, fold-out.

Meunié, Terrasse, and Deverdun 1957
Jacques Meunié, Henri Terrasse, and Gaston Deverdun, *Nouvelles recherches archéologiques à Marrakech*. Paris, 1957.

Michael 1973
The Poem of the Cid. Edited by Ian Michael. Manchester, 1973.

Migeon 1927
Gaston Migeon, *Manuel d'art musulman: arts plastiques et industrielles*. 2d ed. 2 vols. Paris, 1927.

Miles 1950
George C. Miles, *The Coinage of the Umayyads of Spain*. Part 1. The American Numismatic Society, Hispanic Numismatic Series, 1. New York, 1950.

Miles 1954
George C. Miles, *Coins of the Spanish Mulūk al-Ṭawāʾif*. The American Numismatic Society, Hispanic Numismatic Series, 3. New York, 1954.

Millás Vallicrosa 1932
José M. Millás Vallicrosa, "Estudios sobre Azarquiel: el tratado de la azafea." *Archeion* 14 (1932), pp. 392–419.

Millás Vallicrosa 1937
José M. Millás Vallicrosa, "The Work of Petrus Alfonsus" [in Hebrew]. *Tarbiz* 9 (1937), pp. 55–64.

Millás Vallicrosa 1943–50
José M. Millás Vallicrosa, *Estudios sobre Azarquiel*. Madrid and Granada, 1943–50.

Millás Vallicrosa 1944
José M. Millás Vallicrosa, "Un ejemplar de azafea árabe de Azarquiel." *Al-Andalus* 9 (1944), pp. 111–19.

Millás Vallicrosa 1949
José M. Millás Vallicrosa, *Estudios sobre historia de la ciencia española*. Barcelona, 1949.

Miquel 1967–88
André Miquel, *La géographie humaine du monde musulmane jusqu'au milieu du XIc siècle*. 4 vols. Paris, 1967–88.

Monneret de Villard 1935
Ugo Monneret de Villard, *La Nubia medievale*. 2 vols. Cairo, 1935.

Monneret de Villard 1938
Ugo Monneret de Villard, *Monumenti dell'arte musulmana in Italia: I, La cassetta incrostata della Capella Palatina di Palermo*. Rome, 1938.

Monneret de Villard 1941
Ugo Monneret de Villard, "Un codice arabo-spagnolo con miniature." *La Bibliofilia* 43 (1941), pp. 209–33.

Montêquin 1982
François Auguste de Montêquin, *Classicisme et anti-classicisme andalous: les motifs décoratifs végétaux dans l'Islam occidental sous les dynasties berbères, almoravide et almohade*. Nouadhibou [Mauretania], 1982.

Montêquin 1985
François Auguste de Montêquin, "Persistance et diffusion de l'esthétique de l'Espagne musulmane en l'Afrique du Nord." *The Maghreb Review* 10, no. 4 (1985), pp. 88–100.

Monteverde 1949
J. L. Monteverde, "El Museo de Telas Medievales del Real Monasterio de las Huelgas." *Boletín de la Comisión Provincial de Monumentos y de la Institución Fernán González* 27 (1949).

Moreno Menayo 1987
María Teresa Moreno Menayo, "Los jardines y alcázares musulmanes de la Buhayra (Sevilla)." In *Actas del II Congreso de Arqueología Medieval Española, Madrid, 1987*, vol. 3, pp. 43–51. Madrid, 1987.

Moritz 1905
Bernhard Moritz, ed., *Arabic Palaeography: A Collection of Arabic Texts from the First Century of the Hidjra till the Year 1000*. 2 vols. Cairo, 1905.

Müller-Wiener 1961
Wolfgang Müller-Wiener, "Mittelalterliche Befestigungen im südlichen Jonien." *Istambuler Mitteilungen* 11 (1961), pp. 5–122.

Müller-Wiener 1962
Wolfgang Müller-Wiener, "Die Stadtbefestigungen von Izmir, Siğacik and Çandarli: Bemerkungen zur mittelalterlichen Topographie des nördlichen Jonien." *Istambuler Mitteilungen* 12 (1962), pp. 59–164.

Mundo and Sánchez Mariana 1976
Ascario M. Mundo and Manuel Sánchez Mariana, *El comentario de Beato al Apocalípsis: catálogo de los códices*. Madrid, 1976.

Munich 1982
Bayerische Staatsbibliothek München, *Das Buch im Orient: Handschriften und kostbare Drucke aus zwei Jahrtausenden*, exh. cat. Wiesbaden, 1982.

Nasr 1964
Seyyed Hossein Nasr, *An Introduction to Islamic Cosmological Doctrines*. Cambridge, Mass., 1964.

Navarro Palazón 1986a
Julio Navarro Palazón, *La cerámica esgra-*

fiada andalusí de Murcia / La céramique hispano-arabe à decor esgrafié de Murcie. Publications de la Casa de Velázquez, Etudes et Documents, 2. Madrid, 1986.

Navarro Palazón 1986b
Julio Navarro Palazón, *La cerámica islámica en Murcia*, exh. cat. Vol. 1, *Catálogo*. Murcia, 1986.

Navarro Palazón 1987
Julio Navarro Palazón, "Nuevas aportaciones al estudio de la loza dorada Andalusí: el ataifor de Zavellà." In *Les Illes Orientals d'Al-Andalus i les seves relacions amb Sharq Al-Andalus, Magrib i Europa cristiana (ss. VIII–XIII): V Jornades d'Estudis Històrics Locals*, edited by G. Rosselló Bordoy, pp. 225–38. Palma de Mallorca, 1987.

Navarro Palazón 1991
Julio Navarro Palazón, *Una casa islámica en Murcia: estudio de su ajuar (siglo XIII)*. Islam y arqueología, 1. Murcia, 1991.

Navascués 1959
Joaquín M.ª de Navascués, "Los sueldos hispano-árabes: catálogo de las primitivas monedas arábigo-españolas de oro que guardan el Museo Arqueológico Nacional y el Instituto de Valencia de Don Juan en Madrid." *Numario Hispánico* 8 (1959), pp. 5–66.

Navascués y de Palacio 1964a
Jorge de Navascués y de Palacio, "Una escuela de eboraria, en Córdoba, de fines del siglo IV de la Héjira (XI de J.C.) o, Las inscripciones de la arqueta hispano-musulmana llamada de Leyre." *Al-Andalus* 29 (1964), pp. 199–206.

Navascués y de Palacio 1964b
Jorge de Navascués y de Palacio, "Una joya del arte hispano-musulmán en el Camino de Santiago." *Príncipe de Viana* 25 (1964), pp. 239–46.

Nice 1982
Musée National Message Biblique Marc Chagall, Nice. *Le temple: représentations de l'architecture sacrée*. Paris, 1982.

Niño y Más 1942
Felipa Niño y Más, *Antiguos tejidos artísticos españoles*. Cartilla de artes industriales, 2. [Madrid], 1942.

North 1986
J. D. North, *Horoscopes and History*. Warburg Institute Surveys and Texts, 13. London, 1986.

North 1989
J. D. North, *Stars, Minds, and Fate: Essays in Ancient and Medieval Cosmology*. London and Ronceverte, 1989.

Nuremberg 1983
Germanisches Nationalmuseum, Nuremberg, *Treasures of Astronomy: Arabic and German Instruments of the German National Museum*, edited by J. Willers and K. Holzamer. Nuremberg, 1983.

Nykl 1941
A. R. Nykl, *Historia de los amores de Bayad y Riyad: una "chantefable" oriental en estilo persa (Vat. Ar. 368)*. New York, 1941.

Ocaña Jiménez 1931
Manuel Ocaña Jiménez, "Capiteles de la residencia califal de Medīnat az-Zahrāʾ: estudios de sus inscripciones." *Boletín de la Academia de Ciencias, Bellas Letras y Nobles Artes de Córdoba* 10, no. 32 (1931), pp. 215–26.

Ocaña Jiménez 1936–39
Manuel Ocaña Jiménez, "Capiteles epigrafiados de Madīnat al-Zahrāʾ." *Al-Andalus* 4 (1936–39), pp. 158–66.

Ocaña Jiménez 1940
Manuel Ocaña Jiménez, "Capiteles fechados del siglo X." *Al-Andalus* 5 (1940), pp. 437–49.

Ocaña Jiménez 1942
Manuel Ocaña Jiménez, "La Basílica de San Vicente y la Gran Mezquita de Córdoba: nuevo examen de los textos." *Al-Andalus* 7 (1942), pp. 347–66.

Ocaña Jiménez 1945
Manuel Ocaña Jiménez, "Inscripciones árabes descubiertas en Madīnat al-Zahrāʾ en 1944." *Al-Andalus* 10 (1945), pp. 154–59.

Ocaña Jiménez 1970
Manuel Ocaña Jiménez, *El cúfico hispano y su evolución*. Cuadernos de Historia, Economía y Derecho hispano-musulmán, 1. Madrid, 1970.

Ocaña Jiménez 1985
Manuel Ocaña Jiménez, "Los supuestos bronces califales del Museo Arqueológico Provincial de Córdoba." *Actas de las II jornadas de cultura arabe e islamica (1980)*, pp. 405–33. Madrid, 1985.

Oliver Hurtado 1875
José Oliver Hurtado and Manuel Oliver Hurtado, *Granada y sus monumentos árabes*. Málaga, 1875.

Otto-Dorn 1967
Katharina Otto-Dorn, *L'art del Islam*. Paris, 1967.

Pach 1925
Pere Pach, "El Bisbat de Roda." *Butlletí Excursionista de Catalunya* nos. 361–62 (1925), pp. 181–202.

Palacio Real
Archivo del Palacio Real, Madrid. History Section, box 321, file 19.

Palladio 1738
Andrea Palladio, *The Four Books of Architecture*. Translated by Isaac Ware. 1738. Reprint. New York, 1965.

Palma de Mallorca 1991
Museo de Mallorca, *El tresor d'època almohade*, exh. cat. Palma de Mallorca, 1991.

Paris 1971
Orangerie des Tuileries, *Arts de l'Islam des origines à 1700 dans les collections publiques françaises*, exh. cat. Paris 1971.

Paris 1973
Bibliothèque Nationale, *Trésors d'Orient*, exh. cat. Paris, 1973.

Paris 1977
Grand Palais, *L'Islam dans les collections nationales*, exh. cat. Paris, 1977.

Paris 1987
Institut du Monde Arabe, *Splendeur et majesté: corans de la Bibliothèque Nationale*, exh. cat. Paris, 1987.

Paris 1989
Musée du Louvre, *Arabesques et jardins de paradis: collections françaises d'art islamique*, exh. cat. Paris, 1989.

Paris 1990
Musée du Petit Palais, *De l'empire romain aux villes impériales: 6000 ans d'art au Maroc*, exh. cat. Paris, 1990.

Partearroyo 1977
Cristina Partearroyo, "Spanish-Moslem Textile." *Bulletin de Liaison du Centre International d'Etude des Textiles Anciens* 45, no. 1 (1977), pp. 78–85.

Partearroyo 1982
Cristina Partearroyo, *Historia de las artes aplicadas e industriales en España*. Arte Catedra. Madrid, 1982.

Partearroyo Lacaba 1991
Cristina Partearroyo Lacaba, *La seda en España; leyenda, poder y realidad*. Museo Textil de Tarrasa. Tarrasa, 1991.

Pastor and Rosselló Bordoy forthcoming
X. Pastor and G. Rosselló Bordoy. "Naves andalusíes en cerámicas mallorquinas." *Trabajos del Museo de Mallorca*. Forthcoming.

Patrologia Latina
Patrologiae cursus completus: series latina, edited by J.-P. Migne. 221 vols. Paris, 1844–64.

Pauty 1931
Edmond Pauty, *Catalogue général du Musée Arabe du Caire: les bois sculptés jusqu'à l'époque ayyoubide*. Cairo, 1931.

Pavón Maldonado 1966a
Basilio Pavón Maldonado, *Memoria de la excavación de la mezquita de Madīnat al-Zahrāʾ*. Excavaciones Arqueológicas en España, 50. Madrid, 1966.

Pavón Maldonado 1966b
Basilio Pavón Maldonado, "Nuevos capiteles hispano-musulmanes en Sevilla (contribución al corpus del capitel hispano-musulmán)." *Al-Andalus* 31 (1966), pp. 353–72.

Pavón Maldonado 1972
Basilio Pavón Maldonado, "La loza doméstica de Madīnat al-Zahrāʾ." *Al-Andalus* 37 (1972), pp. 191–227.

Pavón Maldonado 1973
Basilio Pavón Maldonado, *Arte toledano: islámico y mudéjar*. Madrid, 1973.

Pavón Maldonado 1975a
Basilio Pavón Maldonado, *El arte hispano-musulmán en su decoración geométrica (una teoría para un estilo)*. Madrid, 1975.

Pavón Maldonado 1975b
Basilio Pavón Maldonado, *Estudios sobre la Alhambra*. I, *La Alcazaba, El Palacio*

de los Abencerrajes, Los accesos a la Casa
Real Vieja, El Palacio de Comares, El
Partal. Granada, 1975.

Pavón Maldonado 1977
Basilio Pavón Maldonado, Estudios sobre
la Alhambra. II, El Generalife, Torre de la
Cautiva, El Cuarto de los Leones, Puertas
y torres de la Alhambra (siglo XIV), Las
columnas en la arquitectura nazarí, De-
coración mural pintada, Conclusión: la
Qubba del Islam occidental. Granada, 1977.

Pavón Maldonado 1981
Basilio Pavón Maldonado, El arte hispano-
musulmán en su decoración floral. Ma-
drid, 1981.

Pavón Maldonado 1982
Basilio Pavón Maldonado, Alcalá de Hen-
ares medieval: arte islámico y mudéjar.
Madrid, 1982.

Pavón Maldonado 1984a
Basilio Pavón Maldonado, Guadalajara
medieval: arte y arqueología árabe y
mudéjar. Madrid, 1984.

Pavón Maldonado 1984b
Basilio Pavón Maldonado, "Jaén medieval:
arte y arqueología árabe y mudéjar." Al-
Qantara 5 (1984), pp. 329–66.

Pavón Maldonado 1986
Basilio Pavón Maldonado, "Arte, símbolo
y emblemas en la España musulmana."
Al-Qantara 6 (1986), pp. 397–450.

Pavón Maldonado and Sastre 1969
Basilio Pavón Maldonado and Felisa Sastre,
"Capiteles y cimacios de Medīnat al-Zahrā'
tras las últimas excavaciones (hacia un
corpus del capitel hispano-musulman)."
Archivo Español de Arte 42 (1969),
pp. 155–83.

Pedersen et al. 1990
J. Pedersen et al., "Minbar." In The
Encyclopaedia of Islam. 2d ed. Vol. 7,
pp. 73–80. Leiden, 1990.

Pellat 1986
Charles Pellat, Cinq calendriers égyptiens.
Textes arabes et études islamiques, 26.
Cairo, 1986.

Peña 1978
J. Peña, Los marfiles de San Millán de la
Cogolla. Logroño, 1978.

Percy sale 1825
L. J. J. Dubois, Catalogue des antiquités,
armures, armes . . . qui composaient la col-
lection de feu M. le Baron Percy, sale cat.
Paris, 1825.

Percy sale 1829
Catalogue des armures et armes diverses
composant la collection formée origin-
airement par feu M. le Baron Percy, et
complétée par M. D[urand], sale cat. Paris,
1829.

Pérès 1953
Henri Pérès, La poésie andalouse en arabe
classique au XIème siècle: ses aspects
généraux, ses principaux thèmes et sa
valeur documentaire. 2d ed. Paris, 1953.

Philon 1980

Helen Philon, Islamic Art, exh. cat. Benaki
Museum. Athens, 1980.

Pita Andrade 1967
José Manuel Pita Andrade, Los tesoros de
España. Geneva, 1967.

Porcella 1988
Maria Francesca Porcella, "La ceramica."
In Roberto Concas et al., Pinacoteca
Nazionale di Cagliari: catalogo, vol. 1,
pp. 177–202. Cagliari, 1988.

Poulle 1986
Emmanuel Poulle, "L'Astrolabe." La
Recherche no. 178 (1986), pp. 756–65.

Presedo Velo 1964
Francisco Presedo Velo, La fortaleza nubia
de Cheikh Daud, Tumas (Egipto).
Memorias de la Misión Arqueológica
Española en Nubia, 4. Madrid, 1964.

Price 1955
Derek J. Price, "An International Check-
list of Astrolabes." Archives internatio-
nales d'histoire des sciences 34 (1955),
pp. 243–63, 362–81.

Prieto y Vives 1926
Antonio Prieto y Vives, Los Reyes de
Taifas: Estudio histórico-numismático de
los musulmanes españoles en el siglo V de
la Hégira (XI de J. C.). Madrid, 1926.

Prieto y Vives 1935
Antonio Prieto y Vives, "Temas de compo-
sición de los taracistas musulmanes: el
lazo de doce." Investigación y Progreso 9
(1935), pp. 206–7.

Pryor and Ballabarba 1990
John H. Pryor and Sergio Ballabarba,
"The Medieval Muslim Ships of the Pisan
Bacini." The Mariner's Mirror 76, 2 (1990),
pp. 99–113.

Puertas Tricas 1989
Rafael Puertas Tricas, La cerámica islámica
de cuerda seca en la Alcazaba de Málaga.
Málaga, 1989.

Puig 1985
Roser Puig, "Concerning the Safiha
Shakkāziya." Zeitschrift für Geschichte
der Arabisch-Islamischen Wissenschaften
2 (1985), pp. 123–39.

Puig 1986
Roser Puig, Al-šakkāziyya—Ibn al
Naqqāš al-Zarqālluh: edición, traducción
y estudio. Barcelona, 1986.

Puig 1989
Roser Puig, "A Geometric Device Used by
al-Zarqālluh for the Computation of Lunar
Parallax." In Science and Political Order/
Wissenschaft und Staat: Proceedings of
the Symposium of the XVIII International
Congress of History of Science at Hamburg-
Munich, 1.–9. August 1989, edited by
F. Krafft and C. J. Scriba, sect. P2, no. 14.
Bochum, 1989.

Pyhrr and Alexander 1984
S[tuart] W. P[yhrr] and D[avid] G.
A[lexander], "Parade Helmet." The Metro-
politan Museum of Art: Notable Acquisi-
tions 1982–1984, pp. 21–22. New York, 1984.

Qaddumi 1990
Ghada Hijjawi Qaddumi, "A Medieval
Islamic Book of Gifts and Treasures: Trans-
lation, Annotation, and Commentary on
the Kitāb al-Hadāyā wa al-Tuhaf." Ph.D.
diss., Harvard University, 1990.

Rada y Delgado 1874
Juan de Dios de la Rada y Delgado, "Arco
del mihrab de la antigua mezquita de
Tarragona." In Museo Español de Antigüe-
dades, edited by Juan de Dios de la Rada
y Delgado, vol. 3, pp. 471–80. Madrid,
1874.

Ramírez de las Casas-Deza 1837
Luis María Ramírez de las Casas-Deza,
Indicador cordobés, o sea resumén de las
noticias necesarias a los viajeros y curiosos
para tomar conocimiento de la historia,
antigüedades, producciones naturales e
industriales y objetos de las bellas artes
que se conservan en la ciudad de Córdoba,
especialmente en su iglesia catedral.
Córdoba, 1837.

Renaud 1937
H. P. J. Renaud, "Les Ibn Bāso." Hespéris
24 (1937), pp. 1–12.

Retuerce and Zozaya 1986
Manuel Retuerce and Juan Zozaya, "Var-
iantes geográficas de la cerámica omeya
andalusí: los temas decorativos." In La
ceramica medievale nel mediterraneo occi-
dentale: atti del III Congreso Internatio-
nale, Siena-Faenza, 1984, pp. 69–128.
Florence, 1986.

Retuerce Velasco and Lozano García 1986
Manuel Retuerce Velasco and Isidoro
Lozano García, "Calatrava la Vieja: pri-
meros resultados arqueológicos." In Actas
del I Congreso de Arqueología Medieval
Española, Huesca, 1985, vol. 3, pp. 57–75.
Zaragoza, 1986.

Retuerce Velasco and Zozaya forthcoming
Manuel Retuerce Velasco and Juan Zozaya,
"Un sistema defensivo autosuficiente:
Calatrava la Vieja." In Actas del III Con-
greso de Arqueología Medieval Española,
Oviedo, 1989. Forthcoming.

Reuther 1938
Oscar Reuther, "Parthian Architecture.
A: History." In A Survey of Persian Art,
edited by Arthur Upham Pope, vol. 1, pp.
411–44. London and New York, 1938.

Revilla Vielva 1932
Ramón Revilla Vielva, Catálogo de las
antigüedades que se conservan en el Patio
Arabe del Museo Arqueológico Nacional.
Madrid, 1932.

Riaño 1879
Juan F. Riaño, The Industrial Arts of
Spain. South Kensington Museum Art
Handbooks. London, 1879.

Ribera i Gómez 1986
Agusti Ribera i Gómez, "En Castell
d'Alpont (Valencia): noticia sobre restos
constructivos de época Califal." In Actas
del I Congreso de Arqueología Medieval

Española, Huesca, 1985, vol. 3, pp. 249–79. Saragossa, 1986.

Ricard 1925
Prosper Ricard, *L'art de la reliure et de la dorure*. Arabic text by Abou el-Abbas Ben Mohammed es-Sofiani. 2d ed. Paris, 1925.

Ricard 1933
Prosper Ricard, "Reliures marocaines du XIIIᵉ siècle: notes sur des spécimens d'époque et de tradition almohades." *Hespèris* 17 (1933), pp. 109–27.

Ricard 1934
Prosper Ricard, "Sur un type de reliure des temps almohades." *Ars Islamica* 1 (1934), pp. 74–79.

Rice 1965
David Talbot Rice, *Islamic Art*. New York and Washington, D.C., 1965.

Rico y Sinobas 1863–67
Manuel Rico y Sinobas, ed., *Libros del Saber de Astronomía del Rey D. Alfonso X de Castilla*. 5 vols. Madrid, 1863–67.

Rivero 1933
Casto M.ª del Rivero, *La moneda arábigo-española: compendio de numismática musulmana*. Madrid, 1933.

Rivero and Mateu y Llopis 1935
Casto M.ª del Rivero and Felipe Mateu y Llopis, *Museo Arqueológico Nacional, adquisiciones en 1933–1934: colecciones de numismática y glíptica*. Madrid, 1935.

Rodríguez Lorente 1963
Juan José Rodríguez Lorente, "Las dagas o puñales de oreja: su origen hispanoárabe." *Archivo Español de Arte* 36 (1963), pp. 119–30.

Rodríguez Lorente 1964
Juan José Rodríguez Lorente, "The XVth Century Ear Dagger: Its Hispano-Moresque Origin." *Gladius* 3 (1964), pp. 67–87.

Rodríguez Lorente and Ibn Ḥāfiẓ Ibrāhīm 1985
Juan José Rodríguez Lorente and Tawfīq Ibn Ḥāfiẓ Ibrāhīm. *Aportación a la numismática hispano musulmana: las láminas inéditas de Don Antonio Delgado*. Madrid, 1985.

Román Riechmann 1986
Carmen Román Riechmann, "Aproximación histórica-arqueológica al castillo de Fuengirola." In *Actas del I Congreso de Arqueología Medieval Española, Huesca, 1985*, vol. 3, pp. 405–26. Zaragoza, 1986.

Rome 1987
Palazzo Venezia, *Anatolia: immagini di civiltà —tesori dalla Turchia*, exh. cat. Rome, 1987.

Rosenberg 1972
Marc Rosenberg, *Geschichte der Goldschmiedekunst auf technischer Grundlage*. Osnabrück, 1972.

Rosenthal 1971
Franz Rosenthal, "A Note on the Mandīl." In *Four Essays on Art and Literature in Islam*, pp. 63–99. Vol. 2 of *The L. A.*

Mayer Memorial Studies in Islamic Art and Archaeology, edited by R. Ettinghausen and O. Kurz. Leiden, 1971.

Rosenthal 1986
Franz Rosenthal, "Laʿib." In *Encyclopaedia of Islam*. 2d ed. Vol. 5, pp. 615–16. Leiden, 1986.

Ross 1940
Marvin Chauncey Ross, "An Egypto-Arabic Cloisonné Enamel." *Ars Islamica* 7 (1940), pp. 165–67.

Rosselló Bordoy 1978a
G. Rosselló Bordoy, *Decoración zoomórfica en las islas orientales de Al-Andalus*. Palma de Mallorca, 1978.

Rosselló Bordoy 1978b
G. Rosselló Bordoy, *Ensayo de sistematización de la cerámica árabe en Mallorca*. Palma de Mallorca, 1978.

Rosselló Bordoy 1985
G. Rosselló Bordoy, "Notes en torn al castell reial de Madina Mayurqa." *Quaderns de Ca la Gran Cristiana* 4 (1985).

Rosselló Bordoy 1986
G. Rosselló Bordoy, "Mallorca: Comercio y cerámica a lo largo de los siglos X al XIV." In proceedings of *II Coloquio Internacional de Cerámica Medieval en el Mediterraneo Occidental, Toledo 1981*, pp. 193–238. Madrid, 1986.

Rosselló Bordoy 1987
G. Rosselló Bordoy, "Algunas observaciones sobre la decoración céramica en verde y manganeso." *Cuadernos de Madīnat al-Zahrāʾ* 1 (1987), pp. 115–37.

Rosselló Bordoy 1991
G. Rosselló Bordoy, *El nombre de las cosas en el al-Andalus: una propuesta de terminología cerámica*. Palma de Mallorca, 1991.

Roux 1982
Jean-Paul Roux, *Etudes d'iconographie islamique: quelques objects numineux des Turcs et des Mongols*. Cahiers Turcica. Paris and Louvain, 1982.

Roxburgh 1991
David Roxburgh, "Umayyad Inscriptions." Master's thesis, University of Pennsylvania, 1991.

Rubiera 1988
María Jesús Rubiera, *La arquitectura en la literatura árabe: datos para una estética del placer*. 2d ed. Madrid, 1988.

Ruggles 1990
D. Fairchild Ruggles, "The Mirador in Abbasid and Hispano-Umayyad Garden Typology." *Muqarnas* 7 (1990), pp. 73–82.

Ruggles 1991
D. Fairchild Ruggles, "Madīnat al-Zahrāʾ's Constructed Landscape: A Case Study in Islamic Garden and Architectural History." Ph.D. diss., University of Pennsylvania, 1991.

Ruibal 1984
Amador Ruibal, *Calatrava la Vieja: estudio de una fortaleza medieval*. Ciudad Real, 1984.

Ruibal 1985
Amador Ruibal, "Castro Ferral, las Navas y Baños de la Encina: tres enclaves islámicos de la Alta Andalucia." In *Homenaje al Profesor Garzón Pareja*, pp. 285–301. N.p., 1985.

Sadan 1976
J. Sadan, *Le mobilier au Proche Orient medieval*. Leiden, 1976.

Sadek 1990
Noha Sadek, "Patronage and Architecture in Rasulid Yemen, 626–858 a.h./1229–1454 a.d." Ph.D. diss., University of Toronto, 1990.

Samsó 1981
Julio Samsó, "Instrumentos científicos." In Vernet et al., *Historia de la ciencia árabe*, pp. 97–126. Madrid, 1981.

Samsó 1981–82
Julio Samsó, "Ibn Hišām al-Lajmī y el primer jardín botánico en al-Andalus." *Revista del Instituto Egipcio de Estudios Islamicos en Madrid* 21 (1981–82), pp. 135–41.

Samsó 1987
Julio Samsó, "Sobre el tratado de la azafea y de la lámina universal: intervención de los colaboradores alfonsíes." *Al-Qantara* 8 (1987), pp. 29–43.

Samsó 1990
Julio Samsó, "En torno al problema de la determinación del acimut de la alquibla en al-Andalus en los siglos VIII–X: estado actual de la cuestión e hipótesis de trabajo." In *Homenaje a Manuel Ocaña Jiménez*. Córdoba, 1990.

Samsó 1992
Julio Samsó, *Las ciencias de los antiguos en Al-Andalus*. Madrid, 1992.

Sánchez Ferrer 1986
José Sánchez Ferrer, *Alfombras antiguas de la Provincia de Albacete*. Albacete, 1986.

Sánchez Trujillano 1976
María Teresa Sánchez Trujillano, "Las torres de Covarrubias y Noviercas." *Revista de Archivos, Bibliotecas y Museos* 79 (1976), pp. 665–82.

Sánchez Trujillano 1986
María Teresa Sánchez Trujillano, "Catálogo de los tejidos medievales del M[useo] A[rqueológico] N[acional] II." *Boletín del Museo Arqueológico Nacional* 4, no. 1 (1986), pp. 91–116.

Santa Cruz 1985
Convento de San Francisco, Santa Cruz de la Palma. *Instrumentos astronómicos en la España medieval/Astronomical Instruments in Medieval Spain*, exh. cat. Santa Cruz de Tenerife, 1985.

Santos Jener 1951
Samuel de los Santos Jener, *Guía del Museo Arqueológico Provincial de Córdoba*. Madrid, 1951.

Santos Jener 1952
Samuel de los Santos Jener, "Botella de

cerámica hispanomusulmana con representaciones humanas." *Al-Andalus* 17 (1952), pp. 401–2.

Santos Jener 1955–57
Samuel de los Santos Jener, "Las piezas árabes de latón de la plazuela de Chirinos." *Memoria de los Museos Arqueológicos Provinciales* 16–18 (1955–57), pp. 190–93.

Sarre and Martin 1912
Friedrich Sarre and F. R. Martin, eds. *Die Ausstellung von Meisterwerken muhammedanischer Kunst in München, 1910.* 3 vols. Munich, 1912.

Sarthou Carreras 1947
Carlos Sarthou Carreras. *El Museo Municipal de Játiva.* 1947. Reprint. Valencia, 1987.

Sauvaget 1949
Jean Sauvaget, "Sur le minbar de la Kutubiya de Marrakech." *Hespéris* 36 (1949), pp. 313–19.

Savage-Smith 1985
Emilie Savage-Smith, *Islamic Celestial Globes: Their History, Construction, and Use,* with a chapter on iconography by Andrea P. A. Belloli. Smithsonian Studies in History and Technology, 46. Washington, D.C., 1985.

Scerrato 1966
Umberto Scerrato, *Metalli islamici.* Milan, 1966.

Scerrato 1979
Umberto Scerrato, "Arte islamica in Italia." In Francesco Gabrieli and Umberto Scerrato, *Gli arabi in Italia: cultura, contatti e tradizioni,* pp. 275–571. Milan, 1979.

Schacht 1954
Joseph Schacht, "Sur la diffusion des formes d'architecture religieuse musulmane à travers le Sahara." *Travaux de l'Institut de Recherches Sahariennes* 11 (1954), pp. 11–27.

Schacht 1957
Joseph Schacht, "An Unknown Type of Minbar and Its Historical Significance." *Ars Orientalis* 2 (1957), pp. 149–73.

Seco de Lucena Paredes 1958
Luís Seco de Lucena Paredes, "La Torre de las Infantas en la Alhambra: sobre sus inscripciones y la fecha de su construcción." *Miscelánea de estudios árabes y hebraicos* 7 (1958), pp. 145–48.

Seco de Lucena Paredes 1960
Luís Seco de Lucena Paredes, *Los Abencerrajes: leyenda e historia.* Granada 1960.

Sédillot 1841
L. A. Sédillot, *Mémoire sur les instruments astronomiques des Arabes: mémoires présentés à l'Académie Royale des Inscriptions et Belles Lettres, I. série,* vol. 1 (1841). Reprint. Frankfurt am Main, 1989.

Seitz 1965
H. Seitz, *Blankwaffen: Geschichte und Typenentwicklung im europäischen Kulturbereich von der prähistorischen Zeit bis zum Ende des 16. Jahrhunderts.* Brunswick, 1965.

Sénac and Esco 1991

Philippe Sénac and Carlos Esco, "Le peuplement musulman dans le district de Huesca (VIIIᵉ– XIIᵉ siècles)." In *La marche supérieure d'al-Andalus et l'occident chrétien,* pp. 51–65. Publications de la Casa de Velázquez, Archéologie, 15. Madrid, 1991.

Serjeant 1951
Robert Bertram Serjeant, "Materials for a History of Islamic Textiles up to the Mongol Conquest." *Ars Islamica* 15–16 (1951), pp. 29–85.

Serjeant 1972
Robert Bertram Serjeant, *Islamic Textiles: Materials for a History up to the Mongol Conquest.* Beirut, 1972.

Serrano García 1988
Carmen Serrano García, "Los jarrones de la Alhambra." In *Estudios dedicados a Don Jesús Bermúdez Pareja,* pp. 127–62. Granada, 1988.

Sezgin 1991
Fuad Sezgin, *Arabische Instrumente in orientalischen Studien.* 2 vols. Frankfurt, 1991.

Shepard 1972
Sanford Shepard, "Islamic Monuments in Christian Hands." *Islamic Culture* (Hyderabad) 46 (1972), pp. 293–95.

Shepherd 1943
Dorothy G. Shepherd, "The Hispano-Islamic Textiles in the Cooper Union Collection." *Chronicle of the Museum for the Arts of Decoration of the Cooper Union* 1, no. 10 (1943), pp. 357–401.

Shepherd 1951
Dorothy G. Shepherd, "A Twelfth-Century Hispano-Islamic Silk." *The Bulletin of the Cleveland Museum of Art* 83, no. 3, (1951), pp. 59–62.

Shepherd 1955
Dorothy G. Shepherd, "Two Hispano-Islamic Silks in Diasper Weave." *The Bulletin of the Cleveland Museum of Art* 42, no. 1 (1955), pp. 6–10.

Shepherd 1957
Dorothy G. Shepherd, "A Dated Hispano-Islamic Silk." *Ars Orientalis* 2 (1957), pp. 373–82.

Shepherd 1958
Dorothy G. Shepherd, "Two Medieval Silks from Spain." *The Bulletin of the Cleveland Museum of Art* 45, no. 1 (1958), pp. 3–7.

Shepherd 1978
Dorothy G. Shepherd, "A Treasure from a Thirteenth-Century Spanish Tomb." *The Bulletin of the Cleveland Museum of Art* 65, no. 4 (1978), pp. 111–34.

Shepherd and Vial 1965
Dorothy G. Shepherd and Gabriel Vial, "La Chasuble de St. Sernin." *Bulletin de Liaison du Centre International d'Etude des Textiles Anciens* 21 (1965), pp. 21–32.

Sherrill 1974
Sarah B. Sherrill, "The Islamic Tradition in Spanish Rug Weaving: Twelfth Through Seventeenth Centuries." *The Magazine Antiques* 105 (1974), pp. 532–49.

Sijelmassi 1987
Mohamed Sijelmassi, *Enluminures des manuscrits royaux au Maroc (Bibliothèque al-Hassania).* Paris, 1987.

Simonet 1872
Francisco J. Simonet, *Descripción del Reino de Granada sacada de los autores arábigos, 711–1492.* 2d ed. 1872. Reprint. Amsterdam, 1979.

Soler 1988
María Paz Soler, *Historia de la cerámica valenciana.* Vol. 2. Valencia, 1988.

Sotheby's 1990
Sotheby's, *Islamic Works of Art,* sale cat. London, April 25, 1990.

Sourdel-Thomine and Spuler 1973
Janine Sourdel-Thomine and Bertold Spuler, *Die Kunst des Islam.* With contributions by Klaus Brisch et al. Propyläen Kunstgeschichte, n.s. 4. Berlin, 1973.

Soustiel 1985
Jean Soustiel, *La céramique islamique.* Paris and Fribourg, 1985.

Spuhler 1978
Friedrich Spuhler, *Islamic Carpets and Textiles in the Keir Collection.* Translated by George and Cornelia Wingfield Digby. London, 1978.

Stern 1946
Henri Stern, "Notes sur l'architecture des châteaux omeyyades." *Ars Islamica* 11–12 (1946), pp. 72–97.

Stern 1976
Henri Stern, *Les mosaïques de la Grande Mosquée de Cordoue.* With contributions by Manuel Ocaña Jiménez and Dorothea Duda. Madrider Forschungen, 11. Berlin, 1976.

Stillman et al. 1986
Yedida K. Stillman et al. "Libās." In *Encyclopaedia of Islam.* 2d ed. Vol. 5, pp. 732–53. Leiden, 1986.

Strong 1937
Eugénie Strong, "Terra Mater *or* Italia?" *Journal of Roman Studies* 27 (1937), pp. 114–26.

Talbi 1966
Mohamed Talbi. *L'Émirat aghlabide, 184–296/800–909: histoire politique.* Paris, 1966.

Al-Tāzi 1972
ʿAbd al-Hādī al-Tāzi, *Jāmīʿ al-Qarawīyin/La mosque Al-Qaraouiyin.* 3 vols. Beirut, 1972.

Terrasse 1928
Henri Terrasse, "La grande mosquée almohade de Séville." In *Mémorial Henri Basset,* vol. 2, pp. 249–66. Paris, 1928.

Terrasse 1932
Henri Terrasse, *L'art hispano-mauresque des origines au XIIIᵉ siècle.* Publications de l'Institut des Hautes Etudes Marocaines, 25. Paris, 1932.

Terrasse [1942]
Henri Terrasse, *La Mosquée des Andalous à Fès.* Publications de l'Institut des Hautes-Etudes Marocaines, 38. Paris, [1942].

Terrasse 1944
　Henri Terrasse, *La Grande Mosquée de Taza*. Paris, 1944.

Terrasse 1957
　Henri Terrasse, "Minbars anciens du Maroc." In *Mélanges d'histoire et d'archéologie de l'occident musulman*. Vol. 2, *Hommage à Georges Marçais*, pp. 159–67. Algiers, 1957.

Terrasse 1961
　Henri Terrasse, "La reviviscence de l'acanthe dans l'art hispano-mauresque sous les Almoravides." *Al-Andalus* 26 (1961), pp. 426–35.

Terrasse 1963
　Henri Terrasse, "Chapiteaux oméiyades d'Espagne à la mosquée d'al-Qarawiyyīn de Fès." *Al-Andalus* 28 (1963), pp. 211–16.

Terrasse 1965a
　Henri Terrasse, "The Alhambra." In *Encyclopaedia of Islam*. 2d ed. Vol. 2, pp. 1016–20. Leiden, 1965.

Terrasse 1965b
　Henri Terrasse, "Notes sur l'art des reyes de Taifas." *Al-Andalus* 30 (1965), pp. 175–80.

Terrasse 1968
　Henri Terrasse, *La Mosquée al-Qaraouiyin à Fès*. Archéologie méditerranéenne, 3. Paris, 1968.

Terrasse 1969
　Henri Terrasse, "Crónica arqueológica de la España musulmana." *Al-Andalus* 34 (1969), pp. 409–17.

Terrasse 1976
　M. Terrasse, "Le mobilier liturgique mérinide." *Bulletin d'Archéologie Marocaine* 10 (1976), pp. 185–208.

Teruel 1988
　Museo Provincial de Teruel, *Exposición de arte, tecnología y literatura hispano-musulmanes*, exh. cat. II Jornadas de Cultura Islámica. Teruel, 1988.

Thomas 1977
　Bruno Thomas, "Aus der Waffensammlung in der Neuen Burg zu Wien: Orientalische Kostbarkeiten." *Gesammelte Schriften zur Historischen Waffenkunde*, pp. 185–204. Graz, 1977.

Thomas and Gamber 1976
　Bruno Thomas and Ortwin Gamber, *Katalog der Leibrüstkammer*. Part 1, *Der Zeitraum von 500 bis 1530*. Führer durch das Kunsthistorische Museum, 13. Vienna, 1976.

Thomas, Gamber, and Schedelmann 1965
　Bruno Thomas, Ortwin Gamber, and Hans Schedelmann. *Armi e armature europee*. Translated by Luisa Cavalli. Milan, 1965.

Thomas, Gamber, and Schedelmann 1974
　Bruno Thomas, Ortwin Gamber, and Hans Schedelmann. *Armi e armature europee*. Edited and translated by L. G. Boccia. Milan, 1974.

Toledo 1984
　Museo de Santa Cruz, Toledo. *Alfonso X*, exh. cat. Madrid, 1984.

Tornberg 1849
　C. J. Tornberg, *Codices Arabici, Persici et Turcici Bibliothecae Regiae Universitatis Upsaliensis*. Uppsala, 1849.

Torrella Niubó 1949
　Francisco Torrella Niubó, *Las colecciones del Museo Textil Biosca: breve historia del tejido artístico a través de una visita al museo*. Tarrasa, 1949.

Torres 1987
　C. Torres, "*Cerâmica Islâmica Portugesa*," exh. cat. Campo Arqueológico de Mértola. Mértola, 1987.

Torres Balbás 1926
　Leopoldo Torres Balbás, "Paseos por la Alhambra —una necrópoli nazarí: la Rauda." *Archivo Español de Arte y Arqueología* 2 (1926), pp. 261–85.

Torres Balbás 1931
　Leopoldo Torres Balbás, "El exconvento de San Francisco de la Alhambra." *Boletín de la Sociedad Española de Excursiones* 29 (1931), pp. 126–38, 206–15.

Torres Balbás 1934a
　Leopoldo Torres Balbás, "Monteagudo y 'El Castillejo', en la Vega de Murcia." *Al-Andalus* 2 (1934), pp. 366–72. Reprinted in Torres-Balbás 1981, vol. 1, pp. 25–31.

Torres Balbás 1934b
　Leopoldo Torres Balbás, "Pasadizo entre la Sala de la Barca y el Salón de Comares, en la Alhambra de Granada." *Al-Andalus* 2 (1934), pp. 377–80. Reprinted in Torres-Balbás 1981, vol. 1, pp. 36–39.

Torres Balbás 1934c
　Leopoldo Torres Balbás, "Plantas de casas árabes en la Alhambra." *Al-Andalus* 2 (1934), pp. 380–87. Reprinted in Torres-Balbás 1981, vol. 1, pp. 39–51.

Torres Balbás 1934d
　Leopoldo Torres Balbás, "El Puente del Cadí y la Puerta de los Panderos en Granada." *Al-Andalus* 2 (1934), pp. 357–64. Reprinted in Torres-Balbás 1981, vol. 1, pp. 18–25.

Torres Balbás 1935
　Leopoldo Torres Balbás, "Hojas de puerta de una alacena en el Museo de la Alhambra de Granada." *Al-Andalus* 3 (1935), pp. 438–42. Reprinted in Torres-Balbás 1981, vol. 1, pp. 118–22.

Torres Balbás 1945a
　Leopoldo Torres Balbás, "La mezquita real de la Alhambra y el baño frontero." *Al-Andalus* 10 (1945), pp. 197–214. Reprinted in Torres Balbás 1981, vol. 3, pp. 30–55.

Torres Balbás 1945b
　Leopoldo Torres Balbás, "Notas sobre Sevilla en la época musulmana." *Al-Andalus* 10 (1945), pp. 177–96. Reprinted in Torres-Balbás 1981, vol. 3, pp. 11–30.

Torres Balbás 1948
　Leopoldo Torres Balbás, "Dar al-ᶜArusa y las ruinas de palacios y albercas granadinos situados por encima del Generalife." *Al-Andalus* 13 (1948), pp. 185–203. Reprinted in Torres Balbás 1981, vol. 4, pp. 99–119.

Torres Balbás 1949
　Leopoldo Torres Balbás, *Arte almohade, arte nazarí, arte mudéjar*. Ars Hispaniae, 4. Madrid, 1949.

Torres Balbás 1951
　Leopoldo Torres Balbás, "Los Reyes Católicos en la Alhambra." *Al-Andalus* 16 (1951), pp. 185–205. Reprinted in Torres Balbás 1981, vol. 4, pp. 371–93.

Torres Balbás 1953
　Leopoldo Torres Balbás, *La Alhambra y el Generalife*. Madrid, 1953.

Torres Balbás 1957a
　Leopoldo Torres Balbás, "Almería islámica." *Al-Andalus* 22 (1957), pp. 411–53.

Torres Balbás 1957b
　Leopoldo Torres Balbás, "Arte califal." In *España musulmana hasta la caída del Califato de Córdoba (711–1031 de J. C.)*. Vol. 5 of *Historia de España*, edited by Ramón Menéndez Pidal, pp. 333–829. Madrid, 1957.

Torres Balbás 1958
　Leopoldo Torres Balbás, "Patios de crucero." *Al-Andalus* 23 (1958), pp. 171–92.

Torres Balbás 1959
　Leopoldo Torres Balbás, "Cronología de las construcciones de la Casa Real de la Alhambra." *Al-Andalus* 24 (1959), pp. 400–408.

Torres Balbás 1960a
　Leopoldo Torres Balbás, "Las puertas en recodo en la arquitectura militar hispano-musulmana." *Al-Andalus* 25 (1960), pp. 419–41.

Torres Balbás 1960b
　Leopoldo Torres Balbás, "En torno a la Alhambra: el tiempo y los monumentos arquitectónicos." *Al-Andalus* 25 (1960), pp. 203–19.

Torres Balbás 1967
　Leopoldo Torres Balbás, "Diario de obras en la Alhambra: 1925–1926." *Cuadernos de la Alhambra* 3 (1967), pp. 125–52.

Torres Balbás [1971]
　Leopoldo Torres Balbás, *Ciudades hispano-musulmanas*. Introduction and conclusion by Henri Terrasse. Madrid [1971]. 2d ed. [reprint], Madrid, 1985.

Torres Balbás 1981
　Leopoldo Torres Balbás, *Obra dispersa—I. Al-Andalus: Crónica de la España musulmana*, compiled by Manuel Casamar. 5 vols. Madrid, 1981.

Trias 1982
　Miquel Trias, "Notícia preliminar del jaciment islàmic de la Cova dels Amagartalls." *Quaderns de Ca la Gran Cristiana* 1. Palma de Mallorca, 1982.

Tunis 1986
　Institut National d'Archéologie et d'Art. *30 ans au service du Patrimoine: de la Carthage des Phéniciens à la Carthage de Bourguiba*, exh. cat. Tunis, 1986.

Uppsala 1982
　Universitetsbibliotek, *Koranen*, exh. cat. Uppsala, 1982.

Uranga Galdiano and Iñíguez Almech 1971
　José Esteban Uranga Galdiano and Francisco Iñíguez Almech, *Arte medieval na-*

varro. Biblioteca Caja de Ahorros de Navarra, 1. Pamplona, 1971.

Valdés Fernández 1984
Fernando Valdés Fernández, "Kalifale Lampen." *Madrider Mitteilungen* 25 (1984), pp. 208–21.

Valdés Fernández 1985
Fernando Valdés Fernández, *La Alcazaba de Badajoz: I. Hallazgos islámicos (1977–1982) y testar de la Puerta del Pilar*. Excavaciones Arqueológicas en España, 144. Madrid, 1985.

Valencia de Don Juan 1898
Conde Viudo de Valencia de Don Juan, *Catálogo histórico-descriptivo de la Real Armería de Madrid*. Madrid, 1898.

Vallejo Triano 1990
A. Vallejo Triano, "La vivienda de servicios y la llamada Casa de Yaʿfar." In *La casa hispano-musulmana: aportaciones de la arqueología*. Granada, 1990.

Velázquez Bosco 1912
Ricardo Velázquez Bosco, *Madina Azzahra y Alamiriya*. Madrid, 1912.

Vernet 1975
Juan Vernet, *Historia de la ciencia española*. Madrid, 1975.

Vernet 1983
Juan Vernet, ed., *Nuevos estudios sobre astronomía española en el siglo de Alfonso X*. Barcelona, 1983.

Vernet et al. 1981
Juan Vernet et al., *Historia de la ciencia árabe*. Madrid, 1981.

Viada Rubio 1987
María Rosario Viada Rubio, "El castillo de Guadalerzas: I. Estudio histórico." *Castillos de España* 93 (1987), pp. 35–40.

Vial 1983
Gabriel Vial, "Analyse technique de la tapisserie num. 29.782." Archives du Centre International d'Etude des Textiles Anciens, Lyons, 1983. Typescript.

Viladrich and Martí 1983
Mercè Viladrich and Ramón Martí, "Sobre el *Libro dell Ataçir* de los *Libros del Saber de Astronomía* de Alfonso X el Sabio." In *Nuevos estudios sobre astronomía española en el siglo de Alfonso X*, edited by Juan Vernet, pp. 75–100. Barcelona, 1983.

Vilchez Vilchez 1988
Carlos Vilchez Vilchez, *La Alhambra de Leopoldo Torres Balbás*. Granada, 1988.

Villanueva 1935
Antolín P. Villanueva, *Los ornamentos sagrados en España: su evolución histórica y artística*. Barcelona and Buenos Aires, 1935.

Villanueva 1851
Jaime Villanueva, *Viaje literario a las iglesias de España*. Madrid, 1851.

Villard de Honnecourt 1986
Villard de Honnecourt, *Carnet de Villard de Honnecourt, d'après le manuscrit conservé à la Bibliothèque de Paris (no. 19093)*. Edited and with texts by Alain Erlande-Brandenburg, Régine Pernoud,

Jean Gimpel, and Roland Bechmann. Paris, 1986.

Viñez Millet 1982
Cristina Viñez Millet, *La Alhambra de Granada*. Córdoba, 1982.

Vives 1893
Antonio Vives, "Arqueta arábiga de Gerona." *Boletín de la Sociedad Española de Excursiones* 1, no. 8 (1893), pp. 99–100.

Vives y Escudero 1892
Antonio Vives y Escudero, *Catálogo de las monedas arabigo-españolas que se conservan en el Museo Arqueológico Nacional*. Madrid, 1892.

Vives y Escudero 1893
Antonio Vives y Escudero, *Monedas de las dinastías arábigo-españolas*. 1893. Reprint. Madrid, 1984.

Volbach 1969
Wolfgang Friederich Volbach, "Etoffes espagnoles du Moyen-Age et leur rapport avec Palerme et Byzance." *Bulletin de Liaison du Centre International d'Etude des Textiles Anciens* 30 (1969), pp. 23–24.

Walker 1956
John Walker, *A Catalogue of the Muhammadan Coins in the British Museum*. Vol. 2, *A Catalogue of the Arab-Byzantine and Post-Reform Umaiyad Coins*. London, 1956.

Wardwell 1983
Anne E. Wardwell, "A Fifteenth-Century Silk Curtain from Muslim Spain." *The Bulletin of the Cleveland Museum of Art* 70, no. 2 (1983), pp. 58–72.

Wardwell 1988–89
Anne E. Wardwell, "*Panni tartarici*: Eastern Islamic Silks Woven with Gold and Silver (13th and 14th Centuries)." *Islamic Art* 3 (1988–89), pp. 95–173.

Washington, D.C., 1989
Islamic Science and Learning, exh. cat. High Commission for the Development of Arriyadh. Washington, D.C., 1989.

Wasserstein 1985
David Wasserstein, *The Rise and Fall of the Party-Kings: Politics and Society in Islamic Spain, 1002–1086*. Princeton, N.J., 1985.

Watson 1983
Andrew M. Watson, *Agricultural Innovation in the Early Islamic World: The Diffusion of Crops and Farming Techniques, 700–1100*. Cambridge and New York, 1983.

Weibel 1952
Adèle Coulin Weibel, *Two Thousand Years of Textiles: The Figured Textiles of Europe and the Near East*. New York, 1952.

Welch 1979
Anthony Welch, *Calligraphy in the Arts of the Muslim World*, exh. cat. Asia House Gallery. New York, 1979.

Williams 1908
Leonard Williams, *The Arts and Crafts of Older Spain*. 3 vols. Chicago and Edinburgh, 1908.

Williams 1977
John Williams, *Frühe spanische Buchmalerei*. Munich, 1977.

Wulff 1966
Hans E. Wulff, *The Traditional Crafts of Persia: Their Development, Technology, and Influence on Eastern and Western Civilizations*. Cambridge, Mass., and London, 1966.

Zaki 1957
ʿAbd al-Raḥmān Zakī, "Al-Nuqūsh al-zukhrufiya wa-l-kitābāt ʿalā-l-suyūf al-islāmīya." *Revista del Instituto Egipcio de Estudios Islámicos en Madrid* 5 (1957), pp. 227–39. Synopsis in Spanish, "Las escrituras e inscripciones ornamentales sobre las espadas islámicas," pp. 278–79.

Zozaya 1967
Juan Zozaya, "Ensayo de una tipología y de una cronología." *Archivo Español de Arte* 40 (1967), pp. 133–54.

Zozaya 1980
Juan Zozaya, "Aperçu général sur la céramique espagnole." In *La céramique médiévale en Méditerranée occidentale, Xe–XVe siècles: actes du colloque international, Valbonne, 1978*, pp. 265–96. Paris, 1980.

Zozaya 1981a
Juan Zozaya, "Aproximación a la cronología de algunas formas cerámicas de época de Taifas." In *Actas de las Primeras Jornadas de Cultura Arabe e Islámica, Madrid, 1978*, pp. 277–86. Madrid, 1981.

Zozaya 1981b
Juan Zozaya, "Cerámica andalusí." In T. Sánchez-Pacheco et al., *Cerámica esmaltada española*, pp. 35–50. Barcelona, 1981.

Zozaya 1984a
Juan Zozaya, "El proceso de islamización en la Provincia de Soria." In proceedings of *I Symposio de Arqueología Soriana, Soria, 1984*, pp. 481–95. Soria, 1984.

Zozaya 1984b
Juan Zozaya, "Islamic Fortificacions in Spain: Some Aspects." *British Archaeological Report* 193 (1984), pp. 636–73.

Zozaya 1986
Juan Zozaya, "Arqueta andalusí." In *Thesaurus/Estudis: l'art als Bisbats de Catalunya, 1000–1800*, exh. cat., pp. 26–27. Barcelona, 1985.

Zozaya 1988
Juan Zozaya, "De torres y otras defensas." *Arevacón* 14 (1988), pp. 6–9.

Zozaya and Fernández Uriel 1983
Juan Zozaya and P. Fernández Uriel, "Excavaciones en la fortaleza de Qalʿat ʿAbd al-Salam (Alcalá de Henares, Madrid)." *Noticiario Arqueológico Hispánico* 17 (1983), pp. 411–529.

Zozaya and Rosselló Bordoy forthcoming
Juan Zozaya and G. Rosselló Bordoy, *Los candelabros en bronce de tipo arquitectónico en Al-Andalus*. Forthcoming.

Zozaya and Soler forthcoming
Juan Zozaya and Alvaro Soler, "Castillos de planta cuadrangular." In *Actas del III Congreso de Arqueología Medieval Española, Oviedo, 1989*. Forthcoming.

Index

Alcazar de los Austrias, Madrid, 68
Alcazar of al-Mubārak, Seville, 179
Alcira, 76
Alcoba de la Torre, tower fortification at, 65
Alcocer, west of San Esteban de Gormaz, 68
Alcubilla del Marqués, tower fortifications at, 65
Aledo, castle of, 75
Aleppo, 53, 382
Alfonsine tables, 180, 182
Alfonso (infante of Aragon), 112, 328
Alfonso I, the Battler (king of Aragon), 76
Alfonso VI (king of León and Castile), 75, 181
Alfonso VII (king of León and Castile), 107, 328;
 pillow cover of, 108
Alfonso VIII (king of Castile), 77, 110, 112, 113,
 174, 182, 321, 326, 328, 385, 390
Alfonso IX (king of León), 321, 326
Alfonso X, the Learned (king of León and Castile),
 175, 182, 183, 185, 228, 286, 334
Alfonso XIII (king of Spain), 288
Alfonso de la Cerda, 334; coffin lining of, 336;
 pillow cover of, 334; No. 96
Algeciras, 131
Algeria, 115
Algiers, Great Mosque of, 85–86, 87; 86, 87
Alhambra, the, 185
 access to Granada from, 155–56
 Acequia Real, 153, 161
 administrative area in, 158
 aerial view, 126
 Albaicín quarter in, 128, 154
 Albercones, 153
 Alcazaba, 68, 128, 129, 133, 148, 153–55, 156,
 160, 169; 128, 129, 155
 Almohad building tradition followed by, 156
 analogy between decorative motifs used at and
 Qurʾan manuscript decoration, 117
 apartments for the sultan's wives at, 140, 141
 aqueduct constructed for, 128, 153, 160, 161, 170
 archaeological excavations at, 155, 159, 160
 architectural decoration at, 117, 121, 129–30,
 131, 137, 138, 139, 141, 143–44, 145, 169,
 335, 338, 368, 370, 375
 architectural forms at, 317
 areas and buildings outside the walls of, as
 integral part of, 153, 157
 ʿAyn Dār ʿĀʾisha, 170
 Barrio Castrense, 154, 160
 baths of, 129, 130, 141, 147, 148, 150, 159
 Cadi (also called Candil) tower, 130
 Calle de Ronda (Calle del Foso), 159, 161; 158
 Callejón del Compás, 160
 Callejón del Guindo, 160
 Calle Mayor, see Calle de Ronda
 Calle Real Alta, 159–61
 Calle Real Baja, 159
 El Campo de los Mártires, outside the walls of, 153
 canopy used at, 137–38, 139
 Casa Real, 129; Nueva, 147; Vieja, 135, 147
 Cauchiles, 160
 ceiling decoration at, 139, 143, 146, 368; 142,
 143; No. 116; see also domes at
 ceramic decoration at, 117; see also tile work at
 ceramics from, 101, 103, 112; see also Alhambra
 vases
 Charles V's private quarters at, see Palacio de
 Carlos V
 under Christian rule, 131–33, 141, 148, 149,
 150–51, 157, 159, 160, 161, 168
 cisterns at, 159, 160
 compared to: Alcazaba, Almería, 169; Alcazaba,
 Málaga, 169; Castillejo of Monteagudo,
 Murcia, 169; Madīnat al-Zahrāʾ, 168, 169

congested atmosphere of, 135
construction, reconstruction, and repair of, 127,
 128–33, 157, 158, 161, 375
courtyard areas of, 135, 136, 140, 141, 142, 146,
 149, 154, 156, 158, 159
Cuarto Dorado, see Patio del Cuarto Dorado
as cultural center, 135
Dār al-ʿArūsa, see Palacio de la Desposada
destruction of, 135, 146, 148–49, 150
difficulty in establishing chronology for, 129,
 130–31
domes (cupolas) at, 144, 145–46, 150; see also
 ceiling decoration at
early history of, 127
easy penetration of, in battle, 127
faience decoration at, 145
financing for, 129
fountains of, 140, 142, 168, 169, 211, 270;
 sculpture for, 168, 270
frescoes (wall painting) at, 140, 147; see also
 paintings in
gardens of, 140, 144, 146, 147, 148, 163, 168,
 169–70; 162; addition of, in modern times,
 159; the Generalife, servicing, 153; post-
 Islamic, 170
gates of, 130, 155–57, 159; 156, 157
Generalife (summer villa), outside the walls of,
 128, 133, 147, 149, 150, 153, 157, 169, 170;
 162; stucco panel from, 370; 371; No. 117
Granada protected by, 155
hygiene at, 148
industrial and artisanal areas of, 159–60
inscriptions, 141, 183; as architectural decora-
 tion, 129–30, 131, 139, 141, 143–44, 145,
 169; on ceramic floor tiles, 139; on foun-
 tains, 169; as means of gaining informa-
 tion, 129–30, 131; poetry written as, for
 specific sites, 143–44; as program of ex-
 planation for architecture and gardens of,
 169; in stucco decoration, 139
Ismāʿīl I, as patron of, 129, 130, 135, 141
lamp for the mosque of, 276–77; 277; No. 57
madrasa at, 159, 160
medina (qaṣba) area within, 153, 157, 159, 160
Mexuar, 129–30, 131, 135, 158, 338, 375; 138
Mezquita Real, 129
mihrab at, 140, 150
military areas of, 153–54, 161; see also Alcazaba
Mirador de Lindaraja, 145, 169, 170; 145
miradors at, 140, 144, 145, 147, 148, 149, 169,
 170, 317
modeled after Madīnat al-Zāhira, 129
modeled after Madīnat al-Zahrāʾ, 129
modest proportions of original castle, 127
Morisco artisans, as repairmen for, 132, 375
mosaics from, 129, 375; 375; No. 119
mosques of, 129, 147, 159, 160, 161; bath of,
 159; lamp for, 276–77; 277; No. 57
Muḥammad I ibn al-Aḥmar, as patron of,
 128–29
Muḥammad II, as patron of, 129
Muḥammad III, as patron of, 129, 149
Muḥammad V, as patron of, 129, 130–31, 135,
 141, 142, 146, 149, 150, 158, 335, 338, 368
Muḥammad VII, as patron of, 131, 149, 151
Napoleon's destruction of, 132, 157, 160, 161
Naṣrid construction and control of, 127, 129,
 133, 135, 145, 154–55, 157, 160, 168, 169,
 170, 361
national monument, declaration as, 132–33
necropolis at, 129, 159
never conquered militarily, 131, 153
Oratorio, 129

orientation of, to landscape and vistas, 135, 144,
 169, 170
original castle of, 127, 128
paintings in, 140, 228, 284, 297, 299; see also
 frescoes at
palace areas of, 135–51, 153, 157–58, 159, 161,
 168; plan, 136–37
palace facade, as most highly decorated wall in,
 137, 138
Palacio de Carlos V, 129, 132, 135, 141, 146, 147,
 150, 155, 159, 160, 161, 170
Palacio de Comares, 130, 131, 132, 135–41, 142,
 144, 145, 146–48, 150, 158; 134, 138, 139
Palacio de Ismāʿīl, 158
Palacio de la Desposada (Dār al-ʿArūsa), 153
Palacio del Conde de Tendilla, 148–49, 150
Palacio del Convento de San Francisco, 146,
 147, 149, 158, 159, 160
Palacio de los Abencerrajes, 129, 149–50, 158,
 159, 160, 161
Palacio de los Alijares, outside the walls of, 153
Palacio de los Leones, 135, 140, 142–46, 147,
 149, 150, 158, 159, 160, 335, 368; 141–43, 145
Palacio del Partal, see Partal
Palacio de Yūsuf III, 158, 159
Parador de San Francisco, 159
Partal, 129, 147–48, 158, 159, 160, 170, 228,
 284; 148; Torre de las Damas, 153, 170,
 368; No. 116
Patio de Comares, 132, 135, 140, 141; 134, 138
Patio de la Madraza de los Príncipes, 158
Patio de la Reja, 140, 141
Patio del Cuarto Dorado, 135, 136, 137–38, 140,
 169, 375; 139
Patio del Harén, 147
Patio de Lindaraja, 145, 146, 147
Patio de los Arrayanes, 131, 375; see also Patio
 de Comares
Patio de los Leones, 131, 142, 150, 168, 169,
 170, 211, 270
Patio de Machuca, 158, 375
Patio of la Daraja, 170
Persian influence on, 142
Placeta de las Pablas, 161
plans, 129, 146, 153–61; 130, 136–37
plasterwork, see stucco decoration from
Plaza de Armas, 154
Plaza de los Aljibes, 155
preservation of, as act of royal patrimony, 132
preservation of, by the state, 132–33
protocol of the sultan, reflected in architectural
 forms at, 135, 136, 137–38, 139, 140
public buildings at, 159
public plaza in, 155
Puerta de Hierro, 157
Puerta de la Justicia (Puerta de la Explanada),
 130, 138, 140, 150, 155, 156–57, 159, 161;
 131
Puerta del Arrabal, 155, 157, 160, 161; 156
Puerta de las Armas, 150, 155–56, 157; 156
Puerta de las Granadas, 157
Puerta de la Tahona, 156
Puerta del Compás, 160
Puerta de los Carros, 161
Puerta del Vino, 129, 156, 159, 370; 156
Puerta de Siete Suelos, 130, 150, 155, 157, 160,
 161
Puerta Real, 156, 159
Rauda, 129, 144–45, 150, 159, 160
red clay, used for the original construction of,
 127
Renaissance palace carved into, 25, 135, 146,
 170; see also Palacio de Carlos V

Raḥmān III, 190, 191, 192, 199; No. 2;
inscriptions on, 45, 58; Palencia, 58, 204,
206, 219; *205, 206*; No. 7; Pamplona, 42,
43, 198–200, 202, 261; *40, 200, 201*; No. 4;
panel from, 203; No. 6; of San Millán, 229
(textile lining of, 229, 230; *228*; No. 23);
Tortosa, 265; No. 51
Castell Formós, Balaguer, 67
Castellón: Villareal, 68
Castile, Spain, 77, 178, 181, 185, 370
Castilian language, 175
Castillejo, Mesleón, 66
Castellejo de los Guájares excavations, Granada,
101
Castillejo of Monteagudo, Murcia, 68, 76–77,
146, 165, 167, 169, 170, 171; aerial view, *76*;
plan, 68, 77; *76*
Castillete de ʿAmra, 68
Castillo, Alonso de, 150
Castillo de Santa Elena, outside the Alhambra,
see Silla del Moro
Castillo Real, Majorca, 67
castles, as military structures, 63, 65, 67–68; *see
also* fortifications
Catalonia, 76, 175, 230
Catharism, 180
Cauchiles, the Alhambra, 160
ceiling decoration, 139, 143, 146, 368; *142, 143*;
No. 116
celestial globe (attributable to Ibrāhīm ibn Saʿīd
al-Sahlī), 378; No. 121
celosías (window screens), 252, 254; No. 42
Cendoya, Modesto, 150
censers, 196
Centre International d'Études des Textiles An-
ciens (CIETA), Lyons, 106
ceramics, 97–103; from Albaicín, 360; from
Alcalá de Henares, 238, 240; from the
Alhambra, 101, 103, 112; Alhambra vases,
103, 112, 354–59; *96, 355, 357, 359*; Nos.
110–12; from Alicante, 97; from Almería,
101; Almohad period, 99, 100, 101, 346, 350,
351, 353; Nos. 103, 106, 107, 109; Almohad
period(?), 347; No. 104; Almoravid period,
99–100, 348; No. 105; Almoravid period(?),
237, 347; Nos. 30, 104; from Andalusia, 97,
100; from Antequera, 357; in Arabo-Berber
period, 97; as architectural decoration, 117,
238; artistic independence and diversity, of
workshops in, 98–99, 100, 101; *ataifors*, 56,
232, 237, 238, 350; Nos. 25, 30, 32, 33, 106;
from Badajoz, 99; from the Balearic Islands,
99, 100; bases for water jars, 352; No. 108;
blue-and-gold ware, 101, 103; bottles, 233,
347; Nos. 26, 104; bowls, 56, 99, 232, 233,
234–40, 346, 350, 361; Nos. 25, 28–33, 103,
106, 114; Byzantine work, effect on, 97, 98;
from Calatrava, 99, 237; caliphal period, 44,
46, 97, 98, 99, 101, 177, 232, 233, 234, 236,
355; *178*; Nos. 25–29; caliphal period(?),
237; No. 30; carriers, 352; Chinese influence
on, 98; Christian imitations of, 101, 103;
compared to Persian, 235; as containers for
fragrances, 43; from Córdoba, 98, 233, 234;
cuerda seca technique, 56, 99, 238, 240, 348;
decoration of, 97, 98, 99, 100, 101, 347; from
Denia, 100, 219, 240; from Deniya, 347;
discovered in cave of *dels amagatalls*, 346,
350; distribution of, 101; domestic, 98, 101,
352; drinking vessel, 351; No. 107; Egyp-
tian influence on, 235; emirate, 97; *estamp-
illado* technique, 100–101; excavated at
Mazzara del Vallo, Sicily, 354; exportation

of, 101, 103; Fāṭimid, 237, 350; foreign
influences on, 97, 98; glazing techniques for,
97–98, 99, 101, 234, 236, 237, 238, 240, 346,
351; from Granada, 101, 103, 235; green-
and-manganese ware, 44, 98, 99, 232, 233,
234, 236, 237, 238; green-and-white ware,
98, 101; imported, 99, 347; inscriptions on,
98, 100, 232, 302, 348, 350, 351, 353, 354,
355, 356, 358, 359, 360; from Iran, 236;
from Iraq, found at Madīnat al-Zahrāʾ, 44;
44; jars, 234, 348, 352, 353; Nos. 27, 105,
109; jug, 352; No. 108; lusterware, 44, 97,
99, 101, 103, 232, 233, 234, 237, 238, 345,
346, 350, 360; *44, 102*; Nos. 25–27, 30, 31,
103, 106; as luxury art, 44, 270; from
Madīnat al-Zahrāʾ, 98, 99, 232, 233, 235,
236, 355; from Majorca, 99, 101, 236, 238,
361; from Málaga, 99, 101, 103, 240, 345,
361; Málaga ware, 101, 103; from Medina
Elvira (Ilbira), 98, 233, 234, 235, 236; from
Mértola, 101; from Mesopotamia, 236; mo-
tifs, compared with metalwork, 219; motifs,
symbolism of, 352; Mudejar, 101, 352; from
Murcia, 99, 100, 101, 346, 351, 352; Naṣrid,
101, 103, 354, 356, 357, 358, 360, 361; *102,
355, 357, 359*; Nos. 110–14; naturalism, as
uncommon aspect of, 235, 236; from
Navarra, 99, 237; partial *cuerda seca* tech-
nique, 99–100; from Paterna, 352; Persian
influence on, 98, 235; pipe bowls, 177; *178*;
from Portugal, 236; post-Almohad period,
352; No. 108; pre-Islamic antecedents of,
97; relationship to metalwork, 219, 351;
resemblance of, to Syrian, 345; Roman
influence on, 97, 98; from Saragossa, 99;
sgraffito technique, 100, 101, 237, 346, 350,
351, 353, 360, 361; symbiosis of cultural
influences coming together in, 97, 98; sym-
bolism in the color choices for, 98, 232;
tableware, 98, 101; *Taifa* period, 98, 99, 101,
238, 240; Nos. 31–33; *Taifa* period(?), 237;
No. 30; techniques of, 56, 97, 98, 99, 100–101,
234, 236, 237, 238, 240, 346, 347, 348, 350,
351, 353, 360, 361; from Toledo, 99; from
Toledo, imported to Denia, 56; from Tudela,
99, 237; from Valencia, 99, 100, 101, 103,
236, 240, 348, 361; variety of shapes of, 100,
101; vases, 103, 112, 354–59; *96, 355, 357,
359*; Nos. 110–12; Visigothic influence on,
97; *see also* tile work
Cereijo, Purificación, 327
Cerro del Sol, near the Alhambra, 153
Ceuta, Morocco: as center for papermaking, 124;
illustrated manuscript from, 123
Charlemagne, 5
Charles (archduke of Austria), 132
Charles I (Holy Roman Emperor), 375
Charles III (king of Spain), 132, 150
Charles IV (king of Spain), 132
Charles V (Holy Roman Emperor), 25, 81, 132,
141; quarters at the Alhambra converted for,
132, 146, 147, 170; *see also* Palacio de Carlos
V, the Alhambra
Charrilla hoard, 222, 301; coins from, 220;
jewelry from, 45, 220, 301; No. 17
chasubles, 108, 318, 331, 336; *319*; No. 87; from
Provins, cathedral at, 107; of San Juan de
Ortega, 106, 320; *107*; of San Valero, 332,
333; No. 95
chess, game of, 175–76
chests, Morisco, 373; *see also* pyxides
China: ceramics from, 98; papermaking originat-
ing in, 176; textiles from, 344

Chinchilla, 342
Christians, of the Iberian Peninsula: adoption of
Muslim customs and culture by, 6, 176;
advance of, checked by Almohads, 173; ad-
vance of, checked by Almoravids, 173, 181;
advances of, into al-Andalus, 56, 57, 63, 68,
75, 85, 95, 100, 101, 173, 174, 181; the
Alhambra, under control of, 131–33, 141,
148, 149, 150–51, 157, 159, 160, 161, 168;
allegiance of, to center outside of Spain, 7;
artistic forms of, shared with Muslims, 207;
attempts of, to delve into Muslim thoughts
and beliefs, 182; carpets produced for, 342;
ceramics imitated by, 101, 103; church towers
of, destroyed, 18; coins minted by, 385;
conflicts of, with Muslims, 3, 17, 18; conver-
sion to Islam by, 4, 6, 21, 22; Coptic, 207;
difference in perception, between Muslims
and, 4; eastern Arabic influence on, 184;
effect of advances of, on fortifications, 63,
68; emigration of, after the Muslim con-
quest, 176; equilibrium and coexistence with
Muslims and, 6, 8, 11, 19, 21; expulsion of all
Muslims by, 186; expulsion of, by Almora-
vids, 174, 181; increasing power of, during
Taifa period, 49; influence of, on develop-
ment of Islamic iconography, 22–23; Jewish
converts to (Marranos), 186; languages spo-
ken by, 174–75; late Roman scientific works
in Latin used by, 175; metalwork and, 209,
295; Mudejars tolerated by, 186; Muslim
converts to (Moriscos), 186; under Muslim
rule, 176–77; original culture created by, in
al-Andalus, 7; persecution of Muslims and
Jews by, 185, 186; pressure of, on *Taifa*
kingdoms, 56; reassertion of power by, 6;
role of bishops in the influence of, 7; scientific
study relegated to Arabs by, 185–86; secular
dimensions to, 163; slavery and, 24; swords
used by, 282; tolerance of Muslim authori-
ties toward, 176–77; as zealots, under
Muslim rule, 176
Chu Ssu-pen, 182
Cid, the, 76
CIETA, *see* Centre International d'Études des
Textiles Anciens
circuses, 183
Cisneros (cardinal), 276
Ciudad Real, fortifications at, 71
clepsydras, 180
clocks, 180
cloisonné enamels: on arms, 286, 287, 290, 294,
295, 298; on jewelry, 222, 302
Codex Vigilanus, 176
coffin cover of María de Almenar, 112, 324–25;
325; No. 91
coffin cross of Enrique I, 113
coffin linings, 112; of Alfonso de la Cerda, 336; of
Fernando de la Cerda, 112
Cogolludo, tower fortification at, 65
coiffure, art of, 42
coins, 384–91; Almohad period, 385, 389–90;
Nos. 132–34; Almohad period(?), 300;
Almoravid period, 385, 389; No. 131;
Almoravid period(?), 300; Arab-Latin
series, 384; bilingual, 384; caliphal period,
178, 213, 384, 387; No. 128; Christian
minting of, 385; dating of, 384; dinar or
maravedi, 390; No. 133; dinars, 384, 385,
386, 387, 388, 389–90, 391; Nos. 126, 128,
129, 131, 132, 135, 136; dirhams, 384, 385,
387, 390; Nos. 127, 134; doblas, 385; emir-
ate, 384, 387; No. 127; Fāṭimid influence

tunics, 107–8, 330–31; *108, 331*; No. 94;
Turkish patterns, as influence on, 342, 344,
345; veils, 225–26, 328; No. 21; vestments,
111, 112, 113, 328, 332–33; *113, 333*; No. 95
third-dinars, 384
Thomas Aquinas (saint), 185
Tignarī, al-, 181
tile work: at the Alhambra, 139, 144; Almohad,
80–81, 82; Fortuny tile, 360–61; No. 113; at
Madīnat al-Zahrāʾ, 39; motifs of, related to
textiles, 335; Naṣrid, 101, 360–61; *102*; No.
113
Tinmal, 87; as Almohad capital, 77, 87; mosque
at, 87–89, 92–93, 94; reconstruction of
ground plan with geometric scheme, *88*;
reconstruction model by J.P. Wisshak, *89*;
ruin of, view from north, *88*; eastern
muqarnas dome, *90*; transverse arcade in
front of south (qibla) wall, *89*; view from
court toward mihrab, *89*
ṭirāz textiles, 105, 109, 218, 224, 226, 270
Tlemcen: Almohad occupation of, 77; Great
Mosque of, 76, 86, 367
Toledan tables, 180
Toledo, 3, 4, 177, 182; aerial view, *62*; Almohad
occupation of, 77; architectural decoration
from, 204, 255, 257, 258, 259, 260; astrono-
mers working in, 380; Bāb al-Mardūm,
mosque at, 86; capitals from, 257, 258, 259;
No. 47; cathedral at, textiles from, 108, 228,
264, 327; as ceramics center, 99; ceramics
from, imported to Denia, 56; Christian con-
quest of, 75, 173, 178, 181, 219; coins minted
at, 384, 385, 390; commercial relations of,
with Denia, 56; Cuenca under control of, in
Taifa period, 206; emigration from Córdoba
to, after fall of caliphate, 178; fortifications
at, 63, 70; garden at, 181; metalwork from,
214, 219; palace of al-Maʾmūn at, 259, 260;
patronage of Cuenca by, 204, 206; rivalry
of, with Saragossa, 57, 204; as scientific
center, 181; *Taifa* rule of, 6, 52, 204, 219;
Visagra Vieja, 70, 71; *71*; Visigothic library
at, 177
Toledo in the Hizam, castle at, 67
Tongiorgi, Enzo, 238
Torre de Abūʾl-Ḥajjāj, the Alhambra, 130, 131,
146; *133*; *see also* Torre del Peinador de la
Reina, the Alhambra
Torre de Comares, Palacio de Comares, the
Alhambra, 130, 138, 146, 150
Torre de la Barba, the Alhambra, 161
Torre de la Cautiva, the Alhambra, 130, 149, 150,
161; *149*
Torre de la Contaduría, the Alhambra, 149, 150
Torre del Adarguero, Alcazaba, the Alhambra,
155
Torre del Agua, the Alhambra, 160, 161
Torre del Andador, Albarracín, tower fortification,
65
Torre de las Damas, Partal, the Alhambra, 153,
170; cupola ceiling from, 368; No. 116
Torre de las Infantas, the Alhambra, 131, 149, 150,
151, 161; *149*
Torre de la Tahona, the Alhambra, 156
Torre de la Vela, the Alhambra, 127, 154, 155, 156;
155
Torre del Cabo de la Carrera, the Alhambra, 161
Torre del Candil, the Alhambra, 161
Torre del Cubo, the Alhambra, 156
Torre del Homenaje, Alcazaba, the Alhambra,
129, 154; *129*
Torre del Oro, Seville, 70, 71, 80; *82*

Torre de los Abencerrajes, the Alhambra, *see*
Torre de la Contaduría, the Alhambra
Torre de los Picos, the Alhambra, 130, 147, 157,
160, 161
Torre del Peinador de la Reina, the Alhambra, 71,
130, 146; *133*; *see also* Torre de Abūʾl-Ḥajjāj,
the Alhambra
Torre de Muḥammad, the Alhambra, 161
Torre Hueca, Alcazaba, the Alhambra, 155
Torreiro Luengo, Carlos, 327
Torre Quebrada, Alcazaba, the Alhambra, 155
Torres Balbás, Leopoldo, 129, 131, 140, 141, 142,
145, 150, 171, 360
Torres Bermejas, outside the Alhambra, 153
Tortosa casket, 265; No. 51
Toulouse, France, 4: Saint Sernin, 108, 318
Tours, France, 4
towers, as fortifications, 65–67; *65, 66*
tower minarets, 17–18
treasure of La Mora Lucena, Córdoba, perfume
bottle from, 213; No. 12
Troyes, Chrétien de, 179–80
Trujillo: castle at, 67; fortifications at, 63, 70, 72;
70
Tuaregs, 181
Tudela: ceramics from, 99, 237; fortifications at,
64
Ṭūlūnid dynasty, 85
tunics: of Don García (infante), 107–8; *108*; of
Don Rodrigo Ximénez de Rada, 330–31;
331; No. 94
Tunisia, 5, 115, 238, 249, 355
Turks, 184; patterns used by, as influence on
textiles, 342, 344, 345

ʿUbaydullāh (Fāṭimid caliph), 27
Ubeda, 273
Ukhaydir, 68
Umayya Abūʾl-Ṣalt, 180
Umayyad dynasty, al-Andalus, 123; agricultural
transformation during, 163, 164; architec-
ture of, 17, 21–22, 23, 25, 85, 86, 89, 94;
artistic decline during, 252; artistic heritage
of, disseminated by the Almoravids and
Almohads, 85, 86, 89, 94; brevity of, 34;
Byzantium, as ally of, 5; capital of, 5; cen-
tralized system of government developed by,
5–6, 65; ceramics of, 98; coins minted by,
384, 386; Nos. 124–26; cultural superiority
felt by, 7–9; development of, after disso-
lution of ʿAbbāsid caliphate, 49; economic
development during, 163; equilibrium be-
tween Muslims and Christians maintained
by, 6; Fez controlled by, 249–50; fortifications
made during, 66, 67, 69, 70, 71; gardens and
garden estates, as tradition of, 47, 163, 164,
170; governors of, 4; establishment of, 5,
11; Great Mosque of Córdoba, as source of
identity for, 17; Great Mosque of Córdoba,
as symbolic link to the Syrian caliphate,
21–22, 23, 25; history of, 5; independence
of, from the ʿAbbāsid dynasty, 175; influ-
enced by ʿAbbāsid dynasty, 7, 41–42, 45;
influenced by Ziryāb, 42; jewelry of, 302;
luxury arts of, 41, 42, 47; Madīnat al-Zahrāʾ,
importance of, 44–45; minarets constructed
by, 367; minbar heightened during, 366;
mythology of, 8–9; nostalgia for Syria
experienced by, 7, 15, 41; overthrow of, 166,
177; pageantry of the court life of, 45;
palaces of, 255; protocol for public audience
with sovereigns of, 34; shift of power be-

tween Fāṭimids and, 367; struggles with the
ʿAbbāsid dynasty, 7; symbolism of architec-
tural forms, as link to Islamic world for, 17,
21–22, 23, 25; trade with North Africa, 43;
urbanized countryside, as element of society
of, 68; wealth and culture created by, 7–8, 9;
white, as color symbolic of, 232; *see also*
caliphal period, emirate; Great Mosque of
Córdoba; Madīnat al-Zahrāʾ
Umayyad dynasty, Syria, 4; desert palaces of,
imitated by Aljafería, 57; empire established
by, 5; monuments and mosques built by,
14–15, 23, 115; overthrown by the ʿAbbāsids,
5, 11, 384; palace of, Jerusalem, 68; remem-
bered by, in al-Andalus, 7, 15, 41
ʿUmdat al-kuttāb waʿuddat dhawi al-albāb,
123–24
universal astrolabes, 382
universal disk, 180
universal plates: (Aḥmad ibn Ḥusayn ibn Bāṣo),
382; *383*; No. 123; (Muḥammad ibn
Muḥammad ibn Hudhayl), 180, 380–81,
382; *381*; No. 122
universities (madrasas), 184, 185, 279
Upper Garden, Madīnat al-Zahrāʾ, 34, 35, 164,
165–66, 170, 171; plan, *165*; view of, from
Salón Rico, *167*

Vajda, 185
Valencia, 76; Almoravids resisted by, 76; Bufilla
in Bétera, 66; as ceramics center, 99, 100,
101, 103, 236, 240, 348, 361; Christian con-
quest of, 107, 178, 184, 320; coins minted at,
384; Cullera, castle of, 69; fortifications at,
66, 72; hospitals introduced via, 184; manu-
scripts from, 83, 307; Qurʾan manuscripts
copied in, 83, 116–17, 118–19, 121, 122, 125,
306, 308; San Vicente, 184; *Taifa* rule of, 6;
Valero (saint), 328; vestments of, 112, 113, 328,
332–33; *113, 333*; No. 95
Vascos, Toledo, fortifications, 63, 70
vases, 357; Alhambra, 103, 112, 354–59; *96, 355,
357, 359*; Nos. 110–12
Vega, Murcia, 146
Vega tower, Madrid, 70
veils: of Hishām II, 44, 225–26; No. 21; of Saint
Eudald, 328
Velázquez Bosco, Ricardo, 31
vellum, 124
Venice: San Marco, 196
vestments: of Bernardo de Lacarre, 111; of Bishop
Gurb, 112; of San Valero, 112, 113, 328,
332–33; *113, 333*; No. 95
Viana, de (marqués), 291
Viana, Viuda de (marquesa), 288
Vic cathedral, Barcelona: textile fragment found
in tomb at, 320
Viète, François, 180
Vikings, 5, 9, 65
Villard de Honnecourt, 183
Villareal, Castellón, 68
Visagra Vieja, Toledo, 70; Puerta de Alcántara,
70, 71; *71*
Visigoths, 4, 8, 13, *133*, 177; battle of, with
Berbers, 173; ceramics of, 97; jewelry of,
221; relief sculpture of, 248
Vitruvius, 142
Vocabulista in arabico (Martí), 184

Wādiḥ, 209
Walīd, al- (Umayyad caliph, Syria), 22

Photograph Credits